MW00474630

CIVILIZING WOMEN

CIVILIZING WOMEN

British Crusades in Colonial Sudan

Janice Boddy

PRINCETON UNIVERSITY PRESS

PRINCETON AND OXFORD

COPYRIGHT © 2007 BY PRINCETON UNIVERSITY PRESS

PUBLISHED BY PRINCETON UNIVERSITY PRESS, 41 WILLIAM STREET,

PRINCETON, NEW JERSEY 08540

IN THE UNITED KINGDOM: PRINCETON UNIVERSITY PRESS, 3 MARKET PLACE,

WOODSTOCK, OXFORDSHIRE OX20 1SY

LIBRARY OF CONGRESS CATALOGING-IN-PUBLICATION DATA

BODDY, JANICE PATRICIA.

CIVILIZING WOMEN : BRITISH CRUSADES IN COLONIAL SUDAN / JANICE BODDY.

P. CM.

INCLUDES BIBLIOGRAPHICAL REFERENCES AND INDEX.

ISBN-13: 978-0-691-12304-2 (HARDCOVER) : ALK. PAPER)

ISBN-10: 0-691-12304-7

ISBN-13: 978-0-691-12305-9 (PAPERBACK : ALK. PAPER)

ISBN-10: 0-691-12305-5

1. WOMEN—SUDAN—SOCIAL CONDITIONS. 2. FEMALE CIRCUMCISION—SUDAN.

3. MUSLIM WOMEN—SUDAN. 4. ZAR—SUDAN. 5. SEX CUSTOMS—SUDAN.

6. GREAT BRITAIN—COLONIES—AFRICA—CULTURAL POLICY.

7. BRITISH—SUDAN. I. TITLE.

HQ1793.5.B637 2007

392.1—DC22

2006028289

BRITISH LIBRARY CATALOGING-IN-PUBLICATION DATA IS AVAILABLE

THIS BOOK HAS BEEN COMPOSED IN SABON

PRINTED ON ACID-FREE PAPER. ∞

PRESS.PRINCETON.EDU

PRINTED IN THE UNITED STATES OF AMERICA

1 3 5 7 9 10 8 6 4 2

In memory of my grandmother

Margaret Rushman Pougnet

Who was born in 1898 shortly after the Battle of Omdurman

And died in 2003 just before the Invasion of Iraq

CONTENTS

LIST OF ILLUSTRATIONS

ACKNOWLEDGMENTS

Had I realized at the start just how long and complicated this project would be, I might have run for the hills. That it is now at last concluded owes much to the intellectual generosity and practical kindnesses of numerous colleagues and friends. The research on which the book draws was funded by grants from the Social Sciences and Humanities Council of Canada (1990–91, 1996–2000), a Connaught Senior Research Fellowship from the University of Toronto (1994), an H. F. Guggenheim Foundation Research Fellowship (1998–99), and a faculty grant from the University of British Columbia. I gratefully acknowledge their support. A Rockefeller Foundation Bellagio Residency in 2003 provided a congenial atmosphere, a tower study, and much needed time to write and think.

Many people and institutions have facilitated the archival portions of this work by guiding me to documents, providing photocopies, locating copyright holders, and granting permissions. In particular I would like to thank El Haj Bilal Omer of the Institute of African and Asian Studies, University of Khartoum; Clare Cowling, Archivist, Royal College of Obstetricians and Gynaecologists, London; Shirley Dixon and Amanda Engineer, The Wellcome Library for the History and Understanding of Medicine, London; Maureen Watry and Katy Hooper, Special Collections (Rathbone papers), University of Liverpool; Susannah Rayner, SOAS Archives, London University; Ken Osborne, Church Missionary Society Archive, Birmingham University; Lucy McCann, Bodleian Library of Commonwealth and African Studies at Rhodes House, Oxford; Debbie Usher, Middle East Centre Archive, St. Anthony's College, Oxford; and the patient staffs of the National Records Office, Khartoum; Public Records Office, London; and the British Library. My warmest thanks are reserved for Jane Hogan of the Sudan Archive, Durham University, who remains the most invaluable help and fund of knowledge, and for the men and women who served in Sudan whose papers and photographs now reside in that remarkable collection.

I am delighted to thank Major General H.D.G. Butler for permission to quote from the letters of his father, Major S. S. Butler; Mrs. L. Poulter for permission to quote from the papers of S. R. Simpson; Mr. William Arber for permission to quote from the papers of H. B. Arber; and the daughter of Sir Harold MacMichael for permission to quote from her father's papers. I am grateful to the Bodleian Library for permission to

quote from the Gladys Leak papers; to the Sudan Archive, Durham University, for permission to quote from documents in its care and to reproduce the photographs in chapter 8 (figures 4–9); to the Church Missionary Society for permission to quote from the CMS Archives; and to the University of Liverpool for permission to quote from the papers of Eleanor Rathbone. Thanks also to Noah Salomon for permission to quote from his unpublished paper, "Undoing the Mahdiyya." Every effort has been made to locate potential copyright holders of other documents quoted in the text; in the event that someone has been missed, please contact me through the press.

I am forever grateful to the women from the Kabushiya and Gedo regions of northern Sudan for our continuing conversations, now by letter, telephone, and (who could have guessed?) even occasional e-mail. Julie Anderson, Ellen Gruenbaum, and Rogaia Abusharaf have also been wonderful for keeping us in touch. I owe a great deal to the indispensable efficiency and assistance of George Pagoulatos and family at the Acropole Hotel, Khartoum, and even more to Peter Shinnie without whom I would never have considered research in Sudan.

My intellectual debts are numerous, but I would especially like to thank Wendy James, Tom Csordas, Michael Lambek, and two anonymous reviewers for Princeton University Press, who read all of the manuscript save its conclusions and made countless valuable suggestions. Ronald Wright provided sound editorial advice. Thanks to the members of our erstwhile reading group in Toronto—Sandra Bamford, Charles Hirschkind, Michael Lambek, Saba Mahmood, Anne Meneley, and Andrew Walsh—for their criticisms, ideas, and support during the early stages of writing. All have contributed to its strengths; its faults are mine alone.

At the University of Toronto, Gail Currie and Camilla Gibb did yeoman's service in organizing and summarizing notes and archival photocopies, Hana Mijovic did outstanding work on sources, and Audrey Glasbergen helped in all the ways she does so well.

Draft sections of the book have been presented to audiences in several seminars and colloquia over the years, and I am grateful for their attention and remarks; they include the University of Edinburgh; University of Chicago; University of Toronto; University of British Columbia; Oxford University; Trent University; McGill University; the International Women's University in Hannover, Germany; the International Colloquium on African Ritual and Religion (aka Satterthwaite West); and meetings of the American Anthropological Association and Society for the Anthropology of Religion. Early versions of chapter segments have appeared in the following publications: *Transgressive Surfaces: Dirt, Undress, and Difference in Comparative Perspective*, Adeline Masquelier, ed., University of Indiana Press, 2005 (chapter 1); *Social Analysis*, 47(2), Special Issue: *Ill-*

ness and Irony, Michael Lambek and Paul Antze, eds. (chapter 8); *Religion and Sexuality in Cross-Cultural Perspective*, Stephen J. Ellingston and M. Christian Green, eds., New York: Routledge, 2002 (chapter 4); *Rethinking Violence against Women*. R. Dobash and R. Dobash, eds., Thousand Oaks, California: Sage, 1998 (chapters 7, 12); *Pragmatic Women and Body Politics*, Margaret Lock and Patricia Kaufert, eds. Cambridge: Cambridge University Press, 1998 (chapter 12).

Thanks also to the following colleagues for their thoughtfulness, suggestions, and help at various stages of the project: Rogaia Abusharaf, Julie Anderson, Margot Badran, Heather Bell, Karen Brown, Stacei Burke, Jessica Cattaneo, Karen Colvard, Jean Comaroff, Marlene de Rios, Barbara Duden, Amal Fadlallah, Lesley Forbes, Claudie Gosselin, Larry Greenfield, Ellen Gruenbaum, Krystoff Grzymski, Kelly Hayes, Susan Kenyon, Douglas Johnson, Margaret Lock, Adeline Masquelier, Bill McKellin, David Pokotylo and my colleagues at U.B.C., Lesley Sharp, Rick Shweder, Jackie Solway, Brad Weiss, Judy Whitehead, and Alan Young. At Princeton I was delighted to begin work with Mary Murell, who acquired the book, and wish her success in her new career; thanks to Fred Appel for his patience and understanding. Thanks also to Dale Cotton, Marsha Kunin, and Maria denBoer for their contributions to the book.

Friends and family have kept me afloat through some difficult times and I am particularly grateful for their support. Carol, Bill, Dee, Don, Jackie, John, Judy, Linda, Marcia, Margot, Michael, Rosey, Sandy, the whole Port Hope crowd, my brothers and my mother, Pat—I can never thank you enough.

J. B.
Toronto
November 2006

ABBREVIATIONS

CMS Church Missionary Society (Anglican)
CO Colonial Office, London
CSM Church of Scotland Mission
CPCW Committee for the Protection of Coloured Women
 in the Colonies
DC District Commissioner
FGC female genital cutting
FGM female genital mutilation
FO Foreign Office, London
GTC Girls' Training College, Omdurman
KCA Kikuyu Central Association
MTS Midwives Training School, Omdurman
NCW National Council of Women of Great Britain
NRO National Record Office, Khartoum
SAD Sudan Archive, Durham University
SAR Sayyid ʿAbd al-Rahman al-Mahdi
SMS Sudan Medical Service
SNR Sudan Notes and Records
SPIS Sudan Political Intelligence Summaries
SPS Sudan Political Service
SWU Sudan Women's Union
WRL Wellcome Research Laboratories, Khartoum
WTRL Wellcome Tropical Research Laboratories, Khartoum

GLOSSARY

ʿâdat an-niswân	Women's customs.
amîr (emir)	Commander, leader of an army (also used for a hereditary political leader).
angarîb	Native bed, rectangular cot made of rope woven on a four-legged frame.
ansâr	Adherents, helpers, followers of the Mahdi; reference to the followers of the Prophet Muhammad in Medina who gave him refuge after the Hijra (migration from Mecca to Medina).
arûs az-zâr	"Bride of the *zâr*", woman who is the focus of a *zâr* ceremony.
awlad	Children, sons of.
awlad al-balad	Children of the country (normally, rural people).
awlad ʿamm	Children of brothers (paternal uncles).
awlad khalât	Children of sisters (maternal aunts).
darawîsh	Dervishes, typically refers to followers of a Sufi (mystical) order of Islam but generalized here to mean a follower of the Mahdi in Sudan.
daya	Midwife, pl. *dayat*.
effendi	Educated man, civil servant.
Fallata	West Africans, Nigerians.
garmosîs	Bridal veil, a cloth that is predominantly red and gold.
habl	Rope.
hajj	Pilgrimage to Mecca.
hôsh	Courtyard, normally surrounded by high mudbrick walls.
hukûma	Government.
jallâba	Merchants, typically identified as Arab and Muslim because they wear *jallabiya*s, the long kaftanlike garments of northern men.

jibba	Tunic made of homespun cotton and patched with colored cloth worn by male followers of the Mahdi as a mark of piety and poverty. In the later years of the Mahdist state the colors of the patches varied by regiment in the Mahdist army.
jihâd	Holy war.
jinn	"Spirits" or sprites, genies; like humans, *jinn* are creatures of Allah; they are sentient, have personalities, belong to families, tribes, and nations, are male or female, get married and have "children," grow old and die, though they live much longer than humans. *Jinn* are made of wind and fire; compared to humans they have extraordinary powers such as the ability to enter into a human body and thereby "possess" it.
khayt, khuyût	Thread/threads. In the context of *zâr* these are the personalized chants that are sung (or pulled) to entice a particular spirit to descend into the humans present.
kisra	Thin crepelike bread made of sorghum flour.
kuttâb	Elementary, preprimary vernacular school.
Maʾmur	Officer, policeman.
mushâhara	Ailments, cures and prophylactics having to do with excessive loss of uterine blood. See also *ʿâdat an-niswân*.
nazîf	Hemorrhage.
nizûl	Descent; in the context of *zâr*, *nizûl* is the quick up and down movement a person makes as their spirit descends into their body.
rahat	Skirt made of narrow strips of maroon-tanned leather, described by British soldiers as "boot-lace fringe" worn by young girls in the past until their marriage.
rîh, rowhan	Wind, winds; *jinn*, spirits.
rîh al-ahmar	Red wind, *zâr* spirit.
sâqiya	Ox-driven waterwheel for irrigation, the land that it irrigates.
shariʿa	Islamic principles, "law" loosely defined.

shaykh	Leader (masc.), often used as an honorific.
shaykha, *shaykhat*	Female leader, leaders (fem.); in the context of the *zâr* these are *zâr* leaders, women who preside over *zâr* rituals. They have developed close and productive relations with their own spirits that enable them to negotiate with spirits troubling others.
sirdar	Commander in chief.
sufragî	Waiter, domestic servant (pronounced with a soft *g*).
sûq	Market.
tarbush	Fez, often red.
tarîqa	Religious brotherhood, branch of a Sufi order (lit. "way").
tôb	For *thôb*, women's modesty wrap, literally: bolt of cloth.
zâr	A spirit-possession practice found in Sudan, Egypt, Ethiopia, and Somalia among other places, which differs, however, in each; also the illness the spirits cause, the ceremony staged to relieve it; singular for this type of *jinn*. See also *rîh al-ahmar*.
zayrân	*Zâr* spirits, plural.
ʿulama	Sages, Muslim religious scholars, graduates of Islamic schools such as Al-Azhar.
umma	Community of the faithful (Umma Party: the neo-Mahdist faction).

FREQUENTLY MENTIONED NAMES

Arkell, Anthony	First anthropological advisor, member of the SPS.
Atholl, Catharine	Duchess of Atholl and Conservative Member of Parliament, founder of the All-Party Committee for the Protection of Coloured Women in the Crown Colonies in 1929.
Atkey, O.F.H.	Medical Officer of Health in Blue Nile Province, became director, Medical Department, in 1922; director of the renamed the Sudan Medical Service 1924–34.
Beasley, Ina	Superintendent, later comptroller of Girl's Education in Sudan, who worked in the country from 1939 to 1949.
Bedri, Babikr	Former soldier in the Mahdi's army who became a prominent educationist, and in 1920s founded a school for Sudanese girls in Rufaʿa. Father of Dr. ʿAli Bedri of the SMS who was involved in the anti-female-circumcision campaign in the 1940s. The Bedri family, associated today with Ahfad University for Women in Omdurman, continues to play a leading role in efforts to abolish female circumcision in Sudan.
Cromer (Lord)	Evelyn Baring, British agent and consul-general in Egypt. After the (re)conquest of 1898, the governor-general of Sudan reported to him or his successors.
Gilks, Dr.	Director, Kenya Medical and Sanitary Services during the 1929–30 female circumcision crisis.
Gillan, Angus	Governor, Kordofan 1928–32, civil secretary 1934–39.
Grigg, Edward	Governor of Kenya during the 1929–30 female circumcision crisis.

Gordon, General Charles	British officer sent to Khartoum in 1884 to evacuate Egyptian troops threatened by the Mahdist revolt.
Grylls, Dr. E.	Inspector of Health, Sudan Medical Department 1922–24, prior to it being renamed the Sudan Medical Service.
Henty, G. A.	Former war correspondent and prolific author of boys' adventure books, who wrote two novels centered on Gordon's plight.
Hills-Young, Elaine	Matron, MTS, 1937–43.
Huddleston, Constance	Wife of Hubert Huddleston, active in the campaign to end pharaonic circumcision in Sudan especially during the 1940s.
Huddleston, Hubert	Governor-general of Sudan 1940–47.
Kenyatta, Jomo	Representative of the Kikuyu Central Association in London during the female circumcision crisis (1929–30), who trained in social anthropology under Malinowski at London University, and later became first prime minister of independent Kenya.
Kitchener, Herbert	Commander of the Anglo-Egyptian invasion force (1896–98), first governor-general of Sudan 1899, soon left for the Boer War.
Lorenzen, A. E.	Director, SMS, 1945–48.
MacMichael, Harold	Assistant civil secretary 1919–26, civil secretary 1926–33.
Maffey, John	Governor-general of Sudan 1926–33.
Newbold, Douglas	Former governor of Kordofan, appointed civil secretary 1939, died in office, 1945.
Perham, Marjorie	Oxford historian of empire and colonial administration, biographer of Lord Lugard and confidante of several members of the SPS during the 1930s and 1940s.
Pridie, Dr. E. D.	Director, SMS, 1934–45.

Rathbone, Eleanor	Independent member of Parliament, feminist reformer, member, with Catharine Atholl, of the Committee for the Protection of Coloured Women in the Colonies founded in 1929.
Robertson, J. W.	Successor to Newbold as civil secretary 1945–53.
Sayyid ʿAbd al-Rahaman al-Mahdi	The Mahdi's posthumous son, central figure in Sudan colonial politics with Sayyid ʿAli Mirghani.
Sayyid ʿAli Mirghani	Head of the Khatmiyya religious fraternity and central figure in Sudan colonial politics with Sayyid ʿAbd al-Rahaman al-Mahdi.
Shiels, Dr. T. D.	Parliamentary undersecretary for colonial affairs during the female circumcision crisis in Kenya, 1929–30.
Stack, Sir Lee	Acting governor-general 1917–19, governor-general 1919–24, assassinated in Cairo, November 1924.
Symes, Sir Stewart	Governor-general of Sudan 1934–40.
Taha, Mohammad Mahmud	Leader of the Sudan Republican Party, jailed for leading a riot against the anti-pharaonic-circumcision law in 1946.
Wingate, Sir Reginald	Second governor-general of Sudan from 1899–1916, assumed office shortly after Kitchener resigned to join the Boer War. Had been an intelligence officer in the Anglo-Egyptian invasion force and in the earlier Gordon Relief Expedition 1884–85.
Wolff, Gertrude L.	Older sister of Mabel, nursing instructor, Omdurman Women's Hospital 1925–30; matron MTS 1930–37.
Wolff, Mabel E.	First matron MTS, 1920–30, inspectress of midwives 1930–37.

CHRONOLOGY OF EVENTS DISCUSSED
IN THE TEXT

1820	Ottoman Egypt invaded Sudan seeking gold and slaves, Sudan becomes a colony of Egypt.
1863–81	Under European influence, Egypt attempted to end Sudan slave trade; Europeans employed in important colonial posts.
1881	Islamic uprising under the Mahdi, Mohammed Ahmed began.
1882	Britain gained de facto control of Egypt (Tel al-Kabir).
1883	Hicks's failed expedition to retake Kordofan from the Mahdi, few survivors.
1884	Gordon arrived in Khartoum, was soon besieged.
1885	Gordon relief expedition failed; Gordon was slain (martyred) on January 26. The Mahdi died in June.
1885–98	Mahdist rule continued in Sudan under the Khalifa ʿAbdulahi.
1896–98	Anglo-Egyptian reconquest, British "avenge Gordon."
1898	September: Battle of Omdurman; Mahdists were defeated.
1899–1955	*Anglo-Egyptian Condominium Government.*
1899	Christian proselytizing was forbidden in Islamic north.
1914	Funds for the Gezira Cotton Growing Scheme approved in Britain.
1914–18	World War I, development plans in Sudan on hold.
1919	Building of Gezira scheme began, acute labor shortage, rising rates of malaria in central Sudan.
1919	Postwar nationalist uprising in Egypt suppressed; British protectorate of Egypt ended (Milner report).
1921	British officials plan secretly to withdraw Egyptians from Sudan. Opening of the Midwives Training School and Girls' Training College (for female teachers) in Omdurman.

1922	Britain declared Egypt "independent"; talks resumed on Sudan.
1923	Egypt was made a constitutional monarchy.
1924	Continuation of slavery in Sudan was revealed in London press. Pharaonic circumcision became seen as a political and economic problem for the government in Sudan, blamed for low birth rates, labor shortages, and poor work habits of Arab Sudanese (winter). Pro-Egyptian revolt in Sudan (White Flag League). Sudan's governor-general, Lee Stack, also sirdar of the Egyptian Army, was assassinated in Cairo (November).
1924–25	Expulsions of Egyptian army officers, government employees, from Sudan.
1926	Harold MacMichael became civil secretary in name as well as fact.
1929–30	Kenya "circumcision crisis."
1929	Katharine, Duchess of Atholl founded an all-party committee to investigate the health and conditions of women in the colonies and British territories, joined by Eleanor Rathbone. Parliamentary debate on female circumcision (December).
1930	Miss Stumpf was murdered in Kenya (January).
1934	Angus Gillan became civil secretary.
1937	The Wolff sisters retired from midwifery service in Sudan, their replacement, Elaine Hills-Young reversed their method. A new campaign against pharaonic circumcision was planned.
1939	Douglas Newbold became civil secretary. Ina Beasley arrived in Sudan as superintendent of girls' education.
1939–45	World War II. Plans for a concerted crusade against female circumcision put on hold.
1942	Cultural Centre debates, Khartoum. Graduate Club demanded self-determination.
1943	Hills-Young left the Midwifery School for war work in Europe, began a crusade against female circumcision from abroad.
1944	Hills-Young's report on pharaonic circumcision in Sudan was circulated to Parliament.

1945 Newbold died, was replaced by J. W. Robertson (March). Pharaonic circumcision was addressed in Advisory Council of the Northern Sudan: law proposed (May); numerous pharaonic circumcisions were performed in advance of the imminent ban. Society for the Abolition of Female Circumcision in the Sudan founded; "spontaneous" group of anticircumcision activists, mainly men, orchestrated by the civil secretary's office. Law against pharaonic circumcision was passed (end of 1945).

1946 Law against pharaonic circumcision was declared (February).
Society for the Abolition of Pharaonic Circumcision was by now led by Sudanese men.
Civil secretary's office set up Standing Committee on Female Circumcision; first meeting in June to create propaganda that would build support for the law.
Tensions between Egypt and Britain, the Sudan Government high. Rufaʿa riots against enforcement of the anticircumcision law (September).

1947–49 More propaganda produced by the education department in Khartoum, meetings of the Committee on Female Circumcision continued, new forms of "pharaonic" circumcision flourished. The ban was ineffective.

1949 House of Commons debate on pharaonic circumcision in Sudan, January 26 (the anniversary of Gordon's death).

1956 Sudan gained independence (January 1).

CIVILIZING WOMEN

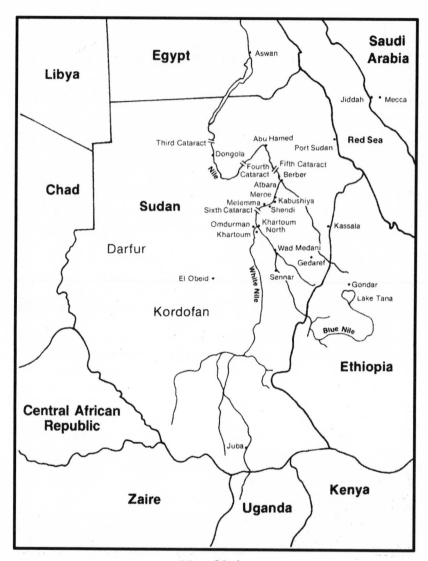

Map of Sudan

INTRODUCTION

History is not a succession of events, it is the links between them.
—E. E. Evans-Pritchard

The seeds of this book were sown when I began anthropological fieldwork in northern Sudan in 1976. My main interest then was to research *zâr* spirit possession and its practices among rural Muslim women. But when talking to friends about my plan, their inevitable reaction was, "You know they circumcise women there?" For most of my fellow graduate students, female genital cutting was the salient ethnographic fact about the people with whom I wished to work.

The tendency for female genital cutting to overdetermine perceptions of northern Sudan is not unusual. Indeed, no other cultural practice that refigures human bodies is more vilified in the Western press than what it calls "female genital mutilation" or "FGM." The term, however, homogenizes several distinct practices performed for different reasons in different parts of the world. The World Health Organization identifies four types of FGM, the most widespread in Africa being excision or clitoridectomy, which accounts for some 80 percent of cases. The most invasive but less common at roughly 15 percent is infibulation or "pharaonic circumcision," the type widely performed in Sudan. Known as pharaonic *purification (at-tahûr faraowniya)*, it entails paring a girl's external genitals and stitching together remaining skin so as to cover the wound, all but obscuring the urethra and vaginal opening.[1] Infibulation is also practiced in Djibouti, Eritrea and Somalia, parts of Mali, and southern Egypt. Though relatively rare, it is often misleadingly portrayed as representative of FGM by writers detailing its implications for girls' and women's health.[2] Moreover, the techniques of operators (who may not have medical training) vary tremendously, groups have distinct preferences, and practices evolve. In Sudan during the 1920s and 1930s, British midwives encouraged a modified and somewhat medicalized form of pharaonic circumcision, as we'll see.

When I settled into the Sudanese village of Hofriyat on the banks of the Nile some two hundred kilometers north and slightly east of Khartoum, I found it wasn't only friends at home who focused on the custom. Hofriyati women insisted that if I wanted to learn about their ways, I would

have to learn about *at-tahûr* and observe it being performed. As my familiarity with Hofriyati grew, I came to appreciate how the practice underwrote every facet of women's daily lives. It established the meaningful parameters of their selfhood, safeguarded their fertility, and informed their vulnerability to spirit possession. I have explored these issues in earlier publications; they form the background to *Civilizing Women* too.

Crusades

Over the past two decades or more, a highly visible international crusade to end female genital cutting (FGC) has taken place, aimed at African countries such as Sudan. While those who practice FGC belong to a variety of religions, the majority are Muslims, and the custom is said to support premarital chastity, strongly associated with Islam. The issue has arisen in debates about the "clash of civilizations," between Islamic societies—often labeled "medieval" and "barbaric"—and the "civilized" West. As Richard Shweder notes, "the global campaign against what has been gratuitously and invidiously labeled "female genital mutilation" remains a flawed game whose rules have been fixed by the rich nations of the world."[3] This book describes an opening test match in that game, set in Sudan during the first half of the twentieth century under British colonial rule. I offer it as an extended critique of the continuing campaign, the discourse that informs it, and the imperialist logic that sustains it even now.

My aim is to examine the means, at first subtle, and later not, by which colonial agents strove to alter the sensibilities and practices of northern Sudanese women and men, especially in the domain of reproduction. The book adds historical depth to discussions of FGC in the popular and academic press, and does so from an anthropological standpoint, by situating protagonists in their respective cultural milieus. The topic is pressing: female genital cutting not only persists in Africa but is currently practiced among Africans of recent international diasporas. That a number of Western governments and medical associations forbid doctors to perform requested genital surgeries, and enjoin those who treat already circumcised women not to restore their circumcisions after they give birth, attests to the prevalence of the practice. Female genital cutting has become grounds for refugee claims in some jurisdictions; cases have been successfully pursued in France and the United States. In 1994 the United Nations condemned "FGM" as a violation of the person, despite protests from a number of African feminists; a call to end it was issued in 1995 at the Fourth World Conference of Women in Beijing.[4] Male circumcision, even its most severe versions, has never received such attention.[5] "FGM" is a media issue and even the subject of novels;[6] television and film celebrities speak out

for its abolition.[7] Still the operations continue both in Africa and abroad; efforts to stop them have had but modest success; castigations by governments and international agencies have produced little sustained effect.

Much literature on the subject is moralizing and polemical, and regularly alienates those in positions to stimulate change. There are noteworthy exceptions, among them Ellen Gruenbaum's *The Female Circumcision Controversy: An Anthropological Perspective*,[8] two books edited by Bettina Shell-Duncan and Ylva Hernlund,[9] one edited by Stanlie James and Claire Robertson,[10] and the recent *Female Circumcision and the Politics of Knowledge*, edited by Obioma Nnaemeka, written under the banner of transnational feminism and framed as a collaborative dialogue among African and Western scholars.[11] These works move beyond judgmental confrontation toward an appreciation of social and historical context and the value of strategic alliances based on mutual respect. Yet in cases too numerous to list, self-righteous critics present and past have leaped to condemn what they've only presumed to understand, citing unverified statistics culled from other disparaging publications, relying on self-reference and reiteration to create the truth of their cause.[12] Their typical verdict: that female genital cutting regularly kills, has no valid meaning, and is inflicted on ignorant and powerless women by sadistic men.[13]

My research warns that this view is mistaken, born of little contextual data and a specifically Euro-American set of ideas about person, agency, and gender. I am not arguing that we can reposition an elusive Archimedean point to achieve greater "objectivity"; one can never be truly outside of a culture, there is no such nonplace to be, no "view from nowhere."[14] To say that one's culture guides and perhaps mystifies understanding is incontestable and trite; taken to its logical conclusion, it applies to analysts as well as their subjects, granting Western critics no unmediated purchase on the practices they decry. Admitting one's situatedness clarifies one's responsibility to take seriously what people have to say for themselves, to credit the contexts of their lives. Insight comes neither by Olympian fiat nor through spurious, if therapeutic, empathy.

Given these limitations, *Civilizing Women* contributes obliquely to the current debate by looking historically at one of its earlier phases as a confrontation of cultures with very different modes of reason, value, and belief. Through this lens it examines the processes that colonial health and education projects set in train in order to reform individual dispositions and customary ways. While I focus on the period between 1920 and 1946, when colonial efforts were most intense, I also consider the wider historical, political, and economic conditions that spurred these endeavors and, at times, impeded them. Several questions have framed my investigations: Why were colonial campaigns against pharaonic circumcision undertaken, and why did they achieve such limited results? Where and

how did they succeed, and did they have desired or unintended effects? How were Muslim women affected by colonial forays into domestic space and what motivated individual actors to seek their reform? Looking for answers (not all of them found) led me in directions seldom germane to female genital cutting in any immediate way. Thus I have explored the social and cultural contexts of British colonial agents, their assumptions about human nature, Islam, Arab family life, women and men. In addition to archival records, the book makes use of a range of published work: accounts of Sudan in period novels and advertisements, scholarly and popular histories from the late nineteenth century to the recent past. I consider, too, the Sudanese elites who furthered the cause of abolition and those who stymied it by making female circumcision a nationalist cause. Juxtaposed with all of this is the world of Muslim women from the village of Hofriyat, the locus of my anthropological research.

Outline and Rationale

The book is divided into three parts. Part 1 consists of three chapters on the contours of imperial culture in Sudan. The first describes how the example of General Charles Gordon provided the leitmotif for British rule. In 1820 the region had been invaded by the khedive of Ottoman Egypt, Mohammed Ali, and made an Egyptian colony. Sixty years later, a charismatic Muslim holy man and political dissident, known as the Mahdi, rose up to threaten Egypt's control. In 1884 his supporters besieged the colonial capital, Khartoum; in 1885 the city was overthrown, and Gordon, the colony's contractual governor, was killed. Sudan then became an independent Islamic state. It remained so until 1898 when a joint invasion by Britain and Egypt defeated the Mahdi's successor. The victory was presented to the British public as vengeance for Gordon's "Christian martyrdom." Indeed, Britain's colonial venture in Sudan was thoroughly informed by the religious tenor of Gordon's death.

Yet Christian missionary activity was prohibited by the British in Sudan's Muslim north, a topic pursued in chapter 2. This would, it was hoped, forestall native rebellion, disarm charismatic Islam and prevent its spread to the south. It was also designed to mollify Muslim Egypt, Britain's junior partner in the Sudan. From 1899 to 1956 the country was governed by a joint but lopsided and politically trouble-prone administration that reported to the British Foreign Office; the Anglo-Egyptian Sudan, officially a "condominium," was a British colony in all but name. In the Muslim north, state projects were largely secular: establishing (with a crucial hiatus) formal education for boys and latterly girls, improving standards of hygiene, bringing "civilization" and "progress" to "supersti-

tious tribal folk" in the form of orderly settlements, markets, and land registers, and—theoretically—by abolishing slavery. Despite Egypt's involvement (indeed perhaps because of it), there was a Christian undertone to these efforts; to most British officials, Christianity and civilization were the same.

The title of this book is an intended pun. The women it refers to are both Sudanese, to be civilized, and British, who worked to civilize them. Yet the former were seldom more than chimerical figures in official accounts. Colonial efforts were directed to local women as colonial *men* imagined them to be, based on prejudice born of little knowledge and a great deal of hazy "othering." Sudanese women's behaviors were, to the British, opaque, inscrutable, more barbaric than those of Sudanese men. Still, the fact of female circumcision meant that women did not go unnoticed, for the practice was widely held to account for low birthrates and high levels of infant and maternal mortality, hence lost population and ensuing low levels of production and consumption of imperial wares. To a metropolitan government bent on making its empire pay, the colonies' vital statistics were important economic concerns.[15] Female genital cutting purportedly added to the burden in Sudan. Yet apprehensions about igniting an Islamic backlash (part 1) militated against explicit action to stop infibulation, at least for some time (part 3).

The British women of my title began to appear in Sudan after World War I, when several unmarried professionals were recruited for posts in female education and health. Indeed, before the war, resident European women were scarce, the cohort comprised of a handful of missionaries and the spouses of senior administrators. From the late 1920s on, wives of midrank officials were allowed to come out for several months each year.[16] Sudan was never settled by the British, merely governed by them. The expatriate community had a distinctly masculine ethos, formal more than familial or domestic, and was based on a muscular (if sometimes muted) Christian stoicism (chapter 2).

In the early twentieth century, few Sudanese women left a trace in the colonial record and fewer still were literate. But their imaginings of the British were caught in the personae of *zayran*, ethereal analogues of historical humans who materialize in women's bodies during spirit possession rites.[17] Each chapter in part 1 is thus followed by a short ethnographic "interlude" describing *zayran* and the rites in which they appear or appeared in the past. Gordon and Kitchener have, or once had, spirit parallels. British (*Inglizi*) *zayran* were said to speak "English," drink whiskey and soda or unsweetened tea, and generally behave as the British were seen to behave by Sudanese. There are other spirit nations too, and I consider some of these in relation to pertinent historical events. The spirit interludes will, I hope, convey a sense—albeit partial—of Sudanese wom-

en's consciousness of their history and the process of colonization, even as that consciousness was in the process of being transformed. Importantly, Sudanese women's interactions with *zayran* are themselves civilizing ventures, and among those to be tamed were the "colonizers" themselves.

The means by which British officials gained knowledge of Sudan and Sudanese and put it to use are detailed in chapter 3. Here we encounter the role of anthropology in colonial administration and its patchy application in Sudan. The chapter discusses how the state encouraged ethnicity and tribalism both to govern through native elites and to prevent the spread of Islam. It emerges why and when female circumcision was discussed by officials in non-Muslim areas as well as those in the north.

The importance of Arab Sudanese women to colonial efforts thus surfaces gradually as the book moves from part 1 into part 2, where the relation of female reproduction to colonial projects becomes clear. Part 2 consists of three chapters, each presenting a facet of the context in which postwar crusades against pharaonic circumcision took place. Like the ethnographic interludes that precede it, chapter 4 shifts from British perspectives to Sudanese, in this case the cultural logic of procreation in the region of Hofriyat with its implications for gender relations and the creation of moral persons. I am more than mindful that the ethnography in this chapter is limited to a specific place and time: my research was conducted largely in the 1970s and 1980s with an additional trip in 1994. Yet its underlying themes, especially the morality of "covering" or enclosure, are widespread in Sudan and, judging from the accounts of women who trained local midwives in the 1920s and 1930s, were so in the past.

Chapter 5 relies on colonial and academic sources to describe political events, particularly the nationalist, pro-Egyptian rebellion of 1924, and considers how that crisis both invoked Gordon's martyrdom and shaped future relations among the British, Egyptians, and Muslim and non-Muslim Sudanese. In chapter 6 the focus shifts to economic conditions and the implications of a perceived shortage of tractable labor for imperial development schemes. These chapters show how initiatives in health and education were undertaken to make the colony profitable, maintain political control, and discharge the "white man's responsibility" to "civilize" and "uplift" Arab Sudanese. They suggest why pharaonic circumcision became a problem for the regime, and adumbrate the confrontation of moralities that colonial campaigns to abolish it entailed.

The first five chapters in part 3 describe the campaigns themselves. In the 1920s, two decades into Condominium rule, authorities became convinced that pharaonic circumcision lay behind Sudan's apparent "moral and economic backwardness." Chapters 7 and 8 describe attempts to remedy the situation by introducing civil medicine to Sudan and reforming midwifery practice. Here we meet the British nurse-midwives and educa-

tionalists whose work was framed by the demand for population growth and the goal of making "modern individuals" of Sudanese. To reduce the harm of pharaonic circumcision, midwifery instructors at first taught a modified operation as well as simple hygiene and biomedical birth techniques. Yet their use of local images to impart scientific ways may have helped to sustain the very practices they sought to dislodge.

Chapter 9 concerns some implications for Sudan of the 1929–30 "female circumcision crisis" in Kenya, and the role of British parliamentarians in challenging colonial governments to end indigenous customs inimical to women's and children's health. Chapter 10 describes the second phase of Sudan's campaign, which began in 1937 with the retirement of the Wolff sisters, who had established the modern midwifery school, and their successor's reversal of their controversial approach. During World War II several British women who had lived in Sudan questioned parliamentarians and Foreign Office bureaucrats about the persistence of pharaonic circumcision in the colony. Their challenge sparked a movement in Khartoum to make performing the operation illegal; that process and its consequences are pursued in chapter 11. As the story drew to a close in 1949 with a parliamentary debate—held, significantly, on the anniversary of Gordon's death—it was clear that the practice of infibulation had survived colonial attempts to abolish it with slight revision at best.

Threaded throughout these chapters are concerns about the growth of Sudanese nationalism, Egyptian influence, and competing interpretations of Islam. I offer some conclusions about the process of civilizing Sudanese women, and those who set out to do so, in chapter 12, where I consider the book's relevance to the present controversy over female genital cutting.

Sources

The historiography of colonial Sudan privileges public individuals, conflictual events, and institutional development over social processes and cultural meanings. This is entirely consonant with how officials sorted documentary remnants of their thoughts and deeds. Government archives are organized by regions and departments that cleave the life of Sudan into efficient, discrete domains. They house copies of correspondence, reports, and administrative overviews that, in an age before photocopiers and computers, circulated from one staff member to the next, acquiring penned critiques and marginal notes that enliven the texts no end. But archives are fickle informants. Some documents potentially useful to my study may have been destroyed because their contents were deemed inconsequential or damaging to government interests. When independence

loomed and the British prepared to leave Sudan, officials were ordered to burn any records that could prove embarrassing to the administration if scrutinized by Sudanese.[18] Yet a wealth of files survives in the National Record Office, Khartoum, furnishing invaluable information on debates internal to the regime, revealing the anxieties and fractures of opinion behind its smooth facade. Still, the papers I consulted were fragile, beginning to crumble with age and wear.[19] In London, a number of listed documents have vanished from the Public Record Office, among them a dossier on female circumcision. Still others were embargoed for fifty years, off limits when this study began.

Academic and institutional archives are less severely policed. Several I consulted were set up along biographical lines, containing the miscellaneous contributions of private individuals over the course of a colonial career: letters, memoirs, but also copies of internal reports, official minutes of meetings and the like. The repartee of circulated documents is here compensated by depth, candor, and sometimes telling self-defense.

To an anthropologist, all such texts are repositories of social and cultural information, but given their partial and partisan nature in detailing the actions and words of individuals who cannot be queried on the spot, this may be difficult to tease out in any straightforward way. They are, however, expressively redundant, and in this they disclose common modes of thought, cultural dispositions. They are telling for what their authors reacted to, how they said what they did, and what they neglected to say. As Comaroff and Comaroff note, "modes of representation, and the diverse forms they take, are part of culture and consciousness, hegemony and ideology, not merely their vehicles. 'Reading' them, then, is the primary methodological act of any historical anthropology."[20] For Sudan, the files are numerous. Works by historians, political scientists, and economists have been useful in navigating the masses of text, especially in the book's opening chapters, which frame later sections specific to anticircumcision crusades. Several other materials furnished discursive material in themselves—published memoirs of retired officials, colonial retrospectives, photographs. Finally, though an anthropological perspective privileges the meanings and manners of social groups, one cannot ignore the fact that in an expatriate world as small as that of colonial Sudan, personalities mattered a great deal.

Allegory

This book is not only about colonial efforts to end infibulation in Sudan, or the shape of a colonial venture in one small part of the world. It is also a protracted allegory for imperialism in the early twenty-first century. The

dark impress of the colonial past is palpable in today's Darfur and the long-standing conflict between northern and southern Sudan.[21] Indeed, so much of the current era, the strained relations between Christianity and Islam, claims of "civilization" and "barbarism," individualism and communal values, is a complicated echo of former times.[22] Before moving on to chapter 1, where the situation described below will be explained, I ask readers to picture this:

A huge convoy of troops and weapons is massed in the desert awaiting instruction to move. When it comes, a mobile strike force sweeps over the barren landscape, followed by several battalions of infantry. Their task: to oust the Muslim tyrant whose barbarous regime has defied Western power and ideals. Men and machines move swiftly toward the country's core; journalists "embedded" with the force report on the campaign to a riveted public at home. The invaders push on with confidence and resolve, encountering fierce resistance as they do, their losses far lighter than their foes'. An observer will later write, "the whole final advance could only be likened to the precise & methodical movement of some enormous machine, which approached gradually, silently & remorselessly, lessening the distance daily until near enough to strike a paralyzing blow."[23] Before the decisive battle, the capital is bombarded with refined high explosives leveled against the symbols of the rogue regime.

You didn't watch these events on CNN, or read about them in the *Times*. The year was 1898; the place not Iraq, but Sudan.

PART 1

IMPERIAL ETHOS

1

THE GORDON CULT

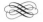

Rarely has public opinion in England been so deeply moved as when the news arrived of the fall of Khartoum. The daily movements of the relief expedition had been watched by anxious multitudes of General Gordon's countrymen, yearning for news of one who seemed to embody in his own person the peculiar form of heroism which is perhaps most of all calculated to move the Anglo-Saxon race. When General Gordon's fate was known a wail of sorrow and disappointment was heard throughout the land.
 —Lord Cromer, 1908

That one man, a European among Africans, a Christian among Mohammedans, should by his genius have inspired the efforts of 7,000 soldiers of inferior race, and by his courage have sustained the hearts of 30,000 inhabitants of notorious timidity, and with such materials and encumbrances have offered a vigorous resistance to the increasing attacks of an enemy who, though cruel, would yet accept surrender . . . is an event perhaps without parallel in history.
 —Winston Churchill, 1899

On the last Sunday evening of January 1945, British men and women living in Sudan gathered at All Saints Cathedral, Khartoum. The world war was not their purpose. They were there instead to remember General Gordon, slain in that city sixty years before by followers of the infamous Sudanese Mahdi. Two days earlier, on the 26th, the anniversary of Gordon's death, the governor-general had hosted a palace tea for thirty-five aged Sudanese veterans who'd known the celebrated man. It was Friday, the Muslim holiday. And on the 28th, Gordon's birthday, the governor-general placed a wreath at the base of the hero's statue while the Anglican bishop said a prayer written for the first Gordon memorial service in 1898.[1]

The original Gordon service had been held soon after a joint British and Egyptian force roundly defeated the Mahdist armies near Omdurman, on the west bank of the Nile opposite the ravaged city of Khartoum. Kitchener, the triumphant commander, ferried troops across the river to the spot where Gordon had died in 1885. The Grenadier Guards played *God Save the Queen* as the Union Jack, then the Egyptian flag, rose above a broken palace wall.[2] Next came a solemn religious ceremony, complete with Bible readings, prayers, and hymns. A participating cleric "prayed that God would 'look down . . . with eyes of pity and compassion on this land so loved by that heroic soul' whose memory they now honoured."[3] As the men sang Gordon's favorite hymn, the stoic Kitchener wept.[4]

Thereafter while Britain ruled Sudan, an annual "Gordon Sunday" was observed on or near January 26th in memory of Gordon's death. It was a highlight of the year.[5] At first, services were held in the palace, resurrected from the rubble under Kitchener's orders in 1899. Later they took place in the imposing Anglican cathedral built near the palace in memory of Gordon and consecrated in 1912 on the anniversary of his demise.[6] Inside was a Gordon Chapel, with gold braid from the martyr's uniform woven into its altar cloth.[7] Near the church stood a bronze statue of the man sitting astride a tasseled camel, a stern and commanding look upon his face. Years later the image was floodlit on Sunday evenings, "an impressive and ghostly reminder of a great Christian who gave his service and his life for the Sudan."[8]

What, you will ask, does a book about efforts to stop female circumcision in Sudan have to do with General Gordon's death? Surprisingly, a great deal. Studies of women are never only about women. This book is at least as much, perhaps more, about men. It asks, from a standpoint in the twenty-first century, why certain colonial projects were begun and how they were framed, for they have much to tell us about the nature of imperialism, even in our supposedly postcolonial times. Empires exert dominion not only from above, but, by engaging and seeking to mold subjects' sensibilities, they also rule by colonizing consciousness, to the extent they are able, from within.[9] In Sudan these struggles, their starts and stops, methods and motivations, owed their beginning and their tenor to the encounter between Anglican Christianity and Sudanese Islam that Gordon's clash with the Mahdi set in train.

Monuments to Gordon and rites exalting his "sacrifice" both realized and invoked what Paul Connerton calls "social memory":[10] a background narrative that shapes experience in the present by reference to the past. Historical images embodied in meaningful objects, places, and deeds, or calendrically summoned in rites, serve to legitimate and sustain a moral

order, provide a thread of continuity through the weave of time. Thus even members of a group born long after its formative moments participate in and help to shape its past. This is a past suffused with present concerns, a past that is never anachronous but, in offering a perspective on the contemporary world, continuously relevant and alive. For the British in Sudan, communal memory crystallized around the tragedy of Gordon's death in 1885; his conflict with the Mahdi proved remarkably resilient in this regard.

The event had seized public attention at home. Newspapers reported it with predictable outrage. Poems, advertisements, novels—including A.E.A. Mason's oft-filmed book, *The Four Feathers*—all played upon the theme. Subsequent interactions between colonizing Britons and Muslim Sudanese were inexorably shaped by the myth of "Gordon and the Mahdi" to which the affair gave rise.

For Europeans, that myth condensed some key antitheses: between Christianity and Islam, civilization and barbarism, modernity and the "archaic" past. As a foundational narrative, ever present and annually revived, it became second nature, a touchstone for habits of thought and action that passed from generation to generation of Britons serving—never settling—in Sudan. Sometimes Gordon's image was invoked explicitly, as when his example was set before novice officials as "the ideal of what a British administrator should be."[11] Often it was tacit, asserted in ceremonies, naming practices, the symbolism of built and rebuilt civic space. The image worked in several related ways—as a disciplinary tool summoned to unify Britons internally divided by gender, creed, and class; as a moral support that clarified Victorian racial categories and their attendant "character" traits; as an allegory of sacred, ultimate truth. Of course, colonial relations were dynamic and evolving; the actions and values of masters and subjects shaped those of the other over time. The "human factor" begot familiarity, sometimes the intimacy of friendship across the power divide.[12] Yet the parties—British, Egyptian, Sudanese— came to their unequal relationship steeped in awareness of their common, troubled past.

The suppositions that informed British endeavors, endorsing officials' actions and demeanor especially in times of stress, furnish the context for my story of the subtleties of the colonial enterprise. It is a story of British men seeking to civilize Sudanese women, and of the British professional women they later engaged to carry out that task. The story unfolds gradually, as it must; in the opening chapters the tale revolves around colonial administrators and the social world they inherited and produced in early twentieth-century Sudan.

Gordon and the Mahdi

I do not debate "what really happened" to Gordon—that is not my aim. There are numerous variants and interpretations, their convergence in popular discourse signaling, for the anthropologist, a dense node of cultural concern. The standard plot goes like this: Early in 1884 a blue-eyed British officer mounted a camel on the east bank of the Nile and rode into the Nubian desert en route to Khartoum, the administrative center built by Egyptian officials following the conquest of Sudan by the Ottoman khedive of Egypt, Mohammed Ali, in 1820–21. Gordon's task was to quell a stubborn native revolt or evacuate the Egyptian garrison if he could not.

For three years khedival authorities on the upper Nile had tried to stifle an insurrection against the "apostate Turks" and their European masters. Its leader was a charismatic holy man, Muhammad Ahmad, whom followers had proclaimed the Mahdi—the divinely guided one: a member of the Prophet's family who, according to Islamic belief, will rise up after an age of oppression to renew the faith and restore justice shortly before the end of earthly time. The Mahdist revolt has been linked to abuses by an exploitative Egyptian administration. But contributing to this, and perhaps more important, were Egypt's attempts to suppress the slave trade, inspired by the lately acquired scruples of European powers to whom Egypt was deeply in debt.

Soon after Ottoman Egypt conquered Sudan in 1821, its rulers had organized an annual hunt through the southern reaches of the Nile for women, children, and men to enslave. For decades the brutal task was led by Europeans, but by the 1870s, with suppression under way, control of the trade had fallen to "Arabs," a portmanteau term for Sudanese Muslims, Muslim and Coptic Egyptians, Syrians, and Turks. Ironically, eliminating the trade entailed a further extension of Egypt's sway, accomplished by increasing numbers of European officials—largely Christian—in the khedive's employ. Among these were Samuel Baker, and, from 1874 to 1879, Gordon himself. Abolition efforts "struck at an important source of wealth" and "basis of the agrarian economy"[13] in the Muslim north. Foretellings of the Mahdi rumbled through Sudan, auguries that Muhammad Ahmad fulfilled.

Early in 1883 Mahdist armies captured El Obeid, capital of Kordofan province southwest of Khartoum. By then Egypt was under British occupation, a move designed to protect European interests—above all, the Suez Canal—in the wake of a nationalist revolt.[14] Britain sanctioned an expedition to retake Kordofan, led by a British officer in Egypt's service, William Hicks, or Hicks Pasha. In November 1883, Hicks's force of

eight thousand men, two thousand camp followers, and thirteen Europeans, including two British war correspondents, was surrounded by Mahdists south of El Obeid. All but a few hundred were killed; no Europeans survived.

As the Mahdi's revolt gained momentum, the British press catalyzed public opinion in favor of sending General Gordon to sort the matter out. Gordon was already known for daring and unconventional maneuvers in China as well as against the slave trade in southern Sudan.[15] Though few in the halls of power thought him a suitable choice, Queen Victoria championed him. He was commissioned to evacuate Egyptians and Europeans and abandon Sudan, or restore Egypt's authority in Khartoum.

This ambiguous mandate was born of the Liberal government's reluctance to fund overseas ventures of any kind, let alone to secure a seemingly worthless province for its ailing Egyptian ward. And Prime Minister Gladstone was loath to interfere in what he believed to be an oppressed people's struggle to shake off corrupt Ottoman rule. Gordon, however, saw it as his duty to deliver the Sudanese from "an evil fate."[16] His vision gripped Victorian imaginations. Guided by quixoticism and fervid readings of the Bible, he made several tactical errors, miscalculated his opponents' strength, grossly misjudged their conviction. By May 1884 he and his retinue were besieged by Mahdist forces in Khartoum.[17] At length a relief expedition was sent up the Nile, arriving too late to save him.

The manner of Gordon's death in the early hours of January 26, 1885, is still unclear. The favored scenario, perpetuated in art and later again in film (with Charleton Heston as Gordon and Sir Laurence Olivier in blackface as the Mahdi),[18] shows him wearing his uniform, fez, and sword, standing alone at the top of the palace stairs as dervish soldiers—"wild, harlequin figures," wrote Churchill[19]—threaten with broad-bladed spears. Four of the enemy rush forward, and one, shouting "Oh cursed one, your time has come!" thrusts a spear into Gordon's chest. Gordon responds with a scowl of disdain, turns from his attackers and falls.

This image, wrote historian Denis Judd on the hundredth anniversary of the event, "confirmed the prejudices of many Britons who saw Imperial confrontation in terms of a conflict between the forces of darkness and disorder and the upholders of Western civilisation and Christian values."[20] Note how the conduct of the figures and their arrangement in space—self-possessed Gordon above, his Muslim attackers an unruly rabble below—affirm that distinction. Gordon's alleged passivity and heroic sacrifice combine with his celebrated Christian piety to suffuse the image with religious import. Yet Gordon was more than a Christian martyr or sacrificial lamb; to the late Victorian public he embodied the highest ideals of his time: progress, individualism, enterprise, and, despite his impetuosity, discipline when it mattered most. His unconventional lack of interest

in money or rank endeared him to countrymen unrewarded in such pursuits. A reporter for the *London Times*, reflecting on the failure of the relief expedition to reach Khartoum in time, described him as:

> a grand historical figure, the ideal personification of English genius, courage, endurance, and unselfish devotion to duty. Europeans of all nationalities regard the death of General Gordon as both a personal loss and a world-wide calamity. No possible event that I can conceive would have caused such a general feeling of unfeigned sorrow among the entire community, nor, alas, such a sense of national disgrace among Englishmen.[21]

Scholars question whether Gordon's character merited the luster it acquired. A man of exceptional energy and stamina, he was also prone to dark moods and fits of temper, given to secluding himself with his Bible—some say a bottle too—and delegating command when expecting to be the worse for his devotions.[22] For Gordon, the spirit waged perpetual war against the flesh; he remained celibate, was modest in his needs to the point of asceticism and more generous than most of his class to the poor both at home and abroad. He made a constant study of Thomas à Kempis's *Imitation of Christ*, and—like the Mahdi—had a mystical faith in his own divine inspiration. He felt God's will was evident in his work, leading some to believe that he sought his death or embraced it as foretold.[23] He was inclined to impromptu shows of exuberance, sticking religious tracts onto walls or throwing them out of train windows.[24] But whatever his earthly excesses, the exemplary qualities of duty and steadfastness condensed upon his figure after death. Even Cromer, a critic, lauded his moral qualities and humanitarian aims.[25]

Gordon had been convinced that the only way to promote the white man's civilizing mission and end the traffic in slaves was to open Africa to European influence by means of "legitimate trade."[26] In this he echoed the Scottish missionary, David Livingstone, and many other pro-imperialist British.[27] It was a strategy those who later ruled Sudan would embrace. Kitchener, for example, remarked that "the Battle of Omdurman had at last opened the whole of the Nile valley 'to the civilizing influences of commercial enterprise.' "[28] If commerce and Christianity anchored Britain's venture in Sudan, an altruistic Gordon graced its prow.

Still, Gordon's cultic import owed as much to the fact of his death as to his character or his views on enlightening natives. To no small degree the British mission in Sudan was shaped by the failure of the force sent up the Nile to relieve him. Several men who played key roles in the reconquest and subsequent administration of Sudan had been part of the humiliating campaign of 1884–85, among them Kitchener and Wingate, the first two governors-general of the Anglo-Egyptian Sudan. The ethos of their administration was forged in the belief that popular Islam posed

a grave threat to British ascendancy on the Nile. Predictably, the Mahdi personified that threat.

Gordon had gravely underestimated the Mahdi, thinking him an upstart of limited influence, susceptible to conciliation. He sent him a fez and a red robe of honor, foolishly offering him the sultanate of Kordofan where his power was already secure. The Mahdi responded with dignified contempt, "Know that I am the Expected Mahdi, the Successor of the Apostle [Prophet] of God. Thus I have no need of the sultanate, nor of the kingdom of Kordofan or elsewhere, nor of the wealth of this world and its vanity." He returned the robe and sent Gordon a patched homespun tunic (jibba), symbol of piety and poverty worn by the Ansâr, supporters of the Mahdi more commonly known as darawîsh or dervishes. The jibba, said the Mahdi, is "the clothing We wish for Ourself and Our Companions who desire the world to come."[29] It was an exemplary moment. The Mahdi rejects the world of European politics and trade, filtered through Ottoman Egypt; in a gesture worthy of Gandhi, he prefers homespun cotton to richly colored Turkish robes and the entanglements they trail. As the siege tightened, another jibba arrived: another invitation to convert. Gordon spurned it, appalled at the thought of donning a "filthy Dervish's cloth" just to prolong his life.[30] When the victors looted Khartoum after Gordon's death, they found little in its shops save an abundance of European cloth which they used to refresh the patches on the jibbas of the Ansâr.[31] Tellingly, cotton production would later became the linchpin in British efforts to civilize Sudan.

Accounts of Gordon's conflict with the Mahdi gave shape to Victorian antitheses other than those between Christianity and Islam, or modernity and "superstition"; they spoke too of modern individualism and archaic collective concerns, capitalist enterprise and subsistence toil, even good and evil, right and wrong. Imperial Manichaeism was multilayered and flexible, continuously reworked as the interactions among British, Egyptians, northern and southern Sudanese evolved. Indeed, for a time in the 1940s, communism trumped Islam—to which it was sometimes linked[32]—as the principal threat to British rule. Yet from the outset, the bodies of Sudan's sainted adversaries, together with the objects and apparel by which they were known and the places where they lived and, more importantly, died, became saturated with significance for conquerors and conquered alike.

In realization of British fears, Gordon was beheaded and his body thrown down a well. His head was sent to the Mahdi's camp in Omdurman to be identified by Rudoph Slatin, an Austrian who had served as governor of Darfur until taken prisoner by the Ansâr.[33] The Mahdi, it is said, was distressed by Gordon's death; his posthumous son, Sayyid ʿAbd al-Rahman, claimed that his father had never lost hope of converting Gor-

don and ensuring him a place in paradise.[34] Nonetheless, the head was publicly displayed in the Mahdist camp.[35] The repercussions unfolded like scenes in a Passion Play.

Six months later the Mahdi succumbed to disease—cholera, typhus, the cause is unclear. His followers built a domed mausoleum over the spot in Omdurman where he died; it became a hallowed pilgrimage site. A year later the Mahdi's temporal successor, the Khalifa Abdullahi, emptied Khartoum and plundered its buildings to build a new capital near the Mahdi's fort and shrine. From then until Kitchener's arrival thirteen years later, Khartoum was "a city of the dead," its only inhabitants jackals, rodents, and birds nesting in the thorny scrub that sprang from its crumbling walls.[36]

Meanwhile, British officers stationed on the Egyptian frontier and Red Sea coast helped arrange the escapes of several Europeans held captive in Omdurman. First to break out were three members of the Austrian Roman Catholic Mission, two nuns and a priest. The priest, Father Ohrwalder, wrote a book about his ordeal, *Ten Years' Captivity in the Mahdi's Camp* (1892), which, translated into English by Wingate, was an instant success. Finally, in 1895, came the escape of Rudolph Slatin, who, for most of his captivity, had been forced to serve as the Khalifa's personal slave. Slatin's story, *Fire and Sword in the Sudan*, published early in 1896, again with Wingate's help, proved even more popular than Ohrwalder's and ran to several editions. By now the British public, "fed by the episodic treatment of events and the unrelieved descriptions of bloodshed and oppression" in these books, were eager to crush the Khalifa's regime.[37]

A decade after Gordon's death Britain was ready to move. No ill-timed venture this, but a resolute massing of technology and troops in the desert north. A railway, said to be the "most formidable enemy of barbarism,"[38] was laid across the desert and south along the Nile. Winston Churchill's "River War" was in fact a railway war[39]—an orderly, scientific, thoroughly industrial campaign that struck "with machine-like precision"[40] into the obdurate heart of Muslim Africa. An observer remarked: "the whole final advance could only be likened to the precise & methodical movement of some enormous machine, which approached gradually, silently & remorselessly, lessening the distance daily until near enough to strike a paralyzing blow."[41] Morale was high: as daylight waned, a ballad composed for the expedition rang through imperial camps:

> Then roll on, boys, roll on to Khartoum,
> March ye and fight ye by night or by day,
> Hasten the hour of the Dervishes' doom,
> Gordon avenge in old England's way![42]

As the troops neared Omdurman, Kitchener sent gunboats ahead to bombard the town, using shells armed with Lyddite, a high explosive. The shells tore huge holes in the dome of the Mahdi's tomb; the city's fortifications were breached. Thus had "western science sounded the knell of the Dervish empire."[43] When darkness settled, searchlights from British gunboats lit up the clouded sky.

The Battle of Omdurman began at dawn next day on the plain below the Karari Hills. Superior artillery, Gatling guns, and rapid-fire rifles assured a British success. Of the Mahdist army, eleven thousand died, and sixteen thousand were wounded. There were fewer than fifty deaths and four hundred casualties on the winning side.[44] Queen Victoria telegraphed, "Surely he is avenged!" and promptly made Kitchener "Baron of Khartoum." The Khalifa escaped to Kordofan, to be hunted down and killed the following year.

Winning the war was not enough. Little compassion was shown to dying and wounded Ansâr. For souvenirs, the victors looted banners, spears, and *jibba*s that would later deck the halls of Britain's stately homes.[45] To eliminate a vital hub of Mahdist devotion, Kitchener ordered the Mahdi's tomb razed, his body dug up, and his bones cast in the Nile.[46] Gordon's fraternal nephew, a major in the force, was entrusted with the task. Like his adversary, the Mahdi was denied the religious burial required to ensure his resurrection at the end of human time. If Gordon's error had been to misjudge his opponents' zeal, the British would not let it happen again.

The major disposed of the Mahdi's bones but kept his skull, "which was unusually large and shapely" and presented it to Kitchener as a trophy. Kitchener toyed with mounting it in silver or gold for use as an ink stand or drinking cup, then decided it should be sent to the College of Surgeons in England for scientific exhibit—a common fate of alien and aberrant foes. This story, widely reported, excited the ire of Kitchener's fellow officers, the press, and the Queen, who felt it could do "great harm."[47] At length, Cromer reported that the skull had been secretly buried in the Muslim cemetery at Wadi Halfa, though a copy of this letter I found at the Public Record Office in London bears a prominently penciled "Ahem!" beside the news.[48]

Kitchener now set out to rebuild Khartoum, beginning with the palace on the spot where Gordon fell. But funds were scarce. On January 26, 1899, the fateful anniversary, he privately instructed Wingate to "loot like blazes. I want any quantity of marble stairs, marble pavings, iron railings, looking glasses and fittings; doors, windows, furniture of all sorts."[49] So adamant was Kitchener about the reconstruction that he refused to let railcars earmarked for the transport of building supplies be diverted to carry grain needed to alleviate famine in several parts

of Sudan.[50] He meant to show the Sudanese that the British were there to stay. By early February, five thousand men were at work on the palace and government buildings, laying out roads, and planting seven thousand shade trees, a startling extravagance for this most frugal of commanders whose troops had grown increasingly restive under his Spartan regime.[51]

Shortly after his victory Kitchener went home to a tumultuous welcome and an exhausting round of celebrations. The City of London presented him a sword of honor with his new initials, "KK," set in rubies and diamonds and its hilt of gold carved in the figures of Justice, Britannia, and the British lion. Cambridge and Edinburgh granted him honorary degrees. Kitchener seized the moment to announce he was raising funds to endow a college in Gordon's memory in Khartoum. His appeal in the *Times* declared, "those who have conquered are called upon to civilize. In fact, the work interrupted since the death of Gordon must be resumed."[52] The campaign was an instant success, netting all the funds required.[53] Construction of Gordon Memorial College began early in 1899, east of the palace on the banks of the Blue Nile.

Unlike the native capital of Omdurman, with its organic tangle of mud-brick buildings and narrow alleyways, Khartoum would be a modern, rational city, the material realization of an abstract plan, systematically arranged for a notional bird's-eye view. It would convey a sense of order befitting a civilized regime, order that inhabitants and visitors would experience in bodily ways as they went about their daily lives. British engineers aligned streets parallel to and running toward the Blue Nile, with diagonal connectors for ease of access. A common but likely spurious story has the town laid out in the shape of a Union Jack.[54] The image of the British flag—the intersecting crosses of Saints Patrick, Andrew, and George—stamped on Gordon's cusp of Sudan plain soon became a legend: when I arrived in Khartoum in 1976 English friends told me I'd never get lost if I recalled that the city had been planned to resemble the Union flag, though portions of its diagonals had since been filled in. Whatever the truth of this notion, the fact that many *thought* it was true surely tells a tale. Metaphorically, at least, the consummate symbol of imperial Britain and its creed underwrote the town, superseding its past. Yet its intersecting avenues and streets were more than emblems of Christian saints; they were tangible extensions of imperial personae, too, named Kitchener, Cromer, Victoria, Gordon. Khartoum was a persuasive, evocative city, both a crusader fortress and an outpost of reason in a barbarous land. Defying it across the Nile lay Omdurman—the Mahdi's bastion, "the Orient," Islam.

In Khartoum's rebuilt palace a grand staircase led to public reception rooms on the second floor. Its walls were "thickly hung with Dervish

knives, guns, and other mementos . . . evoking the memory of Gordon's death . . . on the same spot in 1885." Elegantly dressed officials and guests summoned to the annual Palace Ball would "move with slow dignity up the wide stairway before being received by the Governor-General and his wife in the lofty . . . veranda above."[55] They walked a gauntlet of captured arms, relics of holy war put to work for the regime in a tangible display of its triumph over popular Islam. The tableau conjures the image of Gordon just before his death, with the governor-general his specter, alive at the top of the palace stairs. The aesthetics of reconquest reverse the events of 1885, while declaring British permanence by invoking domesticity in the person of a woman, the governor-general's wife, one of the few British women allowed to reside in Sudan from the start. Dervishes are conspicuous by their absence; only their weapons remain, frozen to walls and archways built to replace those they had once destroyed.

Construction of the Anglican cathedral began in 1904. A daughter of Queen Victoria laid the cornerstone, whereupon the rector, the Reverend Gwynne, seconded from the Gordon Memorial Mission of the Church Missionary Society (CMS),[56] gave a stirring homily. It is a telling document, a spiraling allegory that tacks between the hubris of British industrial culture and events in Sudan since 1884.[57] In it, Khartoum becomes Jerusalem; Britons are likened to Israelites who "in their prosperity . . . forgot God and became proud in their hearts and would only worship the works of their own hands." Thus "when Nebuchadnezzar, the King of Babylon, came up with a large army and laid siege to Jerusalem, he took it." Pace the Mahdi and Omdurman. Gordon he described as a deliverer and "martyr for the Sudan" whose people are "already . . . reaping the benefits of his death. How he would rejoice at the kind of revenge his fellow countrymen are meting out . . . Christian tolerance, justice, liberty and fair dealing."[58] For Gwynne, British occupation was a biblical event; Jerusalem, England, and Khartoum were folded into one. No mention of Egyptian contributions or those of pro-British Sudanese. British rule was conflated with Christian rule, centered on the reborn "holy city" of Khartoum. As one officer mused: "some cities have the power to evoke memories. . . . Khartoum commemorates the devoted life and sacrificial death of General Gordon, a Christian victim of Islam."[59] The city is a monument, a flag, a shrine.

It must be said that few Britons who served in Sudan between 1898 and 1956, when the country became independent, matched Gwynne's exuberance, nor did all endorse missionary ventures even in the non-Muslim south. Yet most were devout Christians or had been raised in a Christian milieu. Over a third of all Sudan Political Service officers were clergymen's sons, and even the least pious held Islam to be a backward-looking

faith that inspired fatalism, superstition, and indolence. Most joined Cromer and Salisbury, the architects of Anglo-Egyptian condominium rule, in regarding Islamic values to be incapable of stimulating economic progress as Protestant Christianity had done in the West.[60] Officials' memoirs, letters, and formal reports all bristle with such claims. This, despite the sympathies they developed for individual Sudanese, despite their growing respect for the latter's character, intelligence, and wit.

Though suspicion of Islam was hardly exceptional for Victorians, memory of the calamitous events of 1885 magnified their fears in Sudan. Moreover, it did not go unnoticed that the Nubian ancestors of Nile valley "Arabs" had been Christian only a few centuries before.[61] Some hoped their descendants would be stirred to "reconvert." Gwynne, who dabbled in archaeology, once helped excavate the site of an ancient Coptic church at Soba on the Blue Nile. There he uncovered the capital of a pillar carved with a cross, and the statue of a ram that he took for the Lamb of God (though it was more likely Amun, a pre-Christian deity from Meroitic times). He had these remnants set up outside the cathedral as testament to the antiquity of the true faith in Sudan.[62] The cathedral itself held a stained-glass window dedicated to Philip the Deacon who, in 37 CE, is credited with having baptized a Nubian official in the court of Meroe, the first native Christian on the upper Nile.[63]

Haunted yet authorized by history; imbued with Christian values; assured of the merits of industrial technology, scientific rationalism, discipline, hard work, and commercial enterprise; ideological, sometimes arrogant, and perpetually defensive, the British mission in Sudan had about it the aura of a crusade. Under Gordon's aegis strode its high-minded knight-administrators, its foot soldiers—professionals who served the regime, and, not least, its scribes—the novelists, journalists, artists, and entrepreneurs who chronicled the venture for those at home. The image of a crusade is more than figurative: the Sudan official who rose to executive rank would doubtless receive a knighthood ("get his K") by the time he retired; Kitchener had been made baron of Khartoum; a spirit of chivalry, courtliness, and probity underwrote the British presence, tempering its emissaries' deeds while intensifying their allegiance to the sovereign who anchored their authority.[64] As we see in chapter 2, the ethos of this very masculine regime was externalized in uniformed pomp and spectacle that helped condition sensibilities, both British and Sudanese.

This, then, was the shape of the world that was built from existing circumstance, a world to which successive generations of British who worked in Sudan were schooled. I turn next to how the "Gordon and the Mahdi" myth played out in the popular culture of Britain that sustained the regime's creators and, importantly, nurtured their heirs.

Of Dervishes and Gentlemen

By the late nineteenth century books and newspapers were widely available in Britain, and the ranks of the literate had grown. Schooling was no longer an upper- and middle-class preserve; compulsory education had begun in 1870, and increasing numbers of the working class gained basic reading skills. Despite economic fluctuations, wages remained fairly stable, but as prices generally fell, standards of living rose. Technological innovations had substantially reduced the costs of paper, machine printing, and composition; news transmission was accelerated and its expenses pared by improved overland telegraphy, recently laid ocean cables, and the birth of international agencies such as Reuters; taxes affecting news sheets were repealed; the expansion of advertising greatly subsidized production. And, by the 1880s "a vast industry of cheap . . . papers and publications had come into existence to cater to the new habit of reading."[65] Book publishing grew exponentially. In England in 1810, only 580 titles were issued; by 1901 the figure had reached 6,000.[66] The last quarter of the century saw the founding of municipal lending libraries as well.

More than twenty-five books about Gordon were published within a decade of his death, while several works of poetry and popular fiction— two stories by G. A. Henty; Sir Arthur Conan Doyle's *Tragedy of the Korosko*; A.E.W. Mason's *The Four Feathers*; Kipling's verses and stories—used events in Sudan as their setting.[67] Recall too the captivity memoirs of former European prisoners in the Mahdi's and Khalifa's camps, whose stunning success owed much to the fact that their descriptions of dervish cruelty confirmed European images of Islam. All this had begun with the spirited advocacy of the "jingo press," first to send Gordon to Sudan, then to deliver him from the Mahdi's grasp. An article in the *Pall Mall Gazette* days before he left for Khartoum, described him as having a "step . . . as light and . . . movements as lithe as the leopard."[68] Heroic, with the sheen of a popular idol, Gordon was an alluring figure indeed. His tragic end brought public outrage; disconsolate editorials, letters, and biographies drenched the reading public in lament. Cromer ventured that Gordon's published journal was "probably read by every educated man in England."[69] But Victorian writers of popular fiction who used the saga as their backdrop offered more than elegiac praise: they gave hope of vindication, of the imperial master narrative redeemed.

G. A. Henty, former war correspondent and prolific author of boys' adventure books, wrote two novels centered on Gordon's plight: *The Dash for Khartoum*, which appeared in 1892, and *With Kitchener in the Soudan*, published in 1903. They are complex assertions of Victorian values and, given their wide and impressionable readership, worth exploring

for the images of Africa, Arabs, and Empire they contain. Both are lively yarns with obvious pedagogical intent; Henty usually wrote a preface, sometimes addressed "Dear lads," which laid bare the moral of his tale. Though he stuck close to reported events, he suppressed the brutality of imperial ventures so as to convey a wholesome image of the British abroad; his heroes are always chivalrous, dutiful, humanely benevolent. Their native adversaries are not, though some are portrayed as ameliorable. To the anthropologist, these highly formulaic tales are myths, imparting sacred truths in the guise of secular entertainment. Doubtless they schooled more than a few future officers of colonial Sudan.

Dash depicts Mahdists as barbaric foes whose courageous if misguided exploits shatter the smug expectations of drilled but unseasoned British troops:

> "I don't call it 'fighting' against these savages," one of the troopers said.
> "What chance have they got against regular troops?" . . .
> "You don't suppose, sergeant, that these naked beggars are going to stand for a moment against a charge of eight hundred cavalry?"

At the Battle of El Teb in February 1884, the British military square holds:

> As if utterly heedless of death the Arabs rushed forward through the leaden storm, but were mowed down like grass before it. . . . the wild courage of the natives was of no avail against the steady discipline of [the British troops].[70]

Two weeks later, dervishes break the British square at Tamai, an event immortalized in Kipling's poem, "Fuzzy Wuzzy," a reference to the hairstyle of eastern Arab Sudanese.[71] Though the dervishes are courageous, their tactics are chaotic, as one of Henty's soldiers describes:

> "[A]s for these slippery black beggars, the less we have to do with them the better I shall be pleased. You go at them, and you think you have got it your own way, and then before you can say knife there they are yelling and shouting and sticking those ugly spears into you and your horses, and dancing around until you don't fairly know what you are up to. There ain't nothing natural or decent about it."

Contrast the "wild," "indecent," "unnatural" conduct of the Mahdists with that of the British who remain civil and disciplined under duress: as the camel corps crosses the broiling desert, water supplies run dangerously low, yet the men ensure there is always enough for tea.[72]

The story set against the background of Gordon's demise concerns two British boys, Edgar and Rupert, one from a titled family, the other not, who are switched as infants. When they cannot be told apart it is decided that the wealthy family shall raise them as twins. Well educated and now in his teens, Edgar learns of the mix-up from the treacherous woman—

the selfish untitled mother—who had engineered it. Convinced that he is the pauper, he runs off and joins the expedition to extricate Gordon from Khartoum. In the desert a few days before the city's fall, Edgar is caught and made the slave of an Arab *shaykh*. As he now speaks a little Arabic, he learns that his captor has come to the front not from faith but for profit, to plunder British baggage camels. In this he has met some success.

When Edgar overhears news of Gordon's death in January 1885, his hope of rescue dissolves. But this is not his first concern:

> The blow was a terrible one to Edgar. . . . [I]t was grievous to think that the expedition had been made in vain, and that . . . it had failed in its object, and that the noblest of Englishmen had been left to die, unaided by those who had sent him out. He thought of the intense disappointment that would be felt by the troops, of the grief there would be in England when the news was known.[73]

Though the Mahdi had reportedly claimed all white captives as his personal property, the wily *shaykh* plans to keep Edgar for himself. To avoid detection he disguises Edgar in Arab clothes and has his skin stained dark. The entourage departs for Kordofan, beyond reach of the British troops.

Once in the *shaykh*'s village Edgar resolves to learn "the native language" well enough to make his escape. He applies himself patiently and resourcefully to his servitude. Though young and slight, he works diligently in the fields and accomplishes twice as much in a day as the *shaykh*'s southern Sudanese slaves, both of them full-grown men. He becomes the favorite slave of his master's favorite wife, who intercedes to prevent his mistreatment. He makes himself useful: showing people what to do with their looted supplies—how to open tins, boil tea, prepare cocoa and arrowroot. He teaches the *shaykh* to fire a Martini rifle, the Englishman's modern weapon, better than the Arabs' Remingtons or spears. One stolen camel carries medical supplies, and, despite Edgar's lack of formal knowledge, his innate good will and practical common sense allow him to become physician to the *shaykh*'s people, dispensing quinine, cleaning and dressing wounds. In short, he is a civilizing influence: hard working, eminently practical, an envoy of modernity in the barbarians' midst. When the village is threatened by dervishes sent by the Mahdi to punish the *shaykh*'s defiance, Edgar shows his captors how to form a military square, enabling them to thwart a mounted force over twice their size with few casualties of their own. For this he earns his freedom.

Meanwhile Rupert, who had joined the relief expedition later than his "brother," learns by a series of coincidences that Edgar—whom he and his parents have been desperate to find—has been abducted. As the imperial force retreats down the Nile in 1885, Rupert is granted leave to stay

and search for his "twin." He has a wig made up to resemble native hair, stains his skin dark, and with the lure of payment in camels and cash engages some friendly Sudanese to accompany him. He too has learned some Arabic, rapidly learns more, and is careful to mimic the gestures of his companions lest his breeding reveal his Englishness. At length Edgar and Rupert serendipitously meet in the desert. They take a few moments to recognize each other, as both look and act like Arabs. Ultimately it is Edgar's voice that gives him away: his accent, of course, reveals his true identity, race, and class.

Similar themes unfold in *With Kitchener in the Soudan*. There the second son of an all but bankrupt earl secretly marries a governess, an orphaned woman of good family, and falls out with his father who had wished him to make a lucrative match. The son alters his name and moves with his wife to Egypt. He speaks Arabic and in 1883 enlists in the Egyptian army as a translator with Hicks's doomed campaign. He is given up for dead. His wife, however, is sure her husband is alive, that aided by his language skills, he would have disguised himself as an Arab and somehow escaped the Mahdi's spears. Never losing hope, she remains in Cairo where she teaches to support their son, Gregory. Gregory, in turn, learns several dialects of Arabic and "the negro language" from the family's Sudanese servant. When in the mid-1890s his mother dies, Gregory resolves to find out what became of his father and arranges to be taken on as a translator in Kitchener's avenging force.

Once in Sudan, Gregory rapidly proves his worth by staining his skin dark, donning a dervish *jibba*, and crossing the desert to infiltrate the Mahdist camp as a spy. He returns unscathed with information that Kitchener uses to secure the site where the advancing railway is to join the Nile. Next, Gregory is assigned to a gunboat. His vessel engages craft carrying dervish fighters and their families across the Nile to where they are massing for assault on imperial troops. When a boatload of natives is struck by a shell and sinks, Gregory gallantly dives into the river to save a drowning woman; the two wash up beyond British lines, whereupon Gregory is captured by a dervish amîr. The amîr has sworn to kill any unbeliever he meets. Yet before he can strike, the rescued woman, who happens to be the amîr's favorite wife, cleverly intervenes by throwing her robe over Gregory, placing him under her protection. Thus released from his vow, the amîr praises Gregory's courage, confessing that he would never have risked his own life for a stranger's. Gregory replies:

> What I did, Emir, I believe any white officer who was a good swimmer would have done. No Englishman would see a woman drowning without making an effort to save her, if he had it in his power. As to the fact that she was not of the same race or religion, he would never give it a thought. It would be quite enough for him that she was a woman.[74]

Eventually, Gregory breaks free and rejoins the imperial force. After the dervish defeat, he makes inquiries of those who had lived through the siege of Khartoum. He learns that his father had indeed survived the Hicks debacle in 1883—the only white man to do so. He had escaped disguised as a dervish, and made his way to relative safety with Gordon in Khartoum. But early in September 1884, he had joined a party heading north via the risen Nile to report on conditions in the beleaguered city. When their steamer ran aground, all were slain by the Mahdi's allies.

Gregory visits the site and miraculously finds his father's tattered diary recounting his audacious battlefield escape, telling how, wearing a blood-stained *jibba*, he had befriended a wounded dervish and successfully doctored him by mustering his common sense. And it reveals Gregory's noble birth, that he is now the rightful earl. The present claimant, described by his peers as a wastrel and "consummate ass,"[75] is thus undone.

The mythic elements in these tales are legion. That they are variants of the Prince and the Pauper theme is clear: nobility resides in the blood, and will "out" in chivalrous deeds; more, they assure the newly elevated middle class that one needn't be born a prince to be a gentleman, indeed, that every gentleman is noble at heart. Female characters are predictably few, deployed mainly to deepen the contrast between British and Sudanese men. They tend to be kind, self-sacrificing, shrewd, thrifty and, whether native or English, protective of the white youth in their power. They are "good mother" figures, whose foil to the deceitful mother in *Dash* heightens their benevolence. Sexuality is underplayed, the apparent preserve of Arab men, whose leaders invariably have several wives.

Unlike British women who, if present in spirit, are bodily safe at home, Sudanese women follow the troops whether they fight on the Mahdist or Anglo-Egyptian side. Henty's Sudanese women are intelligent, vivacious and glib, forthright with their husbands and other men. Little is said of their looks and attire save the occasional hint, as when the amîr's wife, rescued from drowning, sinks down beside her savior on the shore, "but not before hastily rearranging her veil."[76] Like their British counterparts they are modest and vulnerable; importantly, however, their own male defenders fail to protect them as they should. The breeding and native "good sense" of the British lads allow them to redress the Arabs' lack. Thus in Henty, native men are not so much "feminized," as McClintock suggests regarding colonial imagery of African men farther south,[77] as they are "puerilized," outclassed and outcivilized by their chivalrous white protagonists who, though younger in age, are yet the more advanced.

The gentility of Henty's Sudanese women provokes recognition in the British boys, who treat them much as they would their own kind. Here

gender ideals prevail over distinctions of race, letting the Victorian doctrine of sexual politesse and men's and women's separate spheres pass transparently to juvenile British readers of these books. And if native women seem amenable, so might their societies be open to civilizing and domestic improvement. Nonfictional images of Sudanese women were less sanguine, as we'll see.

Darkening Skins and Staying Pure

A striking theme in Henty's Sudan novels is the ability of British males to disguise themselves as dervishes and pass undetected by dervishes themselves. Kitchener, in 1884, had actually done this to gain information on the Mahdists holding Gordon and Khartoum.[78] And Henty was not the only author to use the device. A.E.W. Mason did so in his adult novel *The Four Feathers*, which likewise invokes Sudan and the Gordon tale.[79] There were, of course, precedents for Victorian men "passing" as Arabs. Most prominent was Sir Richard Burton, whose *Personal Narrative of a Pilgrimage to Al-Madinah and Meccah* first appeared in 1855 and ran to numerous printings. Burton's account, like those of less venturesome Orientalists, filtered into Victorian imaginations and took hold.[80]

Disenchanted, he owned, with "progress" and "civilization," Burton journeyed out from Europe hoping to experience from within a culture concurrent yet, he implies, mysteriously not coeval with his own.[81] He sought refuge from the strictures of Victorian morality by immersing himself in Eastern life and thought. That was scarcely true for all Britons who donned Arab attire, whether in authors' imaginations or no. For Victorians, dressing as an "Arab," though not passing for one, was a common affectation; oriental costume was popular at fancy dress balls and on the London stage. Such putting on of "Arabness" was frivolous, perhaps, and romantic, a means to tame the exotic by emulation. Yet it was no less serious for that. In displaying the capacity to know and assume "the other" at will, it affirmed the superiority of the self beneath the guise.[82]

Edward Said believed that "for Europe, Islam was a lasting trauma." In time European civilization incorporated that peril and its lore—Islam's great figures and events—weaving them into European imaginative life. The discursive practices known as Orientalism emerged at a time of European ascendancy, not defeat, furnishing images that enabled Europe's self-realization by contrast with "the other." Moreover, by the late nineteenth century, speculation that racial and ethnic differences had biological roots had linked older views of social hierarchy to Darwinian insights on secular, natural time.[83] Guided by the teleology of progress, scholars calibrated

the features of advanced and backward races, classes, and societies—categories often conflated in Victorian works. Social and physical "types" were ranked as more or less evolved. Europeans, of course, were the apex, but with an admonition. For if nature is dynamic, as Darwin and others proposed, then surely the telos could reverse. Degeneration, Sander Gilman observes, was "the underside of progress." Its possibility challenged the confident classifications on which imperialism relied.[84] Bourgeois Europeans, fearing for the continued supremacy of their race, thus came to regard stigmatized groups within their fold—prostitutes, the Irish, criminals, the unemployed—as congenitally "atavistic," bestial, savage, and "dark." Braced by the Lamarckian idea that environmentally induced characteristics could be fixed in the social organism—"in the blood"—fears of European retrogression inspired a number of liberal movements: to improve the lives of the poor; apply newly devised principles of hygiene to the seething slums; educate the masses; promote sobriety, chastity, and moderation so as to prevent overindulgence that, it was thought, leads to insanity. They also gave rise to programs of eugenic modification and surveillance of those deemed "unfit" to breed.[85]

Central to the idea of degeneration, and the source of "the particularly Victorian paranoia about boundary order," was the threat of disease and contagion.[86] For privileged Victorian women this threat was especially acute. "Body boundaries," writes Anne McClintock, "were felt to be dangerously permeable and demanding continual purification, so that sexuality, in particular women's sexuality, was cordoned off as the central transmitter of racial and hence cultural contagion."[87] Or, by extension, fitness and health. For middle class women, childbearing and "improving the racial stock" became national and imperial duties, and motherhood an exalted, if debated, role. In periodicals and commercial advertisements, and through voluntary societies promoting health and domestic hygiene, women were counseled to apply scientific principles to all facets of household life: infant feeding, child rearing, cleaning, meal planning and preparation, curing common ills.[88] The ideal Victorian home was a hub of rationality, in contrast to the supposed disorderly, unscientific, dirty habits of "inferior" groups. Maintaining imperial boundaries—physical, social, territorial—depended on domestic discipline, sexual probity and restraint, moral and physical hygiene.[89]

In Sudan Arab women, too, would be enjoined to apply scientific mothercraft for the good of the colonial state.[90] Yet in an ironic contradiction, the relative impermeability of their infibulated bodies, to them a defense of social and procreative purity, was thought by colonial British to impede their progress and the state's success. Thus, Sudanese women's bodies were tainted and unproductive, while local anxieties over social and physical boundaries were not sagacious but perverse.

The Victorian doctrine of racial degeneration supported views of "oriental" history as a legend of decay, of the erosion of Islam and decline of its once glorious civilization to ignorance, indulgence, and excess. But if Arabs were deemed backward, fallen from levels they had once attained, they were nonetheless more highly evolved than Africans. Victorian social geography was, as Johannes Fabian suggests, both spatial and temporal at once; leaving Europe meant traveling back in time, finding ever earlier "stages of man" the farther from Europe one went.[91] The idea that such distances could be lessened if not wholly eclipsed, that "backward races" could be uplifted by having the "advanced" in their midst, offered a compelling rationale for imperial expansion.

However rarefied the debates of late-Victorian scholars became, their ideas, like those of scholars in any age, were not created of whole cloth but engaged with issues abroad in the society of the day. Nor did they remain an elite preserve. The discourse of "scientific racism" seeped into everyday life through advertisements, novels, stage shows, and broadsheets, contributing to dispositions in civil society. Such a dialectic between pedagogues and the populace is, in Gramsci's view, essential to successful hegemony, the socially produced assumptions about the world that have become naturalized and serve to regulate social relations in the interests of the ruling class.[92] The scientific mystique that cloaked ideas of reproduction, race, and class presented them as objective and morally neutral, empirical facts of life. Popular media normalized such views by reflecting them as only so much common sense.

Still, to understand how Victorians understood Sudan we must take a further step: the lands of the upper Nile were anomalous, Arab and African at once, a liminal zone. In his *Tragedy of the Korosko* (1898) Conan Doyle portrays Sudan as a "wild unruly place," capable of erupting into savagery at any time.[93] Since nomads were thought to outnumber farmers—an impression likely created by the upheavals of Ottoman and Mahdist regimes—it was seen as less advanced than incipiently civilized Egypt, which had slipped from past grandeur but was reviving under Europe's sway. Egypt, for its part, and aided by Europeans, had been on the point of taming Sudan by putting an end to the slave trade when native "atavism" flared. Righting the havoc was up to British "gentlemen"—the confident paragons of Henty's tales.

Gordon's death and his rescuers' reverse were shocking proof of the potential for entropy in the imperial world that a single misstep could cause. Queen Victoria had written, "If not for humanity's sake, for the honor of the Government and the nation, he must not be abandoned."[94] Liberal Prime Minister Gladstone had ignored popular sentiment and delayed the relief; when on February 5, 1885, London learned of Gordon's fate, an angry mob gathered before 10 Downing Street, shouting and hurl-

ing stones at the facade.[95] At length a Conservative parliament resolved to shatter the "forces of darkness" and resume the "march of civilization." By 1896 that advance was being measured mile by railway mile as troops pushed south into Mahdist terrain.

Henty's characters who successfully "pass" as Sudanese Arabs leave the frontier of enlightenment and cross, like Gordon, into the realm of danger and the imperfectly known. Though modeled, perhaps, after Burton, they are less bent on gaining inner knowledge of their foes, than, as Gordon, on domesticating them. But unlike Gordon they are willing to compromise, to play at what they are not. Their success at deception implies that the skills of a Burton reside in every English gentleman. Burton had perfected his mannerisms before venturing out in disguise, training himself in the gestures, postures, and pious invocations that mark deportment in the East. In Alexandria he began to play his part, studying the "intricacies of the Faith" with a local *shaykh*.[96] Henty's young men do likewise, though more swiftly and in predictable caricature. Though for Mason's hero, Harry Feversham, who arrives in Sudan disguised as a swarthy Greek, "becoming" a dervish takes three whole years of sun, wind, and study to perfect.[97]

Still, the Burton analogy is inexact. For while Burton sought to be taken for a Persian, those who would pass for Sudanese must stain their skin dark, altering not just their language and habits of gesture and dress but a feature of appearance not readily subject to self-control. For them there is the added frisson of changing race, descending the social ladder in pretence. Aided, perhaps, by the appositely named product "Nubian Blacking," pictured below in ads from the *Illustrated London News* of 1885 and 1887, they undergo a temporary and reversible "devolution" in pursuit of a noble cause—to reclaim a lost brother, rescue a fellow officer, avenge a countryman's death. Yet the Sudanese whose identities they assume cannot repay the compliment, for in character, word, and deed they would, the authors show, fail to pass for English gentlemen even if their skin did not reveal them at once.[98] Gregory's exchange with the *amîr'* on rescuing women is a case in point.

The heroes not only darken their skin, but like Kitchener they also don the *jibba* and live to reclaim their rightful place. Henty's and Mason's protagonists thus emulate Gordon's avenger. Their journeys home from their ordeals rehearse the logic of progress, from Africa to Egypt to England, *jibba* to khakis and red serge, dark skin to white. They symbolically annul the fear of retrogression, the disenchantment occasioned by Gordon's death. They enact, as it were, an implicit rescue of Gordon himself, of the civility he had come to represent. Yet they never abandon their real identities: the inner truth of themselves as white, pure, and wise remains

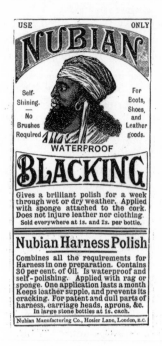

Figure 1: Two Advertisements for Nubian Blacking. (l.) *Illustrated London News*, 28 Feb. 1885, p. 238. (r.) *Illustrated London News*, 8 Oct., 1887, p. 494

intact. Like Kitchener, they mask their race in the cause of civilization: no "going native" is allowed.[99]

Links between savagery and Islam are also rife in Henty's tales. In the aftermath of the Battle of Omdurman, Gregory:

> could not but feel sorry for the valiant savages who under so awful a fire still pressed forward to certain death . . . and yet, when he remembered the wholesale slaughter . . . the capture of Khartoum, the murder of Gordon, and the reduction to a state of slavery of all the peaceful tribes in the Soudan, he could not but feel that the annihilation of these human tigers and the wiping out of their false creed was a necessity.[100]

Henty's characters enact an Orientalist struggle to subdue the "East"— an irregular, African East, beastly and Arab at once. Henty's reference to "their false creed" echoes Prime Minister Salisbury's [1895–1902] public attack on Islam.[101]

At the memorial held for Gordon upon the recapture of Khartoum, Gregory observes:

The Mahdi's cause, the foulest and most blood-stained tyranny that had ever existed, transforming as it did a flourishing province into an almost uninhabited desert, was crushed forever; and it was [Kitchener's] patient and unsparing labour, his wonderful organization, that had been the main factor in the work.[102]

In Henty's Sudan books, the British civilize by violence, something they tellingly refer to as "work." But his young protagonists do more: they are peaceable envoys, demonstrating the wonders of British domestic science to the Sudanese. This too, Henty suggests, is imperial toil. Importantly, when thus employed his heroes' race is not disguised. Their pallor, revealed in words and illustrations, both heightens the contrast between them and their antagonists and, in bringing that contrast to conscious attention, affirms its relevance to Victorian notions of progress. The boys' disguise is a fleeting transgression, a strategic layer of dirt—Douglas's matter out of place—that can always be removed by soap. Indeed, the characters suggest that only those who are white by birth can cross racial boundaries and impart their wisdom unchecked, thus clarifying for readers the Arabs' failure to measure up. Gregory teaches the amîr about gentlemanly ways; Edgar's diligence as doctor and slave instructs his captors in the value of hard work, scientific knowledge, and practical "common sense." As the youths enlighten the Arab Sudanese, so Henty enlightens his audience.

Commerce

A theme that weaves through Henty's books is the progressive influence of trade, and the need for a host of commercially produced "things" to sustain a civilized life. The list of commodities Gregory is counseled to buy before joining his regiment is long and minutely detailed, including not only his specialized kit, but provisions to augment the meager army fare:

> Of course you get beef, biscuit, or bread, and there is a certain amount of tea, but nothing like enough for a thirsty climate . . . so you had better take up to four or five pounds. . . . You might take a dozen tins of preserved milk, as many of condensed cocoa and milk, and a couple of dozen pots of jam."[103]

Once beyond the railhead, Gregory needs a baggage camel and native servant to manage his personal supplies.

Such elaborate preparations for Sudan were not unusual. A pamphlet from 1885 satirizing the Gordon relief fiasco contains a cartoon entitled "The Nile Picnic." It shows General Wolseley, leader of the "too late"

troops, struggling upriver under an enormous sack of British goods: jars of "Gladstone Jam," pickles, marmalade, a broom, a box of Indian ginger, bottles of champagne, a large tin of "Wolseley's Congo Tea."[104] The sketch makes sport of the white man's burden to tame the world through domestic consumption and trade, even as it affirms Britain's place at the hub of global enterprise.

In *The Dash for Khartoum* Henty suggests that some foreign goods had already found their way up the Nile by 1884; Edgar's *shaykh*, for instance, is amply supplied with matches. He implies that other items, like soap and Western attire, first arrived with the British troops. The *shaykh*'s camel raid nets him not just coveted rifles, but articles of European clothing—khaki suits, shirts, socks, boots—as well as medicines and tins of food. The Sudanese are (improbably) "puzzled [by the clothes,] and Edgar had to put on a shirt and pair of trousers to show how they should be worn."[105] The tins' contents are regarded askance by the Arabs, who had filched them for metal to make cooking pots and drums.[106] But Edgar transforms the powders into cocoa and broth, of which the *shaykh* approves. He is unable, however, to persuade the Arabs to like tea, and is able to keep the whole ten pounds for himself.[107]

Like clothing, tea—the elixir of British sociality—serves in these stories as a racial boundary marker; recall the troops conserving their water to brew. If, as Sahlins notes, "one readily grasps the function of tea as delivering a docile and effective working class into the maws of developing capitalism,"[108] then the *shaykh* and his people had a lucky, though short-lived, escape. Whatever their class, readers of the tale presumably did not.

When the entourage arrives at their village in Kordofan, Edgar is required to reveal his whiteness to the welcoming crowd by washing, but finds it impossible to remove the blacking from his skin with water alone: "I wish to goodness," he muttered to himself, "I had got a cake or twoof soap here, but I suppose it is a thing that they never heard of; even a scrubbing brush would be a comfort. I shall be weeks before I get myself thoroughly white again."[109]

The observation is anachronistic. Egyptians had, in fact, introduced soap manufacture to Sudan soon after the conquest of 1821; in Wad Medani on the Blue Nile, soap was produced throughout the Mahdist period, as British surveyors later observed.[110] And Kitchener was dismayed to learn that local markets were stocked with "Manchester goods" despite a strict economic blockade.[111] Indeed, peoples of the upper Nile had been at least peripheral participants in the world market since the seventeenth century, if not before.[112] No matter. The spread of civilization meant the spread of commodity culture—its cardinal products and the ideas that they conveyed. And the civilizing commodity par excellence was soap.

Though soap was in scarce supply at the start of the nineteenth century, by the end it was being mass produced and occupied a privileged place among manufactured goods. Ideas about cleanliness now condensed a range of bourgeois values, among them monogamy (clean sex), capitalist enterprise (clean profit), Christianity (being cleansed of sin), class distinction, rationality.[113] More, a close practical connection obtained between Victorian preoccupations with hygiene and evolutionary thought. Washing bodies, clothes, and homes—work done mainly by women—joined sexual purity rites such as race and class endogamy, as techniques, in Foucault's terms for "maximizing life," and ensuring the "longevity, progeniture and descent of the classes that 'ruled'."[114] Soap was both a symbol and an instrument of "civilization," where "civilization" was meant in a nonpluralizable sense.

Still, Victorian ideas about the intensified, healthy, vigorous, racially clean bourgeois body did not emerge in a Europe focused solely on itself. Rather, Anne Stoler argues, "they were refracted through the discourses of empire and its exigencies, by men and women whose affirmations of a bourgeois self, and the racialized contexts in which those confidences were built, could not be disentangled."[115] The politics and language of race furnished a scaffold to which the discriminations of class were secured; the reverse was also true. Scholars from Mary Douglas to Timothy Burke have shown how beliefs about the disorderliness and filth of others are claims for the integrity and merit of one's own group.[116] By invoking the discourse of cleanliness and dirt, Britons distinguished themselves from a host of unruly "others," be they prostitutes, Irish, or Sudanese.

Soap was thus both agent and material thought; its usefulness was not only practical, but rhetorical: it contained ideas, stood for social values extrinsic to its use. Indeed, its use was a performative act: it brought about hygiene, the rational, scientific, respectable state of being for which it stood. Made increasingly from tropical oils pressed by cheap colonial labor and transformed by British factories into an easily transported, low-cost, widely marketable good, soap, like cotton, was an obvious emblem of empire. More than matches, soap was an allegorical object,[117] a semantically laden vehicle for enlightening the "primitive" world—Africa, of course, but also the dark and festering urban jungles at home. Reciprocally, manufacturers of soap and other items of domestic hygiene drew on images of "evolutionary primitives"—monkeys, apes, and dark skinned peoples—in order to sell their wares,[118] showing the interplay between the periphery and the metropole that Stoler described.[119] A September 1887 ad in the *Illustrated London News* for "Brooke's Monkey Brand Soap" shows a figure of Britannia holding a laurel wreath over the bust of a chimpanzee; the ad claims the soap "saves labour and prolongs life. Pro-

motes cleanliness and secures health. . . . Causes brightness and dispels gloom. Teaches economy and avoids waste."[120]

Advertisements, of course, are highly condensed communications; while they aim to impart sufficient knowledge to persuade, their successful execution already presumes a knowing subject, a reader versed in the "prior meanings" that stand "as a guarantee . . . for the 'truth' in the ad itself."[121] With this in mind, consider the following ad for Pears soap (p. 39) that relies on readers' knowledge of Gordon's conflict with the Mahdi for its full effect.

Entitled "The Formula of British Conquest" it features six half-naked spear-carrying dervishes recoiling awestruck upon seeing the words PEARS' SOAP IS THE BEST emblazoned in white on the side of a massive rock in the Red Sea hills. Thomas Richards, in *The Commodity Culture of Victorian Britain*, suggests that this ad, better than others, shows the commodity as a magic medium "through which English power and influence could be enforced and enlarged in the colonial world." Commodities are not simply the vanguard of imperial rule; they create the empire all by themselves. They are the weapons that will allow "illiterate savages who cannot appreciate the value of things"[122] to be subdued.

Given its historical context, there is more to the ad than this. Victorian conceits notwithstanding, an inability to read English hardly betrays illiteracy, and it was unlikely, as we've seen, that Sudanese of the time would have been quite so perplexed by soap. The advertisement does proclaim the civilizing mission of commerce, but with a wry, self-mocking twist, for in August 1887, when it appeared in the *Illustrated London News*, commodities were the *only* British force with a prospect of penetrating Sudan.

Below the sketch is a quote (omitted from McClintock's version)[123] from a war correspondent covering the Gordon relief campaign:

> Even if our invasion of the Soudan has done nothing else it has at any rate left the Arab something to puzzle his fuzzy head over, for the legend PEARS' SOAP IS THE BEST, inscribed in huge white characters on the rock which marks the farthest point of our advance towards Berber, will tax all the wits of the Dervishes of the Desert to translate.[124]

This was not an apocryphal tale. A precedent had been set by British troops stationed in eastern Sudan in the 1880s who set out their regimental badges in white stones on the black rock faces of the Red Sea hills.[125] There is more. At a halt in the hills along an uncompleted railway begun in hopes of reclaiming the region from the Mahdist troops, imperial navvies had painted the words "Otao Junction" in white on a small rock, and opposite, on the boulders of a hill, "PEARS' SOAP IS THE BEST SOAP 5/5/85." Decades later other such "ads" could still be made out on nearby hillsides: "Drink Eno's Fruit Salts," "Barnes and Co.'s Preserved Provi-

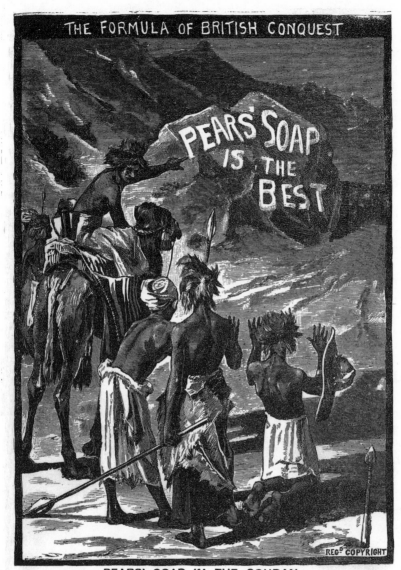

PEARS' SOAP IN THE SOUDAN.

"Even if our invasion of the Soudan has done nothing else it has at any rate left the Arab something to puzzle his fuzzy head over, for the legend

PEARS' SOAP IS THE BEST,

inscribed in huge white characters on the rock which marks the farthest point of our advance towards Berber, will tax all the wits of the Dervishes of the Desert to translate."—Phil Robinson, *War Correspondent (in the Soudan) of the Daily Telegraph in London,* 1884.

Figure 2: The Formula of British Conquest—Pears' Soap in the Sudan. *Illustrated London News*, August 27, 1887, p. 247

sions are the Best."[126] The troops, themselves immersed in commercial culture, had created a "proper English railway depot" complete with painted advertisements, facetiously claiming this hostile place for home before evacuating Sudan with the rest of the relief force in 1885. Not only might British entrepreneurs see commodities as a means of conquest, so too might thwarted British troops in a whimsical attempt to maintain a toehold in the land where Gordon came to grief. Richards and McClintock analyze the ad as a marketers' invention; yet Pears artists had simply taken the navvies' creation and completed it, the addition of wonder-struck dervishes making visible the evolutionary fantasy on which the imperial venture relied.

In Britain, the efficacy of the Pears advertisement depended on popular understandings of dervishes as dirty, violent, backward, and fanatical, in contrast to readers' notions of themselves as clean, orderly, literate, and humane. The dervishes are pictured half clad and, of course, carry weapons—tellingly spears, not guns, albeit they used both. Dervishes twice broke a British square and slew the Christian hero of the age, yet the British leave only words of domestic wisdom as their parting shot. But like forsaken Israelites beholding the commandments carved on stone by an unseen hand, the Mahdists draw back agape. By drolly invoking both biblical themes and domestic commodity logic, the ad reassures Victorian readers that they belong to a "we" who can bring enlightenment—Christianity, cleanliness, and commerce—to the savage Sudanese.

Move on to 1898, and see how the image has changed. Here is another ad from the *Illustrated London News*, this one published in 1898 one month after the British victory at Omdurman. It alludes to the earlier Pears advertisement yet, like Henty's and Mason's novels, replaces the 1885 failure with 1898 success—now in Lever Brothers' name. Entitled "The March of Civilisation: Sunlight Soap at Khartoum," it shows British officers placing an ad for Sunlight Soap on a mud-brick wall while bemused *jibba*-wearing dervishes, a veiled Arab woman, and an all-but-naked boy look on.

Now the hidden hand reveals itself: not God but Britons write the words, and not in the wilderness but in the heart of the former Mahdist state, the town where an exemplar of Christian civility dwelt. Note too the inference that goods such as soap will enlighten the Sudanese, indeed, perhaps, convince them of the imperfection of their faith. And again the ad is documentary, for below the drawing are printed a letter to Lever Brothers and eyewitness reports attesting that one J. R. Williams has been "the first . . . to place your advertisement in Khartoum . . . within one hundred yards of Gordon's Palace."[127] The signs of civilization accompany the imperial force in fantasy and in fact.

THE MARCH OF CIVILISATION: SUNLIGHT SOAP AT KHARTOUM.

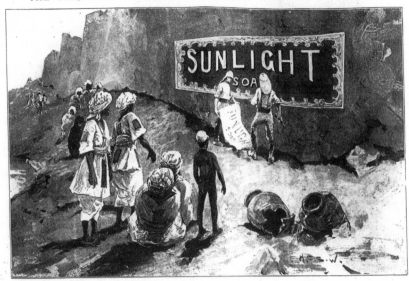

Figure 3: The March of Civilisation: Sunlight Soap at Khartoum. *Illustrated London News*, October 8, 1898, p. 525.

Commerce served empire on the home front too. A host of items produced in late Victorian Britain referred to Gordon's travails. Silk bookmarks bore a picture of the hero and accused one of his Arab officers of contriving the fatal breach in Khartoum's defensive wall. Mass-marketed toy soldiers in the figures of Camel Corps troopers and the Egyptian Army's Sudanese infantry enabled generations of children to restage the expeditions to Sudan, rescue Gordon, and defeat the Mahdist hordes.[128] The dervish enemy was, it seems, left largely to their fertile imaginations to conjure up.[129] When Ina Beasley, controller of girls' education in Sudan from 1939 to 1949, met the renowned Sudanese educationalist Babikr Bedri who had been a *jibba*-clad Mahdist at the fall of Khartoum, she described it as "a link with a storybook past, since one of my earliest recollections was being given the little statuettes from my grandfather's mantlepiece and playing with Gordon and Kitchener."[130] One must imagine other Sudan officials being raised on such stories and games.[131]

Books and toys presume leisure and a modicum of wealth. Yet more prosaic goods were marketed in the rhetoric of empire, too, from biscuits to toothpaste and stomach pills. Objects of everyday life suffused with ideology surrounded Britons in their homes and shops, spoke to them from sandwich boards and broadsheets where they jostled for attention

with news of imperial deeds. They reiterated the imperial vision that he allegory of Gordon and the Mahdi at once thwarted and affirmed. oreover, they belonged to the Victorian and Edwardian "cult of domesticity," which had become "indispensable to the consolidation of British identity.[132]

Sudanese Women and Men

Women, of course, stood central to that cult as well. Yet they are virtually absent from the Pears and Sunlight ads: those who have written the messages and all but one who receive them are men. Cromer held little hope for rapid success in adapting "Western methods" to "Eastern minds" in Sudan, where merely taming the country would take time. He nonetheless held that the position of women "in Mohammedan countries" is "a fatal obstacle to the attainment of that elevation of thought and character which should accompany the introduction of European civilisation."[133] Sudan's progress would thus depend on the uplift of its womenfolk.

What images, then, might Britons have formed of Sudanese women from literature and journalistic reportage? First, recall Henty's conceit that women of the Arab north share qualities with the ideal British mother, but that, given their status as their husbands' favorite wives they are presumably more sexual than she. And they certainly know nothing of domestic science. They accompany their men into battle, after all, as do women attached to the "Black Battalions" of Soudanese, southerners in the Anglo-Egyptian force:

> "their women follow them wherever they go; they cook for them, and generally look after them. They are as warlike as their husbands, and encourage them, when they go out to battle, with their applause and curious quavering cries. . . . I believe [the men] would rather be killed than come back to face their reproaches."[134]

Model British women, on the other hand, are the essence of feminine grace: physically delicate, sensitive, attended by servants, but above all safe "at home." Still, as Mason's Harry Feversham learns, they too hold their men to high account and brook no cowardice at all.

Henty's images of female Sudanese are more generous than those of African women current in Europe at the time. Dark-skinned peoples had long been considered sexually promiscuous, and throughout the nineteenth century and well into the next the figure of the "African woman" was a highly sexualized one in medical science and popular culture alike. Sander Gilman notes that in contemporary iconography the mere presence of a black female servant in a painting, an opera, a play, served to alert

the audience to the deviant sexual roles of white women featured in the scene. As the consummate evolutionary primitive, the "African woman" typified the antithesis of European aesthetic standards and ethics of carnal restraint. European travelers to southern and western Africa had told of women with hypertrophied labia, a condition often induced by manipulation and deemed a mark of beauty in its African settings. In Europe however, female genitals reflected their owner's internal disposition; enlarged labia suggested not only "primitive" unbridled sexual appetites, "but also the external signs of this temperament, 'primitive genitalia.' "[135]

When the century's concerns crystallized around fears of degeneration, European prostitutes—"atavistic" whites—were thought to have exaggerated genitals, too, due possibly to hereditary malformation. In any case, female genital pleasure was judged abnormal and perverse, degenerate, unclean.[136] Women who rebelled against Victorian mores were deemed "hysterical," for which clitoridectomy might be suggested as a cure.[137] As we see in chapter 10, in the second quarter of the twentieth century, some British physicians and educated Sudanese considered the "normalization" of female genital hypertrophy and reduction of its antisocial effects to be the object of pharaonic circumcision in northern Sudan.

As exemplars of rampant, "primitive" sexuality, African women were to be "civilized": washed, clothed, and tamed through domestic training, hard work, and monogamous marriage. Over much of the continent, Christian missionaries shouldered that task.[138] Though embargoed in northern Sudan, missionaries had a hand in reforming local women there too.

British views of Sudanese were likely influenced to a point by Egyptian attitudes, insofar as Egypt was the source of Britain's interest in the upper Nile. Though Egyptian images of Sudan and Sudanese doubtless varied by class, and changed with shifts in triangular power relations over time, in the late nineteenth century they seemed to be ambivalent. Eve Troutt Powell points out, for instance, that as Britain intruded ever more deeply into Egyptian affairs after acquiring shares in the Suez Canal in 1875, educated Egyptians came to identify, against the British, with the inhabitants of the upper Nile over whom Egypt governed. Yet the British occupation of Egypt in 1882 and Egypt's definitive loss of Sudan to the Mahdi in 1884 altered this. Egyptians went from being colonizers under British sway to being colonized themselves, in fact if not in name.[139] They now embraced Mahdists as fellow Muslims who were happily free of British rule.

How far did such images affect the British in Egypt at the time? The Egyptian Army was led by Arabic-speaking British, all of whom held officer rank. Rank, whether military or racial, posed as great a barrier to intimacy as prejudice posed to trust. British in Sudan were suspicious of Egyptians and remained so throughout the Condominium. And though

they reviled Mahdists as heathen fanatics, they also admired them for their courage and desire to be free—of Ottoman Egypt. They were impressed too by the nerve of the "Black Battalions," former slaves with origins in southern Sudan, even as they thought them "slovenly and uxorious" because attended by their womenfolk every step of the campaign.[140]

What of the Sudanese women who sustained the embattled forces or lived in the zone of war? Unlike Egyptian men, some of whom had dwelt in Sudan and taken local concubines or wives, few Britons in Kitchener's force had encountered them before. They saw them, certainly, yet the stock portrait of Muslim women as secluded and utterly dominated by men did not hold for late nineteenth-century Sudan, in part because its peoples were culturally and historically distinct from those of the lower Nile, in part because of the upheavals of war. A harem image would come later, with peace, resettlement, and colonial encouragement of orthodox, conventional Islam. Pace Henty, in the early days of conquest and occupation, Muslim Sudanese women struck British observers as even more primitive than the men. Two of Kitchener's officers had the following to say about women of the Mahdi's ethnic group:

> The average Danagla woman is not a "Venus"—in fact she is appallingly hideous. Her woolly hair, all dripping with grease, is parted down the middle, and hangs in straight curls on each side of the face. Her dress consists of a single piece of broadcloth wound round the body. The bigger children [unmarried girls] wear a *raht* [*rahat*]—which is best described as a fringe of bootlaces round the middle—and the smaller fry go about *puris naturabilus*.[141]

Another wrote that the *rahat* was worn by all women, big and small, and described how they greeted the troops as they steamed up the Nile:

> All along the water's edge raced a horde of half demented women, completely naked except for a girdle of "boot-lace fringe," and ululating frantically. . . . There were hardly any men at all to be seen on these islands. . . . [W]e passed a place which the Dervishes had just burnt and taken all the men away, leaving the women; the latter seemed quite cheerful over it all.[142]

With their "appallingly hideous," "woolly-haired," "greasy" and virtually naked appearance, "half-demented" behavior, "frantic" vocalizations, and apparent disloyalty to male kin, northern Sudanese women were the very picture of female savagery. By comparison:

> The men are a striking contrast to the women, and very different from the coarse featured squint eyed type of Arab so common in Egypt. Their physique is splendid and some of their faces, with their large dark eyes, with a peculiarly wild and mournful expression, were exceptionally handsome.[143]

They are wild, handsome, conspicuously un-Egyptian—but also excep-
tionally brave, as in Kipling's poem "Fuzzy Wuzzy," where a dervish of
the Red Sea hills, a poor benighted heathen, is yet a first-class fighting
man.[144] Arab Sudanese men are admirable but misguided; the women
seem a race apart.

Such gender images recur—albeit in more subtle, attenuated forms—in
the discourse of the Anglo-Egyptian regime that was built from the rubble
of Gordon's Khartoum. While many administrators developed amicable
relations with Arab Sudanese men, especially those of the religious and
educated elite, they consistently reproached women for their "backward-
ness" and superstitious natures, not least because they practiced phara-
onic circumcision. Indeed, the blame women bore for this custom conve-
niently veiled the intransigence of local men in the face of potential
reform. Sudanese women were a prime impediment to imperial progress,
hampering the reform of domestic life that it required.

Might the presence of British women have moderated this view? Very
little, and certainly not at first. In *The Four Feathers*, a Sudan official tells
the heroine, "You are fortunate enough not to know Suakin, Miss Eu-
stace, particularly in May. No white woman can live in that town. It has a
sodden intolerable heat peculiar to itself."[145] The belief that white women,
particularly European gentlewomen, could not survive the rigors of Sudan
was widely held and influenced the character of the administration for
years to come.[146] The first British officials were expected to be stoic and
sexually ascetic, to live the all-male life of the barracks and British public
school. Like Gordon, Kitchener remained unmarried; more, he refused to
enlist as officers men who had wives or were engaged to be wed.[147] Later,
civilian recruits were required to be bachelors and actively discouraged
from developing attachments. After two to five years of service they could
ask permission to marry, which was withheld if an applicant's posting
was considered unsafe.

Indeed, until the mid-1920s European wives were seldom allowed in
Sudan for more than a winter visit, and that was often confined to Khar-
toum.[148] Even if they socialized with Sudanese women, something that
protocol and local modesty codes constrained, their lack of Arabic would
have limited what they could learn. For political reasons—to preclude
offending Muslim sensibilities and guard their own prestige—British men
were admonished to avoid Sudanese women and, by some accounts, that
rule was seldom breached[149] and rarely broadcast when it was.[150] Knowl-
edge of Sudanese women came to the British mainly through Sudanese
men; this, one suspects, was not always faithful to women's points of
view. It is hardly surprising, then, that when officials encountered local
women in the early days of British rule the latter seemed childish, enig-
matic, and also sometimes "wild."

Sudanese women, however, were attentive, and returned the observation and more. Their thoughts are not to be found in government papers. Instead, women kept their own colonial accounts. Theirs is an embodied archive, housed in the long-lived figures of the *zâr*, spirits who appear regularly in their midst and enact the imagined past. Excursions into *zâr* spirit possession enable us to glimpse northern women's impressions of the colonial world and some of the figures who peopled it. As with other forms of knowledge, *zâr* is not impartial; it is knowledge *for* Sudanese women, of the British and others, and very often mediated by Sudanese men.

Interlude 1

ZÂR AND ISLAM

*In April 1907, on the eve of the Prophet's birthday in the recently built
city of Port Sudan, a young engineer saw "the weirdest show." He and his
fellow Britons were guided by native officers to a large enclosure "made of
Venetian masts decorated with flags, and lighted with lanterns." Then a
Sudanese friend took him to see the* zikrs, *ecstatic "remembrance" rites
invoking the names of Allah, that were taking place all around. A* zikr, *he
wrote, "is hard to explain." Its "necessary ingredients are some music, a
crowd (forming a ring), and some form of dancing." The dances, though
"crude," have as "their object, the working up of a rather curious excite-
ment, which seems to be more religious than anything else."*

> The oddest thing I saw was a ring in which the music was supplied by two
> tom-toms and the performers were women: they were crouched on the ground
> and were entirely covered by large blankets spread all over them. All that
> could be seen was the convulsions of the blankets. My guide was very careful
> to explain that the women were not free agents at all, but that their contor-
> tions—they knelt down and waived [sic] their heads up and down violently—
> were entirely the work of a particular devil or spirit which always had the
> same effect. Rich men pay considerable sums for their wives to "work off"
> this devil with appropriate paraphernalia in the way of music and so on. . . .
> All very curious, and, like the native himself, a curious mixture. The per-
> formers are all Sudanese [black southerners] or Berberines [riverain people,
> Arabized Nubians]. I saw no Fuzzies there at all.[1]

The "oddest thing" that the engineer saw was a *zâr*. The term refers at
once to a type of spirit, the illness such spirits bring by taking possession
of humans, and the rites by which the spirits can be appeased. *Zâr* takes
two forms in northern Sudan: *zâr bori* and *zâr tambura*.[2] The former,
linked to *bori* practices in northern Nigeria and Niger,[3] is practiced mainly
by northern riverain Arabs, and widely known simply as *zâr. Tambura*,
however, is regarded as indigenous, associated mainly with the descen-
dants of former slaves and subaltern groups. G. P. Makris writes of a
flexible "*zâr* cult complex," in that some spirits and ritual forms may be
present in both.[4] Variants of *zâr* are found in Egypt, Ethiopia, Somalia,
Arabia, and Iran.[5] In Sudan, *zâr* rituals and coteries of adherents, mainly

women, were modeled in part on those of local Sufi brotherhoods or _tarî-qa_s, whose _zikr_s or "remembrance" rites our witness also observed. Interestingly, his account suggests that in the early twentieth century, _zâr_s and _zikr_s were performed side by side as complementary religious devotions on major Islamic holidays. Today the two are firmly distinguished and those who consider themselves pious condemn the _zâr_ as unIslamic.

Zâr's diminished status as a practice of popular Islam may owe much to the British promotion of religious conservatism. According to Pamela Constantinides, _zâr_ arrived in Sudan about the time of the Ottoman conquest (1820–21) and, by the period of Anglo-Egyptian rule, had grown so popular that it was seen as a threat to orthodox, legalistic Islam.[6] Like the cult of the Mahdi and its sequels, it was denounced by the conservative Egyptian-trained religious scholars (ʿ_ulama_) whom the British appointed to official posts in a bid to stem the tides of charismatic faith. _Zâr_ was one of the "superstitious" practices that to the British marked Sudanese women as more backward than Sudanese men.

Although the ʿ_ulama_ regarded the _zâr_ with disfavor, they subscribed, as all Muslims do, to the foundations on which the practice rests, for _zayrân_ belong to the class of beings called _jinn_, whose existence the Qurʿan substantiates.[7] _Jinn_ are mischievous ethereal entities who inhabit a world that is both parallel to our own (they have homelands, ethnic groups, religions, classes, sex, and age) and contiguous with it (their lands overlie our own), but imperceptible to us most of the time. They are sentient beings created by Allah and both similar to and different from _bani Adam_—sons of Adam, human beings. Whereas humans are composed of water and earth, _jinn_ are composed of complementary elements: air and fire. Though _jinn_ live longer than humans, they are nonetheless bound by natural law and social contract; they are born, have childhoods, grow up, marry, reproduce, live in families, and ultimately die. Yet they have a number of exceptional abilities. They can move unimpeded through walls and doors, transform themselves into animals, assume human form. They can take possession of humans at will, signaling their presence by provoking illness, disturbing visions, or dreams. But while some _jinn_ are malevolent and others benign, _zayrân_ or red _jinn_ are capricious pleasure seekers, amoral and ambivalent. Most of the time they remain "above" (_fôg_) their human hosts, exerting constant pressure on the head or neck, inducing in them specific moods, bodily sensations, and desires whose import can be deciphered with the aid of _zâr_ specialists, _shaykhat_.[8]

During ceremonies, _zayrân_ can manifest themselves to people they do not possess; they do so by entering the bodies of their mediums during trance, displacing their persons and acting in their stead. The possessed seldom enter trance spontaneously; trance is a state one must learn to effect in order to negotiate an appropriate relationship with intrusive

zayrân. As adepts put it, one must learn how *not* to resist a spirit's attempts to enter the human realm through the medium of one's body. Local ideas about women's role in sexual intercourse are implicitly echoed in the fact that a woman should be married before she publicly acknowledges she is possessed, even if she suspects that a spirit began troubling her long before.

When I researched *zâr* in a village in northern Sudan during the 1970s and 1980s, men told me that the proper procedure for dealing with bothersome spirits was to dislodge them by exorcism and force. Women, however, claimed that *zayrân,* unlike other types of *jinn,* cannot be got rid of at all.[9] Adepts insist that if one's illness is caused by a *zâr,* no amount of Islamic or Western medicine can achieve a cure. Attempts to exorcise the spirit serve merely to intensify the person's condition. The best to be hoped for is a remission of spirit symptoms, and that, only if the afflicted agrees to propitiate the as-yet-unidentified *zâr* by holding a ceremony in its honor. Having agreed, she may start to recover, but is nonetheless possessed.

During the ceremony, which may take place long after the initial illness has abated, the patient or "bride of the *zâr*" (*arûs az-zâr*) enters a contractual relationship with the spirit responsible for her lapse from health. But first the identity of the intruder must be resolved. This is done by observing the patient's response to the drummed refrains of known *zayrân.* Each spirit has a personal chant, known as its "thread" (*khayt*). During a ceremony threads are "pulled" (drummed and sung) one after another according to a schedule of spirit nations that begins with Islamic holy men— the dervishes or *darawîsh.*[10] When a spirit is named in a thread, it "descends" (*nazal*), should it desire, into its hosts, where it can interact for a time with humans and other spirits. The quick bobbing motion described by the British engineer is called *nizûl* or "descent," a word whose connotations include submission and revelation. *Nizûl* is performed from a kneeling or sitting position and is the first indication that the spirit has arrived. The atmosphere is lively, each woman's movements becoming ever more rapid as she enters trance and the spirit takes control. If a woman has already sponsored a ceremony she now rises to her feet, manifesting her *zâr.* Several may be possessed by a single spirit and exhibit it simultaneously. If well-behaved, the spirit relinquishes its hosts when its "thread" is over and the rhythm shifts to that of another *zâr.*

But a novice's spirit is rarely so tame. At some point during *nizûl,* she will suddenly throw aside the cloth covering her head: her spirit has appeared. Now its name—usually, but not always that of the thread being played at the time—can be affirmed and its demands revealed. Likewise, if an established spirit is tenacious and reluctant to quit, the curer persuades it to speak. In either case, she will coax the spirit to state its wants,

and bargain with it if these seem outrageous. Ideally, in return for its desiderata the invader agrees to restore, and refrain from further harming its host's well-being.

Human host and possessive *zâr* are thereby joined in continuous but unequal partnership. To some extent a woman can rely on the spirit's compliance in maintaining her health, but only as long as she abstains from mourning customs that oblige her to fling dust on her head (the *zâr* resides above her and abhors dirt), associates herself with clean and sweet-smelling things (spirits love perfumes and fine soaps and detest unsanitary conditions), and is not given over to strong emotion (spirits require their hosts to comport themselves with dignity, though during "descent" one might cause a woman to act in undignified ways). Dignity is the inverse of exposure. It is expressed through bodily restraint, downcast eyes, and closed mouths in the presence of strangers, especially men; in the covered, infibulated, morally fertile female body; in the security afforded by court-yard walls and marriages between close kin. A breach of these conditions renders a woman vulnerable to spirit attack.

When the identity of her spirit(s) is determined a woman must also agree to attend the *zâr* rituals of others whenever they occur, so her spirit has regular access to the human world. Spirits regard such invitations as their right and are apt to become petulant and dangerous if neglected or put off. *Zayrân* are hedonists with an insatiable taste for human finery and food, a disgust of dirt and bad smells, and limited tolerance for local fare and homespun cloth.

Once granted their desires, *zayrân* should confine their appearance to ceremonies where they can frolic and be entertained. But a violation of any negotiated provisions exposes a woman to relapse. Alleviating posses-sion illness is a matter of cultivating reciprocity between spirit and human host; their relationship, like that between spouses, should be one of com-plementarity, exchange, and mutual accommodation. Indeed, possession enables a woman to negotiate indirectly with her husband, before whom she (but not the spirit) is expected to be shy and reserved, for it is her husband who is responsible for funding her spirits' requests.

The identities of spirits, their distinctive demands, and their antics when manifesting themselves to humans, reveal the richness and complexity of the *zâr* as a cultural resource, its capacity—worked out through the women it affects—to comment on both contemporary life and the wider historical challenges that have faced northern Sudanese since the nine-teenth century and before. It is the *zâr*'s historical dimension that most concerns me here.[11] The pantheon of *zayrân* is a chronicle of powers that have impinged on peoples of the upper Nile, especially during the Turko-Egyptian, Mahdist, and Anglo-Egyptian regimes, but also since. Although the roster of spirits varies from place to place in Sudan, most *zayrân* are

the analogues of powerful male strangers who have touched the community in memorable ways. Since the *zâr* world parallels the human, individual humans, living or dead, may have *zâr* facsimiles whose names and characteristics are similar to their own. Even when no specific analogue can be discerned, spirits' requests correspond to their personal and "national" identities. An Islamic holy-man *zâr* asks for prayer beads and dazzling white robes which its hosts are expected wear during its ritual descent. An Abyssinian prince demands red silk robes, an ebony cane, and a coffee service every Sunday. An Egyptian *hakîm* (doctor) requires a fez and a black topcoat worn over a cream-colored gown. A contemporary European asks for Nike running shoes. Most *zayrân* demand imported soap—today Lux, yesterday Pears'?

Little did the official know that the women he saw on the eve of the Prophet's birthday may not have "been" themselves but, perhaps, Mohammed Bikayfu, a fierce "Fuzzy-Wuzzy" dervish who demands a sword that he flourishes with menace; or a Ta'ishi Baggara of the Khalifa's tribe who brandishes a spear; or *khawaja* (European, literally, mister) and *basha* (pasha) *zayrân* including spirit parallels of British army officers and administrators such as Al-Wardi Karoma ("Lord Cromer"), who was overly fond of rum, smoked cigarettes, and was asked to be generous; Nimr al-Khala, Leopard of the Desert, who, like Kitchener or Wingate, rode a fine steed and sailed a steamboat on the Nile; or, indeed, Gordel ("Gordon") who required a khaki uniform, boots, and Turkish *tarbûsh* (fez).[12] Though Gordel and Caroma did not show up at the *zârs* I attended in the 1970s and 1980s, they had done so in the past; several women claimed the two were still "above" them but had "retired" from active participation in rites.

By invoking historical (spirit) personae through the *zâr*, northern Sudanese women rehearse and create *their* social memory, that which shapes experience in the present by reference to the past. In Sudan this is a motley record of foreign invasion, slaving and warfare, peaceful and informative exchange, all captured in the ever-changing, ever-reworked figures of *zayrân*. Moreover, by taking on (rather than exorcising) exotic selves more powerful than they, and drawing them into contractual relations requiring compromise and concession, Sudanese women "civilize" amoral, ambivalent spirits while hinting at how to cultivate human "others" as well.

2

TOOLS FOR A QUIET CRUSADE

At Khartum . . . everything is à la Gordon. . . . On the spot
where his massacre is supposed to have taken place is a superb,
well-kept rose-tree, whose red blooms are witness of the blood
that has watered it.
 —Yacoub Artin Pasha, *England in the Sudan*

Everyone's fanatical in one way or another.
 —Tayeb Salih, *Season of Migration to the North*

Condominium

The Battle of Omdurman had ended Mahdist rule; it was crucial to decide how Sudan would be governed next. Britain's reasons for remaining in Khartoum grant some insight into the process. Of course there was the Gordon debacle and the desire to salve imperial pride; yet the regime that ensued was not punitive. The infamous "scramble for Africa" had decided the timing of the reconquest. For years the Mahdists had usefully deterred other European powers from claiming the watershed of the Nile. But in 1896 events had combined to provoke a British move: Italy was expanding its colony of Eritrea beyond the Red Sea coast, Abyssinians and Mahdists were suspected of treating with the French who sought to develop a band of influence across the Sahel, and Belgium was pushing north from the Congo. Britain's strategic interests in Egypt, especially the Suez Canal, settled the fate of Sudan. Invoking the right of conquest, Britain declared a partnership with Egypt, and in January 1899, the Anglo-Egyptian Condominium was announced, abrogating former Ottoman claims.

Though the flags of Britain and Egypt now flew side by side in Sudan, supreme military and civil command was vested in one man, the governor-general, who was appointed by khedival decree but selected by the British government. He would be British, and his proclamations were to have the

force of law.[1] Moreover, Europeans would occupy all executive posts, with Egyptians in supporting roles. Though the army was Egyptian, its battalions of Egyptians and "Soudanese" (a term initially applied to southerners and former slaves) had both British and Egyptian officers with Britons in commanding ranks. As Sudanese scholar Mohamed Omer Beshir observed, "for all practical considerations the Sudan was an 'autonomous' and independent state" in which, despite Egypt's role, Britain had "a freedom of action and movement . . . she did not normally have in her colonial territories."[2] As noted in the Introduction, Sudan was an anomaly, bound not to the Colonial Office but the Foreign, in the eyes of its administrators not a colony at all.[3]

In other parts of Africa, European missionaries, settlers, and commercial interests were ensconced well before the start of colonial rule. But in post-Mahdist Sudan, political administration came first, making colonial transition a top-down affair. The country had, of course, endured lengthy domination by European-influenced Egypt prior to the Mahdi's revolt; its inhabitants were reluctantly familiar with foreign command. And even before the Ottoman conquest of 1821, Sudan's feudal states and strengthening "Arab" bourgeoisie had developed commercial ties with the Islamic north and east.[4] Thus Muslim Sudanese were hardly novices to state control, production for export, the commodification of land and labor (this last in the form of slaves), or formal education in *kuttab*s, religious primary schools. The British set about restoring past institutions they deemed useful and replacing those they did not. To forestall further unrest, land alienation was prevented by limiting foreign ownership. No special privileges were reserved for Europeans or Egyptians.[5] Sudan would not be a settler colony but, as labor was often scarce, foreign workers were urged to locate or remain in the country from time to time.

If the romantic figure of Gordon besieged on the upper Nile was one side of the colonial coin, its obverse was more pedestrian: security and trade. The occupiers came to civilize, to subdue but also transform. Fanatical barbarians were to become diligent workers who contributed to and consumed the products of a global economy that Britain oversaw. Kitchener, recall, had declared Sudan open for commerce shortly after the Battle of Omdurman. Making Sudanese productive and the administration secure was what officials now set out to do.

The tone of the Condominium was set during Wingate's long administration, which began in 1899 when Kitchener left for the Boer War, and ended with his appointment as British High Commissioner for Egypt in December 1916. Wingate's attitudes had been shaped by participation in the ill-starred Gordon relief campaign and, in the interval before the reconquest, by his role in coordinating military intelligence from the Egyptian frontier. He had arranged for publication of the Omdurman captivity

memoirs discussed in chapter 1, and was anti-Mahdist to the core. He expected British officials to hold high moral standards and display, if not conspicuous piety, a commitment to Christian values. Charismatic Islam was a perennial concern, and policy toward Sudan's religious leaders was therefore in part conciliatory, in part restrictive, yet always apprehensive.

Throughout the colonial era Khartoum guarded its de facto autonomy and was often evasive in dealing with Foreign Office masters in London (via Egypt), for its stewards feared the latter's vacillation. Further, Egyptian officers were deemed untrustworthy, "likely bearers of nationalist and pan-Islamic ideas,"[6] and their influence on northern Sudanese was kept in check. In turn, both Egyptians and northern Sudanese were deterred from influencing southern non-Muslim groups, again so as to curtail the spread of Islam.[7]

Islam

The crusade against Mahdism continued after Omdurman. Fearing a Mahdist resurgence, Wingate and his successors supported conservative mosque-based Islam over charismatic versions with which popular devotion lay. Sufi fraternities were discouraged as being unorthodox, based on "superstition." Their leaders, regarded as sources of potential unrest, were placed under surveillance by the intelligence department, guided by Rudolf von Slatin whose experience as a captive of the Mahdists had earned him the post of "Inspector General" with responsibility for religious affairs. The government arrogated authority to determine what was properly Islamic and what was not, firm in the expectation that its select board of Egyptian trained ʿulama—religious scholars—would back it up. The situation was not unique to Sudan. Faced in Islamic Africa with "the vagaries of local custom," colonizers tended "to champion the shariʿa" which, being formal and explicit, "is 'tidier' . . . from the administrative point of view and provides better political propaganda."[8] Promotion of shariʿa enabled the British to pose as champions rather than enemies of Islam.[9] Still, they were less concerned to match government policy with Islamic ideals than to obtain religious sanction for secular reforms. And by posing as champions of the "true" Islam, they sought to weaken charismatics' followings of devotees. As historian Noah Salomon observes:

> An Islam whose seats of authority and learning were spread out through the villages and towns, and whose teachers were individual sheikhs of Sufi orders, was to be replaced, in the British ideal, by one central authority, one official seat of learning, in the capital, under the watchful gaze (and indirect administration) of the British authorities. In an interesting reversal of the common

secularization thesis, wherein secular government is supposed to encourage the privatization of religion, Kitchener argue[d] that it [was] "private" religious institutions that pose[d] the deepest threat to the Sudan.[10]

And Mahdism deepest of all: its remaining leaders were either imprisoned or their actions confined, for though the Mahdiya was defunct, belief in the Mahdi was not. Several revolts occurred in the first three decades of British rule, of Mahdists who spurned the new regime, farmers using a religious idiom to protest an unfair division of land, thwarted slave dealers, or Sudanese heeding the call of one or another self-declared Nabi 'Isa—Prophet Jesus.[11] These last believed the British to be the Antichrist (al-Dajjâl, the deceiver) who was predicted to appear during an age of chaos, oppression, and injustice following the Mahdi's death. Al-Dajjâl would supply food and water to tempt the suffering, and his miracles and false teachings would lead many astray. His arrival would herald the second coming of 'Isa shortly before the day of judgment and resurrection.[12] Nabi 'Isa outbreaks were localized and garnered slight support, yet officials "bred on the Gordon hagiography" were easily persuaded of their threat.[13] Millenarian movements were unflinchingly suppressed, sometimes by summary execution in defiance of Foreign Office scruples.[14]

Prophets and charismatics aside, great care was taken to avoid antagonizing Sudanese Muslims and to cultivate their trust—by reopening and facilitating the pilgrimage (forbidden by the Mahdi and a source of resentment against him), funding the construction of mosques, affirming *shari'a* law for Muslims in matters of personal status,[15] sponsoring *kuttab*s entrusted to orthodox teachers, and maintaining Friday rather than Sunday as the day of rest in the north.[16] Importantly, Christians were utterly forbidden to proselytize Muslims. So deep ran this concern that during the first few years of British rule, signs posted in public places declared that if a Muslim Sudanese was found talking to a missionary, both would be subject to arrest.[17]

Christianity

Such moves alarmed the Church Missionary Society, the evangelical wing of the Anglican Church, whose members saw government as doing everything in its power to suppress Christianity and promote Islam when it ought to do the reverse. They felt they had a duty to Sudan and the right, as Gordon's congregants, to install themselves in Khartoum. When, in 1878, Gordon had appealed to them for a mission to the "pagan tribes" in the south, they had been financially unable to respond. But at his death in 1885 the society was flooded with donations to found a "Gordon Me-

morial Mission to the Soudan." Fortunes were bequeathed under strict instruction that they be used to convert Muslims once the country had been wrested from dervish control.

The CMS had been founded in 1799 to minister to freed slaves in Sierra Leone and atone for Britain's role in the transatlantic slave trade. It was strongly apostolic, dedicated more to spreading the Word than performing exemplary deeds. Further, though it always attracted a smattering of "country gentlemen, senior military officers and sophisticated theologians,"

> the Christianity it reflected was essentially that of the English middle and lower classes: unintellectual, fundamentalist, intensely Biblical, strongly anti-Romanist and inhabiting a world of moral absolutes with few neutral areas. . . . [Members] intensely distrusted merely human calculations of political prudence which might frustrate [their] mission of universal evangelisation.[18]

In 1900 two CMS "pioneers," Llewellyn Gwynne and Dr. F. J. Harpur, landed in Sudan. Rather than continuing to the south where they had been given permission to work, they stubbornly lingered in Khartoum on the mistaken assumption that the proselytizing ban would be short-lived.[19] Facing competition from American Presbyterians and Austrian Catholics,[20] both of whom set up missions in the "pagan south," the CMS had resolved to establish "an English mission . . . a true Gordon Memorial amongst the people for whom he died."[21]

Intriguingly, period CMS texts are rife with "end-of-the-world" claims similar to those of Muslim Nabi 'Isa cults. Members believed that only after they had evangelized the entire world could Jesus reappear and they be redeemed. To them the empire was an instrument of God entrusted to their use. In 1897 missionaries "proceeding to the field" were invited to celebrate Victoria's lengthy reign:

> Truly wonderful has been the opening by Divine Providence of long-closed doors, and of the way into vast regions previously unreached; and truly wonderful has been the work of the Holy Spirit in the conversion of tens of thousands of individual souls, proud Brahmins, fanatical Mohammedans, shrewd Chinamen, cannibal Maoris, degraded Hottentots—conversion, not merely from one religious system to another, but from darkness to light, from sin to righteousness, from lust to purity, from the slavery of Satan to the liberty of Christ.[22]

Gwynne felt this burden acutely. To him, Gordon was "a saviour" whose death had been necessary to "stir the people of his own race to redeem and lift up . . . the people bought by his own sacrifice."[23] Wingate counseled caution, noting that missionaries precluded from preaching might yet "show by their life what Christianity was."[24] He made Gwynne

chaplain of Khartoum, thinking, perhaps, to temper his zeal by enticing him into the conventional Church.[25] Though Gwynne still preferred to tell rather than show, he welcomed the opportunity to cultivate officials and press his cause from within.[26]

In 1901 Dr. and Mrs. Hall, who had started a CMS dispensary in Omdurman, complained to the London committee of being forbidden to speak on Christian matters even to their Muslim servants in the privacy of their home. The CMS protested to the Secretary of State for Foreign Affairs, arguing that where British rule is supreme, "the principle of absolute religious freedom" guarantees the right to preach publicly to Muslims. As they had preached without disruption even in Peshawar, "an Afghan city with a fierce and fanatical Moslem population," concerns for security in Sudan were a vain excuse for restraint. "A Christian nation," they wrote, "has no right to suppress or conceal its religion," for "Christianity is more than a theological or ethical system," it was an accepted fact.[27] Cromer and Wingate conceded only that personal conversations with inquirers might be exempt.[28]

Eighteen months on, the injunctions grated still. Gordon College—then a primary school designed to train native youth for minor government posts[29]—was denounced for teaching the Qurʿan, and to Christians and Muslims alike. Worse, the college was employing conservative Muslim *shaykh*s to educate instructors for government-supported schools.[30] The response from the CMS parent committee was swift:

> If we can show that the Government is really teaching the Moslem religion in the Schools, and helping it forward, while they are preventing the Society of Societies [*sic*] from spreading the Truth of the Gospel it would be a most serious state of affairs, and we should be justified in making the matter fully public in the assurance that the Christian conscience of England would not permit [it] to continue.[31]

Cromer, however, remained firm.[32]

Gwynne wrote to Wingate that while he understood the need to harness "irresponsible missionaries" who "would endanger the peaceful administration of the country," he felt "a certain amount of regulated missionary work would be a benefit acceptable to the native people, a quieting influence upon them . . . [that] would strengthen the hand of the Government." He therefore asked permission to open a Christian school so as to reach children of "the hundreds of Abyssinians and Copts, captives for the most part from the days of the Khalifa . . . who still call themselves Xtians."[33] The seeming abandonment of evangelical intent was a ruse officials could live with. Wingate granted his request on condition that Muslim students whose parents objected to classes in scripture be allowed to

withdraw at the relevant times. At once, the CMS took over the languishing Coptic Girls' school in Khartoum.

The concession proved useful to both: government could sidestep the issue of female education which it feared would bring hostile reaction from Muslim men,[34] and the CMS was optimistic that schooling the mothers of the next generation would win the Muslim Sudan for Christ.[35] It is hardly surprising, then, that efforts concentrated "on getting Muslim girls to attend."[36] In 1903 the school had thirty-five Muslim pupils, many of them Egyptian, being taught by a Syrian Christian woman; subjects included the three "Rs," Arabic and English hymns, Bible study, and needlework.[37] Gwynne appointed himself "first headmistress."[38] The CMS had found its niche. Eager to secure a Christian monopoly on female education, Gwynne cannily obtained official agreement that where mission schools existed and met academic standards, government schools for girls would not be built.[39]

It was hardly for lack of devotion that Wingate upheld the proselytizing ban, for he was deeply religious, known to start each day with a Bible reading and prayer.[40] With fellow officers he raised funds to build the Anglican cathedral in Khartoum, which "more than anything else, [would] prove to the Oriental mind the permanent nature of our occupation,"[41] and gave over the palace for weekly services until it was complete.[42] And he was openly suspicious of Islam. Gwynne's account of a meeting with him in February 1903 is instructive, if hardly impartial:

> I . . . asked him whether as a Christian . . . he did not feel that Mohammedanism stopped the way of progress & kept back the people from morality and honesty and that the only remedy was Christ. "I know it," he said, "but be patient, the first sign of aggressive antagonism to Mohammedanism will only strengthen the hands of the ulema. Even now we feel in Cairo Mohammedanism is beginning to crumble. Go on planting Christian ideas and don't press unduly the name. Every child you persuade to call himself a Christian instead of Moslem will be so many years more for the existence of fanatical Mohammedanism, [whereas] so much Christian idea and truth placed in a child's mind tactfully, without the prejudice of giving the idea and truth a name, will bring nearer the downfall of Islam."[43]

With Wingate's concession, the CMS could assure supporters that the Gordon Memorial Mission "to the Mohammedans by whose hands he died" was alive. Acquiring the right to educate Muslim girls had opened the way "for a quiet and judicious witness for Christ. . . . No large or speedy fruits can, humanly speaking, be reasonably expected, but at least 'a flag for Christ' is uplifted in Khartoum."[44]

In their struggle, both government and CMS were guided by Gordon's martyrdom,[45] the former to suppress Islamic zeal, the latter to spread "the

word." These two goals, and the institutions that embodied them, coexisted in mutual mistrust throughout ensuing years. There were class inflections to the discord, a difference between low church and high; the missionaries' fervor threatened not just the peace, but also the dignity, composure, and detachment administrators strove for in the face of "native fanaticism"—actual or supposed.[46]

Hierarchy, Visibility, Display

Ann Stoler has pithily observed that "colonial authority was constructed on two powerful but false premises."

> The first was the notion that Europeans in the colonies made up an easily identifiable and discrete biological and social entity—a "natural" community of common class interests, racial attributes, political affinities, and superior culture. The second was the related notion that the boundaries separating colonizer from colonized were thus self-evident and easily drawn. Neither premise reflected colonial realities.[47]

How then in Sudan were boundaries between ruler and ruled created and maintained? Much depended on the politics of appearance and sartorial display.

As governor-general, Wingate stood at the apex of Sudan's administration. He was also the sirdar, commander of the Egyptian Army; in fact, Sudan was technically under military rule until 1926. At first, British soldiers in the Egyptian Army filled administrative roles, but as they could be recalled abruptly to their units and replaced by younger officers with little knowledge of Sudan, they were gradually replaced by civilian personnel. Still, civilian staff were always thin on the ground, numbering at their maximum some 150 men.[48] They established imperial dominance with the aid of Egyptians and assent of Sudanese, which they fortified by cultivating British prestige and assiduously policing their ranks. As in India and elsewhere in Africa,[49] they relied as much on spectacle and disciplinary protocol as brute force, though the latter was not lacking when required. Preoccupation with hierarchy and its flourishes sustained the gulf between governors and governed; between the British, and Egyptians and Sudanese.

Wingate, notes historian Martin Daly, "exalted his position with viceregal trappings, and by simulating a court at Khartoum." Out from the splendid new palace he would ride each morning in state, parading the broad avenues of the new imperial city, "the cavalcade . . . glittering and immense, black cavalry men with lances, ADCs, P.S.'s and a herd of all grades of officials" in ceremonial plumes and braid.[50] Wingate spent the

better part of the year in England and Cairo avoiding the heat, being feted by royalty and consulting with colleagues who were also there on leave. With November's cooler weather, he and his wife Kitty (by her son's reckoning "the first English lady to live in Khartoum"[51]) would return to Sudan for "the season," arriving at the palace with grandeur and dash in a double landau "and four," complete with outriders and an escort of mounted aides-de-camp. They were met by executive officers, *shaykh*s, and *ʿulama* in ceremonial attire, and a regimental honor guard mustered before the steps.[52] The weeks from December through February were punctuated by formal "levées," garden parties, teas, and receptions for dignitaries touring Sudan. March usually found Wingate "on trek" to outlying districts. Squired by an entourage of servants, officials, and guests, the excursions echoed the circulating courts of sixteenth- and seventeenth-century Sennar, the indigenous state whose remnants fell to Ottoman troops in 1821. Like them, such journeys made the British "sultan" a visible reality to rural folk.[53]

Tourists were encouraged to visit Sudan, particularly European nobility, royalty, and socialites whom the Wingates met on leave; they were often accommodated in the palace at government expense. The costs, mind, were met not by British citizens but Egyptian, who underwrote Sudan's bureaucracy until 1913 and bore its military burden for some time after that. Sudan became a popular holiday stop for the wintering well-to-do, with cruises organized to the south and visits to the dust-blown site of Kitchener's victory near Omdurman. The mysterious land of Gordon became an imperial marvel: an open air exhibit in which all manner of exotic flora and fauna, including humans, were displayed. As the travelers bore witness to British mastery of Sudan, a European spectacle was laid before Sudanese, who glimpsed them visiting ancient monuments, sailing by government steamer along the White Nile or the Blue, disembarking periodically to hunt or watch a "native show." To an exasperated governor faced with meager resources and asked to facilitate a steady stream of such tours, Wingate wrote, "I much sympathise with you in the failure of the Shilluks to turn out when Winston Churchill passed through, but . . . they quite made [it] up . . . by giving such a very interesting show to the Duchess D'Aosta."[54]

Wealthy hunters were "an awful nuisance" to overworked officials required to organize safaris, guides, and "the presence at a convenient spot of a first rate specimen of the particular wild beast which the visitor wished to shoot." But there were lighter moments too. A former governor recalled how two royals, riding in separate trains, were halted by a dust storm at the same desert station, whereupon "a burly British traffic warden" introduced them, " 'King of the Belgians have you met the King of Denmark?' "[55]

Wingate was eager to impress; though of unpretentious origins, he and his wife affected a lifestyle in Sudan they could never have led at home. They entertained lavishly if, by most accounts, on a cheerlessly formal scale. In Khartoum a golf course was laid out to cater to Wingate's fondness for the game; he and Reverend Gwynne would plod from tee to tee, Gwynne now and then "trying to extract concessions . . . on the sandy greens."[56] Wingate had use of a steam launch (named *Catherine*, for his wife) and a paddle-steamer converted into a "state barge" for royal use that was officially known as "H.E. the Governor General's yacht." A special railway carriage was on hand for inspection tours and conveying the Wingates to the government's "hill station" cottages at Erkowit when the heat began to build.[57]

Such displays were useful for dazzling natives, convincing them of Britain's status in lands beyond their own. Wingate, for example, justified the cost of fireworks in honor of a nobleman's visit as good for "giving these Sudanese people some impression of Govt. prestige."[58] He and his successors hoped to draw Sudanese into the imperial project and diminish the influence of Egypt which was, after all, another largely Muslim, Arabic-speaking country immediately downstream. They promoted the British sovereign at the expense of the khedive. Photographs of the king and his family were hung in prominent places to convey a sense of their immediacy. A memorial for Queen Victoria was held in Khartoum and attended by native luminaries. The coronation of Edward VII was observed with considerable pomp, celebrated annually until his death in 1910, then superseded in 1911 by that of George V. When the Prince of Wales visited Sudan in 1916 and relations with Egypt were especially strained by the war, Wingate ordered that "two or three hundred pounds" be doled out to the poor, hoping it would be seen as imperial largesse.[59]

Analogous tactics used throughout colonial Africa were intended "to turn the whites into a convincing ruling class."[60] But in Sudan there was a complication: most Sudanese saw both British and Egyptians as "Turks," and the Condominium as the "second Turkish regime." The British thus strove to distinguish themselves from Egyptians in Sudanese eyes without antagonizing either or raising the specter of religion officials feared. For though they gravely mistrusted Egyptians (even the many Copts in their employ), without them their prospects of governing Sudan were poor. By cultivating the monarchy as a secular creed, they hoped to foster a unifying ideology and gently counter Egypt's sway. There were setbacks of course, and more drastic measures (such as censoring the Egyptian press in Sudan) were occasionally applied.[61] But a proliferation of royal holidays with their grand parades and palace receptions is proof of Wingate's faith in ritual politics, in fabricating consent by inventing traditions and embellishing others brought from home.[62]

By 1914 some eighteen annual celebrations were observed through-out Sudan, at substantial government expense.[63] The policy long sur-vived Wingate's leadership. In Khartoum in 1994 I met a former civil servant who fondly recalled the many public holidays that, well into the 1940s, had enlivened the working year. He was especially nostalgic about "King's Day," which marked the only visit of a British sovereign to colonial Sudan.

On January 17, 1912, the ship carrying George V and Queen Mary home from the King's "Coronation Durbar" in Delhi stopped briefly at Port Sudan. "Wingate," writes Daly, "was determined to do everything possible 'to impress the natives of the Sudan with the importance' of the occasion."[64] Arab notables were brought from around the country to at-tend. Major Butler, attached to the Intelligence Department, guided them through Khartoum before taking th.m off to the coast to meet the king. In a letter to his family he described his charges: "dignified Arab Sheikhs [acting] just like school boys out on the spurr, laughing and ragging and absolutely thunder struck at all they saw." Visiting the palace they were amazed to see an electric light and "all had to have a go at it, turning it on and off to the accompaniment of shrieks of delight from all their pals."

> But the "succès fou" was the hot and cold water taps in the bath room!!! You see they nearly all come from a country where water is priceless and in some cases has to be fetched in skins on donkeys many days and to see water gushing from a wall, hot or cold at will, simply flattened them out. Everyone came and put his hand under each tap in turn. . . . Those that didn't volunteer were made to by their pals so that they could bear witness to the truth of the story on their return to their country.[65]

The tactic of amazing the few to persuade the many continued in Port Sudan. There they were presented to the King who "gave them each a big silver medal on a chain."

> It has made a most enormous impression on them . . . and if [the show] had cost the country £50,000 would still have been worth it for the general effect it will have on the country when these sheikhs get back to their tribes. . . . The "Medina" gliding into the docks I think impressed them most. One said, "It is not a ship it is a mountain" and another "A city, nay! three cities piled one on another" (referring to the decks)—"Medina" as you may possibly gather is the Arabic for city. The medals they were delighted with. I made the remark that they were nice and heavy and was sternly rebuked. . . . "What is weight, it is not that we value in the medal but the representation of the 'Melek al Meluk' (King of Kings) which we wear now round our necks and forever in our hearts."[66]

Upon returning to Khartoum the *shaykh*s were received at the Palace dressed in their "scarlet robes of honour" like the one Gordon had offered the Mahdi to no avail. The robes were a legacy of the Turko-Egyptian state, "given for good administration or tribal management" to both religious and secular appointees according to their class of service, and could be withdrawn for unsatisfactory performance.[67] In Sudan receiving and wearing a robe of honor signaled loyalty to the colonial state, in contrast to the *jibba*, whose meaning was holy poverty, submission to God and the Mahdi's cause. After the Battle of Omdurman, routed dervishes threw off their *jibba*s to avoid retribution, or turned them inside out; wearing the garment was thereafter outlawed on penalty of being pressed into a government work gang.[68] By appearing in ceremonial robes the *shaykh*s not only legitimated British rule in terms of the Ottoman past, but visually opposed Mahdist aims. More, their attire was a formal expression of social hierarchy that was remaking a world where free cultivators or herders, however unequal in practice, were bound by sturdy bonds of kinship that masked political disparities and very often mitigated them. Like the richly braided uniforms of the British, these obvious symbols of rank and commitment to the regime were worn on all ceremonial occasions, Islamic and imperial both. Here too Islam was linked to British rule, and Islamic and Christian calendars were made to intersect. Whatever administrators' rationale, in their subjects' experience, politics, religion, and economics converged. For his part, Butler thought that "the visit of the sheikhs to Khartoum should prove a stimulus to trade in may respects."[69]

The royal visit of 1912 was commemorated annually thereafter. Governors were required to send to Khartoum one third of their provinces' senior notables (men with special or first-class robes of honor, British decorations, King's medals or civil Beyships) to participate in "King's Day" celebrations.[70] Those not on that year's rota for Khartoum were expected to grace provincial rites.

Colonial rituals focused on the governor-general as the symbol of imperial authority and embodiment of the Condominium—to many Sudanese he and his successors were simply known as *al-ḥukûma*, "the government." When he passed, soldiers were required to salute; civilians were expected to doff turbans and hats, and risked being scolded by his aides for failing to conform.[71] In the provinces, the governor substituted for the governor-general at the apex of the ceremonial state. Protocol policed the steps from low to high, casting each post in "objective" terms of rank that concealed the structure's racial slant. The problem of anomalies makes this clear. Gwynne, for instance, tells of the first Bairam ('Id al-Kabîr, the Islamic Great Feast) held in Khartoum after the reconquest, which "the administration took great trouble to keep in grand display."

The great notables of the Sudan were . . . present in wonderful festival robes, and the sheiks of the mosques and the schools were present in good numbers, also the officers of the Egyptian Army, the British, the Egyptian and the Sudanese, with all their medals and in their best uniform. Then came the native Government officials, all in order according to their rank and pay.

As each man's name was read aloud, he was directed to salute, shake hands with the governor-general and move on. Having been asked his rate of pay the impecunious missionary was lined up with the Egyptian and Sudanese clerks. It was a mistake: "shortly afterward a young officer galloped down along the procession, and seeing a white man in a helmet hauled me out. . . . I found myself placed right up against the high dignitaries of the British."[72]

Decorum was serious business in Sudan, and fraternizing across ethnic lines a threat to imperial power. A dozen years later Butler wrote that he was "busy about a mad Dutchman, [w]ho . . . professes Islam and is a great nuisance. He goes about among the lowest natives dressed in a kind of towel and pair of sandals only and is generally lowering the prestige of the white man. I am going to boot him out of the place."[73]

The veiled protocols of race encouraged cohesion among expatriate British, eliding internal differences of class and creed. State rituals were pedagogically useful, accustoming participants and observers to the habits of hierarchy on which imperial rule and global commerce relied. Moreover, they "offered many Africans models of 'modern' behaviour."[74] This observation leads us to consider the founding of the civilian political service and the "ethnographic" orientation its members espoused.

Rank

Peace was not guaranteed by display; most northern Sudanese complied with British rule because it conferred some tangible boon: land disputes were settled; cultivation, herding, and trade were restored; famine was averted, communications improved, new opportunities opened up. By and large people were left to get on with their lives. Taxes were low, since excessive demand was thought to have sparked the Mahdist revolt; initially they could be paid in kind rather than coin. Most controversially, in order to promote the resumption of irrigation and rainland farming, landowners in the Muslim north were permitted to keep their slaves, a point I return to in chapter 6. In general, officials were advised to make no precipitate changes and respect local custom lest impatience shatter the brittle peace.

As under Turkish occupation, the country was divided into provinces, and within these, districts. A district was entrusted to a district inspector

(later called district commissioner, hereafter DC), supported by assistant district commissioners—British for most of the regime—plus one or more Egyptian or Sudanese *maʾmur*s (officers) and sub-*maʾmur*s. Together they were responsible for collecting taxes, enforcing civil and criminal law modeled after the Indian penal code, and managing trade, commerce, roads, and wells. Soon after the Condominium was declared a civil service was established to overcome the problem of administrators subject to military recall. The desire to suppress Egyptian influence played a role as well: short or erratic tours were thought to leave military officers unlikely to develop sufficient feeling for the work, and liable to play unwittingly into the hands of their Egyptian subordinates.[75] Soldiers continued to dominate political ranks until World War I, when civilians began to outnumber them. In the south, not reconciled to the regime even then, soldiers remained in place for some years hence; moreover, unlike officials in the north, who were moved between districts and provinces with sometimes dizzying speed, seasoned southern officials were left in place for lengthy terms. The civilian service consisted of a political wing and a technical one whose staff were trained in medicine, education, and engineering. Here I consider the first, the administrative corps that shaped the character—the "culture"—of the regime.

Unlike Colonial Service recruits who might be posted all over the empire during their careers, Sudan had a dedicated force. Lord Cromer, British consul general in Cairo and architect of Sudan's administration, called for "active young men, endowed with good health, high character and fair abilities, not the mediocre by-products of the race, but the flower of those who are turned out from our schools and colleges."[76] Not all who held administrative posts belonged to this elite, which in the 1920s was named the Sudan Political Service (SPS) to distinguish it from professional and technical ranks. Some former military men were employed on contract, and only one governor-general rose through SPS ranks. Though Cromer did not spurn graduates of military colleges, some four-fifths of those who joined the SPS held university degrees. The martial establishment, skeptical of the value of Latin or Greek for ruling Sudanese, insisted that recruits be given military drill and taught to shoot and ride.[77]

Along with education, athletic ability and leadership were prominent criteria for selecting recruits. In an oft-quoted aphorism, Sudan (whose name is derived from the Arabic for "black" or Negro, *âswad*) was "the land of Blacks ruled by Blues," referring to those who had competed in interuniversity (Oxford-Cambridge) sports. Some men were renowned for rugby, others cricket, rowing, fencing, boxing, field hockey, soccer, shooting, or golf. A few had "Blues" in more than one sport. Though distinguished university sportsmen accounted for only about a quarter of SPS officers over the life of the service, "overwhelming evidence of the

importance attached to athletic prowess" comes from the "further score of international and trial cups, county players, national and University captains, and three Olympic gold medalists" among recruits.[78] Athleticism was especially prized in the early days of the regime, when an officer could expect to lead an outdoor life in unhealthy, uncomfortable conditions, with a good deal of time spent on trek.[79]

Probationers were chosen by serving officers, a system that ensured a high degree of conformity in outlook, accomplishment, and belief. Non-British subjects were not formally barred, but none was hired; one applicant was rejected because his "Levantine" features made him "undesirable."[80] Most appointees had middle- or upper-middle class backgrounds and were the products of British public schools. Of the 393 men who served between 1901 and Sudan's independence in 1956, the majority had been educated at one of the sixty-four "leading schools," of which Charterhouse, Edinburgh Academy, Eton, Haileybury, Harrow, Marlborough, Rugby, Shrewsbury, Westminster, and Winchester accounted for almost half of all recruits.[81] Few state-educated applicants were selected unless they also had degrees from "good" universities. Tellingly, not a single student from an English provincial university or college was hired. The SPS counted 180 Oxford men, 103 from Cambridge, the rest from a smattering of historic institutions in Scotland, Ireland, and Wales. University subjects varied, but history and classics accounted for the largest number of degrees. While most held second-class diplomas, a notable one in ten—roughly twice the average for a graduating class—had the distinction of first-class honors.[82] They were idealistic, bright, and very young, between twenty-one and twenty-five years of age. They spoke with a standard accent (occasionally leavened by a Scottish burr), affected similar mannerisms, and embraced a common set of values.[83] The majority held a deep belief in Christianity and, while parentage is no guarantor of conviction, a striking third of their number were clergymen's sons.[84] Robin Baily recalled that of the ten bachelor officials he roomed with during his early days in Khartoum, at least half said their prayers every night. He noted that they were not overly religious, but "had in common . . . a sense of being picked gentlemen with a realisation of nobless oblige [and] a genuine belief in Britain's God given mission to rule Indians and Africans."[85]

Historian Robert Collins suggests that SPS officials "sincerely believed in their 'mission' with a confidence and faith which the Sudanese never quite understood nor fully appreciated." Moreover, "by not comprehending the traditions and education of their rulers, the Sudanese frequently misinterpreted actions motivated by paternal concern and devotion as only another device to maintain imperial rule."[86]

I am less sanguine; as one Arab Sudani eloquently observed, the British were

> "rulers and guides. . . . They gave you guidance with respect. . . . When they
> tie your hands, they tie you with silk, not with iron chains. . . . There was
> virtue in their presence, and if they were not colonialists and imperialists
> one would not even question their treatment." But "no man would accept"
> colonial rule without reservations.[87]

Other Sudanese praised their rulers' capacity for discipline and hard work and were impressed by their confidence, if not their initial grasp of native etiquette or respect for Sudanese ways of life.

It is almost unbelievable that such young and untried men should have been granted power over the lives and livelihoods of so many. "At the age of 24," reflected Peter Acland (SPS 1925–42),

> I was put in charge of the district—made a 1st class magistrate with powers to
> convene a major court, sit as its president and try all cases including murder. I
> was expected to be capable of keeping the peace, running the office adminis-
> tration, assessing and collecting taxes, overseeing building repairs, digging
> reservoirs, treating sick animals and often human beings—all this in a foreign
> language.[88]

But had this handful of British men who were dispersed over a million square miles of land been granted fewer powers, it might have been diffi-cult to convince Sudanese of their worth. A fictional *ma'mur* in Tayeb Salih's novel, *Season of Migration to the North*, observes:

> The English District Commissioner was a god who had a free hand over
> an area larger than the whole of the British Isles and lived in an enormous
> palace full of servants and guarded by troops. They used to behave like
> gods. They would employ us, the junior government officials who were na-
> tives of the country, to bring in the taxes. The people would grumble and
> complain to the English Commissioner, and naturally it was the English
> Commissioner who was indulgent and showed mercy. And in this way they
> sowed hatred in the hearts of the people for us, their kinsmen, and love for
> the colonizers, the intruders.[89]

In Francis Deng and Martin Daly's incisive Condominium retrospec-tive, *Bonds of Silk*, both SPS officers and the Sudanese men with whom they worked acknowledged how heavily the former came to rely on the experience of Egyptian and Sudanese junior officials, and on the wisdom of tribal or village elders in managing district affairs. But while the British continuously negotiated their relations with Sudanese, few were given to question the ultimate validity of their task. What stands out in the mem-oirs of officials who entered the SPS before World War II is an unwavering

certainty that they were doing the proper thing.[90] Authority bred of impe-
rial self-confidence empowered them to act as agents of order and change.
SPS officers were Henty's exemplary young gentlemen, matured.[91]

Among the "invented" traditions of bourgeois Victorian Britain that
Terence Ranger suggests furnished models for command in colonial Af-
rica, two were consistently mobilized in Sudan: that of the public school
and of the regiment. Similar trappings of office surrounded SPS officials
and British officers in the Egyptian Army. They wore the same uniforms,
but army helmets sported a crescent and three stars, while those of politi-
cal staff bore an SPS badge and were girded by a blue puggaree (scarf).[92]
As in the military, junior members of the SPS were required to salute
those senior in rank regardless of relative age, a dictum that often rankled
Sudanese for whom deference is reserved for one's elders. Still, public
school and regimental models, while used "to create a clearly defined
hierarchical society in which the Europeans commanded and Africans
accepted commands," also linked the two estates "within a shared frame-
work of pride and loyalty." The protocols of subordination and dominion
were instruments of "modernization" that offered Africans "a series of
clearly defined points of entry into the colonial world" however humble
these might be.[93] In Sudan the narrow discipline required of native offi-
cials, recruited early on for martial and constabulary roles, contrasted
sharply with the breadth and flexibility required of the British, who were
expected to be jacks-of-all-trades and were transferred from district to
district so as not to become partial to one but master of them all. The
"co-dominant" Egyptians occupied intermediate positions that, however
useful and important, brought them closer to the people than the British
and rendered them suspect in British eyes.

The majority of SPS officials served their entire careers in Sudan, devel-
oping both an impressive knowledge of the country, and fidelity to its
peoples and the regime. Such knowledge and allegiance were, of course,
conditioned by the commonsense world SPS officials shared, a compara-
tively elite sociality with a hearty esprit de corps that hegemonic status
conferred. Elliot Balfour, who joined the service in 1932, writes of the
strong "public school spirit" in which everyone he served with appeared
"to be an 'awfully good fellow' or 'a splendid chap.' "[94] Camaraderie was
born of similarities in upbringing and interest. Sports continued to be a
focal point and supplied a degree of ensemble training. Polo was the game
of choice, played wherever teams could be mustered and a flat stretch of
land could be found. Most famous were the grounds at Omdurman, focus
of an article from the *Manchester Guardian* in 1913:

> Three days a week the players cross over [from Khartoum] in the Sirdar's
> steam yacht, a rebuilt relic of Gordon's fleet, always generously placed at

their disposal. . . . Disembarking near the site of the Khalifa's prison, they have a ride of over two miles before arriving at the grounds, and there some forty players play their games on the Omdurman sand.[95]

Some acquired a perilous mania for the game: during World War II, U.S. Air Force planes seeking permission to land in Darfur were put off because the governor "would be playing polo that afternoon on the landing strip."[96]

Other bourgeois predilections occupied SPS members in their leisure time. For many, hunting was an obsession—indeed the challenge of an outdoor life in exotic Africa was a considerable attraction to recruits. Author Wilfred Thesiger, who joined the SPS in 1935, wrote that as "lion and leopard were officially accounted vermin" in Sudan where they threatened humans and stock, they required "no game license to shoot," and he killed thirty during his two-year stint in Darfur. He also hunted Barbary sheep, oryx, addax, elephant, and crocodile.[97] Along with large game, officials took huge "bags" of waterbirds, far more than could be used for food. The enormity of their kills could not have failed to impress the Sudanese. One DC wrote of a day in the early 1950s when, together with a French baron and his entourage who were traveling in the governor-general's "yacht," he shot a hundred sand grouse before breakfast, and rounded off the day with six Nile geese and four ducks after lunch.[98]

If the SPS sounds like a gentlemen's club, in several ways it was. In keeping with public-school traditions, annual cohorts were sometimes named, and biblical epithets preferred; the illustrious dozen who joined in 1920, for instance, were christened the "Twelve Apostles." Less fabled were the "Four Horsemen" and the "Seven Deadly Sins." When independence was declared in 1956, sooner than most expected, and several senior officers had their careers peremptorily curtailed, they formed a self-mocking club called "The Fallen Angels," which met for dinner in London once a year. Wives were included (as "fallen women"), and when numbers began to decline from attrition, or waning interest from "early-leavers" like Wifred Thesiger (who resigned rather than serve outside the deserts of the north), their children were invited to swell the ranks as "angelettes."[99]

British Women

The Political Service was a men's club in another sense. Unlike the rest of the civil service, whose members were hired for their expertise and could not be so compelled,[100] SPS recruits were required to be single men. Marriage during the two-year probationary period was cause for dismissal, and permission to wed was routinely denied for a further two or three

years after that. Even then, juniors were actively discouraged, and often prevented, from bringing their wives to Sudan. Social occasions in the early days sound distinctly bizarre, with British officers "gorgeously arrayed" in formal dress riding donkeys to a ball, where they danced with each other, "in their mess kits with spurs."[101] Only in the 1920s did SPS wives begin to come out for more than a brief winter stay. Provincial governors set their own policies, typically granting a wife permission for a seasonal visit, and then only if her husband's post was on a railway line or navigable river lest she fall ill (or pregnant) and need to be evacuated. Baily, governor of Kassala from 1926 to 1933, allowed visits from DCs' wives only "for some extraordinarily limited period of sixty days a year" as "they distracted a man's attention from his work."[102] K.D.D. Henderson was nine years a bachelor in Sudan, Elliot Balfour twenty; several, like Douglas Newbold, never wed. At the end of 1930, "only 64 of the service's 158 members were married, and 26 of those were governors or district commissioners at headquarters."[103] Senior officials often obstructed a couple's plans. One woman told how in 1929 her fiancé's wedding leave was suddenly revoked and he was moved to a district where wives could not go without special permission. Their wedding was delayed twenty months.[104]

Still, many young officers favored such restrictions and the five-year marriage ban, regarding British wives a bothersome liability.[105] In the first decades of British rule, European women's exclusion was justified by fears that Muslim fanaticism could erupt at any time. The harsh climate and rudimentary facilities were another problem: in many respects Sudan was an unhealthy place, and European women were considered delicate, more likely to fall ill from any number of diseases and be less able to recover from them than men. Their children were thought fragile too, and would have to be schooled in Europe in any case. Ultimately such arguments waned as towns grew and communications improved. After World War I, officials' wives were a growing presence in Sudan, and a trickle of British professional women were assigned to medical and educational posts in the towns. This did not, however, greatly affect the SPS design for married life.

For their part, Sudanese found it "incomprehensible" that adult men with responsible positions should remain unwed, even granting the exotic proclivity of Britons to marry for life. But if celibacy was alleged and undoubtedly expected to be the British norm, there was yet an infamous brothel in Khartoum that catered to expatriate needs.[106] Sudanese popularly assumed that homosexuality among Britons was widespread; many still believe the practice "was a colonial import previously unknown" among themselves.[107] Stoic bachelor officials were thought to lead lonely

lives eased of an evening by the comforts of whiskey and soda and "a book of English fiction."[108]

In 1924 the medical director told SPS recruits that H.Q. would not object if "in an outlying district" one were to take a Sudanese girl, but warned that as they could not "expect to find a sweet young virgin," they should choose someone healthy at least. Further, they should look beyond their district on pain of being "accused of partiality."[109] Despite this, accounts of liaisons between SPS officials and Sudanese women are rare. Relations rumored or avowed were concentrated in the period before restrictions on British wives relaxed, and took place mainly in the south and the far west.[110] Remarkably, as we see in chapters to come, British men who were celibate and schooled in all-male institutions were obliged to make life-changing decisions for and about Sudanese women and girls.

The effect of a European wife's presence was complex; some former officials reported that, given the concern for modesty and sex segregation in Muslim society, wives inhibited their relations with northern Sudanese men. Others spoke of women's value to the administration. "Make no doubt about it," one retiree remarked, "the presence and the infiltration of the British wives into the lives of the Sudanese families made a tremendous influence for good in the Sudan, which the men alone could not have achieved."[111] The phrasing of this comment and the timing of the wives' respite—the mid-1920s—are intriguing, and relevant to issues I discuss later on.

The Sport of Rule

SPS officers' shared purpose, uniform backgrounds, and bachelor society served to accentuate quirks of character, often benign eccentricities that Sudanese, with a keen sense of the absurd, could cope with very well. Being so thinly scattered, they exercised considerable personal influence, especially in outlying districts.[112] Sudanese were often disconcerted when an officer they'd grown used to was replaced and they were obliged to fathom the *hukûma* anew. Still, Khartoum maintained a stealthy presence, and tyrannical British Kurtzes,[113] it seems, were rare. Unsuccessful native disputants, the self-described *mazlumîn* ("oppressed"), had rights of appeal in civil and criminal suits, and officers used this to advantage. Balfour reckoned that when passing judgment for serious crimes it was always better to impose a heavy sentence, for that left the legal secretary and the governor-general, who were required to confirm his judgment, "a chance to exercise compassion which they dearly liked to do."[114] Granting clemency surely inflated the governor-general's image and bolstered the strength of the regime.

Several former officials saw governing Sudan as something of a sport with each side trying to outwit the other.[115] Kipling's caustic satire, "Little Foxes," makes the point well: It is 1900, the Mahdists have just been defeated, and land holdings along the upper "Nile" are in chaos.[116] The governor of a northern province "inspects" his districts by leading mounted hunts complete with horses and English hounds. To salt the sport he orders farmers to block up the foxholes in their fields on pain of the owner being beaten. The astute farmers seize the chance to press their land claims by disregarding the order and offering themselves to be thrashed.[117]

Playing to British conceits did not always work so well in practice. In the 1920s and early 1930s, Omdurman was overseen by DC Bramble Bey (for whom a cinema was later named), a severe man and a legend in the town. Each morning he would embark on a formal "town ride" in full kit, attended by his assistant, his *ma'mur*, and an escort of mounted police in spotless white livery. He would alternate visits among quarters of the town to hear petitions, ensure the streets were kept clean, examine new buildings, and inspect the *sûq* (market), a sprawling affair of stalls and shops with dates, vegetables, dry goods and spices displayed in colorful heaps on tables or mats on the ground. Bramble was especially concerned with the hygiene of open-air meat stalls and was known to divert his route so as to descend on the butchers unawares. Balfour recounts that one day near the *sûq* the entourage "passed a cluster of women who sounded the '*zaghagheet*' [ululation], the high, trilling, note that women make to mark their approval of whatever is happening." When this ocurred three weeks running, Bramble had the women arrested. Asked to explain their behavior, they replied, "But, your Excellency the Bey, you know the custom of the country. We sound the *zaghagheet* because we are so happy under your kind and just rule and to show how pleased we are with this beneficent Government." Bramble was not satisfied and refuse to let them go until they confessed the truth. "A few embarrassed giggles and then, 'Well actually, your Excellency, the butchers gave us five piasters each so they could have early warning of your approach.' "[118]

Gender, Status, and Domestic Service

Relations between British and Sudanese were hardly one-sided or lacking in ingenuity; nor were Sudanese women necessarily absent from the public realm. Yet gender did serve to distinguish ruler from ruled in important ways. Domestic work usually carried out by women in both Britain and Sudan was performed for officials by servants, most of whom were Muslim men.[119] Even had they wished to work, Muslim women would have been

compromised if left alone with men who were not their kin, and the British were anxious to oblige local sensibilities. Moreover, historically, female servants were slaves or ex-slaves, and no "free" woman would risk her own or her family's reputation with that stain.[120] The profile of domestic service in colonial Sudan was thus quite different from that which emerged elsewhere in Africa where Europeans hired women as well as men.

Having servants not only created the appearance of exalted status but enabled Britons to approximate an upper-middle-class European lifestyle that few could afford at home. It might be supposed that servants were unwitting collaborators in the colonial project. The reality is more complex. Servitude was a portal to "modernity." It was, first of all, waged work, and offered the potential for upward mobility: from gardener or lowly cook's assistant, who did most of the menial labor, to head servant (*sufragi*), the best of whom "resembled the traditional English butler" and might even have their own slave. Compared to farming, domestic service was considered "clean" work, with "cleanliness" in northern Sudan connoting purity and health, that which increases vitality and protects social honor. Many servants went about their jobs with alacrity, taking keen interest in preserving and enhancing their employers' prestige, as this was reflected in their own: "For each grade in the Sudan Political Service there was an expected number of servants imposed by the *sufragi* whose *sharaf* (pride) would be upset were they not, on master's promotion, able to have more servants to control, as well as an automatic rise in salary."[121]

Sudanese servants were (and still are) renowned for their competence and unaffected courtesy throughout the Middle East, and many were recruited to work abroad; those employed in colonial Sudan were often migrant workers who remitted earnings to village homes and returned there for extended visits during employers' annual leaves. Once experienced, they were in high demand, apt to be lured away from one house on the promise of better wages in another. They quickly grasped the nuances of rank and domestic decorum:

> Of the whole canteen [servants] particularly prized fish knives and forks which they considered a sign of status. Therefore if their master chose to entertain and owned no fish knives, these would be borrowed from next door. They also borrowed other items to ensure prestige, invariably without the knowledge of the owner. At a dinner party in Khartoum a wife "was intrigued to notice that our hostess had exactly the same coffee service that we had. Only next day did I discover that it *was* ours."[122]

Importantly, as migrant workers, servants, like Butler's *shaykh*s, were conduits of information between enclaves of the British and native domains.

Yet if they were mediators and "collaborators," servants were also imperial subjects. Terms of address underlined distinctions of status: while servants were called by their first names, "the British expected to be addressed as 'jenabik' for men and 'saatasitt' [sa'adat al-sitt] for women. Both words literally mean 'your honor.' " Still, servants could use their own cultural values to parry excessive demands and control relations with employers. Sex segregation meant that their quarters were off limits to British women; nor did class-conscious British men feel free to venture there, an unease that servants encouraged. Language was often a barrier and, as most British women had little knowledge of Arabic, they usually found keeping track of their cooks' spending in the sûq to be "a losing battle."[123] Thus Sudanese domestic staff effectively set limits to their domination, and one can only imagine how missionaries such as the Halls might have fared if they'd tried to proselytize their Muslim staff.

Strict status distinctions prevailed among the British and between them and other Europeans too. The capriciousness and formality of such boundaries proved irksome to some officials, particularly in the period following World War II. Peter Shinnie of the Sudan Antiquities Service who arrived in Sudan in 1946, was warned against socializing with Greek shop owners; the Dutch guest of an official's wife was allowed to swim at her hosts' British club on one designated day each week, noticed by some to be the day before the pool was cleaned.[124] Such unwritten rules were rife despite the fact that during the war the mood had begun to relax. Until then Khartoum, especially, was a stilted, sticky place with an endless winter round of official calls complete with calling cards, dress parades, and formal dinners where men were expected to arrive in starched shirts with stiff winged collars and the inevitable red tarbush.

In daily and administrative life the British were rent in two. The civilian service was divided into junior and senior posts, and informal socializing seldom crossed the line. In the capital there were separate clubs for each, the Sudan Club for senior officials and the Khartoum Club for juniors, ensuring that people socialized largely with their peers. The same split was found in Port Sudan or Atbara, wherever a British enclave was lodged. In 1924 the wife of a professional in the Public Works Department complained that her husband's quick promotion had made it "rather awkward as most people make friends in the junior set & stick together as they get promoted. Now we can't mix with the juniors very much & nearly all the seniors have been here ten or twelve years at least and naturally have their own set of friends."[125] There was an important codicil to the rule: even the youngest, most inexperienced and poorly paid Political Service probationer was automatically classed as senior, and belonged to the Sudan Club. Needless to say, neither Egyptians nor Sudanese could belong to either club and were left to form their own. In fact for much of

the Condominium, social contact between British and Sudanese in government employ rarely took place outside of office hours or official levees.

While most Sudanese likely cared little for the petty entailments of colonial rank, emblems of the system were publicly visible wherever government officials went. It is tempting to dismiss concern for the trappings of hierarchy as just so much fluff and finery, the insignificant airs of an effete ruling class. But the extraordinary amount of time and effort it took to establish such protocols and enforce them betrays the inaccuracy of that view. At the outset, SPS officials wore army uniforms as daily attire; these were replaced in 1925 by military-style bush jackets and shorts, with full uniforms being reserved for formal occasions—holidays, parades, or Omdurman "town rides." Administrators were distinguished from other civilians who wore quasi-martial dress by the gold braid on their shoulder tabs that signaled rank.[126] Among the documents in Khartoum that survived independence, there is a file labeled "Personnel: Appropriate Dress." It contains a flurry of annotated memos circulated in the 1930s and early 1940s among the offices of the civil secretary, governor-general, and provincial governors over revisions to the dress code. They deal, for instance, with such matters as whether ties might be dispensed with between April and November. Since the director of the Sudan Medical Service had ruled it unhealthy to wear buttoned collars and ties in the office in hot weather, this had been approved, with the proviso that "any tendency to untidiness [would] lead to the cancellation of this relaxation." Three years later the ruling was reversed and officials in open-necked shirts were deemed "slovenly"; it was reinstated with a similar spate of memos and marginal discussions in the early years of World War II. Whether rebukes for malperformance were conveyed by gossip or memorandum, they took energy and interest that might have been channeled into other pursuits.

Even more revealing are the intricate points of decorum debated in memos about what civilians (men of course) should wear when dining in the regimental mess. From November 1 to March 31: "Full evening dress with miniature medals"; from April 1 to October 31: "Mess jacket as on P.H. [public holidays] with miniature medals, or black or white dinner jacket without miniature medals." The mess jacket, correspondents point out, takes the place of the civilian tail coat and must be "perfectly plain," without official emblems or badges of rank. It was to be worn with "black tie, white waistcoat, [and] black trousers or black tie, black cummerbund and white trousers," though the first, wrote Civil Secretary Newbold, is much "smarter." H.E., the governor-general initialed his agreement. Ambiguities must have remained, however, for in 1939 it was determined that only the Sudan Defense Force had "the right to wear plain brass buttons."[127]

Sartorial standards were neither frivolous nor trifling but, one suspects, effective tools for creating difference, realizing hierarchy and consolidating control. The regime drew on a disparate array of precedents—British, Turkish, Egyptian, Sudanese—from which there emerged a corporeal culture specific to Anglo-Egyptian Sudan. Its spectacle politics concealed a subtle but radical exercise of power. Assuming participants to have acted in good faith, observance of conventions concerning dress, salutes, postures and such would have had both performative effects (where commitment to a canonical order is achieved and sustained by enacting it) and mnemonic ones (where bodily habits of hierarchy and subjective dispositions are mutually informed).[128] British officers were not alone in being subject to these disciplines; Egyptian and Sudanese subordinates also lived them day by day. Differences of rank displayed on the human body hid salient if unspoken disparities of race and ethnic affiliation beneath the garb of individual achievement, subtly facilitating participants' "consent" to a hegemonic order that their very practices created and maintained.

British sumptuary conventions had political implications: mandatory three-month annual leaves worked to refresh cultural memory and stop officials "going native"; generous rates of pay supported lifestyles well above those of Egyptians and Sudanese in government employ; and obligatory retirement at age fifty, earlier even than in the Colonial Service, meant that no British official would be seen by his subjects to grow old or infirm, or, as Said observed, "see himself, mirrored in the eyes of the subject race, as anything but a vigorous, ever-alert young [lord]."[129] Administrators' intellect, energy, and health were emblematic of the regime's, hence the focus on athleticism and education in SPS recruits, their youth and class conformity. Every effort was made to ensure that those who governed Sudan appeared to belong to a "natural" category—a class of like-minded, Christian, and like-bodied men.

Interlude 2

COLONIAL ZAYRAN

Zayran who trouble and fascinate Sudanese women are also called "winds" (*rîh, rowhan*)—specifically, <u>red</u> winds (*rîh al-ahmar*), alternatively, red *jinn*. Unlike black *jinn* who are malevolent, and white *jinn* who are benign, the proclivities of red *jinn* fall between such extremes. They are self-indulgent, capricious, and amoral, yet no less powerful for this. Tellingly, such traits show *zayran* to be what northern Sudanese are not and ought not to be.

Likewise, *zayran* belong to "foreign" ethnic groups that invisibly parallel divisions of the human world, such that differences among spirit "nations" (*jinis*) or "types" (*noʿa*) correspond roughly to those of human cultures. Both nations and the individual spirits within them are identified by style and color of dress, ceremonial demands, typical gestures and demeanor during *nizûl* (trance descent), and the illnesses they are most likely to provoke. Ethiopian spirits favor red and are tied to fertility concerns, Islamic holy men wear green or white and behave with dignified restraint. When summoned during a ritual, *zayran* appear in order as their "threads" are "pulled"—drummed and chanted by assembled devotees. The sequence is ranked from first to last, from religious figures such as ʿAbd al-Gadir al-Jaylani whose chant is drummed near the ritual's start, through a succession of powerful yet decreasingly prestigious foreigners, much like the colonial parade that Reverend Gwynne described. In the *zâr*, however, Islamic figures outrank colonial ones. But even "slave" spirits—whose threads are drummed toward the end of the rite—are impressive and alarming. Collectively, *zayran* are all that is exotic, all that northern Sudanese regard as "other" than themselves. Zâr, and by extension Sudanese women's impressions of human others in their milieu, thus provides a historical foil by which participants' own identity—their difference—is affirmed. Yet this is not unchanging: the pantheon of spirits and their traits is a moving backdrop, an aggregate social memory always sensitive to present concerns.

Among the liveliest and most revealing spirits are the *khawajât* (misters, Europeans, Westerners) or Naṣarîn (Christians, Nazarenes), and *bashawât* (pashas or high officials); as noted earlier, these are Europeans, Turks, and Egyptians. Some figures date to the Mahdiya or before, others

to the Anglo-Egyptian regime, the rest to more recent times. Interestingly, the *bashawât* have lately come to include current government officials, a telling addition.[1] Spirits discussed here were prevalent in the mid-1970s and 1980s and still appeared in 1994, though by then *zâr* was being discouraged by the Islamic regime that seized power in 1989. Female spirits were few among the *bashawât*; like their human counterparts, colonial *zayran* were principally male and unaccompanied by wives. They typically directed their hosts to acquire European men's clothing for *zâr* ceremonial wear: socks and shoes, trousers, shirts, ties, military or civilian jackets, pith helmets, Sam-Brown belts.

The SPS was well represented among the pashas. Abu Rîsh, Ya Amîr ad-Daysh—Father of Feathers, O Commander of the Army[2]—demanded a white plumed helmet and gold epaulets on his uniform, echoing the governor-general's formal dress, an ornate version of the livery worn by British rank-and-file for town rides, levees, and official parades: "white helmet with gilt spike and chinstrap, replaced in the evening by the tarbush, gold-laced overalls, a double-breasted white jacket with gilt loops and epaulets, with gilt rank indications on the sleeves."[3] Basha-t-ʿAdil—"the Just Pasha"—was the *sikritayr al-madani*, "civil secretary" *zâr*, and managed a large staff. His job was described as absorbing and busy, with many concerns, one of them building railways. Described as traveling frequently by train, he was often conflated with the railroad engineer, a lesser-ranked *khawaja zâr*. In the 1980s Basha-t-ʿAdil required a hybrid costume: a European business suit, a peaked cap, and a whistle.

British *zayran* announced their ritual arrival by marching, walking with a pronounced swagger and imperious mien, twirling their "moustaches," and pointing with batons, horsehair fly swats, or canes. An exception was Basha Bashîr (Good News Pasha or Evangelist Pasha—avatar of Bishop Gwynne?), a corpulent colonial spirit who loathed the hot sun, found desert travel a torment, and moved with ponderous fatigue. Bashîr constantly used a handkerchief to mop his sweaty brow; his human hosts wore a towel slung over one shoulder, signaling Bashîr's readiness for a cooling dip in the Nile.

Several *khawaja* spirits loved to hunt. In *zâr* poetics, the avocation is a veiled warning of the dangers that *khawajas* (human and spirit) pose to female Sudanese. More, Sudanese women are icons of the homeland (nation, village, camp, or *hôsh*), hence *khawajas*' fondness for the kill intimates their threat to the integrity of northern Sudanese society writ large. In Hofriyat, for instance, the spirit Dona Bey, Mudir at-Turʿa (Dona Bey, governor of the Canals), is "an American doctor and big game hunter who drinks prodigious amounts of whiskey and beer, wears a khaki suit [sometimes a white lab coat], and carries an elephant gun."[4] As a hunter and a physician associated with canals, Dona Bey is clearly a composite

figure. He may be a *zâr* echo of a Mr. Dunwoodie, radiographer at Khartoum Hospital during the 1930s,[5] a Dun Bey who took part in an early swamp clearing expedition, or even Leigh Hunt, an American who in 1906 launched an irrigation scheme at Zeidab, on the west bank of the Nile just north of Hofriyat. Dona Bey is fierce, though his prey are scarcely fitting, for unlike most white hunters he pursues not lion or elephant or giraffe but *sa'id*, tiny antelope known elsewhere in East Africa as *dik-dik* (genus *Madoqua* or *Rhynchotragus*). *Sa'id* are described as beautiful, with smooth soft fur and large dark eyes; in the past, villagers sometimes kept them as pets. A comely young woman is compared to a *sa'id*. Unsurprisingly, Dona Bey has a lecherous disposition. Moreover, he destroys what he most desires by using technology excessive to his needs.

In a similar vein, a *zâr shaykha* in Hofriyat regularly dreamt of the female Ethiopian spirit "Hamâma-t-al-Bahr"—Pigeon of the River—being shot at by European spirits on the banks of the Nile; the tie to colonial hunters described in chapter 2 seems clear. More, like "*sa'id*," "*hamâm*," meaning pigeons, is a common metaphor for infibulated Sudanese women. Infibulation is said to make a woman's genitals "as smooth as a pigeon's back" (*na'im zay ad-duhr al-hamâma*);[6] circumcised women are *tahir* (pure) and *nadîf* (clean), as are pigeons, which are preferred as food over chicken, considered by some to be "dirty" meat (*lahma waskhâna*, a term also applied to the flesh removed at circumcision). Girls who have been purified by circumcision become marriageable; when attending a wedding they refer to themselves as "pigeons going to market" where prospective suitors can watch them perform the sensuous "pigeon dance." Hamâma-t-al-Bahr is, however, an Ethiopian prostitute spirit; as such she can only feign the dance of a moral, sexually reserved, circumcised Sudanese woman, rendering it with exaggerated steps that invariably give her away.[7]

Readers will no doubt have deduced the complexity of *zâr* performances and the intricate multilayered messages they bring to life. Importantly, not only are comportment and attire crucial to identity in northern Sudan, as they were for the British, but, for Sudanese women, who one is depends in part on practice: one assumes an identity by enacting it. Yet as the *zâr* teaches, identity is inconstant, shifting, and people may not always be who they seem. To presage an issue taken up in chapter 3, identity is more complex than human colonial masters seemed to believe.

Northern Sudanese women's rites filter, interpret, and obliquely put to use information about the world beyond their courtyard walls—information passed on to women by local men when the former were unable to observe for themselves.[8] The rites suggest how to handle encounters with spirit or human foreigners who materialize in villagers' midst. Caution

and a willingness to bargain: both are warranted when dealing with entities different from and apparently more powerful than oneself.

Moreover, *zâr* ceremonies are commemorative rites. Decades after the last British official left Sudan, the figures of British *zayran* periodically materialized in domestic space, refreshing people's memories of their former colonizers, keeping them meaningful in ways that made local sense. The powers of *Inglizi* civil secretaries and governors-general were recalled, tapped, and enlisted to ends that, as we'll see, SPS officers decried: being other than one's "authentic" self.

Not all *khawaja*s and *basha*s are government officials. Birulu, Lord of the Chains, is a nineteenth-century European slave-concessionaire portrayed as driving a long line of his sorry shackled wares to markets in the north. There are also Greek, Jewish, and Armenian traders whose human counterparts brought "Manchester goods" to Sudan well in advance of British troops. More: there are bespectacled archaeologists, British and Syrian doctors, Italian soldiers (analogues of prisoners taken on the border with Ethiopia in World War II), Catholic nuns and priests, a Coptic monk who flies in an airplane and an Englishman *zâr* who pilots it, even a spirit called Kahraba, "Electricity." There is a British civil servant *zâr* who demands a good mattress, another who chain-smokes Benson & Hedges cigarettes while riding around town in a taxi. There is also Hashîra, a well-laced English gentlewoman who gazes disdainfully through the window of her railway carriage as it crosses the Blue Nile Bridge to Khartoum while Sudanese farmers toil in the blistering sun on the banks below. Note the prevalent themes of colonial encounter: the role of the railway in conquering Sudan, the elevated position of the colonial wife, the marvels and humiliations of Western technology, British privilege, indulgence, and apparent indifference to Sudanese.

In his book, *The River War* (1899), Winston Churchill described how in building the desert railway through northern Sudan, men encamped at the railhead were replenished:

> Every morning in the remote nothingness there appeared a black speck growing larger and clearer, until with a whistle and a welcome clatter, amid the aching silence of ages, the "material" train arrived, carrying its own water and 2,500 yards of rails, sleepers, and accessories. At noon came another speck, developing in a similar manner into a supply train, also carrying its own water, food and water for the half-battalion of the escort and the 2,000 artificers and platelayers, and the letters, newspapers, sausages, jam, whiskey, soda-water, and cigarettes which enable the Briton to conquer the world without discomfort.[9]

If the woman holding a *zâr* rite was sufficiently well off, a sequence called *mayz* (for mess?) was staged for assembled *khawajat*. A long table

was set up, covered with a cloth, laid with forks and knives, and surrounded by wooden or metal chairs. The offerings were European fare: Churchill's sausages, biscuits, hard cheeses, olives, sardines, jam, white baguettes, exotic fruits such as apples and cherries, bottles of Pepsi and Fanta, and before the *shari`a* prohibitions of 1983, beer, sherry, and (most essential) whiskey. *Khawaja* spirits would be invited to eat and drink and smoke cigarettes. They would sit on the chairs or circle the table, speaking to one another in "English" or "Italian" or "Greek," tasting the food and sipping the tipple, enacting, as Constantinides puts it, "their image of Europeans. A typical exchange, in Arabic, between two 'Europeans' swaggering around arm in arm: 'C'mon, let's go to Church,' 'Naa, let's go to the bar.' "[10]

Khawaja spirits required the trappings of European modernity to "be" themselves. They wanted imported soap, whiskey and soda, socks and shoes, jars of jam, and helmets to be appeased. They were partial to electric fans, air-conditioning, swimming pools, trains, cars, airplanes, other Europeans, churches, bars. *Khawajât* were wealthy, arrogant, and often very drunk. Here *zâr* furnished an inverted, perhaps unwitting parody of the Gordon cult with its emphasis on self-sacrifice, martyrdom, and asceticism. In *zâr*, earthly desires, selfishness, and irreverence reign supreme. Of course, to colonial British, the *zâr* was another example of women's "superstition," unorthodox Islam, and fanatical excess; but for the women colonized, it contained an indirect critique of British self-importance, intemperance, and zeal.

Equally, however, *zâr* enabled a subtle if ambivalent embrace of "modernity," a trying-on of other selves that in the process invariably affirmed the value of one's own. Here gender and colonial subjectivities, hierarchy and difference would intersect: a Sudanese woman might be a prosperous *khawaja* official one minute, a Muslim cleric or lowly slave the next. But ideally she returned to herself when the thread was "let go" and the rhythm changed to another chant. She came back to herself refreshed, participants said, and with better awareness of herself and the outside world. In this sense, *zâr* served as more than a continually revised narrative of foreign contact; in enabling cultural comparison through participant observation it was also an indigenous unintended form of anthropology.

3

"UNCONSCIOUS ANTHROPOLOGISTS"

> In India the British entered a new world that they tried to comprehend using their own forms of knowing and thinking. There was widespread agreement that this society, like others they were governing, could be known and represented as a series of facts. The form of these facts was taken to be self-evident, as was the idea "that administrative power stemmed from the efficient use of these facts."
>
> —Bernard Cohn, *Colonialism and Its Forms of Knowledge*

Though Cohn's words refer to eighteenth- and nineteenth-century India, they readily apply to twentieth-century Sudan. The desire to understand the world of the colonized, to classify it so it could be physically and intellectually controlled, led the British to devise a range of methods—what Cohn calls "investigative modalities"—to compile the facts required. An investigative modality includes "the definition of a body of information that is needed, the procedures by which appropriate knowledge is gathered, its ordering and classification, and then how it is transformed into usable forms such as published reports." Some modalities were quite general, others firmly linked to administrative concerns. Among the former, the "historiographic" was, in India and I would argue Sudan, the most powerful, compelling, and basic. To the British, notes Cohn, history had "ontological power" in that it furnished assumptions "about how the real social and natural worlds are constituted."[1]

Here and in subsequent chapters we also encounter "the survey" mode (of mapping, collecting botanical specimens, recording architectural and archaeological sites), the "enumerative" (establishing "certain knowledge" by assembling numerical data), the "museological" (collecting antiquities and defining the nature of the past), and the "surveillance" mode (whereby groups of people seen as threats to "the prescribed sociological order" are identified and controlled). For Sudan the list would be woefully incomplete without an "anthropological" mode—a form of the historiographic—through which investigators "sought to erase the colonial influ-

ence by describing what they took to be authentic indigenous cultures."
Its epistemological framework, of course, was European, part of "the
world of social theories and classificatory schema" that underwrote state
endeavors to reshape subjects' lives.[2]

Scientific Imperialism

We begin by returning to 1898. Soon after the Battle of Omdurman,
Kitchener received an offer of laboratory equipment for the future Gor-
don Memorial College and stores for the school's dispensary from Henry
Wellcome, an American entrepreneur living in London who, in partner-
ship with Silas Burroughs, had made a fortune marketing tablet medi-
cines in Britain. Wellcome dabbled in archaeology, befriended explorers
of Africa, and championed British imperialism.[3] Quick to recognize the
empire's commercial prospects, he had produced the Burroughs Well-
come and Company "tabloid" medicine chests, sturdy, fitted boxes "de-
signed to withstand rough treatment under extreme conditions." The
first of these, the Congo Chest, accompanied Henry M. Stanley on his
mission to Equatoria in 1889. The chests were often returned to Well-
come "appropriately battered," to be depicted "with testimonials in com-
pany advertisements"[4]—versions of the tributes to British soap placed on
Sudan's walls and hills, described in chapter 1. In this instance, however,
readers were to be astonished by the marks of *Africa* on the salvaged
chests, tangible evidence of the power of pharmaceuticals to overcome
the continent's afflictions.

Wellcome was fascinated by Sudan. He traced his interest to Gordon
who had begun "the great work of regeneration in Africa" by trying
to end the slave trade and stifle the Mahdi's revolt. When Kitchener's
"wonderful campaign" brought the Mahdist "reign of terror" to an end,
Wellcome became a patron of the college to be founded in Gordon's
name. It was, he claimed, "the first step in the rescue, education and
uplift of the natives from their state of savagery and disease."[5] Wellcome
believed that a people's social and intellectual development depended,
not surprisingly, on their race, but also on their health. Traveling to
Sudan early in the new century, "he saw for himself the utter desolation
that reigned," and concluded that "disease was undoubtedly the most
deadly factor that, unless checked, would defeat the most determined
efforts at reconstruction."[6]

Wellcome's gift of stores and furnishings for chemical and bacteriologi-
cal research was gratefully accepted by Wingate in 1901.[7] Two years later,
the Wellcome Research Laboratories (WRL, changed to the Wellcome
Tropical Research Laboratories in 1911) opened on the second floor of

Gordon College, with Dr. Andrew Balfour (father of Elliot of the SPS) as its first director and Khartoum's Medical Officer of Health.

While the WRL was supervised by the Sudan government, with Balfour reporting to the director of education, its staff were expected to undertake "pure" scientific research—systematic investigations unconnected to government needs or demands.[8] As David Arnold notes, "medical topography epitomized the colonial order's practical and political need to know," and even nongovernment researchers thus became servants of the state.[9] The institution's mandate was exceedingly broad: to promote technical education; study tropical diseases of humans and animals peculiar to Sudan, and assist health workers to combat these; perform "experimental investigations in poisoning cases . . . particularly the obscure and potent substances employed by the natives"; conduct chemical and bacteriological tests in relation to water, foods, health and sanitary matters; and "undertake the testing and assaying of agricultural, mineral and other substances of practical interest in the industrial development of the Sudan."[10] Reflected here was Wellcome's conviction that knowledge was key to the empire's commercial success.[11] Indeed, given his grasp of the links between research, medicine, and commerce, Wellcome's philanthropy was never disinterested.[12] His vision for Sudan was salvific: "All Central Africa is going to be made perfectly habitable for the white man. Its agricultural, industrial, and commercial resources will become available. The Niles and their tributaries will teem with the commerce of a numerous and happy people."[13] And at the center of the enterprise would be the Wellcome name.

According to Heather Bell, the WRL became the gateway for scientific research in Sudan. Balfour invited government doctors to use WRL labs for their studies, though personality clashes stalled cooperation for a time.[14] WRL scientists investigated agricultural pests and devised methods for their control. Much of Balfour's work was regulatory, practical: as both laboratory director and Medical Officer of Health he organized mosquito brigades that, by 1905, had substantially reduced the risks of contracting malaria in Khartoum. The feat contributed to the city's image as a hub of scientific rationality and order. "Research," writes Bell, "defined Sudan and the civilizing project of the Sudan government to government officials themselves, and to the wider world."[15]

WRL scientists and staff not only collected specimens and studied local disease. In 1906 a Carnegie-funded anthropologist, Dr. Alexander Pirrie, joined an expedition to measure the physical traits of several southern tribes.[16] His posthumous accounts furnish an imperial taxonomy of "Sudanese types" accompanied by "specimens" of their "ethnographical objects."[17] WRL findings, published in handsome annual reports, also included native healing techniques and religious rites. For instance, Captain

R. G. Anderson, a military physician, contributed "Medical Practices and Superstitions amongst the People of Kordofan" (including male and female genital cutting), and "Some Tribal Customs in Their Relation to Medicine and Morals of the Nyam-Nyam and Gour People Inhabiting the Eastern Bahr-El-Ghazal." Anderson began his articles with reflections on how difficult it was to dissociate native medical customs "entirely from others of a general nature," noting the indefinite "borderline between purely medical and general superstition," which "are so blended with religious rite that it is impossible to touch on one without encroaching on the other."[18]

Ethnographic accounts appear alongside technical reports on diseases such as trypanosomiasis and *kala-azar*,[19] poisonous snakes, "interesting reptiles," the chemical properties of gum arabic and Nile waters, attributes of "scorpions and allied annulated spiders of the Anglo-Egyptian Sudan," the classification of finches and weaver birds, and "municipal engineering problems in the tropics."[20] An extensive inventory of scientific knowledge, discretely partitioned, systematically organized, minutely detailed and arcane, is thus distinguished from native thought that muddles religion and empirical observation. Science not only contrasts with local belief but subsumes it: Sudanese groups appear in the reports as faunal specimens in a savage and perilous nature, taxonomic problems to be solved, or sources of commercially useful preparations. Like Henty's British lads, educated and endowed with "practical common sense," WRL authors affirm the imperial project to save Sudan from credulous and fanatical natives, and the latter from themselves.

By the 1920s and 1930s the relevance of science to civilizing practice had become so well established that moves were afoot to bring the (now) WTRL more firmly under government control. A reviewer of Balfour's book, *War against Tropical Disease, Being Seven Sanitary Sermons Addressed to All Interested in Tropical Hygiene and Administration*,[21] observed that "the prosperity of commerce," the ease of communication "with areas supplying raw material," and "the availability of suitable labour," all "largely depend upon the prevention of . . . diseases in the tropics."

> No politician need reflect that the matter thus condensed does not concern the prosperity of the Empire, no administrator dealing with tropical races will fail to perceive that there is here much matter that will aid decision. . . . [N]or need the man of commerce hesitate in arriving at the conclusion that there is an indissoluble connection between production and the health state of labour.[22]

And in Sudan, "the health state of labour" was understood to depend on the practices of Muslim women, as we shall see.

There is another angle to this story. For as Bell suggests, "medical knowledge reflected, reinforced, or even created images of different social and racial groups as strong or weak, diseased or healthy, susceptible or resistant to infection,"[23] thereby defining their usefulness to colonial projects. Such images promoted the categorization of Arab Sudanese, Southerners, and West African migrants as indolent or industrious, dependable workers or capricious, a topic further explored in chapter 6. For now the point is this: in the Anglo-Egyptian Sudan, membership in a particular ethnic group or "race" described one's economic and political capacities. And the shorthand to this classification was, ideally, dress.

Ethnicity Clothed

The military and the SPS wore uniforms distinguished by rank, ostensibly individual achievement. But others in Sudan were expected to dress in keeping with their race, faith, and tribe. Those who did not, like Butler's ill-fated Dutchman, were apt to be considered out of place.

The example of the *jibba* shows that for Sudanese, too, apparel was a statement of commitment and social position. The convention had lengthy precedents. During the seventeenth century, nobles of Sennar were distinguished from commoners by sumptuary laws prohibiting the latter to wear sewn garments or cover their upper bodies. Moreover, only the highest aristocrats and the sultan were privileged to cover their heads.[24] Such protocols were a matter of heredity rather than wealth; when, for instance, a nobleman of Ghule found some of his subjects in Arab attire "he seized [the] clothes and tore them to pieces—puw!—saying, you are wearing the clothes of my father."[25] Surprisingly similar scenes took place in the 1930s when the British tried to prevent "detribalization" in the south (chapter 5).

During the Condominium, clothing signified social status for women and men alike. In northern riverain regions, a girl wore the leather *rahat* until her wedding, when her husband "broke" it by pulling off some of its "threads" or thongs. Thereafter she wore a homespun wrap skirt or shift, and a length of cloth (*tôb*) covering her body and head. Her hair was dressed in corn-row plaits (*mashat*) and oiled. Men's clothes varied by trade and erudition rather than marital status: farmers of all ages wore a skull cap (*tâgîya*), homespun tunic (an unadorned *jibba*, now called a "shirt," *gamîs*), and baggy trousers. Merchants and scholars wore turbans over their *tâgîya*s and long loose kaftans (*jallabîya*s) of fine cotton or silk; men renowned for piety or leadership and known by the honorific "*shaykh*" might have worn beards as well. Such practices reliably indi-

cated adherence to Islam and putative origins along the Nile. Beyond this, men who had rendered a service to the state would have worn robes of honor on formal occasions. Dress was a language well understood by Arab Sudanese.

Men employed in government and allied occupations were normally uniformed or emulated Western attire. Domestics, for instance, wore spotless white *jallabîya*s and turbans, colorful cummerbunds, and, on festive occasions, gold-embroidered waistcoats[26]—romantic "oriental" attire that set them apart from those they served. For graduates of Gordon College, however, moving into the orbit of "modernity" often meant donning "modern" clothes: trousers, shirts, closed shoes, jackets, and ties. Here officials were less willing to endorse their subjects' claims, viewing European dress as incongruent with the wearer's identity or indeed threatening to their own. Perhaps, as Nancy R. Hunt observes for missionaries in the Belgian Congo, they were anxious to avoid being parodied[27] (as they would certainly be in the *zâr*). Whatever its cause, the friction recalls Homi Bhabha's observation that the colonial process worked to produce, vis-à-vis Europeans, a "reformed, recognizable Other, as *a subject of difference that [was] almost the same, but not quite.*"[28]

To the SPS, demeanor and dress declared one's intrinsic ethnicity, and one was subject to discipline if they did not. Yusuf Bedri, son of the distinguished educationalist Babikr Bedri, "vividly recalled" when, on his way to school one day at the age of twelve, he was confronted by the district commissioner and rebuked for "wearing European shoes, not *marcoub*, the locally produced shoes."

> He said, "Why are you wearing these?" . . . I said, "These were given to me by my brother who bought them from a shop." He sent me back in a furious temper to change my shoes and put on my *marcoub*, the native shoes. By the time I got back to school, I found the whole school paraded. . . . Every boy wearing European shoes was sent home to change into Sudanese shoes.

Southern schoolboys were also forbidden European dress "lest they appear different from their people." Andrew Wieu recalled how he and his fellow students in Upper Nile Province demanded "shirts and shorts," arguing that they "should not be kept halfway, neither with civilization nor completely with the traditional way of life."[29] In the end the headmaster requested a change of government policy.

Officials were preoccupied by ontology, concerned that Sudanese "be" who *in essence* they "were." They saw "tribes" as natural units of administration, which seems to have had a Sudanese precedent too. According to Kaptiejns and Spaulding, commoners in Sennar and other Sudanic states,

usually appear in the [vernacular] historical record in groups—the "clans" or "tribes" of conventional discourse—each of which owed allegiance to a designated representative of the state and occupied an assigned geographical area. The cohesion of these groups derived in part from their internal organisation, notably kinship relations, but also from a threat imposed externally by the state. It was a fact of life that individuals who left the security of kin and community became masterless men, subject to robbery and enslavement.[30]

Anthropologist Wendy James, analyzing how British colonial officers and their academic contemporaries deduced the origins of Sennar's elite, notes the "overriding importance" they attached "to the collation of fragments of data concerning tribal names, language, traditions of origin . . . in order to build upon the basis of concrete evidence an apparently objective account of the part played by ethnic groupings in history."[31] This "positive knowledge" of the past would form the armature of "native administration" or indirect rule.[32] Thus, wittingly or ironically, colonial practice revived and hardened the structure of the defunct Sennar state. Sudanese "tribes" were seen as having "characteristic" traditions and physical features; their social, reproductive, and geographical boundaries could be defined and ostensibly enforced. Officials would pronounce a custom legitimate or inauthentic, and often challenged evident "borrowings" as clashing with local ways of life. Later researchers, responding to postcolonial concerns, would stress fluidity and contextuality in Sudanese social life: that far from ontology determining practice, practice—and pragmatics—might well shape ontology, rendering questions of authenticity obsolete.[33] James's work, for instance, demonstrates the malleability and porousness of social ascriptions in central Sudan, the political relativity of their meanings.[34] Identity, whether ethnic or religious, was hardly the enduring trait officials took it to be (a lesson the *zâr* makes clear). But ambiguity was anathema to a government seeking to classify, segment, and thereby tame the bewilderingly complex population it was attempting to rule.

Dress denotes category

In 1919, Harold MacMichael of the civil secretary's office founded the journal *Sudan Notes and Records* (SNR) to which political and civilian staff, as well as a smattering of missionaries and academics, contributed articles on all manner of "Sudanalia": political history, genealogy, folklore, ethnomedicine, religious customs and beliefs.[35] The idea was to build up a comprehensive picture of Sudan's peoples that would be useful for effective rule. Several SPS officials, driven by boredom or genuine interest as much as a desire to govern well, were ingenious anthropologists, amateur only in name, and the journal remains an invaluable resource to this day. Its articles helped acquaint neophytes with their subjects in lively and

exotic detail; few accounts were contextually replete. Contributors wrote largely within and about the districts to which they were sent, whose borders had been defined by their "ethnic" composition. The resulting mosaic of cultures, each occupying (or originally thought to have occupied) a relatively discrete social and geographical space, was therefore already presumed, and tautologically affirmed in the pages of SNR. Further, the presumption that peoples are historically and ontologically distinct was uncritically reinforced when they held similar views about themselves.

Contributors to SNR and contemporaneous works sifted through native rhetoric and colonial effects in search of unfettered truth. MacMichael, for instance, in his ethnohistorical work among the Ja'aliyyin, argued that native genealogists willfully erred in tracing their descent from the Prophet's uncle, Abbas, and neglecting the stronger Nubian strains in their makeup.[36] Such "willful" errors reduced native genealogies to the status of parables, he claimed, making them unreliable guides to what had "really" taken place and who people "really" were.[37] The discovery that genealogies are not unvarnished fact was hardly surprising to MacMichael; he knew that this was not their point. But he seemed unconcerned that, as socially relevant versions of history, they were not open to "impartial" correction.

Having rejected local histories as fallacious, officials obsessed with origins were left to base their reconstructions on "such apparently unbiased clues as material culture, linguistic and ritual forms." However, as James observes,

> a body of local tradition, besides containing evidence of this type, represents an interpretation of the evidence in the memory of those who have inherited a particular past. That interpretation is itself a social and historical fact; and to take account of it is to enrich, not impoverish, a historical enquiry.[38]

In an article ironically titled "Breaking the Pen of Harold MacMichael," Sudanese anthropologist Abdullahi Ibrahim explores the intricately segmented nature of Ja'ali identity, and the uninhibited ways in which Ja'alis strategize with genealogy. My own fieldwork in a Ja'ali village bears this out. Ja'ali claims to Abbasid identity, we would agree, must be understood in the context of specific, and not immutable, political relations between and among persons and social groups. Similar observations can be made for Sudan as a whole. Ibrahim records a telling incident (from which his title derives) when MacMichael, as DC of Northern Kordofan, settled a dispute between two groups over possession of a watering point. MacMichael ruled against the Kawahla, but when he took up his pen to sign the verdict, their indignant chief, Jad Allah, "a devout Mahdist follower,"

snatched the pen and broke it. . . . His praise singer recorded his feat for posterity. A line of his song refers to MacMichael (spelled Muk-mayk) [his SPS nickname was MacMic] as "Jana Hicksi" (the son of Hicks). Hicks, it may be remembered, was the British general sent at the head of a huge army . . . in 1883 to put an end to the successful Mahdist revolution. Hicks's army was eventually routed to a man by the Mahdist forces. . . . Prompted by an irresistible association of images, the singer meshed together Jad Allah's defiance of MacMichael, which resulted in a crushed pen, and the Mahdist's crushing victory over Hicks. . . . Neither the singer nor his audience were particularly interested in the accuracy of the genealogy. To them, it was more important that it served as a metaphor for defiance.[39]

Clearly, the configuration of an identity depends on the uses to which it is put.

An Ethnological Administration

MacMichael, when civil secretary (1926–33) (de facto minister of state in the Sudan government, second only to the governor-general), extolled the value of ethnographic research to colonial rule in his introduction to C. G. and Brenda Seligman's *Pagan Tribes of the Nilotic Sudan*:

> If it be the aim of the government, as indeed it is in the Sudan, to fortify such native institutions as it finds . . . are not repugnant to generally accepted canons of decency and justice, clearly it cannot do so successfully unless the beliefs and traditions upon which those institutions rest are fully understood.[40]

Surely this sounds like so much common sense. Who would deny that understanding is the basis for sound (if not such aggressive) intercultural exchange? Yet the trait-list approach to ethnography, ensuing from the phylogenic view of human history that dominated nineteenth- and early twentieth-century social science, elides as much as it reveals—such as the politics of practice, as James's work attests.[41] And while officials sought to preserve customs they judged admirable, helpful, or benign, they were also resolved to abolish those they deemed inimical to "progress." The latter included pharaonic circumcision. However, a focus on traits and origins was not always fruitful to appreciating why such practices persisted, how they had been transformed, or their meaning to present adherents. And the "accepted canons of decency and justice" were rather selective, for well into the 1930s the colonial government was disinclined to quash domestic slavery. Notions of "progress" and "essence" also informed attempts to check the diffusion of northern practices to the "pagan" south, several of which pertained to women. These issues are

pursued at length in chapters to come. Here I discuss how ethnographic knowledge was regarded as an instrument of social control.

In the 1920s, Khartoum shifted more firmly to "indirect rule" or governing through native leaders, in the belief that "tribes" might be reconstituted if no longer politically viable, or prevented from disintegrating if they were on the point of collapse. A memorandum circulated by the civil secretary's office in 1924 spoke of the DC's task "as that of 'regenerating the tribal soul.' " Officials were convinced that authoritarian tribal structures had characterized even acephalous groups in the past and, with proper nurturing, their remnants might "develop and perhaps in time . . . give birth to genuine 'chiefs.' " Thus, "it became one of the major duties of DCs to discover by research this 'ancient governing organisation,' and if possible to revive it."[42] In the 1950s as the Condominium drew to a close, the civil secretary's office declared, "The effect of these reforms was not only to restore but also to increase the prestige of tribalism."[43] Tribes that had "lost" their "coherence" were considered casualties of the Mahdiya, the slave trade, or both.

Granted, such events had disrupted social alignments; yet the idea that there had ever existed a stable set of discrete social entities is difficult to defend.[44] More problematic still is the notion that "tribes" so defined (rather than, say, family, village, or herding group) had ever provided Sudanese with their vital affiliations, leadership, and self-respect.[45] Nonetheless, a host of challenges to colonial government, from crime, snags in the implementation of indirect rule, to the glimmerings of Sudanese nationalism, were put down to the calamity of "detribalization." Tribal institutions were held to provide a "stable foundation" for rule; "detribalization" was a synonym for trouble and unrest.[46]

The desire for precision in classifying subjects remained strong to the end of the Condominium. In preparation for its only census undertaken in 1955–56 just as independence was declared, a circular entitled "Tribes of the Sudan" codified peoples in descending order of race, groups of tribes, subgroup, tribe, subtribe. While conceding that such divisions "are bound to cease having their original importance sooner or later," the document states it is the government's aim to enumerate the population by "race" and "tribe." Yet the list includes several queries. Should the contemporary Fung (Funj) be classed as "Race I, Arab" or "Race III, Negroid"? Should the Gaafra be included in "Arab, Miscellaneous Central," and if not, where?[47]

Such doubts and a desire for (ever elusive) clarity suggest why ethnographic research was encouraged by government authorities, whose needs stimulated and helped shape "the infant industry of anthropology," in Robert Collins's phrase.[48] Ethnographic inquiries were felt most needed in the south where the British confronted a confusing array of "primitive"

peoples who, ruthlessly exploited by prior regimes, were inclined to defend themselves against this latest invasion of "Turks." Good administration, it was believed, "was largely a matter of applied social anthropology."[49] All DCs should attend to the "ethnological side of their work" because, wrote the Governor of Bahr al-Ghazal in 1923, "one of the surest means of gaining the confidence and respect of savage people is to learn as much as possible of their sociology, their life histories, social organisation, folklore, songs, etc." He drew his staff's "attention to 'Notes and Queries on Anthropology' which will be found valuable as a guide and assistance," and offered to obtain copies for those who lacked "as soon as the new consignment has arrived from England."[50]

The "ethnological side" also warranted expert help. In January 1929 MacMichael wrote to the financial secretary defending his plan to hire a permanent government anthropologist. Government, he noted, had already granted funds "to enable Mr. Evans-Pritchard to carry out his researches" and "assist Professor Seligman . . . [with his] anthropological survey of this country." And Evans-Pritchard was required as "a condition of the grant" to furnish "the Sudan Government, within a reasonable time, a report of his studies . . . suitable for the use of administrative officials." Anthropology, MacMichael was convinced, "is a science of vital importance to the European administrator of primitive peoples."

> [Anthropology] is concerned with the study of the social structure, customs, beliefs and ways of thought of the races of mankind. Some understanding of these will be conceded to be an essential equipment of the administrator responsible for the tutelage of primitive races whose mental processes are not as ours. Between the mind of the educated European with its heritage of some centuries of occidental civilization and that of the primitive savage a great gulf is fixed which the former can bridge hardly and with patient study only. But unless that gulf is bridged with at least a slender span, there is little hope of really constructive administration of the primitive by the European. So much is this an axiom, that the well-intentioned administrator has at all times been compelled by force of circumstance to become an amateur though possibly unconscious anthropologist.

But "unconscious anthropologists" were not enough. To gain intimate knowledge of native thought required the services of a trained anthropologist in government employ.[51]

His proposal was unluckily timed. Shelved during the Depression, it was revived in modified form eight years later by Angus Gillan, MacMichael's successor as civil secretary. Gillan lauded the work of professional anthropologists—"in particular Mr. Evans Pritchard has contributed very valuable information on certain southern tribes"—but wanted greater coordination of the work, without which ethnographic information was of

little practical use. Anthropological research should be tied to government priorities, and thus be more "applied" than "pure."[52] He was likely taking his cue from Margery Perham, Oxford colonial historian, champion of Lord Lugard and indirect rule, who was a confidante of key Sudan officials and gave courses on colonial administration to SPS and Colonial Service recruits. In her lecture, "The Political Officer as Anthropologist" (1933), she commended the advantages of having an anthropologically trained official who could advise DCs and maintain an organized collection of ethnographic information at "H.Q."[53]

Gillan proposed that a member of the SPS be appointed "Anthropological Adviser and Conservator of Antiquities to the Government" so as "to coordinate the various anthropological, ethnological and linguistic studies" undertaken by officials and missionaries, and "make the best and fullest use of material collected." The adviser would manage "reports by officials on tribes" kept in the civil secretary's office, and assist in editing SNR, which would continue to publish "everything of value" that Khartoum received.[54] To reiterate Asad's critique of anthropology's role in colonization, such work would furnish the kind of understanding that ultimately confirmed the powerful "in their world."[55]

The first anthropological advisor was A. J. (Tony) Arkell, who had been a DC in White and Blue Nile Provinces, deputy governor of Darfur, and was already deeply interested in North African archaeology. C. G. Seligman suggested that Arkell take a year's anthropological training at Oxford, as the articles in *Sudan Notes and Records* would be far more informative if the authors had more systematic knowledge of the field.[56] In 1938 Arkell was granted leave to study for a diploma in anthropology at Oxford under the tutelage of Evans-Pritchard (then a research lecturer) and newly arrived Professor A. R. Radcliffe-Brown. What became the Oxford structural-functional approach of comparing, classifying, and generalizing about indigenous political institutions proved well suited to both the demands of indirect rule and the proclivities of the SPS.

Containing Arab Culture and Islam

Relying on political officers for ethnographic information did not mean that studies by independent anthropologists ceased.[57] These continued to be supported in areas of special government interest. Gillan, for one, "was entirely in sympathy" with a plea from Douglas Newbold, governor of Kordofan "for an anthropological survey of the Nuba Mountains" that each (for different reasons) considered "vital at this stage of economic expansion affecting a very primitive people."[58] Gillan, Newbold's predecessor in Kordofan, had formed a paternal attachment to the Nuba, the

collective name for diverse peoples speaking over fifty distinct languages who inhabit the hills and enclaves of southeastern Kordofan. Some Nuba were relatively Arabized and had been organized as hereditary kingdoms since the time of Sennar; others were "pagan" and led by "big men" who owed their position to their wealth or renown as warriors or priests; still others were, like the Nilotic Nuer, acephalous.[59] Well armed and given to mutual raiding, the Nuba had proved difficult to govern since the early days of the regime.

Ethnographic research on the Nuba began in 1937 under S. F. Nadel.[60] Gillan engaged him not only because his findings might facilitate Nuba administration, but also because they would be useful in developing the Nuba along "indigenous" rather than "Arab" lines. Moreover, Gillan— like MacMichael, a clergyman's son—was keenly interested in the activities of the CMS and helped secure the society approval to open a mission in the Nuba Hills, technically within the embargoed "Muslim" north.[61] When governor, Gillan had become alarmed that the region was yielding to northern sway, and pointed to the increased incidence of pharaonic circumcision among Nuba women and girls. That practice, he wrote, was not necessarily connected "with the spread of Islamisation even in the native mind," but instead, with the spread of "Arab" influence: Nuba seeking to rise in social status were now speaking Arabic and adopting female circumcision as markers of prestige. (Ironically, they had thus internalized and were seeking to transcend the place they'd been assigned in the hierarchy of race and civilization endorsed by British officials and Arab Sudanese.) "Personally," wrote Gillan in 1930, "I feel very strongly that it is our duty as guardians of primitive people like the Nuba to prevent the adoption by them of this brutal and dangerous practice."[62] We return to Gillan's appeal later on. Here I want to stress that interest in ethnographic inquiry was generated not just by government's desire to classify the populace as tribes or implement indirect rule, but also to contain the spread of Islam, Arabic, and the culture of the Arab north. Political officers, anthropologists, missionaries—all were deployed to that end. Not every Briton was as adamant as Gillan about the need to suppress northern influence, and some, like Newbold, grew skeptical of the project in light of the missionaries' failure to manage their schools.[63] Yet this was the aim of Khartoum's infamous "Southern Policy," addressed in chapter 5. Ethnicity was endowed with new import by colonial officials, accentuated and ominously politicized, and anthropology played a significant part in that affair.

Few SPS officials had read anthropology at university, only six in the entire cohort of 393.[64] Elliot Balfour (Cambridge 1931) was one, and he questioned whether the cultural relativism of the field was compatible

with governing. He hypothesized "a tribe which had the custom of killing and eating its grandmothers before they reached the age of fifty years."

> The Anthropologist would consider this custom as both interesting and important as it was clearly an attempt to conserve for the tribe in general the wisdom and experience of these ageing ladies before they vanished into senility. He would advise strongly against modifying, let alone abolishing a custom on which the whole stability of the tribe depended. The Administrator, on the other hand, would be obliged to inform the tribe that it was his duty to lead them into the 20th Century where the eating of grandmothers was strictly discouraged and that if he found anyone even looking sideways at his grandmother and licking his lips, he would hang him as high as Haman.[65]

Raillery aside, it is a telling comment. Indigenous institutions were seldom consonant with European ideals. Attempts to sustain those considered innocuous while "modernizing" their practitioners were soon seen as hypocritical by officials and the growing class of educated Sudanese: the former because tradition was being eroded nonetheless, the latter because it was an excuse to block their advancement. Apropos of Elliot Balfour's remarks, though government had designs for the information that professional anthropologists supplied, it invariably ignored their expertise in deciding matters of policy. According to Evans-Pritchard, despite "all the years [Seligman] had worked in the Sudan," he "was never once asked his advice and . . . the only time he volunteered it . . . it was not taken." Moreover, during Evans-Pritchard's own fifteen years of Sudan research he "was never once asked [his] advice on any question at all."[66]

What about ethnographic research among peoples of the riverain north? A smattering of amateur articles appeared in SNR between 1919 and 1950,[67] but otherwise little exists. Indeed, because they were "Arab" and Muslim it was widely believed they were already "known"; northerners, on the whole, were taken for granted. Reflecting on the role of anthropology in colonial Sudan, MacMichael wrote that "if local customs and ways of thought were to be respected, so long as they were not repugnant to equity and decency, they must be understood. *In the north this presented no great difficulty.*"[68] Arabic was the official government language and spoken in the northern two-thirds of Sudan. All SPS probationers were expected to learn it well enough for their work; cadets took courses at university, sometimes an extra year, learning Classical Arabic and law, and were required to pass exams on these subjects within two years of initial appointment. But they were left on their own to master the colloquial language—more useful to them by far—for which they relied on Arab Sudanese. Northern Arabic speakers who held low-grade government jobs or were servants in officials' homes were the colony's most

accessible subjects, and became deceptively familiar to British eyes, if never entirely "tame." And they wielded a precarious power, being cultivated as collaborators and appeased as potential zealots. It is tempting to suggest that it was their "known-ness" in the present and purported decline from a nobler (Christian as well as Meroitic) past that made history and archaeology the disciplines of choice for learning about them, rather than systematic ethnography, more valuable for fathoming inscrutable unruly "others" in the here and now. When ethnographic inquiry was undertaken among Sudanese Muslims before World War II, the preferred subjects were nomads, exotic and appealing to sedentary Europeans schooled in the Orientalism of the day. In 1937 Evans-Pritchard wrote to Arkell that, upon concluding work among the Nuer and Azande of the south, he would like to research Caucasian Arabic-speaking nomads and proposed the Kababish.[69]

Mercantile and agrarian Arabs, the *awlad al-balad* (sons/children of the country), were not only more intelligible to the British, but also culturally akin to Egyptians, Britain's rivals for the hearts and minds of Sudanese. As one Northern Province governor wrote of the region, "it was of course the most civilized province with so many of its sons in the educated class, and with tribes and tribal leaders long experienced in trade and travel up and down the Nile."[70] Yet while the *awlad al-balad* were more accessible, more civilized, less romantic than other Sudanese, they were widely mistrusted by Britons, who were wary of Arabs schooled in Western ways—those who behaved like Britons, "but not quite." Witness a young official, describing the road from Gedaref to Kassala where "bare-footed herdsmen with their flocks—and a sling or a spear—looking like Michael Angelo's David, pass across in front of you under the telegraph wires, while every now and then a beastly Ford goes by full of young quasi-Effendis in tarbooshes—like people in Cairo or Port Said."[71] The title "*effendi*," applied to educated Muslim Sudanese, was aspired to by "detribalized" townsfolk whose susceptibility to Egyptian political influence and anti-British propaganda was thought to be especially acute. The notion that educated Sudanese and Egyptian Arabs were apt to conspire against the British was partially borne out by experience, but not entirely so. To better grasp the regime's developing approach to Islam and Arab culture in Sudan, a chronology of political events and processes is provided in chapter 5, concentrating on the period from World War I to the start of World War II. Here it remains to query how deep British acquaintance with Sudanese Arabs actually ran, and what Sudanese men of the elite, with whom the British interacted most, thought of their masters and their wives. Sudanese women's impressions of colonial others must be gleaned indirectly, through the *zâr*.

Uneven Contact

Throughout the Condominium, social relations between British and Sudanese were strained by differences of culture, race, and rank. Beyond official levees, social occasions seldom crossed racial lines. Relations between British teachers and native students were closer than those between political officers and Sudanese, but even then, "it [was] clear that the meaning of 'close touch' in the colonial context concerned the performance of official duty rather than personal contact." British in cities and towns tended to develop fewer rather than more social contacts with Sudanese, even though educated natives, "intellectually closer to the British," were likely to live there and not in the countryside. Francis Deng and Martin Daly note that "the overwhelming majority of the British [men] who commented on the matter expressed an unequivocal preference for the rural population." In the towns,

> the presence of a large, nonofficial foreign community entailed all the responsibilities and customs of European society, from which Sudanese were largely excluded. Then, too, was the fact . . . that the educated townsman and his ways were of the future while the rural chief represented a passing, if still vital, way of life to which many British officials were themselves greatly attached. British officials in towns, therefore, often felt isolated from the local community.[72]

Robin Baily recalled that in 1920, when Khartoum was becoming a winter resort, "female relations and friends would get married officials to ask them to stay."

> There were endless dinner parties and dances with competition as to whose were the smartest. Far too much was spent on champagne. Officials would arrive at their offices next morning with hangovers. Their contact with their foreign [sic] subordinates would end when it was time for lunch and not be resumed till next morning. The British went home to their charming houses on the river with their well irrigated gardens and trees while their subordinates were relegated to dismal rows of houses in the dusty back parts. There were good exceptions to the absence of social contact but the above picture was the rule.[73]

Officials who, like Baily, often sided with Sudanese or had a general sympathy for them were apt to earn the dubious distinction of being "too pro-*nâs* (people)."[74] Aloofness was clearly required to maintain prestige.

Some ex-officials opined that familiarity was constrained less by British reticence than Sudanese. One remarked that Islamic views on alcohol and women were obstacles to social intimacy. Another noted that "an En-

glishman in those days simply couldn't be taken into the heart of a Sudanese family. . . . he simply couldn't reach the stage at which he could ever meet the womenfolk."[75] A British couple invited to dinner or tea in an Arab home would be entertained by men, and the wife led off to meet the household's women at the end of the meal. Sudanese wives almost never accompanied their husbands when the invitation was returned.

European women who learned only "kitchen Arabic" usually stuck together, occupying their time with "the demands of the household, Club and Church." "Hardly any sought out Sudanese women, and frequently such attempts were misguided such as the British lady who tried to teach Scottish songs to the Sudanese girls."[76] Some were titillated by the proximity of "savages." Baily remembered how in 1920 he was asked by "a well known society lady . . . to take her to the prison to show her a murderer in chains. The Sudanese were still [sic] regarded by the likes of her as zoo specimens."[77] Others who attained fluency in Arabic, did unofficial "civilizing" work, such as running a local chapter of the Girl Guides, teaching young women the bodily disciplines of modernity. A few were teachers or nurses in government employ who, along with wives who accompanied their husbands to outlying posts, interacted more freely with local Sudanese. Though impressed by Arab women's generosity and humor, obstacles remained.[78] One retired SPS officer put it bluntly:

> What seemed to me to exclude an easy social relationship with the Sudanese was the banishment of their women to the background or behind walls. I accepted this, of course, although I considered it both backward and degrading. . . . [and] the barbaric practice of female circumcision was always an insurmountable barrier to full social relations between British and Sudanese families throughout my whole twenty-six years (1929–1954) in the Sudan.[79]

The wife of a former British official wrote:

> How the Arab women ever produced any children is difficult for a European to imagine. The universal and barbaric practice of genital mutilation, whether infibulation or clitoridectomy, would make intercourse painful. There could be no birth without preliminary slashing and subsequent cobbling together by, in the majority of cases, untrained locals using septic tools. The courageous efforts of one Governor-General's wife [Lady Constance Huddleston] immediately after the War [WWII], and the constant teaching and preaching of the Midwives' Training School, did nothing to alter public opinion. . . . The apparent determination of Arab women, enduring this primitive treatment, to continue to inflict it on the next generation, is shocking.[80]

Even more odious, it seems, than slavery, the practice of female circumcision tainted northern culture, compromising the demotic Islam that was widely believed to support it and, as we'll see, firming British resolve to

prevent the Arabization of the south. Still, labeling the custom barbaric and primitive said more about British sensibilities than Arab Sudanese; it was an exercise of discursive authority that precluded any need for indigenous women's points of view—the very ones that might have helped steer effective attempts at reform.

If the British had trouble imagining how Sudanese women reproduced, the bodily functions of European women were sometimes mysterious to Sudanese. Recall Major Butler, tasked with shepherding rural Sudanese notables through Khartoum in 1912. The *shaykh*s were awed by more than palace bathrooms. Butler wrote that at the reception in the palace garden they were introduced to some European women, "among them an ultra-wasp waisted French woman who much surprised one of the old boys who asked 'But where can she find room for her food?' "[81]

Moreover, changes in European fashion could mislead Sudanese. When Baily was about to retire as governor of Kassala in 1932, the town's chief merchant inquired if he would mind being asked a personal question. " 'One thing that absolutely staggers us,' " the merchant said,

> "is why you English have never brought your wives out to this country since the war." That was the '14–18 war. . . . Baily said, "You were having tea in my house last week." "Oh yes," he said, "indeed I was. And nobody could possibly ask for a more charming hostess. And we all in this town greatly appreciate the work she has done for the hospital and midwives." . . . But, he said, "We know what an Englishman's wife looks like. She wears a blouse up to there and she wears a skirt down to there. Not one of them has been out here since 1914." [Baily] then realized that for fourteen years they had all assumed that all the Englishmen's wives were in fact their mistresses because they wore short skirts, weren't respectable. But they never let on.[82]

If true, it was a telling mistake, revealing how discordant were the meanings of female attire and self-presentation for Britons and Sudanese, how unalike their concepts of time. That Sudanese might fail to recognize a reputable British wife when she lived among them—unaware, perhaps, that her body was a sign-bearer of "modernity" and "progress," a mobile frontier of commerce where time materializes fleetingly as "fashion"— attests to the resiliency of their own cultural and temporal horizons.

Culturally configured bodies manifest in clothing, deportment, and race estranged rulers from ruled in colonial Sudan, making efforts to bridge the gap ambivalent and fraught. Arab Sudanese contributors to Deng and Daly's retrospective remembered social occasions with British couples as being formal, polite, disconcerting affairs:

> "The Sudanese would be called into a British home, usually for tea. Meals were rather rare, because meals meant handling forks and knives, and for

some, forks and knives were not such a great amusement. Tea was alright because you just drank tea and had a bit of cake. It was stuffy because there was this tremendous effort on the side of the hostess to keep you happy. . . . I even remember some sticky person telling you how to dress for coming to tea. . . . [He would say] 'Come in your shorts.' " Jamal only later realized that the man was trying to make the Sudanese feel comfortable: "At the time we thought it was just a way to order us about. . . . We resented it."[83]

From the founding of the Condominium to well after World War II, sexual relationships between Arab Sudanese men and British women were even less common than the reverse. Some Sudanese claimed lack of interest, given "the general view of the word *khawaja* [foreigner] which meant not the epitome of cleanliness."[84] Importantly, circumcision is held to make Sudanese men's and women's bodies "clean."[85] Another Sudanese recalled that "we did not believe [British women] were sexually accessible," so fully insulated were they by their husbands, an intriguing inverse perspective. He continued, "The country was, in those fifty years of British rule, so 'scandal-less,' as one of [the British] said, that that itself was a scandal. No rape took place; not even a flirtation that could anger the husband or another European."[86]

By British accounts that is not entirely correct. In the National Record Office in Khartoum there is a file labeled "Assaults on European Women by Natives."[87] Its creation when there seems not to have been a need for one before, and the year—1931—suggest that MacMichael was anticipating trouble at the time. Why this should be so will become clear as my story unfolds. Yet the extent to which trouble arose seems slight, for only two cases appear: in April, 1931, an Arab Sudanese man followed a British woman as she walked her dog along the banks of the Blue Nile. He threw his arms around her but ran off when her servant appeared; when apprehended he was found to have been convicted of such acts before. The governor of Khartoum Province, E. S. Sarsfield-Hall, described him as being "of low mentality" and ruled that after finishing his prison sentence he would be sent to a rural area where he would not come in contact with European women. The second assault was more doubtful. In May of that year a European woman walking along a tarred road was approached by a Sudanese man on a bicycle. As he passed he pushed her in the face, causing her to reel two or three yards. The man was caught, and admitted his guilt. He was sentenced to twenty lashes. Sarsfield-Hall wrote to MacMichael, "It appears to me to be more likely that the boy pushed [her] to prevent himself falling over than that he intended to assault her. Under the circumstances do you consider the sentence adequate[?]"[88] (Flogging, it should be noted, was lawful punishment in colonial Sudan long after it had been banned in Britain.)

In 1931 when P.B.E. Acland was district commissioner of Port Sudan, one of his tasks was to censor films:

> I was instructed that I should be wary of any items that might adversely affect British prestige. To be advised as to the effect some films might have I took with me one evening the Kadi [religious judge] and the Mamur. Their advice was interesting—"It will have no harmful effect on the respect for and security of white ladies if films are shown in which women behave with open immorality—we all know that you have harlots in your country and obviously any woman who acts for the films must be a slave girl or a harlot. What you must not show is any film in which the British armed forces suffer a defeat; that might give people ideas."[89]

Nonetheless, in 1931 sexual politics and fears of rising nationalism were intimately entwined in British officials' minds.

Signs of antagonism between British and Sudanese increased after World War II as the colony rushed toward independence. Elliot Balfour observed on being posted to Khartoum in 1951, that "respect for the British was going." He pointed to "a bad bribery scandal in the Department of Trade involving a number of British officials" and noted that "a British woman was raped on the banks of the Nile in broad daylight, something which would never have happened some ten years before."[90]

Yet barriers between British and Sudanese were eroding apace. In the Gezira, prosperous native beer-houses-cum-brothels began to attract expatriate Europeans posted to the irrigation scheme. The houses functioned as social clubs, where British and Sudanese of all ranks could meet, drink, and gossip on an equal footing. Spaulding and Beswick suggest this countercultural setting made possible "the articulation of seriously subversive new discourses, as the colonized exchanged views with the colonizers under the benign hegemony of the madam." Native women benefited by learning it was possible to press legal claims against men; one British man who had "abandoned his African mistress of three years on the sudden and unexpected arrival of his British wife" was forced to pay her compensation, though laying such charges was still beyond contemplation for most female Sudanese. And a "seedy music hall"— the ironically named "Gordon Cabaret"—had opened in Khartoum. It offered a

> variety show that in its better seasons included a fresh troupe of imported female dancers every two months. The dancers . . . were indisputably Caucasian. On opening night the patrons, drawn from every prosperous segment of society in the capital, could watch wealthy men, Sudanese as well as foreign, negotiate the terms by which each newcomer would become a paid compan-

ion for the duration of her visit. It was the only place in the colonial Sudan where white women were routinely available, for a price, to black men.[91]

As the Condominium drew to a close initially hesitant efforts to "modernize" Sudan gained momentum, and self-professed quixotic officials grew less tolerant of their subjects' "lack of progress." Female circumcision was one contentious issue, but by conventional accounts it was less prominent than most. Few mainstream histories of the period discuss it and those that do grant it no more than a passing nod.[92] Yet as former SPS officers remarked, that practice, and the inferior position of Sudanese women it was thought to express and maintain, were significant obstacles to mutual understanding. It was also thought to hinder economic development. When indigenous gender constructs clashed with colonial imperatives and ideals, dilemmas at once moral, political, and practical arose. What these were, and how and why the British set out to resolve them, are considered in chapters to come.

Elsewhere in colonial Africa—in, for example, the much analyzed east and south—the project of reshaping the material and ideological dimensions of local lives began with European traders, missionaries, and settlers; government was only one factor, and often quite late to arrive on the scene.[93] But in colonial Sudan, civil and political officials were the conspicuous conduits of planned and adventitious change. They based their decisions on knowledge acquired from research or, in the case of the Arab population, from supposed familiarity. If these emissaries of "civilization" stood apart from their subjects in many ways, their conventions and dispositions were nonetheless insinuated into Sudanese lives through a variety of practical, corporeal means: the reorganization of inhabited space, the changes brought by medicine and secular education, the regulation of comportment and attire. Officials also intervened spiritually, by promoting what they deemed a "rational" and politically tractable form of Islam. They nurtured and reinterpreted "tribalism" while trying to limit the seepage of Arab influence from north to south. In the following chapters I consider—more sequentially than here—the unfolding of the colonial relationship and the triangular politics that gave it shape. But first, as we might expect, the *zâr* has something to say about tribes and ethnic groups outside the riverain north.

Interlude 3

SPIRIT TRIBES

"Tribalism" is salient to the *zâr*, much as it was to the British regime. The nations of *zayrân* include representatives of the larger groups in southern Sudan—Azande (Nyam Nyam), Nuer, Dinka, Shilluk—plus French-speaking spirits from Equatorial Africa (CAR), and Nuba from Kordofan. These nations are referred to as ʿAbîd (Slaves), Khuddâm (Servants), or Zurûg (Blacks): nonbelievers whom Muslims (and Europeans) once captured and enslaved. The most virulent and powerful of such spirits belong to a separate nation called Saḥâr, cannibal sorcerers, said to be Azande. The "Soudanese" troops in the army that Kitchener led to Omdurman were described by some British soldiers as "reformed cannibals";[1] Azande are feared for their witchcraft and culinary preferences by women in the north.

Zurûg and Saḥâr symbolize primitiveness and savagery in the *zâr*, as witness their demands: scant black loincloths, animal hides, and for the Nuer leopard-skin priest *zâr*, a spotted cape. Some demand that their hosts go naked, and observers are often required to prevent the possessed from removing their clothes during trance. Male Zurûg require long spears on which to lean with one leg crooked, as in Evans-Pritchard's photographs of Nuer.[2] Or they ask for ebony walking sticks and clay pipes—accoutrements of many southern Sudanese. Female Zurûg demand mortar stones on which to grind grain, an arduous task and one that was abandoned with alacrity by nineteenth-century women of the Muslim bourgeoisie when slave-owning became widespread in the north (chapter 6).[3]

Most female Zurûg are also prostitute spirits, not unlike Hamâma-t-al-Bahr discussed before. As we see later on, colonial officials' view that female slaves would invariably become prostitutes if freed justified their refusal to liberate them: on an evolutionary scale, they ranked southerners as savages, inherently immoral and corrupt. Essentialism aside, fugitive bondswomen had few means other than prostitution to survive. Khuddâm (servants), as female Slave spirits are generally known, request *rahats*—the thong skirts ("boot-lace fringe") once worn by northern girls before marriage. The spirits simper and act flirtatiously when summoned during rites. Their dress presumes the spirits' clientele to be Arab Sudanese by invoking the "cutting of the *rahat*," the northern wedding rite

that signals the bride's sexual maturity and precedes her defloration. But if sexual connotations inform the spirits' antics, they invariably misfire. A servant in the body of her Sudanese host might behave *as if* she were a northern bride, but everyone knows she is a fake. Whatever the case for human prostitutes and slaves, Khuddâm *zayrân* are invariably pagan and uncircumcised.[4] Again a wanton harlot spirit tries to pass as a moral, circumcised northern woman, but fails, making circumcision's link to legitimate sexuality translucently clear.

Other spirit nations include the H̲abish (Ethiopians, Abyssinians) to whom Hamâma-t-al-Bahr and several other *zâr* strumpets belong, as well as Ethiopian princes, Oromo warriors, and a well-bred Christian noblewoman who requires her Muslim hosts to wear a Coptic cross and perform a coffee service every Sunday beneath a shady tree.

There are also H̲alib spirits, Syrian tinkers who roam northern Sudan performing odd jobs and disconcerting village women with their brashness and evident greed.

And there are Fallata: Muslim spirits from the west. The spirit nation Fallata (for "Fula" or "Fulani") includes West Africans and those from Darfur who migrated to central Sudan in the nineteenth century and early decades of the twentieth. Human Fallata, like their spirit counterparts, include Hausa refugees from the nineteenth-century Fulani *jih̲ad*s (holy wars), religious scholars from Takrur in Senegal (known as Takari or Takarin), plus Fulani, Kanuri, and other Hausa who decamped when the British conquered Sokoto in northern Nigeria, in 1903: as members of the Sokoto elite led their followers toward the Hijaz, they were joined by others in the emirates through which they passed. In 1906, Mai Wurno, son of the Sokoto leader, Muhammad Attahiru, settled with his cohort in a village on the Blue Nile near Sennar that came to bear his name (Maiurno). By 1912 Maiurno's population was estimated to be four thousand; other villages were founded nearby, and "Fallata" quarters soon began to appear in major towns.[5] In the Gezira, settlements of Fallata became "labor villages," reserves of seasonal workers paid to weed fields and pick cotton. A number of Fallata were and are pilgrims working their way to Mecca and Medina in the Hijaz. Settled or transient, they were generally welcomed by the British because they willingly undertook hard, low-paying agricultural work. Some, however, were more controversial, having come to Sudan seeking the son of the Mahdi, Sayyid ʿAbd al-Rahman, whom they revered. Not only were Fallata among the most devout of the postconquest Mahdists, they were also widely alleged to be slavers. Both distinctions earned them British surveillance and control.[6]

Among the Fallata *zayrân* are Sarkin Bornu, the king of Bornu, who wears a stripped *jallabîya* and a turban of the type worn by West African Muʿallims, Muslim sages. Female Westerner spirits, Fallatiyat, are the

zâr analogues of women who sell perfume, peanuts, and *tasali* (roasted melon seeds) in rural markets and whose hygiene and morals northerners gravely suspect. Their distinctive gold nose rings and colorful homespun *tôb*s are Fallatiyat *zâr* requests. Like their human counterparts, Fallata spirits are feared for their ability to perform ʿ*amal* ("work," black magic) and sell their wares to the highest bidder. They are wily, mercenary spirits but ardent Muslims and, like human Fallata, do not recoil from physical work. Fallata pilgrim spirits are wretchedly poor and imploring in the *zâr*, demanding their hosts don ragged clothes, and dine on plain boiled sorghum (*balîla*) and water; when manifest during rituals, they beg from those present in a pathetic wheedling style, "for Allah, O my sisters!" Their lack of dignity, reputed spells and witchcraft, and apparent affinity for menial work merit human and spirit Fallata the disdain of northern Sudanese, while their religiosity and willingness to endure humiliation in the cause of completing the *hajj* are envied and grudgingly approved. Ironically, several women I spoke to avowed that if not for their spirits' costly demands, they too might have massed sufficient funds to perform the *hajj*.

For the settled peoples of the Nile, there are also Beja *zayrân*, and Hadendowa, peoples of the east, even the western Sudanese Taʿishi Baggara of the Khalîfa's principal force whose human counterparts became dreaded foes of northerners soon after the Mahdi's death. Most of these *zayrân* belong to the "Arab" genus and are depicted as nomads: one is a lorry-driver crossing the desert, another an unwed homosexual male who tries without success to wear his *jallabîya* like the modesty wrap (*tôb*) of a woman from a northern village or town. And there is a lost Arab "boy" who runs about weeping, calling for his stolen camel (*jamal*), a euphemism for "clitoris," which the spirit's host indeed has "lost."

Sexuality, gender, morality, even female circumcision, all are issues raised in the *zâr*, in ways that may be both comical and serious at once. For recall that spirits materialize in the bodies of infibulated northern women, who are ideally dignified, virtuous, and sexually self-restrained. The powers of alien groups, whether political, religious, sexual, or all of these at once, are here aired and contrasted with those of "Arab" Sudanese. The ritual is an invitation to think otherwise about the taken-for-granted and mundane. In more elaborate *zâr* episodes, the figures of the human host, her male or eccentric female spirit, and the spirit's feigned (and faltering) role are juxtaposed in the possessed's body, creating for onlookers a collage of characteristics that destabilizes quotidian understandings. Yet the scene also revivifies and affirms them. Unlike Henty's characters who impersonate Sudanese Arab men with great success, foreign mimics in the *zâr* invariably fail to pass. Moreover, they parody not men but local women, the heart of northern society. Note, however, that

spirits who try this ploy are Africans—Ethiopians, Fallata, southern Sudanese—powerful in their own right but conquered all the same. They are not the determined colonial administrators who, like Dona Bey, threaten to annihilate nubile circumcised girls; nor are they the *zâr* counterparts of British gentlewomen who regard Sudanese with disdain. Buried in spirit traits and feats is information of an anthropological sort, "useful" information that rehearses encounters with social others who then materialize in the confines of domestic space. Yet in foregrounding alienness and satirizing it, spirits invoke and endorse the normative world of Arab women, the domestic, the everyday. All this is made possible by the unselfconscious mobilization of history: traces of the past kept alive in women's enacted archive of the "spirit" world.

An important attribute of *zayrân* should be noted before we resume the colonial narrative: *zayrân* have an abiding interest in local women's fertility, as did British officials. Examining this point in ethnographic detail (chapter 4) helps provide some context for the clash of moralities that colonial campaigns against pharaonic circumcision set in train. Chapters 5 and 6 then return to colonial documents to reveal British rationales for those campaigns, showing how in the 1920s the practice was linked to both the spread of Islam and Arab nationalism, and the dearth of employable labor.

PART 2
CONTEXTS

4

DOMESTIC BLOOD AND FOREIGN SPIRITS

> The earth is motionless, but its bowels are astir with gushing water, the water of life and fertility. The earth is moist and ready; it prepares itself for giving . . . in the place where the bowels of the earth have been pierced the seed flows in, just as the female womb embraces the embryo in tenderness, warmth, and love.
> —Tayeb Salih, *Season of Migration to the North*

Zayran are powerfully attracted to women's blood, the locus of their fertility, and can be serious obstacles to pregnancy and birth. That is why women in Hofriyat were anxious to placate troublesome spirits. Colonial officials also worried over northern women's reproductive health, blaming poor outcomes not on *zâr*, but infibulation, while deeming women's support for both to be a symptom of their "backwardness." Part 2 of the book explores the cultural, political, and economic contexts in which British efforts to end infibulation and Sudanese responses to them must be placed. Why were officials interested? How might women's embodied ideals have been challenged by colonial initiatives? Or the campaign thwarted by local concerns? In light of this discussion, part 3 goes on to describe the efforts themselves and reactions that ensued. But first let me describe some Sudanese cultural principles surrounding reproduction, blood, and its relationship to infibulation and possession.

According to women in Hofriyat, womb blood that is "clean"—red, productive—nurtures the growing fetus, and without a sufficiency in the body, conception cannot occur. The blood shed in menstruation or childbirth is referred to as "dirty" and "black": its potential exhausted, it is dark, smelly, thick, inert. Yet even the presence of black blood signifies continuing fertility. In northern Sudan, female blood is an intrinsically valuable substance that requires considerable effort to defend and conserve.

specific to Hofriyat

By delving into the meanings of blood and the womb and threats to their integrity in Hofriyat, I do not intend that all northern Sudanese hold precisely these ideas, though affinities exist with popular beliefs found elsewhere along the Nile and even as far west as Darfur.[1] The epigraph above, taken from Sudanese author Tayeb Salih's remarkable novel *Season of Migration to the North*, refers to the Dongola region far downriver from Hofriyat. And while the embodied practices and concepts I describe below show remarkable resilience and capacity to adapt to altered circumstance,[2] I do not suggest that they are timeless and unchanging within the village itself. Moreover, they are in no way separable from the course and conditions of daily life, but exist only in being lived. Bodies and things do not "stand for" each other but are intimately connected by common properties: the smoothness and enclosure of fertility ornaments mirror the smoothness and enclosure of an infibulated woman's womb, which in turn mirror the protective enclosure of the walls that surround a family's home. And these call to mind enclosed foods such as tinned fish, grapefruit, mangoes, and watermelon, which are "clean" and said to build blood. Such connections are not so much symbols in a post-Enlightenment sense—where meaning is abstracted from materiality, or code from its realization. Rather, meanings reside in lived congruities. No underlying pattern may be articulated by those whose lives they inform. For Hofriyati they are self-evident and need no elucidation. Putting them into words as I do here is a means by which the particularities of one world can be grasped by participants in another.[3] My purpose in revisiting these ethnographic themes is to outline, by way of a specific example from a particular time and place, the sorts of tacit, common-sense meanings that inform both pharaonic circumcision and the *zâr* in northern Sudan. Such meanings erupt into chapters to come where they confront or even seem to endorse colonial understandings. I begin the discussion with kinship.[4]

Relating Bodies and Enclosing Kin

It is not surprising that in the north's precarious physical, political, and economic climate people have devoted considerable attention to strengthening and maintaining social networks as potential sources of sustenance and support. The proclivity remained strong despite colonial attempts to promote individualism, capital accumulation, and mercantile exchange. There has long been a tendency here—by no means a rule—for wealth to be "deciduous": to fall from the hands of provisional holders into those of supplicant kin. The prosperous person who hoards is unwise, for for-

tunes can shift and one might someday be in need. Disputes over how to divide the assets of well-to-do deceased are common, showing that, ideally, wealth should be shared among kin. Even when amassed by individuals for investment in farming or trade, resources may be subject to family claims that can prove difficult to ignore without incurring relatives' wrath. Affluence, then, is commonly converted into social assets by contracting marriages, sponsoring relatives' schooling or, more recently, helping to defray the costs of their foreign work permits—creating interdependency and compounding moral obligations. Social investment thus softens disparities between cultivators and off-farm workers or merchants, city and rural folk. Even more than class, it has been kinship that defines allegiances and determines opportunities in northern Sudan. And given the preference for endogamy—especially marriage among first cousins—such investments tend to be highly concentrated, and kin networks multilayered and dense.

Insofar as marriage is an economic and political institution, control over fertility, its bestowal and realization in morally entangled kin, is crucial to social and physical well-being. And crucial here in turn has been female circumcision. In Hofriyat a number of men linked infibulation to the maintenance of a family's honor, its social capital. Thus, the practice was expected to preserve women's chastity and enhance their marriageability. Women, however, generally emphasized not sexuality but fertility: to them, infibulation ensured moral motherhood.[5] Yet in either case, it was a guarantor of kinship: local idioms propose that infibulation encloses the womb and defends it against misappropriation much as courtyard walls enclose and protect kin.[6] The fact that both infibulation and endogamous marriage were being adopted during the colonial period by families in the south—families not only of natives but of Arabic-speaking traders and "Soudanese" ex-soldiers who aspired to become elites—suggests that they too were seeking to consolidate moral and economic status and defend it from outside threat.[7]

The idiom of enclosure also implies that infibulation conserves the source of a woman's fertility, her blood. "A Sudanese woman is like a watermelon," a popular saying goes, "because there is no way in." The image—red juicy flesh impregnated with seeds and encased by a tough, impermeable rind—condenses well the issues discussed below; it required no clarification for women in Hofriyat.

In Hofriyat, fertility inheres in red blood, it is not an abstract process that blood represents. As noted above, local cultural logic favors homology and metonymy: images participate in each other's contents and forms; they are immanent and recursive, resolving to other images and yet other

images, creating a deeply textured universe out of objects, relations, attributes, and conditions. To depict them as something apart from the persons or things that embody them—as in Western notions of "representation"—is not just unfaithful to their context, but inhibits our grasp of them as bodily states and proclivities for behavior.

This may account for some discrepancies between Hofriyati understandings of circumcision and those that prevail in the West. For Hofriyati, genital cutting completes the social definition of a child's sex by eliminating external traces of androgyny: I was told that to remove the clitoris and inner labia is to remove male body parts in female form, while to remove the foreskin is to remove a female body part in male form. The female body is then covered, closed, and its productive blood bound within; the male body is unveiled, opened and exposed. The operations were said to make children marriageable. They enable their bodies for procreation, producing a lack in one that only the other can meet, but not in any crude physical way (Hofriayti were well aware that uncircumcised people reproduce). Rather, they endow their bodies with moral and social consequence. The operations were typically performed between the ages of six and ten, when a child has achieved ʿaql, reason or "social awareness": the ability to internalize standards of deportment and proper behavior, to anticipate others' needs and respond in appropriate ways, to demonstrate the reciprocity of perspectives that is the basis of human sociality. Children should understand that their bodies are being "purified" and socially controlled; the respective cuttings indelibly impress their bodies with moral gender, socialized sex. The operations on boys and girls were seen as analogous, complementary.[8] By accentuating difference—physical, spatial, social—they forged the potential for intensified relationship.[9]

Grounded in science and the idea of a socially unmediated body, Western analysts have challenged Sudanese claims: removing the clitoris is not "equivalent" to removing the foreskin, but to amputating the penis.[10] Yet such critics, including those who argue similarly from the position of Islamic law,[11] have missed the cultural point. They mistake a moral and cosmological statement about collective and personal identity for poor scientific observation, and social complementarity for physiological equivalence. The slippage is made worse by the tendency in Western cultures to map gender onto presocial sex, to fix social roles onto anatomical differences—to see, for instance, the act of "mothering" as "natural" and "essential" to one who has a womb. But in Hofriyat anatomical "sex" dictates nothing; rather, it indicates a *potential* that needs to be socially clarified and refined. Genital cutting makes it possible for persons to embody their envisioned moral gender.

Blood and Bone

Infibulation, by enclosing the womb, socializes and safeguards uterine blood. Older Hofriyati said that, although children now learn differently in school, a child's bones and sinew (hard parts) are formed from the semen or seed of its father, while its flesh and blood (soft parts) are formed from its mother's blood.[12] Blood is inherently transformative: it awakens the potential in (dry) seed; implicit here is a humoral model of health tailored to local circumstance. Like the Anatolian villagers Carol Delaney describes, Hofriyati employed agrarian imagery when discussing procreation.[13] Thus a man's offspring are his *zariy*ᶜa, that which is planted, his crop. Yet unlike Anatolians, they depicted woman neither as soil nor field—which suggests a passive, if nurturing role during pregnancy— but linked her instead with fluids whose presence enables the triumph of life over death, growth over desiccation in the north's desert climate. Like the annual flood of the Nile upon which riverain farming relies, womb blood is periodic and animating. Yet like the Nile it is also subject to dangerous fluctuation.

Women mix water from the Nile or village wells with sorghum flour obtained through men's farm labor or wages to make a thin flat bread, *kisra*, the staple in northern Sudan. Like the body of a child, *kisra* embodies the proper combination of substance and fluid, the fruits of male and female work, which, transformed by heat—the heat of a woman's *kisra* griddle, the heat of her womb—is required to sustain human life. Thus, a miscarriage after the first trimester is placed in a vessel used for mixing *kisra* before being buried in the courtyard or *hôsh*.

Red and black blood differ, not in kind, but in potency, in *time*: blood that circulates in the body and pools in the womb turns "black" and sluggish when its capacity is lost. The shift from red to black, quick and moist to heavy and slow, charts declining productivity, advancing age, and the fugitive nature of maternal connection, discussed below. Recognition of blood's unavoidable entropy fuels a concern to conserve its physical and social vigor by maintaining internal balance and compounding prior embodied relationships.

Circumcision socializes a child's androgyny but does not eliminate it. The merging of seed and blood in the womb makes all bodies internal composites of male and female substance. Genital cutting creates the capacity for relationship between those able to confer the vital substances— blood and bone—and their attendant social attachments to future kin. Kin participate in each other's bodies and persons: bodies are neither unique nor finite and a person is unthinkable except in reference to kin. One's bodily components, for instance, are wholly shared with full sib-

lings of either sex. Further, full siblings of the same sex are physical and social "doubles" and may substitute in each other's marriages after one of them has died.

Still, the body's combination of parental matter is bound to separate over the generations, for only women transmit blood, only men transmit seed. Moreover, blood becomes increasingly weak inside the aging human frame: one's body is said to "dry up" as it matures, skin cedes its moisture, red blood in the womb loses its fruitfulness, flesh no longer adheres firmly to bones but becomes slack, withers, and ultimately, after death, decays. The bones alone remain. Maternal blood is ephemeral, fleeting, like the temporal world itself.[14] Paternal connection prevails, structuring bodies and social relations over time; indeed, the rigid appendages of the body— foot, calf, thigh—are terms for progressively inclusive generational levels in local genealogies. Maternal relations are the tissue that attaches bony descent groups to form the social whole. Eventually they yield to decomposition, allowing the bones to disengage and lineages to emerge distinct—unless, that is, connection is regenerated by successive marriages among maternal kin.[15] Here then is a clue to villagers' preference for endogamy, why most first marriages are between first or second cousins and virtually all are contracted within the village area or its urban extensions. Ideally the village is physically and socially integral and enclosed.

And so, while the individual human body is a microcosm of social relationships, the ideal village is a bounded body writ large, whose bones are fixed by successive intramarriages among its women and men. Preferred spouses belong to the same patriline, with the children of brothers being closest and thus best to wed. Yet the lineal principle is completed by a uterine one that braids related descent lines in corporeal exchange. The most fitting marriage, the socially closest but most difficult to achieve, is that between the children of brothers who are also the children of sisters (bilateral parallel cousins) and whose grandfathers are brothers, or grandmothers sisters. Such couples share a sociophysical constitution derived from identical paternal and maternal origins. Their children will be precise replicas of themselves. Exemplary marriages are in practice rare (I counted between one and two percent of some 205 first marriages traced over an eighty-year span); still, they provide a measure by which people gauge the suitability of partners whose moral and physical matter is less present in their own. When sisters marry into different patrilines, people remember; their offspring are called "children of maternal aunts" (*awlad khalât*). This extension of relationship may be intensified and contained over time, for the consubstantiality of the children of maternal sisters provides a basis for marriages among their descendants. Bodily matter cycles continuously through the village body; its differentiated bones are bound and re-bound over time by the flesh and blood that maternal con-

nection provides.[16] Local practice favors condensing exchange, intensifying sociality, and preventing temporal and moral decay by using present and past relationships to create close kinship one or more generations hence. Blood is thereby enclosed in the village body much as it is contained in the body of an infibulated girl.

Yet, despite such maneuvers, decline in bodily and social health occurs. Things come apart—as indeed they must. The point is this: female fluids, and the flesh that they produce, must be expended so that human life can be sustained, and eternal life, which follows death, can be ensured. In order to merit paradise one first must be born and then live a Muslim life. Those conceived and raised in the moral and social womb of the maternal body/house/village can anticipate such a reward. But the eternal implications of spent uterine blood may not be acknowledged by men. *Zayrân* are more sanguine, as we'll see.

Blood and Gold

Two sets of local practices invoke somewhat different, if overlapping, accounts of blood and the female body. One takes place in the wedding and summons images common to women and men; the other consists of "women's customs" (*ᶜâdat an-niswân*) and, I think, shows how women elaborate such images in addressing their own experiences and concerns. I begin with the wedding, in Hofriyat a cultural performance par excellence.

At several points during this now three-day rite,[17] the groom struggles to gain access to his bride: twice he must give her coins to "open her mouth," for she remains silent in his presence. The word for mouth, *khashm*, also refers to body orifices such as the vagina: the bride is both uncommunicative and sexually reticent. The men's entrance to the *hôsh* is also a *khashm*: the *khashm al-bayt*, or "mouth of the house," which refers to the descent line arising within it as well. And the vaginal opening is the *khashm al-bayt al-wilâda*—the "mouth of the house of childbirth," that part of the female body which is penetrable by men. Once accepted, the groom's coin initiates the dynamic reciprocity of material support (gleaned largely from the world beyond the *hôsh*) for moral reproduction within it that is the mark of successful marriage.

Other nuptial rites depend on the homology between architectural enclosures and the womb. In Hofriyat, the bride does not move to her husband's house, he comes to hers. When he arrives with his entourage outside the walls of her family's *hôsh* on the night of the wedding feast, he is prevented from crossing the threshold, the *khashm al-bayt*, by a group of the bride's kinsmen. He must fight them to gain admittance. On another occasion, the groom returns to his bride's house after ritually bath-

ing in the Nile to find that a sheep has been slaughtered at the threshold. To enter he must overstep the animal's blood. This rite recalls the ʿId al-Kabîr (Great Feast), the festival that is the high point of the Islamic year, when each male head of household slaughters a ram, thus renewing his family's submission to God. In Islamic terms, the covenant was first made when Allah, having required Ibrahim to sacrifice his son Ismail (who, born of Hagar, was Ibrahim's only fully Arab male descendant), spared Ismail at the last moment by substituting a ram to sacrifice in his stead, thus sustaining Ibrahim's line. Yet the context is different. The Hofriyati wedding sheep "substitutes" for the bride: the blood of the animal killed at the bride's threshold invokes both the blood of defloration and, as in spirit possession contexts explored below, uterine blood required for procreation. The bride's blood, her fertility, possibly her life, will be sacrificed like the sheep's that her husband may gain descendants. The sheep's blood both anticipates the loss and celebrates the transfer of female blood that ensures the flow of patrilineal descent. Red bridal blood must be shed to guarantee continuity in this world and the next: female substance is inherently expendable.

Red in northern Sudan is strongly associated with fertility: it characterizes the paraphernalia of weddings, births, and circumcisions. Brides, newly delivered mothers, boys and girls undergoing circumcision, all recline on "red" (actually multicolored) mats. All are smeared with "red" sandalwood and dry perfumes kept in red containers. The scent made specially for weddings is called "*humra*" or redness; in the Hofriyat area a midwife keeps her utensils in a "red" tin box. The bridal veil or *garmosîs* is predominantly red—the color of active, productive uterine blood.

Yet the *garmosîs* is also shot with gold, and a bride is decked out in gold jewelry—given by her husband, loaned by her family—when on public display. Gold condenses another form of value, distilling men's productive engagement with nature, or their work (today) in foreign lands. Unlike blood, it is transitive and convertible, the essence of value extracted from the outside world. In the wedding, however, it is removed from day-to-day exchange, and congealed into protective adornment for women—put to the service of kinship and descent rather than individual gain. For gold is a defensive substance; it is said to ward off unwanted genital bleeding and spirit attack. In all, the wedding reverberates with images advising caution and control in opening the protected social/female body through marriage and exposing its active moral asset, its blood. It also asserts the virtue of that act under appropriate conditions. Yet the bride herself is quiescent; here it is men who master, expose, and expend.

Consider now the other set of practices I mentioned, the ʿâdat an-niswân, or women's customs, specifically, *mushâhara*.[18] Collectively *mushâhara* refers to ailments, cures, and prophylactics having to do with exces-

sive uterine blood loss (*nazîf*). *Nazîf* refers to hemorrhage, not to menstruation: the distinction is that between red and black blood. Yet *mushâhara* derives from *shahr*, meaning "new moon" or "month." The connection can hardly be fortuitous, for just as *mushâhara* practices are concerned to control genital bleeding, lunar rhythms signal predictable, disciplined genital flow. This link implies the ambivalence with which women regard a loss of uterine blood: regular menses mean continuing fertility but the absence of pregnancy, while their failure suggests either pregnancy or its dreaded reverse, sterility.

Causes of *nazîf* and means to prevent it are several: one who has just given birth, or is newly infibulated or recently wed, must wear a ring faced with a gold "Egyptian" coin (*khâtim ginay masri*). Given Egypt's historical role in northern Sudan, the archaic currency is a potent concentration of external value, now copied by local goldsmiths and presented by grooms to their brides. Significantly, too, the ring invokes the coins that "open the mouth" of the bride in a morally disciplined way. Should a vulnerable woman neglect to wear her Egyptian ring, and then see a woman wearing gold, she will surely start to bleed. Moreover, when a woman discovers she is pregnant, whatever gold she is wearing cannot be removed until after the birth lest she miscarry. *Nazîf* is said to be caused or intensifed by spirits (*jinn*) who are attracted to blood and gold; a menstruating woman who visits a graveyard risks barrenness, for as a site of openness and physical entropy it is a popular abode of *jinn*. I was told that gold is worn on the upper body to divert spirits' attention from the vaginal area, which is open and thus assailable because it bleeds.

Women recently cut to enable childbirth are apt to suffer hemorrhage if visited by people returning from a funeral, or by those who have seen a corpse or butchered animal and not yet cleansed their vision of death. To prevent this a bowl of Nile water containing some sorghum seeds or dried *kisra*, plus an ax head or some coins is placed at the threshold to the invalid's room. Visitors must first look into the bowl, after which they can enter the room with impunity. If river water is not provided, guests should gaze into a well and see in its depths a reflection of the moon or stars before proceeding to their destination. Should a new mother suffer *nazîf* owing to a guest's omission or because she has seen the blood of circumcision, she may remedy the affliction by peering into a bowl of Nile water containing a gold coin—here a feminine medium surrounding a masculine object whose reflective properties avert harm.

Mushâhara hemorrhage has to do with mixing antagonistic experiential domains involving blood: with a woman whose blood is vulnerable and exposed seeing blood-protecting gold when she is wearing none, seeing someone who has seen death or the blood of death, and, for the newly delivered, seeing blood shed at circumcision. The ailment can also

cause her milk—a female fluid—to weaken or dry up, and thus endangers her child even after successful delivery. In a pregnant woman not yet come to term, miscarriage or stillbirth can result.

The logic of *mushâhara* emerges more clearly if we explore what happens when a vulnerable woman sees a female gypsy, or Halibîya. The Halib, recall, are itinerant "Syrian" blacksmiths whose forceful salesmanship has earned the women among them a dubious reputation in northerners' eyes; they are paralleled in the *zâr*. Halib contrast with Hofriyati in a number of ways: while Hofriyati women are residentially fixed, and their homes both enclosed and divided into men's and women's parts, Halib women are peripatetic, moving "from acacia to acacia" (*min as-sayâl as-sayâla*) in the desert, traveling openly in the company of men. And unlike Hofriyati, Halib women are not infibulated. If a gypsy enters a courtyard (as she is likely to do uninvited) where a circumcised woman is ritually confined, the door to the invalid's room will be shut and closely guarded so as to prevent the two from seeing each other.[19]

Mushâhara has to do with weakening and restoring women's fertile fluids by means of sight. Sights harmful to ideally contained fertility/blood include those having to do with female openness, male value generated outside the village if one is not simultaneously protected by same, and physical entropy—death. The eyes are orifices of the human body, which, like mouths, communicate between its interior and the world. This is the basis for villagers' concept of the "hot" or evil eye (ʿayn hârra): that someone's appreciative look might unwittingly cause illness or misfortune to the person, animal, or thing admired. In *mushâhara*, damage to women's blood and its products—fetuses and milk—stems from the improper mutual exposure of complementary domains. It occurs when the essence of death—and in Hofriyat both burying and butchering are the province of men—is exposed to that of birth, solely women's sphere; when one who has shed black blood in childbirth is exposed to the red circumcision blood whose loss capacitates fertility; when a normally reserved, dignified, and enclosed Hofriyati is exposed to an uninfibulated, unconfined Halibîya, the antithesis of moral womanhood. In the idiom of exposure and vulnerability, such mixings threaten a woman's bodily integrity with precocious decomposition.

Mushâhara thus sustains proper order while reiterating the value of women's contribution. The gold ring made from a foreign coin that a husband gives his wife at marriage contractually binds her fertility/blood with the promise of future provision. She endows it with another, but not unrelated significance: wearing it protects her blood by diverting the attentions of *jinn*, spirits ready to exploit her openness, waiting to enter her womb and seize or release its blood. Gold and money are identified with men who, as the village's defenders, are charged with controlling

and filtering "foreign" influences so as to preserve village life, prevent its value from seeping away. But *jinn* are forceful assailants, and gold's prophylaxis can fail; moreover, neglecting to wear it exposes an "open" woman should she then see it worn by another. For now the spirits attracted to a visitor's jewelry are drawn, not to hers, but to her blood. With this she is reminded that blood and gold are close yet inexact equivalents; blood that flows in the veins and from one generation to the next is irreplaceable, but gold can be acquired. Gold is an unspecified medium of exchange; it momentarily fixes value that can be converted into a variety of other things. Blood is anything but; it is the value of life itself. *Mushâhara* is an implicit assertion of gender complementarity that adjusts the asymmetry of everyday values: between females, fluids, blood, internal space, and intrinsic worth on the one hand; and males, substances, gold, the outside world, and humanly attributed value on the other. Its practices reiterate the bride when, at the wedding's climax, she appears before the assembly covered by her red and gold *garmosîs*. Indeed, a woman keeps contact with a *garmosîs* whenever her uterine blood is unsafe, open, exposed. Like the patched homespun *jibba*s worn by Mahdist Ansâr, the *garmosîs* is more than a simple article of dress; it is a material assertion of ideal selfhood. For Hofriyati women the interwoven colors of the bridal cloth evince the proper *union* of male and female contributions, extrinsic and intrinsic wealth.

Recall that the *mushâhara* bowl contains Nile water and some *dura* seeds or *kisra* dough, plus a metal ax head, or hatchet, or some coins. Water invokes women's work and both human and agrarian fertility; metal tools, coins, and sorghum invoke farming, male labor and human seed; *kisra* is the result of women's and men's combined subsistence work, iconic of their separate contributions to the body of a child. The prophylactic power of the *mushâhara* bowl would seem to lie in its affirmation of fertile order. Visitors visually transmit that order to the woman whose blood is endangered because it has been exposed.

Scent

Sight is not the only sense implicated in the exposure and defense of uterine blood. In Hofriyat, bad odors can cause illness. The smells of sweat or the black blood of childbirth signify unboundedness and dispose one to possession by bloodthirsty *jinn*. Bridal chambers and confinement rooms were fumigated regularly with "sweet" wedding incense so as to repel lingering spirits, and both sexes liberally used commercial perfumes. Referred to as "cold" scent (*rîha barda*), the thermal properties of store-bought perfumes link their use to men's ablutions such as shaving, de-

scribed as a "cold" technique. *Rîḥa barda* is purchased from "outside" the village with money that men have earned. Indicative of generosity, extravagance, purity, cleanliness, and health, it is lavished on guests at a wedding, and even casual visits end by passing around a bottle of Bint as-Sudan (Daughter of Sudan) cologne and invitations to *itrayḥatik*, "perfume yourself." Cold scent is also sprinkled on woods burned in the bridal smoke bath, *dukhâna*, which, like *mushâhara*, is a "women's custom."

A woman takes her first smoke bath shortly before her wedding. A hole dug in the kitchen's earthen floor is filled with fragrant wood shavings and lit. When the slivers are smoldering, she undresses, wraps herself to the neck in a thick, tightly woven blanket, and sits astride the pit, entrapping the rising smoke. She emerges hours later with her skin emitting a powerful smoky odor that lasts for several days.[20] The bath simultaneously prepares her for sexual intercourse[21] and purifies her body (by sloughing off the top layer of skin) while reiterating affinities among femininity, closure, fertility, and heat. This and other women's customs—among them infibulation—are described as *ḥârr*, "hot" and "painful," also meaning "fertile" in Sudan; they enable the bride, thereafter the married woman, to prevent fluid loss (*dukhâna*, for instance, is said to stop one from sweating) and conserve and augment her body's heat. Her internal heat is naturally less than a man's, yet hers will be depleted in the transformative process of pregnancy and must be renewed from time to time.

Still, a woman sprinkles *cold* scent on the burning woods of her bath. And cold scent is also used in women's cosmetics, in, for example, *dilka*, a skin-smoothing paste of sorghum dough that is itself smoked over fragrant woods in the early stages of its manufacture. There are resonances here with the gender-complementary meanings of *kisra*. Moreover, cologne is often mixed with Nile water in the *mushâhara* bowl to protect visitors from breathing unsavory odors upon entering the room of a newly circumcised girl or a woman recently delivered.

Breathing—taking into one's body—a proper complement of cold and smoky scents is crucial to well-being. Here again it is important to achieve balance. "Sweet" bridal incense indicates this well: fragrant woods including sandal are first tossed with sugar and "cooked" in a large pan, then sprinkled with cold scent and smoked liquid perfume; fragrance is released by burning the mixture in a brazier. The smell, as noted earlier, is designed to avert meddling jinn. For its own part, smoked perfume, that which is called *ḥumra* or "redness," is a condensed expression of complementarity made by combining precious oils with granulated musk, smoked sandalwood powder, and cold perfume. As a final touch a woman pours the blend into a bottle, lights a cigarette, and blows tobacco smoke through the neck, shaking the bottle vigorously to dissolve the smoke. Women preparing to attend a nuptial dance—such as the "pigeons going

to market" discussed in Interlude 2—daub themselves generously with
humra: it is aesthetically pleasing and guards against bad smells. But more
than this, its redness and smoky odor suggest productive femininity. Like
wedding incense, and the red and gold threads of the wedding veil, its
specific blend of elements serves to protect female fertility and reiterate
the appropriate union of male and female spheres. (Color symbolism re-
surfaces in the discussion of midwifery training in chapter 8.)

Body openings, whether untoward or desired for creating relationship,
signify interaction with the world that can disrupt a woman's internal
balance. The measures known as "women's customs" synesthetically
brace and restore the harmony essential to physical integrity and repro-
ductive health. It is the proper and dynamic conjunction of male and fe-
male domains, such practices suggest, that is necessary to conserve uterine
blood and the moral community it sustains.

Spirits and Alien Powers

Mushâhara is not always successful in stopping *nâzif* or directing atten-
tion to women's worth. When it fails, the *jinn* have won, at least for
the moment, and must be appeased. But not all *jinn* cause or aggravate
problems with blood. Women's fertility is untroubled by white *jinn* who
are Muslim and benign, while black *jinn* or devils (*shawatîn*) cause mad-
ness and grave disease. It is instead *zayrân*, the "red winds" (*rowhân al-
ahmâr*), who possess women because they are attracted to their blood.
Zayrân are drawn to married women whose bodies have been "opened";
they covet women's finery—perfumes, soaps, and scented oils, elegant
wraps, and gold. Both women and *zayrân* are consumers of goods pro-
vided by men.

A *zâr* is apt to wreak havoc with a woman's fertility unless its desires
are met, but can be coaxed into a positive relationship with her if they
are. Unlike black *jinn*, *zayrân* effectively resist exorcism—or so women
said, for most men disagreed. Once a *zâr* has settled on a woman, it stays
with her for life, hovering above her, as we saw, periodically becoming
co-present in her body with her self, ethereal companions to her substan-
tively co-present kin. And like kin, spirits are cumulative: a woman may
be under the sway of several *zayrân* at once, who have contradictory char-
acteristics and demands. Yet recall that *zayrân* are foreigners, always
"others" in the counterpart world.

Ethiopian *zayrân*, whose preferred color is red, are most frequently
linked to fertility problems. Yet no *zâr* nation is exempt. Difficulty in
getting pregnant or carrying a child to term, or nurturing a child through
the first years of life when it is still closely tied to its mother all are signs

of possession. Any *zâr* may be implicated, depending on the signs it communicates through a woman's dreams, cravings, or responses to ceremonial "threads." Yet certain spirits will be suspect from the start, for *zayrân* are said to "follow the blood": a woman is likely to be possessed by spirits that afflict her mother, maternal grandmother, and maternal aunts, that is, those who share her blood. Similarly, on the rare occasions that a man or boy is judged to be possessed, his spirit is likely to be one of his mother's who seized him in her womb or at her breast. Spirit lines are traced through maternal ties, providing a shadowy complement to patrilineal descent.

Alleviation of possession illness requires an extravagant ceremony that men, specifically husbands, are enjoined to provide for their wives.[22] The rite is expected to tame a willful spirit, domesticate its influence, and convince it to restore the woman's health. It involves a feast, gifts to the *zâr* consisting of perfume, jewelry, clothes, foods, and other items consonant with its identity. In this and in the patterning of ritual events, a *zâr* rite parodies a local wedding, though the reverse might also be claimed.[23] Tellingly, the woman at the center of the rite is called a "bride" (*arûs*) and the spirit bothering her requires the sacrifice of a sheep. Participants anoint themselves with the animal's blood, which the *zâr* is said to "own."

In keeping with men's roles as protectors and filters of external influence, husbands are known as *boab*s, "gatekeepers" or "doormen" in the lexicon of the *zâr*. The possessed refers to her husband as *boabi*—"my doorman," one who stands at the threshold between human and spirit worlds, much as he is "doorman" to her womb. And just as a husband's actions affect his wife's bodily integrity, hence village integrity too, so might he facilitate or thwart the spirit's controlled materialization in the human realm. The *zâr* enlists men not as defenders, but as mediators who help forge an alliance with exotic and powerful others to the benefit of women's, and society's, health.

Even when a healing rite is delayed or fails to come off, a diagnosis of possession can marshal support for a woman by bringing to conscious attention the dynamic that should exist between husband and wife, but practical and religious asymmetries can obscure. Because spirits are capricious, their appearance carries the potential for disruption, novel ideas, and change. Equally, however, spirits' very "otherness" can work to clarify and intensify participants' commitment to local values and ideals.[24] And this may be true of husbands as well as wives.

The cultural logic outlined here was gleaned from conversations with women who had lived through much, in some cases all, of the Condominium period and describes some of their enduring concerns.[25] While colonial administrators accused "superstitious" women of hindering population growth by practicing infibulation, infibulated women accused the

spirit parallels of foreigners such as British officials of preventing procreation by arresting or loosening their blood when their bodies were inappropriately opened and exposed. The message about colonial effects on social, as well as physical reproduction seems clear. Importantly, women's awareness of foreigners apt to exploit their openness may have strengthened their commitment to infibulation rather than weakened it, as British reformers hoped.

Still, human British and northern Sudanese shared an apparent goal: women's reproductive success. For officials, this had to do with expanding the subject population, enlarging the labor force by increasing the numbers of births, and reducing the mortality of mothers and young. Here pharaonic circumcision was a barrier, an atavistic trait to be cut from the cultural whole. But for Arab women success meant social reproduction in the widest sense; here infibulation, pharaonic purification (*tahûr*), was inextricable from its cultural context, embedded in the objects, qualities, and habits of everyday life, and unthinkable save in tandem with male circumcision, the creation of morally gendered male and female selves. It was such thinking that colonial agents deemed irrational and sought to replace. In this sense, the culturally informed perspectives of colonizers and northern women could hardly have been more disparate or opposed.

Embodying the Foreign

Zâr possession in northern Sudan transfigures people's bodies as they try to control an unsought confrontation between foreign and local ways. In this respect it resembles colonization. The possessed, who are overwhelmingly women, are obliged to follow the dictates of powerful spirits, to indulge the spirits' requests for foreign foods, clothing, manners of conduct and speech. One who ignores a spirit's demands—or those of colonial agents, officials would have claimed—imperils her reproductive health. By modifying her behavior to appease a spirit/colonizer she might save her threatened fertility. Yet even as the *zâr* insists that women adapt to other ways, it covertly ratifies local ideals, for spirits are most likely to "seize" a woman whose cultural defenses are down, when one who is normally covered and enclosed—by courtyard walls, supportive kin, her body's genital scar—finds herself unhappily exposed. Health and well-being require the maintenance of boundaries between local women and the "outside" world, as well as those boundaries' controlled and selective breach. Conform, yet discreetly defend; this was the irony of being colonized, the dilemma of being possessed. Colonization was possession on a human plane.

The British would have demurred, of course. To them no irony was involved. *Zâr* was superstition, proof of the backwardness that stymied their efforts to develop and govern Sudan. Or it was farce, as suggested in this report by nurse-midwife Gertrude Wolff in 1928:

> Was at a case and heard the tomtom of a Zar nearby so asked to see the performance. . . . in a corner sat some women playing the tomtoms and a very old lady wearing glasses was clanging the cymbals. During the playing the various women would suddenly have contortions, wiggling, odd jerky movements and some would go through what looked like a wild kneading movement with their elbows while they kneeled on the floor and in between whiles they would sit up when the tomtoms stopped apparently to give them a breather now and again, and talk and act as normally as if nothing strange had been performed a few minutes earlier by them and their companions. . . .
>
> The most interesting scene I witnessed was when the devil in them took the form of a devil mecare [*sic*] Egyptian Effendi. Out of a bundle of clothes they selected garments to suit the part, i.e. tarbushes which they wore rakishly on their heads some over red tarhas or shawls and some straight on their head [and] various types of men's black coats or abayas all very crumpled. Some (the older women) wore a great deal of red and to the best of everybody's ability they all acted the part of the rakish Effendi—whistling, smoking a cigarette and laughing. . . . in the meanwhile the hostess has put on a black longcoat and gets up and dances a kankan up and down the room, though she never loses her identity to the same degree that the others do at least while I am there.[26]

"Cross dressing," as will be seen in chapter 6, had been forbidden under the Vagabonds Ordinance of 1905, and while the law was intended to curb (homosexual?) prostitution, it had implications for *zâr* adepts too. Many *zâr* leaders in the principal towns were freed or fugitive slaves for whom colonial anti-"indolence" laws were framed; *zâr* healing, like prostitution and beer making, was one of the few professions that independent women could take up.[27] Depicting transvestite spirit performances as theatrical display—as in Wolff's references to "scenes" and "acting the part"—deflects the political import of the rite, the power of spirits to command women's bodies despite colonial rules, indeed the defiance of such rules by women themselves in acceding to spirit demands. Further, the preponderance in *zâr* of the color red, the color of power and capacity in local thought, of female fertility and the spirits ("red winds") able to usurp it, suggests the danger that foreigners posed to Arab women's lives.

Since *zayrân* are organized into ethnic groups similar to those of humans, women's embodiment of spirits sustains, as we've seen, a history

of their engagement with powerful others—Egyptian effendis, Ethiopian princes, southern Sudanese "sorcerers" abducted as slaves, Islamic holy men, and, of course, Europeans. The *zâr* pantheon shifts over Sudanese space and time, reflecting inhabitants' experiences of various groups, the ripples stirred in their lives by the breath of exotic "winds." From a local perspective, colonization and possession are not just analogous but intersect. Women's bodies are vital terrain that colonizers and spirits, as well as local men, strive to control—colonizers to make them more prolific, spirits to gain access to the delights of the human world. Both manipulate women's bodies for their own ends.

Thus *zâr* supplied a parable for the colonizing process in Sudan, and "British officials" were some of the most demanding spirits to "descend" at possession rites. When they appeared in the bodies of Arab women, the division between colonizer and colonized was temporarily undone. "Officials" became accessible to all who attended the rite. Moreover, such episodes hinted at villagers' recognition of colonial aims. The *zâr* at once caricatured colonial British, familiarized women with their conduct and desires, and drew "them" into productive exchange through the bodies of those whose selfhood they pressured most. By exposing "foreigners" (rather than infibulation) as the source of women's infertility, *zâr* simultaneously revealed and disrupted colonial maneuvers at the level of individuals, and beyond them, the Sudanese population at large.

Not only do foreign spirits appropriate women's fertility, they also take offense when their hosts seek medical care, as this denies the primacy of spirit claims. Should the possessed consult a physician, her *zâr* will surely intensify her illness. This was true even of Ḥakîm Basha (Doctor Pasha) and Ḥakîm bi-Dûr (Doctor by Turns [or Rounds]), spirit counterparts of European medical men. *Zâr* and biomedicine thus clash over the control of women's bodies, though spirits, women said, are by far the more potent force. For their part, human British doctors declared a monopoly on the right to define health, identify illness and treat it, for which they were supported by the colonial state.[28] Government sought not to conciliate Islam on this point but to displace it; religious etiologies, and Qurᶜanic and spirit remedies were cast as "superstition."

The ambivalence surrounding physician *zayrân* suggests how such moves were received. European doctor spirits were haughty, imperious characters who declared their commitment to science by demanding white lab coats, stethoscopes, and hard-backed chairs for patients to sit on in straight surveillable rows. Yet as spirits, physician *zayrân* do not cure; they cause or intensify affliction. The intersections of the *zâr* with colonization are subtle and complex but always contain an implicit critique of power.

Mediators

Materially, the *zâr* demanded Sudanese men's involvement in the market economy, for British spirits required manufactured European goods to be appeased: pith helmets, caps, khaki uniforms, socks and shoes, radios, tinned foods, sausages, scented soaps, cigarettes, bottles of whiskey and jars of jam—just the things that "enable[d] the Briton to conquer the world without discomfort."[29] Sudanese husbands did (and do) their best to provide these for *zayrân* in hopes of redeeming their wives' reproductive health. Thus, though the British reviled it as "superstition," *zâr* possession actually encouraged Arab men to perform the waged work that realized colonial designs.

Reconsider the possessed woman's term for her husband, *boabi*, "my doorman." The image invokes either paid labor (many northern men have worked as doormen in Egypt and Sudan), or servitude, for in the distant past Nubian slaves were stationed as guards before the homes and harems of Egyptian elites.[30] The term also invokes the bodily thresholds that a husband crosses and defends: his wife's vaginal orifice, the door to her "house of childbirth" or womb; the *khashm al-bayt* or "mouth of the house," meaning both the men's courtyard door (symbolic of the vaginal passage) and a patrilineage, the offspring that she and her husband produce. Beyond this it calls up the bride's ability to "open her mouth" (speak to her husband, engage in sexual intercourse) awakened in the wedding; the threshold between temporal being and spiritual afterlife, birth and death; and, more immediately, the gateway of trance that links human and *zâr* domains in the natural world. At each sociocorporeal threshold, her husband stands guard and facilitates his wife's transition. He activates her fertility, performs the sacrificial rites that link humans with God on her behalf, provides for her spirits' demands and thereby helps to restore her health.

Arab women's bodies were a crucial site where political, economic, and moral concerns of both British and Sudanese, women and men, met, were contested and, at least in the *zâr*, negotiated. Relations between foreign male rulers and indigenous female ruled were oblique, mediated at both *zâr* and human levels by Sudanese men. But they were also mediated by British women, some of whom are characterized in the *zâr*. Female British *zayrân* are mainly the wives of political and civil officials, such as the spirit who travels in a comfortably padded railway carriage over the Blue Nile Bridge. To my knowledge, the *zâr* is silent about British women who were nurses and teachers in colonial Sudan. Perhaps they became too close to their subjects, or lacked sufficient power to be chronicled in the *zâr*.[31] British men, whom the *zâr* took up with alacrity, kept their distance from

northern women; chastened by Gordon's fate, they bent to local mores lest they rouse the enmity of Muslim men.

British professional women who came to Sudan from 1920 on belonged to a generation simultaneously advantaged and disadvantaged by the ravages of World War I, which diminished their chances and need of marriage by affording them unprecedented work opportunities in the public sphere. The women were especially wanted overseas where their sex granted them greater access than men to the dwellings of the colonized. They were engaged to improve female bodies and local homes, inculcate Western domesticity and hygiene, and make women, in the process, more useful to the colonial state. The majority were single when hired and most remained so all their lives; the irony that unmarried foreign women hoped to reform their intimate practices was not lost on Sudanese. But before we consider these "civilizing women" and their deeds, we need to know more about *why* they were summoned to such tasks. Here the story revolves around pro-Egyptian nationalism, the spread of Islam, the demise of slavery, and the perennial need for labor at the end of World War I, topics addressed in chapters 5 and 6.

NORTH WINDS AND THE RIVER

[I]n the valley of the Nile England may develop a trade which, passing up and down the river and its complement the railway, shall exchange the manufactures of the Temperate Zone for the products of the Tropic of Cancer, and may use the north wind to drive civilisation and prosperity to the south and the stream of the Nile to bear wealth and commerce to the sea.
 —Winston Churchill, *The River War*

Al-bâb al-bijik minu ar-rîh̲—siddu wa istiruh̲.
The door that lets in the wind—shut it and abide.
 —Northern Sudanese proverb

Anglo-Egyptian Rivalry, Islam, and Nationalism to 1924

From the start of his administration, Wingate strove to increase Sudan's autonomy so as to weaken the influence of Egypt. Little headway was made in relaxing ties to Cairo until Cromer retired as British consul general in 1907. Yet moves were afoot to position the country so it no longer relied financially on Egypt's annual subvention. Wingate and his successors regarded Egyptian influence in Sudan as an ill wind that swept unrest—Islam, Oriental culture, precocious nationalism—upstream along the Nile. The specter of Gordon haunted their moves.

Some officials believed there was little affinity between Egyptian officials and Sudanese in any case. According to Robin Baily, northern Sudanese mistrusted Egyptian civil servants, while the latter regarded Sudan as a place where "only Egyptians . . . who were too poor to bribe their superiors" were sent.[1] Whatever the truth of these views, in the early days of the Condominium Egyptians were seen as a necessary if hostile presence on the upper Nile, at once vital and threatening to imperial authority.

Initially, the British felt powerless to check the spread of Islam, which had intensified during the Ottoman period owing to trade, and resumed

under the Condominium when Muslim civilians and soldiers were deployed to the south. Government outposts also attracted *jallâba*, itinerant Arab merchants who were de facto emissaries of the faith. The portability of Islam—with no need for clergy or church—surely expedited its reach. At first little was done to curtail its diffusion save government neglect: opening the south to Christian missions and leaving responsibility for inhabitants' education entirely in their hands. However, Warburg reports that when the governor of Bahr al-Ghazal started a school for the children of his Muslim staff, "he was ordered by Currie, the director of education, to close it. Currie argued that by employing a Muslim teacher ... "the net result ... must tend towards Mohammedanism.' "[2] There was no neutral path: Muslims who did not want their children taught by Christians would have to send them north.

Such measures had little effect. Islam advanced, to British chagrin. In 1911 Reverend Gwynne joined senior officials in advising that government take further steps: encourage European merchants to unseat the *jallâba*, remove Egyptian *ma'mur*s, and replace Muslim troops with locally recruited police.[3] In most southern stations a unit of the Egyptian Army was the only government presence. Apart from its British commanders, the army was a Muslim force; recruits "not already nominally Muslim, almost always soon 'converted.' "[4] And conversion for men required circumcision, an indelible mark of religious allegiance. Taken in the ethnographic context of southern groups where initiation to manhood typically entailed scarification but not always genital cutting,[5] the exercise obeyed a grammar of body signs by which disparate affiliations were carved in flesh and inculcated by pain. Yet few southerners enlisted. Whether Wingate was correct that their reluctance signified aversion to Islam,[6] Islam was making inroads all the same.

To block the military path of its spread and the "detribalization" that conversion produced, government agreed to raise local forces to serve under British command. It publicly claimed fiscal reasons for the move: local troops would be cheaper to maintain than Egyptian; southerners would know the area and its languages better than outsiders did. In 1911 the Equatorial Battalion was formed; by 1914 it was five companies strong, allowing for a reciprocal contraction of Egyptian units. The Nuba Territorials were also established that year, but recruits were few. Owing to a shortage of suitably educated southern men and, after the start of World War I, of British officers too, the tactic of excluding Muslim troops from the south was less than a thorough success. It also proved impractical to expel the *jallâba*, though they were now "restricted by government orders" and required to obtain special permits to trade in the south.[7] Wingate endorsed the idea of making English the "semi-official" language of

the south and Sunday the day of rest. Such practices that divided Sudan would be revived with vigor in the period between the wars.

Rudolph Slatin, an Austrian national, resigned as inspector of intelligence at the outset of hostilities. With his departure and the exigencies of the war, the regime's suppression of popular Islam eased. The conflict between the Allies and the Central Powers, including the Ottoman Empire to which Egypt still technically belonged, placed Britain and Egypt in an awkward and potentially dangerous position vis-à-vis each other and Sudan. To clarify matters, Britain at once declared Egypt a protectorate. In Sudan, Wingate faced a rash of wartime Islamic propaganda—Turkish calls for a *jihâd*. He agreed to grant noncombatant status to Egyptian officers who objected to fighting the Turks (only two requests were made).[8] He then assembled Sudan's *ʿulama* to assure them that Islam would be upheld in the British Empire and remind them of the evils of Ottoman rule.[9]

Some five hundred religious and tribal leaders rallied to the regime by signing the "Sudan Book of Loyalty." Notable among them were Sayyid ʿAli Mirghani, head of the anti-Mahdist Khatmiya *tarîqa* (religious brotherhood), who, in 1900, had been granted a C.M.G. (Companion of the Order of St. Michael and St. George—a British title bestowed to honor individuals who have rendered an important service to the Empire, now Commonwealth, or to a foreign land) for his help during the Mahdiya, and, more surprising, Sayyid ʿAbd al-Rahman al-Mahdi, the Mahdi's posthumous son, who, by 1914, had emerged as undisputed leader of the Mahdi's family and cult. Sayyid ʿAli was given a knighthood; restrictions on Sayyid ʿAbd al-Rahman were reduced in return for his support. As Khalid Mansour notes, the last was "an amazing turnabout for the Mahdi's political and, more importantly, religious heir to undertake, a mere fifteen years after the final demise of the Mahdist forces."[10] It was a calculated move. Devout Mahdists had misgivings about the Turks (and Egyptians) whom they blamed for having brought about the infidel regime. As the British were likely to leave Sudan one day, and the Turks had proved difficult to dislodge in the past, Mahdist support for Britain made tactical sense.[11] Yet Sudanese allegiance surely owed much to the handling of local hardship, for in 1913–14 famine was relieved in the drought-stricken north by government's timely distribution of Indian grain.[12]

Still, it was clear that Sudan's charismatic religious groups could no longer be ignored. Surveillance of *tarîqa*s was lightened and their leaders gradually drawn into cooperating with the colonial regime. This they did largely on their own terms. In 1915 Sayyid ʿAbd al-Rahman toured villages and tribal areas admonishing Sudanese to remain loyal, but also to read the *ratib* (the Mahdi's prayer book).[13] C. A. Willis, now head of the intelligence department that oversaw religious affairs, helped to rehabili-

tate Mahdism by portraying it as a branch of the Sammaniya brotherhood instead of a revolutionary force. Use of the *ratib* was no longer banned. Willis's support advanced ʿAbd al-Rahman's fortunes during and after the war, yet his rapprochement with Mahdism was poorly tolerated by fellow British who had come to Sudan "to avenge Gordon, not enthrone his conqueror's son."[14]

During the first two decades of colonial rule, government revived the Ottoman structure of native administration consisting of *shaykhs* (tribal and village elders, a generic term), and above them *omdas* (town and village leaders) and *nazîrs* (tribal leaders whose positions were often hereditary). These men were to assist government officials—governors, DCs, *maʾmurs* and sub-*maʾmurs*—in meting out justice and gathering taxes on herds and crops. For this they were paid very little; their main recompense was prestige: satisfactory efforts were rewarded with "robes of honor," which, like the titles themselves, could be revoked at the governor-general's discretion. The system proved unwieldy, confusing, and corrupt. While claiming to bolster the autonomy of Sudan's natural leaders—the largely untutored native elite—British officials reserved the right to override their decisions and appoint or dismiss them as they saw fit. At length, British and Egyptian staff assumed increasing responsibility for administrative work, and the system resembled direct rule.[15] Events conspired, however, to alter this at the end of World War I. Again relations with Egypt held the key.

In 1917 Wingate succeeded Kitchener as British consul general in Egypt; in Khartoum, Lee Stack, the civil secretary, became acting governor-general and *sirdar* of the Egyptian Army. Egypt's support for the Allied effort had been costly, and, given the rhetoric used to muster it and the breezes of emancipation stirring the Fertile Crescent and Hijaz, Egyptians expected to have won their independence at war's end. It was not to be. The British had no intention of abandoning Egypt; they would negotiate only the form their control would take.[16] Delays in reaching agreement culminated in an Egyptian nationalist revolt in 1919. The rebellion was suppressed; soon after, Sir Alfred Milner, the colonial secretary, arrived in Egypt to report on the state of affairs.

Milner's proposals brought an end to the protectorate. A unilateral declaration of Egyptian independence was made in February 1922, and a constitutional monarchy formed in 1923. The question of Sudan, however, was " 'absolutely reserved to the discretion' of the British government," along with matters such as foreign policy, pending further negotiation.[17] Stack now officially became *sirdar* and governor-general of Sudan. Relations between the co-dominie remained unresolved and would deteriorate further in the months to come.

The 1919 revolution gave Sudan's government a perfect excuse to reduce Egypt's role in the colony. Discontent Egyptians, it was thought, would surely conspire "by whispered rumours, lies, insubordination, and propaganda to turn the unsophisticated Sudanese against the very government that had rescued them from the brink of extinction a generation earlier."[18] Plans to rid the country of Egyptian personnel were laid. Also facing restrictions were Sudanese men in government posts, the emerging educated "effendi class" whose loyalty Egyptians were feared to have swayed.

To create a defense against Egyptian influence, Milner advocated "Sudanizing" the lower ranks of the civil service and making better use of indigenous authorities. Apropos the latter, in 1922 government passed the "Powers of Nomad Sheikhs Ordinance" regularizing the judicial functions of nomadic tribal leaders but allowing provincial governors to decide what powers should be granted to each.[19] In 1924, Stack proposed a "dual policy," with councillors in the "developed" north and tribal leaders in rural zones; "advisory councils" at town, district, and provincial levels would provide a modest outlet for educated men. The plan was overtaken by events and would not be revived for a dozen years or more. Instead, the British moved to bolster traditional elites over the cadre of Sudanese schooled at Gordon College, founded to create just such a clerical class. With the act of 1922, "Native Administration" (indirect rule) began in earnest and educated Sudanese saw their hopes for promotion dissolve. The regime claimed fiscal restraint, but the underlying intent was to slow the rise of a modernizing elite that one day soon might oppose it. As Daly observes, it is hard to distinguish reaction from provocation in these moves.[20]

Predictably, by 1923 there had emerged in Sudan an anti-British nationalist group known as the White Flag League, named for its banner—white, with an outline of the Nile down the center and a small Egyptian flag top left.[21] The league advocated unity of the Nile Valley under Egyptian rule and cultivated Egyptian nationalists to that end. Sympathizers were drawn largely from the "effendi class" but included urban artisans as well. Its president, ʿAli ʿAbd al-Latif, was a military-school graduate and former army officer who had been dismissed for responding to an insult from a British superior.[22] ʿAbd al-Latif was the consummate "detribalized" Sudanese: born of a Dinka mother and Nuba father, both ex-slaves, he had "social roots . . . in the 'black' community of the Three Towns area—that de-tribalized and fairly numerous section of the urban populace . . . whose vulnerability to politicisation was clearly recognised by the British."[23] An official report stressed that because such men were positioned "outside the . . . appeal to tribal or national sentiment," they were readier than most to seek a Western education. However, "while the best have done very well, many have failed," leaving their ambitions and

expectations for advancement unfulfilled and offering "a fertile field for any propagandist against the state of things as they are."[24]

Such criticism of educated Sudanese masked growing ambiguities of the boundary between between ruler and ruled by deflecting them onto the "unnatural" state of "detribalization" and the precocity of nationalist sentiment. As Timothy Mitchell argues, nationalism in Egypt, as in Europe—indeed by extension Sudan—was not a natural "truth" awaiting discovery at an opportune time, but a historically specific invention, an attempt to envision "society" as "a political and conceptual structure existing apart from people themselves."[25] Surely, reference by senior officials to "Britain," "Egypt," and "the Sudan" in inclusive and anthropomorphic terms—as having needs, desires, interests, capacities—supported images of social bodies functioning independently of people's lives and wills. That educated Sudanese should come to participate in this discourse, albeit to contest what Sudan's needs and interests actually were, was hardly a surprise. Later generations confessed that the nationalism of the British themselves had been their most useful example.[26] Moreover, for Egyptian nationalists of the late nineteenth century, whose writings influenced Egyptians and Sudanese in the next, the instrument held to discipline, order, make industrious, and thus form a "nation" out of initially disparate parts was, precisely, education.[27] And it was largely over education—how much, how soon, what sort—that the struggle between the British and nationalist Sudanese took place.

In reaction to the rise of secular dissent, government deepened its ties to Sudanese religious organizations. In 1919 a deputation of religious leaders including Sayyid ʿAli Mirghani and Sayyid ʿAbd al-Rahman al-Mahdi was honored at Buckingham Palace for their loyalty during the war and affirmations of allegiance in the wake of rebellion in Egypt. Sayyid ʿAbd al-Rahman presented King George with the Mahdi's sword, whereupon the king—in a gesture said to be choreographed by Wingate—returned it to him, "to hold 'in defence of His Majesty and His Majesty's Empire for ever.' "[28] British officials sought to polarize religious elites and nascent "effendis," yet their successes were neither permanent nor unequivocal, as will be seen.

By 1924 the co-dominie had more than prestige at stake in Sudan. Britain had significant financial interests in irrigated cotton schemes started since the war; Egypt feared losing control over the river on which its own economy relied. During further negotiations on the "Sudan question" and other issues left unresolved in 1922, Sudan government officials, afraid of being sold out to their rivals by Foreign Office politicians and staff, canvassed tirelessly for redefining Egypt's role in the colony. It was a feat of their vigilance that no mention of Sudan appeared in the Egyptian constitution of 1923. In 1924 the governor-general (Stack) and the financial

secretary (Schuster) at last persuaded the Labour government to their views, despite party sympathy for Egypt's nationalist desires. This fortified the ensuing Conservative government when, later that year, the parties debated the future of the Egyptian Army, comprised of Egyptian and Sudanese battalions, paid for by Egypt, and commanded by the British governor-general of Sudan. If Egypt refused "to separate the army command into Egyptian and Sudanese halves," the British declared, "Britain should demand the evacuation of all Egyptian troops from the Sudan."[29]

1924: Rebellion

In light of such developments, the pro-Egyptian White Flag League orchestrated antigovernment protests in the major northern towns beginning in June 1924.[30] Following the demonstrations, leaders were arrested and imprisoned, or fled, and civilian disturbances waned. But by August "the spirit of opposition had . . . taken hold within the Sudanese battalions of the Egyptian army."[31] On August 9, cadets of the Khartoum Military School took to the streets in the belief that they were being unfairly overlooked for commissions; they marched to the central prison where they called for ʿAbd al-Latif and presented arms. The same day there occurred an uprising of railway employees and troops at Atbara, who attempted to free a leader of the League as he was being conveyed by police to Khartoum. Though the insurrections were soon put down, rumors of a general mutiny led to riots in Omdurman on August 15. Sporadic troubles "only abated when aeroplanes and an extra battalion of British troops arrived from Egypt" a few days later.[32] The regime promptly closed the military academy, considered a hotbed of Egyptian intrigue.

Meanwhile, there was also an upsurge of religious unrest. In 1923 and 1924 groups in western Sudan were said to be preparing a *jihâd* against the British, whom they regarded as the Anti-Christ, citing ʿAbd al-Rahaman al-Mahdi as the revived Nabi 'Isa (Prophet Jesus). Administrators relied on the *sayyid* to calm and disabuse them, though his role in the affair was never entirely clear. In May 1924 his influence was also deployed on the secular front, to counter "the intensive Egyptian campaign of propaganda" by collecting petitions of loyalty in the cotton-producing Gezira region between the White and Blue Niles immediately south of Khartoum.[33]

Though further serious incidents held off for several months, "seditious notices" and circulars began to appear in Khartoum and Omdurman, rallying support for a holy war to "drive away the English" who "come to oppress us and do evil to us, what do they know of the wise ways?"[34] All manner of depravity and chaos were put down to British influence. In

the translation of one such tract, the link between nationalism and sexual morality rings clear:

> Time is short; situation is stringent; religion is lost; churches have increased. Boys, though reaching the age of 20 and 30, are still attached to vices; far away from religious law; not attending to their prayers; and breaking the fast openly, the Shar' having no power to interfere in their cases, being afraid of the Government.
>
> The pure virgin lady, of good breeding, practices prostitution, not careing [sic] for the honour of her people or her tribe; but we cannot interfere in her case as the Government has given her permission to do so.
>
> Vice and the act of sodomy have increased in our pure and religious country; but we cannot stop them for fear of Government.[35]

On November 19, 1924, Governor General Stack was shot in Cairo by "a group of Egyptian extremists";[36] he died the following day. Two days later Lord Allenby, British high commissioner in Cairo, issued an angry ultimatum to the Egyptian prime minister, Sa'd Zaghlul, demanding an apology, justice for the assassins, monetary compensation for Stack's death, and the immediate withdrawal from the colony of all Egyptian officers and troops. He then informed Zaghul that the Sudan government was increasing the amount of Nile water used for irrigation and would continue to do so as the Gezira scheme expanded. Rather than assent, Zaghlul resigned, whereupon Allenby instructed Khartoum to begin evacuating Egyptian troops, a move that had actually been "meticulously planned well in advance of the crisis."[37]

The troops were to be disarmed and withdrawn by rail over a twenty-four-hour period beginning on November 24. Most complied, but Egyptian artillerymen stationed at Khartoum North refused to leave unless ordered to do so by the Egyptian minister of war. Orders from Egypt were being arranged, but the question of allegiance troubled the Sudanese battalions too (if not their British officers), all of whom had sworn an oath to the Egyptian king. On the 27th, armed members of several Sudanese units marched through Khartoum toward the Blue Nile Bridge, intent on joining the Egyptian holdouts across the river. En route they encountered British troops. The official report of the incident notes that as confrontation became imminent, "British officials, accompanied by their wives and children, passed among [the troops], all unsuspecting of anything more than a precautionary practice parade." The Sudanese "merely told them to pass along, or not get in the way."[38]

When challenged by the acting commander, Hubert Huddleston, the Sudanese troops refused to obey any but the senior Egyptian officer. The British opened fire, killing several soldiers and dispersing the rest. Some took refuge in the nearby military hospital; those who failed to surrender

or escape (later to be rounded up) were annihilated by British artillery.[39] The report self-servingly notes that "in certain small detachments where the personal contact of British officers was lacking . . . wholesale misrepresentation by native officers, whom politics had depraved, led the ignorant and docile black troops" to rebel.[40] The Egyptian troops whom the Sudanese had set out to join made no move to come to their aid.

By the end of 1924, most Egyptian military personnel had been removed from Sudan, and the Sudan Defence Force (SDF) was established to replace them. Recruits swore allegiance to the Sudan government and tellingly received their commissions on January 17, 1925, "King's Day," honoring George V. Over the winter, Egyptian *maʾmur*s, teachers in government schools, and those in other "politically sensitive" posts were deported. While most of the four thousand Egyptians in civilian service were retained, they were closely watched henceforth and their careers stymied; Egyptian men who taught in private schools were gradually reduced in number and, though Egyptian women teachers were allowed to stay, they were carefully supervised.[41] So too were educated Sudanese. Moreover, the curriculum of Gordon College was revised to favor technical over academic subjects, consistent with plans for native administration already well underway.

As Daly astutely remarks, "What occurred in late November 1924 was the final act not of revolution or mutiny but of a British *coup d'état*"; not just the outcome of unforeseen insurrection, but the result of months of planning by Sudan Government officials in London and Khartoum that required but a pretext to complete.[42] One senior bureaucrat himself referred to the affair as "our great coup" in a letter to MacMichael in 1929.[43] Several leading SPS officials now urged, without success, that Britain revoke the Condominium and make Sudan an imperial colony in name as well as fact.[44] Intriguingly, 1924 was also the year the regime began seriously to consider pharaonic circumcision a political, economic, and demographic problem, a view closely linked to processes set in train by these events.

Tensions between Egyptians and Sudanese on the one hand, and British on the other, revived fears of Muslim volatility. Yet not all officials were apprehensive. The rising, they reasoned, had been limited to the most susceptible minority; it had involved few men in administrative posts (just others of their "class"), and most Sudanese remained "grateful for British rule." Moreover, religious and tribal leaders had rallied to government's side, knowing they had as much to lose "in the face of challenge from below" as did their British rulers.[45] Still, plans were now made to prevent a repeat of Gordon's fate by improving security measures, increasing the number of British troops in Sudan, and creating auxiliary defense units among civilian personnel.

During the fray, the growing numbers of British women in Sudan had made officials feel especially exposed. Baily, deputy governor of Khartoum, described "rifles and machine guns . . . rattling in the dark streets, bullets flying about and desperate spirits lurking in the shadows. One felt happy when all the women were safe in the Palace. Women cramp one's style in a show like this."[46] It is significant, however, that no looting of British houses occurred, nor was harm done to European women by disaffected Sudanese. The file "Assaults on European Women by Natives" discussed in chapter 3 was opened later, in 1931. The reason was not unconnected to these events, but another catalyst was required—the rise of nationalism in Kenya, with its emphasis on the value of female circumcision for Kikuyu girls, addressed in chapter 9.

Repercussions

The man sent to replace the ill-fated Stack as governor-general was Geoffrey Archer, former governor of Uganda and product of the Colonial Office. He got off to a bad start, with "his small disheveled party" arriving "on foot from Uganda to be greeted by an immaculate array of senior officials on a no less immaculate Nile steamer."[47] Archer was reservedly sympathetic to Sayyid ʿAbd al-Rahman al-Mahdi and secured him a coveted imperial knighthood for service to the regime in 1924.[48] But it was his visit to Aba Island, where the Mahdi had declared his mission in 1881 and the *sayyid* had established a prosperous cotton estate, that alienated senior administrators. Against their advice to make the visit informal, the meeting had the look of a state occasion with Archer and his aide in full dress kit.[49] Seasoned officials were suspicious of the *sayyid*'s reputed desire to become Sudan's constitutional king; they were apprehensive, too, of widespread revivals of Mahdism, particularly in Darfur, Chad, Nigeria, and west across the Sahel where Mahdist "propaganda" was circulating in the form of letters purportedly written by ʿAbd al-Rahman himself.[50] Insufficiently steeped in the culture of colonial Sudan, Archer failed to win officials' confidence and left within two years.

His successor (1926–34) was John Maffey, late of the India Political Service, whose inclinations aligned more closely with those of establishment SPS. Under Maffey's leadership and guided by MacMichael, native administration was expanded and the influence of "graduates" and other elements of the effendi class ever more strictly curtailed.[51] Maffey used the troubling language of social hygiene to declare his government's direction. "Before the old traditions die," he wrote,

> we ought to get on with extension and expansion [of indirect rule] in every
> direction, thereby sterilising and localising the political germs which must

spread from the lower Nile into Khartoum. Under the impulse of new ideas and with the rise of a new generation, old traditions may pass away with astonishing rapidity. It is advisable to fortify them while the memories of Mahdism and Omdurman are still vivid. . . . The bureaucracy must yield either to an autocratic or to a democratic movement and the dice are loaded in favour of the latter. If we desire the former, the British Officer must realise that it is his duty to lay down the role of Father of the People. He must entrust it to the natural leaders of the people whom he must support and influence as occasion requires. In this manner the country will be parcelled out into nicely balanced compartments, protective glands against the septic germs which will inevitably be passed on from the Khartoum of the future.

Only, Maffey minuted, "when we have made the Sudan safe for autocracy" would government consider setting up local councils to advise the native elite. "Otherwise Advisory Councils contain the seeds of grave danger and eventually present a free platform for capture by a pushful intelligentsia."[52]

A host of what administrators labeled "evils"—bureaucratization, liberalism, modern education—would be dispelled by regenerating tribal authority, and a bulwark created against the continuing threats of nationalism and Mahdist resurgence. The results were, however, incongruous, as the number of British officials actually rose between 1924 and 1930 by 30 percent in the provinces and 54 percent in central government departments.[53]

In the wake 1924, the Intelligence Department came under investigation. Willis, whose rehabilitation of Mahdism had made him unpopular in the SPS, was chastened for being "responsible for no small amount of interference," and failing to secure reliable information about "current and recent political events and tendencies"[54]—secular no less than religious. Willis was replaced as director by a champion of indirect rule, and the intelligence department brought under the civil secretary's purview.[55] Educated Sudanese now became subject to increased scrutiny, censorship, and occupational constraint, though many benefited materially despite the conservative milieu.[56] Still, deprived of coherent leadership and disillusioned by the failure of Egyptian forces to support the Sudanese mutineers in 1924, early political organizations waned. Nationalist aspirations remained alive, concealed in anonymous and overtly innocent literary works: allegorical songs and poems, classic venues of the politically oppressed.[57] Activist groups only re-emerged in the late 1930s, when a new generation of graduates, having formed into literary societies and discussion groups, began to coalesce around the two leading figures of the Sudanese politicoreligious establishment, Sayyid ʿAli Mirghani and Sayyid ʿAbd al-Rahman al-Mahdi.[58]

Events that took place between the end of World War I and 1924 form the political horizon on which attempts to abolish female circumcision emerged. Here was one native custom that was neither consonant with British ideology nor, it seemed, useful to British rule. Several reasons for this will appear in the continuing synopsis below; officials' equivocation on the issue is adumbrated as well.

Identity and Education, North and South

Native administration rapidly became SPS orthodoxy: though inexpensive and expedient, it was promoted as enlightened self-government, a progressive, culturally sensitive approach. Some administrators were genuinely persuaded of its benefits to Sudanese; nonconformists were rare and their prophecies rebuffed. But what had seemed plausible in theory never quite worked in practice. For the policy was paradoxical. People who had no memory of tribal authority were to be "tribalized" and assigned hereditary leaders; these were expected to be both autocratic and compliant with British rule, wise yet uneducated, concerned for improving their peoples' well-being yet satisfied with the status quo. "Reduced to absurd lengths," Daly notes, "Indirect Rule was self-contradictory, since it posited colonial rule as the chief danger to the system it sought to serve."[59]

Despite the bloated rhetoric of the Maffey years, an opportunistic mix of British administration and reliance on "tribal" authorities prevailed, varying by local conditions and the liberal or illiberal proclivities of individual governors and DCs. In the north, judicial and executive powers of the *nazîr*, *omda*, and *shaykh* were enhanced and their offices better financed. Leaders who saw advantages often collaborated with the colonial state.[60] Yet in far-flung regions, native administration was tantamount to neglect. "Politically," writes Woodward, "it meant encouraging the isolation of the rural Sudan to avoid any repetition of shocks such as those of 1924."[61]

The most isolated region was to be the south, where measures begun under Wingate to check northern influence were intensified. In 1922 the three southern provinces, plus Darfur, and parts of Kassala and White Nile Province had been declared "closed districts," barred to outsiders without government license to enter. Concerns about activities of Mahdists and West African pilgrims in the north as well as Muslims in the south lay behind the move.[62] That same year, a formal directive stated that English should be the language of southern administration. Despite these steps the *jallâba* continued to operate below the tenth parallel, and Muslim, Arabic-speaking staff still held the majority of government posts.

Indeed, some British officials considered Islam a civilizing force, "administratively useful because it promoted styles of moral and political behaviour far more intelligible and predictable than those generated by the traditional socio-religious systems of the South."[63]

Then, following the crisis of 1924, the number of northern Sudanese *ma'mur*s and sub-*ma'mur*s in the south was reduced as a corollary to Egyptian deportments from the north. But little was done to ensure trained southern personnel to replace them. Government primary schools were nonexistent, being considered "too geared to literary education, and therefore potentially detribalising."[64] From 1922, the regime had provided small grants-in-aid to mission schools; in 1926 it was decided to normalize and increase these subsidies in view of the new demands for southern staff. Government deployment of the missions owed more to miserliness than a desire to proselytize. Christianity was convenient, in this and other ways; during the 1920s there emerged a consensus among British officials that the south should be fortified against potential mischief from Islam and Arab culture, to prevent these gaining further ground. This opinion, and the practices of indirect rule that had erratically supported it in the past, were crystallized by MacMichael in his "Southern Policy" circular of January 1930. With its dissemination, "the growing grass curtain against Arabic and Islam"[65] matured to become a hedge.

The policy "involved two general propositions":

> that the backwardness of southern peoples made necessary [1] the construction of artificial barriers against more sophisticated outside influences, if the basis of local cultures was to be preserved; and [2] the progressive replacement, through improved and extended education, of "outsiders" by local people in government posts, thus creating a nucleus for further development.

Only the first proposal was effected to any degree; the prospect of an educated class in the south was as alarming to British officials as the presence of one in the north, and the call to reform southern education was largely ignored. Moreover, government parsimony continued to ensure the region's lack of economic development vis-à-vis the north. Education and administrative needs were so closely linked that, during the Depression, enrollment in mission schools actually declined from 1932 to 1938 in view of the scarcity of government jobs.[66] By 1930 there was but one government school, and that for intermediate grades; its enrollment fell apace, though the worst of the slump was over by 1936.[67] Sweeping improvements counseled in the late 1930s were ignored until the mid-1940s, and the south suffered as a result of the delay.

Sudan's "Southern Policy" is best known for the tyrannical intemperance of its anti-Arab enthusiasts, officials known as "Bog Barons," eccen-

tric and tough-minded ex-military men posted to the south on contract. Salient here was the management of dress and bodily conduct, matters that, to those who created and enforced the restrictions, were neither petty nor banal, for the bodily expression of Arab identity in the south was a potentially subversive act. In 1930 MacMichael reported that "substantial headway has been made in the elimination of administrative officials *who would likely render conspicuous*, if not actually disseminate, the influences that are at work in the Central and Northern Sudan."[68] Southerners were forbidden to wear northern dress; in the western district of Bahr al-Ghazal, where the social border with the Muslim north was exceptionally porous and blurred, it was prohibited to make or sell Arab clothes, and if an official happened to find some, they were burned.[69] Speaking English was encouraged, and Arabic, including Arabic words commonly used in English, was gradually (if incompletely) suppressed. Where Arabic was inevitable for correspondence, as in Kordofan, it was to be taught to non-Arabs in Roman script so as to curtail their access to Arabic literature.[70] For this MacMichael, in his capacity as civil secretary, but drawing surely on his reputation as a distinguished Orientalist, had already rallied support and dismissed gainsayers in a scathing memorandum from 1928:

> It is not necessary to stress the fact—presumably undisputed—that the spread of Arabic among the negroes of the south means the spread of Arab thought, Arab culture, Arab religion, but I would venture to dispute the assumption that these in fact occupy so high a plane as to deserve to be regarded as intrinsically desirable. The religion of the Arab is the fruit of thirteen centuries of discipline and dogma, and it appears now to have reached a stage of world-wide stagnation periodically rippled by political restlessness. . . . It has shown, it is true, a wonderful power of inspiring the ignorant to sudden heights of fanaticism, but has it in it the seeds of any real mental or moral progress? Is it not, rather, stationary in essence, and therefore retrograde?

In fact, the path of Arabization, while "not worth taking," would increase the danger to government by extending "the zone in which Islamic fundamentalism is endemic," allowing rebellious Arabs to call on the south for aid "in the name of a common religion," or indeed the reverse, "which might become a serious embarrassment."

> The Arab regards the black as a "slave," and the more intelligent of the blacks are aware of it. The simpler type of black, for his part, regards the Arab as an aristocrat, and, more especially when detached from his tribal environment, is apt to succumb to a form of snobbery and ape Arab fashions. He finds that he is not admitted into the circle of the elect so long as he [or she??] remains uncircumcised and he adopts Islam as a potent form of ju-ju well worth acquiring. . . .

tribalization (handwritten)

[By preventing the spread of Arab culture] a series of self-contained racial units will be developed with structure and organisation based on the solid rock of indigenous traditions and beliefs . . . and in the process a solid barrier will be created against the insidious political intrigue which must in the ordinary course of events increasingly beset our path in the North.[71]

In light of these remarks it is hardly surprising that even career officials who had assiduously studied Arabic so as to qualify for the SPS now feigned ignorance of the language in the south.[72] Behind all such acts and assertions was a tacit recognition that social identity is not inherent or primordial, but achieved, and maintained or altered, through practice. Indeed, they suggest that for "simpler" folk, comportment *is* identity, *tout court*: British who spoke Arabic hardly chanced losing their Britishness (witness Henty's heroic characters, to say nothing of the SPS), but southerners who spoke it put their ethnicity—not their race—at risk.

There were more drastic measures still. Along the border dividing Bahr al-Ghazal (in the south) from Darfur and Kordofan (in the north), where a welter of shatter groups intermingled with northern traders, Dinka, and Baggara Arabs and some two-thirds of the population spoke Arabic, a no-man's-land was cleared. Muslim inhabitants were expelled to Darfur, sometimes departing ill-provisioned and suffering privation as a result. Settlements were moved or burned, mosques were destroyed—methods that even MacMichael compared to those of "Tamburlane or Genghis Khan"[73] and today evoke images of "ethnic cleansing." Intermarriage was forbidden (how successfully so is not clear), in part to prevent the adoption of "Arab" customs like pharaonic circumcision that southern peoples and Nuba had begun to emulate "in order to get a better dowry for their daughters from their Arab neighbours,"[74] more likely, as discussed in chapter 4, to consolidate and defend their meager gains. "Arabs," wrote Governor Brock of Bahr al-Ghazal, "wander all over the District hunting and indulging in petty trade. No wonder the local natives, many of them immigrants from the North and West, follow Islam as a definite religion or as a form of snobbery. They have adopted the worst features of Islam including female circumcision."[75] As the operation was sometimes performed by the wives of northern civil servants,[76] their expulsion was expected to curb its extent.

Justifying the restrictions in 1963, a former governor of Equatoria and Upper Nile cited not just female circumcision but the need to halt the spread of venereal disease, which was prevalent in the north but "practically unknown" in many parts of the south.[77] Again, detribalization was held to blame. Freed or runaway slaves who had been concubines of soldiers or had become prostitutes to earn their keep not only bore a veneer of Arabness but brought disease and immorality to settlements in the

circumcision comes from Islam? (handwritten margin note)

south. Despite concerns with public health, Brock declared his three northern medical orderlies expendable,[78] possibly because—unlike the northern clerks whom he retained—they were in close and often unsupervised contact with local people. Envoys of hygiene thus removed, sexual discipline and population control were enjoined to create a *cordon sanitaire* that would check the various "contagions" of Arab society.

No effort is required to detect in these acts the shadow of eugenics, a prevalent discourse not yet discredited by the ravages of National Socialism and World War II. Maffey had invoked its idiom in advocating the creation of social "compartments" to act as "protective glands against the septic germs" that would "inevitably be passed on" from Khartoum.[79] MacMichael's "self-contained racial units" echoed that remark. Lugardism leavened by eugenics made for a heady authoritarian brew. Ethnic intermarriage could lead to "detribalized" offspring and was inimical to indirect rule; mating within one's tribe was politically preferred, and may have been why the ostensibly unsafe Arab custom of marrying close cousins excited little concern.[80] Tribalism was the watchword: where groups had become mixed, they were separated, where inappropriately divided, they were joined: nonsouthern groups were forcibly removed from the south; southerners in towns were assigned to residential quarters according to tribe; outside of towns peoples deemed ethnically similar were combined. Southerners were forbidden to use Arab names, and, though Christianity was welcomed over Islam, baptismal names were frowned on as nonindigenous.[81] It was imperative during the Maffey-MacMichael years that "detribalization" be checked and the development of "inauthentic" social homogeneity be quashed; this meant thwarting emulation of Europeans too. In light of such measures, northern women's appropriation of European and other non-Arab dress in the *zâr* offered brave if oblique defiance and a veiled critique.

Reform?

In 1934 there came a turning point: Maffey was replaced as governor-general by Stewart Symes, who had been Wingate's private secretary from 1913 to 1916. Ended too was MacMichael's dominance; he was posted as governor of Tanganyika.[82] The office of civil secretary went to Angus Gillan who, along with Symes, proved more conciliatory to educated Arab Sudanese. Symes considered the emergent intelligentsia "a vital force that could be co-opted and utilized by the regime."[83] According to Muddathir ʿAbd al-Rahim, Symes hoped thereby to parry the appeal of fascism that was feared to be gaining ground with Sudanese nationalists. Censorship

was therefore relaxed and literary journals such as the influential *Al Fajr* (The Dawn) began to print essays critical of the regime. "Native administration," ran one editorial, "is liable to be a failure so long as it is in the hands of the ignorant, whereas we see in it but a counterfeit of the Feudal System." "Give Us Education" was the headline of another.[84]

If Symes resolved to alter the status quo, the result was modest at best. Though tentative steps were taken to increase the numbers and responsibilities of Sudanese civil servants, frugality and realpolitik invariably hindered change. Nor were Symes's efforts unopposed by the SPS old guard. Importantly, however, he endorsed improvements to education. Where Maffey's administration had relied on the notion of parallel and unequal development for Sudanese and Europeans, Symes in the late 1930s allowed for some convergence, granting educated natives a role in determining the colony's future. To both, education—restricted or enhanced—was the key to governing Sudan. Still, if Symes's policy seems the more liberal, he sought to manage the pace of change lest its seedlings wither for want of roots.

During the 1920s and consonant with the dictates of indirect rule, a great many government-sponsored elementary vernacular schools (*kutâbs*) had been closed in northern Sudan while the numbers of subsidized *khalwa*s (religious schools) had risen tenfold. The latter were run by *faki*s, local Muslim clerics, few of whom were formally trained. *Faki*s were granted curricular discretion so long as their teaching suited administrative needs: "respect for authority, obedience, and self-discipline," qualities geared to produce docile, compliant subjects: no mavericks desired. Moreover, provincial governors took it upon themselves to decide what was truly "native" about native schooling and what was not. In 1926 the noted Sudanese educationalist Shaykh Babikr Bedri and his associates had proposed a basic syllabus for the *khalwa*s consisting of simple arithmetic, literacy, and hygiene; it was rejected on political grounds. Too progressive, it was deemed, and hygiene especially so.[85] Considered "Western" and not "indigenous," its lessons were expected to incur parental wrath. This, despite the counsel of native teachers, and the widespread value placed on cleanliness in Islam. Yet if hygiene were banished from curricula, problems like venereal disease and female circumcision could hardly be tackled in the systematic way that British medical personnel advised. Clearly, some officials were averse precisely because airing the topic might prompt social change. When political exigencies clashed, the more conservative agenda was likely to win: preserving internal security came first, bolstering native leadership second; all else was subordinate to these aims. In the heyday of native administration, if a project to suppress harmful practices might weaken traditional authority, it failed to win official support.

As education was politicized and "nativized," the demand for teacher-training courses waned. Though the country was growing more prosperous thanks to increasing cotton yields, the overall budget for education fell from a high of 4 percent of government expenditure in 1912 to 1.9 percent in 1926; meanwhile "the government brazenly cloaked its illiberality in spurious statistics" for the benefit of would-be critics at home.[86] In addition to the military academy, the school for training Sudanese sub-ma'murs was closed. Given the shortage of civil servants following the expulsions of 1924–25, enrollment in Gordon College was increased; yet students were tutored by untrained members of the SPS who'd been seconded to posts vacated by repatriated Egyptians until British and Lebanese teachers could be found.[87] From 1927 to 1938, the director of education was a political officer, not a professional educationalist. This, for the same reason that a political officer was made anthropological advisor: in colonial Sudan politics, ethnicity, and education were intimately intertwined. Selfhood was the front on which colonial power pressed with greatest force. While elsewhere in Africa missionaries and secular modernists may have aimed to fashion natives in their own image (if manqué), in Sudan between the wars, anxious officials strove to preserve "authentic" indigenes—along lines that the officials, of course, approved.

Administrators in several provinces had succeeded in limiting education to the sons of native elites, hoping to invigorate hereditary authority and prevent competition from beyond the ruling class.[88] Yet literacy was politically dangerous, and too much education was a drawback for local chiefs. Arkell, writing as acting resident of Dar Masalit in 1926, discouraged the sultan from sending his sons to Gordon College because it would create a distance between his heir and "and his rather wild and simple people" that would be "fatal to the NA [Native Administration], the idea of which is to produce a government for Africans on African lines."[89]

In 1933 the director of education discovered that even in villages near Khartoum "it was a rare *khalwa* leaver who could so much as write his own name."[90] Clearly reform was needed if only to shift the population away from its supposed "customary indolence." A committee to report on the quality of instruction for boys advised that systematic teacher-training be improved, and an institute for that purpose set up in a rural area, far from the politically charged climate of Khartoum.[91] The facility was built in 1934 at "Bakht er-Ruda" near Duiem on the White Nile. The man selected to head it was V. L. Griffiths, a professional educator and advisor to the committee who, together with a staff of British and Sudanese instructors, quickly got to work devising a new syllabus for primary schools, writing textbooks and experimenting with their use. I return to the story of Bakht er-Ruda in chapter 7. Here it should be noted that despite the much-touted reforms, little change was seen for some time. In

the north, *khalwa*s remained the principal means of instruction. Toward the end of the 1930s the government began to reclassify the more "advanced" *khalwa*s as pre-elementary schools. While these modestly subsidized *khalwa*s were improved largely in name, they justified the dearth of standardized elementary schools so ill-suited to the needs of indirect rule.

The growth of secular education was therefore slow under Symes, with changes geared to the demands of the developing economy. Post–secondary schools beyond the level of Gordon College were set up for men in the practical fields of law, agriculture, veterinary science, and engineering, each admitting no more than a handful of students at first. (A medical school had opened in 1924.) In 1937 Lord De La Warr's "Educational Commission to East Africa" visited Sudan and made sweeping recommendations: primary education should be expanded, including that for girls, and funding for *khalwa*s be withdrawn; more teacher-training schools were required; standards should be greatly improved. Not all the proposals were welcomed or considered feasible at once. The government nonetheless accepted the report and reforms were begun—in the north. Yet as Daly notes, "to the end of the Condominium there were those who considered provision of education the most serious error of British rule."[92]

Girls' education lagged far behind that of boys despite rising demand, having been left largely to the CMS. (In view of issues pursued in this book, the topic arises again in part 3.) Yet the idea of educating Arab Sudanese girls was widely scorned by the powers-that-be. In 1938 Christopher Cox, as newly appointed director of education and the first in over a decade to be a professional teacher, reported that Symes "ridiculed the notion of an Intermediate . . . school for Sudanese girls or for giving them anything more than the 3Rs and a little hygiene. . . . [A]s for intellectual companionship for those half-baked wogs or for giving a lead in solving social questions affecting women, all that lay generations ahead."[93] The De La Warr Commission had, however, conveyed "little doubt that the inadequacy of women's education was one of the main causes of backwardness in the Sudan," and advised that schooling for girls be "greatly expanded." Cox agreed, citing a lack of "Sudanese women sufficiently educated to be consulted on matters of social policy which intimately affected themselves and their homes." He noted too "the marked contrast in this respect with Egypt to the north and Uganda to the south and urged that the *opportunity* of a measure of emancipation should at any rate be provided through proper educational facilities."[94] Between the lines of this memo, and Symes's unflattering comments above, lies the matter of female circumcision. On this point, as on many others, Sudanese women themselves were granted little voice.

Egypt Again

Throughout the 1920s Britain, Egypt, and Sudan engaged in sporadic negotiations to settle issues left unresolved when Egyptian independence was unilaterally bestowed in 1922. The status of Sudan was a sticking point. In 1929 the parties agreed on partitioning the waters of the Nile in a pact that ensured Egypt's lifeline by granting Sudan less than 5 percent of Egypt's share. This was widely resented by Sudanese and eroded their trust in Egypt's benevolent intent.[95] Drafts of treaties in 1930 and 1933 foundered on the question of Egypt's role in the colony itself. Then in 1936, with Mussolini's troops threatening from Libya in the north and Ethiopia in the east, agreement was struck at last.

It basically preserved the Condominium status quo. Egypt informally abandoned its claim of sovereignty over Sudan and endorsed Britain's assertion of moral guardianship until the Sudanese had achieved "a higher stage of progress in civilisation."[96] As a show of faith, a battalion of the Egyptian army was returned and Egyptians were allowed to compete for government posts, though in practice few were hired. The treaty alienated educated Sudanese, both anti-Egyptian and pro-, who were offended at having been bargained over and not consulted at all. Incensed by its paternalism and fueled by the indictments of the De La Warr report, they transformed the Omdurman Graduates' Club (an alumnae association of Gordon College)[97] into the Graduates' General Congress and in 1938 demanded a consultative role. Rivalry between British and Egyptians for the allegiance of Sudanese resumed, now with involvement from Sudanese themselves.[98]

In the late 1920s political groups had begun to re-form as literary societies and social clubs; in the 1930s they were drawn into the orbit of the country's two most influential religious leaders, Sayyid ʿAbd al-Rahman, the Mahdi's son, and Sayyid ʿAli Mirghani, head of the Khatmiya religious brotherhood. Over time, the groups evolved into relatively pro-British and pro-Egyptian political alliances at first within the Graduates' Congress, and later without. I do not propose to dwell on their development,[99] as my interest here is oblique: the relevance to continuing British attempts to "civilize" northern Sudanese women. The mid-1930s marked a turning point in that story too, for the nature of the British mission to abolish pharaonic circumcision and the alacrity with which it was pursued were tempered by politics from the start: nationalist agitation, indirect rule, Southern Policy rationales, negotiations with Egypt, events in neighboring Kenya, the re-emergence of nationalist politics in Sudan and the drive for independence. Punctuating these processes and helping to shape them

were external factors: the Great Depression, the rise of fascism, World War II, and the threat of communism which, as the century wore on, came to surpass that of "unorthodox" Islam.

A few significant moments may be noted for the names and events that arise later on. In 1940 Hubert Huddleston, famed for crushing the mutiny of 1924, succeeded Symes as governor-general; he would take a largely ceremonial role, trusting domestic administration to able subordinates. Douglas Newbold, an empathetic official who saw the inconsistencies of indirect rule,[100] had become civil secretary on Gillan's retirement in 1939; ever since MacMichael's time the civil secretary's office was Sudan's "Home Office," where responsibility for all internal matters lay.

In 1942 the Graduates' Congress presented government with a list of requests in the name of "the Sudanese people." They asked, among other things, for a declaration that Sudan would be granted the right of self-determination at the end of the war. Newbold's response was an uncharacteristic rebuff: such matters were for the co-dominie to determine; Congress had with this memorandum lost the confidence of administrators whose business it was to decide the extent and timing of Sudanese participation; the graduates must agree to confine themselves to domestic affairs and renounce claims to speak for the country at large. Privately, Newbold met with several members of the executive committee, and expressed "sympathy with the graduates' hopes and expectations," noting that "government had every intention of working gradually towards the realisation of most of [their] demands."[101] The committee split over whether to accept his assurances or resume confrontation, deepening existing rifts. Congress now divided along sectarian lines. The issue was not whether, but how best to bring colonialism to an end. The Umma party, patronized by Sayyid ʿAbd al-Rahman al-Mahdi, advocated cooperating with the British toward eventual independence and adopted the slogan "Sudan for the Sudanese,"[102] while the coalition surrounding Sayyid ʿAli Mirghani called for dislodging the British by means of tactical union with Egypt. The unionists became known as the anticolonial group for their refusal to cooperate with British-initiated reforms.

It was an intriguing about-face. For years the Mirghanists had been thought "loyal" to the government (in fact the Khatmiya was widely known as the *tarîqa'-t-al-ḥakûma*, the "government *tarîqa*" or "way"), and the Mahdists latently "disloyal," however much Sayyid ʿAbd al-Rahman defended government initiatives and helped calm potential unrest. But by 1942 Mahdism was no longer a credible threat. Although religious leaders chaffed against the strictures of British rule, they did not seek to replace it with an Islamic state; rather, they maneuvered within its secular framework and profited well thereby. By the 1940s their rivalry was less for spiritual ascendancy than for earthly power.[103] The British, for

their part, were wary of precipitate demands for independence, fearing that Sudan would again "come under the domination of the despised Egyptians."[104] They therefore cultivated cooperative nationalists, those who, like the Mahdists, advocated "Sudan for the Sudanese." At the same time, they remained adamantly opposed to northern dominion over the south.

Among the conciliatory reforms accepted by the colonial regime, the most significant for my purposes was the establishment of the Advisory Council of the Northern Sudan in 1943. Each province in the north was to form a number of district-level councils; these sent members to a provincial board, from whose ranks the governor-general would in turn appoint three to an omnibus council in Khartoum. Other participants would include two members of the Sudan Chamber of Commerce, eight members at large, and several honorary appointees including religious notables. The council's mandate was to advise government during semiannual meetings whose agenda, rules, and debates the latter controlled.[105] The south was not included as it was not deemed sufficiently advanced. The membership of the first session held in May 1944 was unsurprising: handpicked tribal and religious notables, prominent merchants, professional Sudanese, many of them civil servants.[106] The council was dominated by cooperative Mahdists; among the topics discussed were education, economic development, finance—and, in 1945, a law that proposed to make performing a pharaonic circumcision or willingly submitting to it criminal acts, punishable by imprisonment for seven years.[107]

Circ. illegal

Culture and Conciliation

The decade of the 1930s was in many ways the apogee of British rule in Sudan. Nationalism and Mahdism seemed relatively quiescent, the south appeared more tractable, British civilians and officials led a good life in provincial capitals and Khartoum. Even in out-stations there were servants, costume parties, recreational clubs. Some were uncomfortable with the lifestyle. Wilfred Thesiger described a fancy dress Christmas in Fasher, the capital of Darfur, in 1935:

> We wore dinner jackets since neither of us wanted to don fancy dress as required. When criticized for this, we said that we were parodying Englishmen who dressed for dinner in the jungle. . . . I felt embarrassed, wondering what [the Sudanese] all thought of the way we Christians were celebrating the birthday of our Prophet. They saw the Governor dressed up as a prisoner, his middle-aged wife as a schoolgirl, other wives dressed as men, their husbands as sheikhs, troubadours, bull-fighters and God knows what else.[108]

With few exceptions, Britons' descriptions of their time in Sudan are rife with details of exclusively European social events, where Sudanese were relegated to cameo appearances and "supporting roles" as servants and standard-bearers in resplendent array. Historian Heather Sharkey, having looked at scores of photos in officials' archives, notes that "the very Northern Sudanese men whom the British educated and groomed for employment almost never appear in the snapshots taken by Britons in their leisure hours."[109] By the end of the decade it was becoming clear to senior officials that indifference to educated Sudanese was contributing to political friction, especially in Khartoum.

Several remedies were advised, from giving Sudanese "frequent opportunities of visiting and making contacts with England,"[110] to hosting them to tennis parties and teas. In 1938 Gillan, then civil secretary, admonished personnel to improve relations with educated Sudanese, and advocated founding a cultural center where the groups could regularly meet.[111] The center was intended not only to give purpose to such contacts, but would be "coupled with a scheme for disseminating propaganda favourable to the Government" so as to rebuild the waning moral authority of the regime. Though the center was disguised as "a cooperative endeavour" between British and Sudanese, membership and "a helpful interest" were "required of all British officials, as a normal part of their duties." The full-time officer who managed it would liaise with the education department "with regard to the purely cultural side of his work" and "the Public Security Department with regard to the political aspect of it." The center was justified in terms of the "moral obligation inherent in the humanitarian tradition of British Imperialism" as well as "administrative expediency." Native education was now reproached for having stressed "utilitarianism" at the expense of "idealism":

> The usefulness of the educated Sudanese is limited too rigidly to his effectiveness as a technical employee. But from a moral point of view his real significance is not his technical efficiency but his passing from the mental doldrums of barbarism into the driving winds of Western culture. If he is to take full advantage of this change he will need help. . . . The educated Sudanese must be taught to be a real patriot, with a sympathetic understanding of the many problems of his country, rather than a protagonist of his class. He must be taught to take a broader-minded view of the policy of native administration and he must learn that he can find contentment and a livelihood from applying his educated intelligence to the tilling of the soil.

The political rationale was the need yet again to offset creeping Egyptian influence, where, wrote Gillan, having "lost the remedy of prevention," there was nonetheless "an effective antidote in the marked appeal of British cultural and social institutions to the Sudanese."[112] Margery Perham

try to make Brit cult
appealing to Grads than
Egyptian

more

at Oxford took up the cause, and secured an inaugural grant for the center from the Rhodes Trustees.[113]

Perham's involvement notwithstanding, it remained to be decided "whether ladies should be eligible for membership" or "only be allowed in as guests of members to certain lectures as decided by the Executive Committee"—whose Sudanese members included Ismail al-Azhari, a teacher at Gordon College and president of the Graduates' Congress (later prime minister); ʿAbd al-Halim Mohammad, a doctor at Khartoum Civil Hospital; and ʿAbd al-Magid Ahmad of the Finance Department. The latter was deemed the safest route.[114] Whether modesty concerns or gender bias was to blame, the cultural center was not to be a forum in which all British and all Sudanese took part.

The center opened in 1940 and was at best a modest success. Roughly half the members were Sudanese and a quarter British, with Egyptians, Greeks, Syrians, and a smattering of other nationalities making up the rest. A year later it had to be admitted that the "contact" value of the center was low.[115] Subscriptions were falling off; British attendance was negligible save for major events. Richard Hill, secretary of the center in 1945, gave an optimistic radio talk on its role in breaking down the intolerance and mistrust between British and Sudanese that came from "ignorance of one another's habits of living."[116] Laudable though the call for understanding was, entrenched power relations could not be put down to mutual naïveté. Nor was it the center's function to dispel British ignorance of native ways: it was to acquaint Sudanese with British culture, not the reverse. In this it triumphed, for the library of English books and periodicals was used to an "astonishing" degree by Sudanese,[117] whose knowledge was further advanced when government acted on the proposal to send selected graduates to the United Kingdom.

The urgency of improving relations redoubled when, at the end of World War II, the colonial era began drawing to a close, labor strife arose, and communism posed a new if not fully realized threat to the regime.[118] In 1946 J. W. Robertson, the civil secretary, felt pressed to repeat the counsel of his forebear:

> Many British seldom make any attempt to get into real contact with their Sudanese staff or to meet them socially and influence them in a friendly way. It is little use planning for the political, economic and educational future of the Sudan if we fail over the "personal" factor. What is needed is a real change of attitude and outlook. I believe that it is on a change of spirit that the main hope of retaining our influence and power for years to come depend.[119]

Interestingly, this latest call was made a few months after proclamation of the law that criminalized pharaonic circumcision, "always an insurmountable barrier to full social relations between British and Sudanese."[120]

6

COTTON BUSINESS

The Sudan is the latest thing in European exploitation, and it is
the best. The English rulers struck straight out for an incredible
objective—the welfare of the conquered alone.
—Odette Keun, *A Foreigner Looks at the British Sudan*

The logic of indirect rule counseled respect for local customs so long
as they were not, in MacMichael's words, "repugnant to generally
accepted canons of decency and justice."[1] Pharaonic circumcision
did offend European sensibilities, but it would be rash to think that ideals
alone drove British attempts to abolish it. Insofar as the practice forged
on a woman's body an indelible claim to Muslim/Arab identity, officials
had political reasons to block its movement south. Yet they showed little
interest in preventing the spread of male circumcision which, unlike fe-
male genital cutting, is obligatory under Islam. It could be argued that
confining Islam to the north would ultimately limit both. Witness MacMi-
chael's diatribe on the need to save "the simpler type of black" from
adopting Islam "as a potent form of ju-ju" upon finding "that he is not
admitted into the circle of the elect so long as he remains uncircumcised."[2]
But the main point is this: infibulation—not clitoridectomy, not male cir-
cumcision—was widely thought to impede procreation. The present chap-
ter explores the colonial government's desire to foster population growth
in the riverain north with the aim of creating a sufficient and tractable
workforce to support the production of cotton. The alleged need intensi-
fied in 1924 when the persistence of slavery in Sudan was brought to
public attention in Britain and officially stopped. As we'll see, this was
also the year Khartoum began to deliberate putting an end to pharaonic
circumcision. The putative links between slavery, population, and infibu-
lation made the need to civilize Arab women clear. Contributing to this
was the regime's resolve to check Islam, Arab influence, and pro-Egyptian
sentiment that led to the expulsion of Egyptian workers from Sudan.

Labor

This next strand of the story returns us again to 1898. Sudan's economy was in ruins. According to Wingate, the population had dropped from over 8 million before the Mahdiya to under 2 million at its end.[3] Such figures made good propaganda and cannot be confirmed, yet the decline was substantial all the same. Vast areas were depopulated, villages and fields abandoned. An assessment of Dongola Province in 1896 found a "striking" excess of females over males in the population, with the latter consisting mainly of old men and boys. Countless able-bodied men had died in battle; others had gone north to avoid the conflict or join the Anglo-Egyptian forces marching south.[4] The situation was even worse in Berber, closer to Khartoum, where disaffected Ja'aliyin had suffered the Khalifa's wrath and most survivors had fled. Where refugees collected, famine and epidemic prevailed.

Human costs were written on the ravaged landscape. Large tracts of arable land, especially the fertile strip that borders the Nile, had fallen to disuse, and waterwheels that had not been torn out and used for firewood lay idle and overgrown. In the rain-fed farmlands of the Gezira, too, the comings and goings of the Mahdiya had left derelict fields and tangled rights. Much of the economic infrastructure built up under the Ottomans had been demolished by century's end. Because Condominium revenues were negligible at first, the Egyptian treasury was made to subsidize the extension of railways, build Port Sudan, and finance the Egyptian Army on the upper Nile.[5]

The British sought to restore cultivation by granting loans of cash and grain to displaced farmers who returned to the land, registering plots on the basis of continuous possession or proven titles (including some acquired during the Mahdiya by dubious means), settling boundaries and disputed claims, putting measures in place to curb land speculation and limit foreign purchase. Resettlement was seen as the "best guarantee of peace."[6] To force property holders to farm, a progressive land tax was imposed from 1906, but had little effect, and the traditional system of ʿushûr—a tithe on staple crops such as dura (Sorghum vulgaris)—was widely applied instead. Since reductions were regularly granted to those who appealed, little tax was paid; indeed the British were convinced that exorbitant levies under the Ottomans had triggered the Mahdist revolt. As they had no wish to rekindle resentments, demands at first were kept low.

To colonial officials, reviving the agrarian economy was Sudan's best hope for generating sufficient exports to cut the umbilical cord to Egypt

and keep Whitehall at bay. As pacification and resettlement advanced, Manchester textile magnates arrived to test Sudan's cotton-growing potential. Results were promising, and the government enacted measures allowing state arrogation of land with eventual plantations in mind.

Yet Arab Sudanese were deemed too few and habitually "indolent" to supply the disciplined workforce that export as well as subsistence cropping required. Thus slavery was allowed to continue. However expedient, it was an incongruous solution.[7] Gordon's mission to end the slave trade had, after all, furnished strong justification for the Anglo-Egyptian conquest. The paradox was obscured, we shall see, by an official distinction between the condition of bondage and the conduct of human trade.

Labor, Land, and Social Differentiation

From the earliest days of the Condominium, labor was in short supply. Foreign rule produced a demand for workers: to build Khartoum and Port Sudan, complete the railway system, lay out roads, and clear steamer channels through southern swamps—economically useful projects performed in the name of pacification. Soldiers and Mahdist prisoners were initially pressed into working on these schemes. Later, high wages were paid to attract "free" labor, though the need regularly surpassed the numbers willing or able to work.

Under the Ottomans in the nineteenth century, agriculture had come to depend on the deployment of slaves. Though the British ascribed this to an "Oriental mentality," there are less partial explanations. Historians Jay Spaulding and Anders Bjorkelo, among others, have shown how Ottoman colonization accelerated a process of economic differentiation that had started in northern Sudan at least a century before.[8] Until 1820–21, most land was cultivated communally, in ostensible usufruct from nobles or, increasingly, Islamic merchant-divines. The latter had obtained royal land grants free of feudal obligation and had begun to attract resident followings. Within these enclaves, sanctuary was granted the distressed and maverick alike, Islamic rather than traditional law applied, and an incipient bourgeoisie rose up around trade and the transmutation of use rights into private property claims. Elsewhere the situation, though turbulent, remained largely feudal and redistributive; commoners held rights to farm within a particular community but not outside it, and expected the lord who claimed a share of their harvest to alleviate seasonal want. The lord, for his part, exacted "annual levies . . . upon riverbank lands, payable only in sesame, tobacco, and cotton" and required "a part of the cotton tax in the form of finished cloth"[9]—items for both internal use and export abroad.

Throughout the Muslim north, the Ottomans enforced Islamic prop-
erty rights and inheritance protocols that divide an estate in specified por-
tions among heirs. They did so less from faith than for profit: to compel
the commoditization of land, intensify agricultural production, and gener-
ate cheap materials for trade. Accordingly, rights to shares in the annual
yield of a *sâqiya* (referring to both a waterwheel and the land it irrigates)
were transformed into divisions of the *land itself*, which could now be
registered to individuals and more readily bought and sold. This, along
with the application of *sharī*a conventions by Ottoman courts, caused a
"spectacular" fragmentation of land along the Nile, where farming was
limited to floodplains, basins and riverbanks. Spaulding notes that in pre-
Ottoman Sennar no harvest share less a twelfth of a *sâqiya*'s output was
recognized; yet when *sharī*a was strictly applied, deeds suggesting the
prospect of 1/72,864 of a *sâqiya* plot were not unknown.[10] It often hap-
pened that one's holding was too small or scattered to be worth the costs
of labor, water, and other requirements to work it; this benefited those
who were anxious to see land, in Bjorkelo's words, "enter more smoothly
the market sphere."[11] Moreover, the Turks altered the usual division of
returns on a *sâqiya* in favor of the landlord and, to draw Sudanese more
tightly into the exchange economy, changed tax assessments on farms and
herds from kind to coin or its equivalent value in slaves, used for export
or as soldiers in the Egyptian Army.

High taxes, along with land fragmentation and individualized risk,
meant that less prosperous farmers were often forced to sell, or indefi-
nitely mortgage (thence forfeit) their land in order to pay; others simply
abandoned their fields to be confiscated by someone who redressed the
debt. Debt was also built up through the infamous *shayla* ("carrying")
system, a form of crop mortgage entailing exorbitant rates of return; this
too could lead to forfeiture.[12] Those loath to relinquish their rights but
unable to farm might arrange for their land to be held in trust (*âmâna*)
and cultivated by others; even today sales of family land are stigmatized
and such arrangements commonly made. Men with means and demo-
graphic luck thus acquired workable parcels of land or rights to manage
a consolidated estate—often at the expense of kin, especially women, who
as daughters inherited one half the share of sons and could be pressed to
"forgive" their holdings in return for fraternal support. Moreover, land-
rich farmers preferred to cultivate with slaves rather than paid help or
tenants, since slaves had no legal claim to a portion of the yield. Free men
unable to make a living migrated out, some to the north, far more to the
south where they joined the ranks of *jallâba* (petty traders) and fueled the
ruin of insolvent fellow villagers by trafficking in slaves, the only "com-
modity" that was not a monopoly of the Ottoman state. *Jallâba*, for their
part, had few options but to become complicit in the system that had

dispossessed them and precluded their earning a living on the land. Though out-migration had long been practiced in the unforgiving north, its escalation from the mid-nineteenth century on was untoward and firmly linked to the human trade.[13] Migrants' wives and widows remained behind, and, though little is known of their fate, it is likely that many took refuge with kin.[14]

Slavery

Under the Ottomans, social differentiation grew increasingly marked in northern Sudan. Yet owning slaves became affordable even for those of modest means. The bases for the seeming incongruity lie with the institutionalization of the slave trade and the exactions of the Ottoman state.

Until the late eighteenth century, slave-owning had been the prerogative of nobles. But as royal power waned in medieval Sennar and Darfur, and commerce was no longer controlled by hereditary elites, slave-owning and slave-trading gradually became more demotic.[15] The Swiss adventurer J. L. Burckhardt, traveling up the Nile shortly before the Ottoman conquest, estimated that in the town of Shendi roughly thirty kilometers south of Hofriyat, some one thousand slaves of Nuba or southern origin were bought each year by regional farmers and set to work in their homes and fields.[16]

The Ottomans, under Egypt's khedive Mohammad ʿAli, had gone to the upper Nile in search of its fabled wealth, including slaves to swell its army. For the first two decades of their rule the state conducted annual slave raids, abetted by irregular forces from northern Sudan who invariably took a share of the human spoils. From the 1840s on, the trade was run by private individuals and companies of concessionaires, early among them Europeans, later also Arab Sudanese. At first, surplus slaves were distributed among the khedive's troops in lieu of pay; soldiers who could not afford to keep them sold them locally, sometimes at a "loss."[17] While the majority were acquired by Sudan's well-to-do and middle class, the practice ensured that the price of an agricultural slave stayed "within reach of the average consumer"—the peasantry—who had also begun to acquire them.[18] Indeed, the less affluent sometimes pooled their resources to buy a slave, allotting rights to his or her labor according to the system used to divide the fruits of a jointly owned date tree.[19]

Servile labor became crucial to growing and processing the work-intensive commercial crops—sesame, tobacco, indigo, cotton—demanded by the Ottoman state (with modest results) for foreign trade. In the mid-1860s trade disruptions during the American Civil War starved Britain's textile mills of cotton. This resulted, ironically but consistently, in a slave-

trading boom in Sudan when cotton production along the Nile expanded to fill the void.[20] Thus, domestic slavery in Sudan was neither atavistic nor aberrant but an economically "rational" response to the pressures of European industrial capitalism mediated by the Ottoman Turks. On the eve of the khedive's invasion, European visitors to Sennar estimated that slaves accounted for about 4 percent of the population; by the end of the nineteenth century virtually all domestic and agricultural work in northern Sudan was performed by slaves, whose portion of the population had risen to as high as a third.[21]

Burckhardt claimed that slaves were treated well. Boys were circumcised and given Arabic names.[22] Some of the slave girls he encountered in Shendi market were "*mukhayt*" or "sewn"—that is, infibulated, the operation likely having been arranged by the merchants to enhance the women's price. He wrote that "girls in this state are worth more than others" and "usually given to the favourite mistress or slave of the purchaser."[23] Infibulation may have eased the acceptance of non-Arabs in their masters' homes, but it did not effect their assimilation. For slaves, at least in Ottoman Sudan, were the absolute property of their owners, referred to as "talking animals," legally classed with livestock, and sold by the "head" (*râs*).[24] In contrast to other parts of Africa, they were not absorbed into their owners' kin groups: even children born to a slave and sired by her owner were the latter's legal chattels to be used or sold as he saw fit.[25] Spaulding suggests that the "peculiar names" given to slaves, "such as 'Sea of Lusts' (a woman), 'Patience is a Blessing,' or 'Increase in Wealth,' " were likely meant to distinguish them from the free, whose names usually had religious import. Further, he notes that in some districts "it was not customary to bury a slave—funerals were expensive. The corpses of slaves were left exposed to scavenging animals or, if inconveniently located, thrown into the river."[26] The last procedure anticipated British treatment of the Mahdi's bones and surely fueled its ignominy to his devotees. It seems to have ceased in the 1840s and Spaulding infers that slaves were given a simple Islamic burial from then on.[27] Though most slaves professed Islam, this had no effect on their status. Indeed, the stigma of servitude endured, if mutedly, among their descendants under the British and beyond, and marriages between freeborn families and those of former slaves are still rare.[28]

During the American Civil War, European abolitionist groups such as the Anti-Slavery Society turned their sights on east Africa, just as accounts of geographical expeditions to the slave-hunting grounds of Equatoria— by Speke and Grant, and Samuel Baker—began to appear in the British press. The indignation such reports sparked helped pave the way for Gordon's first mission to Sudan in 1874.[29] Yet Baker, for one, was no advocate of prompt liberation, believing that a freed African slave would become

both indolent and "a plotter and intriguer, imbued with a deadly hatred of the white man." Moreover, "when the Negro was a slave, he was compelled to work, and through his labour every country where he had been introduced, prospered. But after the Negro had been emancipated he refused to labour" unless he could be compelled to it by strict vagrancy laws.[30] Such views would find advocates among officials in early postconquest Sudan. During the first three decades of Condominium rule, the government was convinced that without the perpetuation of slavery Sudan's agrarian economy would crash. And so, while they were resolved to end the trade, they were loath to urge a swift demise for the institution.

Given the ubiquity of scientific racism in turn-of-the-century Europe, it is not surprising that the British viewed their subjects in ethnic and racial terms and ranked their capacity for work on an evolutionary scale. They considered 'Soudanese'—then meaning southerners, slaves, and former slaves—to be strong, energetic workers but innately undisciplined, whereas "Arabs" or northern Sudanese were possessed of a "slave-owning mentality" and averse to manual toil. The Fallata, West African (mainly Nigerian) Muslims ostensibly en route to Mecca and "anxious to make money" to further their progress, were deemed "the most useful population." Seen as "thrifty hard working people, willing to work for small wages," they were encouraged by administrators to prolong their stay in Sudan.[31]

British views were reciprocally shaped by their subjects, who had ethnic hierarchies of their own. To the extent that servitude was sanctioned by Islam, only captives of a holy war against idolatrous resistors could be enslaved. The hegemony that formal Islam had attained under the Turks furnished a context in which claiming Arab descent and adopting a genealogy to support it were—at the very least—sensible, pragmatic means to define oneself as "unenslaveable." As Ahmad Sikainga notes, "Arab ancestry" signified liberty, adherence to Islam, and antipathy for manual work, "while animism and darker skin were associated with servility and hard menial labor."[32] These tenets shaped responses of Arab and southern Sudanese to British demands. "Arabs" spoke of manual labor as "fit only for slaves," thus validating officials' sense that they were decadent and lazy.[33] Moreover, in the past the geographical spread of Islam had periodically pushed back the frontier beyond which the "enslaveable" dwelt to ever remoter groups—or so the theory went and the vulnerable hoped.[34] Thus, for the British to bar southerners and Nuba from adopting Arab practices on the pretext of preserving cultural authenticity, while refusing to abolish slavery and even abetting it at times, was to prolong the latter's exposure to duress. For as Gabriel Warburg observes, "as long as the price of a hired labourer was nearly three times that of a slave, it was quite natural that there was an increasing demand for slaves in the Sudan it-

self."[35] The British did curb large-scale raiding; but well into the 1930s and possibly after that, small groups consisting mainly of children and young women were abducted each year along the Sudan-Ethiopian border and the pilgrimage routes from western Sudan to the Hijaz.[36]

The conviction that climate and race conspired to shape one's constitution lent certainty to colonial appraisals of Sudan's potential labor force. According to H. C. Jackson, governor of Berber Province in the 1920s, the incentive to work was low in the tropics, "where the sun is hot and nature prolific." Moreover, while Arabs abhorred manual labor,

> southern Sudanese would only work sufficient hours to enable them to spend a riotous night in the nearest *merissa* [beer] hut. Even the offer of higher wages could not induce them to work; their demands upon life were very limited, and the higher the wages the less need there was to work to satisfy them.

He admitted, however, that "the laying-up of something for a rainy day had ... only served to precipitate a deluge upon the provident when a tax-collecting expedition descended."[37] Was reluctance to work an effect of nature, experience, or both?

Condominium policy was contradictory and ambivalent, informed by all these concerns and more. Though slavery was decried by officials abroad, in Khartoum it was tacitly endorsed. Slatin, its most ardent supporter, regarded it as "an essential and natural part of Sudanese society and economy" and did "everything in his power" to preserve it.[38] The need to keep peace and prevent "disorder" offered justification, for sudden manumission would surely rock the fragile economy and renew religious unrest.[39] In 1899 Kitchener sent a memorandum to provincial governors stating that "slavery is not recognized in the Soudan, but as long as service is willingly rendered by servants to masters it is unnecessary to interfere in the conditions existing between them."[40] Whence rose the fiction that slaves (ʿabîd) were actually unpaid "servants" (khuddâm), voluntarily employed; indeed the term "ʿabîd" was to be banished from public use.[41] Yet as Jackson tellingly notes, "Our official instructions were that escaped slaves should be returned to their masters and the slaveowners warned that they would be deprived of their slaves if they maltreated them."[42] In fact the instructions were more extreme. According to a government memorandum of 1902, "runaway slaves were to be investigated: those with legitimate grievances were to be forced to work on public projects, and those considered to be without such grievances forced to return to their 'masters.' "[43] Slaves were thus condemned for their servitude, compelled to the land in agricultural districts, prevented from congregating in towns. To facilitate their return if they absconded, and allegedly prevent an increase in their ranks, they were required to be registered

they didn't tell the slaves

they were free

and made imp. like not slaves

and, in some areas, obliged to carry passes listing their owners' names. Though anyone born since the conquest was legally free, the circular to that effect was classed as "Secret" and kept under lock and key.[44] Thus it often happened that the children of slaves were registered too, hence officially enslaved. Yet where registration was lax, new slaves could be readily introduced, which served to stimulate the trade. Daly considers it "difficult to avoid the conclusion that any increase in the labour force was welcomed by 'masters' and officials alike."[45]

It was widely accepted by the British that former slaves were inherently immoral and required strict discipline to control. "Possibly," wrote Governor-General Archer in 1925, "the ex-'slave' obtains and continues in some employment, in which case all is well; but all too often the man takes to a life of idleness or crime, the woman to prostitution."[46] The language is revealing. By the logic of social evolution, primitive peoples such as "Soudanese" lacked a sense of private property, including proprietary rights in women. Their supposed inability to objectify themselves and their labor was, then, why others were both able and aided to do so. In the idiom of property, slavery was for the slaves' own good; "savages" could be ennobled by being put to hard and steady work. Runaway slaves living in towns were not to be pitied for their hardships, but feared as obdurate, disruptive, and corrupt.[47] And no matter their success in the informal economy, unless they performed waged work and observed its temporal disciplines they were deemed unproductive, "parasitical." According to the Vagabonds Ordinance of 1905, a person was liable to prosecution if found without a permanent home or approved means of livelihood. In order to check the growth of beer-brewing houses where sex was typically for sale, the order "forbade cross-dressing" (possibly also aimed at the *zâr*) and "made it a crime to live off the profits of prostitution."[48] If convicted, one could be pressed into service for the state—re-enslaved, in effect, for the length of their sentence. Subsequent offences merited higher penalties, longer terms of public work.[49]

Despite such risks, freed and fugitive slaves began collecting on the fringes of Khartoum in the "*daym*s" (residential quarters): squatter settlements and former villages south of the rebuilt core. Beginning in 1909 the *daym*s were subject to regulation: neighborhoods were assigned a class from first to third, new streets (often named for departed British officials) were laid out in better areas, poor dwellings were demolished, and class-specific standards (size and type of house, sanitary facilities, spacing) were enforced.[50] In the lowliest *daym*s, the government retained titles and rights of eviction.[51] Such areas attracted a mix of uprooted people, freeborn and former slave, who formed a valuable pool of labor. Still it was inadequate to the colony's needs.

The British had assumed that by ending the trade in slaves, slavery itself would die out and a free labor market evolve to replace it. But several factors thwarted the plan, not least the help that officials gave in returning slaves to existing "masters." Moreover, DCs were advised that in order for a slave to be freed, his or her "ransom" would have to be paid.[52] This to compensate the property owner; without it, compulsory emancipation was held to be "grossly unfair" and apt to cause "widespread rebellion."[53] In theory, slaves could work for their freedom. Given the scarcity of labor, owners thus began hiring them out and retaining most of what they earned. Though the slave's share might be put toward his redemption (*fidya*), the final sum depended on "the owner's estimate of the value of the slave" and was often exorbitantly high.[54]

Female slaves were doubly disadvantaged by the property logic on which British and Arab concurred. Their alleged propensity for prostitution made officials even less disposed to liberate them than men. A woman could not earn her own redemption; her only hope was to marry a free-born man, who was first required to pay the *fidya* on her behalf.[55] Women who escaped or were let go because their owners were too poor to keep them had few opportunities. If hired as servants their pay was much lower than men's, making illegal beer brewing and prostitution their principal options for self-support.[56] (Some, in fact, would have been hired out by their owners as prostitutes in the past.) A few likely became *zâr* healers, others midwives who performed pharaonic circumcisions and reinfibulations, thereby sustaining the "backwardness" of women in British eyes. All such pursuits enabled women to tap the resources of "Arabs" and whites, and the wages paid to men.

As Ahmad Sikainga has shown, the regime's religious and legal policies delayed the emancipation of female slaves for decades after the start of Condominium rule. This, because female slaves were considered concubines whose disputes with their owners were family matters to be decided by *sharî*a courts. Ostensibly officials were reluctant to break up families and disrupt domestic arrangements, though their hesitation likely owed more to a fear of social chaos than humanitarian concern. Male owners took advantage of this, retrospectively claiming female slaves as lawful concubines and their children as legitimate offspring, "thereby denying them the possibility of manumission."[57] The women had no choice but to lose their children or stay with their masters against their will. Yet the alternative was also bleak: if unacknowledged, the children would be stigmatized as bastards with no patrimonial claim. Since bondswomen greatly outnumbered bondsmen, as was the case elsewhere in Africa that slavery thrived, such measures ensured that female slavery persisted even as male servitude declined.[58] The productive and reproductive capacities of female slaves were useful to owners and the state alike. Slave women

performed indispensable unpaid domestic and agricultural work and bore children to replenish Sudan's depleted workforce.[59] If cast adrift from a "stable family life," they and their children would surely become wastrels in the *daym*s of Khartoum. What about Sudanese women who were free?

Women's Roles

Embodied Domains

Economic expansion under the Ottomans had promoted a gradual role change among free-born women of the Arab north, especially in families of ample means. With the widespread deployment of slaves they were not expected to contribute to household production, but to lead modest, secluded lives in keeping with religious ideals. Spaulding notes that bourgeois women's adoption of the *tôb* (*thôb*)—the exquisite and costly modesty wrap that is recalcitrant to wear and unsuited to demanding labor— was the most visible mark of their families' newfound respectability.[60] Such women's elevated position and "proper" Islamic deportment, attesting to the entanglements of ideology in economic and political change, thus depended on the servility of other women set apart from them by ethnicity, race, and dress.

In villages along the Nile north of Shendi, I learned that in the early decades of British rule all free women, whatever their families' fortunes, surrendered the adolescent's thong skirt (*rahat*) at marriage and donned the *tôb*.[61] By then the ideological severance of "productive" from "reproductive" work was general and complete, and clearly expressed in women's attire. Moral women's vocation now focused on the inner precincts of the *hôsh* (courtyard, family dwelling), and men's on the world beyond. These distinctive gender orientations persist and, today as in the past, are physically inscribed on the bodies of boys and girls. Witness Burckhardt's observation that slaves who were *mukhayt* claimed a higher price than those left uncut.

Though genital cutting is ancient in this part of Sudan,[62] the meanings linked to and derived from it are far from fixed. The practices are performed within specific social and historical horizons that cannot but temper their import, however basic to personal or ethnic identity they continue to be. Surely, then, as the expansion of slave-owning rippled through local lives, it helped shape the meanings of circumcision too.

In northern Sudan it goes without saying that genital cutting in preadolescence deeply affects developing personhood. The procedures respectively orient girls and boys to their incompletely shared social worlds, shape their sensibilities and adult perspectives. The female body is purified, feminized by the removal of its outer (masculine) sexual parts, then enclosed by infibulation and, since the nineteenth or early twentieth

slavery linked to circ.

centuries, by the courtyard walls behind which the girl now should remain. The male body is masculinized, uncovered ("unveiled"), exposed to confront the world. Each sex is thus ritually completed, made whole and pure, *tâhir*, a term that also refers to the operations themselves (*tahûr*, or *tahâra*).[63]

Yet the circumcised female body is more: it is a metonym and an icon for embattled local society, an oasis of reproductive continuity guarded by its own scar tissue, compound walls, and the defensive efforts of local men.[64] The prostitute's body is its antithesis: she is a *sharmûta*, one who is tattered and parched like *sharmût*, meat that has been cut in strips and hung in the sun to dry. The *sharmûta* is "dry" or morally barren because she is physically and socially exposed, opened to the world like a man.

The axiom of distinct domestic and public spheres that prevails in riverain Sudan was a legacy of widespread slavery and the consequent emulation of pan-Islamic norms—perhaps too the realization of local ideals—that slave-holding allowed. However different in origin, it was consonant with the European notions of woman's place that were projected onto Arab Sudanese in the areas of education, law, and health, as we shall see. And as with slavery, colonial efforts to eradicate pharaonic circumcision were often undermined by other measures that supported it, that adventitiously confirmed indigenous understandings because they drew on their obvious forms. Before considering such endeavors, let me continue to sketch the economic context in which they were conceived.

Labor, Discipline, and Cotton

In much of Africa the problem of recruiting labor for colonial projects was solved by impoverishing self-sufficient farmers: levying taxes payable in coin and taking the best land for European plantations. Colonizers often benefited from indigenous "female farming systems" of the sub-Sahara, in which women perform most of the daily agricultural work.[65] While women labored on subsistence farms, a government-imposed need for money drew men into cash cropping, or to places of paid employment in a pattern of cyclical migration. Wages were low, in part because workers' daily needs were underwritten by women's productive toil. Thus African women effectively subsidized colonial projects: as local self-sufficiency declined, they assumed the function "of reproducing the labour power of a cheap and flexible labour force."[66]

The situation in northern Sudan was different, though a similar form of semi-proletarianization was what colonial authorities sought.[67] Agriculture was both land and labor intensive, yet slavery had released women in more prosperous peasant families, and many men, from manual work.

If from the start the British had set taxes high, enforced their collection, and made them payable in cash, people would have been compelled to make their farms more productive and sell surplus produce or forfeit their land, as had happened under the Turks. Presumably, weather conditions, inheritance rules, and the like would have conspired to create a pool of wage workers out of escaped or liberated slaves and dispossessed landowners: the makings of a proletarian class.

As desperate as they were for labor, administrators in Sudan were also fearful of letting an unruly proletariat emerge. Moreover, in the interests of peace they were loath to challenge Muslim sensibilities on the ethics of slavery or women's roles. Instead they sought to generate a group of "gentlemen farmers" by dividing and registering land. Even common lands were broken into individually held plots with an eye to building "a contented class of small landowners."[68] These measures, along with low taxes, agricultural subsidies, and sustained domestic slavery, were meant to help the agrarian economy recover. But authorities went further: within a decade of conquest they were encouraging exports of *dura*, the staple food, in an effort to induce continuous production and nudge commercialization along. The surplus of a bountiful harvest in 1909 was therefore sold rather than stored. This led to widespread shortage when yields fell steeply during the drought of 1911–13. Though grain was imported from India, the message was clear: the dread of hunger would surely prime the population for steady and diligent work.[69]

At the same time as surplus farming was being encouraged and slaves kept on the land, Arab Sudanese were courted for paid labor. Here the paradox of colonial economics was clear: though Arabs were thought to have the best potential for steady work, few of them felt need of employment, because they held land or rights to the crops it produced. Thus they could be attracted to colonial projects only at high rates of pay and even then not for long stretches of time. The "labor problem" stemmed less from an absolute lack of manpower than a dearth of freeborn recruits who could meet British standards of discipline—a willingness to work dependably, without slacking off or returning home as seasonal duties or family obligations required.[70] Daly notes that "the point was reached before 1910 of unskilled labourers earning between 90 and 130 piastres a month while needing only 10 to 15 piastres to subsist";[71] predictably, men took to working part-time. Faced with labor shortages, government departments competed in offering ever higher amounts, further depressing levels of full-time work. Moreover, strong extended kin ties among Arab Sudanese meant that one wage earner invariably supported several relatives, excluding *their* labor from the market by default. Despite the efforts of officials in agricultural provinces, then, high wages continued to draw slaves rather than "Arabs" from the land.

The 1905 Vagabonds Ordinance was designed to control the "unproductive" urban populace and redress its leisurely habits of work. Attempts were also made to fix daily wages and encourage foreign immigration, to desultory effect, not least because of anticipated Egyptian fury over a potential influx of Asian recruits.[72] Labor remained expensive and relatively scarce. Then in 1914, Wingate triumphed in securing parliamentary loan guarantees to raise capital for the Gezira cotton-growing scheme, based on constructing a massive dam near Sennar on the Blue Nile. Though the project was suspended during the war, when construction resumed at its end the chronic need for labor became acute.

Plans for the Gezira Scheme, a vast, orderly plantation on the fertile clay plain between the White Nile and the Blue, had been under consideration for some time. The Sudan administration and the Empire Cotton Growing Association saw the region as a reliable, inexpensive source of long-staple cotton needed to make high-quality yarns and fine textiles, goods that the Lancashire mills, faced with growing international competition in the manufacture of cheap cotton wares, had lately begun to produce. In 1909 crop failures in Egypt and the United States exposed Lancashire's vulnerability.[73] Egypt was an increasingly uncertain supplier, as production there "had been static for ten years and practically the whole of the cultivable soil was already under cotton."[74] Significantly too, harsh treatment on Egyptian cotton estates had, since the late nineteenth century, provoked peasant resistance and contributed to political unrest.[75]

In Sudan's Gezira, cotton production would entail a highly touted partnership of government, local farmers, and foreign entrepreneurs—investors in the Sudan Plantations Syndicate and its contracted expertise. It was based on a tenancy model worked out over several years at Zeidab, a basin on the west bank of the Nile south of Damer, where in 1906 Leigh Hunt, an American businessman, had begun growing pump-irrigated cotton on a concession of 10,000 *feddan*s (1 *feddan* = 1.038 acres). The problem of labor vexed Zeidab at first; Egyptians proved unreliable and "West African cotton workers" (blacks from the southern United States) had failed to work out, as many of them succumbed to malaria.[76] But by dividing the land into tenancies under food crops as well as cotton, rather than relying directly on a hired workforce for time-sensitive tasks, the predicament of securing adequate labor could be left to Arab-Sudanese farmers themselves.

Forged in the desire to cut loose from Egypt's purse, the Gezira Scheme was a political venture as much as an economic one. Not only would the project—proposing to irrigate up to 300,000 *feddan*s within the first few years—compete with Egyptian cotton, it also called for diverting Nile waters on which Egypt's crops relied. Construction on the Sennar Dam began 1919, just as Britain's relations with Egypt sank to their lowest

ebb. In 1922 the scheme required further injections of capital to complete. Parliamentary guarantees for the needed loans demonstrated British support for Sudan and weakened Egypt's negotiating position on its status, left unresolved when Britain ended its protactorate in 1919.[77]

A Display of Reason

Whatever its implications for the colony's political and fiscal autonomy, the Gezira Scheme quickly became enveloped in ideological mystique. Here "modernity" and "progress" were writ bold upon the landscape, in a military grid of gravity-fed canals and monotonous flat fields worked by "gentlemen farmers" who were contractually bound to plant the same crops in identical seasonal rotation, compelled to toil in rhythmic precision to a schedule set by European managers and rigidly enforced.[78] In the Gezira, European rationality was brought to life for "indolent" subsistence-farming Sudanese. To many British, subsistence production meant poverty, and, consonant with Protestant belief, poverty resulted from sloth. The colonizers felt they had a natural right to make the land more productive if they could.[79] As Victoria Bernal observes, "Colonial officials could hardly describe the Gezira project without some reference to its 'rational,' 'scientific,' and 'modern' qualities."[80] Like Kitchener's Khartoum, the Gezira was an enclave of order, efficiency, and reason, surrounded by native chaos and neglect.

Conversely, just as tradition was called upon to authorize colonial projects elsewhere in Sudan, so tradition—as envisaged by colonial officials—was summoned to sanction arrangements on the scheme. *Sâqiya* dispositions were cunningly invoked as models for profit sharing that saw net revenues divided between "capital" (the syndicate and the state, 60 percent) and "labor" (farmers, including farmer-*owners*, 40 percent). Moreover, the syndicate was allowed to deduct all input and debt from general yields before determining the tenants' profit share, thereby leveling returns across the scheme and disregarding farmers' variable rates of success. Farmers were still individually liable for their debts, which were claimed against future profits.[81] The social and economic changes wrought by the scheme were further obscured by describing its mandatory farming methods as mere "improvements on" indigenous ones, despite profound differences of pace and the distribution of risk, to say nothing of chemical interventions, mechanization, and the appropriation of decision-making by British supervisory staff. Declared beneficiaries were to be "Sudanese families," for whom a guarantee of subsistence was deemed sufficient gain; they paid for it with raw cotton, from which they were entitled to dwindling profits and accumulating arrears.[82]

Further, to the British, "family" meant something other than it did to Arab Sudanese. Administrators saw conventional extended kin groups as inefficient, nepotistic, even morally corrupt; hereditary principles contributed, they thought, to Sudan's "failure to progress."[83] The scheme was intended to rupture such forms. Gezira landowners were obliged to lease their irrigable fields to government for ten piasters per *feddan* a year and received in turn tenancies of a size (initially thirty *feddan*s, later forty) cultivable by an "individual" tenant. "Individual" here meant a married man commanding the unpaid labor of his wife and children. By thus contracting each tenancy to one person's name, administrators sought to shift social relations in favor of "possessive individualism" and nuclear families, though variable compliance by tenants and less sanguine officials allayed the effects of these moves.[84] Moreover, at the outset, larger landowners could nominate tenancies for their sons and slaves as well as themselves. Women, Bernal notes, "were generally denied tenancies,"[85] even when they held title to government-appropriated land.

Thus in the Gezira, northern Sudanese gender relations and patterns of generational authority were being molded to those of early twentieth-century Britain, even as respect for "local custom" was proclaimed. Farmers who joined the project entered a revised world order. Yet they did so as vested participants; tenants were alienated not so much from the means of production as from its mode, its social configuration and techniques. They could be expelled from a tenancy for failure to conform, and if their work was deemed inadequate inspectors were empowered to recruit paid labor and bill the tenant's account.[86] According to Arthur Gaitskell, manager of the scheme from 1945, the syndicate was consciously devoted to "emancipating, by the opportunity of economic independence, the individual tenants from the control of masters and fathers to whom otherwise they would still have been subservient." Only "incidentally," he continued, was the process "enveloping them in a new dependence upon the Scheme" and its European personnel.[87]

Illusions of emancipation and economic independence sustained the rational world the Gezira Scheme was devised to both realize and represent. The Sennar Dam, an "engineering masterpiece," was seen as "the chief key to the economic development of the Sudan"—farmers, clearly, were not. Indeed, even skeptics such as journalist Odette Keun praised Britons for their generous "co-operation with the native," who, "abandoned to himself . . . would certainly never have succeeded. Not only is he ignorant, but he is nonchalant, with a child's lack of thoroughness and the real Arab lack of foresight." Tenants were subject to extraordinary levels of surveillance and control. "Up and down the immense plains, on horseback, ride the superintendents of the Cotton Syndicate, checking the sowing, the watering, the gathering and at last the burning of the stalks."[88]

Scheme's importance

Every plot was a cog in a great agricultural machine. One tenant's delay in completing a task could jeopardize the entire yield on which SPS officials had staked the relative autonomy of the country and the government itself.[89] Though small-scale irrigation began in 1923, it is significant that the Sennar Dam was completed and the project officially opened in 1925, soon after the murder of Governor-General Stack and the compulsory repatriations of Egyptian personnel described in chapter 5. The politics of the scheme was that of the Anglo-Egyptian rivalry, with British fears of rising nationalism and religious upheaval adding to the mix.

First results of the scheme were encouraging. In fact, good crops coincident with high world prices for cotton soon led officials to decry the "apparent decadence induced by the scheme's success."[90] The project created an enclave of relatively prosperous small farmers whose subsistence and more seemed assured; though worse times were to come, harvests were so heavy in the first few years that tenants could afford to hire costly seasonal labor, women were seen less often in the fields, and sons chanced rebuke for being idle.[91] Yet tenants were but a fraction of the country's population. The attention government directed to the Gezira wildly surpassed its inclusiveness.

The Writing on the Wall

In the early 1920s, finding labor to build the scheme and ensure a reserve of workers should tenants and their families fall short was problematic. Most rural folk were still reluctant to enter the labor market. Southerners were not recruited "for political reasons," and, according to Sikainga, by 1921 all available workers in Kordofan, Kassala, Blue Nile, and White Nile provinces were locally employed. Only the northern food-producing provinces along the main Nile remained. Indeed, to northern governors' chagrin, high wages offered in building the Sennar Dam had lured essential labor from those parts. Some of the migrants were land-owning farmers seeking a few weeks' work to "pay taxes when poor harvests made payment in kind difficult or unwise,"[92] or to finance a wedding, fund a wife's *zâr*. Others were former slaves.

Shortly after World War I, officials' continuing efforts to restrict the movements of slaves drew attention from antislavery activists in Britain, making the euphemism of "reconciling servants and masters" increasingly hard to sustain. Not all members of the Sudan Government concurred with the practice of assisting slave-owners. Two officers in Berber, one an agricultural inspector, P.G.W. Diggle, the other an assistant DC, T. P. Creed, campaigned vigorously to expose discrepancies between official policy and common routine. Early in 1924, Diggle submitted a scathing

report to Governor-General Stack describing the miserable plight of Berber slaves—toiling for "a bare minimum of food and clothes," prostituted by their owners, discarded in old age, arbitrarily refused freedom papers by rigid British personnel.[93] Diggle's account was rebuffed and steps were taken to silence him. He resigned and brought his case to the Foreign Office and Anti-Slavery Society at home.

Anticipating a reprimand, the government announced it would hasten the pace of abolition. At once "slaveholders began to raise their voices in objection." Conspicuous among the protestors were members of the religious establishment: the Grand Qadi, and the three prominent sectarian leaders, Sayyid ʿAli Mirghani, Sayyid ʿAbd al-Rahman al-Mahdi, and Sharif Yusuf al-Hindi, who sent a joint petition advising caution and restraint.[94] A new circular on slavery was issued nonetheless; yet its reiteration of the distinction between "slavery" and "domestic slavery" failed to satisfy the Foreign Office. Nor did it assure the League of Nations, alerted to the controversy when Diggle's allegations were aired in the popular press.[95]

The League decided to investigate. In July 1925 Archer, appointed governor-general after Stack's untimely death, responded to members' questions with groomed evasion: "the use of the term 'slave' in this connection is apt to be somewhat misleading," and followed with the usual excuse that freed slaves were inclined to become prostitutes and thieves. He quoted Lugard: "It is not a question of what we would like to do, but of what we can do to abate an evil without causing more mischief than we can cure."[96]

Brave words aside, the 1924 crisis had barely abated and a concerted attack on slavery just now must not have seemed opportune. With the Gezira Scheme newly opened and already under expansion, and the cotton crop needing a seasonal workforce to harvest and prepare, the shortfall of tractable labor was especially grim. Northern peasants drawn to the Gezira owing to drought in 1925 furnished a short-term solution, but as ever were an unstable source of supply. Workers imported from Egypt, Yemen, and Ethiopia were expensive. Moreover, recruiting foreigners entailed political risks. The Italian stonecutters who built the Sennar dam had been suspected of Bolshevist leanings and needed constant attention. Foreign workers also posed a medical threat, possibly entailing quarantine and endangering the health of British and Sudanese.[97] Yet freed and absconded slaves were considered erratic, diseased, and lubricious, while southern Sudanese were susceptible to Arab culture and Islam.[98] Instead, writes Sikainga, "from the government's perspective, what was needed was a landless Muslim population that would become totally dependent on wage employment."[99] Whence was such a population to come?

In answering this question, most scholars discuss how officials enticed the "Fallata"—the Muslim West African immigrants deemed more adaptable and industrious than Arab Sudanese—to reside continuously or for long periods near the Gezira Scheme.[100] Indeed Fallata, or Takari as they refer to themselves, provided most of the labor for weeding cotton when tenants were busy with subsistence crops, and later for harvesting the bolls.[101] But political, medical, and syndicate officials were divided on their suitability.

Fallata were popularly seen as embarked on the *hajj*. A government report from the late 1930s observed that they spent from five to seven years in Sudan where they provided "a valuable, possibly an essential, supply of labour." As most of the pilgrims were "accompanied by their women," children were born during the sojourn; this made it difficult for them to leave or work their way back west. Moreover, there was

> the appeal that the Holy Cities have for Nigerians. Many of them are reluctant ever to leave the Hejaz and when they do so, they choose as a residence the country nearest to it, where they will be at hand either to make a second pilgrimage or to await the apocalyptical events which they expect to happen at Mecca.[102]

"Fallata" who settled did so in central Sudan, within the northern limits for rain-fed cultivation between Kordofan and the Red Sea Hills.[103] The de facto, later proclaimed, "Southern Policy" banned them from the south,[104] while their expertise in rainfall farming kept them away from the dry lands of the north, but made them invaluable to Gezira operations.[105]

Arthur Huddleston,[106] governor of Blue Nile Province, was "the real protagonist" of "Fallata" settlement, or so wrote G. J. Lethem of the Nigerian government after visiting Sudan on a fact-finding mission in 1924–25:

> [Huddleston] is quite frank. Within five minutes of meeting me he said "I want to have a long talk with you about Fellata immigration. You see we want all the pilgrims to come through here and for about three-fifths of them to be available as casual labour on the Gezireh at two seasons of the year, not as actual cultivators for our own people are enough for that; and then we want the other forty per cent to settle in the Gedaref region where we want to go in for rain cotton and where we lack population.["][107]

Colonial officials in Nigeria objected and moved to expedite the *hajj* so as to hasten their subjects' return, for they were short of labor too.[108] Further, West Africans faced hostility from Gezira tenants who, given a choice, hired "less hardworking" White Nile nomads for seasonal jobs, offering them fodder plots as a portion of their pay so as to engage them in patron-client relations.[109] Fallata were feared by Arab Sudanese

for "their reputed . . . spells and witchcraft," and seen as unclean, disease prone, wily, and dishonest because pitiably poor.[110] Managers' occasional use of Fallata to discipline Sudanese tenants made matters worse: a tenant could be evicted from his holding for failing to meet contractual obligations only to see a West African installed in his place.[111] Willis of the intelligence department was especially opposed to land grants to Fallata in view Arab antagonism.[112] Not least, Fallata were widely reputed to be slavers.[113]

There was also the resurgence of Mahdism to consider: Fallata made up a notable contingent of the Mahdist Ansâr.[114] In 1908 Sayyid ʿAbd al-Rahman al-Mahdi had been allowed to begin cultivation on Aba Island, his father's refuge, in an effort to divert his attention from politics.[115] He was later granted the wood-cutting contract for the Sennar dam, and used the proceeds to build up his estates.[116] By the 1920s his plantations had "a virtually unlimited supply of free labor from his followers, who believed that working for the Sayyid would bring them *baraka* (blessing)."[117] To offset his advantage the government limited travel to Aba by West Africans and western Sudanese, and tried to establish a monopoly over labor by curtailing recruitment to private estates. The reining in of Sayyid ʿAbd al-Rahaman gained momentum, but little success, following Archer's resignation as governor-general and his replacement by Maffey in 1926 (chapter 5).[118] For present purposes it is enough to note that the West Africans' Mahdist inclinations, along with their disputed integrity and antagonistic dealings with tenants, to say nothing of Nigeria's insistence on having a prior claim to their work, strained their image as the saviors of the Gezira Scheme.

Arab Women

If "detribalized" former slaves were unsuitable workers and susceptible to Egyptian propaganda, southerners too unruly and receptive to Islam, and Fallata less than the comprehensive solution that Sudan officials had hoped, were other remedies to the labor problem proposed? Where would be found a vigorous, potentially tractable Muslim population that depended on wages to meet its needs? A local proletariat of a specific sort, formed not by measures so harsh that they provoked unrest, or concentrated land in the hands of a small and dangerously powerful elite, but still enabled a relatively "contented class of small landowners" to form the basis of the convalescent economy? It is here that we return to the issue of pharaonic circumcision.

Recall the prevailing conviction that Sudan had been severely depopulated both during the Mahdiya and before.[119] Even if figures were exagger-

reproduction of working class

ated to stress the enormity of prior strife, there had clearly been considerable misery, dislocation, and loss.[120] In the early 1920s most northern families held some farmland or a small herd, and fiscal policies gave little call for freeborn labor to be prized from its social context.[121] Eventually, the application of Islamic inheritance rules to newly registered fields could be relied on to produce fractionation, especially along the main Nile where arable land is hemmed by desert wastes. Still, if fractioning were to do more than reapportion finite resources, the population would have to grow, not merely reproduce itself. For presumably, in the absence of drastic inducements to work for pay, only when the limits of the land were reached would a reliable source of land-poor (not destitute) labor arise and reduce the north's productive and reproductive autonomy vis-à-vis the state. Yet the process could take generations: how to hasten it without inciting discord?

The concern to repopulate the Arab Sudan with productive, disciplined, and loyal Muslim Sudanese was a key motive behind the regime's vaunted attentions to education and health. Professionals in these fields were tasked not merely with swelling the workforce, but with schooling sensibilities, working subtle transformations at the level of bodies and minds. Muslim women were all but inaccessible to British political officers and civil servants, yet a transformation to "modernity"—however ambivalent and incomplete it would be under indirect rule—required that native women be enlisted as collaborators: their capacities for social and physical reproduction would have to be developed and improved.

But again, how? Arab women were seen as obstacles to progress in their own right, not merely because they were secluded and subordinate to men. In fact, the British regarded them as social agents, not the passive "victims of tradition" that some recent writers suggest.[122] Enlightened though this may seem, it was a dubious honor. Sudanese women were seen as "superstitious" and "irrational," failings that nurtured their support for such "backward" customs as the *zâr* and infibulation; here Arab men were all but absolved from blame. And infibulation, for its part, was held to inhibit population growth by sustaining low birth rates and high infant mortality. Women were thus thwarting British efforts to draw Sudan more firmly into the imperial stream and out from Egypt's shoals. They would have to be civilized.

Opening Moves

In February 1924, the very month that Diggle's accusations were laid, four months before the simmering nationalist crisis boiled over, nine before Governor-General Stack was killed, a circular was sent to all district

commissioners explaining female circumcision and outlining its effects. It seems extraordinary that field officers should have been ignorant of a practice at once ubiquitous and vital to northern Sudanese; if true, it exposes the social abyss between British DCs and those they ruled. The information in the circular had been compiled by Dr. Grylls of the medical department, "making use of Miss Wolff's notes"—referring to the founder of the midwifery school in Omdurman, about whom more in chapters to come. Though approved for distribution by the civil secretary, the circular had originated with Willis, director of intelligence, he who for political reasons was averse to relying on Fallata labor. According to MacMichael, it was the first time that female circumcision was given serious consideration as a problem for the regime.[123]

Grylls maintained that the operation makes for difficult childbirth and sterility. But "perhaps even more important," he wrote, "is the mental effect on the child when circumcised, as the shock is so severe as to be liable to cause serious mental disorder, thus further handicapping a sex that is considered behind the development of the men of the country."[124] The suggestion is elliptical: female circumcision engenders unreason, hence the backwardness and superstition that serve to perpetuate it and the reproductive problems to which it gives rise.

DCs were exhorted to give every encouragement to "enlightened natives who had begun to abolish or modify the custom." Islam should be marshaled to that end:

> The Mohammedan law which is universal in the Sudan is that excessive cutting is undesirable because it spoils the woman's complexion and interferes with the pleasure of the man. The idea of a connection between the female complexion and other organs is curious but widely spread and it is locally supposed that very deep cutting tends to make the face dry and it is much affected in some parts of Kordofan. Thus circumcision is not forbidden but it is meritorious to avoid it.[125]

The main obstacles to abolition were identified as "the old women" who "want others to suffer as they did." "They are ignorant, obstinate, brutal, and are quite capable of stirring up trouble, so that the only way to deal with them is by overwhelming public opinion." "Mohammedan men" on the other hand, realize that female circumcision is against their faith but need government help to stop it.[126] One detects here a slight but clever shift in officials' approach, consonant with the regime's self-image as champion of learned Islam and its efforts to appease sectarian leaders such as Sayyid ʿAli and Sayyid ʿAbd al-Rahman. Gordon's adversary has transmogrified. Now the fanatical savages who carry the burden of error are not spear-wielding Mahdists of Pears advertisements and palace stairs so much as their impious mothers, sisters, and wives. Still, as long as

pharaonic circumcision was practiced by Muslims, it spread as a corollary of conversion to Islam; conciliation with Muslim leaders thus fell short of opening the south or the Nuba Hills to their ministry.

In a memo accompanying the circular, Willis tellingly laid his motives bare:

> Setting aside the ordinary motives of humanity, the Government is deeply interested in the increase of population and I believe it to be within the bounds of accuracy to say that no very great propaganda with the male population of the country can be expected until the female portion of it which controls the children for all their early and impressionable years, is raised to a higher standard of mental and moral development, which seems impossible as long as the custom of Pharaic [sic] circumcision holds.[127]

MacMichael, in a "strictly confidential" memo to "H.E.'s [His Excellency's] Private Secretary," was predictably more reserved:

> I am entirely in sympathy with the objectives of Dr. Grylls and the Director of Intelligence have in view but emphatically I do not consider Governors and District Commissioners should be the channels of propaganda in the matter. They ought, in my view, to be extremely careful to steer very clear of anything of the sort which would tend to be construed as unwarrantable interference. On the other hand I think useful results might be achieved without any offence by the Director Medical Department instructing his officials in provincial hospitals and dispensaries in the sense described by the Director of Intelligence.[128]

H.E. agreed, but resolved to inform provincial officials about the methods of female circumcision "in the event of their being consulted or approached on the subject by any prominent or more enlightened native."[129] Medical staff were asked to use cases that came their way as opportunities to point out drawbacks of the pharaonic form: clearly, not all types of female circumcision were at risk of abolition, only those most harmful to reproduction.[130] The matter, suggested Stack, must be handled delicately, as "efforts to remedy the present state of affairs would be liable to misinterpretation unless backed by a stronger public opinion than is evident at present."[131]

A few days later, Dr. O.H.F. Atkey, the new director of the medical department (soon to become the Sudan Medical Service, or SMS), wrote to senior officials, conceding that the medical route was best:

> I think that the general improvement in the type and education of midwives throughout the Sudan, which is just beginning to take place as a result of the Midwifery School at Omdurman, is likely in time to have a beneficial

effect in this matter. Similarly, the establishment of a training school for nurses at Omdurman, and the subsequent provision of a better and more enlightened type of female hospital nurse . . . is also likely to favourably affect female opinion.

Indeed, he continued, gradual modification of the practice could be expected to follow the "gradual spread of education and enlightenment throughout the Sudan, and particularly among women."[132]

In April 1924, while preparations for formal negotiations over the status of Sudan were underway, Stack revised his position. His original memo had gone too far; more discretion was needed. Governors and DCs should take no initiative on the subject and give information only when approached.[133] Least welcome was a suggestion that the issue be tackled by *fatwas*—legal opinions of religious scholars—something the Grand Qadi (an Egyptian) had also proposed. Willis objected that this was unacceptable "on the grounds that [it] would excite opposition":

[A]n influential sheikh told me recently that he was unable to open his mouth on the subject because the women would not tolerate interference in their affairs and cared little or nothing for "Fetwas" and as far as his people were concerned, education of girls and inter-marriage with better-class women (uncircumcised) appears to be the only course. In a few words, the unstable sex fashion rules over religion.[134]

While both SMS and SPS officials favored a temperate approach to abolition, they disagreed on the role of pharaonic circumcision in obstructing population growth. Atkey, for instance, though he regarded the custom "as an extremely objectionable and dangerous one," doubted "its actual adverse effect on the birth and infant mortality rate," which he believed "to be relatively small compared to that of malaria or the venereal diseases."[135]

His opinion fell on disbelieving ears. In an agenda item mooted for the annual meeting of northern governors in 1925, Willis proposed that "an appreciable amount" of the half million pounds that Egypt was to pay as indemnity for the assassination of Stack,

should be devoted to Maternity Hospitals, nurses and trained Midwives, particularly from the point of view of combating Pharaic circumcision, inasmuch as this practice probably causes more damage to the health and fertility of the population of the Sudan than any other agency.[136]

The issue—too volatile for stricken and wary officials—was dropped; the lion's share of the indemnity was spent on laboratories and medical improvements, with the Gezira firmly in mind.[137]

Conclusion

The issue of female circumcision was caught up in the currents of nationalism, modernity, and capitalist development then coursing through Egypt and Sudan. For economic reasons the government sought to increase the population of Arab Sudanese. It would be necessary to educate that population, of course, away from its customary "indolence" and compelling reliance on kin, to the values of hard work, economic individualism, and "the importance of money as a means to civilization."[138] Over the next several years administrators would stimulate the cash economy by revising tax laws. They would aggressively promote what became Sudan's main consumer goods—tea, coffee, sugar, manufactured cloth—while manipulating their availability so as to regulate the supply of seasonal labor.[139] They would revise public education to favor technical subjects over academic ones, following a syllabus designed to induce compliance and quicken local desires for British-manufactured wares. Female education would soon be addressed, with government schools for girls beginning to supplement those run by the CMS, all with an eye to "elevating" the position of native women, making them into proper housewives concerned with hygiene, preparing and consuming introduced foods, giving birth and caring for more and healthier children in scientifically suitable ways. Through its secular medical missionaries, the regime would attempt to change indigenous lifeways affecting health—that is, fitness for disciplined work—while extending colonial surveillance into domestic space. Its pedagogic emissaries would attempt to colonize consciousness itself.[140] Beneath the rhetoric of indirect rule, beneath too the altruistic face of endeavors in education and health, lay a prosaic, utilitarian, and largely unexamined design to naturalize modernity and British ("humanitarian") ideals, thus to forge a new civil consensus through the subtle conversion of Sudanese bodies and minds. Salient to this project was the fertility of northern women, a potential to be tapped, amended, regulated, made more productive, all in service to the colonial state. But the task was politically charged. It launched a tacit struggle over the identity that Arab Sudanese womanhood expressed. These issues are addressed in the final section of the book.

PART 3

THE CRUSADES

TRAINING BODIES, COLONIZING MINDS

Here I am, standing in Mustafa Sa'eed's house in front of the iron door, the door of the rectangular room with the triangular roof and the green windows. . . . [T]he four walls from floor to ceiling were filled, shelf upon shelf, with books and more books and yet more books. . . . [T]he wall opposite the door ended in an empty space. . . . How ridiculous! A fireplace—imagine it! A real English fireplace with all the bits and pieces, above it a brass cowl and in front of it a quadrangular area tiled in green marble . . . on either side . . . were two Victorian chairs covered in figured silk material, while between them stood a round table with books and notebooks on it. I saw the face of the woman . . . a large oil portrait in a gilt frame over the mantelpiece; it was signed in the right-hand corner "M. Sa'eed."
—Tayeb Salih, *Season of Migration to the North*

"A Fatal Obstacle"

Recall that in 1924 Willis, as director of intelligence, had ventured that "the male population of the country" could not be expected to advance "until the female portion of it which controls the children for all their early and impressionable years, is raised to a higher standard of mental and moral development," which he thought "impossible as long as the custom of Pharaic circumcision holds."[1] In colonial thought, female genitals configured female minds, morals, and mothering skills; infibulation was both a sign and a cause of women's degradation. Implicit here was the alignment of body, morality, intellect, and development stage—the crux of early-twentieth-century social hierarchies, to say nothing of lingering views that a woman's mind is ruled by her breeding parts. Since their distorted genitals made northern women a cruel and unhealthy influence on their offspring, female bodies would have to be

"normalized" before they might reproduce efficiently and their sons learn to labor and consume in useful, rational ways.

In order to improve maternal bodies (a postwar global trend) the colonial state in the 1920s devoted modest attention to women's domestic education and health. The seeds of "civilization" might thus take root within Arab households and grow from the inside out.[2] British professional women were enlisted to plant those seeds in enclosed and hitherto enigmatic domestic space.

Later in the chapter, I describe how state schooling was directed toward making energetic and reliable workers of northern boys, and prolific mothers and modern housewives of girls. Likewise medical interventions. However disparate their methods and halting their success, medicine and education shared a goal of "native enlightenment." In 1908 Cromer had opined that "the position of women in Egypt, and in Mohammedan countries generally, is . . . a fatal obstacle to the attainment of that elevation of thought and character which should accompany the introduction of European civilization." Indeed, he thought, civilization would not develop if "the position which women occupy in Europe is abstracted from the general plan."

edu/ med = mod.

> The European reformer may instruct, he may explain, he may argue, he may devise the most ingenious methods for the moral and material development of the people, he may [try] . . . to graft true civilisation on a society which is but just emerging from barbarism, but unless he proves himself able, not only to educate, but to elevate the Egyptian woman, he will never succeed in affording to the Egyptian man, in any thorough degree, the only European education which is worthy of Europe.[3]

Timothy Mitchell observes that if, in Egypt, "modern political authority was to work through the forming and disciplining of 'character,' " then "the individual household . . . had to be transformed into a site of this discipline."[4] So too for Muslim Sudan. Yet while the European women engaged to realize the plan agreed with its disciplinary aims, some were unconvinced that civilizing efforts should stop so short. Take Ina Beasley, appointed superintendent of girls' education in 1939. Contrary to what she'd been led to think, Beasley found that Arab Sudanese men generally favored Western-style schooling for girls. But to her chagrin, they were not keen that their daughters become independent thinkers, wage earners, or "autonomous citizens," like herself. Rather, they should develop into "good" wives and mothers along European lines.[5] In making this accommodation, the men became unwitting arbiters of colonial desires. Mediations of both Sudanese men and British women were contradictory and ambivalent, subject to cross-cutting alignments of culture, gender, race, and class.

The focus of this chapter and the next is on British women who were employees of the colonial state. To a lesser extent I consider the work of missionary women too. Female government and missionary staff shared an objective: to improve women's well-being by eliminating all that was "backward" in local customs and beliefs. As advocates of practices that would ultimately further colonial ends and, it was hoped, undermine local ideals, they were government agents even when they quarreled with male officials or balked at their limited aims. They assumed that the reform of domestic routines (sanitation, cooking, the preferred position for giving birth, but especially infibulation) was liberating, morally uplifting for women, as well as useful to the state—remedial of low birthrates, high infant mortality, and habitual lethargy. And while their ministrations were often welcomed by Sudanese, the introduced practices could and did have newly subordinating effects.

Bodies and Minds

Early in the interwar era distinctions were drawn between health workers and educators, those who civilized bodies and those who civilized minds, with the latter ranked superior in terms of deference, perquisites, and pay. The disparity affected both British and Sudanese, but was especially marked between native teachers and medical midwives. This, despite their common purpose: to persuade women to inhabit their bodies differently.

Native teachers and midwives were taught to engage their charges through bodily practice so as to alter their sensibilities and tastes, modify their dispositions. The primacy granted to practice was luckily consonant with local forms of learning and self-transformation. In Hofriyat, for instance, body and mind, things and words, matter and meaning, are neither separated nor ranked in a Cartesian sense. One learns the Qurʾan by reciting it, performing God's words.[6] Islamic healing is a matter of drinking or inhaling those words: appropriate verses are copied on a plate in carbon ink then diluted with water and therapeutically drunk; or written onto paper that is burned and the smoke breathed in. Even the attainment of "reason," ʿagl (for ʿaql), is based on cultivating somatic dispositions together with cerebral ones. ʿAgl refers to social and moral sense or savoire faire: a person's implicit knowledge of her position relative to others that compels her to behave as befits a given social situation. To be ʿagila (reasonable, aware) is to have internalized the reciprocity of perspectives that inform moral sociality. Learning, whether social or religious (the distinction would be meaningless to villagers), is accomplished through bodily engagement with the world of which one is integrally part.

In a similar, if more individuated way, colonial educators sought to shape students' sensibilities by engaging them bodily in "character-build-

ing" exercises believed to result in steadfast work and disciplined, fruitful reproduction.[7] But while administrators endorsed such aims, they also thwarted them, owing to their principal, but irreconcilable mandate of encouraging ethnic authenticity as a means to indirect rule. Despite the need for a trained and compliant workforce, they were reluctant to erode indigeneity by letting Europeanization go too far. Rather, as we've seen, they nurtured "tribalism" by exhorting its expression in dress, language, deportment, and the like. Here pharaonic circumcision posed a significant challenge. It symbolized "indigeneity," yet was inimical to population growth and enlightenment, dependent as these were on "modern motherhood." Authenticity lost. Women would have to be reformed, their bodies made more intelligible, "almost the same" as Europeans', "but not quite."[8]

Still, if population growth and vigor were dominant concerns, why was infibulation decried, but not the prevalence of endogamy—marriages arranged between first or second cousins repeatedly, generation after generation—since European science held inbreeding to be unsafe? And why no great outcry over the circumcision of *boys* by unsanitary means? The answer: male circumcision and cousin marriage were customs strongly linked to Islam, which, however contained by the British, could not in the end be opposed. Infibulation, popularly allied with Islam but spurned by the ʿulama as un-Islamic, was shadowy ground.

In MacMichael's view, efforts to fortify native institutions that were compatible with "generally accepted canons of decency and justice" would fail "unless the beliefs and traditions upon which those institutions rest [were] fully understood."[9] Infibulation was judged incompatible, and ethnographic study of it not pursued. Indeed, the extent to which "useful" customs were entwined with "repugnant" ones may not have been clear. The categories were, after all, British, not Sudanese. Thus, while officials condemned infibulation, their approval of northern gender dynamics—overt male supremacy, patriarchal leadership, female subservience and domesticity—lent it unintended support.

In colonial Sudan, security needs came first, lest a religious or nationalist backlash catch the British unawares. Yet if political concerns could undermine health and education efforts to alter native subjectivities, they also thoroughly informed them. Below I tack between medical and scholastic "biopolitical" projects to show the underlying similarities in their pedagogical methods and goals.[10]

Medical Steps

Historian David Arnold observes that in British India the propagation of Western medicine "involved ideas and practices which need to be under-

stood as part of the exploratory and regulatory mechanisms of colonial rule."[11] His words are relevant to Sudan, but especially to assaults on pharaonic circumcision. Here I diverge from scholars who, attending to the tensions between health officials and administrators, distinguish medicine from politics in the colonial context. Heather Bell, for instance, in discussing biomedicine and midwifery in colonial Sudan, writes that:

> The government did not even view female circumcision primarily as a medical issue. Female circumcision was always first and foremost a politically explosive matter of "native policy" for a government whose top political priorities included avoiding any provocation of fundamentalist Islamic groups.[12]

Bell is not wrong, she describes the government position well. But to note that political concerns were pitted against medical ones and there let the matter rest conveys a problematic impression that medicine was (and is) apolitical, or that political officers did not think biomedicine useful to their cause. Colonial medicine cannot be separated from politics, even in the restricted sense of that term, for the two were allied in a deeply political quest for control over subjects' bodies and minds. Judith Snively, analyzing the female circumcision controversy in colonial Kenya (considered in chapter 9), reaches similar conclusions; in Kenya, the determination of missionaries and medical personnel to transform the lives of individual women was consistently overruled by an administration preoccupied with ensuring social calm. Yet these were equally political aims.[13] Still, in neither Kenya nor Sudan were positions evenly embraced; where female circumcision was concerned, administrative, medical, and academic personnel did not sort neatly into "pro" or "anti" intervention camps.

In 1920 the head of the Sudan medical department, Dr. Crispin, ostensibly due to "insistent persuasion" by the director of education's wife, Grace (Molly) Crowfoot, "after she had witnessed the barbarous customs at circumcision and birth,"[14] convinced the government to establish a school for midwives in Omdurman. It is telling that in colonial imagination the Midwives Training School owes its start to a spectacle of African barbarity. There were other, less openly acknowledged reasons for the move. World War I had just ended, and development projects put on hold for its duration were being resumed. Wingate's plans for the Gezira were under way, though he was no longer at the helm in Khartoum. Sudan's relations with Egypt were in a sorry state and cotton supplies uncertain. As noted in chapter 6, the internal labor shortage was critical. While the success of the Gezira Scheme depended on there being a steady supply of workers, the number of "tractable" Arab Sudanese willing to work for wages was alarmingly low. Further, the mortality caused by the influenza epidemic of 1918–19 had intensified government concern.[15] An ample, loyal, and disciplined population in northern Sudan was now more

midwives trained to ↑ labor force

needed than ever. Phrased in the language of humanitarian advance, and surely inseparable from this in officials' regard, the midwifery school was conceived as a means to achieve that end.

Civilian medicine had been practiced in Sudan since the turn of the century mainly by missionaries, not the state, and never on a large scale. In keeping with government policy, missionary efforts were concentrated among non-Muslims in the south, which was divided into denominational spheres (CMS, Austrian Catholic, and American United).[16] In 1900 Dr. Harpur, Reverend Gwynne's fellow CMS "pioneer," was permitted to open a small dispensary on the edge of Omdurman (chapter 2). His work, however, was "hampered by the reputation of 'poisoner,' " as the Khalifa had used physicians to that end.[17] Harpur was soon succeeded by Dr. Hall, who is credited with having gained the confidence of Sudanese and gradually increased the mission's reach; those "unwilling to endanger themselves" first tested his skills on their female slaves.[18] When Hall died in 1903 the clinic closed; it reopened in 1908. In 1914 it was replaced by a small, permanent CMS hospital, which, by 1921, was run by three British nurses and three doctors, one of them a gynecologist. Its facilities and staff furnished "temporal foundations" for the faith;[19] missionary medicine was a means, not an end. Hospital personnel leavened healing with prayers and "a Christian outlook,"[20] though proselytizing in public was, of course, still banned. Yet even in northern Sudan, missions received occasional state subventions for their medical and, more controversially, education work, as we shall see.[21] Though formally distinct, government and mission often collaborated and may not have appeared distinct to Sudanese.

By tending native bodies, the CMS hoped to convert descendants of Gordon's assassins, while the government sought to shield its British staff. Following the reconquest, military doctors were obliged to create enclaves of health for soldiers and officials in Khartoum, Atbara (the railway headquarters), and the newly built town of Port Sudan.[22] In 1904 a civil medical department was formed (later called the Sudan Medical Service), but given financial constraints, its work was confined to the region around Khartoum; army doctors continued to serve the south and "peripheral provinces of the north" that remained under martial control.[23] During World War I, army physicians were called to the front, and the medical department lost its military complexion. Bell suggests that the resulting professionalization of medicine in Sudan, along with the urgent desire to increase the colony's workforce, may explain the timing of Crispin's consent to found a midwifery school.[24] Thus the school was born less of idealism than postwar pragmatism, a shift in imperial priorities from medical enclavism to public health. Its purpose was to bring reproduction under closer scrutiny and control, while providing—and being seen to provide— compassionate care.

At the same time, Crispin's decision tied in with an emerging international movement to improve the welfare of women and children in the wake of wartime devastation.[25] The issue was advanced by the League of Nations, which looked beyond Europe to the colonized world as well.[26] Elsewhere in Africa, maternal and child welfare was the purview of Christian missions,[27] but the preaching embargo in northern Sudan meant that, aside from the highly circumscribed ventures in health and female education, such work would be done by the secular state.[28] Despite this, many charged with realizing the initiatives did so with Christian convictions in mind.

The "Wolves"

The first matron of the Midwives Training School (MTS) was Mabel E. Wolff, a British woman who had been born and spent much of her early life in Egypt. Wolff and her older sister Gertrude, who joined the school in 1930 having originally arrived in Sudan to train nurses five years before, were a formidable pair whom officials dubbed the "Wolves"— fondly and perhaps a bit archly, for the sisters were famous for their inability to take "no" for an answer. Compatriots described them as "intrepid" and "implacable."[29] One SMS doctor reminisced:

> To describe the Wolves as individuals of strong personality is a considerable understatement. Where anything connected with the welfare of the Midwives Training School was concerned they were absolutely irresistible, and it made no difference whether the opposition came from inertia in high circles or from the presence of old customs and superstitions among the people. . . . It was not long until the male Sudanese of Omdurman feared less to be brought up on a criminal charge before the District Commissioner, Major Bramble, than a private castigation from the Wolves, grim and eloquent.[30]

The sisters' background was lower middle class; their occupation as nurse-midwives was low status, if thought "worthy" by their countrymen; their school, also their residence, was in Omdurman, the native town; their professional lives were devoted to native women—the source of all that was deemed unprogressive about northern Sudan. On a personal level, the Wolffs were career women who had no discernible desire to wed and whose religious inclinations appear from their letters and talks to have been low church.[31] All this relegated them to the peripheries of colonial society in Khartoum, with its Anglicanism and decidedly upper-middle-class, university-educated, athletic, and above all, masculine tone.

Moreover, the Wolffs' work with native women centered on sexuality and reproduction—concerns that were indelicate if not taboo for both

British and Sudanese. They trained "folk" practitioners who dealt with the messy, bodily, feminine, "irrational" side of life—not only pregnancy and birth but circumcision too. And they bore the stain of their profession at home. In Britain medical midwifery had emerged as a formal occupation only decades before. The Midwives Act of 1902 required female birth attendants to be licensed and subject to (overwhelmingly male) doctors' supervision; thenceforth they were pressed to take medical training as well.[32] Yet many physicians, concerned to establish their own authority, actively discredited even trained midwives, portraying them as dirty and ignorant crones. As Mabel wrote to her family, "the English Drs. are all so blessed afraid of their positions. I would rather be an English char lady than a nurse or midwife in England."[33]

The Wolffs and their pupils were thus stigmatized despite their reliance on scientific technique. Female teachers and physicians were typically spared such taint. Still, the Wolffs' vocation and social class do not fully explain their inferior position in the professional and social hierarchies of British Sudan. Here the sisters' consummate realism, their willingness to adapt their methods to local practices and ideas (if only in order to change them) may well have played a role. I return to this further on.

To Britons, Arab Sudanese women consistently failed to behave in civilized ways. Remember how they were described by Kitcheners' men: "appallingly hideous," having hair "all dripping with grease."[34] And later, Kenrick reporting the views of SPS wives: "How the Arab women ever produced any children is difficult for a European to imagine. . . . [Their] "apparent determination . . . to continue to inflict ["the universal and barbaric practice of genital mutilation"] on the next generation is shocking."[35] Privately, the Wolffs shared these opinions to no small degree. Yet they were forced to wage daily battle against their effects. Funding for their work was insufficient, whatever good it was said to do. They were constantly obliged to defend their acolytes, appeal that graduate midwives be given adequate compensation and supplies. Their superiors voiced doubts for the school's success, believing that pupils might be "satisfactory when under supervision but lapse into dirtiness and carelessness when on their own."[36] Notwithstanding the Wolffs' achievements, the contradictions of their work mounted over the years, and, when they retired in 1937, their replacement, Elaine Hills-Young, radically changed the school's approach.

Before discussing the Wolffs' work in detail, several issues should be addressed. An appraisal of their techniques requires delving more deeply into the world on which colonial understandings encroached. We should also consider the methods and themes of colonial education, for the sisters regarded themselves as teachers above all. Not least, we should

examine how knowledge of Western medicine was disseminated in post-war Sudan, and why.

Colonial Medicine

At the end of WWI the focus of Sudan's administration shifted from pacification to economic development. The MTS was one of a flurry of practical training programs that got under way to support the change. In 1921 the medical department standardized a year-long course to transform hospital orderlies into assistant medical officers who would alleviate the shortage of qualified doctors by dispensing vaccines, staffing rural clinics, and reporting on "simple medico-legal cases."[37] Then in 1924, the best Gordon College graduates were admitted to the new Kitchener School of Medicine.[38] The first class of seven qualified as "general purpose" doctors in 1928. In 1926 a two-year program to educate women as practical nurses began, housed in the new government women's hospital in Omdurman and supervised by Gertrude Wolff.[39]

Thus science was enlisted to produce a fit and industrious population. Concerned officials had reported in 1913 that "infant mortality is excessive" in the Muslim north "as far as can be judged from imperfect returns." It was "still excessive" in 1914 with "recorded births . . . less than last year by 1,257." Since it was acknowledged that "birth and death registration is still very imperfect and applicable only to certain districts,"[40] the figures have little empirical worth but do reveal a preoccupation with counting native subjects and preventing their numerical decline. To that end, the British vaccinated against smallpox, controlled mosquitoes, and improved public sanitation especially in the towns. The last involved inspecting prostitutes for venereal disease. In 1910 a campaign against syphilis was launched when treatment with salvarsan became available; the infection had spread with reconquest dislocations and the presence of foreign troops, igniting fears "that unless it was checked the urgent need for an increase in population would be endangered."[41]

Despite efforts to control disease, expand food production, and establish peace, the northern population had not grown sufficiently by the end of the war to satisfy government needs. So it was that in the 1920s, medical and political staff lit on pharaonic circumcision as the cause. But there were other factors to consider. A woman's ability to reproduce depends on her mother's health while pregnant with her, as well as on her own from the time of her birth.[42] Thus if the nutritional status of Sudanese had been compromised during the Mahdiya, as we are repeatedly told it was, population decline would have been slow to remedy even had no other factors intervened—no new epidemics, famines, or social disruptions, no

slavery or pharaonic circumcision. It could well have taken two, even three generations for improved living conditions to result in a notable rise in viable births.

Moreover, conquest and colonial rule had altered disease patterns in Sudan by modifying the landscape and stimulating movements of people both within the country and across its porous frontiers. In 1921 Dr. O.H.F. Atkey, then senior medical inspector for Blue Nile Province, advised that increased rates of malaria were sure to follow the opening of the Gezira scheme. "It must be remembered," he wrote, "that during good rains considerable parts of the Gezirah are thoroughly malarialised. If the Gezirah is to support a considerable population healthy enough to work it must be drained."[43] It was not. Presumably, government thrift and the altered epidemiological profile of Sudan were what Atkey was alluding to when, in 1924, he ventured that low birth rates and high infant mortality owed less to pharaonic circumcision than to malaria and venereal disease (chapter 6).[44] But politcal staff were not convinced. Pharaonic circumcision was a convenient explanation, one that deflected blame from the regime and its prospective workforce of Muslim men onto Muslim women's "superstitious" natures and "degenerate" morals, the "backwardness" of Sudan itself. How much easier for administrators to reproach Sudanese custom than to recognize their own contributions to the labor problem they so desperately wished to overcome.

Steps other than medical ones were taken to enlarge the pool of available workers. We've seen how West African pilgrims—the Takari or "Fallata"—were encouraged to reside near the Gezira scheme, though Nigeria pressed a prior claim to their labor and some officials thought there were political and medical risks to settling them in Sudan. Further, after the political crisis of 1924, new attention was paid to boys' education; technical subjects were promoted over academic ones with a view to training dutiful replacements for expelled Egyptian staff (chapter 5). The trend away from literary education was consistent with government desires to prevent the rise of a Westernized pro-Egyptian elite and implement native administration. The accent was on disciplining bodies more than, or indeed as a means of, livening and shaping minds.

Girls' Education

This was also true of the limited steps taken to expand female education. The CMS girls' school started by Gwynne soon outgrew its Gordon Avenue quarters; by 1905 over one hundred pupils were enrolled at its new, larger site.[45] In 1906 the government rejected a petition by Sudanese and Egyptian parents demanding the establishment of a government

school for girls, only to reconsider when an article in a Cairo newspaper announced that "mission schools in Khartoum were trying to advance the cause of Christianity among Moslem girls." To offset the reproach, two classes for girls were added to the Khartoum *kuttâb* (elementary vernacular school) for boys. But the move was opposed by Gwynne, who reminded Wingate of his promise not to open state primary schools for girls so long as mission schools met government criteria (chapter 2). Gwynne threw down the gauntlet: "it would be a test to Islam to attempt to do for herself what Christian bodies were doing without any government assistance."[46] A compromise was reached. The two Khartoum classes were closed, and Babikr Bedri (a former Mahdist warrior), who, having reasoned that educated youths would seek foreign wives unless Sudanese girls kept pace,[47] was now granted permission to open an independent school for native girls, at his own expense, in the Blue Nile Province town of Rufaʿa.[48]

Bedri's school was "staffed by a venerable *sheikh* who taught Koran, religion and the rudiments of reading, writing and arithmetic and a village woman who taught native embroidery."[49] Several other private girls' schools were soon begun; the state reserved its resources for educating boys.[50] For several decades this was the way matters stood: a limited number of government schools for boys, an even more limited number of private religious (Christian and Islamic) schools for girls.

By 1912 there were three CMS girls' schools in the principal towns of northern Sudan: Khartoum, Omdurman, and Atbara.[51] Another opened that year in Wad Medani.[52] Though CMS teachers urged Muslim girls to attend, the institutions drew mainly non-native Christians—Egyptians, Syrians, Abyssinians, Greeks. Only the school in Omdurman seems to have enrolled more than a few Sudanese.[53] The missionaries, however, considered it "the most important part of our work in the Northern Sudan, in view of the influence it was exerting upon the Sudanese girls."[54] Girls' schools run by Austrian Catholic sisters in Khartoum, Omdurman, and Port Sudan were attended primarily by the daughters of European residents; there were American (United Presbyterian) Mission facilities in Khartoum North and Wadi Halfa as well. In 1912 the director of education put the total enrollment in mission girls' schools at 505 (in a population of over 2 million), while observing that the "missionary bodies . . . do not command the confidence of, perhaps, the most intelligent section of the [native] community—the Mohammedan Arab."[55] The curriculum was aimed "to help [girls] to become better wives and mothers, and through religious teaching to develop a purpose in life." Subjects included literacy, numeracy, home economics, child care, English, and ever controversial scripture.[56] Indeed the purpose of the schools was to provide "an

education with a Christian foundation and outlook,"[57] whatever the instruction supplied.

State ventures were more modest: by 1912 there were four state-sponsored *kuttâbs* for Sudanese girls, with 131 students in all.[58] The curriculum was basic and inconsistent. The principal subject was needlework, with reading, writing, and arithmetic taught "by the head-masters of the boys' schools in any intervals they can spare from their other work."[59] Eight years on, the number of girls' *kuttâbs* had risen by only one.[60] A major drawback was the lack of native women teachers, as it was unseemly for Muslim girls to be tutored by unrelated men.

A solution was struck in 1920, as part of the government's postwar development push. J. Dorothy Evans, a British educator who, like Mabel Wolff, had formerly worked in Egypt, was hired to organize a system of elementary girls' schools on an experimental basis for the Arabic-speaking north. The task entailed grooming a number of female elementary graduates as teachers, for which a Girls' Training College (the GTC) opened in Omdurman the following year. Again like Wolff, Evans was joined by her sister (Dora Evans) in 1925. According to Ina Beasley, the Evans sisters were "determined to avoid the over-literary bias of the Egyptian schools and to lay the foundations of a practical curriculum." Under their supervision, girls' elementary schools would be set up by popular subscription in towns and rural areas; district leaders were required to petition the government and supply "the names of fifty to eighty girls of not less than seven years old" whose parents had agreed they would attend.[61] By 1928 there were seventeen such *kuttâbs* "with an average [total] attendance of 1000 girls."[62] It was a promising if humble start.

The CMS, wanting to preserve its now fading monopoly and obviate government efforts,[63] in 1921 considered opening its own *kuttâbs* for girls in districts where the Society had primary (post-*kuttâb*) schools.[64] Six years later the CMS parent committee deliberated a "Report on the CMS Girls' Schools in the Northern Sudan," which advised streamlining efforts and concentrating on native areas.[65] In Omdurman, attendance by Muslim girls had fallen off as mission teachers "succumbed to evangelical temptation" and Sudanese parents complained.[66] The report counseled greater subtlety. Education for older girls should aim to instill "the desire for Social Service" in the CMS dispensary, hospital, and schools. In Wad Medani, the hub of the cotton-growing district, there should be a training course for *kuttâb* teachers, and *kuttâbs* for Sudanese girls to rival the government's "pro-Moslem" efforts. Then the coup de grâce: "the time is ripe," it advised, for a girls' secondary school in Khartoum.

[T]he vital question for the future of women's education . . . is the provision of properly trained teachers, women of strong spiritual character and powers

of leadership. Such alone can be provided through the Christian Schools, with their opportunities of contact and intercourse with Christian women of fine character, broad sympathies and high ideals.[67]

Gwynne, now bishop, was delighted by the idea. A high school, he felt, was likely to attract the daughters of cotton-rich Sudanese as well as those of Greeks and Copts. Intriguingly, he went on to suggest that should the reorganization occur, the government might be inclined to increase its annual £500 grant to the CMS for girls' education in northern Sudan.[68] Here we have new evidence: if the colonial administration indeed underwrote CMS efforts to provide girls "an education with a Christian foundation and outlook,"[69] then it could hardly deny collaborating in a project to imbue Sudanese women with Christian values. Nor could the ban on proselytizing have been more than a face-saving gesture designed to appease Muslim men—much as Wingate allegedly confessed to Gwynne in 1903: "[S]o much Christian idea and truth placed in a child's mind tactfully . . . will bring nearer the downfall of Islam."[70] Here lay implicit instructions for missionaries in northern Sudan and, through them, can be glimpsed indirect government efforts to weaken the hold of Islam.

The original CMS school in Khartoum was duly relaunched as Unity High School in 1928, financed by popular appeal to all Christian denominations, and grants from the government and the British Council. English was the only language of instruction, and "great care was devoted to domestic training, for much was hoped from a new generation of wives and mothers." The school was expected to make "a distinctively Christian contribution to the educational life of the Sudan: a qualitative contribution in character-forming and development of personality" that provided "noble standards of life and culture for the women."[71]

In the 1940s, J. Spencer Trimingham, head of the CMS in Sudan, observed:

> One of the important influences of Christian schools is that the missionaries seek to reach and influence the home life of the children by visiting after school hours. Other out-of-school activities, especially amongst old girls, now mothers themselves, are well-developed and consist of old girls' meetings, girl guide companies, net-ball teams, Bible study classes, needlework classes, preparatory and revisionary classes for teachers, and social service activities through a "Guild of Help."

While we do not know how many native homes and women were involved, clearly the CMS envisioned life-long domestic supervision under the aegis of the cross. Likewise, the evangelical American Mission mobilized "Bible Women" in the "three towns" and Wad Medani to:

give weekly lessons in reading and writing, with the Bible as the textbook, to Sudanese women in their own *hôshes*. They know, of course, that the women can never become Christians, but they hope to influence their home life and bring some measure of hope to lives condemned otherwise to the narrow boundaries of the *hârim* outlook.[72]

As for overt state efforts, Ina Beasley noted that the success of the teacher's college started by Evans in 1921 owed much to its respect for the modesty conventions of northern Sudanese. Each pupil-teacher was accompanied by an elderly female chaperone. Both were boarded in the school that, for its part, was a larger version of a native *hôsh*, or domestic enclosure. These arrangements and the realization that, once trained, instructors would live and work under similar conditions, ensured that teaching became a respectable profession for northern women. Fears that teachers would so flout convention as to become unmarriageable were surmounted by providing each with a dowry proportionate to her length of service if she left in order to wed. This was also a bid to reduce early teacher attrition.[73]

The requirement that prospective teachers live in the college enabled the British principal to oversee the personal habits and hygiene of pupils in her care. Girls between the ages of eleven and thirteen were admitted; their youth was seen as an asset; they were considered malleable, open to new ideas. At school they lived "in simple dormitories with the same kind of basic furniture as would be found in the average house."

> The students themselves were responsible for the management and cleaning of their rooms, laundering and care of their clothes, and were also expected to help with the preparation of food. This regime gave them valuable domestic experience and introduced disciplined and orderly methods into their lives.[74]

While a girl's "chaperone would undoubtedly be an old and conservative relative long past any possibility of change" who would try to contradict the "good habits" with which her ward was being infused, by the time of her appointment the young teacher would have experienced "three years or in some cases more of boarding house life, where she had been impelled firmly into decent, cleanly ways of living."[75]

Teachers were expected to disseminate these "cleanly ways" to elementary-level students. The curriculum was based on "two aims, literacy and domestic order." Topics "included native cooking by rather more orderly and less wasteful methods than in many homes with a striving after variety which could be obtained in most places," for which, Beasley notes, "Sudanese husbands were most appreciative." Girls were taught to sew, and all had made themselves a set of clothes by the time they finished the four-year course. "More than any notions of vocational training these

girls were to be encouraged to make things [so as] to be prised out of the distressing apathy of the generations of women, who spent their time 'just sitting,' frequently slatterns amid the squalor."[76]

Rationalizing native ways, instilling order and hygiene, eliminating "habitual indolence" and inertia, these, in addition to simple mathematics and Arabic literacy, formed the mandate of government schools, few and basic though they were in the interwar years. Until the late 1930s, when the De La Warr Commission counseled improvements, and for some years after that, female education was a preserve of the privileged few in the towns and larger villages of the north. In 1932 the education department admitted that "no more than 2/3 [of one] per cent" of girls were receiving an elementary education.[77] Lilian Sanderson, who taught in both pre- and post-independence Sudan, observed in 1960 that "30 per cent of the male population were literate [whereas] only 4 per cent of the women could read and write." Moreover, the absence of remedial facilities for women led her "to suppose that the disparity . . . [was] even greater than these figures show."[78] If girls' education was a means to social reform, its progress in Sudan was agonizingly slow and anything but inclusive.

Boys' Schools

Was the practical approach, the disciplinary training that Evans and her successors stressed, limited to girls? And did boys' education forge ahead while girls' made meager gains? Not quite. Despite the exigencies of postwar economic development, *all* native education deteriorated during the 1920s—the zenith of indirect rule—but especially following the political troubles of 1924. Yet by 1932 "if only for the success of native administration," both British and Sudanese had become increasingly critical of the education system for boys, with its reliance on nonstandardized, occasionally state-subsidized, rural *khalwa*s run by Muslim clerics, few of whom were formally trained (chapter 3). Sweeping reforms were advised by the chief inspector of education, G. C. Scott, who argued, "it was only through education . . . that the government could cure 'indifferent agriculture, fanatical Mahdism, disease-carrying dirt, female circumcision, and all the cruelty and barbarity of a backward people,' " a typical list of obstacles to progress in Sudan. Scott's recommendations, especially for more teacher training and technical education so as to adapt the curriculum "to the practical needs of the country,"[79] were quickly endorsed by a committee led by the education director.[80] Yet little reform took place until after Maffey resigned as governor-general in 1933. To the bitter end Maffey held "that few Sudanese possessed the 'requisite stability of char-

acter to turn their intellect to good account,' and this constituted a 'serious disqualification' for posts of responsibility."[81]

Reforms to boys' education got under way in 1934 with the opening of a native Elementary Teachers' Training College at Bakht ar-Ruda near Dueim on the White Nile, far from the distractions and political stimuli of Khartoum. The curriculum was similar to that set earlier by the Evans sisters for girls, but with a complementary gender bias.[82] Emphasis was placed on practical education, and creating a rural teaching service for the Muslim north in keeping with the country's agricultural character. In practice this meant teaching through local tradition in the interests of political stability, while cultivating boys' dispositions in ways useful to the state. A newsletter regularly sent to practicing teachers kept the Bakht ar-Ruda message alive. During the 1930s and 1940s, for instance, instructors were taught to extol "the importance of money as a means to civilization." Another bulletin tellingly counsels that a teacher's task is "not only to spread new knowledge but also to train the next generation to be enterprising and hard working." And to train it to want to consume: "Civilisation means, amongst other things, having more possessions—more furniture than the man in the grass gutia [hut], books, better clothes, a clock—and at a more wealthy stage, perhaps a car, a gramophone, a refrigerator, a radio." Before the luxury items, a clock, classic disciplinary tool, means to ensure punctual habits of work that bring newly imaginable rewards. To that end, teachers were urged to consider "what sort of things the civilized man should have in his house." The passage is worth quoting at length:

> [T]hose who have given thought to the difficult question of what are the characteristics of a civilized man are agreed that he hates ugliness and loves beauty and orderliness. His furniture must be of good design, his walls of a pleasant colour and perhaps decorated with pictures of suitable size and design, his books he will like to have decently bound and in repair. He will buy coloured rugs that are in general keeping with the rest of the room. His tea cups and plates will be chosen for their good shape and colour and so on.
>
> Now this choosing or designing of beautiful things is not easy. . . . If you are unpracticed you may easily choose something which attracts you very much for the moment but which after you have bought it, quickly bores you. People, who have been poor and therefore unused to this difficult art of choosing, often make this mistake when they first get money. They fill their houses with china, rugs, curtains etc. which do not agree together and which are very ugly to anyone who has thought a little and observed a little as to what is really beautiful and orderly.
>
> How then are we going to help the Sudanese boy as he grows up, to avoid wasting his money on things that are really ugly and instead choose what is beautiful and orderly? The most important . . . way to learn to appreciate

what is really beautiful is [by] trying to make beautiful things yourself. Hence both in the Elementary School and in the Training School Handwork lessons are giving boys opportunities for trying to make designs, use different colours, create varying forms in various substances so that by experience each one for himself may gradually form a standard of judgment.[83]

Sensible if patronizing as this sounds, note the seemingly noncoercive rhetoric of universal aesthetics, rationality, and individual choice. Native teachers were taught to shape pupils' sensibilities, cultivate their work skills, discipline their habits and material desires.

Still, even after expansion, schooling for northern boys was far from universal.[84] Moreover, officials remained convinced that the key to reforming male dispositions lay with the women, who control "the children for all their early and impressionable years." And efforts to raise women "to a higher standard of mental and moral development" were thought unlikely to bear fruit as long as pharaonic circumcision remained routine.[85] But childhood education was not the only or most immediate way to reform northern Sudanese. While very few girls went to school, virtually all would become mothers. A more direct and ultimately less exclusive approach, pedagogical as well as pragmatic, lay within the mandate of the MTS.

The Midwives Training School and Female Bodies

The trends in health and education outlined above suggest that during the interwar period the colonial government's political and biopolitical goals converged. Yet this was more wishful than complete, for despite the regime's support for efforts to generate healthy and disciplined workers, influence the next generation by shaping the sensibilities of prospective mothers, and "improve" the human and natural environments for intensive cotton cultivation, lingering apprehensions about the spread of Arab culture, Islamic enthusiasm, and Egyptian influence always tempered its moves. So too did London's demands for economic efficiency, especially during the Depression years. Though producing trained midwives was presumably in the government's interests, there were clear limits to how far officials were prepared to back the women trained.

The mission of the MTS was "to overcome, combat and improve harmful rites and customs" by instilling in native midwives a knowledge of simple hygiene and biomedical birthing techniques.[86] The agency so unflatteringly attributed to Sudanese women was here to be mobilized, coopted rather than suppressed in the cause of population improvement and control. Though there was ample skepticism of the venture's success, the

ennobling and training of midwives—*dayas*—was dual purposed, for it was they who performed pharaonic circumcisions, then cut through the resulting scar tissue to enable delivery, and restitched a woman's genital wound after birth. Because of infibulation, no birth went unattended in northern Sudan. Calculated or not, the practice thus ensured that women monitored each others' pregnancies and births. Midwifery provided a convenient entry point for pronatal colonialists, affording them a platform for preaching the morality of hygiene and benefits of Western medical technique.

The "barbarous custom" played endlessly on Mabel Wolff's mind, as her records attest.[87] But in a prescient move, rather than forbid midwives to continue the practice once trained, she taught a modified operation that was less physically destructive than the "full pharaonic" type. The improvised procedure was called *tahûr al-wasit* or *tahûr mutwassit*, "intermediate purification"; it involved removing the clitoris and parts of the inner labia, then stitching together the outer labia leaving a wider opening than had been customary for the passage of urine and menstrual blood. All this was to be performed with scrupulous attention to hygiene and "patient" after-care. Wolff's plan was to encourage medical midwives to spread propaganda against genital cutting, while introducing progressively milder operations until the custom died out or was replaced by the religiously permitted form wherein only the prepuce of the clitoris is removed.[88] The approach was designed to mitigate adverse implications of female genital cutting for both physical and social reproduction— motherhood in its widest political sense. If the procedure caught on, the midwife's role in childbirth would be undiminished, giving medically trained *dayas* a continuing presence in Sudanese domestic space.

Interestingly, the intermediate operation popularly came to be known as *tahûr al-hukûma*, "government" circumcision, in contrast to pharaonic or Egyptian (*tahûr faraowniya*, *tahûr misriy*) circumcision, which the Wolffs and fellow Britons vilified. The resulting distinction between "government" and "Egyptian" procedures is a perceptive arrogation of colonial imagery by Sudanese, with Egypt as the source of harm and the British as guardians of local tradition, rationalized and scientifically improved. Importantly, the antithesis between Egypt and Sudan affirmed by the colonial practice ensured the abiding relevance of infibulation as an identity marker for Arab Sudanese, and inadvertently justified its spread among groups less favored by the government than they.

Securing the demise of pharaonic circumcision was only a part of what the MTS was expected to do. Wolff had come to Sudan to introduce women to the elements of sanitation and biomedical birth, starting with the Muslim north. When the school opened in January 1921, there were only two pupils, a seasoned *daya* of seventy and the MTS doorkeeper's

wife, whom Wolff described as "young and fairly intelligent." By the end of the month she had persuaded two more to join the class, another elderly *daya* and a younger woman without prior experience. Wolff, whose Egyptian Arabic and unfamiliarity with "the customs and rites of Sudanese women" made communication with them difficult at first, also faced suspicion from practicing midwives who wondered how an unmarried childless woman of thirty could know anything about childbearing, let alone "Sudany deliveries."[89]

During my own first visit to Sudan I was forbidden to witness a birth because I had not yet wed. Births are important social events for women; female kin and neighbors of the mother-to-be are expected to attend and naturally I was keen to participate. I was told that it was having been married, having been legitimately tied to man who has opened and enabled one's body for reproduction, that distinguishes women allowed to attend a birth from those who must wait outside the room. It is unsafe for potent but unactivated blood (whether of the newly circumcised or the unwed) to come into contact with the "black (dirty, exhausted) blood of childbirth," for the unwelcome conjunction can provoke *nazîf* (hemorrhage) in the mother, and attract *zayran* who are drawn to genital blood and nubile girls.[90] In the area where I lived, midwives, whether biomedically trained or not, are generally regarded with ambivalence and a touch of awe.[91] They are powerful, not least because they must withstand the regular exposure to different forms of feminine blood—sexually charged and reproductively potent, or exhausted and defiled, sometimes both on the same day. Like husbands of the *zâr* possessed, they too are *boab*s, doorkeepers, those who control the charged bodily thresholds of the female sex. One trained *daya* I knew held periodic possession ceremonies lest her spirits, irritated by the stench of black blood, assert their priority and cause her to fall ill. Another listened to tape-recorded *zâr* refrains to soothe herself as she went about her daily tasks. Wolff's regular transgression of local boundaries may well have enhanced her reputation for indomitability with MTS pupils and clientele; but whether they saw the work of spirits behind the serious illness she suffered in 1929 is impossible to tell.

Wolff would have preferred to train younger women who, she thought, were more educable and would not yet have formed the "bad habits" of those who had already begun to work. The less than thorough training of traditional *daya*s—"very conservative, completely ignorant and extremely dirty"[92]—could, she believed, bring both the school and her methods into disrepute. Her immediate supervisor, Dr. L. Bousfield, Medical Officer of Health for Khartoum, felt that if existing *daya*s had "drummed into them" even a cursory "new knowledge of cleanliness," "the dangers of sepsis and puerperal fever [would be] greatly reduced."[93] While the

training of traditional *daya*s was a pragmatic concession Wolff was required to make, it did little to alter her compatriots' image of midwifery as the lowly calling of Dickens's Sarah Gamp.

Given the emergent status of schooling for girls, the MTS pupil who could read and write was rare. Moreover, existing midwives had learned to deliver by feel, and many of them, being older and prone to the ophthalmic disorders of desert climes, were blind. Traditional delivery methods made seeing difficult in any case, for it was customary for a midwife to work beneath a cloth—a *tôb* or woman's wrap—that was drawn over the abdomen and legs of the woman in her care. This of course was intended to meet the demands for modesty. And it afforded some protection against the harmful effects of seeing black blood. But it was also consonant with the sensory dispositions of northern Sudanese women, dispositions oriented not solely or primarily by visual reference, but also by texture, smell, the sense of space and one's bearings within it, indeed by the values, meanings, and ideas embedded in the objects and spaces of everyday Sudanese life.[94] Illustrating this point requires a detour from Wolff's pedagogy, but in a way that should help contextualize it, show how it was interculturally informed.

Thus I expand on some of the cultural imagery outlined in chapter 4. I remind the reader that this is spatially and temporally specific, gathered between the mid-1970s and 1990s from women in one three-village area of northern Sudan. Yet several women who spoke about the practices of pregnancy and birth, and the meanings of enclosures and blood discussed in this book, had been young and reproductively active when the Wolffs began to teach. While certain expressions have undoubtedly changed since then, and others may be new, I am reasonably confident that the ideas they hold are similar to those that shaped women's dispositions in the recent past. Other reports, by J. W. Crowfoot of the education department (whose wife, Molly, had attended women's "barbaric" rites) and Sophie Zenkovsky of the CMS, as well as the Wolffs' own ethnographic observations, lend credence to that view.[95] However partial, the discussion is meant to convey a general sense of indigenous images in order to consider in chapter 8 how they would have interleaved with those presented at the school.

Recall that in the region of the main Nile where I worked, houses and wombs are analogous in function and form. Wombs, moreover, share qualities with vessels used in mixing *kisra*, the thin moist bread that is the staple in northern Sudan. *Kisra* in turn is analogous in composition— male seed/flour combined with female fluid/water—to the body of a child. The vessel used for mixing *kisra*, in the past a *gûlla*, or nonporous pottery jar, now most often an enamel bowl (*korîya*)—must be impervious, such that the contents cannot seep out when the batter is left to prove. In these

features it resembles an infibulated womb. Likewise, eggs, foods enclosed in tins, and fruits surrounded by rinds or peels are prized as "clean" (*nadîf*), for the enveloping material conserves moisture and protects the contents from contamination. Hence the adage cited in chapter 4, "a Sudanese girl is like a watermelon"—not only "because there is no way in" as the saying ends, but also because like blood, the melon's protected flesh is moist, red, and clean. Consuming clean foods is said to "bring blood," red blood that strengthens female fertility. Foods that are white are also regarded as clean and said to increase the body's blood; those that are both white and enclosed (such as eggs) are considered especially beneficial. In chapter 4 I noted that a fetus miscarried during the second trimester is placed inside a *gûlla*, like the unfinished *kisra* it resembles, then buried in the *hôsh*. The unmarked grave is usually dug near the kitchen, the women's area in the back of the *hôsh*. The string of associations disclosed in chapter 4 can thus be extended; to "maternal body = house = village," add "*hôsh* = *gûlla* = womb."

Customs for handling other failed pregnancies are intelligible by this cultural logic. A stillborn is wrapped as a corpse and buried along the outer wall of the *hôsh* just to one side of the men's door, the *khashm al-bayt* or "mouth of the house." As the infant's body has emerged from the womb/house fully formed (formed by the womb's internal heat much as *kisra* is baked by the heat of a woman's griddle), it rests near the wall of the house/maternal body next to the door/orifice (*khashm al-bayt*/vagina) through which it has passed and its father (formally, legitimately) comes and goes. The *khashm al-bayt* also, recall, is an idiom for the descent line arising within the *hôsh*. The path of the stillborn babe is arrested in the womb; he does not enter "society," the world of other families, patrilines, and houses, for that requires breath, the obvious presence of a soul. Infants who breathe then die are buried like any other person, in the cemetery on the fringe of the desert beyond cultivated and humanly occupied space.

Such features of everyday logic in one region of northern Sudan are echoed in other parts.[96] I outline them so as to locate infibulation—the enclosure of the womb—in one historical and cultural order that made that practice possible, an order whose ideals and meanings must be "understood as positional values in the field of their own cultural relationships rather than appreciated by categorical and moral judgments of our making."[97] The values linked to infibulation outline a world where meaning resides in qualities that persons and objects share, where images do not condense to underlying truths but are themselves truths—iconic, recursive, nonreductive. Bodies and identities are inherently relative, implicating other bodies, objects, and humanly constructed space. Within this world infibulation is deeply naturalized, as it was when Wolff began to teach.

Undergoing infibulation profoundly affects a child's developing self-perception. Along with other routine procedures, like smoke bathing and depilation, that purify women's bodies, cleanse them, and make them smooth by means of heat or pain,[98] it develops her dispositions physically, cognitively, and emotionally, orienting her "to a particular universe of probabilities" and significances.[99] For the trauma of circumcision is not enough on its own to shape a feminine or masculine self, to propel it in prescribed directions. Clearly, the experience must be meaningful to those who undergo and reproduce it. Through exposure to the connections immanent in the practical acts and objects of everyday life, meaning is gradually built up and continuously reinforced. The routine tasks of fetching water or baking bread, which girls begin to do after their circumcisions, the errands between villages that boys are asked to run, even, perhaps, the simple, everyday acts of peeling fruit or opening a tin of tomato purée—all reverberate with unspoken messages. They are practical metaphors, means by which subjective reality is not merely expressed, but subtly realized and maintained, planted in bodily memory and periodically renewed. Girls, especially, are asked to relive their painful initiatory experiences as they mature: actually, when their bodies are opened and restitched with each delivery; vicariously, when they witness others' circumcisions and births; and metaphorically, with any procedure involving heat or fluids or the attributes detailed above. The panoply of correlations comes to light on cardinal occasions such as weddings. Yet they are not only invoked ceremonially. The very walls of a ḥôsh, its layout, thresholds, rooms, open spaces, doors, speak to the infibulated woman of her self. Indeed, she is housed within her own "body" when she is bodily present in the ḥôsh.[100] In many small moments throughout her working day informative values are restated and her dispositions reaffirmed. While not all domains of experience are as coherent in Hofriyat, the congruity and interwovenness of ideas that identify infibulation with womanhood and procreation render them especially powerful, compelling, and politically effective.

Viewed from this angle, female circumcision was not an obsolete or isolable "trait" that colonizers could extract from its matrix like a rotten tooth, or expect northern women to discard on outsiders' advice. Nor was it separable from male circumcision, however incommensurable the practices were to Europeans, arguing from a scientific perspective in which human anatomy is seen as ideologically neutral and historically transcendent—unmediated, culture-free. Indeed, as I suggested earlier, the apparent lack of attention paid to male circumcision, often performed on children in unsanitary conditions, shows that colonial interests lay less with the altruistic betterment of native health than with population growth—and, as male circumcision is religiously required, with avoiding

affronts to Islam. Moreover the presence of threatening foreigners in Sudan may have affirmed the protective value of infibulation to some of its advocates at least. Still, Mabel and Gertrude Wolff did not support a peremptory ban on the practice, but gradual elimination, as we've seen. As such they chose to work *with* rather than *against* local understandings.

The next three chapters look more closely at the campaign to abolish female circumcision in colonial Sudan, beginning with the Wolffs' gradualist approach, through the shift away from harm reduction in the mid 1930s, to repercussions of the law that banned all forms of pharaonic circumcision in 1946. The story weaves through political controversies and metropolitan demands for change, threats and fears of violence, a colonial murder, the emergent configuration of women's bodies as national symbols. Here events in Kenya and in Britain played decisive roles.

8

BATTLING THE "BARBAROUS CUSTOM"

> Perhaps we do believe in the superstitions [the European] men-
> tioned, yet he believes in a new, a contemporary superstition—
> the superstition of statistics. So long as we believe in a god, let
> it be a god that is omnipotent. But of what use are statistics?
> —Tayeb Salih, *Season of Migration to the North*

In his account of efforts to end pharaonic circumcision in Sudan, Har-
old MacMichael wrote that officials paid little heed to the practice
until the watershed year of 1924—the year of nationalist rebellion and
the killing of Governor General Stack, the year that state complicity in
slavery was exposed in the London press, one year before the Gezira
Scheme was formally launched.[1] Yet as we've seen, Wolff's work had
begun a few years before. In view of the expected volatility of circumci-
sion in the climate of pro-Egyptian revolt, overt political measures to curb
the custom were not attempted in the early 1920s, save to suggest that
DCs counsel against it if, and only if, they were questioned by Sudanese.
Toward the end of the decade, events in Kenya brought female circumci-
sion to international attention, a point addressed in chapter 9. Threatened
by these developments, the regime in Sudan voiced concern but little
more. Moreover, the world slump of the 1930s redoubled the thrift of
the Maffey-MacMichael government and intensified its reliance on native
authorities. In 1937 resolve to halt pharaonic circumcision was revived
under improved financial conditions, a change of executive, and a newly
appointed matron of the Midwifery School. From then until 1940, aboli-
tion efforts gained momentum as officials enlisted religious leaders and
educated Sudanese to lay the groundwork for a law. Efforts all but
stopped with the outbreak of World War II, but resumed with vigor in
1945. On January 1, 1946, performing a pharaonic or modified phara-
onic circumcision became a criminal offense. Ironically, the regime's volte-
face from cautious immobility to legal riposte had been enabled by the
Wolffs' pragmatic "harm reduction" approach.

In this chapter and the next I consider the uneven trajectory of the first two colonial campaigns against pharaonic circumcision in Sudan—their methods and means, the information on which they were based, the upheavals they faced as agendas clashed or coalesced. I discuss the impetus for a legal remedy in chapters 10 and 11. Each of the three phases reveals something of Britons' shifting cultural suppositions while detailing how and why they sought to orchestrate a transformation in northern Sudanese. To start, we return to the Wolffs and their legendary troubles with officialdom.

"Facts about Pharaoh's Circumcision"

When Mabel Wolff undertook to "combat harmful customs" in Sudan she may not have grasped the full measure of her task. Female circumcision was rarely discussed in polite company or official circles, though the restraint may have been more British than Sudanese.[2] Certainly there were administrators who, even after the intelligence circular of 1924, remained "officially" uninformed of the practice. One DC wrote privately to Wolff in 1937, "I well remember my feelings when I first came across the details of it myself."[3]

What, then, are the details? I have alluded to some of these in earlier chapters, but it seems useful here to discuss the full range of practices so as to clarify the form most commonly practiced in Sudan and its consequences for health. As noted in the introduction, the World Health Organization identifies three main forms of "FGM." Beginning with the least invasive these are:

A. Sunna *circumcision*, which WHO calls "circumcision proper": removal or incision of the clitoral "hood" or prepuce. This is the least common type, despite being labeled *sunna*, meaning "the way (of the Prophet)," often mistranslated as "traditional" or "orthodox." Since all Muslims follow *sunna*, the term may describe whatever is usual in a given Islamic society; in practice, it is often confused with excision and sometimes a modified pharaonic operation, described below.[4] Sudanese physician Nahid Toubia questions calling the *sunna* "circumcision proper," as she found no case of female circumcision "in which only the skin surrounding the clitoris is removed, without damage to the clitoris itself."[5]

B. *Excision or clitoridectomy*: removal of the clitoris and all or part of the labia minora (inner lips). In sub-Saharan Africa this form is the most common and geographically widespread.

C. *Infibulation* or *pharaonic circumcision*: removal of the clitoris (sometimes not in its entirety), plus all of the labia minora. The labia

majora (outer lips) are then pared (more or less completely) to create raw surfaces that are stitched together with silk, suture, or thorns, leaving a sheath of skin that covers the urethra and partially blocks the vaginal opening. A narrow implement such as a reed inserted in the wound ensures that a small passage is left for urine and menstrual blood. A resilient layer of scar tissue forms and the genital area appears relatively smooth. Upon marriage a woman may need a midwife to widen her vaginal opening, and when she gives birth someone must cut through the scar to release the child. Infibulation is the most severe procedure and accounts for some 15 percent of cases.[6] It is the principal form practiced in northern Sudan.

The above types are only approximations. The techniques of operators (who may not have medical training) vary tremendously, groups have distinct preferences, and practices evolve. In Sudan, for instance, the Wolffs encouraged a modified and partly medicalized form of pharaonic circumcision that, over the years, gained considerable ground. On the strength of informants' contrasts between their own and their daughters' operations, it involved less cutting of the labia than before; moreover, only the forward parts of the outer lips were joined, resulting in a larger genital opening.[7] A compromise between *sunna* and infibulation lately practiced in urban Sudan is called "*sunna magatia*"—likely meaning "*sunna* with amputation": after the clitoris is removed, the labia minora are roughened and lightly stitched to provoke adhesion; the form is also known as a "sandwich."[8] Ellen Gruenbaum reports a newer operation in which the clitoris remains uncut but is sewn beneath a small flap of tissue. This resembles a procedure I was told of in the late 1970s where the labia majora were (reversibly) joined so as to enable otherwise intact girls to save face before their infibulated playmates at school. According to one of Gruenbaum's midwife informants, the increasing demand for (actual) *sunna* operations that followed the 1989 Islamist coup in Sudan was nonetheless accompanied by a request for some covering of the urethra "in order to avoid the sound of urination, which is considered unfeminine."[9] For northern women it is important that the genital area be "covered" or veiled. Adaptations of the pharaonic procedure can take place because men's ignorance of women's uncircumcised bodies and of what the operations entail gives women space in which to maneuver and still behave appropriately.[10] That said, many Sudanese women request re-infibulation after every birth because they "feel naked," impure, or ashamed when no longer "closed."[11]

These are not harmless procedures. It is sadly ironic that a custom intended to defend women's fertility can actually damage it. Yet paradoxically, the practice has had little effect on *overall* fertility rates in Sudan,

where women average six to seven live births each.[12] Colonial officers were not convinced of this, as we have seen.

Immediate complications of infibulation may include hemorrhage and severe pain, which can lead to shock and death.[13] Blood loss can result in anemia and impair the growth of an already poorly nourished child.[14] Septicemia and tetanus have been reported: even when performed by trained midwives the operations may take place under unhygienic conditions.[15] Physicians have performed infibulations in hospitals or clinics, believing that with antiseptic conditions and skilled techniques children will suffer less than in the hands of untrained operators.[16] Yet once the practices are medicalized their perpetuation seems assured, and WHO has vociferously discouraged the involvement of health professionals except to offer repair.[17]

Death from the operation itself is far less common than long-term complications resulting from interference in the drainage of urine and menstrual blood. Many Sudanese women I met suffer frequent urinary infections,[18] which may contribute to miscarriage and infertility. However, as Gruenbaum notes, "The most severe, life-threatening, long-term complication of infibulation is obstructed labor. Fibrous, inelastic scar tissue across the vaginal opening may require excessive bearing down during the second stage of labor, exhausting the mother and stressing the infant."[19] I would venture to say that no one who has undergone the procedure is unaware of the suffering it can cause; this does not mean, however, they consider it dispensable.

Yet in 1921 Wolff was optimistic, writing in her inaugural report "that constant teaching will, in time, have an effect in influencing the younger generation and the trained Diayas [midwives] against the barbarous custom."[20] Where other Europeans were reluctant to discuss the practice, she was unafraid, if fettered at times by decorum and government interests. Invited in 1922 to address the British women's Guild of Service in Sudan, she spoke briefly about the midwifery school, then launched into a discussion of "a very barbarous custom." Both pharaonic and sunna circumcisions, she said, "are a great shock to the young girl's system & Pharaoh's Circumcision necessitates at child-birth an unavoidable wound which often is the cause of puerperal infection and much useless suffering to the lying in mother." Wary of causing alarm, she paused, "If you would like me to give you more particulars of these customs . . . I should like your approval first!"[21]

She then described a procedure "called 'Sunnah' which is performed in Egypt & is allowed by the 'Koranic' law," wherein the clitoris and labia minora are removed. While she was correct that excision is often referred to as "sunna," the only form of female genital cutting admissible under Islam, not required, involves nicking or cutting the clitoral

prepuce, no more. Wolff declared that Sunnah "when healed causes no further trouble."

> [T]hough the operation is naturally painful and a certain shock to the child, I have rarely seen in all my experience in Egypt or here in Omdurman any very serious after effects, unless performed by a very unskilful person, and this operation does not interfere with the urinary or vaginal orifice.[22]

These are revealing comments. Wolff's concern lay less with removing sensitive tissue than obstructing the birth canal. What she calls "Pharaoh's circumcision" is, she noted, far more traumatic. Not only does it require cutting away the clitoris and labia minora but also "making a raw surface on either side of the labia majora."

> [I]n order that the parts may adhere together a piece of tissue paper, generally cigarette paper, & the white of egg [are] used as an adhesive; the girl's legs are then tied together in several places & if no complications set in she remains lying for seven or more days. . . . [T]he shock to the poor child's system is tremendous & the manner of doing the operation is brutal as no anaesthetic is used & she is held down by force[;] frequently haemorrhage, retention of urine & a supperating wound is the result. This is only the beginning of the girl's troubles however for at child-birth to enable her to be delivered the cicatrice has to be cut open by a razor, some of the openings being no bigger than an eyelet hole.[23]

There is hyperbole in Wolff's remarks, as her terms "brutal" and "frequently" show; hemorrhage, for instance, was always a terrible danger but less common than she implies.[24] Clearly, Wolff was appalled by the pharaonic practice, and sought also to kindle her listeners' ire. Yet her muted concern for excision conveys that its effect on sexuality was less grave than the threat of infibulation to safe childbirth, maternal health, and infant survival—problems for individuals and populations, both. Reproduction, after all, was Wolff's stock in trade and childbearing women her ken.

Intriguingly, the implied superiority of womb over clitoris, emblematic of the moral contrast between the maternal and the sexual, the civilized and the retrograde in British society of the day, echoed Sudanese understandings. Yet to Sudanese it counseled *for* infibulation, not against. Indigenous precepts enjoined protecting the womb—a vulnerable social space—by physically containing it, even, perhaps, at the cost of a woman's sexual response. It goes without saying that both Wolff and the Sudanese women with whom she worked desired successful pregnancy outcomes. However, their views of what counted as success—for Wolff, statistics showing an increase of healthy offspring and mothers; for Suda-

nese, the production of virtuous women and morally entangled kin—did not altogether converge.

Wolff considered it particularly cruel that women should fear childbirth because of the razor, "the instrument of torture," for cutting was required even for routine deliveries. Fright, she noted, "frequently delays labour and at times at the actual delivery the patient becomes quite hysterical and maniacal and has to be forcibly held." Moreover, "owing to the thick scar tissue, adherences, and to the parts, through the mutilation, being abnormally tight and narrow, it is with the greatest difficulty one is able to deliver the child alive, and without pereneal laceration and severe bruising of the mother." And then there was the "remedial operation" whereby a few days after childbirth the traditional *daya* "resealed" the mother's circumcision wound by:

> drawing it together with a thorn which naturally festers, or else she applies a V shaped splint made out of a bent piece of reed and keeps it in place by tying the free ends together. . . . Needless to say the wound invariably becomes infected, inflamed, offensive and sloughing, resulting in agonizing pain when micturating, so that the patient refrains from micturating for three or four days, and the over distended bladder pressing on the uterus causes needless suffering.[25]

Unlike members of the SPS, Wolff became convinced that husbands shared blame for these acts, a view that Gruenbaum's subsequent research supports.[26] But much as Wolff sympathized with women's plight, she did not consider them victims:

> Usually after the birth of a second or third child the opening is reduced, so as to oblige the husband to pay all sorts of bribes. Occasionally the husband does get annoyed, and I actually know of a case where the irate husband on finding his wife had had the remedial operation . . . took his knife and slit her up causing severe haemorrhage and injury.[27]

I have been quoting here from "Miss Wolff's notes," actually a formal memo, used by the head of the medical department (Dr. Grylls) and the intelligence director (C. A. Willis) when composing their circular to DCs on the custom's destructive effects. Wolff's *Facts about Pharaoh's Circumcision*, was dated February 13, 1924; Willis's circular was drafted February 17, 1924, and two days later submitted to the civil secretary and governor-general for approval. Attached were Willis's comments, quoted in chapter 6, advising that since "the Government is deeply interested in the increase of population," "propaganda" should now be undertaken to stem the "Pharaic" practice. [28]

But MacMichael, the power in the civil secretariat,[29] shrank from taking the steps advised by Willis and Grylls. The governor-general, Stack,

decided against a propaganda campaign but consented to inform provincial officers of the procedures "in the event of their being consulted . . . on the subject by any prominent or more enlightened native." He further advised medical personnel not to hesitate in using actual cases to explain the harms of "the Pharaonic method."[30] Excision, Wolff's "sunnah" operation, was obviously exempt. This was the way matters stood at the end of February 1924. Indeed, on March 1, Atkey, newly appointed director of the SMS, minuted approval of the medical initiative. He cited the good work being done by the Midwifery School and foretold the custom's disappearance with the gradual spread of female education.[31]

But by April, Stack had abjured this position."[32] As senior staff prepared to negotiate with Cairo and London on the outstanding issue of Sudan's future status, they grew apprehensive about being seen to meddle in religious affairs, however doubtful the religious dimensions of the practice to scholars of Islam.

Willis's memo had addressed the question of religion, noting that "[female] circumcision is not forbidden but it is meritorious to avoid it." He had gone on to say that older women who want others to suffer as they did were the principal obstacles to change. Men, he had claimed, while aware that pharaonic circumcision contravenes their religion, were unable to stop it without government help.[33] Note the subtle difference between this image of Sudanese men and that held by Wolff, for whom men were complicit in both initial and postpartum procedures; in support, she produced several handwritten requests from husbands that their wives be tightly restitched after delivery.[34] Yet, to male officials, blame lay with Sudanese women themselves, whose powers over children and thence adult sons were thought to be compelling. Note too the state's adopted position as defender of orthodox Islam.

Wolff's February *Facts* underwent revision in March 1924, and in the final version—evidently approved for circulation to senior officials—some telling elisions occur. The first draft states:

> After delivery, there is always this unavoidable external wound to deal with; *the midwifery school trained midwives are taught to suture the wound and treat it as aseptically and antiseptically as possible*; the untrained midwives' mode of treatment is, on the second or third day to draw the wound together with a thorn which naturally festers.[35] [Italics mine.]

Compare it to this, the amended version:

> After every delivery there is always this unavoidable external wound to be dealt with, as *the patient or her relations insist* that the wound shall be made to adhere together again, so that no child can be born without the aid of the

"razor" and very frequently the husband has to have recourse to it too.[36]
[Underlining in original, italics mine]

Aside from minor clarifications and the title—where *Facts about the "Circumcision" of Girls* replaces *Facts about Pharaoh's Circumcision*—this is the largest change to the second draft. Yet it is a significant one. For we are told that women and their kin demand re-infibulation, and, reading between the lines, if MTS midwives perform it, they do so under duress. More importantly, any acknowledgement of trained midwives' collaboration in the practice has been expunged from the authorized text. Wolff does not account for the omission, but other documents reveal that the sisters were obliged by senior officials to keep quiet about teaching midwives to perform more hygienic and less severe infibulations and remedial operations.[37] For if this became widely known, Sudanese nationalists might raise the bogey of cultural interference, and British at home might learn of the regime's apparent collusion in prolonging, not just slavery, but female circumcision too. Official support for Wolff's methods was always tacit, and government deniability maintained. Here, surely, was one reason for administrators' ambivalent regard for MTS midwives and the Wolffs themselves.

MTS Methods, Truths, and Consequences

What specifically did the sisters do? They were charged with two duties, first, to inspect practicing *daya*s (traditional, also later trained) to ensure they were licensed, equipped with basic supplies, and were maintaining (via male amanuenses) registers of their cases so the medical department could "keep some slight control or track of them;"[38] and second, to instruct as many practicing and prospective *daya*s as the Omdurman school could receive in hygiene and biomedical technique. Their papers suggest they took heed of pupils' experiences and taught by invoking their embodied memories. They did not try to make pupils literate, but used images that first summoned, then sought to reform women's prior sensory dispositions. They taught in Arabic, incorporating words from "women's vocabulary."[39] They built discursive bridges between local understandings and their own by creating scientific analogies to the objects and acts of Sudanese daily life with which women's bodies are linked—though how far they grasped that relation is not clear from the evidence at hand. By these means they devised an ingenious and powerful synthesis of biomedical and lay techniques that bent to local custom even as they strove to undermine it.

While the strategy of linking lessons to women's daily lives was hardly novel or unique, it may well have foiled the sisters' wider aims. In a report

about her first year's work, Wolff wrote, "I illustrate by local colour all their lectures as I find they understand and assimilate them better,—viz. in giving them an anatomy and physiology lesson I compare the body to a house and the organs [to] the furniture—the functions of the lungs as windows that air the house etc. etc."[40] She lectured, "the body resembles a furnished house and all the contents have a special use."[41] Did students experience a shock of recognition? Or were their responses subdued, the wisdom so recognizable and banal, so matter-of-fact? For these were analogies they could readily understand, a native "house" (*ḥôsh* or *bayt*) being not just homologous with the body of a woman in local thought, but with an *infibulated* body at that. Wolff did not invent this association but, unwittingly perhaps, invoked it. Student midwives may well have gleaned from her classroom images that their much maligned "common sense" was more modern than they were told. Or perhaps that Wolff understood things as did they. Undoubtedly students creolized instructional terms,[42] creating notional malapropisms—at least from the sisters' point of view. To the Wolffs any resonance between local ideas and biomedical constructs was fortuitous or heuristic, not sincere. Their mission remained uncompromised: to substitute rational science for harmful practice and fallacious belief.[43]

In steps consonant with their nonliteracy and multisensory predilections, students were taught to identify chemicals and drugs not only by sight but also "by touch, smell or taste." Container shape and color were wisely deemed unreliable.[44] They were taught how to wield scissors using "pieces of motor tyre . . . for practising slitting and suturing the vulval obstructions resulting from ritual circumcision."[45] They practiced delivery with "full antiseptic precautions and prolonged washing"[46] on a realistic, if uninfibulated, papier-mâché model (known as the "Phantom") with movable parts and resident fetus. They learned infant bathing by handling articulated Caucasian baby dolls. (Photographs do not reveal whether the bodies of the dolls were flawlessly enclosed like women's bodies were, though this seems reasonable to suppose.) What the Wolffs could not teach by somatic means, students were required to learn by rote.

Equally central to Wolff's pedagogy was hygiene. "The first lesson a midwife must learn," she exhorted, "is the importance of good manners, morals and cleanliness." Cleanliness was demanded of the midwife's person, hands and nails, plus children, husband, house, midwifery equipment and work.[47] To Wolff, as Bell notes, "cleanliness" meant more than the material absence of dirt and germs. It was, in itself, a moral state.[48] In this one detects the impress of Christianity, where washing clean is an idiom of social and spiritual "enlightenment." Thus, Wolff counseled, "You must remember that in midwifery there are two or more lives dependent on

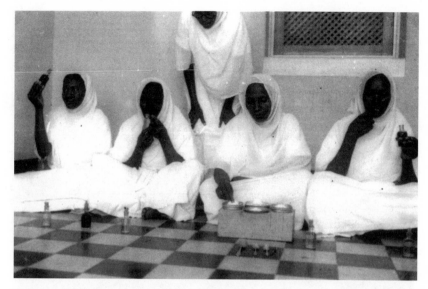

Figure 4. Learning to recognize by sight, smell, feel and taste. SAD 583/5/31 (Wolff photographs). Reprinted courtesy of the Sudan Archive, Palace Green Library, Durham University.

your skill and care, each baby you help from darkness to the light of Day, is a gift from God and you should be at all times worthy to receive it."[49] The image was at once Christian and Muslim Sudanese: an infant is indeed considered "Allah's gift," who, in being born, moves from the darkness of the womb (enveloped by exhausted "black" blood), into the social world, toward divine Light (Nûr, one of the names of Allah). Thus, in Wolff's inaugural lecture, addressed to each new class of recruits, Islam and the northern Sudanese principles of morality, purity, and bodily cleanliness with which it is entwined were at once invoked and deposed, for to be truly worthy of receiving "Allah's gifts" a midwife needs the civilizing guidance of the MTS. Recall the ads for soap in chapter 1, and the British cult of domesticity uniting motherhood, morality, cleanliness, and soap in allegories of imperial progress from "black" to "white."

McClintock suggests that the depiction "of Africans as dirty and undomesticated" served to legitimize the enforcement of colonialists' cultural and economic ideals. "Domestic ritual," she notes, "became a technology of discipline and dispossession."[50] Yet as Wolff mapped British domestic ritual onto Sudanese meanings, she proposed a substitution that was not violent but subtle and astute. In reforming her pupils' dispositions, she hoped they would become moral examples to other Sudanese:

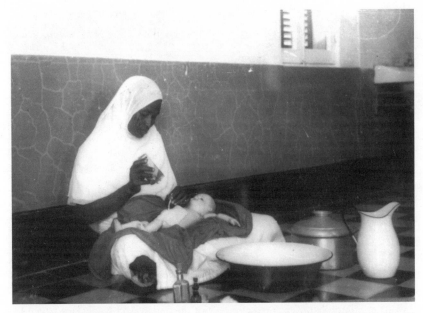

Figure 5: Learning to bath a baby. Note the Caucasian baby doll. SAD 583/5/44 (Wolff photographs). Reprinted courtesy of the Sudan Archive, Palace Green Library, Durham University.

The midwives thus trained become in a minor way missionaries in the homes of people, in the cause of cleanliness and simple hygiene, and it is to their growing number and increasing influence that we must look . . . to combat the almost universal custom of . . . circumcision which is so barbarous in its execution, and which is fraught with so much danger both to mother and child. It may be years before this custom is effectually checked, but in the meanwhile the first seeds of a silent revolution to cleanliness and hygiene are being sown in the homes of the people.[51]

The "mindful bodies" of pupil midwives were being shaped to new canons of normalcy and propriety even as existing meanings and gender relations were apparently respected and implicitly reinforced.[52] The process may have carried fortuitous weight in that the dolls exemplifying infant "normality" affirmed a local prejudice, for "white" skin is a mark of holiness and nobility, an attribute of the Prophet and his kin. Moreover, whiteness, as we've seen, connotes cleanness and purity, and purity enclosure, properties that pharaonic circumcision is said to confer. The tactic of drawing links to students' everyday lives was hardly innocuous or one-sided, as the Wolffs may have presumed, for surely the students conceptualized back. Judging from the persistence of pharaonic circumcision

throughout the colonial period and beyond, such discursive and practical blendings may well have supported the practice despite, or indeed because of, the endorsements of cleanliness and purity they contained.

As the quote above suggests, by professionalizing *daya*s the Wolffs sought to create a class of indigenous collaborators, thereby gaining for themselves and their methods admittance to household space. They accepted mature, respectable women to train, of sound moral character and nonslave status, hoping thereby to ennoble the profession as well as appeal to cloistered Arab wives. Predictably, never-married women were precluded from practicing, and young women subject to "strong prejudice." Further, the sisters found that a woman who had

> too independent a character or is energetic and athletic in her movements . . .
> is liable to be accused by her enemies of being a "Dakarieh" (sexual pervert)
> [lit. "feminine male"] especially if she happens to be young, unattached and
> sufficiently moral or interested in her work to refuse men's advances.[53]

The Wolffs were bound to reject even a capable woman unless she had popular support. Those selected to train were therefore married or divorced; most were older and had earned community respect. From the (albeit imperfect) information in the MTS Trained Midwives Register, Bell has calculated their average age as 50.9 in 1921, dropping to 38.7 in 1925, but never falling "much below the high thirties thereafter."[54]

Women often came to the school with infants and toddlers in tow; provision was made to house and feed them all for the three-, later six-months' duration of the course.[55] While Wolff may not have welcomed the prospect of boarding pupils' families,[56] the domestic retinues of several indigenous women were nonetheless regularly brought within the confines of the school, which, like the GTC, consisted of a number of rooms within a high-walled Omdurman *ḥôsh*. Initial recruits were unhappy with the food prepared by Wolff's cook, and were granted leave to make their own meals with rations bought from their stipends.[57] In the 1930s the allowance was stopped (as enough women could be induced to train without it), but students and their children were given free room and board.[58] Larger and better-appointed premises were built in 1930, along the same "*ḥôsh*" lines. In 1937 Wolff reported that anywhere "from one to two dozen children, ranging as a rule between the ages of six months to 12 years" lived at the school each term.[59] The sisters thus gained an intimate knowledge of Sudanese family life from maternal groups resident within the MTS *ḥôsh*, which was also the sisters' home. Trainees, a Sudanese visitor observed, lived in clean and orderly rooms, with their children "playing in the yard as if they belong to one family under the care and patronage of Miss Wolff and her sister, who kindly take into their charge the food, the cleanliness and bringing up of those children."[60] Behind the

modesty walls of the school, far from the prying eyes of officials, husbands, and other kin, Sudanese domestic space was being organized by the matron and her staff even when lessons were not under way.[61]

Prospective *daya*s who had not yet begun to practice were required to obtain written approval from indigenous male authorities in their districts, and assurances that they would be permitted to work there once trained. Here too the Wolffs conformed to local gender norms. Further, insofar as the criteria of respectability were met, the tradition whereby the midwife's role passes from mother to daughter was preserved. A report by the Sudan Medical Service in 1932 emphasized the acceptance of trained *daya*s in the neighborhoods where they worked. As "the children and grandchildren of the village or tribal midwives," they return "to their own villages" where "they have, by tradition the right of entry to every hut."[62] The "female population" awash "in a sea of conservatism and prejudicial custom" was at last being civilized and, wrote Wolff, "on the surest principles . . . entirely through the Sudanese and through their most conservative element, the women." The work was "not attempting rapid revolutionary changes in a small part of the population but a gradual enlightenment and improvement over a large area and . . . introducing that enlightenment into the very foundations of the people and their homes."[63]

In suffusing their students with fresh sensibilities, the sisters selectively sought to amend "bad habits." In fact, "bad habits" were useful ports of entry into the lives of female Sudanese. Wolff felt strongly "that until only recognized licenced midwives are allowed to perform the circumcision operations and facial scar marking, our influence over the midwives, as well as amongst the majority of the people, will always remain unsatisfactory."[64] Controlling access to all body-cutting conventions was seen as the surest way to eliminate those that were objectionable. Facial scarring was a means to mark tribal or ethnic identity; as such, it seems not to have been targeted for abolition. Yet scarification has largely disappeared in northern Sudan (see chapter 11) while female circumcision, of course, has not.

The Wolffs did not challenge the rites surrounding pregnancy and birth so long as these did not jeopardize their work. Indeed, they were keen ethnographers, keeping detailed notes on Sudanese customs and beliefs, and taking photographs that provide a valuable record of women's lives in the interwar period.[65] But in addition to circumcision there was one tradition they refused to abide, that smacked to them of savagery. This was the preferred upright posture for giving birth. Here is Wolff describing her first Omdurman case in the company of a trained local midwife:

[A]gainst their customs I succeeded in inducing the patient to lie down (on an angareeb) but at the approach of the critical moment the women onlookers and even the menfolk became excited, there was a loud jabber of protests against the patient being delivered lying down. . . .[66] [Then] some one enveloped both the Diaya and my head [sic] in a tobe and for a few moments we were quite helpless, or at least I was, being unused to such an ordeal.[67] But in the meantime I was able to present to them a fine baby and all their anger was turned to deafening trills of joy. The usual method of delivering . . . is to suspend a rope from the ceiling, dig a hole in the ground over which is spread a special round mat plaited with a hole in the centre. The daya squats on the mat with bared legs which she spreads out across the hole and has in readiness by her side a razor with all but the tip of the blade wrapped round with, in most cases, a very dirty piece of rag. The patient stands over the hole and clings onto the rope and when she gets too tired or exhausted she is supported by various relations—none too gently as the poor things have often told me how they ached for days after.

Finding that I had done no injury to this first patient who progressed favourably under the better and cleaner methods, I found there was a gradual improvement in the attitude of the people.[68]

Traditional *daya*s were known as *dayat al-ḥabl*, "midwives of the rope"; those trained by the Wolffs as *dayat al-ḥukûma* "government midwives," or *dayat al-mushammah*, "midwives of the macintosh," after the waterproof fabric with which they learned to drape the delivery bed. In her annual report for 1926, Wolff claimed she was making headway against the *ḥabl*:

[A]s the trained women are becoming more popular . . . the younger generation of women are themselves forgoing the untrained women and their barbarous methods for the trained midwife. In fact young mothers will proudly say their child is an "ibn or bint el mashamma" meaning they were delivered lying on a mackintosh sheeting instead of the primitive old method of hanging onto a rope, & even the age of infants is reckoned from the . . . advent of the trained midwives with the "Mashammas."[69]

The rope was not entirely forbidden, for women in the early stages of labor could avail themselves of it if they chose; only when birth was imminent was the reclining position decreed.[70] And to be fair, the Wolffs believed that the upright posture invariably caused the laboring woman to lean forward, making delivery, especially for infibulated women, more strenuous, painful, and slow.[71] Chances that the infant would be injured when the mother's genital scar was cut were also reduced, perhaps, when lying down.

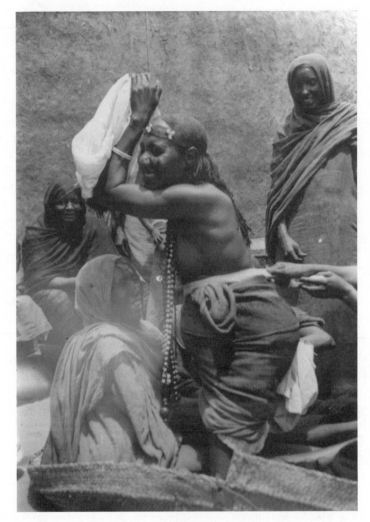

Figure 6: Rope birth. SAD 583/3/14 (Wolff photographs). Reprinted courtesy of the Sudan Archive, Palace Green Library, Durham University.

Unstated but perhaps more important, however, was that the rope interfered with the midwife's reconfigured role.[72] Note Wolff's use of the term "patient" to describe the laboring woman in the quote above. By the time the sisters had begun to practice, birth in Western societies was seen less as a woman's feat and more as a pathological event requiring biomedical management. If the Wolffs prevailed, so would it be seen in Sudan. Barbara Rothman has suggested that both Cartesian dualism (resulting in

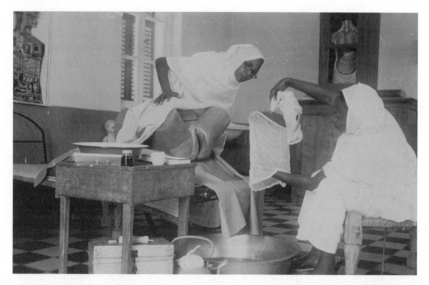

Figure 7. Examining the placenta. Note the dummy 'reclining torso'. SAD 583/5/ 35 (Wolff photographs). Reprinted courtesy of the Sudan Archive, Palace green Library, Durham University.

the notion of the human body-as-machine) and androcentric ideology (in which the [young] male body is the *normative* body-as-machine) are responsible for pathologizing women's bodies in Western societies. Female reproductive events are seen as complications of the normal body, and as such appear to constitute systemic stresses requiring "treatment," "supervision" and "care."[73] Hence the notion that a woman in childbirth, like a reluctant machine, requires external management and control.[74] Given the fact that an infibulated woman was compelled to seek assistance at birth, the image of her as a "patient" must have seemed ready-made to the Wolffs, a good transcultural fit. Further, in a striking photograph of the MTS schoolroom taken in the early 1930s, the Caucasian training dolls are shown lined up against a wall beneath a poster of profiled human head and large-framed torso with internal parts rectangularly stylized and exposed. The poster is entitled "The Human Factory."[75]

The step from indigenous homologies of the house and female reproductive tract to foreign representations of a normative and apparently male body as a mechanized factory may seem slight, but the consequences were potentially profound. For to the extent that the image was taken up, the student was being distanced from her cultural self and her agency very subtly reassigned.

A further Wolffian analogy helps make the point. In 1932 prenatal care was added to midwives' responsibilities and introduced to the women thus:

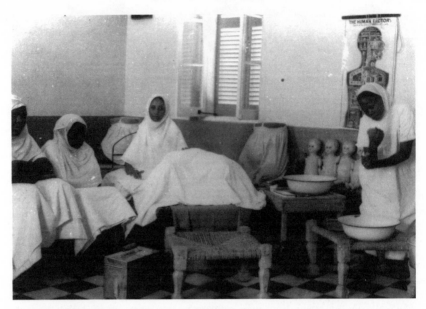

Figure 8. Learning to scrub up. Note the poster, "The Human Factory" on the wall. SAD 583/5/38. (Wolff photographs). Reprinted courtesy of the Sudan Archive, Palace Green Library, Durham University.

> [We asked,] when they put a cooking pot (halla) with food on the fire, did they leave it until the food was burnt and spoilt or was it usual to occasionally inspect the contents of the pot? Now amongst the womenfolk, the words "Kashf el Halla" [pot check] have become a recognized meaning for "Ante-Natal Examination" and attendances are so far very encouraging.[76]

Again, wittingly or not, in likening gestation to cooking the Wolffs had tapped into local meanings while shifting them to accommodate a bio-medical view. Women I lived with, recall, tacitly compare pregnancy to making the batter for bread: mixing (female) fluid and (male) seed in an impervious container, something only enclosed, circumcised women are properly able to do. As depicted by the Wolffs, pregnancy is like making a stew: a mechanical, curiously disembodied, asexual physical process that needs to be monitored, helped along, indeed disciplined by continuous visual surveillance. But note that the midwife, not the mother-to-be, is now the "cook" responsible for care of the "pot."

Thus would the Sudanese midwife, on whom every reproductive couple is compelled by infibulation to rely, become an agent of civilization backed by the authority of the colonial state. Instilled with the disciplines of hygiene and proper birth, she would manage women's bodies. But the success of MTS reforms was uneven at best. My observations in the 1970s

and 1980s among Hofriyati women and the trained and untrained midwives who delivered them or had done so in the past, suggest that pupils and their clients made selective use of introduced images and techniques. They made sense of the new knowledge by absorbing it into familiar understandings of purity, cleanliness, and enclosure. When Wolff wrote in 1921, "It is pitiful to see the poor patients' dread of the 'Mousse' (razor) and their useless suffering and yet how they are bound down by the abominable custom,"[77] she could not have anticipated how thoroughly modern anesthetics would be incorporated into the techniques of infibulation, predelivery cutting, and postpartum repair.

It is true that in time a partially Westernized "habitus" of pregnancy and birth became commonplace, entailing a modified set of corporeal dispositions with potential implications for identity and subjectivity. The Wolffs considered erect birth posture brutish and unnatural, and for Sudanese, the welcome reduction in maternal and child mortality that came with aseptic procedures lent truth to this view, though posture and hygiene are not necessarily linked. Even skepticism about colonial definitions did not prevent rope delivery's demise: in 1976, older women who had delivered both ways told me that—pace Wolff—they had found labor to be quicker (with gravity helping) and much less painful "on the rope." Yet the anesthetic administered prior to being *cut* was available only to the recumbent. Their compliance had been reluctant, but assured.

The paradox for abolitionists is not just that women invest in their cultural self-worth by discounting or even valorizing the harm that attends infibulation. Their material vulnerability, which is part of that image, makes it difficult to contemplate remaining uncut. It is because childbearing in the context of marriage is the socially approved route to social and economic status, and infibulation makes bodies morally fit to reproduce, that Sudanese women were loath to risk their daughters' futures and continued to insist the procedure be done.[78]

The civilizing of midwifery was intended not only to expand the population, but also to improve the "degraded" condition of local women and effect a rise in their status that would indicate progress for Sudan as a whole.[79] Yet it effectively supported an image the women themselves refused: that they are inherently passive beings, at the mercy of physical processes beyond their ken and control. To the extent that women adopted a locally tempered biomedical view of their bodies, it seems likely to have cultivated their subordination, while enhancing, at their expense, midwives' agency and independence under protection of the state.

By 1924 all Khartoum Province midwives had been trained, and schooling was extended to rural zones. Periodic inspections by the Wolffs identified backsliders, who risked delicensing and the loss of their modest subsidies and supplies. They could be suspended if found with dirty fingernails

when the inspectress arrived unannounced, even though some were forced to eke out their meager incomes with rough agricultural work. Repeat offenders were either sent for retraining or struck from the roll.

The fact that trained midwives received even a modicum of state support was a result of Wolff's incessant efforts to persuade officials of the need. Families were expected to pay midwives for deliveries and circumcisions—by custom, in kind and some coin. Some did, but many were too poor. Moreover, most Muslim Sudanese saw midwifery "as a charitable work and . . . the midwife by her kindly and necessary help gains thereby sufficient 'Heavenly blessings' to amply compensate her for her trouble . . . though it gives her no material benefits in this world." Trained midwives complained of disadvantage relative to untrained *daya*s, who were not burdened with maintaining equipment at their own expense and had "none of the difficulties of gradually working up a practice and overcoming peoples' opposition and prejudices."[80] Small stipends were approved in 1929, though Wolff faced an uphill battle to get midwives' supplies replaced through rural dispensaries free of charge.[81] Stipends, of course, gave medical officers more control over trained *daya*s, a point that may have swung the decision in favor.[82]

As the MTS grew, its ablest graduates were enlisted as staff teachers and rural inspectors. To Wolff's intense frustration, the government decreed they were entitled only to third-class travel accommodations given their low rates of pay.[83] The women she had chosen for their upbringing and groomed as exemplars of propriety were thus forced to journey on post-boats and trains, often overnight and even for several days, in cramped, overcrowded conditions, exposed to unfamiliar men. Wolff protested the elitism that gave schoolmistresses better wages and second-class travel warrants, though the midwives' work was just as important as theirs.[84] "I deeply regret to think," she wrote Atkey in 1932, "that female 'Effendyism' is being fostered by and through education, when actually class distinction amongst women in the Sudan at present does not exist if you bar the slave."[85] Indeed, in the sisters' constant struggle to ensure trained midwives were respected and adequately paid, there is defiance over the status of midwifery at home as well as in Sudan. A letter Mabel wrote to her sister on inspection tour in 1931 illustrates:

> [R]eally it makes my blood boil to think that our <u>four</u> staff women should not be granted 2nd Class warrants, when they are doing such fine work, & yet those blessed school teachers who really are not worth any more than our women are allotted 2nd Class. . . . [B]esides, I feel strongly it is demeaning to our work & gives people a wrong impression of the <u>social status of midwives in this country</u>. I had quite an argument with [Mr.] Wallace on the subject . . . [who] said that <u>midwives</u> in <u>all</u> countries were rather looked down

upon. . . . It is a fact in most countries but it is <u>not so in this</u>, where they are respectable women and quite frequently related to the Mek, Omdah, or Sheikh, in fact the best in the land. . . . I feel it almost as a personal affront to the good we are trying to aim at in raising the general standard of work. Of course the whole crux of the question is that we ourselves officially should be on an equal footing to the Evans', for after all isn't our work as important as female Education, and as successful in every way within our control as theirs? "Fight, Fight, Fight!" that is my motto. . . . [O]ne gets nowhere without PUSH.

Wolff privately rebuked British officials who ill treated native MTS staff that they should "remember they are not dealing with cattle or slaves."[86]

Trappings of Modernity

One means to cultivate an aura of respectability was to clothe trained midwives in uniforms—visibly set them apart from other Sudanese women and *daya*s "of the rope" as per the sartorial canons of the colonial regime. Student midwives thus wore immaculate white dresses and head scarves, and aprons when they worked. Although both British and Sudanese adhered to principles of cleanliness and linked these to morality, the import of their concepts did not coalesce. Trained *daya*s were required to maneuver within both worlds. So drummed into them was the need for cleanliness that to Wolff's "horror" she once found a trainee dressed "only" in "a loin cloth . . . squatting in front of the patient on an angareeb like a monkey . . . [because] she was afraid of soiling the government uniform."[87] Northern Sudanese women oiled their bodies after bathing; for Wolff this was a loathsome practice that caused no end of grief. Soon after the school opened she requested an increase in her uniform allowance, for, she complained, "owing to the peculiar customs of the natives greasing themselves and their surroundings" hers were suffering "much greater wear and tear." She was refused, and tersely advised that "for the present" she "use water proof aprons," to which she penned a huffy marginal note: "for daily visits—water proof aprons—116° in the shade!"[88]

Upon graduating, each midwife received a free outfit, which was "greatly valued as the visible sign of their profession."[89] She was expected to keep it spotless and replace it as needed on her own. To ensure that officials recognized them when abroad in public on call, they wore "a distinguishing blue scarf" over their white *tôb*s.[90] Unlike Egyptian or Islamic green, blue was an imperial color; worn around the helmets of the SPS, it was the color of power and achievement, of the political service varsity "Blues."

Graduates also received a certificate and a midwifery box the size of a small rectangular tool kit, made of tin, affixed with a wooden handle, and equipped with the requisite supplies of their vocation. The successful *daya* "is intensely proud" of her midwifery box, wrote Wolff, "as it is the visible sign of her superiority over the untrained."[91] So coveted were these signs that by 1932 she was urging SMS officials that "untrained midwives . . . not be allowed to have boxes and drugs and pose as trained midwives,"[92] or wear similar uniforms, suggesting emulation of "macintosh" by "*ḥabl*" *daya*s was becoming rife.

Interestingly, a tin box (*ʿilba*) plays a significant role in *zâr* therapeutics too, and *zâr* as a whole has much to do with women's reproductive lives. North of Khartoum a *sitt al-ʿilba* or "lady of the tin box" is a *shaykha* or other long-term adept of the *zâr* gifted with prophetic dreams. Her title refers to the tin box in which the adept keeps *zâr* incense and other spirit supplies. A woman who experiences symptoms associated with possession—such as miscarriage, infertility, amenorrhea, or less specific *zihûj* (for *zihûq*) "weariness, depression"—will visit a *sitt al-ʿilba* to have her suspicions confirmed or denied. If confirmed by *zayran* appearing in the seer's dreams, the latter will hold a private fumigation for her client with incense appropriate to the troublesome spirit's group. This rite, known as "opening the tin box" (*fataḥ-t-al-ʿilba*), is intended to placate the spirit until its host has sufficient funds to stage a proper cure.[93] Thus "opening the tin box" is a means to restore a woman's spirit-threatened fertility, at least for the time being.

Throughout northern Sudan sturdy metal boxes have long been used as convenient storage receptacles. Was the midwifery box a model for the *zâr ʿilba*, or vice versa? Did the Wolffs capitalize on the link between tin boxes and techniques to preserve female fertility? Was the midwifery box simply a practical conveyance or was it also symbolic, intended to invoke more recondite understandings? Susan Kenyon's work suggests that the symbolism of the *ʿilba* as an esoteric source of healing knowledge has a lengthy history and is even more developed in Sennar, south of Khartoum, than on the main Nile. In contemporary Sennar the *ʿilba* is the means by which a *zâr* leader's "powers and paraphernalia are handed on from one generation to the next."[94] The leader, known in Sennar as an *ummiya*,[95]

> derives her powers and knowledge from her ilba, which she has either inherited from a relative or acquired by apprenticeship with another leader. Each box has its own history, elaborated contents and intangible assets, many of which are known only to the leader herself. Both literally and figuratively it encapsulates a set of beliefs.

The *ummiya*'s *ʿilba* and that of a trained midwife have similar healing and authorizing functions:

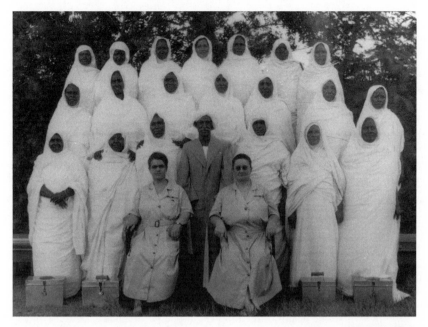

Figure 9. Staff and midwives of the Omdurman Midwifery Training School. SAD 583/5/82. (Wolff photographs). Reprinted courtesy of the Sudan Archive, Palace Green Library, Durham University.

[The] box acts as a mnemonic device which both aids and reinforces other historical sources, primarily oral accounts supplemented by documentary evidence. . . . The box contains the means to contact and control zar spirits and symbolises the identity, power and knowledge that is associated with a particular leader. . . . People who work closely with an ummiya and are beginning to build up their own powers in zar do so by acquiring their own ilba. At first, this is smaller, less impressive than that of the leader. . . . As more knowledge and power is acquired, so the contents and the type of container itself become more elaborate.[96]

The midwifery boxes in MTS photographs from the 1930s (e.g. figure 9, bottom) are plain, unadorned, as Kenyon reports they are today in Sennar.[97] Yet in the area where I worked they are ornately adorned in red and gold, the colors of the bridal veil (*garmosîs*), of gender complementarity, dynamic social and physical reproduction. In this too the midwifery box picks up the symbolism of the *zâr*.

In the *zâr*, the sick woman's *garmosîs* is placed over the animal to be sacrificed; the sheep substitutes for the woman, who thereby makes a covenant with the spirit who, in return, should now restore her health. Part

of the work of a *zâr* ceremony is to convince a woman that procreative problems do not originate in her body—they are not her fault—but are caused by capricious exotic spirits who have seized her womb. The diagnosis confirms her as inherently fertile; her sense of self, closely identified with her reproductive role, is thereby reinforced. Thus a successful curing rite, in which a spirit is convinced to relent, is the ethereal counterpart of remedial reinfibulation after birth: both re-close the body and thus renew its integrity.

*Zâr shaykha*s are thus like midwives, who help to channel and assuage female fertility by restoring and conserving a woman's blood. Possession healing and midwifery are parallel techniques of the self that share a set of aims. Nor are they exclusive: trained *daya*s seek out *zâr* curers to help them become or remain well, while *shaykha*s seek trained *daya*s to help them give birth. Medical midwifery was conveyed to the public by women steeped in knowledge of the *zâr* who, borrowing perhaps from its symbolic lexicon, tempered biomedicine with local insights and concerns.

By 1928 Wolff had reason to think that midwifery reform was having an impact on population growth:

> On the whole the health of the mothers in puerperium has enormously improved since the Midwifery Training School first started in January 1921, this is even remarked on by the midwives and older mothers themselves who say that women attended by the trained midwives are more prolific than in former times when sterility following a first and second confinement was very common and still appears to be in the Provinces.[98]

The improvement came without any decline in the incidence of pharaonic circumcision. Reproductive rates, the preoccupation of the colonial state, could thus be addressed without significant compromise to reproductive quality, the concern of northern women and men for producing morally entangled children, especially sons. Canons of hygiene and health disengaged from their Western contexts were being selectively absorbed into northern Sudanese life.

Ironies and Doubts

Trained and traditional *daya*s were private practitioners, and, though their skills were available to all, it was understood that clients should give some payment in return. Yet the sum was voluntary, depended on a family's means, and was seldom generous, as we've seen. Midwives routinely earned a portion of their income from circumcisions; the proceeds from attending births were rarely sufficient to relieve pressures on medical *daya*s to perform pharaonic and postpartum remedial procedures for

which they were better paid. Indeed, many families were reluctant to switch to a trained midwife for fear she would not respect their conventions. But some graduates clearly did.

In 1928 the Medical Officer of Health for Khartoum was informed by Omdurman Civil Hospital that a midwife trained by the MTS was "practising the circumcision of girls in a way contrary to that which she was taught." This because a four-year-old client had been brought to hospital "suffering retention of urine, due to complete occlusion of the opening."[99] The midwife, Farazein, was ordered to report to Wolff and warned that "if another report of circumcision by method other than that taught" was received, her license would be revoked.[100] That was not the end of the matter, for Farazein was popular. Wolff discovered that her reputation for obliging parents meant she was regularly called to cases in an area beyond her jurisdiction in preference to the designated midwife, whom native leaders reviled with fabricated sins.[101] Farazein was unlucky to have been found out; doubtless other trained *daya*s felt compelled to perform old-style circumcisions because they could do so hygienically and gain acceptance for themselves and their untried ways.

Since trained midwives were an inexpensive way for government to promote the health of native women and, they supposed, advance population growth, it would have made sense to fund them from the public purse. But as strenuously as Wolff pleaded the case, modest stipends for trained *daya*s were granted only after years of wearisome struggle with medical and political staff. Whatever change was effected in childbirth practice was due largely to the efforts of midwives themselves, whose training made them arbiters between British and Sudanese worlds. They formed a small legion of native agents in what Hunt, writing of Congo, pithily called "a hygienic form of 'indirect rule.' "[102]

The Wolffs preached endlessly to their pupils about the dangers of pharaonic circumcision; they recruited several able MTS graduates (among them Gindiya Salah and Sitt Batul)[103] as instructors in the school who did the same. When the Wolffs retired in 1937, there were six staff midwives, three of them literate: two had been educated by the CMS,[104] the other had attended the Girls' Training School, Omdurman.[105] These women, even more than the *daya*s they trained and oversaw, were charged with transmitting colonial meanings in ways that made sense to Sudanese. Converting scientific ideas into vernacular terms meant adapting them to existing cultural logics and making links, perhaps conciliations, between Islamic concepts of purity and British notions of hygiene, further explored below. Though Wolff laid the groundwork for such syncretisms and adaptations, they were likely more convincing when imparted by Sudanese, who thus worked colonial knowledge into the conventions of making women and giving birth.

Yet they did not necessarily have the hoped-for effect; far from phara-onic circumcision losing ground, it may have gained new meaning. For one thing, given the midwife's pivotal role, the partial medicalization of birth naturally entailed a partial medicalization of circumcision. Indeed, as the Wolffs' lesson book advised, "Should a midwife do circumcisions . . . she must perform the operation with all cleanliness just as she would a labour case, and attend the case daily for seven days, or more if neces-sary, in order to avoid infection of the wound."[106] Though clearly benefi-cial, the regular use of local anaesthetics, antiseptic powders, surgical su-tures, and the like, insinuated biomedicine into customary practice, thereby enveloping "tradition" in modern medical mystique, lending it new authorizations (though it needed none), and fostering further syncre-tisms that seemed likely to enhance the custom's resilience.

Women in Hofriyat and elsewhere in Arab Sudan speak of pharaonic circumcision (tahûr al-faraowniya) as creating bodies that are ritually pure (tahir), smooth (nâ'im), and clean (nadîf), concepts that invoke both hygiene and enclosure in local thought. When reading the following pas-sage from the Wolffs' lecture book, think of the logic of zâr possession and closure discussed earlier on:

> Most illnesses are caused by the entrance into the body by way of the mouth [khashm], the eyes, the nostrils, through the skin or a wound (or ulcer) of minute living things which cannot be seen except under a microscope. Just as there are a great variety of insects and seeds, so there are microbes. . . . There are microbes that will turn milk sour and meat putrid and food poison-ous, but if food is sterilized and kept in *sealed tins*, the microbes cannot penetrate and the contents such as tomato sauce, milk, sardines and numer-ous other foodstuffs, will keep good for long periods but as soon as the tin is opened microbes get on the food and it will soon be poisoned and unfit to eat.
>
> *If our bodies are healthy and strong like the sealed tins*, the microbes can-not harm us, but if microbes get a hold of us, they may give us some illness according to what microbe has infected us.[107] (my emphasis)

Wolff's analogies made perverse yet perfect vernacular sense.

There are few records of MTS midwives themselves, and we can only speculate how they absorbed and retransmitted the lessons they learned, what inflections and nuances they gave such words and deeds. Yet Wolff's similes are homey and suggestive, and she may well have relied on staff midwives in devising them. We do know that MTS staff were regularly sent to rural districts on inspection tours to keep track of all licensed dayas, examine their appearances and the trained midwives' kits, preach hygiene and exhort villagers to abandon "Pharaoh's circumcision."

As more and more midwives were trained in the less destructive "government" procedure, Wolff hoped the message of total abolition would start to bear fruit. She understood the popular link between pharaonic circumcision and Islam and the regime's reluctance to offend Muslims; the fate of Gordon was not lost on her, and she had lived through the events of 1924. But she was not so content with a gradualist approach that she shrank from urging legal measures when they seemed due, as her reaction to a tragedy in 1926 makes clear. The case involved a Coptic girl in Omdurman, a *muwalada*, or daughter of an Egyptian husband and a Sudanese wife. A trained *daya* had been summoned to circumcise the girl, and claimed to have performed a "Sunnah" operation. She told Wolff that she "attended the case for the usual seven days."[108]

> Later [she said] I visited the child to remove the leg binders and the wound was quite healed but the mother and Grandmother said they were very displeased with the "Sunnah" circumcision, the Grandmother even came to my house and asked me to bring my razor and operate on the girl again according to the "Pharaoh's" method as they were very displeased at my having left so large a vulva. I absolutely refused.[109]

A few weeks later the grandmother again summoned the midwife, as the girl's condition had worsened.

> When I . . . saw the state of the child I exclaimed that they must have got someone to have used the razor on [her] . . . for the vulva opening to have become so small that the child could not pass urine.
> The mother and grandmother denied [this] . . . but admitted they had used certain native remedies said to decrease the vulva opening, one being a poultice of chewed dates, and the other being a poultice of "Samgha Abu Baka" ["gum of Abu Bakr"], and "Rashad" [*Senebiera nilotica*].[110]

Wolff reported that the last two substances were "so irritating that they will easily produce a raw sloughing surface if applied to the skin." She strongly recommended that "severe measures . . . be taken in this case which unfortunately ended fatally, for it is only by exposing and making an example of such cases that there is any hope of overcoming this awful barbarous and cruel custom of Pharaoh's circumcision."[111]

Informed by the Medical Officer of Health that there would be no legal sanction, she wrote,

> I quite realize the difficulties in dealing with native customs . . . [however] with reference to this particular case . . . as the parents of the deceased . . . are Christian Copts and not Mohamedans, I cannot see why they could not be prosecuted or at least severely reprimanded by the Government for what as you mention . . . "amounts to manslaughter."[112]

Still, the government was loath to create a precedent, whatever the religious beliefs of those involved. Wolff suspended the midwife; yet interestingly, in a 1931 list of all trained midwives struck off or suspended, none had been openly disciplined for performing a pharaonic circumcision.[113] And indeed, slowly, in some parts of Sudan, the modified operation Wolff taught began to replace the full pharaonic form. Whether the trend might have continued had the sisters' methods not been rejected by their successor can only be guessed.

Circumcision, Childbirth, and Statistics

Gertrude Wolff kept a notebook in which she recorded Sudanese "customs" surrounding marriage, health, and childbirth. Among her entries is one that posits the origin of pharaonic circumcision.

> It dates from a little before Moses was born. Pharao [*sic*] had a dream in which he dreamt a male child would be born who would when grown to manhood kill him. So to prevent such a thing happening he ordered circumcision with infibulation for all females, thinking thereby he would prevent conception. But when he found this method wasn't the success he had anticipated he next ordered the death of all children or newly born babes.[114]

Throughout their careers and beyond, the sisters championed the idea that infibulation was imposed on the exiled Hebrews by the Egyptian king, citing Exodus 1:11 (italics below) in support:[115]

> And the children of Israel were plentiful, and increased abundantly, and multiplied, and waxed exceedingly mighty; and the land was filled with them. Now there rose up a new king over Egypt . . . and he said to his people, Behold the people of Israel are more and mightier than we: . . . let us deal wisely with them; lest they multiply, and it come to pass, that, when there falleth out any war, they join also unto our enemies, and fight against us, and so get them up out of the land. *Therefore they did set over them taskmasters to afflict them with their burdens.* And they built for Pharaoh treasure cities. . . . But the more they afflicted them, the more they multiplied and grew. . . . And the king of Egypt spake to the Hebrew midwives . . . "When ye do the office of a midwife to the Hebrew women, and see them upon the stools, if it be a son, then ye shall kill him; but if it be a daughter, then she shall live." (Exodus 1:7–16)

The reference appears stretched to an ungodly eye. And if Pharaoh did impose infibulation on Hebrew women, it seems to have had little effect on childbearing. One might easily take the opposite from the passage, particularly in light of ensuing verses:

> But the midwives feared God and did not as the king of Egypt commanded them and saved the men children alive. And the king of Egypt sent for the midwives, and said unto them, Why have ye done this thing, and have saved the men children alive? And the midwives said unto Pharaoh, Because the Hebrew women are not as the Egyptian women; for they are lively, and are delivered ere the midwives come in unto them. (Exodus 1:17–19)

Were Egyptian women the less prolific because it was they who were infibulated, and *could not* deliver "ere the midwives come in unto them"? The allusions support either view; both readings imply that infibulation limits population growth. This was, of course, what British officials feared, and the Wolffs' biblical reference fortified their concerns.

The sisters were aware, however, that the relationships between infibulation and the ability to conceive, bring a pregnancy to completion, and give birth to a viable child were not simple or direct.[116] While the practice does have a harmful effect on fertility for some and, as earlier discussed, puts all reproductive women at risk, this is mainly because it creates the conditions for secondary problems—bladder infections, pelvic inflammation, inelastic scar tissue—that may become chronic or arise only after successive postpartum repairs.[117] Rose Oldfield Hayes argued that pharaonic circumcision is an indirect form of birth control;[118] yet even if this were a latent function of the practice, it is difficult to confirm. According to the Sudan Fertility Survey of 1979,[119] and my own small sample from Hofriyat compiled between 1976 and 1984, women in northern Sudan have, on average, seven children who live beyond the age of five, and approximately ten pregnancies during their lifetimes. Many women have more. While these figures may have been lower in the early Condominium years, there is little to suggest that female circumcision had a significant impact on slowing population growth.

But what were the commonsense understandings in the 1920s? Most expatriate British were certain that infibulation impeded procreation, and, as we've seen, SPS officials held it to account for failure of the northern population to recover under colonial peace. With experience, Wolff was less convinced, as were Drs. Grylls and Atkey, consecutive heads of the medical department during her tenure in Sudan. In 1927, for example, Atkey's office reported that "syphilis is second only to malaria" in causing miscarriage, stillbirth, and sterility; pharaonic circumcision was notably absent from the list.[120] In 1932 Douglas Newbold sought Wolff's estimate of pre- and postnatal casualties of the practice, as Dr. Grylls had said "he didn't think it had much effect on infant mortality. . . . [Yet] there is a widespread belief among DCs that it does kill off children."[121] Wolff replied that while "the actual number" of infant deaths "in comparison to

the population would probably be small . . . it does not lessen the evil of the custom."[122]

In 1930, in response to a parliamentary request (discussed in chapter 9), Governor General Maffey assembled vital statistics for the north. The riverain provinces reported as follows, using figures obtained for 1926:

Khartoum Province

Birth rate:	18.9/1000 pop.
Death rate:	10.8/1000 pop.
Still birth:	31.5/1000 births
Infant mortality:	60.0/1000 births

Berber

Birth rate:	27.6/1000 pop.
Death rate:	19.5/1000 pop.
Still birth:	12.4/1000 births
Infant mortality:	71.0/1000 births

Dongola

Birth rate:	23.5/1000 pop.
Death rate:	14.6/1000 pop.
Still birth:	42.9/1000 births
Infant mortality:	83.1/1000 births[123]

The apparent precision of these figures lends them an aura of truth, yet their accuracy is doubtful. There had been no census, and none was undertaken until 1955. Wolff often noted in her reports that trained and untrained licensed *daya*s, who were responsible for reporting births, stillbirths, maternal and infant deaths, neglected their registers, especially when no one literate was available to act as scribe.[124] It is possible, then, that the actual figures were higher than those recorded. What is remarkable, however, is that they compare favorably to data for Britain at the time. In Sudan's riverain northern provinces combined, infant mortality was claimed to be 71 per thousand births in 1926. By 1929 that rate had dropped to 60 per thousand.[125] To put this in perspective, the infant mortality rate in England and Wales between 1896 and 1900 was 156 per thousand. By the early 1930s, with improved hygiene and nutrition especially for the poor, it had fallen to 62 per thousand, on par with contemporaneous accounts from northern Sudan.[126]

What do these numbers mean? Were figures from Sudan low because of inadequate reporting, and if so, why claim them to be fact? Alternatively, was the health and nutritional status of the riverain population so improved that it now equaled that of people in the United Kingdom? In

the last chapter I noted that in 1913, a year of drought, the Sudan medical department had reported "excessive" rates of infant mortality "as far as can be judged from imperfect returns." And the following year the situation was even worse; not only was infant mortality "still excessive" but the department announced that "recorded births" were "less than last year."[127] We do not know what criteria were used to label infant mortality "excessive"; however, by 1923 the Sudan Medical Service was optimistic that the influence of the recently founded midwifery school would gradually "result in an appreciable decline in the maternal and infantile death rate at child-birth, and a consequent healthy increase of the population." It claimed much the same in 1925, noting "there are already indications that [the MTS] will not only have a marked effect in the increase of a healthy population, but will in time modify some prejudices and undesirable customs which are at present unassailable." And for 1929 we learn that "all the midwives practising in Omdurman [not Sudan as a whole] have been trained . . . and the effect of their work is making itself felt in a lowering of the infantile death rate and in the diminution of the incidence of puerperal casualties."[128] These summary accounts are presented without numerical support. Yet they alert us that Sudan's aggregate figure from 1929, which, as cited, was lower than the frequency of infant mortality at home, must be read with caution if not mistrust. After all, in Britain the decline to such levels was welcomed as a major advance.[129] If Sudan's rates were lower still, this would hardly have gone unremarked.

One wonders if the admittedly imperfect figures for Sudan were useful precisely *because of* their flaws, else why were they cited with such authority? Did they oblige the SPS with statistical "facts" to brandish before Parliament, thereby shifting attention from the existence of female circumcision itself? In a letter written in 1961, the Wolff sisters claimed that "the attitude taken by the authorities was that these customs should not receive official recognition—though in our experience, what you do not recognize, you cannot cure."[130] The situation was strikingly similar to that of slavery, discussed in chapter 6. Whatever the case, in the next chapter we see that by 1930 Sudan officials had fresh reasons to obfuscate both the customs and the methods employed by the Wolffs to stamp them out.

OF "ENTHUSIASTS" AND "CRANKS"

"Is it true," Wad Rayyes asked me, "that they don't marry but that a man lives with a woman in sin?" . . .

They were surprised when I told them that Europeans were, with minor differences, exactly like them, marrying and bringing up their children in accordance with principles and traditions, that they had good morals and were in general good people.

—Tayeb Salih, *Season of Migration to the North*

Why, in 1930, was Sudan's governor-general asked to supply infant and maternal mortality rates when Parliament seems not to have wanted them before? To answer we must determine who in Britain was interested in these figures and to what ends. As we'll see, the query points to conditions in colonies beyond Sudan—in India and East Africa. The story revolves around a book and the odd coalition it brought about.

The Duchess and the Reformer

In 1897 a young Scottish woman born to privilege and comfort became secretly betrothed. Her fiancé was the Marquis of Tullibardine, heir to the Duke of Atholl; she was Katharine Ramsay. Secrecy enabled the Marquis to join the expedition to avenge Gordon's death, as Kitchener had refused to enlist officers who were married or engaged.[1]

The Marquis fought in the Battle of Atbara, and was with Winston Churchill at the Battle of Omdurman. When plunder for mementos began, the Marquis "was not to be outdone." He returned to Scotland with "trunks full of Dervish weaponry and loot . . . including a finial from the tomb of the Mahdi." Though Katharine claimed to have repatriated the spoils after her husband's death,[2] Mahdist *jibba*s, banners, swords,

spears, flags, and drums still decorated ballroom walls in Blair Castle, Atholl's official residence, when I visited in 1991.[3]

Katharine and the Marquis married in 1899. He followed Kitchener to the Boer War; in 1900 when British victory seemed secure, she traveled to southern Africa, spending two years in the region all told. During World War I, she accompanied her husband to Egypt, living in Alexandria and Cairo. Before the war he had become a Conservative member of Parliament, but was required to resign his seat upon acceding to the dukedom in 1917. She was persuaded to enter politics in his stead and, in 1923, became the first Scottish woman elected to the House of Commons.[4]

Katharine Atholl is seldom described as a feminist. She believed that motherhood was a woman's highest calling—a conviction that surely made her childlessness an ordeal. She was acutely concerned for the welfare of poor and powerless women and children, an interest that was forged or possibly deepened during her sojourns overseas. In 1927 she met Katherine Mayo, author of *Mother India* published earlier that year; the book had a profound effect on Atholl's life.[5]

Mayo had traveled to India in 1925 with the goal of investigating "public health and its contributing factors."

> I would try to determine, for example, what situation would confront a public health official charged with the duty of stopping an epidemic of cholera or of plague . . . or what forces would help or hinder a governmental effort to lower infant mortality, to better living conditions, or to raise educational levels, supposing such work to be required.

She was appalled by what she found, and boldly argued that the persistence of poverty and disease was the fault of Indians themselves. The trouble, she wrote, lay with the abject subordination of Hindu women, but chiefly the practice of early marriage "anywhere between the ages of fourteen and eight."[6] As Kumari Jayawardena observes, "few books . . . contributed more violent coloring" to the image of India in American and British minds. Mayo held that "Indians were morally unfit for self-government and . . . British rule was the best thing that ever happened to them."[7]

According to her biographer, Atholl was deeply moved by Mayo's descriptions "of unbearable suffering . . . of small girls being subjected to sexual brutality; of the horrors endured by Indian widows; of poor medical services and of the taboos which surrounded the processes of childbirth, making it a terrible and hazardous experience." Her response was not unique; *Mother India* sold well and was reprinted seventy times. One British feminist was so incensed by its disclosures that she ran for Parliament solely in order to improve conditions for women in the empire.[8] She

was Eleanore Rathbone, a well-known social activist, Oxford graduate, and president of the National Union of Societies for Equal Citizenship. In 1928 Rathbone issued a pamphlet stating her case:

> Knowledge of the deplorable conditions is already widespread, through Miss Mayo's book, through the League of Nations, and through the closely internationalised women's movement. One constantly meets the comment, "How is it that a century and a half of British rule has done so little to combat these evils?" . . . At international women's conferences in Berlin, Paris, and Rome, I have witnessed the active and sometimes skilful propaganda carried on by Indian women for the purpose of simultaneously shewing up the weak points of British administration in these respects and glossing over Indian responsibility. So far as these criticisms are unjust, they can be ignored. But they are not entirely unjust, and from patriotic as well as humane reasons, one shrinks from the prospect of the British Government relaxing its hold on the reins, without introducing stimuli and safeguards respecting women's welfare.[9]

Rathbone was elected the following year. Now Atholl and she drew together in a joint crusade, though they did not always see eye to eye.

More revelations were to come. In 1929 Atholl attended a London meeting of the Church of Scotland Mission (CSM)[10] to the Kikuyu in present-day Kenya, at which a missionary described the customary circumcision of pubescent girls, a procedure that "involved extensive mutilation and lifelong suffering." Atholl was horrified and dismayed that "the British Government could countenance such brutal assaults on innocent victims in its colonies in the twentieth century."[11] In response, she formed an all-party "Committee for the Protection of Coloured Women in the Crown Colonies," chaired by the distinguished Labour politician and former magistrate in Africa, Josiah Wedgewood. Atholl became vice-chair and Rathbone a prominent member. The committee drafted a list of questions and gathered evidence from witnesses with experience in eastern Africa during the closing months of 1929.

The transcripts of their inquiries make chilling reading. The missionaries' reports are laden with images designed to unnerve and persuade. Not surprisingly, they portray Africans as savage, justify the missionaries' task, and condemn colonial authorities loath to intervene. They contain a good deal of salacious "fact" and a dearth of ethnographic context. One, for instance, described the collective circumcisions of Kikuyu girls as calling for "feasting and beer drinking . . . and much immoral dancing"; between 1,000 and 1,500 onlookers, men, women, and children, encircle the initiates—"even the old married women are painted up in such a heathen fashion"—and dance. Soon a female "witch-doctor" appears waving a small knife "in shape like a safety razor blade, and she starts the operation."

She first of all cuts away all she can see from the one side of the front passage, and there you can see the arteries spurting forth. The loss of blood is tremendous. . . . Without cleaning the knife in any way, the Witch-doctor then passes to the next girl and does the same thing and so on down the line. She then comes back to the first child and cuts away the other side, and so on to each girl. She returns a third time and lifts the skin so that she sees that she has cut everything, and she chips here and there until she is finished with each. Then the girls get up and walk back to their village, perhaps walking as far as 4 to 6 miles, losing blood all the way. . . .

She is rather made much of in her village for a month or so; and if she were examined after that you would see that the front passage was utterly closed up, & that it had become like the palm of a hand. There is not even an outlet to pass urine, or when mensuration [*sic*] period begins no outlet either. So it must find its way by the back passage.

A year or two afterwards the Witch-doctor . . . makes a slit where the passage ought to be but meantime the inner organs have suffered badly. . . . When the girl bears children she must lose her first child because of this evil, and very often her own life as well. On a test of 10 maternity cases in hospitals, out of 20 possible lives, only 6 were saved. The reason for this operation in the eyes of the natives is that, unless [it] is performed, a girl won't give birth to children. . . . No attempt has been made by Government to stop this dreadful practice, or rather very little.[12]

Committee members were unsurprisingly "sickened by what they heard."[13] Aside from the grim report, the numbers of deaths revealed gave serious cause for alarm.[14] These were confirmed by Mrs. Hooper of the Church Missionary Society, who had "made a practice of helping [Kikuyu] women in their confinement" and recommended tackling the problem "on the grounds of racial suicide."[15]

Dr. Gilks, director of the Kenya Medical and Sanitary Services, explained that the operation took two forms, one more drastic than the other. In the former, "certain parts are removed wholesale. After results mean a large amount of scarring which causes obstruction and contraction. The first child is therefore frequently born dead. The mother may die." Gilks had "not himself heard of deaths resulting immediately from the operation, but would not necessarily hear, as statistics are not kept."[16] The moderate form apparently involved clitoridectomy alone; however, another witness reported that "no less severe method" than complete excision was "practised by the Kikuyu tribe."[17]

Atholl's committee resolved to fight these practices. Rathbone, Wedgewood, and she formed a deputation to the colonial secretary, Lord Passfield (Sydney Webb), asking for an inquiry into the situation of Kenyan girls, convinced that circumcision "was there inflicting grave suf-

fering and injury to health and life among women, and causing much infant mortality." Passfield refused, but suggested they continue their inquiries and offered to "communicate with the Governors of the various African Crown Colonies on the matters."[18]

Thus it happened that early in 1930, the committee drafted a questionnaire for all "governors and high commissioners of colonies and protected and mandated territories."[19] In April one would land on the desk of Governor-General Maffey in Khartoum.

Its arrival was hardly unexpected, for in Britain the issue had lately been much in the news. Because of it, the new Labour government's commitment to a British "trusteeship" in Africa, promising to protect Africans' land rights, end forced labor, develop health and educational services, and extend self-government, was being sorely tried. On December 11, 1929, Parliament had just affirmed the policy of "native paramountcy" in Kenya, when Atholl stood to speak. She submitted that if Britain was obliged to guarantee equal rights between the races in its colonies, it should also guarantee equality between African women and men and protect women from brutal practices.[20] She referred to "a pre-marriage rite . . . practised on young girls among many African tribes . . . [that] in its most severe form consists of actual mutilation and causes great suffering and subsequent most serious injury to health."[21] She was interrupted by James Maxton, leader of the Scottish Independent Labour Party, who questioned the relevance of Atholl's remarks. Hearing this, Rathbone shouted "Women do not count!" A flustered Maxton resumed his seat and Atholl finished her address.[22] Rathbone spoke next, admonishing the House to remember its long opposition to slavery, noting that the position of African women in relation to their husbands "often precisely mirrored that condition."[23]

In a follow-up question on December 23, Atholl asked what steps were being taken to "bring home to the people" the risks of the custom to women's and children's health. Dr. T. D. Shiels, parliamentary undersecretary for colonial affairs, replied that in 1926, Kenyan native councils had been advised "that in the interests alike of humanity, of eugenics, and of increase of population, the milder form of the operation [clitoridectomy] . . . should be reverted to."[24] Later, however, he rued such means insufficient.[25]

popular interest

With these disclosures, female genital cutting became a matter of public censure and concern. Summaries of the House debate appeared in the popular press; digests were circulated to the colonies. Sudan officials and educated Sudanese learned of the startling events. As the pharaonic procedure was more extreme than excision, Sudanese vulnerability was clear.

In March 1930, two physicians with experience in Sudan appeared before Atholl's committee. One was a missionary, the other not. The first was Dr. E. Lloyd of the CMS, who had spent eighteen years in the country.

Compared to statements from Kenya, his evidence was restrained, perhaps because the missionary ban had tempered his zeal, or this and women's seclusion had inhibited his acquaintance with Muslim Sudanese; another deterrent may have been the covert government support for CMS projects in Muslim Sudan. Lloyd gave a description of the pharaonic procedure heavily weighted with medical terms that did not, however, diminish its impact. The practice consisted, he said,

> of the complete removal without anaesthetic, using a razor, of the labia majora and minora and clitoris. The legs are tied together, and the wound heals by granulation. The child may be away from school 6 months. Urine escapes thro' an aperture which may no more than admit a slate pencil or may be large enough to admit, with force, the male organ. Retention of menses with haemate colpos may occur caused by cicatrisation. Great and needless pain is caused at the operation, at consummation of marriage, and at childbirth . . . [when] puerperal sepsis frequently results.

Yet, he reported, "a divorced woman often gets herself re-circumcised" in anticipation of remarriage. Moreover, women's "wish to be circumcised" was made plain by "the case of a girl who escaped from a boarding school [in order] to be done." Asked about the custom's religious implications and its effect on population, he shrewdly replied, "Islam is no more responsible for circumcision than Christianity is for tight lacing." Moreover, "as regards mortality, accurate statistics are not available. Outside the big towns there are no hospitals and few certified doctors. The operation does not appear to have any great results in the deaths of women and children."[26] Having heard the opposite from Kenya, this surely sounded a sprung note to Atholl and her group.

A few days later the committee met again, now to hear from Dr. V. S. Hodson, former director of Sudan's medical department, described in the minutes as the Sudan government's "Medical Representative" in London. Also present was Sir Andrew Balfour, former director of the Wellcome Tropical Laboratories in Khartoum, now director of the London School of Hygiene and Tropical Medicine. Between them they defused the political damage wrought by Lloyd's remarks. Balfour steered members to publications "relating to our subject" in the third WTRL Report and library of the London School.[27] Hodson confirmed Lloyd's observation that "there is not a large maternal mortality . . . [though] child birth is sometimes interfered with by scarring from the operation." Yet he also claimed, contra Lloyd, that "births and deaths are registered all over the Northern Sudan. The Arabic population is increasing, shown by the Sudan Government's report."[28] With this he inclined the committee to accept as accurate the "vital statistics" indicated in chapter 8, which Maffey would forward "the Duchess" later that year.

Queries and Fears

Atholl's committee framed its questionnaire so as to obtain systematic information on practices in British Africa. I quote and summarize these below:

> Do the following customs exist among the tribes under your jurisdiction? If so, among what tribes do they exist, and what information can you supply as to their nature, and as to the injuries they inflict on the health, morale and status of girls and women, and the health of the children who may be born to them. What efforts, direct or indirect, are being made by Government or other agencies, to combat them; what official protection is afforded to any girl who desires to escape from them; and what further action do you consider to be possible? Have you any information as to the origin of these customs, and what evidence is there that native opinion is turning against them?
>
> (1) Circumcision of girls as a preliminary to marriage.
> (2) Forced fattening of girls as a preliminary to marriage.

The committee then asked for information on "any other customs injurious to girls" or "barbarous customs practised in childbirth, or in connection with sick and dying people?" And if twin and abnormal births are subject to harmful treatment, "is this evil being dealt with?" They wanted statistics: "(a) the birth rate, (b) infant mortality rate, (c) maternal mortality rate, for the last ten years?" They asked to know "the extent of hospitals, midwives, infant welfare and any other health services. . . . How far do women take advantage of these hospitals and in how many are there women on the staff?" They questioned "the extent and nature of education for girls" and asked "what protection . . . (a) the Law, (b) British Administration, provide for women who wish to avoid a marriage they hate, or to escape from a brutal husband?" They inquired into the powers of kin and husbands over women, whether "cruelty of this sort is condoned by native public opinion," how a woman's marital infidelity is punished, "how far is the woman free, how far the property of father or husband," what was the status "of a widow as respects her own rights over her person, her minor children, or her husband's property," if there was much prostitution and procuring of girls, whether women could own land, and whether they were protected "against the performance of heavy labour, such as road-making?"[29]

A few weeks after the testimony of witnesses for Sudan, Maffey received the questionnaire. He distributed copies to governors and DCs outside Khartoum and its catchment, asking them to prepare replies, but reserved response on the Nile Valley and central Sudan to the civil secretary and himself. This was too delicate a matter to leave to DCs in the field; the

Where is agency of women — did girls run away?

north demanded a coordinated approach lest awkward information be supplied and the political situation become inflamed.[30] For something else had happened in the interval since Atholl's address to Parliament of the previous December—in Kenya, a woman missionary had been killed.

The Female Circumcision File

At this point I must back up a bit, and return to MacMichael's "female circumcision" file. What steps against the practice had been taken in Sudan between 1924, when the matter was first raised, and 1929 when Atholl's committee set to work? None that were overt, it seems, in the wake of the nationalist revolt and reaction that ensued; none save the Wolffs' efforts at the Midwifery School. Following a six year hiatus, the file resumes in early 1930, soon after the parliamentary debate, with a decision to censor an article by a Sudanese medical student that condemned pharaonic circumcision in light of the disclosures in Britain. The newspaper in question was *al-Hadara*, to which the regime gave financial support. Were the article published now, officials feared, Sudanese would "jump to the conclusion" that it had been government inspired.[31]

The duchess and her committee had surely struck a chord, and Khartoum geared up to withstand the din that was to ensue. Indeed, next in MacMichael's file comes a letter from Angus Gillan, the governor of Kordofan initially quoted in chapter 3. Gillan's dispatch, dated February 3, 1930, suggests that government should seize the "opportune" publicity of the parliamentary question to act.

> Apart from the brutality of the severe form of female circumcision and its degrading moral effects, I assume that there is not the slightest doubt that it is responsible for much maternal and infant disease and mortality. . . . Personally I feel very strongly that it is our duty as guardians of primitive people like the Nuba to prevent the adoption by them of this brutal and dangerous practice. . . . Even the limited propaganda visualised under the 1924 ruling appears to have died down and I know of nothing being done except by the enthusiastic but small midwifery staff.

Propaganda, the only measure then "permitted . . . with the Mohammedan population," had proved unavailing; though it might "slow down the spread of the poison" it was not an effective antidote. Gillan advised drafting a law to impose "penalties against any person inciting or abetting the practice," even Muslim midwives. At minimum, he asked for a policy statement from Khartoum, and chided senior officials for being "unduly fearful of Moslem opinion." "Are we justified," he wrote, "as a civilised Government in shutting our eyes to all intents and purposes to the preva-

lence of this brutal and degrading practice? Short of legislation is the time not ripe to declare that it is contrary to all the tenets of civilisation and humanity?"[32]

MacMichael drafted a reply "for general circulation," anticipating a chorus to Gillan's concerns. While he agreed that public opinion was now "more ripe than it was six years ago" and now was the time to act, "the problem [was] one of ways and means." He and Maffey insisted that no direct propaganda by "non-Mohammedan officials" be attempted, as this, "willfully or otherwise," was open to misinterpretation.[33] In the file is an unsigned handwritten note, likely from Maffey, perchance by Mac-Michael himself, that makes their position clear:

> We have to find the right men from the active and official community to put on the forefront and we must back them securely with the means of propaganda. . . . And we must be careful not to get a sectarian split on the question, e.g. S.A.R [Sayyid ʿAbdalrahaman al-Mahdi] and the Mahdists for circumcision, Sir Syad Ali and the Mirghanists against it. The first moves in this game are of total importance and I want no mistake to be made.[34]

In his circular MacMichael declared that starting with legislation would be "fatal to success," "for law must either be based on custom, or conform to what the people realise to be just or necessary, to be effective." Instead government would "enlist Mohammedan leaders." At "H.E.'s" invitation, the Grand Qadi could meet alternately with government officials, and religious and leading secular "non-official Mohammedans," "to explore the best lines of attack" and fully explain "the Sharia aspect of the matter." Lastly, a *fatwa* might be proclaimed, or a resolution "issued jointly by the official and unofficial leaders . . . to all Sheikhs who were Presidents of Native Courts, stating the [*shariʾa*] law and giving a considered opinion as to the spirit in which it should be interpreted." In this way, the religious elite would "appear as leaders of enlightened opinion." Not until the third stage of the process, "probably not arising for a few years," might legislation be introduced, "but this would depend upon the reactions meanwhile noted in public opinion."[35]

Clearly, the executive, persuaded that pharaonic circumcision held deep religious import for Arab Sudanese, still saw popular Islam as a potential source of anticolonial feeling, if not open revolt.

A Colonial Murder

In MacMichael's record, deliberations stop as abruptly as they had resumed. His memo of February 10, 1930, is the last for several months. A few days later, J. G. Matthew, secretary for education and health,

suddenly requested a copy of the 1924 report on female circumcision compiled from Wolff's notes.[36] Next in the file comes a series of press clippings. The first, from the *London Times* of February 18, 1930, is headlined, "Murdered Missionary in Kenya."[37] It reports the death of Miss Hulda Stumpf, an elderly member of the American "Africa Inland Mission to the Kikuyu,"[38] whose body had been found in her house fifty miles from Nairobi on the morning of January 3. The details were disquieting:

> The medical evidence discounted any theory of rape but inclined to the view that certain unusual wounds were due to deliberate mutilation such as might have been caused by the use of a knife employed by native in a form of tribal operation.
>
> The significance of this lies in the fact that for many months past certain missions have been making a stand against this tribal ceremony with the result that there have been conflicts with natives, many of whom are most hostile, while agitators have been attempting to make political capital out of the situation.[39]

The article is followed by others: on February 24, the *Times* reported that "political unrest in Kenya" had "recently taken a new direction." In addition to Kikuyu demands for a land settlement and direct political representation,

> irresponsible members of the young Kikuyu movement have found a new field of activity in the question of the premarital initiation rites of women into the tribe. . . . The young girls represent an economic asset to the parents and, in the eyes of the tribe, their value is completely lost unless the rites are performed. In fact, the older Kikuyu believe that no woman may bear children unless the ceremonies have been observed.

Note the dates of these clippings: a month *before* the testimonies of Drs. Lloyd and Hodson to Atholl's committee. That MacMichael saw fit to enter them speaks volumes about officials' fears. Khartoum was doubtless aware that a distraught governor of Kenya (Edward Grigg) had telegraphed London on January 20, 1930, the first day of the inquest into Miss Stumpf's death. Though asphyxiation was declared the official cause,[40] Grigg reported a different fate: "Medical evidence shows that Miss Stumpf was circumcised in brutal manner and died under the operation. It is clear that circumcision song and dance is being used to work those participating into a state of dangerous fanaticism."[41] As to "fanaticism," Sudan had precedent enough, and may explain Hodson's attempt to underplay the gravity of the practice in Sudan, despite medical and other officials who conceded it. It surely explains why MacMichael directly opened another file, "Assaults on European Women by Natives"[42] (chapter 2), though only two minor incidents were recorded, both from

1931. With professional women and wives now in Sudan for more than a winter stay, the SPS was plainly prepared for more.

In her discussion of the rhetoric of sexual assault during the colonial era at large, and focusing on the fear of rape, Anne Stoler notes that there was:

> virtually no correlation with actual incidences of rape of European women by men of color. Just the contrary: there was often no ex post facto evidence, nor any at the time, that rapes were committed or that rape attempts were made. . . . [N]or did rapes committed by white men lead to prosecution.

In fact, assaults on white women by colonized men were "often based on perceived transgressions of social space," as with the Sudanese cyclist who bumped into a white woman and knocked her off balance (chapter 3). Likewise, as notes Stoler,

> "attempted rapes" turned out to be "incidents" of a Papuan man "discovered" in the vicinity of a white residence, a Fijian man who entered a European patient's room, a male servant poised at the bedroom door of a European woman asleep or in half-dress. . . . With such a broad definition of danger in a culture of fear, all colonized men of color were threatening as sexual and political aggressors.[43]

Tensions were high among Europeans in Sudan; MacMichael's "Assaults" file shows that officers were concerned not just to fortify social and spatial boundaries between British and Sudanese but to remind Europeans where their loyalties lay. For if trouble over female circumcision had flared in Kenya, its sparks could well raise an inferno in Sudan.

Missionaries, Kikuyu, and the Kenya Government

What was the nature of the controversy that pitted missionaries against native Kenyans, was broadcast at the Church of Scotland Mission gathering where Atholl learned of female genital cutting, and allegedly gave rise to the murder of Miss Stumpf? Several scholars have analyzed the crisis of 1929–30 and it is not my aim to repeat their efforts here.[44] But as it was germane to Sudan officials' concerns and the actions they took or, in fact, did not take, an outline will be useful. There were important differences between the two settings, among them, the communal nature of Kikuyu rites, their institutional context, and the role that missionaries played in triggering local unrest; moreover, the practice in Sudan was commonly linked to Islam. Yet in both, colonial intervention provided a context in which the bodies of local women came to symbolize emergent nationhood.

Among Kikuyu, excision was fundamental to *irua*, the public coming of age ceremonies by which girls became marriageable women and boys marriageable men; following their initiations, novices were allowed to engage in limited sexual play, something the missionaries thought depraved. Importantly, *irua* also conferred political and economic rights to full participation in community life. Youths circumcised in the same initiation cycle became members of an age-set (*rika*) that was named for a salient event. Kikuyu political organization hinged on these pan-regional groups, whose members were united by bonds of mutual assistance that broadened and thickened the ties of clan and kinship ascribed at birth.[45] In addition, all persons passed through a lengthy series of clearly marked life stages, from newborn, through unmarried or childless initiate, eventually to elder, each entailing specific responsibilities and rights. The cycle hinged on *irua*. Thus *irua*—and the surgeries that attended it—was the means by which Kikuyu communities renewed themselves and kept their history alive, women and men achieved maturity, acquired citizenship and political authority, and realized moral selfhood.[46] In this last respect, especially, it resembled circumcisions in Sudan.

Early in the twentieth century, missionaries in Kenya began to preach against excision and the ritual complex surrounding it. At first, they sought to alter the rites to make them less "repugnant," and to educate converts about circumcision's harmful effects.[47] Later they took a harder stand, deciding in the 1920s that "disciplinary measures [were] to be taken against all Christians who should countenance it." The missions also agreed to lobby colonial governments for legislation to prohibit it.[48] As Dr. Stanley Jones of the Church of Scotland Mission testified to Atholl's committee, "this rite . . . has absolutely no useful purpose and with the accompanying dances and other customs has a most deleterious effect on the moral [*sic*] of the native girls."[49] The ceremonies, he asserted, were "corrupting" and "indecent"; as they were "accompanied by feasting and beer-drinking," they "tend to become orgiastic."[50]

How had local administrators handled the missions' challenge? In 1926 the Conference of Governors of the East African Dependencies agreed that circumcision was harmful to women's health. Yet delegates were confident that it also sustained social cohesion and, like their colleagues in Sudan, worried that serious discord would erupt if laws were enacted to stop it. They decided against interference, but suggested that governments try "to persuade such tribes as practised the more brutal forms of it to return to the more ancient and less brutal form" of "simple clitoridectomy."[51]

[T]he removal of the clitoris is a simple operation unlikely to be followed by any serious effects whereas the more brutal form . . . results in permanent mutilation . . . with disastrous results not only to the birth-rate but to the

physique and vitality of the tribe. It seems further to be established that the milder form is the traditional one, the more brutal one being a comparatively modern invention.

As there was no evidence that "simple clitoridectomy" was "more ancient" or "traditional" than excision,[52] the tactic was tendentious. While a number of native councils complied by making it punishable to perform anything but the "minor" operation, little in fact would change.

Then in 1929 the CSM upped the stakes by demanding that Kikuyu congregants pledge opposition to the custom and forbid their children to undergo it. Further, they barred the children of nonrenouncers from enrolling in CSM schools. Other missions followed suit. Miss Stumpf, it appears, had forbidden circumcised girls to attend the school she ran. Though the ban was later lifted, native teachers were obliged to condemn *irua* in order to be hired, as only those who rejected it were thought able to "mould the children in the way favourable to the missionary attitude."[53] The CSM also forbade teachers membership in the Kikuyu Central Association (KCA), the political union to which Jomo Kenyatta (future prime minister of Kenya) belonged, because it endorsed *irua*. To gain support for their stance the CSM held information meetings in London, one of which had moved Atholl to form her all-party committee and begin investigations.

Though African converts were not united in their reactions to mission directives, moves to end excision were widely unpopular, for they challenged the entire *irua* complex, hence the social system it underwrote. Historian Susan Pedersen suggests that *irua* had "persisted in spite of (or perhaps partly because of) the stress and dislocation borne by the Kikuyu during the rapid pace of colonization in Kenya." The assignment of land to white settlers, the imposition of "tribal" rule inconsistent with local practice, and "the deliberate use of taxation and legislation to restrict Africans' freedom to grow cash crops and to coerce them into wage labor," had left little of earlier ways intact. Under such conditions, the work of maintaining group integrity became thoroughly vested in the familiar, and portable, *irua* rites.[54] Kenyatta, who trained in social anthropology at the University of London, put it thus: "the moral code of the tribe is bound up with this custom" that "symbolises the unification of the whole tribal organization"; further, the abolition of *irua* would "prevent the Gikuyu from perpetuating that spirit of collectivism and national solidarity which they have been able to maintain from time immemorial."[55]

Such images flew in the face of missionary ideals. Converts were taught to regard the rites as "savage and barbaric, worthy only of heathens who live in perpetual sin under the influence of the Devil."[56] *Irua* was atavistic "tradition," continued allegiance to which precluded the moral transfor-

mation *of individuals* that Christianity required.[57] Indeed, conversion was a rival rite of passage, shorn of *irua*'s communal dimensions. It required no large-scale ceremony, merely that one accept Jesus as her *personal* savior, repudiate her "heathen" past, and adopt a wholly Christian way of life. By breaking with Kikuyu convention, missionaries thought, a girl would be free to develop a "normal" self. But a body indelibly marked for collective tradition and a mind "corrupted" by *irua*'s "evils" were antithetic to Christian existence, with its emphasis on autonomous individuals separately endowed with "reason" and "free will." And, as the missionaries saw it, *irua* victimized women twice, assuring them suffering and subjugation in the present, as well as exclusion from a life in Christ.[58]

Yet Kikuyu women did gain from *irua* rites, as ethnographers have shown.[59] It was prohibited for a Kikuyu man or woman to have sexual relations with an uncircumcised partner; initiated women became marriageable and empowered to reproduce.[60] As mothers, especially of sons, women held limited authority over others and were accorded considerable respect. They also "maintained control over issues related to reproduction including female *irua* and childbirth."[61] Though men had greater command over public affairs, to make good their decisions they were obliged to negotiate with women, especially their wives.[62]

Yet in deliberating female circumcision, the British in Kenya seemed oblivious to Kikuyu women's political and economic roles. Missionaries, as Judith Snivey notes, focused on "the bodies of individual women" and "ignored or downplayed" "sociopolitical considerations," while administrators focused on "the body politic" in androcentric terms, and "women all but disappear[ed] from the discussion."[63] Aspects of women's lives irrelevant to the observer's interests were studiously overlooked or underplayed. Everyone had an allegorical use for Kikuyu women's bodies.[64]

Including Kikuyu themselves. The circumcision crisis proved useful to the protonationalist Kikuyu Central Association, which had formed to address taxation, repatriation of lands taken for Europeans, and the forced labor of native women and girls on European farms. Most of its members were young mission-educated men like Kenyatta, who was in London presenting KCA grievances when the crisis began.[65]

Shortly after Atholl's and Rathbone's December revelations in the House, Kenyatta had told their committee he was doing "his best to turn people away from the custom."[66] Then, in a private interview with Dr. Shiels of the Colonial Office in January, 1930, a "shocked" Kenyatta was told the manner of Miss Stumpf's death, and warned of "the serious reaction . . . [it] would cause against the Kikuyu." Shiels stressed that Britain was dedicated to preserving "tribal customs" and allowing native peoples to develop "on their own lines." But female circumcision was an exception; he emphasized its demographic costs, for surely Kenyatta did not

want Kikuyu, "to suffer any disadvantage on their way to becoming a great and numerous people or to increase in numbers more slowly than other tribes in Kenya." Moreover, he noted, "great grief was caused by the number of still born children and of mothers who died in childbirth."[67]

Kenyatta advised that if government doctors spoke "to the people on the physical dangers of circumcision . . . he believed that would be effective," but if the practice "were condemned as it had been by Government circulars and by pulpit denouncements" the approach would surely misfire.[68] Still, if Kenyatta ever advocated purging excision from *irua* rites, he soon relented, and backed the KCA stance that excision was essential to Kikuyu identity.[69]

Lessons for Sudan

In response to the rumored ban on education for circumcised girls, Kenyans boycotted mission churches and schools and opened their own.[70] By its own account, the CSM lost nine-tenths of its Kikuyu members in the first month of the crisis.[71] Lynn Thomas reports similar levels of desertion in Meru, a region in northeast central Kenya that was also caught up in the events.[72]

Periodically from October 1929, crowds of Kikuyu women and men gathered before the homes of girls who had refused excision, to dance, threaten with knives and spears, and sing songs that insulted missionaries, colonial officers, and government-installed chiefs who backed the government position. Rumors spread that the British wanted Kikuyu girls to remain uncircumcised "so they might marry them, and in this way seize the Kikuyu's land."[73] Things took a millenarian turn: a letter reportedly from Harry Thuku, an early Kikuyu leader detained by the government, circulated through the reserve, "telling all the Kikuyus to be ready, and not to build their houses as yet, till he comes back, & when he returns he is going to rule for 7 years." News spread that Kenyatta had set sail from England but would be prevented from landing, arrested, or killed on his arrival home.[74]

On January 20, 1930, the same day he telegraphed the Colonial Office details of Miss Stumpf's death, Governor Grigg reported that some seventy people had been convicted for "indecent dancing and for publicly singing an obscene and seditious song" forbidden by government. Known as *muthirigu*, the protest was apparently adapted from an analogously named Swahili song "sung at the close of Ramadan." Kikuyu had borrowed the form from their Muslim neighbors and imitated the accompanying dance, embellishing it with steps of the European fox-trot. While stanzas were improvised "according to locality and circumstance," some

were relatively stock. To the missionaries, most were "quite unprintable," though even the "less offensive" are telling:

> Little knives
> In their sheaths,
> That they may fight with the Church,
> The time has come.

To officials such as Grigg, the bearing on Miss Stumpf's murder would have been plain. Similarly, the warning sung to mission-loyal Kikuyu:

> He who signs [against female circumcision]
> Shall be crucified.

And the fate of chiefs devoted to the government:

> When Johnstone shall return
> With the King of the Kikuyu [Thuku, who claimed to be of royal blood],
> Philip and Koinange [government headmen]
> Will don women's robes.[75]

In another version:

> When John Kenyatta comes you will be given women's loin cloths
> and have to cook him his food.
> All uncircumcised girls shall be circumcised and then,
> Drs. Arthur [head of the CSM in Kenya] and Leakey, with what
> will you have connection?[76]
> Koinange was a big man but when John comes he will have
> to wear prisoner's clothes.[77]

Nor were British officials spared:

> The D.C. _____[name]_____
> Is bribed with uncircumcised girls,
> So that the land may go.[78]

And,

> The Governor is called a big man but when John comes, he will have his teeth extracted like a Kavirondo because of the lies he told in Europe. . . . John Kenyatta . . . is stronger than the Governor of Kenya for he defeats the Governor of Kenya.

Grigg was distinctly anxious for his authority, as the KCA had found sympathy in England for their cause. On January 21 he telegraphed the Colonial Office:

> Recent murder of Miss Stumpf . . . was perpetrated with obsceneness and horrible cruelty which indicated aggressive fanaticism which song and dance

quoted does much to inflame. . . . Situation is at present in hand but you will assist me greatly in protecting life and preserving order if in any answer given in Parliament you will indicate clearly that you support Government and Constituted Native Authorities in punishing breaches of law and sedition.[79]

In February Grigg sought support from other East Africa governors, an indication he expected the problem to widen beyond Kenya alone. No friend of the Labour government, Grigg was sure that "subversive propaganda which was being gradually introduced . . . both from India and from Home was making use of native fanaticism on the circumcision issue."[80]

Tensions continued to run high. Colleagues of Dr. Arthur, director of the mission offensive, feared "his wife and daughter may be exposed to risk."[81] The CSM reported that in the second half of 1930 there was a sudden rise in the number of native prophets who claimed supernatural powers to strike dead those they touched and "preached the wrath of God on the European, and the duplicity of the Missions in professing to champion native interests."[82]

Like Britain's imperial mother, the culturally configured and reproductively mature Kikuyu woman had become an emblem of identity, "the 'pure' or true Kikuyu." Those who made use of the image were mainly Western-educated men, those "reformed, recognizable Others" who had absorbed European understandings and now acted on their terms.[83] As Pedersen notes, KCA intervention "catapulted the controversy into . . . a full-scale political revolt, and endowed [excision] itself with new meaning." For as defense of the practice "became entangled with long-standing Kikuyu grievances about mission influence and access to land, [excision] . . . came to be seen as a mark of loyalty to the incipient, as yet imaginary, nation."[84]

The crisis was also, Thomas notes, over how best to constitute community and "prepare female bodies and minds for pregnancy and childbirth." As such it was a battle over "the womb," not just of female circumcision; it condensed a series of struggles over the control of reproduction through which both colonizers and their subjects sought "to gain material resources and fulfill moral obligations" depending on their respective social positions and cultural ideals.[85]

The Kenya crisis was not lost on British in Sudan, whose project to reform reproduction was now under way, if subtly, in the Muslim north. Moreover, memory of the 1924 rebellion was still raw and the danger of "native fanaticism" a perennial fear. In Britain, the crisis brought the Labour government into conflict between its desire to recognize African political aspirations as legitimate, and its wish to conduct policy "along humanitarian and moral lines."[86] In Sudan such ambivalence was rare. The

executive had little sympathy for indigenous political goals, especially should they lean Egypt's way. Recall that in January 1930, Southern Policy became official. It was, to reprise MacMichael, expected to erect "a solid barrier . . . against the insidious political intrigue which must . . . increasingly beset our path in the North"[87]—a barrier against Arab influence and Islam. Female circumcision was a significant mark of "Arabness" that the policy aimed to curtail. The Swahili element in *muthirigu* protests surely suggested to SPS officials that Kenya's troubles owed something to Muslim influence. Vigilant and defensive, Maffey prepared his response to Atholl's committee with an eye to muffling concerns at home, in Egypt, and in the Arab Sudan.

Replies and Silences

In March 1930, Maffey commissioned a brief from Atkey, director of the Sudan Medical Service, who assembled descriptions of pharaonic circumcision and its consequences from material supplied by the Wolffs.[88] In a memo stamped "strictly confidential" Maffey now requested supplementary data—school attendance and vital statistics—from provincial officials via MacMichael, civil secretary, and J. G. Matthew, secretary for education and health. But even before these could be gathered he had framed his response for the north:

> As regards the circumcision of girls, I can reply at once. . . . It will be clear that the abuses are serious: it will, I trust, be equally clear that the path of the reformer in this matter is no easy one to choose. If the matter is not handled aright and with utmost tact and discretion, the effect, so far from being progress along the line of enlightenment, will be the creation of suspicion and prejudice and a state of affairs in which the power of the Government for good will be entirely nullified. The main difficulty lies in the sanction of religion which surrounds the practice.[89]

Maffey then cited an enclosed "extract from a private but authoritative memorandum lately prepared by an eminent Islamic divine," but asked "that no public use be made of [it] since . . . its publication would constitute a breach of good faith." Its author was an "ex-rector of the Azhar and former Grand Kadi of the Sudan,"[90] an Egyptian whom the British had appointed to steer Sudan toward Islamic "orthodoxy." The divine cited a *hadîth* [authoritative precedent] in which the Prophet is reported to have said, "if you excise, cut off mildly and superficially," and interpreted this to mean that only part of the clitoris may be removed. The extract continues:

Hence it is evident that excision as practised in the Sudan . . . is contrary to the precepts of religion. Besides the practice is one of barbarous cruelty, and subjects women to horrible sufferings during childbirth and in the period immediately following—and there is no religious objection whatever to legislating against it. Indeed religion demands that such legislation be enacted.

However the difficulty lies in the fact that . . . the masses in the Sudan, where ignorance and primitive customs prevail, are in favour of it. . . . The majority . . . approve of this kind of excision as being a safeguard of their women's chastity, and therefore of the man's honour—the Sudan being a country where intercourse between the sexes is rife, since the climate and conditions of life generally conduce to indulgence beyond the limits prescribed by religion and morality. Add to this too the fact that ignorance and weakness of character are the chief characteristics of most Eastern countries.[91]

If the translation is faithful, we see where on the ladder-of-progress British-anointed Egyptian ʿulama placed Sudanese, perhaps fellow Egyptians as well. Moreover, the passage quaintly affirmed Maffey's eugenic vision, described in chapter 5. Recall his concern to "fortify" "old traditions," so as to build up an "armour" of "protective glands," "sterilising and localising the political germs which must spread from the lower Nile into Khartoum."[92] Consonant with these aims, "native administration" had been hastily advanced and the ambitions of Western-educated Arab Sudanese were curbed. Yet a public stand against infibulation would undercut the principles on which native rule was based, and indeed expose its spuriousness. Moreover, activists' handbills in 1924 had disclosed the intimate relationship between sexual morality and social identity that obtained among Arab Sudanese (chapter 5). Intellectuals and popular leaders might well seize on the issue to whip up nationalist sentiment, and thwart Britain's claim to moral custody of Sudan (against Egypt's) until its people had progressed to a higher "stage."[93] Officials found themselves in a moral and political bind. The highly public questions asked by Atholl's committee, like those surrounding slavery a few years before, required that government appear to be doing something, even if it wished little be done.

Replying through the Residency in Cairo, Maffey told Atholl's committee that he intended the Sudan Medical Service to undertake "a campaign of quiet propaganda" by communicating the harmfulness of the pharaonic procedure "to the most understanding leaders . . . with a view to the enlightenment of public opinion." If this proved fruitful, it might be possible "to induce them collectively to issue a 'fetwa' [religious opinion]" signed by official and unofficial Muslim clerics; once the *fatwa* was broadcast "the next steps" could be ascertained; "ultimately it might be found possible to introduce legislation." The timing of Atholl's inquires could not have been less welcome. Nothing, Maffey noted, could happen imme-

diately, for with "the [Anglo-Egyptian] Treaty Negotiations in progress the political atmosphere at present was too highly charged."[94]

Dr. Atkey's lengthy report, annexed to Maffey's dispatch, is a fascinating combination of candor and evasion. "The operation," he wrote,

> is commonly carried out between the ages of four and eight years. . . . For a carefully brought up town-bred child of well-to-do parents, the pain must be intense, and the mental shock severe and lasting, and this applies only to a less extent to the Sunna operation. For the village child who runs about in a "rahat" and who even at that age is acquiring with her brothers the attitude of disregarding pain, the operation—if successful—probably amounts to a few minutes' intense pain, followed by three weeks or a month's discomfort. The operation is performed by a few cuts of the razor; no stitches are used. It is associated in the child's mind with new clothes, bracelets and sweets.[95]

Here how one endures pain depends on social class.

Atkey went on to describe some medical consequences of pharaonic circumcision "based on reports from twelve hospitals or provinces" over two years. Those most frequently noted resulted from severe inflammation, which led to "the formation of dense, unyielding scar tissue, causing delay in the second stage of labour . . . [which] may result in still-birth; no actual cases are recorded, but in severe cases they must occur." Cases that had come to the Wolffs' or physicians' notice, however, "can only be a very small fraction" of those that must arise. They included constriction of the urinary orifice, retention of urine, prevention of normal intercourse, and retention of menstrual blood leading to atrophy of the uterus and sterility. Few problems were reported from Omdurman, and none of them severe, for

> the town is now entirely staffed by trained midwives, and thus the likelihood of severe inflammation complicating circumcision is greatly diminished. Moreover, the midwives carry out a modified opertation, which while being acceptable to parents, leaves a less constricted opening.

As if this were not controversial enough, Atkey's next remark would strike the Parliamentary committee as perverse:

> The paramount affliction of women in the Sudan is labour as conducted by untrained midwives; various complications may occur . . . which may go on to septicaemia and death. Compared to this, the evils of circumcision are slight, but they are appreciable. The cause is the same, ignorant and dirty midwifery.

Wholesale displacement of untrained by trained midwives was the solution Atkey proposed. This would reduce infections from circumcision and thus avoid many ailments that might otherwise develop later in life; it

would also result in adoption of the modified procedure, especially if provincial midwives were backed by tribal leaders and courts, as well as British and Sudanese medics in the field.[96]

Interesting in Atkey's submission is the hierarchy of scientific reason over custom and religion, as if the latter were simple matters of erroneous thought, divorced from morality and deportment. Interesting too is the emphasis on childbearing problems congruent with government concerns, and the parallel effacement of the operations' sexual effects. Yet the report anticipates no end to female genital cutting. The severity of the operation might be reduced but excision and infibulation are clearly expected to prevail; even support for less destructive "sunna" procedures is nowhere proposed. This, despite officials' conviction that infibulation contributed to the "backwardness" of Sudanese women and men. More striking still, no mention was made of routine postpartum restitching and its effects. Administrators, it seems, were hardly about to reveal more to Atholl's committee than what the latter knew. Perhaps they already knew too much.

In July, Atholl sought more information on the role of government-trained midwives in Sudan, hoping, she said, to benefit from a woman's point of view. Through J. Murray, the Sudan Government Agent in London, she contacted Constance Huddleston, wife of (Sir) Hubert Huddleston of the Sudan Defence Force (later governor-general). Huddleston wrote in turn to Matthew, Khartoum's secretary for health and education, about the committee "run by the Duchess of Atholl," advising that "the Duchess is anxious to meet women who have done work on the subject, such as Miss Wolff." She asked that Matthew set up a conference between Atholl and "Wolff or others" of her sort.[97]

Matthew wrote to MacMichael at once. He was alarmed that Murray "might have passed [the request] direct to Atkey who might send Squires [of the SMS] or Miss Wolff, and . . . you or I might know nothing about it." He confessed, "I am a little chary of just anyone representing us—and if anyone has to, as Atkey is away, I think I'd rather do it myself, if it is necessary at all."[98]

If anything came of the matter, I found no evidence of it in the files. Presumably the meeting was quashed, for on July 26, Atholl requested an interview with Murray at the House of Commons.[99] A few days later, Murray reported its outcome to Maffey and MacMichael. The Duchess, he wrote, "realises that we have to walk delicately." She appreciated having received "such full information on the position and what we were doing and proposing to do," but apparently thought Atkey's report "rather minimised the serious nature of female circumcision, as . . . Dr. Lloyd had given the Committee full information on the subject and . . . it had created a 'painful impression.' " Murray agreed. He then told Atholl

"all about the work Miss Wolff was doing and also about Miss Evans and girls' education." With obvious relief, he notes "she did not ask to see either." She did, however, inform him of a movement in Geneva called "Save the Children" in which her committee took an interest.[100] Murray knew of it, as a member of the CMS had shown him the movement's questionnaire, similar to Atholl's but more extensive. Atholl explained she would be attending their meeting in Geneva the following year and wanted information from the British colonies and Sudan so as to convince France and Belgium (and others) to take seriously the issue of female circumcision. Murray gave her leave to talk about the custom's widespread nature (since the CMS would do so anyway), and to discuss Sudan's midwifery and educational fronts. But, he admonished, "it would distinctly embarrass us if she said anything about our proposal to approach our religious leaders, as this would then probably become public and might 'queer the pitch.' She quite appreciated this."[101]

Maffey called a brisk retreat: "I think we have now gone as far as we ought in the matter of direct dealing with the Duchess and that we should close down that line of procedure." Henceforth any communication would have to follow formal channels through the Foreign Office and High Commission in Egypt, lest a political slip be made.[102]

Reticence Renewed: 1930–33

From late 1930 through 1931 Sudan officials gathered information from Kenya and pursued the prospect of a *fatwa*, while holding the line against appeals for public action from educated Muslim Sudanese men and British stationed in "pagan" districts. The latter saw their call for legal measures opposed, the former their attempts to speak publicly against the practice checked. In October, "an informant" reported to MacMichael's office:

> I met . . . [a] medical student the other day and he said to me "We wrote a social reform article some time ago on the circumcision of women, and the Public Security Department, would not allow it to be published, pretending that this was a religious subject; as if they were the protectors of religion in this country. Do they see to what extent they try to bind and suppress even in matters that have nothing to do with politics?"[103]

From Kordofan, Gillan again pressed for legislation to prevent Nuba from adopting infibulation.[104]

In January 1931, MacMichael acquired copies of official documents from Governor Grigg of Kenya, with further details of the crisis, Miss Stumpf's death, and steps taken to ban excision.[105] Included was a copy of Grigg's dispatch to Lord Passfield of the previous March, in which

Grigg proposed a penal code amendment to "specify definitely that the more brutal forms of the operation shall be deemed a 'maim' . . . [and that] consent [of the injured] will be no defence to such an operation." Even so, Grigg agreed that abolition would be gradual, and utterly ineffective if "imposed from outside." Legislation against "the operation commonly performed" would require "the full support of the natives concerned . . . [which] cannot be expected until the natives have arrived at a much higher level of general development." As such, "apart from specific legislation to deal with cases of compulsion or of serious mutilation the only means . . . to discourage the practice are education in its widest sense and propaganda." He added:

> Those who are ambitious for immediate results would do well to reflect upon the nature of the opposition and upon the mystical significance attaching to the rite. Your Lordship is aware of the shocking murder of an elderly European lady missionary. . . . From the inquest proceedings it appears probable that it was accompanied by attempted mutilation and that it was a political crime which arose from the attitude of the Mission towards the native custom of female circumcision. . . . [Given] the existing political situation in the Kikuyu Reserve . . . it would be most inopportune at the present time to take any immediate action.[106]

Here was ample support for Sudan government concerns. The bodies of Miss Stumpf—and other European women, as MacMichael's foreboding dossier attests—were metonyms for the vulnerability of the colonial state, just as the bodies of Sudanese women symbolized for Britons the unresolved contradictions of colonial rule.

MacMichael received Grigg's information as "helpful" and a possible way forward in southern Sudan, but seems to have considered it of limited use for the north.[107] Deliberations in Kenya had focused on legally enforcing "simple" clitoridectomy with no further mutilation and no more than one operation per girl.[108] The Colonial Office observed that while doctors' "opinions vary widely . . . as to the after effects of circumcision on women,". . . "on political grounds . . . no attempt should be made to prohibit the simple form: but whether the Duchess of Atholl will be content, is another matter."[109]

She was not, argues Pedersen. But given the distinction between female sexuality and reproduction prevalent in Britain at the time, and the attendant lack of a lexicon in which to phrase the issue of women's sexual response, let alone authorize it, Atholl's committee was unable to persuade officials that "simple" removal of the clitoris, which "need not have serious effects at childbirth,"[110] was in itself a "maim."[111] Grigg's strategy miscarried, however, upon discovering a few months later that "simple" clitoridectomy "was virtually unknown among the Kikuyu, and . . . what

had been dubbed the 'brutal form' was in fact 'the ordinary custom of the people.' " To criminalize "the brutal form" would have meant criminalizing *irua* itself. Ironically, Pedersen writes, "the revelation of the seriousness of genital mutilation in Kenya thus . . . lessened government interest in doing anything about it." Unwilling to risk a revival of native unrest, the Colonial Office justified government inaction to Atholl and her group by agreeing to oppose *all* forms of female genital cutting, as they had hoped, but weakly, through education (in reality a circular to administrative officers) rather than legal means.[112]

Sudan, of course, did not fall under Colonial Office purview; indeed, its virtual autonomy obstructed the committee's access to information, especially for the north where missionaries were few and their activities restricted, and entry points for nosy Parliamentarians were patrolled by layers of assiduous SPS staff. At the same time, the situation in Sudan, owing to the "ordinary" practice there and the north's turbulent past, was potentially more extreme than in Kenya. Hard pressed to answer metropolitan concerns, Atkey wrote gruffly to Wolff in January 1931: "I consider that we should make a very strong stand against the unmodified Pharaonic circumcision. . . . The danger of this form . . . should be most strongly pointed out in your lectures." Further, "every effort should be made to raise the general level . . . of the midwives under training," and those "who do not possess sufficient ability of character" should be "weeded out."[113]

Wolff bristled in defense:

> I can assure you since my advent in the Sudan I have never ceased to preach and teach against the Pharaonic circumcision, to my midwives, my patients, their relations, to women generally as well as to menfolk. And in this Crusade I am ably seconded by my sister and our staff midwives. What I have come to realize is that the continuance of this custom is as much and perhaps more due to the men than to the women.[114]

Though officials denied men's culpability, or concurred but ultimately blamed the circumcised mothers who had raised them, it was clear that Sudanese women alone were unable to effect the required change. "Yes," Wolff wrote, "the old women insist on their daughters being circumcised, but the reason is, that they fear they may not get them married, or if they marry, the husbands will soon divorce them, as owing to generations of this custom, the men prefer the tight vaginal orifice to the normal one."[115] Her midwives were respectable, moral women who acted under constraint, not from want of "character" as Atkey seemed to suppose.[116]

Conservative officials bound by imperial chivalry and fearful of enthusiastic Islam must have blanched at Wolff's blunt indictment of Sudanese men—to say nothing of the presumed threat to their rule should they ever

be called to act on it. Their denial of men's role in perpetuating infibulation was, however, belied by the actions they chose to avoid. Legal remedy had already been ruled politically dangerous and premature. Although the Grand Qadi declared a law would cause no "religious offense," public opinion, he averred, was firmly opposed. As for a *fatwa*, this too was "absolutely impossible," as the families of all Sudanese religious leaders practiced pharaonic circumcision, and those the Grand Qadi had consulted "consider [it] a good thing for the people. As regards the effects they point out that hundreds get over it successfully as opposed to two or three who do not." His advice in February 1931: "to destroy the practice" by educating women, which was already being done, and licensing those who circumcise to do only the "Sunna" type,[117] which went largely ignored.

As the committee assembled facts through the spring and summer of 1931, Atholl repeated her request for more information on Sudan, going through proper Foreign Office channels and acknowledging the matter's delicacy. But political negotiations with Egypt were still under way, and if Maffey or MacMichael prepared a response it has not survived. Atholl presumably went to Geneva without having talked to Wolff.

Then in November, the British medical journal the *Lancet* published reactions to Atholl's Geneva proposals that colonial governments "be pressed to make inquiries" into the existence, form, and purpose of female circumcision, consider how to protect and support girls who wished to avoid it, and make known to native persons "the harmful effects of this practice on the race."[118] From Kenya, Dr. Sequeira wrote it would be beneficial if the operation were limited "to simple clitoridectomy"; however, he warned that only propaganda "be commended to the benevolent enthusiasts who would endeavour to force the hands of the Executive."[119] From Nigeria another physician reported he had "never seen any ill effects due to female circumcision."[120] In April 1932, Wolff prepared a rejoinder, detailing complications of the pharaonic form in children and adults.[121] She sought counsel on whether to publish it from Douglas Newbold who, about to replace Gillan as governor of Kordofan, had asked her help in stopping the spread of the practice among the Nuba.

Newbold advised that she submit the paper, emended to provide an estimate "of pre-natal or post-natal casualties of children due to the practices." "[Dr.] Grylls," he wrote, "didn't think it had much effect on infantile mortality. . . . Of course even if it doesn't, the other evil results with the women are bad enough. But, as there is a widespread belief among DCs that it does kill off children, I think a note would help."[122]

Mindful that voicing concern over population growth might protect her article from censorship, but unwilling to leave the matter there, Wolff sent a frustrated reply: "Yes, any estimate would be very rough and re-

quire leisure to look up . . . [and] the actual number of infantile mortality in comparison to the population would probably be small but it does not lessen the evil of the custom."[123] Her article failed to pass the censors in Khartoum and never made it to press.

Newbold was less circumspect than most senior members of the SPS, and would later play a significant role in the push for criminal sanction (chapter 11). "I entirely disbelieve," he wrote to Wolff, "in the value of propaganda alone."

> I've been discussing this morning with the Governor [Baily, Kassala Province] the possibility of making it a criminal offence & he thinks the way to do it is in 2 steps—1st step get the Govs. and DCs to wake up to your value, and get you and your sister buzzed around the Provinces & put in contact with the big sheikhs as much as possible, 2nd step when everybody has been made to sit up and made to want to stop it, we can tell the Native Courts to start treating it as an offence. . . . [I]t seems to me simply a question of how far the Medical Services will help. Without continual investigation and supervision by the M.I.s [medical inspectors], British and Sudanese, we should get no convictions, & we might really only succeed in alienating the nas [people] from the licensed midwives.[124]

To all of this, wrote Wolff, she quite agreed.[125] The sisters were not opposed to legislation, but, like the midwives they trained, acted pragmatically—under constraint.

As strife in Kenya abated and the issue died down in the press, Atholl's committee turned to other customs, such as bridewealth exchange and widow inheritance, as more tractable lines along which to pursue the improvement of African women's status.[126] Yet their interest in female circumcision endured.[127] Sudan officials continued to compile statistics and forward reports as they slowly trickled in from southern districts in 1932. Word came from Bahr al-Ghazal that female circumcision was being practised wherever northerners—the jallâba—were found. One DC proposed that to halt its spread, southern women should be forbidden to marry northerners, female operators expelled from the region, and jallâba entirely barred. Others echoed his call.[128] Atholl's inquiries thus proved useful in rationalizing Sudan's Southern Policy on humanitarian grounds. Indeed, some officers in the "pagan" south would successfully prosecute practitioners for causing "hurt" under the Sudan penal code, obtaining convictions with penalties of imprisonment,[129] though such measures were not used in the semi-Arabized regions of Fung or the Nuba Mountains for fear of provoking Arab unrest.

In the north, a containment strategy was put into play—less of circumcision itself than of the publicity that a semblance of government interference might arouse. Predictably, the Grand Qadi's call to expand female

education was not taken up, despite the plan to address the issue with "propaganda." The post–1924 period was, after all, one of "nativization" on instructional fronts; disciplining bodies was deemed less incendiary than "opening" minds. Immediate steps were limited to telling indigenous leaders about infibulation's medical effects, and implicitly endorsing the substitution of Wolff's intermediate procedure for the full pharaonic form. Of these, only the Wolffs' methods were pursued with any vigor. Yet the trained midwives entrusted with the task were regularly exposed to bureaucratic indifference that compromised their respectability to other Sudanese. Despite being openly encouraged, the Wolffs were thwarted by officialdom at almost every turn.

In 1933, at the suggestion of Hans Vischer, a former colonial officer in northern Nigeria, the sisters were invited to submit a paper on their work to the British Social Hygiene Council. It too failed to pass official muster. Sections that were not deemed innocent or common knowledge—those outlining complications in adults and detailing remedial infibulation—were suppressed.[130] In a "strictly confidential" memo, Maffey minuted that though "every word in this paper is the tragic truth,"

> in this matter of female circumcision in Africa infinite harm could easily be done. Indeed in some parts of Africa the harm has already been done. I desire to protect Miss Wolff's work from being wrecked, but she must co-operate. If the state of affairs we are seeking to remedy is thrown open to cranks and enthusiasts by indiscreet publication it will be the end of Miss Wolff's work, and cause serious embarrassment to the Sudan Government. Methods which will not work will be forced upon us by ignorant critics, and the native attitude which, thanks to the Misses Wolff, is very, very slowly tending towards helpfulness, will only stiffen into non co-operation and sullen hostility.[131]

Wolff withdrew the paper in its entirety, explaining confidentially to Vischer that "owing to the female circumcision question" the Sudan Government forbade her to mention the subject, "yet we feel to refrain [from] mentioning [it] . . . would not do justice to our work and achievements."[132]

Again the Wolffs were reined in, prevented from stepping foot beyond their sequestered domain. Vischer's response was patronizing but typical: "I am determined . . . to tell you how pleased I was that your Government decided not to pass on any information regarding your work to an outside body such as the British Hygiene Council. . . . The better the work of this nature that we are able to do, the less we ought to talk about it in public."[133] Womens' work, that is, best takes place behind the scenes, in the hidden "domestic realm" of colonial rule.

implication of sexism

Transition

We have arrived at a turning point in the story. In 1934 the MacMichael-Maffey regime came to an end. Gillan became civil secretary and Symes was appointed governor-general; Maffey's system of having political officers represent health and education on the governor-general's council was abandoned, giving professionals in these fields more power to influence policy. Atkey was succeeded by E. D. Pridie as director of the medical service in 1934. Expansion of the Midwives Training School was mooted in 1936, and improved education for both boys and girls was recommended by the De la Warr Commission in 1937. That year, the Wolffs themselves retired, at the end of a difficult period of overwork, straightened means, and dwindling moral support.

In summing up the Wolffs' contribution to colonial efforts to end pharaonic circumcision, Heather Bell writes that Sudan officials considered the sisters "a useful source of information" and given "their apparently apolitical status," improvements to midwifery sometimes provided a convenient cover for government inertia until the time was judged ripe for a public anticircumcision campaign. "But," Bell continues, the Wolffs "had no role in the political sphere where decisions about government policy on female circumcision were being made." Certainly this captures the thinking of SPS and SMS authorities, if not London bureaucrats too. But it is important to stress that the Wolffs' work was only "neutral" or "apolitical" in the sense that medicine and science are classed as such by hegemonic interests, and speciously divorced from an alleged "political" realm. Bell allows that "in modifying midwifery practice, the Wolffs and trained midwives became deeply involved in community and household politics."[134] However, the public/domestic distinction here invoked is again more ostensible than real, for medicine was a key political tool of colonial ventures, a seemingly neutral way to "capture bodies" and, by revising habit, to colonize consciousness itself. It is hard to consider the Wolffs apolitical, given their teachings, and the energy their superiors spent trying to corral them into "gender appropriate" ideological space. Where female circumcision was concerned, the sisters were self-confessed crusaders, entirely confident of their cause.

Imperial Sudan was a masculine world; its ruling elite and professional cadre, plus the missionaries allowed to do limited work in the north, were steeped in a model of gender relations that took for granted "the 'natural' superiority of the English gentleman" over Sudanese of either sex, and, despite the doubts of some, over European women too.[135] In Sudan's colonial culture, manhood entailed stoicism, autonomy, rational self-posses-

sion, an intrinsic regard for hierarchy—attributes forged and affirmed in all-male British public schools, through military drill, competitive sports, formal etiquette and uniform dress, and living arrangements that allowed only limited contact with women. It is hardly surprising that the Wolffs found themselves so frequently rebuffed.

By contrast, to British officials the manhood of the colonized seemed familial and inferior. Raised by mothers and grandmothers in extended family homes, and permitted up to four wives at once, Arab Sudanese men lived in close proximity to women, even if the conventions of segregation restricted contact especially with those who were not their kin. Add to this the colonizers' low opinion of Islam as a backward faith that encouraged fatalism, superstition, indolence, and excess. Little wonder they considered Sudanese men sensual and volatile, prone to fanaticism, lacking independence of mind. Yet in the same breath as officials reproached Islam and Arab women for the "character deficiencies" of Arab men, they acknowledged women's role in the colonial venture's success: for progress to occur, boys needed "enlightened" mothers.

The Wolffs' work was designed to help produce them. They sought to instill hygiene and order in northern domestic life, fight "barbarous customs" with scientific practice, and imbue trainees with selfless devotion to others. The sisters chafed at being denied sufficient recognition for their efforts to "civilize" grassroots Sudanese and the obstacles they faced in doing so. They were kept in check because their tactics and knowledge, if these became widespread, meant political trouble for the regime. For the Wolffs had struck a delicate balance. Trained midwives learned a modified circumcision that Sudanese might denounce as unwarranted meddling, while Britons would be distressed to learn they were taught to circumcise at all. This last was about to change.

10

"MORE HARM THAN GOOD"

As the years rolled on things became more political. There
were demonstrations and shoutings and yellings. There were
also elections.

—Elliott Balfour, "The District Commissioner's Tale."

Into the mid-1930s the Wolffs trained Sudanese midwives and broad-
ened the reach of biomedicine with prenatal clinics and postnatal
checks. Yet their skirmishes with administrators did not abate. The
compromises their work entailed in adapting to local practice deepened
the misgivings of medical and political staff, and made gaps between "sci-
ence" and "tradition" distressingly clear. When, for instance, an officer
collecting figures in response to Atholl's questionnaire criticized apparent
inconsistencies in midwives' reports, a frustrated Wolff replied that she
had long tried "to instil in the midwives . . . some idea of accuracy and
detail but fitting in with the people's own ideas," according to which
"births are not reckoned in weeks but in Lunar months." Scientific rigor
was lost for want of equivalent terms. "The native word 'Saqt' is a vague
word," she wrote, "that appears to stand for a Still-Birth, a Non viable
foetus, premature or full term." Moreover, "the words viable and non
viable do not seem to exist in ordinary colloquial Arabic, so you will
realize some of the difficulties I have had to contend with in trying to
work out . . . the keeping up of midwives' case books and registering
births for statistical purposes."[1] While the Wolffs made concessions to
indigenous ideas, officials required precise, "objective" facts whose own
cultural foundations went unremarked. *ethnocentrism*

Nor did the latter reverse their opinion of midwifery in light of the
gains the sisters made. On and on Wolff pressed for respect and better
conditions for MTS personnel. In 1933 she hesitated "to appear importu-
nate" in asking yet again for "second class travelling accommodation"
for staff midwives, who not only have "a very high standard of Midwifery
knowledge, reliability and respectability," but "are actually TEACHERS"

and "specially trained for propaganda work dealing with harmful rites and customs."[2]

The Wolffs' last years in Sudan were arduous and strained. Their efforts, they felt, were belittled by Medical Service higher-ups, while those of their untried successor-designate, Elaine Hills-Young, matron of Khartoum Hospital, were lauded "to the skies."[3] The main trouble was that midwives were taught to preach against circumcision and to perform it themselves, which struck Hills-Young and her allies as absurd. Whatever the case, in the early 1930s, as prices for cotton sank disastrously low, a cash-strapped government readily argued hardship to pardon indifferent support for trained midwives and the school.[4] A proposal to expand the MTS in 1936 was postponed. The Wolffs departed in 1937 demoralized, but no less convinced that their methods were sound.

Yet the sisters may have been casualties of their own achievement, perhaps too of the fleeting prosperity brought by the Gezira Scheme, for by the end of their term birth and infant mortality figures had improved.[5] Indeed, by 1938 Sudan's population was reckoned to be 5 ¾ millions strong.[6] This, plus Depression retrenchments, explains why the "population problem" no longer gave administrators much cause for alarm.

In 1934 Angus Gillan became civil secretary, he who, four years before as governor of Kordofan had suggested that Khartoum was "unduly fearful of Moslem opinion" where confronting female circumcision was concerned.[7] Worry that the pharaonic form was still spreading and Islam being asserted by ever more members of non-Muslim groups led Gillan and his associates to rethink the Wolffs' approach.

A New Regime

The shift began in March, 1936, when a confidential paper on pharaonic circumcision was delivered by Dr. D. R. Macdonald to the Sudan Branch of the British Medical Association at a meeting attended by Governor-General Symes, Gillan, and the Wolffs. In it Macdonald admitted that female circumcision had long "exercised the thoughts of all medical practitioners" in view of "the deformities and surgical sequelae to which it gives rise." Moreover, since the practice had lately become "the subject of official and semi-official enquiry by influential persons in Great Britain" it was now desirable that Sudan medical staff "attempt to form some collective policy in regard to its suppression or mitigation." Bowing to the sisters' greater experience in such matters, he apologized "for appearing . . . like a sheep in wolf's clothing."[8]

But sheep he was, with the professional cachet that the Wolffs themselves lacked, for Macdonald relied heavily in his address on Mabel's

1924 paper and the sisters' shelved British Hygiene Council piece of 1933. To their practical observations he added comments on the distribution of the practice in Sudan, plus historical information, much of it unconvincing. He traced the origin of excision to "the tendency to hypertrophy of the clitoris or the labia minora" "in certain races," citing the eighteenth-century explorer James Bruce in support. Bruce, he said, had described how Catholic missionaries in Abyssinia two centuries before had forbidden excision among converts, then promptly backed down on finding that if the "enlargement" was left untreated, women had "difficulties in childbirth and even coitus," and their bodies "so repelled the men that they either would not marry or married heretics or unbelievers." Macdonald then invoked the "Hottentot Venus," a woman from southern Africa who, having "enormously hypertrophied" labia, had been put on humiliating display in Europe at the end of the nineteenth century.[9]

The inference that Arab women's genitals must be abnormal because they had been cut is both circular and specious. Since any sample of northern women consisted mainly, if not entirely, of those who had been circumcised in prepubescence, there would have been little evidence for "hypertrophy" apart from the fact of circumcision itself. Moreover, what female body provided the standard by which Sudanese women were judged? Whose genitals, if not those of (some) Europeans, were deemed "normal" and inherently sound? This, despite the fact that clitoridectomy was also practiced in Britain and North America as a remedy for "hysteria" and masturbation.[10] In turn, excision in twentieth-century Sudan ostensibly had the same significance that Bruce, writing in the eighteenth century, suggested that missionaries proselytizing in the sixteenth believed it had in the wider catchment of "Abyssinia." The argument is lamentably strained.

Though Macdonald argued that excision might be warranted to ensure reproduction of races in which women are genitally "malformed," infibulation, he observed "has no such anatomical and religious justifications" despite being regarded "by all except the very enlightened as part of the discipline of the Moslem religion." He listed the familiar reasons for its popularity "with Sudanese" (that is, men): to protect the morals of "their women who, according to them, are highly over-sexed"; to gratify "a sadistic appetite in the Sudanese men," and, "quite erroneously, as most of the Sudanese themselves admit, to increase the man's satisfaction by narrowing the vaginal orifice." Brides and midwives, on the other hand, manipulate such beliefs, and the mooted moral protection that infibulation and reinfibulation provide, to extort money from husbands and kin. Moreover, "with women . . . infibulation is the fashion" and "the very idea of being uncircumcised would be . . . so shameful as hardly to be talked about. To call her an uncircumcised woman is the worst term

of abuse one can address to a Sudanese lady." However, all these, in his view, reduce to superficial explanations, for "the real truth of infibulation is that it is a sign of moral degeneration."

> The chastity of a virgin in cultured races means much more than the mere anatomical condition of virgo intacta. It implies strength of character and high moral development. . . . When we find the conception of virginity has dwindled to the dimensions of a crude surgical operation we must assume that the moral fibre of the race is not longer what . . . it must have been.[11]

Note the decline of northern Sudanese on the ladder of social development, their distance from "morally evolved" Europeans, the failed sovereignty-of-will that would have allowed them to progress. In a classic Orientalist move, Arab Sudanese are chastised for not being "individual" in an ideal Western sense, though Macdonald seems to imply they once were. The image of female sexuality here is complex and inconsistent, in keeping with the anomalous status of the Arab Sudan. If intact, women are inclined to sexual excess and in need of moral guidance. Here Sudan is primitive—carnal and ignorant, yet open to salvation—a state usually symbolized by the sexuality of African men.[12] If circumcised, however, women are sexually cognizant, fallen from innocence and grace. That their sexuality is controlled by external means suggests to Macdonald and others that they lack not knowledge (as do "Africans"), but character and will (as do "Arabs"). To advance from barbarism Sudanese women must cultivate internal discipline; infibulation should then become redundant and disappear. The argument is a roundabout indictment of Sudanese culture and Islam.

Years later, Macdonald's paper would be cited in postcolonial writing on "female genital mutilation" and what excision and infibulation "really mean," though by then the onus of responsibility had shifted from women to men.[13] However discredited they are in critical social science, the nineteenth-century tropes of social evolution continue to inflect the discourse surrounding "FGM."

Macdonald assumes a contrast between European and Sudanese selfhood: where morality is internalized, as in the West, the self is advanced; where it is not, as is claimed of Sudan, the self is degenerate. Yet the ethnographic record confounds such claims. For Hofriyat, for instance, it would be wrong to suggest that when morality is asserted on and through the body through veiling or genital cutting, it is detached from a woman's consciousness and will.[14] That view relies heavily on Western distinctions between individual and society, id and superego, nature and culture, body and mind. Foucault's view of power as creative as well as repressive seems pertinent here.[15] Achieving culturally specific ethical personhood may not be a matter of applying disembodied "reason" to recal-

citrant animality, in an Augustinian sense, but of actively cultivating an intrinsically unified "mindful body."[16] Indeed, it is precisely because morality *is* internalized or embodied by northern Sudanese that its physical expression makes cultural sense.[17] Likewise, its external realization contributes to a woman's sense of personhood and self. Moreover, she defines herself largely in relation to others, not as a singular entity answerable solely to herself or "society" as an abstract whole. The parameters of self, as of virtuous deportment, are culturally and historically specific.

At the end of his talk, Macdonald proposed a standard approach to the problem of pharaonic circumcision: both prevent its spread, and abolish it or mitigate its severity wherever it is entrenched. "If we could induce the Sudanese to substitute excision for infibulation," he concluded, "we should at least have done something."[18] Just what, however, is unclear. For excision and infibulation do not always coincide in northern Sudan, given the variability of traditional midwives' techniques.[19] In some cases the clitoris is neither removed nor reduced but sewn beneath adjacent tissue. In such cases, the substitution would have *introduced* a form of genital cutting rather than transformed an existing practice. Even where excision is immediately followed by infibulation, the former was hardly certain to *replace* the latter where "covering" the vagina, thus ensuring the body's purity, cleanliness, and modesty, are the expected results of female genital shaping. It is worth asking, too, why British doctors and administrators considered excision less odious and thus preferable to infibulation. Was it not because they viewed women mainly as reproducers, rather than, in twenty-first-century terms, whole persons entitled to "bodily integrity" and sexual fulfillment? Surely they knew that cutting a healthy body part would cause suffering and carried risks. Yet since medical and political staff were committed to ensuring an ample and healthy workforce, the presumed impediment of infibulation to pregnancy and birth was their main concern.

At the same time, however, officials were keen to extricate themselves from the public-relations swamp of Sudan's unreconstructed "backwardness." In 1936 the long awaited Anglo-Egyptian Treaty was signed, and with it a major obstacle to more assertive tactics disappeared. As long as negotiations had been under way, the British had forborne interfering with local customs, lest Egyptian nationalists be handed a pretext to stimulate popular unrest. Indeed, as Gillan's office confessed, the "enlightenment campaign"—modest as it was—had been "slow moving" all this time.[20] Now with issues of governance and the Nile apparently resolved, the moment had come "to be more open" about pharaonic circumcision. Officials hoped "to touch the leading Sudanese" and obtain their support for abolition. But they acknowledged the delicacy of the matter and insisted that "Government must keep entirely in the background."[21] King

George VI's coronation in 1937 seemed to furnish an opening: perhaps the young elites chosen to attend the ceremonies in England, including Sayyid ʿAbd al-Rahman al-Mahdi's son, Siddiq, plus a nephew of Sayyid ʿAli Mirghani and an array of professional men, might be prevailed on to publicly repudiate "the barbarous custom."[22] Some officials were skeptical of the plan. "The Coronation 'visit' may help," noted one, "but if Sudanese opinion is not ripe enough to take action on its own, there is no good trying to force the pace." In which case the most to be hoped for was a modified pharaonic circumcision "on the Wolff lines."[23] Legal recourse was not on the cards; in fact, the only administrators arguing for a law were governors of southern provinces who wanted to block the custom's spread.[24] Still, performing a pharaonic circumcision where it was not an established practice was already actionable on the grounds of causing hurt.[25]

About-face

The musings above may read like business as usual—high-minded moralizing tempered by political caution and a reluctance to act. Yet a change of tactics was in the air. Elaine Hills-Young who, late in 1937, succeeded Wolff as principal of the Midwives Training School, was chosen by officials for her refusal to tolerate "retrograde" Sudanese customs. Soon after taking up the post she witnessed a modified pharaonic operation performed by one of the school's staff midwives. Though it was carried out "under more hygienic conditions than were customary," she nonetheless found "the spectacle . . . so revolting" that she at once forbade trained midwives to do circumcisions of any kind.[26] She intensified MTS lessons against all female genital cutting and, with apparent support from the medical service, ceased instruction in the modified technique.[27]

It is hardly surprising, however, that few trained *dayas* complied. The majority continued to circumcise in secret, lest they forfeit the public trust they had taken such pains to win. And their small irregular government stipends meant that illicit infibulations and postpartum repairs were, as Wolff observed, "the most lucrative part of [the midwives'] work."[28] Students may have secretly learned the modified technique from graduates or staff midwives, or, emulating *dayas* of the rope, reverted to more severe forms.

Privately, Hills-Young conceded that it was impossible for trained women suddenly to stop doing circumcisions.[29] She nonetheless proscribed the use of government supplies for the purpose and, if a trained midwife was found to have performed the procedure, her credentials could be revoked. Lessons continued on how to open the genital scar

during labor and "the best method of dealing with the gaping wound after delivery," as well as on the treatment of wives "when they or their husbands desire remedial repair of the impossibly small vaginal orifice."[30] Yet the outcomes she proposed could hardly have matched clients' expectations or desires. To Hills-Young, tactical compromise was anathema where female genital cutting was concerned.[31] In this she joined a growing group of British expatriates, Sudanese doctors, teachers, other professionals, and government *daya*s, among them several staff midwives originally taught by the Wolffs, who campaigned to end the "barbaric institution"[32] once and for all.

In chapter 5 I noted that in the late-1930s, after Maffey and MacMichael retired from the SPS, Sudanese political movements revived. Moreover, as criticism mounted from British and educated Sudanese over the conservative thrust of indirect rule, schooling for northern boys and girls was expanded and reformed. Native politics and education now joined medicine as potential means to mold local sensibilities, including those surrounding female circumcision. Instruction against the pharaonic form was integrated into teacher-education courses, as well as the fourth-year elementary curriculum for girls (not boys), though female students were still relatively few.[33]

With an eye, it seems, to preparing the ground for a future abolition campaign, Gillan sent copies of Macdonald's paper to provincial governors, seeking advice and information on local views. Douglas Newbold in Kordofan openly discussed the issue with native figures, Sudanese officers, and British DCs who "sounded [out] certain tribal leaders." His findings are worth considering at length, for several of his recommendations were eventually put into play. Newbold found that pharaonic circumcision "is generally deprecated by the educated classes," most of whom "are definitely opposed to it" and "anxious for Government action." Few of them, he wrote, would object to a campaign, "provided the religious leaders proclaimed their opposition to [the practice]." Tribal leaders were less sanguine, as "the majority of tribesmen" deemed circumcision "a normal customary and desirable event in the life of a woman." "They do not," he noted, "regard it as particularly cruel and . . . [say] it prevents immorality by safeguarding virginity and damping down the naturally passionate nature of women."[34] Kordofan's native medical officers opined that if the pharaonic procedure were replaced by the "sunna," fewer complications would occur. Trained midwives who "at present do a modified form of Pharaonic" would need instruction in the "new" method though "this would not present a great difficulty."[35] Confidentially, Newbold regretted that there was "no real evaluation of the 'sunna' circumcision" that medics assumed to be less destructive. "Anyhow," he wrote, "let's get rid of Pharaonic first."[36]

To this end, he made several proposals for "a vigorous policy of both propaganda and action," but stopped short of advocating a dedicated law. Extant remedies were, he thought, sufficient, these being "the hurt sections of the Sudan Penal Code" and a section of the Native Courts Ordinance of 1932. "[I]n urban and semi-sophisticated rural areas at least, the brutal and unskilled mutilation of the most sensitive parts of a young girl's body is contrary to justice. It does not seem to me any less barbaric than the castration of boys."[37] The implied reference to eunuchs may have been made to evoke the history of Egyptian slaving in Sudan, thus to deflect fault for the practice from Sudanese men as well as marshal their empathy for women's plight.

Newbold advised that the head of the medical service write a pamphlet for circulation in both English and Arabic "describing frankly and simply the brutality of the method" and its "harmful results." As government had nowhere publicly condemned pharaonic circumcision, it should do so in the pamphlet's preface, by asserting that it "regards the custom as barbaric and inimical to the country's progress, and intends to secure its abolition." Armed with such a document, senior political staff, supported by medical and education personnel, should "undertake propaganda . . . among educated Sudanese and tribal leaders."[38] The Sudanese Graduate's General Congress Committee, formed in 1938 with the aim of promoting the welfare of Sudan,[39] should "be encouraged to study the subject with the hope that [newspaper] articles deploring the practice will be published." Religious leaders should be "approached and persuaded to come into the open and denounce the practice as pagan, either by fetwa, or by some other form of pronouncement." Lastly, the courts should be notified that

> where conditions are favourable and in specific cases of injury, they are at liberty to convict, under a charge of hurt, persons responsible for Pharaonic operations. The degree of public opposition and the public security factor must for some time make us proceed gradually in backward Arab areas. . . . [However] in pagan areas native authorities [should] be instructed to take action in all cases that come to their notice, on the grounds that the Pharaonic circumcision is not customary to pagans and should not be allowed to become so.[40]

A few months later, toward the end of 1939, Newbold succeeded Gillan as civil secretary when the latter retired. Newbold now became the dominant government voice.[41]

A plan was hatched. In a speech delivered shortly before leaving office, Gillan gave advice to educated Sudanese men. His words, he said, were spoken in friendship, and "would be easier to omit," but his "conscience and the claims of humanity" counseled otherwise. For, however close the relations between educated Sudanese and Britons might become,

it is no use pretending that there is not one bar which takes a lot of getting over. We do not ask you unduly to expedite the liberation of your women folk. That is a matter of which only you in your good time, and in the light of educative processes, can judge. But can you wonder if some of us feel that there exists an indefinable but none the less real social barrier between us when we know that many of you . . . at least tolerate, if you do not encourage, the barbarous practice of female Pharaonic circumcision in your homes? That however is only one of the subsidiary aspects of the question. The substance itself lies in the existence of the practice itself as a sin against humanity and an obstacle to real progress in civilisation. . . . [I]t is not a question for the alien administrator but one for the Sudanese, and particularly, for the members of the noble profession of medicine . . . to tackle for themselves and on their own lines. My conscience compels me to say what I have said before I leave the Sudan.[42]

Gillan's words received considerable public attention. Prompted by them, and perhaps buoyed by a confidential chat with his British superiors, a Sudanese doctor soon published a statement in *al-Nil* on the "evils of female circumcision in the Sudan," describing its social and physical mischief "and its injurious effects on women throughout life."[43] He ended by inviting the mufti of Sudan to clarify *shari'a* on this point. A few days later the mufti's response appeared:

My answer is that female circumcision is only desirable, i.e. not compulsory, and that it consists in cutting off part of the clitoris. More than that is forbidden. . . . This is the female circumcision that is desirable in Islam. Other forms such as that known among us as the pharaonic, are mutilations and mutilations are categorically forbidden.[44]

According to Newbold, "the fetwa received favourable press comment and was widely distributed in the Northern Sudan."[45]

As Gillan exits the story—for a while—and Newbold assumes his post, a new voice joins the rising chorus. She is Dr. Ina Beasley, a former lecturer in English at Rangoon University, Burma, first encountered in chapter 7 when she was appointed superintendent of Girls' Education in 1939. Beasley was lodged in Omdurman, near Hills-Young and other British professional women whom she quickly met. From them she learned of pharaonic circumcision, and like them was appalled. She resolved to do something about it and, along with Hills-Young and a teaching colleague, Sylvia Clark, became a zealous crusader against the practice. Indeed, she confessed, the fact of female circumcision "lay always as a shadow at the back of our [other] endeavours, influencing our opinions of people in all walks of life." Even later on, when she had become "accustomed to much that [she] had originally thought would be unbearable, there were times

when the forces of ignorance pressed round like some tangible evil lurking in the darkness."[46] In Beasley's words the image of social evolution was inflected by the moral absolutes of evil and sin.

Early in 1940 Hills-Young's revised policy was formally adopted by the Sudan Medical Service with a circular warning that "female circumcision of children forms no part of the functions of a licensed midwife or any members of the medical staff." Further, in a subtle revision of history, the document proclaimed that the idea "that this operation is at least tolerated by the medical authorities in Sudan" is "entirely without foundation." In fact it "is strongly disapproved of by this Service," and "every effort is made in the training of midwives at Omdurman to condemn and discredit the practice of female circumcision in any form." Medical staff were urged to warn "Sudanese notables and officials, as opportunity arises that this operation is condemned by enlightened medical opinion and by the Sudan Government as a whole."[47] While not the pamphlet Newbold sought, it was a start.

The stage thus seemed set for an escalated assault on pharaonic circumcision. But World War II had begun. By 1940 several members of the SPS had left to join the military, and those who remained were busy defending Sudan's border with Ethiopia, beating back an invasion by Mussolini's troops. Though female circumcision remained on the agenda under Newbold, who was deeply troubled by the practice and a staunch supporter of the Wolffs, nothing formal was undertaken until 1944. But the issue was kept simmering among professional Sudanese.

In April 1942 a discussion on female circumcision was held in the recently completed Cultural Centre built to encourage relations between British and educated Sudanese (chapter 3). The *Sudan Herald* published a report on the evening's events. The chair, Muhammad Salih Shinqiti, a prominent member of the Umma (neo-Mahdist) party,[48] began by explaining that pharaonic circumcision has "no religious backing" and was likely an ancient Egyptian practice that "the Arabs picked up on their way to the Sudan." *Sunna* circumcision, on the other hand, was "desirable but not obligatory." A Sudanese doctor, Mansur ʿAli Hassib, then gave "a severely scientific talk of great force and frankness" that "bitterly" condemned pharaonic circumcision, "which not only interfered seriously with vital biological functions, but also exposed the victim to the danger of dying from hemorrhage or sepsis as a direct result of the operation, usually performed by old and ignorant women using dirty instruments." Newbold then outlined government's view that "Pharaonic circumcision was a real evil that caused widespread and intense suffering not only in physical pain and danger to health and life, but also in conjugal happiness." Yet because "the question was a delicate one involving an old

and deeply rooted custom . . . [administrators] had been reluctant to of-
fend . . . honest convictions and deeprooted susceptibilities by taking pre-
mature action." He asked whether infibulation should be replaced by
sunna, as his inquiries had revealed divided opinion on the point. And
he pledged "Government support for Sudanese public opinion against
Pharaonic circumcision, even to the extent of penal action, where possible
and desired."[49]

The ensuing debate did not settle the question of sunna circumcision,
but endorsed an urban campaign against the pharaonic form led by edu-
cated Sudanese and "backed by government action." The *Herald* reported
that the (all-male) group had "agreed that the main obstacle to abolition
lay in the conservative stubbornness of the older women." Thus, "the
educated Sudanese man" has "the duty . . . to persuade the women of
his household to abandon the practice," which, one assumes, left him a
convenient excuse for defeat. While participants resolved "that the mo-
ment for action had come," this "should at first be confined to sophisti-
cated urban localities and gradually radiate outwards."[50] Newbold's re-
spectful equanimity may have effected this harmony of opinion, a
harmony that seems precipitate in view of what happened next.

In May 1942 *al-Nil* (a newspaper identified with ʿAbd al-Rahman al-
Mahdi and the Umma party) carried three "extremely reactionary" arti-
cles denouncing the meeting. Their author, Amin Effendi Babikr, pro-
tested that the center was not "an official institution intended to represent
the Legislative or Executive power," and chastised the civil secretary for
promising "Government support [for a campaign against the custom] and
the infliction of penalties."[51] Criticism of Babikr's position followed in *al-
Nil* with a Sudanese educator declaring that "Science and Religion are
agreed" on the subject.[52] Babikr was unrepentant, and repeated his argu-
ments in a lecture at the center that June. Newbold did not attend; some-
one from his office took notes and circulated the gist of the discussion to
Beasley, Hills-Young, and Pridie, director of the SMS, alerting them to
expect hostility to their cause.

In his talk Babikr defended modified pharaonic circumcision "on reli-
gious, hygienic, and social grounds." Sounding much like Kenyatta—
whose book, *Facing Mount Kenya* (1938), he may have found in the cen-
ter's library—and just as influenced by functionalist social science and
alive to officials' fear of instability as he, Babikr claimed that because
circumcision was an integral part of the "tradition on which society was
based," its suppression would surely "entail a collapse of the whole fab-
ric." Moreover, "the pain inflicted by the operation was justified by its
results . . . [which include] protection against rape and prostitution and
a lessening of the sexual desire which leads unmarried girls astray." He

supported his contention by appealing to environmental conditions, echoing archaic European views in claiming that "this protection had always been necessary in a hot climate and would be more so . . . as the gradual emancipation of Sudanese women exposed them more to the temptations which had led in Europe to increasing immorality and exhibitionism." He warned that the social consequences of introducing European ways to Egypt and Kenya had been "most unhappy." In Kenya they had provoked "an increase in premarital promiscuity and resultant bastard children," while in Egypt divorce had become more frequent, "and husbands were turning to the rural districts for circumcised brides of whose fidelity and chastity there could be no doubt."[53]

Interestingly, in the ensuing exchange no one challenged Babikr's claims. They spoke of "medical" matters instead: Dr. Malouf stated that pharaonic circumcision "probably did not interfere" with a woman' s enjoyment of sex but "probably did to a certain degree reduce her desire." Yet it is, he said, "undoubtedly more hygienic [to be infibulated]." Moreover, it "should not interfere with normal delivery even if no instrument were used. Nor need it interfere with menstruation. In general [he believed] there was much to be said for the practise if the operation were carried out in hygienic conditions under an Anaesthetic."[54]

Dr. ʿAbd al-Halim Mohammed[55] strongly disagreed; whether modified or traditional, pharaonic circumcision was not hygienic and often impeded delivery and menstruation "with dreadful results." Moreover, the operation "concentrated a child's attention upon her sex organs at a time when she should be unconscious of them and gave her a permanent bias that way." As such, the practice "did not . . . achieve . . . the ends which in the lecturer's opinion were its justification."[56]

This second discussion revealed a range of educated opinion that the first had largely obscured. Some men were convinced of the custom's harmfulness, others were not and believed it beneficial, if on disparate moral, medical, and perhaps nationalist grounds. But note how the first two speakers tailored Sudanese ideas about propriety and health to Western concepts of hygiene, thus aligning custom with biomedicine. Here it seems the English concepts "clean" and "pure" were being subsumed by the Arabic terms "*nadīf*" and "*tāhir*," whose meanings in Sudan, outlined in chapter 4, are incompletely commensurate with those of the former pair. The last speaker, on the other hand, shifted the ground from moral and physical well-being to psychology. His remark that a circumcised girl becomes aware of and even fixated on her sexual parts has a ring of ethnographic truth. Yet if my data are representative, the significance of circumcision—at least for women—has less to do with sexuality than moral re-

production, that is, cultivating the girl's identification with her assigned, carefully regulated, procreative role.

What was at stake in these Cultural Centre debates? Despite some agreement that unmodified forms of pharaonic circumcision were harmful to women's health, no consensus emerged among participants that female genital cutting was without value. Rather, several feared that social changes set in train by colonialism and contact with British women and men were reducing indigenous control over female sexuality that circumcision was held to ensure. Educational opportunities for women—however few—were contributing to a shift in gender relations, but also, importantly, exacerbating a breach in relations between young and old.

For British officials and educated Sudanese men, northern women's sexuality and fertility were contested ground. Government wanted a native population in satisfactory numbers, health, and outlook to secure the colony's fiscal well-being and showcase imperial benevolence; Sudanese sought morally connected descendants and affines, the basis of a man's (and ultimately a woman's) power, wealth, and prestige. To both, women's bodies were resources to be controlled, and not only by men but women too. The regime's plan to abolish infibulation contained both a threat to elders' jurisdiction over female sexuality, and a promise to make women more prolific and improve their physical health. Educated Sudanese did not reject European concepts of body, self, and society; indeed they embraced them, phrasing their concerns in the discourses of Western medicine and social theory. Yet they also expressed anxiety over potential erosions of family integrity and indigenous male authority. Their debates reverberate with the loss, attempted recovery, and rejection of relational personhood, with the conflicts and challenges of constructing community and nation in modern Sudan. They offered an appraisal of Western individualism that was phrased in the idiom of individuality, a gesture that embraced colonial terms even as it sought to control their direction and shape their forms.

The contested position of Sudanese women in emerging nationalist debates is crucial to our story. On the one hand, "women's customs" such as lip tattooing and female genital cutting were an embarrassment to men schooled in European ways, and women thus became targets for social reform. On the other, notes Heather Sharkey, because women signified indigenous culture, "nationalists did not want them to change too much. . . . Indeed, precisely because of their local particularity, women's customs provided a rationale for Sudanese nationalism."[57] Thus pharaonic circumcision came to figure in the struggles of Sudanese to extricate themselves from colonial rule.

Teaching Women

During the war, Beasley, Hills-Young, and other British professional women collaborated in what they called their anticircumcision "crusade." They were supported by staff midwives and several teachers at the Girl's Training College who traveled to outlying areas to preach against the practice.[58] Most mothers were reluctant to change. Yet if mothers seemed beyond reach, schoolgirls might be won.

We have already seen that girls' education stressed "domestic science": housework, cooking, sewing, and, as with trainee midwives, raising children in a rational, disciplined way. From the end of the 1930s, GTC and MTS staffs collaborated to instruct student teachers in matters of health and keep graduate teachers up to speed. In rural areas the latter teamed up with medical midwives to run ante-natal clinics. The girls' elementary curriculum was revised to include lessons in hygiene and infant care with a focus on order and efficiency.[59] Thus the effort to reform Arab Sudanese motherhood that had started with pregnant women and midwives was now extended to their daughters—future mothers—too. Given women's power over children in "their early and impressionable years," "progressive" techniques of mothering were expected to generate healthier, better-adjusted, more mature citizens from a European point of view. Students were enjoined to abandon practices such as sleeping with their babies and nursing them on demand as these were thought to induce character weakness in adults.

Mature women were not neglected, however. In 1941 Hills-Young and her staff opened a Government Child Welfare Centre in Omdurman near the MTS.

> We had a room converted into a model women's quarter, with all native furnishing but kept clean, tidy and simple. The mothers would often say: "Oh, but this is just like ours." Then I would say, "Yes, to a certain extent, but we have shelves for the dishes and do not stack them on the mud floor under the bed or table. Also our windows have wire netting to keep out the flies and the beds have mosquito nets, even baby's cot, also we have small beds for children so that they can sleep alone."

Women were taught to limit and schedule feeding times using the position of the sun for reference, as few households (pace Griffiths's homily) owned a clock. Though babies in northern Sudan were (and are) seldom out of their mothers' arms, those of pupil midwives were placed in wooden playpens while their mothers attended class.[60] All this was supposed to amend character "deficiencies" in Sudanese by encouraging

greater independence, wholesome self-restraint, and a rational, measured sense of time.

The novelties of playpens and scheduled feedings are as revealing as they must have seemed pragmatic. Not only did they show how British envisioned ideal character and typified Sudanese, they also proposed a remedy for Sudan's deplorable statistics. Attention to mother and child welfare in Sudan was part of a global campaign championed in the 1930s and 1940s by the International Save the Children Union in Geneva, and supported by personalities such as Eleanor Rathbone and Katherine Atholl. In the colonies it called for teaching hygiene to native women. The approach was ideological and particularistic, stressing individual responsibility and character change while leaving a woman's social position and economic opportunity largely unexamined.[61] To Beasley and Hills-Young, "civilizing" meant creating self-aware, self-disciplined subjects. If successful, "backward superstitions" and "evil" customs would vanish, population health and conduct would improve. Sudan's resilient evil, however, required more overt intervention.

In 1942 and 1943, women teachers attending refresher courses at the GTC heard a series of hygiene lectures by Hills-Young and her staff in which the issue of female circumcision was aired. They toured MTS facilities where the need for abolition was urged.[62] British educationalists "on trek"—inspection tours of rural schools—carried copies of the Mufti's *fatwa* on circumcision and pressed it on mothers and teachers to discuss.[63] Religion, obliquely present in Christian images of evil and the impassioned crusade against it, had now come squarely into play. The following year the Mahdi's son would join the fray.

In July 1944 Sayyid ʿAbdelrahman al-Mahdi concluded his annual marriage festival for couples who eschewed the excess of a customary wedding, with a sermon against female circumcision. It was a chance to reach those who had already broken with tradition and wished to follow a purer form of Islam. His address was reported in *al-Nil* (of which he owned a major share):

> Our neglect so far of all questions concerning woman has condemned her to a life of backwardness and stagnation. . . . This neglect of women, the failure to reform her condition and to educate her mind [has] led to a far-reaching evil in our social life. . . .
>
> Pharaonic circumcision is a shame and a degradation to woman apart from being contrary to authenticated sunna (the practice prescribed by the Prophet). Moreover it has been condemned by medicine as harmful to health both physically and psychologically, and as particularly injurious in child-birth. . . .

> Why then do we maintain pagan customs condemned by God and Islam, when we are the descendants of a nation from whom other nations received the light of culture[?][64]

It is not clear what effect the sermon produced. It does seem certain that the regime had begun to mobilize native elites and position itself for a concerted attack on pharaonic circumcision. What, aside from Newbold's resolve and the zeal of women professionals, lay behind this push? Why now, in 1944, was the time "ripe" for an all-out campaign when caution and moderation had always ruled before, and seemed poised to continue so with Newbold's measured demurral—"where possible and desired"— of 1942? For answers we again turn to British women, Parliament, and mounting pressure from home.

The Home Front

In 1943 Hills-Young left the MTS to do war work in Europe; her post was filled by Phyllis Dickens, an admirer of the Wolffs. Hills-Young continued what she called "my private crusade" from afar, determined to end government diffidence and delay.[65] Meeting Beasley in London in June 1944, she made known her intention to have a question asked in the House of Commons on female circumcision in Sudan.[66]

That summer and fall, Hills-Young wrote to people in key institutions who might be inclined to help. She outlined the problem in the *Medical Women's Federation Quarterly Review*, stating she was "anxious to rouse public opinion" in Britain.[67] Among those she solicited was Irene Ward, a Conservative member of Parliament.[68]

Ward responded at once, requesting details. Over several blitz-interrupted nights, Hills-Young wrote a report, subtitled "Surgical Seal of Chastity."[69] It described forms of the operation from *sunna* to pharaonic, summarized the popular rationales of preserving virginity and indulging "male sadistic pleasures," and attributed financial motives to mothers-in-law and midwives for sustaining the practice. More, it publicly revealed what administrators had tried so desperately to contain: that until her intervention in 1938, "Government-trained midwives were permitted, in fact taught, to perform this operation on the assumption that they carried out the lesser form with more hygienic methods." Hills-Young described the modified operations an MTS staff midwife had performed on two "little victims," the witnessing of which had determined her to revise the school's curriculum. Sudanese women, she wrote, know this is a cruel and harmful custom, yet having "no assurance as yet that the men will marry their daughters if uncircumcised," feel powerless to do anything but con-

form. Although religious leaders and educated men "admit that the more drastic operation . . . is against the laws laid down by Mohamed," it "continues to be the custom." Indeed, "to this day the greatest insult amongst the Sudanese is to refer to a man as 'the son of an uncircumcised woman' or to a girl as 'uncircumcised.' " Even sepsis of the wound raises no alarm, for the child's female kin "think the scar tissue will become more firm and thus the 'seal of chastity' [be] made more secure." Medical authorities, she continued, have discussed the "uncivilized custom" from time to time to little effect. Indeed, few Europeans have truly "appreciated the brutality and child torture involved."

> It would seem, therefore, that if the practice is to be stamped out it can only be with the active aid of the Government. This is a responsibility which should not be evaded for the Sudanese cannot be expected to help themselves in the matter without the assistance of public opinion in Great Britain and Government action in the Sudan.[70]

The nonsequitur is revealing: that Sudanese "cannot be expected to help themselves" without government assistance suggests they lack the ability to change even should they wish to comply with progressive ways.

Ward sent Hills-Young's report to Oliver Stanley, the colonial secretary. "What are we doing to put a stop to this barbaric custom?" she asked. "It really is frightful that such happenings should still be going on and I shall be glad to know what action you propose to take."[71] She had cornered the wrong man. Stanley redirected her letter to the Foreign Office advising Ward that responsibility for Sudan lay there. He promised, however, to look into the matter in East Africa where a similar "problem" exists, but "on a much smaller scale."[72]

The political dance resumed. Foreign Office staff looking for precedents came up with correspondence dating to 1930 and 1931 from the all-party Parliamentary committee headed by Colonel Wedgwood and the Duchess of Atholl. But Maffey's response to Atholl's questions had not been retained in the files. Indeed, a handwritten marginal note warns that "in drafting [a response to Ward] we must remember that they [the Egyptian desk, Foreign Office?] have destroyed their archives,"[73] possibly as a precaution to invasion, to prevent political damage were such documents to be released.[74] The Foreign Office asked Khartoum for an update and a copy of Maffey's 1930 report.[75] In the meantime, the foreign secretary, Anthony Eden, advised Ward that "the subject of Miss Young's memorandum . . . requires most delicate handling, and . . . direct government pressure may do more harm than good." He informed her that he had sent Hills-Young's paper to Khartoum with a request for news of progress toward abolition. Yet, he cautioned, "when last we consulted them" [thirteen years before] the Sudan Government felt "the time was not ripe for

legislation and that the education of public opinion . . . was the only sure method of leading those concerned away from what is, admittedly, a most objectionable practice."[76]

Hills-Young had picked her champion well. Ward penned a stiff reply to Eden's "disappointing" defense:

> What I would really like to know is what active steps are the Sudan Government taking to educate opinion. I am a little bored with hearing on so many things which are of importance that education is the only means of progress. . . . [T]he test is what finance is forthcoming for the purpose of carrying on the education campaign.[77]

She offered an allegory: At the beginning of the war the naval commander in Freetown learned that the Admiralty was sending experts to decide the site for a new wharf. The commander looked in the records, found that experts had already selected a site in 1895, two others a similar site in 1914, and "signalled back to the Admiralty that it wasn't experts that were required but the wharf." She asked for "much fuller information on what is being done."[78]

Thus in the fall of 1944, Newbold, then acting governor-general of Sudan, found himself responding to a new Whitehall inquiry sparked by Hills-Young's unwavering ire. Hills-Young's approaches to other organizations added to the pressure and netted offers of help but little in the way of immediate results.[79]

Apprised by Ward of Newbold's impending report, Hills-Young doubted it would reveal anything new. "The 'laissez-faire' attitude of local officials," she wrote, has to do with their sex, for "males could hardly be expected" to view the matter "with the same sympathy and sense of urgency as women." She then proposed a draconian move:

> Higher education for girls in the Sudan should be conditional upon their being uncircumcised. (This proposal had the support of the Controller of Girls' Education [Beasley] . . . before I left the Sudan.) The refusal of admission to Intermediate and Higher Schools of circumcised girls would have considerable influence with the parents and the rising generation.[80]

The suggestion was doubtful, in view of what had occurred in Kenya when Miss Stumpf used such tactics years before. Nor, had it been implemented, would it have done more than further polarize the sexes and divide the population at large. Granted, Hills-Young also endorsed religious instruction for men, and health education for male and younger female students. But, if the logic holds that more education equals the demise of pharaonic circumcision, denying circumcised girls higher schooling was paradoxical and would surely have produced unwelcome effects: they would marry less-educated men and continue the practice

with their daughters. Hills-Young and possibly Beasley were betting that because educated young women attract educated, well-placed husbands who enhance their wives' family status, upwardly mobile parents would refrain from circumcising their daughters so as to protect them as a resource. This, however, ran contrary to cultural logic, for such protection was availed not by avoiding circumcision but by practicing it. Moreover, the transfer of status went both ways: an honorable wife enhanced the position of her husband's family, just as an honorable daughter contributed to the status of her parents, siblings, and other kin. And a daughter attending school far from home was susceptible to aspersions that being circumcised partly allayed. In seeking to pit Western education against traditional standards of integrity, British professional women wrongly believed that virtue in Muslim Sudan was an individualized trait.

A Plan

Newbold's response to the Foreign Office—marked "Secret"—went through Cairo to Anthony Eden and Sudan's governor-general, Hubert Huddleston,[81] who was then in Britain on leave. It stated that "the facts about female circumcision in the Sudan . . . are very much as Miss Hills Young has related in a rather more vivid manner" than had Dr. Atkey in 1930. While "the Sudan Government is under no illusions about the evils of the practice," "the difficulties of dealing with it . . . still exist and any hasty action or ill-judged campaign without a reasonable backing of public opinion would do more harm than good." Indeed, because "Sudanese public opinion" was then "in a sensitive condition," he worried that "too much overt Government pressure" would produce the opposite reaction than desired, citing the advice of "leading Sudanese" who had stressed "the religious issue." Newbold listed the steps taken since 1930 to build up "the requisite body of Sudanese public opinion," including "the formation in June [1944] of a small private committee of leading educated Sudanese by El Sayed Siddik son of El Sayed Abdel Rahman El Mahdi . . . to consider the whole subject."[82]

Newbold went on to describe his plan for a pamphlet to be given "the widest possible circulation" and containing "detailed factual information about the practice of excision and its bad physical and psychological effects on girls and women." Having thus prepared the ground, he proposed to "have the whole subject debated by the Advisory Council for the Northern Sudan next year. The result . . . will determine whether a stage has been reached when legislative action can be taken."[83]

Note that the term Newbold used was "excision." Whether the choice was deliberate or accidental, the implied conflation of pharaonic circum-

cision with excision deflected attention from the practice of infibulation, most troubling to government and least like the majority form of female genital cutting in Africa.

Ward asked to share Newbold's information with Hills-Young, who should be assured of government policy as she "is going to devote, as far as I can see, the rest of her life to trying to help."[84] Eden's staff agreed, but not without chiding, "I suppose the lady *sometimes* gives a thought to her own constituents."[85]

When Ward failed to receive the details she sought, she wrote to Eden again.[86] Her inquires were echoed by E. Wilhelmina Ness, president of the National Council of Women of Great Britain. Ness advised Eden that the NCW's executive wanted to know "if the subject of female circumcision and its effects on the female population is taught in the upper classes of both girls and boys schools and also in Gordon College."[87] In February a response arrived from a clearly beset Newbold, via R. C. Mayall, the Sudan government's agent in London. It summarized education expenditures, showing an increased allocation to girls' schooling in both real and percentage terms from £E9,000 of £E147,000 total, or 6 percent of the education budget in 1936, to £E79,000 of £E492,000 total, or 16 percent in 1945. "It must be remembered," Newbold explained, "that Sudan is a poor country whose resources are almost entirely agricultural, and [given its political status] it is not eligible for external assistance from the Colonial Development Fund." The early shortage of educational facilities had delayed steps to deal with the problem. While "considerably more rapid advances" had been made since 1939, including "spontaneous movements towards reform by the more enlightened members of the community," "the support of a small number of the educated classes" was not enough on which to base a countrywide anticircumcision campaign. Moreover, "the medical facts were by no means clear and the very nature renders them difficult to explain especially to primitive people. For these reasons the subject of female circumcision and its effects have not yet been included in the teaching of hygiene in the schools."[88] Had Beasley read this she would have set him straight; the reference was likely to boys' education, not girls'.

Newbold reiterated his plan to place female circumcision on the agenda of the Northern Sudan Advisory Council meeting in May, and to circulate an authoritative pamphlet on the subject in advance.[89] Hills-Young, for her part, was not convinced. "I am extremely doubtful," she wrote, "whether more than lip-service is being paid to the reforms . . . proposed." The fact "that neither the men nor the women of the Sudan have been educated towards the abolition of the custom . . . must surely reflect on the methods of education adopted by the Imperial Government."[90] But was the situation as clear-cut as she supposed?

The Sudan Front

Sudan's government seems to have been forced by the actions of British women into publicly tackling female circumcision sooner than it would have wished. To understand its hesitation we need to explore Newbold's claim for the "sensitive condition" of Sudanese opinion, that is, the opinion of educated Arab men. This may also help to situate differences on the issue that emerged during the Cultural Centre debates. So we need to back up again to 1942.

In April of that year Newbold had been confronted with a list of "constitutional demands" by the Graduates Congress—a political group made up of "the school-educated effendia of the towns"[91] introduced in chapter 5. Buoyed by the Atlantic Charter[92] and anticolonial sentiment in India, they sought assurances that Sudan would be granted the right of self-determination at the end of the war. Newbold seems to have been caught off guard. He refused to consider the memorandum and doubted the credentials of Congress to speak for the country as a whole.[93] The graduates had, he wrote, "forfeited the confidence of Government."[94]

Congress's request was unfortunately timed. Presented at a desperate moment for Britain in the war, with Singapore just fallen to the Japanese, and German forces advancing in North Africa, the demands "drew from Newbold the exclamation that they must beat Rommel first."[95] The Sudanese, however, had felt that with Italy's defeat in East Africa in 1941, the war was drawing to a close.[96] Be that as it may, Congress's leadership, already fragmented by religious loyalties, now split, and Newbold's reply is blamed for having driven "the two groups of educated political leaders . . . to call upon the support of the two great sectarian groupings into which the Moslems of the northern Sudan were divided"[97]—the neo-Mahdists (the Umma party) under Sayyid ʿAbd al-Rahman, and the Mirghanists (the Ashiqqa party) under Sayyid ʿAli Mirghani. Recall that the former favored cooperating with Britain toward gradual independence; the latter called for tactical union with Egypt to dislodge the British more quickly, and generally refused to cooperate with British-initiated reforms.

While Newbold had already anticipated some of the changes that Congress desired, the Atlantic Charter made their realization more pressing. In 1943 province councils and a general Advisory Council of the Northern Sudan were at last set up. The latter met for the first time in May 1944, with the two *sayyids* as honorary members. Huddleston's inaugural address referred to it as the "first concrete expression of a Sudanese nation." As reported in the *Times*, the council met "in the Palace of Khartoum within five yards of the spot where Gordon fell."[98]

For the Ashiqqa, however, it was too little and came too late. The council had only advisory powers and was composed of tribal notables from the provinces, two members of the Chamber of Commerce, eight appointed members at large (educated professionals), and several religious figures. It was dominated by neo-Mahdists, now intriguingly seen as the "government party"; Congress members strategically loyal to Sayyid ʿAli soon boycotted it. As Daly notes, "The quick transformation of the Congress from the hope of the government into its bane is striking: so deep was the government's misunderstanding of its junior civil servants."[99] This was Newbold's predicament when Eden's query and Hills-Young's "Surgical Seal of Chastity" arrived in August 1944.

National Bodies

While few members of the Graduates Congress supported the traditional form of pharaonic circumcision practiced by untrained *daya*s, they were not agreed on the value of ending the practice altogether. Why was this the case? For answers we need to consider how internal political maneuverings were bound up with the ambivalent significance of women and "tradition" in the incipient national project.

Heather Sharkey points out that educated northern men in government posts traveled widely on transfers or inspection treks and thus "developed a sense of Sudan as a unitary whole, with Khartoum as its metropole, and the provinces and districts as its hinterlands."[100] Not only travel, but low-cost print technology enabled them to share ideas, produce and acquire Arabic literature, and develop a sense of Sudan that, while affirming colonial boundaries, transcended the tribal and ethnic divisions promoted by indirect rule, and fostered an imagined national community.[101] Western literary and cinematic portrayals of romantic love and independent modern women challenged established gender ideals and provoked many a painful reassessment.[102] Sudanese men with nationalist aspirations "became champions of the modern, passionately endorsing social progress based on science and reason."[103]

Budding nationalists thus denounced traditional practices as backward and un-Islamic, focusing especially on "women's customs" such as lip tatooing and female genital cutting. Yet they also strove to imagine an identity all their own, rooted in what was specifically and authentically "Sudanese." Here women as "keepers of tradition," and women's bodies as the principal vehicles through which that "tradition" was expressed, became debated terrain. The Cultural Centre discussions of April and June 1942 revolved around whether to condemn pharaonic circumcison as irrational and un-Islamic or to rationalize its modified form. Phrased

otherwise, participants differed over whether to "indigenize moder-
nity"[104] or to modernize indigeneity.

Yet not all customs became matters of dispute. Scarring the cheeks to
specify tribal affiliation (*shillukh*) was broadly condemned by nationalists
who "felt a growing need to abandon primordial loyalties based on 'trib-
alism' (*qabaliyya*) in favor of a broader 'Sudanese' (*sudani*) identity." In
the north these practices began to die out as the differences they signaled
became less relevant to everyday life. Why did female circumcision not
do so too? Like it, ethnic marking, though common to women and men,
was considered a "women's custom" (*ʿâda-t an-niswân*). This, Sharkey
suggests, "points to the symbolic position that women held in the nation-
alist mission as objects of social reform."[105] True, but I think there is more.
For the practices were not alike. Facial scars, after all, marked outmoded
social difference in an emergent field of generic Arab Sudanese; infibu-
lation marked cultural sameness while distinguishing northerners from
British, Egyptians, and southern Sudanese. In a sense it was something
that had been "Sudanese" long before the term was applied to people of
the Arab north. Egyptians, for instance, call it not *at-ṭahûr al-farowni*
(pharaonic) but *at-ṭahûr as-sudani*. Relative to northerners' principal ref-
erence groups the practice was an expedient emblem of the broad yet
unique national identity they sought to create. To the same extent, face
scarring, also practiced by southern groups, was not: it represented differ-
ence rather than sameness. The persistence of pharaonic circumcision in
northern Sudan despite significant controversy and efforts at reform sug-
gests that the circumcised female body symbolized the authenticity and
integrity of the wider group. But also its exclusivity. For infibulation was
not, like male circumcision, required for membership in the *umma*, the
world community of Islam. To be the son of a pharaonically circumcised
woman was to be born not only of honorable Muslim Sudanese, but of
the Arab Sudan, the imagined nation itself.

Was pharaonic circumcision *merely* expedient here? I doubt it. Links
between circumcised women and the homeland reflect a division of social
space and physical and spiritual labor that has deep cultural roots, where,
as described in chapter 4, women's roles revolve around the domestic and
intimately social while men's involve the "outside world."[106] Transforma-
tion of pharaonic circumcision into a national symbol required only a
broadening of what was meant by "home." For the select who took part
in literary exchanges facilitated by print and public transport, and who
sometimes traveled abroad, home no longer meant only one's village and
kin, but more broadly, the Arab Sudan.[107] Incipient "Sudanese" national-
ism was at once globally relevant, territorial, "rational" and less personal-
ized than before, but also locally specific, with origins in the pre-Islamic
past. The challenge of how to be modern, Muslim, and "authentically"

themselves—not Egyptian, or British, or southern Sudanese—informed the debates about women's "backward" customs among educated northern men.

Hills-Young and her supporters in Britain, by mobilizing civil rights organizations, doctors, and parliamentarians to ask awkward questions and raise the specter of public scrutiny, may have forced the hand of Sudan's colonial masters before they felt the time was politically opportune. Then again, it may already have been too late.

11

THE LAW

"I suppose," Brennan broke in, "when you joined first you were instructed to read up carefully the early history of the Sudan?"

"And I did too." . . .

Terrilow took a long drink and went on with his discourse. . . .

"Then Gordon was sent to rescue the remaining Egyptians and see them safely out of Khartum. Instead he tried to swing the whole British Empire to his view and occupy the Sudan. Gladstone and Cromer refused to be swung for a time, until at last they gave in to ignorant public clamour and wasted good efforts on trying to rescue Gordon, who ought to have been shot for insubordination by our rescue party—if they had been in time." "Steady!" Brennan murmured. "There's a lot to be said on his side."

—Michael Fausset, *Pilate Pasha*

At the end of the Advisory Council's second sitting, in December 1944, Governor-General Huddleston—primed by a civil secretary hard-pressed by Foreign Office demands—announced that his government would seek advice on female circumcision when they reconvened in May.[1] Meanwhile the anticipated pamphlet was being prepared by the Sudan Medical Service. Newbold was heartened, but doubtful of Sudanese reaction to the move.[2]

By the end of February, the pamphlet was ready.[3] Written by Pridie, head of the SMS, aided by four other British doctors and four Sudanese, it detailed female genital anatomy and outlined the effects and potential risks of the pharaonic procedure. It was a candid, highly technical document that Beasley, for one, thought flawed. Its descriptions of "what is a commonplace event to the Sudanese" were too "mild," she remarked, and its scientific language too "detached." Statements about harm were not supported "by figures from hospital cases," and important facts, such

as the "difficulty of self delivering" had been overlooked.[4] It made what today might be seen as a spurious claim: that "circumcision tends to retard the mental development of girls and . . . prevent their becoming full and active members of the community."[5] Further, in addressing the operation's effects on sexual pleasure, the pamphlet privileged male experience; women's it discussed solely in relation to childbirth. Nor, thought Beasley, did it emphasize strongly enough that "such operations are useless as a means of promoting chastity," a virtue which "can only be implanted by proper moral education and maintained by the individual's own conscious effort."[6] "Certainly a frank condemnation," she wrote, "but slight doubt arises as to what audience it is intended for. If outside the Sudan, 'preaching to the converted,' if inside, does it really stress the ideas which need eradicating[?]"[7]

Indeed, the pamphlet looked both ways. Printed in Arabic and English, it was calculated to defuse criticism in Britain as much as to shape opinion in Sudan.[8] Forewords by Huddleston and Muslim luminaries gave the text secular authority and spiritual heft. It was nonetheless filled with European notions of "normal," "natural" gender relations. Huddleston, for one, cautioned Sudanese that he was not "asking for the rapid political emancipation of women . . . but . . . for a reasonable status for Sudanese girls and women within your households, based on humanity of treatment and an opportunity for sound domestic progress," which were impossible "so long as the evil of Pharoanic circumcision is allowed to rot the fabric of your home life." The two *sayyid*s endorsed the campaign while the current mufti, Shaykh Ahmad al-Tahir, contributed a second *fatwa* based on *hadîth* interpretations by scholars from the Sunni juridical schools.[9] A letter from the Ismaili leader, the Aga Khan, urged councilors as "brothers in faith" to "stop a pre-Islamic custom of Pagan origin that is injuring the mothers under whose feet we are to go to Paradise."[10]

In March 1945, two months before the scheduled debate, Newbold suddenly died. The key post of civil secretary now passed to his deputy, J. W. Robertson, who strove to stay the course but lacked his predecessor's flair for consensus building. Robertson was cool to the postwar shift from "trusteeship" to "partnership" in colonial policy, certain that Sudanese were "incapable of self-government," and likely to degenerate "without British 'stimulus and help.' " He was not alone. Few in the Political Service thought themselves dispensable, despite the Atlantic Charter and impending self-government in India. In fact, Daly argues, British sense of duty to Sudanese "reached almost obsessive proportions" in the latter days of Condominium rule.[11] The onus to civilize is reflected in how officials handled the increasingly public and political matter of pharaonic circumcision.

The Projected Law

As promised, the topic was raised during the third session of the Advisory Council for the Northern Sudan in May 1945. After hearing Dr. Pridie on the custom's medical effects, councillors passed four resolutions proposed by a cosigner of the pamphlet, Dr. ʿAli Bedri,[12] seconded by educator Makki Abbas. They unanimously agreed that (1) pharaonic circumcision is "cruel and barbarous," (2) "not supported by the religion of Islam," and (3) called on Sudanese to abolish the "retrograde and harmful" practice, which was "hindering the progress of the country." They were divided on the fourth resolution, which asked "Government to prepare legislation making the pharaonic type of circumcision illegal," voting two-thirds in favor. No legislation, however, would be decreed until the Council had examined it in draft.[13] Huddleston reported that the airing would now "enable alleviation of the Pharaonic form of this scourge . . . by more direct methods than could formerly have been used."[14]

To ensure approval of the mooted law, the civil secretary's office set about cultivating public opinion. Apart from the work of female educators such as Beasley, or Phyllis Dickens and Eileen Kendall (consecutive principals of the Midwives Training School after Hills-Young), attention was paid mainly to educated men, who were alleged to support the government's stand. Yet no evidence for this was produced, and Beasley, at least, was unconvinced.[15] It is interesting, too, that men were absolved of responsibility for the practice itself. Indeed, in the eyes of many officials, if Sudanese men could be faulted it was *not* for condoning infibulation, but for failing to exercise control over their wives and mothers who did. Men's insistence that the practice was women's affair was seen as evasive—a sign of weakness, incurable sadism, political obstruction—anything but fact.[16]

Without dismissing such claims, I think it was something more, a sign that gender roles in northern Sudan were modeled differently from those of Europeans and not as colonial reports implied. It's worth exploring this briefly before moving on.

Officials saw Sudanese men as the masters of domestic life, and women (if young) as subservient victims who would surely obey their betters, or (if older) selfish, insubordinate crones who just as surely would not. Thus women's behavior was seen as *reactive* and their agency reckless at best. Women's commitment to "odious" ideals was not, then, reasoned and informed, but sprang instead from their "backwardness" and "superstition," mental states that, in a circular way, their circumcisions had induced.

To ethnographers, however, northern Sudanese society is organized around gender-complementary domains of interest and authority that women and men reciprocally embrace, negotiate, embody, and experience in age-specific ways.[17] This is not to deny gender hierarchy, but to acknowledge its nuances, ambiguities, discrepancies, and gaps. Relative sex segregation sets limits to male domination, while the moral authority of male and female elders tempers gender ascriptions and roles. By this view, Sudanese women are actors who, like men, maneuver within specific social and cultural constraints.[18]

Most mothers worried that without pharaonic circumcision their daughters would be unmarriageable, both personally unfulfilled and a threat to family social position, indeed, then, to their own. They were understandably wary of the imminent decree. Predictably, then, the Council's vote was followed by a rash of pharaonic procedures—an "orgy of operations" in Beasley's words—performed even on very young girls, sometimes with distressing results.[19] Still, I would argue, women acted not from "superstition" or "ignorance" but from reason within the parameters of cultural knowledge: they sought to create properly gendered moral persons before they would be forbidden to do so by law.

In European societies, gender is commonly thought to arise from "presocial" biological sex, and gender assignment depends on what the genitals look like at birth. Today, if sex at birth is deemed ambiguous, a baby's genitals may be surgically "corrected," shaped to fit the "natural" binary form.[20] And in cases of adult gender dysphoria, where visible sex and gender disposition fail to match, the genitals may be surgically altered to bring the two into "normal" alignment, so as to fix the body's "mistake." Here external anatomy affirms and indexes gender.

In northern Sudan a similar outcome unfolds, but its logic differs: once a child has gained social awareness, generally around the age of six, its genitals are conventionally shaped to the exigencies of gender by removing their "naturally atypical" parts—the femalely concealing foreskin or "veil" of the penis, the malely protruding clitoris and labia. The vaginal opening is also "veiled," covered or concealed. Here genital cutting is also normalizing, but conventional, not rare. As previously noted, the procedures respectively help tune girls' bodies and minds to affairs of the enclosed house and womb, and boys' to relations with the outside world, thereby endowing each with the potential for virtuous sociality.[21] The modified body reflects its envisaged moral and social role.[22] If, to Europeans, the naturally sexed body is primary and normally well defined, while gender is secondary or derived, to northern Sudanese gender is primary and the conventionally sexed body derived from an indicative but always imprecise anatomical start. For the campaign against pharaonic circumcision to succeed on its own terms required no less than a sweeping trans-

formation of local gender logics, domestic relations, and embodied personhood. Its British sponsors, true to their own beliefs, argued that if a girl was left uncut, her female essence would develop "naturally," in an uncorrupted way, and this, wrote Beasley, would lead to "normal, sensible relations between the sexes."[23] To many Sudanese the very opposite would result.

[margin note: mis-understanding of culture]

Not all Sudanese women opposed the government's move; several educated women supported it. Beasley reported that, after hearing a talk on the harmful effects of pharaonic circumcision, forty-eight female schoolteachers in Omdurman and Khartoum independently agreed not to have it done to their daughters.[24] Whether they acted or were able to act on that pledge is unknown.

Public Opinion, a Philanthropy, and the Governor-General's Wife

On May 30, 1945, two days after the Advisory Council adjourned, and as alarmed Sudanese mothers raced to avoid the approaching ban, high ranking British members of the judiciary, medical service, and education department met in Robertson's office. Their task: to start a propaganda campaign and draft the legislation. An amendment to the penal code was advised under sections relating to "Hurt." It would "contain a definition of the pharaonic form (any mutilation of the female genitalia other than simple clitoridectomy [sic])" and "make the pharaonic form illegal." The SMS promised propaganda among "local midwives and wise women," and to consider hiring more "women Doctors and British midwives" and opening midwifery schools outside of Khartoum. Educators, including Beasley, promised full support: increased propaganda in the girls' schools, and incorporation of the topic in hygiene courses, at first for girls, ultimately, too, for boys.[25]

Some days later another meeting was held, this time also involving Sudanese. Its outcome was reported in the Arabic and English press on June 14, 1945. "A number of people," the article read, "are anxious to form a Society for the Abolition of Female Circumcision in the Sudan" whose objective, "primarily educational," would be to "draw attention to the evils of the practice by every means in its power." J. S. Owen, deputy assistant civil secretary (present at Robertson's meeting two weeks before) was named "Honorary Secretary." Those wanting to join were asked to write care of P.O. Box 45, Khartoum.[26]

Conceivably this was a fishing expedition, designed to flush out Sudanese sympathizers and shame the apathetic into signing on. Conversely, the society may have been based on the "small private committee of lead-

ing educated Sudanese" which Newbold reported had been formed by Siddiq ʿAbd al-Rahman al-Mahdi the year before (chapter 10).[27] Though publicly heralded as a "spontaneous" move by Sudanese and other interested parties, it was backed by the palace all the same. On June 13, the day before the announcement appeared, Owen was sent £E10 by the governor-general's wife, Lady Constance Huddleston, who wrote, "I imagine the notices and insertions will cost quite a lot. . . . It is more than kind of you to 'hold the fort' and I feel it is in good hands."[28]

Box 45 received a number of subscriptions from both British and Sudanese: railway workers, educators, doctors, a missionary to the Nuba, medical students, merchants, government officials, and more. However, an editorial in *al-Rai al-ʿAmm*, the moderate nationalist newspaper and Sudan's leading daily at the time,[29] justly suspected official involvement. It reproved the society for "not giving wide publicity to its formation and aims," or "revealing the names of the persons with whom [prospective members] are going to work." Perhaps, it continued, "complete secrecy is maintained to avoid a second mass circumcision, similar to that carried out by mothers as a counter-measure to the Advisory Council's proposed Bill."[30]

On November 9, Huddleston contacted Owen again. With renewed thanks for his having "held the fort," she enrolled several prominent Britons, including Sir Edgar Bonham-Carter, the colony's first legal secretary, as examples to Sudanese. Soon, she wrote, Mr. Scott [of the education department] would speak to Owen about "directing the activities of the committee."[31]

Huddleston was not a novice to the cause. In 1930 she had tried to put the Duchess of Atholl in touch with Mabel Wolff (chapter 9), but the meeting had been quashed lest Wolff disclose too much. Like many British women in Sudan, Huddleston was passionate about ending pharaonic circumcision; indeed, she would shortly clash with administrators over how to achieve that end. "It all moves too slowly for me," she wrote to Wolff in England, "but I hope we shall succeed."[32]

In late November the Society's charter was drafted by Owen, Scott, and Drs. Clarke and ʿAli Bedri. It declared that while "all forms of female circumcision are undesirable," it "would do more harm than good" . . . "in view of the Religious and Social sanctions operating in the Sudan" to combat any but the damaging and virtually universal pharaonic form. Given public opinion, "the only effective method of lessening the . . . suffering among the women . . . lay in pressing for the substitution of the Sunna form instead of the Pharaonic." The society would "work independently of Government, but towards the same ultimate objective."[33] The writers prepared a list of seven prominent Sudanese men to form the exec-

utive board: doctors and educators of varied political stripe, and members of both leading religious families.

It seems unlikely that anyone took the society's avowed autonomy to heart. Owen, after all, was a key government official, and the group's inaugural records were kept in government files. In January 1946, shortly after the law prohibiting pharaonic circumcision was proclaimed, Constance Huddleston gave Owen the considerable sum of £E100 for society endeavors. To maintain the façade of independence she suggested that he "treat the cheque as anonymous and hope it [appears] to be a Sudanese donation!"[34] By mid-May 1946, the Society's executive was wholly Sudanese.[35]

In June this file comes to an end with news that half the proceeds of the latest SMS Bulletin, "The Feeding of Sudanese Infants," will go to the Society for the Abolition of Pharaonic Circumcision.[36] Free copies were offered to midwives, SMS dispensaries, and health visitors, while the education department was encouraged "to take a number for girl's schools" in order to reach prospective mothers and get more funds for propaganda work.[37] The inverse relationship between pharaonic circumcision and productive, disciplined motherhood was ingeniously asserted once again.

Propaganda and Its Limits

The anticipated ordinance took effect in February 1946, as an amendment to the penal code. It read:

> (1) Whoever voluntarily causes hurt to the external genital organs of a woman is said, save as hereinafter excepted, to commit unlawful circumcision. Exception. It is not unlawful circumcision to remove the free and protruding part of the clitoris with the assent of the woman, or, if she is subject to guardianship, of her guardian.
> (2) Whoever commits unlawful circumcision shall be furnished with imprisonment for a term which may extend to seven years [later reduced to five] and shall also be liable to a fine. . . . A woman who causes hurt to herself is within the meaning of this section.[38]

Thus, one who willingly underwent the illicit procedure was as vulnerable to prosecution as the operator.[39] The legal form was referred to as "uncomplicated *sunna*" circumcision. It entailed removing the prepuce or hood of the clitoris and the "free and protruding" parts of the glans; paring the labia and infibulating were forbidden. The legal form was not a negligible procedure; it suggests, however, that the law was mainly meant to facilitate birth.

Propaganda efforts now redoubled. Handbills and posters were prepared; lectures given to schoolgirls; senior midwives, and teachers sent on

tour through towns and villages to preach the evils of pharaonic circumcision and urge compliance with the law. Efforts were coordinated by a new "Standing Committee on Female Circumcision" convened by the civil secretary in June 1946, once leadership of the Society for the Abolition of Pharaonic Circumcision had been formally ceded to Sudanese men. Members of the new committee included Beasley as controller of girls' education, the director of the SMS, (British) representatives of the legal secretary and director of education, and a Sudanese representative of the Society—at different times ʿAli Bedri or Mekki Shibeika, both of the SMS, or Ibrahim Ahmed of Gordon College. The committee met twice in 1946, and annually between 1947 and 1949. Owen acted as secretary in 1947, B. A. Lewis (later an anthropologist) in 1948. Only in the last two meetings did a Sudanese woman sit as a member: Sitt Batul Muhammad ʿIsa, staff midwife of the MTS.

Like other native professionals, women teachers and medical midwives were vital to the extension of British authority and western science, whatever their feelings about colonialism might have been.[40] Yet there is little evidence of their experiences under colonial conditions. A few such women are mentioned in official records, memoirs of British personnel, and period publications. Notable were educator Sitt Nafissa ʿAwad al-Karim and Sitt Batul, both ardent campaigners in the anti-pharaonic-circumcision crusade.

Sitt Nafissa was a teacher in the Omdurman Girls' Intermediate School. Early in 1946 she was sent on a monthlong anticircumcision tour of girls' schools in the capital region, Blue Nile Province, and Kordofan. In forthright and impassioned terms she asked women to abandon infibulation, "a barbaric tradition, having nothing to do . . . with religion or civilization." It was, instead, a "harmful habit" that Sudanese had "acquired . . . from the Pharaohs," evil-doers according to the Qurʿan. The damaging effects of pharaonic circumcision were, she said, "confirmed by doctors" who had come to the conclusion "that in almost all cases it was the cause of barrenness."[41] A pointed condemnation for this pro-natal society where women's security lies in fruitful marriage and surely at odds with the sympathies of her listeners, most of whom would have given birth several times.

Still, Sitt Nafissa argued, pharaonic circumcision had been "forbidden by our great Prophet," the strongest reason to endorse the ban. Once when Beasley was disheartened over the campaign's slight success, Nafissa consoled, "At least . . . the women now know that it is wrong. Before no-one had ever told them."[42] By "no-one" she surely meant men, who may have felt their authority threatened by government's claim to know Islam better than they. Nafissa toured tirelessly and was awarded the

Meritorious Service Medal of the British Empire for her courage and achievements in the campaign.[43]

Trained Sudanese midwives had long contributed to the movement against pharaonic circumcision. Those who were MTS staff regularly toured the countryside to inspect practicing graduates and, under the Wolffs, promote the modified operation while condemning the severe pharaonic form. By 1943 the MTS employed seven staff midwives,[44] one of them Sitt Batul. Batul came from a comfortable family in Rufaʿa, where she had attended Babikr Bedri's school for girls. She married young but her husband left her before the birth of their son. In 1925 she attended a delivery overseen by an MTS midwife, and so admired her methods that she resolved to seek training herself. She qualified under Mabel Wolff in 1926, then went on to study nursing with Wolff's sister, Gertrude, at the Omdurman Civil Hospital. Four years later when Gertrude joined the MTS, so did Batul. There she worked for several decades, becoming senior staff midwife under principal E. M. Kendall (1946–55); she was appointed assistant principal in 1953.[45] Batul, wrote Kendall in 1952, "copied [the Wolffs'] . . . practical methods of teaching, using their own illustrations drawn from the simple everyday things of life which women could understand." And "no one," she declared, could "preach the Gospel of anti-Pharaonic circumcision quite as she." In 1950 Batul also received an imperial medal for her work.[46]

Despite a handful of letters preserved by Beasley, and the Wolffs and their successors, there seem to be no documents left by these women that show their engagement with Western ideas. A slight detour may be useful to understanding why. First, while Arabic literacy was demanded of female teachers, for midwives it was only preferred. Midwifery knowledge was largely embodied, laid down in memory and habit rather than texts. This does not, of course, lessen the significance of trained midwives to the colonizing process so much as limit our apprehension of it.[47] Though they and their successors were the main purveyors of hygiene and biomedicine to the female population at large, their voices in the historical record are few and indirect.

Second, while praised by the British as "missionaries"—in the cause of hygiene, or the anticircumcision crusade—there were important differences between Sudan's teachers and medical midwives, who practiced in an ostensibly secular milieu, and missionary teachers and medics elsewhere in Africa who did not. For the Yoruba evangelists described by John Peel, and the Congolese proselytes by Nancy Rose Hunt,[48] reading and disseminating "The Word," along with the need to elicit metropolitan funds, spawned habits of writing that resulted in rich (yet decidedly non-transparent) archives of sermons, diaries, and letters destined for publication in mission tracts. African clerics writing in English or French fused

local and European knowledge in complex and often startling ways. But in northern Sudan, the efficacy of the preaching embargo meant that indigenous and foreign worlds met less (or less openly) on religious or philosophical terrain than on the seemingly neutral and objective ground of medicine and education. Moreover literate professional women wrote in Arabic, their native tongue, and used the skill largely for accounting to superiors and keeping records and case registers.

Thus it was mainly through confrontations of practice that creolizations of vernacular and Western ways arose. Such blendings, as we've seen, were not solely the work of Sudanese but of their British instructors too. They were often tactical, as with Wolff's illustrations from women's daily lives. Another telling case has to do with literacy. A few early midwifery trainees had received an elementary education from the CMS.[49] Mission teaching did little, however, to equip them for the wider world of print, for CMS pupils—all girls in the Muslim north—were taught neither standard Arabic nor English, but Sudanese colloquial Arabic written in Roman characters adapted to Arabic sounds. During the heyday of native administration such measures were endorsed by Sudan officials wherever Arab and non-Arab cultures met, as among the Nuba, where all formal schooling was (exceptionally, above the tenth parallel) entrusted to mission hands. The object of teaching "Romanised Arabic" was political as well as religious: to curtail students' access to Arabic literature and thus limit their knowledge of nationalism and Islam.[50]

By default, then, Muslim girls attending CMS schools acquired what Heather Sharkey calls "a dysfunctional literacy" that had little practical use.[51] Graduates were confined to communicating among themselves and with their Arabic-speaking British superiors who knew the code. Notwithstanding the efforts of Sudanese educators inspired by Babikr Bedri, or Egyptian tutors engaged by well-off parents until the expulsions of 1924–25, it was only from the late 1930s when state-funded schooling for girls began in moderate earnest that Muslim girls in any number learned to read and write Arabic script. The point is this: in the mid-1940s, readers of anticircumcision propaganda would have been few, and overwhelmingly male.

In England on leave in 1945 Beasely researched the media used in health campaigns and the following January gave the standing committee several proposals. She suggested leaflets for use in lectures to mothers, for though the women could not read, "a bright colour and a little sketch would probably arrest their attention" while "taking something home [would] help to fix the subject matter of the talk."[52] Six of these would be designed, each in a different shade. The first, containing a sketch of a schoolgirl with her books, would appeal to the desire to be modern, stating that pharaonic circumcision was:

[margin note, handwritten: propaganda (didn't reach women) Uneducated women]

the one thing [that] holds [Sudanese women] back and which will continue to make them different from other peoples and always behind them. Brain and body must work together and if one is injured the other suffers. Pharaonic circumcision injures both mind and body and your daughters can never be as successful as the daughters of other nations while this practice continues.[53]

The second would claim that circumcision prevents Sudanese from achieving the "ideal of a happy family" because "to make a good wife a woman must be healthy and normal," which is impossible so long as she "lives always in the shadow of . . . pain and fear."[54] The third, entitled "The Empty Cradle," would insist that many women have been carelessly circumcised and, "of [those] who cannot bear children one out of every four has become barren because she has been circumcised by the pharaonic method." It would advocate the *sunna* form, noting that the "pharaonic is absolutely forbidden" by Islam. The fourth flyer, framed as a series of questions, again placed Sudan in a global context, noting that while Sudanese had fought bravely beside other nations in the war, they remain apart because they "are the only people to practice pharaonic circumcision except a few scattered [non-Muslim] tribes." The text concludes:

DO YOU KNOW how shocked and disgusted people are in other countries when they hear of the custom.
DO YOU KNOW that the Sudanese can never rise to be a nation on the same footing as others while this custom persists.

The penultimate pamphlet acknowledged Sudan's wartime generosity, while observing that "there is suffering in our midst today" that "can be alleviated without the expenditure of any money"; moreover, "the intense pain and fear which afflict all Sudanese women when a child is born is unknown in other countries." The series ended by returning to religion, explaining that the leaflets had been produced:

because you think your religion demands that your daughter should be circumcised by the pharaonic method. Your religion does not demand it. There are millions of good Muslims who do not practise circumcision at all and a large number, for example the Egyptians, who use the Sunna method. Of Muslim countries it is only the Sudan which uses the pharaonic method. Now that the Sudan is beginning to take a place among the other nations, her people should know this.[55]

Of course, Sudan even then was not the only Muslim society to practice infibulation; it was (and still is) found in Somalia and parts of Egypt, Mali, Eritrea, and Ethiopia. The tactic was to isolate Sudan for failing to achieve domestic progress consonant with its desired international role, and thus shame its people into renouncing their "outmoded" past. It was

a strategic deployment of difference as inferiority. That suffering and pain could be culturally meaningful experiences seems to have been ignored.

Women I worked with knew very well that uncircumcised women gave birth more easily than they; if a man only wants babies, they said, let him marry an uncircumcised Ethiopian or southern Sudanese. But don't be surprised if the children turn out badly, for only a properly circumcised woman can give birth to moral offspring. Contra Beasley's view, to them ease of birth signified animality and a lack of social control, while difficult birth confirmed the effort that producing virtuous beings requires. Further, though fertility problems described in Beasley's flyers would likely have struck a responsive chord, the message seems strained, in that several conditions can cause sterility. In the 1970s and 1980s rural women long acquainted with biomedicine held sexually transmitted diseases to blame; some heretically offered that men can be "barren" too.[56]

The leaflets show how strongly Beasley felt that Sudanese needed British help to mend their "backward" ways. She and her colleagues sought to replace collective personhood with Western individualism, while condemning all else as fallacious and corrupt.[57] Like Dr. Macdonald in chapter 10, they insisted that virtue is a matter of "character," cultivated by persons who are solely responsible for their acts. Infibulation was no more than a crude chastity device, and reliance on it misplaced. Criticism, however, must be followed "by constructive teaching on chastity as a positive virtue and the ideal of respect for one's body."[58] "It seems only right," Beasley counseled, "when we are upsetting social customs, to try to substitute for them a wholesome re-orientation of ideas." Moreover, the movement to end circumcision, she wrote, "is bound to lead . . . to the consideration of the position of women in general," and warned the civil secretary that "we are fully aware of the larger implications involved."[59] The desired shift of sensibilities was graphically portrayed in an anticircumcision poster showing "the shadow of the old hag, Superstition, being driven away from little girls by the lovely maiden, Enlightenment."[60]

That image must have seemed bizarre to Sudanese. Drawn from European folklore, it disparaged elderly women when Sudanese grandmothers, known as _habobat_ ("little darlings"), are revered and considered wise. Yet in portraying a lovely maiden as knowledgeable, it also, perhaps unwittingly, invoked popular tales about a beautiful virgin, Fatna (Fatima), who dons the wizened skin of an old man to disguise her beautiful smooth (circumcised) body and set limits to her enslavement by a powerful lord. Eventually, clever Fatna outsmarts the prince and, casting off the elder's skin, reveals herself and marries him.[61] One wonders if Beasley's poster—"the most successful" in the campaign[62]—was appreciated in that light, which surely skewed the meanings the committee wished to impart. Who indeed was the "prince" and who the "virgin bride"?

Moreover, did "superstition" carry the negative import for Sudanese that it did for British at that time? If so, it has lately acquired another veneer. During the 1990s Sudanese women in Toronto who'd fled the Islamist regime in Khartoum staged a *zâr*.[63] They were professional women, among them university graduates, doctors, teachers, scientists. Ironically, they announced the upcoming show with a flyer bearing the sketch of a woman's disembodied head—eyes closed, hair fanning out in shock waves from her face—and the words "Sudanese Women Community Invite You to See Superstition and Traditional Dancing ----- Free*****." Their *zâr* was held to celebrate International Women's Day before an audience of Sudanese men, appropriate, said a participant, because in the presence of spirits, "men can say nothing."[64] The evening was a veiled protest against the government in Khartoum, which had imprisoned many of the intellectual elite and recently banned the *zâr*. Surely the "backwardness" of "superstition" lies in a beholder's jaded eye.

The themes of Beasley's handbills were adopted by the Society for the Abolition of Pharaonic Circumcision, which circulated its own pamphlets and, reported ʿAli Bedri, "hoped to form some 50 branches in the Provinces to act as propaganda cells."[65] There was clearly, however, a gulf between the Society's leaders and the women whose lives they sought to change.

Problems with *Sunna*

No sooner had the law come into effect than provincial governors professed reluctance "in view of the present political atmosphere" to indict those who infringed it, and urged that government advocate "substitution of the Sunna form for the Pharaonic," not merely declare the former exempt. This the medical director, A. E. Lorenzen, opposed; though *sunna* was not actionable under the law, he adamantly refused to endorse it or teach the procedure to medical staff. Speaking on behalf of the Society, Bedri hoped Lorenzen would relent and "encourage the Sunna operation for a limited period of perhaps 10 years," followed by total abolition thereafter.[66]

A further problem lay in deciding what *sunna* entailed. So little progress had been made against infibulation that the Standing Committee considered amending the law to allow "Egyptian sunna," which some alleged was tolerated by Islam. Dr. Elfrida Whidbourne of the CMS had witnessed that operation performed by a trained midwife using local anesthetic, and reported that it caused "the minimum of distress and shock to the child." After the clitoral prepuce was removed, leaving the glans intact, the "edges of the labia minora were cut away from end to end."

Whidbourne noted the "considerable importance" attached to the second stage, given participants' insistence that (vide Macdonald) "if any of the hyper-pigmented skin is left it will hypertrophy in after years." The wound was not stitched. Two weeks later, the girl was healing well and the scar was unlikely to hinder childbirth.[67]

The committee considered Egyptian *sunna* a "tactical concession" to Sudanese "public opinion [which was] not prepared for . . . and [would] not support" the "strict Sunna operation" that had been legalized. Sayyid ʿAbd al-Rahman al-Mahdi offered to finance a school where women could be trained in the technique by Helbis Yusif, a Coptic midwife who championed it in Sudan.[68] But the majority was unconvinced, citing insufficient evidence, of the procedure's acceptability. Lorenzen noted that in Egypt neither doctors nor midwives were taught to do female circumcisions; indeed they were forbidden. The "Egyptian" operation was performed instead by "members of the gipsy class" to whom "a blind eye is turned except in cases of accident."[69] Because "all forms of female circumcision are unnecessary and undesirable," the SMS argued strenuously against promoting any.[70] Beasley urged that the present law be given a longer trial, lest government be seen to waver. "A successful result with the lighter form," she wrote," would be preferable to one allowing a more drastic type than was at present legal." The law was not revised.[71]

While Lorenzen forbade teaching medical midwives even the legal form, he conceded that they might learn how it differed from the pharaonic so long as their lessons did not involve actual cutting. He also agreed that physicians could heed their consciences on whether to perform *sunna* circumcisions in hospital wherever the pharaonic procedure was entrenched.[72] The trained midwife's role was thus further restricted and her usefulness to abolition efforts undermined, even as the medicalization of female circumcision was set to ensue. This, despite a call for more trained midwives from virtually every provincial governor in view of the many traditional *daya*s using unsanitary means.[73] In fact, because Sudan's population was growing, and, even if the law prevailed, legally circumcised girls would not wed for several years, more infibulated women than ever would soon be giving birth. The number of unschooled midwives would thus inevitably rise—unless, that is, a concerted effort was made to attract more women to train. Still, Khartoum was lukewarm to paying medical midwives from the public purse; if families were unable, then local authorities, equally averse, were expected to defray the cost.[74] Midwives' services, of course, included circumcisions, their most profitable work. Trained midwives were subject to supervision, had more expenses than the untrained, were told *not* to circumcise, yet had to make ends meet. It was absurd to think they would stop doing circumcisions, and though they might have preferred the legal operation, they were at the mercy

of clients' demands. The conclusion seems inescapable that government reluctance to expand the midwifery service and grant trained midwives professional status and reasonable rates of pay contributed to the failure of the anticircumcision campaign.

Rufaʿa

Midwives became victims of the law they were expected to uphold—the trained because they lacked the financial means to obey it, they and others because the law defied their own and their clients' common sense. Yet few arrests were made; in Khartoum an incident resulting in death saw the midwife sentenced to four months in jail "without stirring any public resentment." In Kordofan a case of "unlawful circumcision" among the Nuba was approved for prosecution in late 1946.[75] But such actions were few. In Khartoum Beasley found the law consistently ignored, leaving her teachers to wonder why.[76] Matters had conspired, however, to give the government pause.

In September 1946, a midwife in Rufaʿa had been found guilty of committing an unlawful circumcision. To the leader of the Republican (Gumhuriya) party, Mohammad Mahmûd Taha, who sought immediate independence for Sudan, the conviction was unjust.[77] After Friday prayers on September 20, Taha addressed the congregation of Rufaʿa mosque, and then "led a mob . . . which rescued the woman from the merkaz [police station] yard, where she was sitting under guard." A while later her brother, a policeman, returned her to the authorities, who spirited her off to nearby Hassaheissa by night, thence to the town of Wad Medani.[78]

Next day, Taha "again roused the populace" and "in the resultant disturbances the mob penned the Deputy Governor, District Commissioner and the Commander of Police in the merkaz, broke windows and furniture and smashed the District Commissioner's car." The midwife was released and the case referred to Khartoum. The crowd dispersed, and Khartoum "subsequently quashed the finding on the grounds of insufficient evidence."[79]

The following morning a company of the Sudan Defense Force arrived in Rufaʿa anticipating resistance when Taha and other leaders were arrested. Again a crowd attacked Rufaʿa police station, and "the police were forced to fire into the ground in front of them, wounding three."[80] Shortly thereafter, Taha was imprisoned in Wad Medani, where he was reported to have started a fast as "a religious exercise."[81] According to British intelligence, "the [Arabic] press published contentious reports at first" but soon "subsided into mutterings about the unwisdom of interfering with the customs of the people."[82]

In a "secret" letter to provincial governors, the civil secretary's office revealed that "the Hassaheissa-Rufaa disturbances" had come "as a complete surprise," but (reprising its Gordon stance) "were indicative of what may be expected when a few fanatics find grounds for stirring up an irresponsible town population which is already undermined by anti-government vernacular press and propaganda." Moreover,

> it was very bad luck that Mohammed Mahmud Taher [sic], the fanatic leader of the Republican party and bitter opponent of the female circumcision reforms should have been living in the very town where the first trial of an offense against the circumcision law happened to take place.[83]

The Rufaʿa incident had merely heightened an already tense situation. Nationalist aspirations were at fever pitch. In December 1945, Egypt had demanded revision of its relationship with Britain, centering on the British occupation and the status of Sudan.[84] Early in the new year talks had begun in London, and the rivalry between followers of ʿAbd al-Rahman al-Mahdi (the Umma) and ʿAli Mirghani (the Ashigga)—respectively demanding immediate independence or union (tactical or permanent) with Egypt under the banner of Islam—threatened to explode. Though such friction had been useful to Khartoum in the past, it now "raised the spectre of another '1924.' "[85] By March, anti-British protests in several towns had led to a ban on public demonstrations. In June, Taha himself had been convicted of distributing "a highly seditious and dangerously inflammatory pamphlet against the Government." He was briefly imprisoned and called a "political martyr" by Congress and the vernacular press; membership in the Republican party soared.[86] In September rumors of a draft protocol unfavorable to union had reached Sudan, whereupon the (Ashigga-dominated) Congress organized "a spate of telegrams in protest." On the day that Taha rallied congregants in Rufaʿa mosque, the unionist newspaper Sawt as-Sudan (Voice of Sudan) published "an 'appeal to the Sudanese people'" that officials saw as "an incitement to revolt." Insurrection was in the air. This coincided with the midwife's arrest for having performed an infibulation, a direct challenge to the cultural and political integrity of Muslim Sudan. Congress was reported to be mobilizing over the event.[87] Now as never before, the bodies of infibulated women symbolized a nascent, uniquely Sudanese national identity, despite doubts about the practice and political differences among the educated elite. By corporeally distinguishing them from the British, Egyptians, and southern Sudanese, pharaonic circumcision became a rallying point for the fugitive unity of northern Sudanese.

Then too, the Rufaʿa incident occurred hard on the heels of another serious affront—this time to the Islamic character of the envisaged nation. In April 1946, a twenty-two-year-old woman who had been cared for

since age seven by the CMS in Omdurman was baptized by the Reverend Trimingham against "agreed procedure" that required "prior reference" to a competent Islamic judge. Upon hearing of it, her mother, who had entrusted the girl to the mission years before, "went about the Omdurman market shouting that her daughter had been forcibly abducted and converted by the Christians." An irate crowd protested before the CMS building and police station. The daughter was placed in protective custody. Next day "the mother again collected an angry and vociferous crowd . . . and proceeded to the District Commissioner's house, where it eventually dispersed without incident on the arrival of the police." The civil secretary's office railed against the CMS whose venture was "most unfortunate and ill considered" and had "profoundly embarrassed everyone concerned, including the [government-selected] Shari'a authorities."[88] Islamic scholars at Cairo's Al-Azhar University telegraphed the governor-general in protest.[89] Imams in Omdurman mosques preached against "Church Missionary Society anti-Islamic intrigue."[90] Not only, then, was rebellion astir at the time of Taha's disturbance, so too, and not without reason, were concerns about British plans for northern girls, future mothers of Muslim Sudanese. Infibulation was a register in which nationalism made sense to the public at large.

Not long after the riots in Rufaʿa, alarm shifted to a case in which a popular Sudanese doctor was "convicted of abetting an illegal operation" performed by a Syrian [Lebanese] physician. There was "a generally expressed desire" by Sudanese that the man in question, Dr. Moghrabi, be granted clemency. This was backed by "talk of rioting and strikes in Atbara . . . and a disturbance in the Central Prison at Port Sudan" that threatened to turn political but "was scotched by the prompt action of the local authorities."[91]

Tensions remained high. In October 1946 an agreement was reached in London that Sudan could advance to self-government once Egyptian sovereignty was achieved; meanwhile, the (largely fictitious) Condominium would remain in place.[92] But on returning to Cairo from the talks, the Egyptian prime minister, Isma'il Sidqi, imprudently "told reporters he had succeeded in 'bringing the Sudan to Egypt' and achieving 'unity between Egypt and the Sudan under the Egyptian Crown.' "[93] Though Khartoum and London quickly demurred, to independence-minded Sudanese it seemed that Britain had betrayed them, and Egypt had no intention of letting Sudanese decide their own fate. A few days later, rioting broke out between members of the Ashigga and Umma parties in Khartoum.[94] There was talk in Umma circles of a *jihâd* against the co-dominie. The Muslim Brothers, already active in Sudan, and a continuing irritant to administrators, now canvassed widely and claimed to have established "some 35 local 'cells.' ."[95]

In late November, Sayyid ʿAli Mirghani appealed "as a personal favour" for Taha's release from jail, despite the men's conflicting ambitions for Sudan. He was refused; it was a case, replied Khartoum, on which it could not possibly yield. Taha kept up his fast, "eating only by night." Two months later his supporters claimed that he lay "at death's door." British officials countered that "public interest has subsided and he is regarded as having got his just deserts. His health is quite satisfactory."[96] He was released two years later, having become fervently religious while in jail, and was alleged to have declared himself Nabi ʿIsa when set free.[97]

1947–49

Continuing political volatility forestalled enforcement of the law in the Muslim north. There seemed never a "good" time for Khartoum to ensure that pharaonic circumcision stop, even had it the means to do so. The shadow of 1924 was ever present; the harrowing reports from Kenya in MacMichael's "Female Circumcision" file gave ominous advice. The claim of forced conversion had surely deepened officials' concern, though this was the only baptism of a CMS-educated Muslim girl in the history of colonial Sudan.[98] The British administration in Khartoum, intensely parochial and anti-Egyptian, was at once fearful of alienating Sudanese and anxious to shield them from condemnations of barbarity that would irreparably hurt them both.

The Standing Committee on Female Circumcision continued to meet from 1947 to 1949. In 1947 more propaganda was released, reminding Sudanese that the law fell within the purview of Islam. A leaflet to complement the anticircumcision talk given in girls' elementary schools showed a crowd of Sudanese women and girls circling a large sheet containing lines of Arabic writing. The women hold the sheet high as an elderly bearded and turbaned man points to the words:

> Which of the two men do you believe, Pharaoh the enemy of God or Mohamed the Prophet of God? Pharaonic circumcison is due to Pharaoh but the sunna comes from Mohamed, the blessing and peace of God be upon him. Which form of circumcision is the better? The holy men of the Sudan ... have agreed that Pharaonic circumcision should be abolished. Is your opinion different from that of the holy men?
>
> The Reverend Mufti and the religious men have given a legal opinion that this custom should be abolished. Do you understand more than they do?
>
> The doctors have advised that Pharaonic circumcision may cause sterility. Do you wish for sterility?
>
> Your religion forbids doing harm to the body. Will you disobey your religion?[99]

Though several schools requested more copies, the lesson had unforeseen results. From Berber to Karima, Beasley reported a tendency to keep girls away from school after its delivery, endangering the modest success of female education and no doubt prompting some parents to settle the matter forthwith. Circumcisions would now be carried out in school holidays, with curtailed celebrations lest they alert the police.[100] Especially in rural areas, but not only there, Sudanese *hôsh*s became even less open to government scrutiny than before.

Questions about whether to allow Egyptian *sunna*, train more midwives, permit the use of anesthetics if *sunna* was performed in government hospitals—all were revisited to little or no avail. Members could not agree on how to obtain the desired results. Some wanted to open a clinic in Khartoum where physicians carried out painless *sunna* circumcisions. The SMS refused, leaving disciples to hope the Society for the Abolition of Pharaonic Circumcision would take the proposal up.[101] Nor did the committee approve the use of local anesthetics for the legal operation, on Lorenzen's advice that "the pain involved . . . is practically negligible even if it entails, as it may legally do, the cutting of the top of the clitoris (and not merely the prepuce). He estimated that, from a surgical point of view, male circumcision was at least 100 times as severe an operation."[102] One wonders how he knew.

In 1948 the committee debated a letter from Lady Huddleston written in April 1947 upon her husband's retirement from Sudan. In it she too called for revision of the law: the incidence of infibulation had not declined; legal *sunna* was clearly unacceptable to Sudanese. She challenged the wisdom of the SMS in forbidding any form to be taught, as no English doctor, or even Sudanese,

> has more than a very superficial experience of female circumcision, and most . . . have none at all. . . . To know a thing in theory, and to be able to carry it out in practice, are two very different things, and when applied to the delicate and sensitive genitals of a woman which vary in degree of construction in each woman, practical experience is important.

Sayyid ʿAbd al-Rahman al-Mahdi, she wrote, believes that Egyptian *sunna*, which involves "cutting the tip of the clitoris, and a slight—repeat slight—paring of the labia minora," was a compromise likely to succeed. As "it would entail *no* repair work, and *no* tying of the legs together" it could not be confused with the pharaonic form. "It would leave the women closed, if closed at all, to such a minor degree that marriage and childbirth would not be the horror they are at present." If adopted, she believed it "would straight away put us up to 75% on the road to total abolition of circumcision."[103]

Huddleston then mentioned something startling, not disclosed before: that "male circumcision is done 100% in hospital for the Sudanese man

who presents himself, not on medical, but religious grounds, and because in hospital he can be circumcised painlessly." Even if male circumcision is beneficial in ways that female genital cutting is not, she wrote,

> could not the Sudan Medical Service [SMS] who take this broad view about men extend it to women also[?] By doing so they would mitigate women's pain, and by helping in the introduction of the lesser evil of Sunna, do away with the greater one of Pharaonic. . . . Do men want women to face what they will not face themselves[?][104]

Beasley sent a stiff retort, claiming that despite her "zeal and sincerity," Huddleston was poorly informed. A dearth of "spectacular results in two years after centuries of malpractice" was only to be expected. As for SAR's request, she thought it politically motivated and "mischievous in the extreme."

> If the Sayed was genuinely concerned . . . he might have done much long before the Government attempted to arrest the evil. . . . I am not in a position to say how many of the men would follow the Sayed's commands but there would no doubt be the old loophole of blaming the women.

Beasley observed that teachers hearing of SAR's interest merely shrugged, "Why doesn't he practice what he preaches?" For her part she doubted that her conscience would let her work "on behalf of this more serious ['Egyptian'] form."[105] The committee was convinced to hold firm.

By the start of 1949 the situation was more dismal still. Fewer legal circumcisions were reported than in former years and many more illegal ones had been done. In Khartoum it was said that Helbis Yusif and un-trained rural midwives ran a brisk trade in pharaonic and modified phara-onic operations. Administrators everywhere were too stretched to inquire into "so difficult a subject."[106] Indeed, the illegality of the procedure mag-nified Sudanese reluctance to report what was taking place. Even the most educated, highly placed men had infibulated kin and "cannot therefore talk with ease."[107]

Yusif, a medical midwife, presented special difficulty. She practiced what officials called the "Begawiya circumcision," which, "though illegal, is less severe than the pharaonic form" and used "a local anaesthetic which makes the actual operation less brutal," hence her popularity.[108] This, I believe, was what I witnessed decades later in Hofriyat.[109] It in-volved cutting the clitoris, then paring the labia minora and stitching the labia majora to partially close the vaginal opening. To all intents it was the modified operation taught by Mabel Wolff.

12

CONCLUSION: CIVILIZING WOMEN

SUDANESE TO MOVE BRITISH STATUES
The Sudanese government have decided to remove the statues
of Kitchener and Gordon from Khartoum. The statues will be
kept in a museum.
—*The Times*, November 26, 1958

The Question

In Parliament on January 26, 1949—the anniversary of Gordon's
death—the Minister of State for Foreign Affairs, Labour's Hector
McNeil, was challenged on the matter of female circumcision in
Sudan. The questioner was Sir Basil Neven-Spence, Conservative member
for Orkney and Shetland and former physician in the colony,[1] who asked
for information about the incidence of the custom and whether the "legal
form" had taken hold. It was an embarrassing moment, for which McNeil
seemed ill prepared. He answered that legislation against the pharaonic
form had been passed in 1926 (not 1946), and gave assurances that the
law and "the subsequent propaganda have checked this repulsive and
harmful practice," though progress was "regrettably slow." Neven-
Spence replied that as his "information about the spread of this revolting
practice" differed from McNeil's, he would raise the matter again.[2]
The parliamentary question of January 26—a date not likely chosen
by chance—was the result of concerted planning in Britain by Constance
Huddleston, Elaine Hills-Young, Angus Gillan, and Neven-Spence,
cheered on by other Sudan retirees for whom the matter still rankled.[3] In
December 1948, Khartoum had been apprised of the forthcoming question
and the date on which it would be addressed.[4] Its timing neatly invoked
the regime's mythico-history and sense of obligation to Sudanese. It also
marked the recent elections to Sudan's Legislative Assembly, a new quasi-
representative body designed to replace the Advisory Council and dilute
Egyptian propaganda in the run-up to further talks on the future of Sudan.[5]

Reports of the debate sparked a raft of letters to the press. Gillan's, drafted weeks before and vetted by Lady Huddleston, appeared in the *Times* on January 29 and lamented a lack "of real co-operation by the educated Sudanese."[6] R. C. Mayall, ex-SPS and now the Sudan Agent in London, grumbled that Gillan might "have kept quiet" as the less said in the press "the better . . . for the Sudan." He arranged a meeting between Neven-Spence and senior Sudanese in London. The former, Mayall reported, "had not realised the progress which had been made . . . or the difficulties . . . faced in stamping out this scourge" and had promised to mention these points in his forthcoming address.[7]

Neven-Spence's second speech, on February 18, relied heavily on Hills-Young's "Surgical Seal of Chastity" exposé which had just been circulated to the House. He noted the horror and revulsion parliamentarians felt upon learning that:

> practically 100 per cent of the girls in the Northern and Central Sudan are subjected to this form of mutilation in its most brutal form . . . and that in many cases the operation is performed with a primitive instrument without any antiseptic precautions . . . [or] anaesthetic, in the presence of a crowd of women who drown the child's shrieks with their babbling and ululating, and at the same time there is background noise from tomtoms and empty kerosene tins.[8]

"The truth of the matter," moreover, "is that this grisly skeleton . . . in the cupboard of the Sudan . . . has been masked by a sort of conspiracy of silence backed up by masterly inactivity at the highest level." Although "the Sudanese . . . have already travelled a long way along the path of civilization," as long as they "allow their girls to be mutilated in the barbarous way which is now done, so long will they stand condemned in the eyes of all civilised people as being themselves barbarious [*sic*] and uncivilised." The opinion might have been penned some fifty years before. He went on, however, to claim that the main obstacle to progress was "the attitude of the men" who blame the women while remaining averse to having uncircumcised wives. "The only practical line to take at the present time is to permit a lesser form of mutilation" to be practiced by "properly trained midwives" and "in Government hospitals" wherever possible. More female doctors were urgently needed. Indeed, he reproached administrators for having "failed in not appreciating" the "work of outstanding merit" that had earlier been done by the Misses Wolff, who would be comforted to know "that the trail they blazed is being followed up."[9] Neven-Spence's tone, "more anti-Sudan-Government" than Mayall and Robertson had been led to expect, was blamed on Lady Huddleston's intervention.[10]

McNeil's response struck a cautionary note. In Sudan

> the deep feelings . . . aroused upon this subject are for most of us incalcula-
> ble. . . . As recently as 1946 there was a riot in the Blue Nile Province because
> of the issue of an ordinance dealing with this barbaric, repulsive, cruel process
> which is unjustified medically and biologically . . . A riot in 1946, and in that
> not the worst province.

Nevertheless, he was "assured by the Government" that in the Khartoum area pharaonic circumcision had "decreased by 75 per cent in the last 20 years," though accurate figures were "impossible to get."[11] His facts were far more sanguine than sound.

Sustained discussion ensued in the *Spectator* and the *New Statesman and Nation*, chiefly among old Sudan hands. Save for one letter from a Sudanese headed "Female Circumcision," they bore the usual sensational titles: "A Barbaric Custom," "Ritual Mutilation," "African Mutila-tions."[12] Most writers continued to debate who was to blame, the grand-mothers or the men, with Constance Huddleston urging the latter. An editorial supported her call to "transfer the operation to the hospitals" on the basis of "a special dispensation" from the General Medical Council to allow doctors "to perform the minor and less brutal operation." It also hoped that Sudanese students studying in the West would "be ashamed to support the custom which demands such loathsome cruelty and start a movement for marrying uncircumcised wives."[13] The Sudanese correspondent 'Abdullah El Fazib, while not condoning the practice, noted the suspicion among nationalists that "British authorities were un-necessarily interfering in an intimate matter in order to divert attention from more vital political issues"—self-government, independence, union with Egypt or no.

Mayall was not hopeful that the uproar could be quelled. "I rather fancy," he wrote, "that since Hills-Young returned from the Sudan she and Lady Huddleston have been putting their heads together" and would not let the matter rest. Only by showing "that the Sudanese themselves, through the Executive Council and the Legislative Assembly, are taking active steps" could he and Robertson "keep these 'ladies' quiet." He was sure "the effect on the Sudanese in this country is the exact opposite of . . . [what] Lady Huddleston and her fellow-travellers desire." Those studying in Britain "bitterly resent" this "foreign interference" and "if the campaign continues there is a very grave risk [that] . . . these boys [will become] far more interested in the Communist Clubs and Societies." A meeting with Sir Hubert Huddleston had produced no result, as his wife "felt very deeply on the subject" and though she had promised to do nothing public during his governorship, she had always intended to "take the lead in initiating a campaign" when he retired. Mayall confronted

Lady Huddleston herself, to no effect; "both Sir Hubert and she . . . feel bound to continue their share in this campaign."[14]

From their respective retirements, Molly Crowfoot and the Wolffs exchanged news of the parliamentary debate and Lady Huddleston's role, and independently sent letters to the press.[15] It had been Crowfoot's suggestion to recruit women doctors "on grounds that their presence would help to combat the practice."[16] Robertson agreed, but refused to make the link public lest Sudanese women "be reluctant to consult [women doctors] for fear that they might act as informers."[17] The Wolffs, consulted by Huddleston prior to her campaign, had guardedly blessed the idea that midwives use anesthetics, and Egyptian *sunna* be taught as a compromise step.[18] To the *Times* they wrote that if their "immediate successor" had not forbidden "trained midwives to perform any circumcisions" or "[discontinued] the licensing of all untrained midwives," there might have been "less opposition to the 1946 Legislation."[19] Perhaps. In any case, Hills-Young's approach had met with scant success.

A fifth meeting of Robertson's Standing Committee on Female Circumcision was held in March 1949 in response to the controversy and realization that the rates of infibulation had not declined. Sudanese were proving tenacious and inventive. Phyllis Dickens, principal of the Midwives Training College, reported on a "new" operation called "*nûss rabat*" (half closed or tied), which was much like traditional pharaonic but left a "small opening . . . through which urine may be passed."[20]

The Society for the Abolition of Pharaonic Circumcision had become moribund, its members divided. Some, chastened by the Rufaʿa incident, worried lest their aims be defeated by political intrigue; others wanted to politicize the matter even more. They differed too on the proper *sunna* practice: was it the so-called legal form, or the Egyptian one backed by Lady Huddleston and Sayyid ʿAbd al-Rahman? Robertson's committee determined to revive the Society and get it to coax political leaders to address the problem "as a national issue and not on party lines."[21] They called for renewed propaganda and stricter application of the law; only four convictions had been obtained between 1947 and 1949 throughout all of central and northern Sudan.[22] When the medical director again "refused to countenance female circumcision in any form" he was asked to reconsider, and support clinics for the legal operation linked to girls' elementary schools and local government offices.[23] None of these moves bore fruit.

In April Robertson submitted a report to the Foreign Office for distribution in parliamentary circles, detailing how Khartoum was handling the problem, on which "there must be no complacency." Though "the interest aroused in Great Britain may serve a useful purpose in bringing home to educated Sudanese the horrors with which female circumcision is contemplated in that country," he feared that "continued reiteration" could "re-

tard the desired result." And while "it is . . . hoped that the Sudanese will be left to stamp out the custom in their own way," administrators agreed that "the matter must not be allowed to become forgotten."[24] But it was. Other issues—fears of spreading communism, eventual replacement of British by Sudanese in the civil service, self-rule—soon preoccupied British officials and the educated elite. On January 1, 1956, Sudan became independent. Pharaonic circumcision had weathered the colonial storm, shaken, perhaps, but not suppressed.

Aftermath

Activists from Condominium days—Hills-Young, Beasley, and Lilian Sanderson, an educationist—fought to end female circumcision long after 1956. Into the 1980s and beyond, they contributed to interested organizations, attended conferences, wrote letters, articles, and books, gave support to Sudanese who pressed for change.[25] Their work encouraged later advocates in the West, such as Fran Hosken, who revived concern in the early 1980s and made the issue into a global cause célèbre.[26]

Yet one wonders whose interests have been at stake in such interventions, as they so regularly denigrate those whose lives they wish to change. The obsolete language of social evolution, of barbarism and savagery that suffused the colonial past, persists in postcolonial diatribes that again claim for the West a monopoly on truth and proper personhood. Hosken, for instance, writes:

> It is evident that female genital mutilation can be abolished and wiped out in our lifetime. We are able to teach those who cling to distorted beliefs and damaging practices some better ways to cope with themselves, their lives, reproduction and sexuality. We know that everyone on earth has the capacity to learn.[27]

Legal scholar Leslye Amede Obiora observes that "the agenda of rescuing nonwhite women from the barbarity of the culture into which they had the misfortune of being born played an important role in justifying the imperial project." And does so still. For, she notes, despite the gains made by Western feminists in bringing women's concerns to international notice,

> owing to their attraction to essentializing categories, their unconscious attachment to stereotypes, and their participation in a culture in which power is enforced by dominance over definitions and truth claims, some feminists renege on the principal insights that animate their initiatives—insights about the problems of unstated reference points and about how privileging a particular experience mystifies difference and situatedness.[28]

Contemporary Western challenges to "FGM" in the popular and semi-popular press reiterate colonial projects in claiming Eurocentric values to be universal and correct.[29]

In Sudan, differences between colonizer and colonized over female genital cutting were always about more than genital cutting alone. They were about how to be civilized, modern, rightly oriented in the world.[30] Like the *amîr*'s favorite wife whom Gregory saved from the Nile in Henty's tale, northern women became catalysts and vehicles for exchanges between British and Sudanese on how to live an enlightened life. Impatient to rescue them from the river of "backward" tradition, Beasley, Hills-Young, and colleagues sought to winkle infibulation from its cultural matrix, dislodge it from local concerns such as family honor and "moral procreation." But they failed. The law against pharaonic circumcision proved unacceptable to most Sudanese and impossible to enforce. Indeed, when Ellen Gruenbaum visited Rufaʿa in 1977, residents referred to the 1946 protest as "our Revolution" against British colonial power.[31]

The Wolffs, in mixing native wisdom with European science and social norms, had been more subtle than their successors, perhaps, but their teachings were similarly shaped by Western, indeed Protestant ideals. For them, too, chastity was a personal virtue realized by a singular mind controlling the singular body in which it is lodged. The image of Gordon, epitome of Christian values and bodily restraint, saturated endeavors that anticipated, if not Wingate's "downfall of Islam," at least the partial transformation of Arab Sudanese. If the campaign had succeeded on its own terms, the onus of reproduction would have fallen on northern women as *bounded individuals*, not imbricated kin, and as *bodies*, rather than constituents of a social, ideational, and physical world in which embodied personhood is relational and shared. Work in Hofriyat in the 1970s and 1980s showed little evidence that British principles of selfhood had taken root.

Colonial campaigns against female circumcision in Sudan were aimed at improving women's reproductive competence. Believing that infibulation led to poor maternity outcomes, officials pressed for its abolition so as to spur population growth and disinhibit women's mothering skills. The project was openly self-interested, not just humane. Government did, after all, legalize the *sunna* form, as it had no desire to be seen as defying Islam.

Postcolonial efforts target all forms of female genital cutting, including *sunna*. Why? Notwithstanding explicit concerns for human rights and women's health, there is more. The twentieth century saw a shift in the significance of female genital cutting *for the West*. Western gender constructs shifted and, insofar as these are thought to be anchored in biology,

so did the body parts that symbolize them. Thus, woman's "essence" was no longer linked chiefly to motherhood and vested in the womb; when medical contraception uncoupled sexual intimacy from reproduction, it became increasingly vested in the clitoris as a site of female pleasure and symbol of the unfettered individual in relation to the world. By this logic, female genital cutting abrogates the sexual and political freedoms formerly linked only with men, that the clitoris has come to represent. It is hardly surprising that feminists "rediscovered" excision in Africa just as the women's movement gained salience in the West.[32]

Step back and note the ostensible progression here from macro- to microbiopolitics. Once blamed for *population* decline and a consequent dearth of free labor, now female genital cutting is blamed for impeding cultivation of the *individual body* as a site of gratification and desire. Each response is logically keyed to a specific moment in the history of global capitalism; both spurn local specificities by reducing them to foils that clarify and reinforce hegemonic ideals. Moreover, the shift is consonant with a change in "the problem of Africa" for the West: where before the trouble was underpopulation and little need for imperial goods, now it is wanton overbreeding, improperly regulated consumption, promiscuous sexuality and AIDS. This is not to minimize people's suffering, only to suggest its figurative import for the West. If "Africa" is an elastic image of all that is currently "primitive," then "female genital cutting" is a potent, malleable symbol of Africa. That it is also associated, if egregiously, with Islam, merely strengthens its rhetorical appeal. Paradoxically, then, FGC remains useful to imagining "Western civilization," even as a good many of the "civilized" seek to stop it. Moreover, the work of civilizing women, taming female bodies to serve a notoriously fickle market is, it seems, a never-ending project for capital (as it is for *zayran*), here promoting fertility or curbing it, there banning headscarves and veils, schooling for the quick-change of fashion, promoting juvenile sexuality, slender bodies, fit bodies, challenging FGC, co-opting feminism itself.

Feminism, however, is not a homogeneous movement, nor is it a Western preserve. Many feminists in the developing world are justly indignant when "female genital mutilation" commands center stage at international meetings, while the immiseration produced by neocolonial policies is ignored. Too often the social and historical contexts of African lives go unexamined, leaving enduring political and economic hardships unaddressed.[33] This has engendered resentment toward those who identify female genital cutting as the ultimate form of woman abuse under patriarchy and presume to define the circumcised as hapless victims of male control.[34] Not all feminists have a "genital definition of women," to use Sondra Hale's apt phrase.[35]

Sudan has a buoyant feminist movement whose inception can be traced to educated women's support for the nationalist struggle in late Condominium years.[36] Several local organizations seek to end female genital cutting, yet do not focus on it exclusively or situate it solely in terms of the right to sexual pleasure. Fatima Ahmed Ibrahim, a leading feminist and prominent member of the Sudanese Women's Union (SWU), pithily notes that "circumcision is a symptom, not a cause of women's subordination." More pressing concerns are women's poverty, illiteracy, and exploitation in and outside of the home. The SWU, for instance, seeks to empower women by providing them the tools, such as literacy and education, with which to challenge entrenched forms of power and achieve social and domestic equality between women and men.[37] Likewise, the Sudan National Committee for Traditional Harmful Practices, affiliated with the United Nations Inter-African Committee on Traditional Practices Affecting the Health of Women and Children (an international successor to Atholl's group), "consistently avoids making female circumcision a separate issue" and in its outreach projects always discusses it as one among several problems affecting reproductive health.[38] Other Sudanese NGOs "armed with extensive knowledge of local conditions" include the Babikr Bedri Scientific Association for Women's Studies, associated with Ahfad University for Women in Omdurman, which has developed teaching methods aimed at achieving total eradication of FGC, and the Mutawinat Group (Cooperating Women), female lawyers who make the law accessible to poor women and support their human rights, get information about the practice into school curricula, and call attention to the negative effects of structural adjustment policies on food security and health services in Sudan.[39]

Support might well come, too, from the side of reformist Islam. In Wad Medani, for instance, Gruenbaum spoke to a married, religiously conservative doctor who thought that "proper *sunna*" might be similar to "experimental surgeries to increase clitoral stimulation for anorgasmic women, which she had read about in American medical journals," and who considered both pharaonic circumcision and clitoridectomy currently called *sunna* in Sudan to be "against Islam, insofar as they might reduce a woman's God-given sexuality." She hoped to work among rural people who were "strongly opposed to giving up female circumcision altogether" as the Ministry of Health advised, and would consider asking them to do the "proper *sunna*" operation instead.[40]

Sudanese women do not speak with one voice about pharaonic circumcision, and even those who defend it do so ambivalently, balancing the desire for bodily purification against the pain and long-term suffering it can bring.

 ## In Ending, Birth

The attempt to colonize women's bodies in northern Sudan, and indeed Sudanese consciousness writ large, was a contradictory, subtle, but eminently practical process, by which the state, through its secular female "missionaries," extended its reach into local domestic space. Some of its long-term results were unforeseen. Despite the Wolffs' abhorrence of infibulation, the creolizations that surely arose from their work helped sever science from its Western conceptual moorings, enabling biomedicine and custom to coexist. Given the midwife's pivotal role, the partial medicalization of birth naturally entailed a partial medicalization of female circumcision, for which local anesthetics, dissolving stitches, antiseptic solutions, and antibiotics are now commonly used. Some wealthy and educated Sudanese, mindful of the need for sterile conditions, enlist physicians to perform circumcisions in hospital. Although this is anathema to the World Health Organization, which warns against confusing the practice with medical treatment, many doctors feel morally bound to comply lest more harm be done to the child elsewhere.[41] While potentially life-saving, such precautions have cultivated a medical mystique, lent the practice another layer of authorization and prestige, and fostered further syncretisms that seem likely to complicate its demise.[42] In the 1980s and early 1990s, for example, infibulation was performed in Hofriyat as medical treatment for a toddler's intractable illness because it was thought to encourage maturation. If the child attained a purified adult body, her childhood disease might be cured.

Still, was some degree of medicalization not inevitable under colonial conditions? And was it the evil that Hills-Young and her colleagues in the 1940s believed? In the end, their attempt to abolish infibulation by legal means was no more successful than the Wolffs' and led to the practice going "underground." It also fed existing political divisions and fomented confrontation between British and Sudanese. So, one wonders, had the Wolffs' pragmatic methods received sufficient support, might they have stood a better chance of success, incremental though it would have been? Might pharaonic circumcision not have become a nationalist cause in 1946 and might the infibulated female body have lost its place as a mark of Sudanese identity? Might "proper *sunna*" eventually have come into vogue?

The questions are unanswerable, of course. Yet largely unnoticed by protesters in Rufaʿa, and often behind the backs of colonizing agents themselves, the transformation of consciousness was proceeding apace. In lieu of predictions, the book draws to a close with a last ethnographic glimpse of the rural north in the 1970s and 1980s, just as the latest "fe-

male circumcision debate" got under way. By then, many of the Wolff's innovations had become routine, while others had been modified to accommodate local ideals. Midwifery practice closely reflects the economic, political, and religious circumstances in which it takes place, as we'll see.

March 1976. Zaineb and Umselima took me to witness a birth. The setting was an ordinary room in an ordinary mud-brick house, but on that day it was dank and unbearably hot, packed with women fingering worry beads, chanting invocations to drown any cries from the mother-to-be. Windows onto the alley were shuttered for privacy, leaving the doorway and a window overlooking the courtyard as the only sources of light. The packed earth floor had been wetted down to offset the heat; the flies were thick wherever some moisture remained.[43]

The laboring woman lay flat on her back on an *angarîb* that had been spread with a mattress topped by an auspiciously "red" fibrous mat. The lower end of the mattress was slightly elevated and covered with a waterproof sheet. This supported the woman's hips and heels. Her knees were raised in a local version of the stirruped position used for gynecological exams. This was the prone (or "lithotomy") birthing posture introduced to Sudan by the Wolffs in their campaign to draw women away from "midwives of the rope." But to deliver, the mother would have to push the baby uphill.

Stretched over her legs was a *tôb*, a women's modesty wrap. A large washbasin was placed on the floor at the foot of the bed and behind it sat Miriam, the trained midwife, on a low woven stool. A table nearby held her red and gold tin box, opened and ready, and a bowl of water containing her implements. From a burner beneath the bed, bridal incense fogged the room with fragrant smoke.

Periodically, Miriam thrust her head beneath the *tôb* while female kin held its ends tight lest it slip and expose the woman to view. When Miriam felt the head crowning, she injected the woman with anaesthetic, took scissors from the bowl and cut. The room filled with joyous ululations. A baby girl was safely born inside the tent after a lengthy labor; the mother, though weak, was well.

January 1984. An angry wind and pale, cold sun. Salima and I shivered as we walked the elevated railway track, laid down by the British at the turn of the century and still the only excavated road in the north.[44] We were going to visit Sheffa, the senior district midwife who lives in a village a few miles away.

We found her at work in an outlying hamlet. Sheffa seemed delighted to see us and suggested I accompany her on her rounds. An eighteen-year-old had gone into labor with her first pregnancy. The birth was likely to

be prolonged and Sheffa offered to arrange transport if it went late. But first we had to check on the laboring woman, then return to the clinic for Sheffa's regular prenatal appointments.

Sheffa astonished me; she was not like any rural woman I'd met. Her clothes—a jeans skirt and tight fitting T-shirt—were urban and, apart from the white *tôb* worn overtop, more European than Sudanese. Slung over her shoulders was a sheepskin coat in case the day stayed cold; instead of a midwife's red and gold box, she carried her instruments in a battered leather briefcase. Sartorial iconoclasm enhanced her commanding presence: tall and handsome, she radiated health, and moved with brisk determination, not the torpid gait considered feminine in these parts. And, Salima said, though only in her mid-thirties, few women or men dared oppose her.

We made our way to her client's natal home where, as per custom, she had come to give birth. There we were served coffee to warm us, though the chill had left the morning and a strengthening sun had begun to shimmer the air. In the dark, still-cool reception room, Sheffa and I were directed to metal chairs set before the laboring girl, Nemad, who lay on a "red" mat on an *angarîb*. We were met by a junior midwife, Foziya, who reported that Nemad's contractions were still well spaced. As we sipped they discussed the examination they would do in a few moments' time. Now and then Nemad moaned and as she did she grabbed my hand. Sheffa comforted her, "It's all right, the pains are good. Soon it will be finished."

Gently, Foziya felt Nemad's belly to check the baby's location. The first position, she noted, head pointing down, face to the back, buttocks on mother's right side. But the body was high—common for a first delivery. Foziya inspected Nemad's mouth and gums for signs of illness, her eyes for anemia, her hair and scalp for lice, which, if present, had to be dealt with promptly lest they infect the baby after birth. All was well.

Sheffa scrubbed her hands with a cake of soap and told Nemad to hoist herself on top of some rolled-up mattresses piled on another *angarîb*. These had been spread with a vinyl ("macintosh") cloth—blue to counter the evil eye, laced with images of Pepsi bottle caps. Sheffa cautiously measured Nemad's dilation. "I circumcised her," she said. "Not too tight." Nemad's eyes widened and she cried out in pain. "I'd like to use surgical gloves for this, but we can't always get them in Sudan." One-and-a-half-fingers' width. Still the latent phase of the first stage of labor; there were several more hours to go. If the baby's head was not engaged by five o'clock, she would go to hospital in Shendi. Nemad was encouraged to walk; we left her to it and moved on to the clinic.

There, a fourteen-year-old girl was waiting to be seen. "I delivered her," boasts Sheffa, "my first in the village." The girl, she explained, had been

married at eleven, before she'd begun to menstruate; she was now five months pregnant. Natural delivery would be impossible as her pelvis was not fully formed and the baby was large. This, Sheffa continued, is the tragedy of a recent trend: a growing number of parents in straightened circumstances are marrying their prepubescent daughters to suitors twice their age or more, who have lucrative jobs in Arabia. The men obtain compliant, partly educated, but indisputably virgin wives unlikely to question their domestic role. Since consummation takes place soon after menarche, the girls may conceive before their bones have matured. If so, their bodies channel energy from their own growth toward that of their babies, leaving stunted pelvises prone to "disproportion"—too small for the baby's head to pass. Sheffa forecast a sharp rise in caesarean sections over the next few years.

I later learn that the World Health Organization considers precocious childbearing and grand multiparity to be "cultural practices" even more pernicious than female circumcision.[45] The latter condemns women to lives of suffering but is seldom lethal; early and frequent childbirth regularly kill.

Sheffa's office at the health clinic has its own women's entrance and court-yard. It is clean and freshly whitewashed, with cheerful curtains and plastic vegetables strung along one wall. On the desk are jars containing fava beans, lentils, rice, and peas—reminders of the foods that expectant mothers should eat.

Sheffa spoke to a client whose blood had tested "light" or anemic. Pointing to the jars, she warned her to eat properly so that when the fetus becomes more demanding she would not suffer dizziness caused by insufficient blood. Several others were tested for signs of eclampsia, the disease of pregnancy that only last week sent a woman into convulsions and caused her to abort twins. Sheffa measured their blood pressure and pronounced them fit; however, she cautioned them to eat foods containing protein and to return next week. But she knew that few could afford meat and eggs on a regular basis, and even lentils and beans were expensive and increasingly scarce. The harvest was below expectations. With less food being imported than needed, pregnant women and their offspring were facing malnutrition.

It is soon two P.M. and Sheffa, Salima, and I depart for lunch. Sheffa lives with her mother and sister who help care for Sheffa's nine-month-old son. Her husband, a clinician, was posted to a village near Khartoum; he visits when he can. They wed two years before, when Sheffa was beyond the usual age for marriage in Sudan. Her work and education had come first, she explained. Unlike most Sudanese couples, their marriage

had not been arranged by kin. She and her husband were friends who met at the medical school in Khartoum. "We chose each other," she says.

Sheffa changes into a loose-fitting dress to nurse her son and plays a tape of *zâr* songs from Khartoum. A man's voice summons European spirits—one who guzzles jugs of bootleg champagne; another whose requests for drink are impossible to fulfil in abolitionist Sudan. Sheffa is a strong believer in the power of spirits. I hadn't expected this, thinking her medical training would have inclined her to doubt. In a few cases, she says, *zâr* is *marad nafsîya*, psychological illness, but in others it is not easy to explain. An innumerate woman who requests a watch while in trance is suddenly able to tell time; another can speak English or knows what foods—clean foods—a European wants and how to eat them with knife and fork. As for circumcision, she says that while she's aware of its dangers, she must still perform it or risk losing villagers' trust. "I prefer just to nick the clitoris, but I do whatever the parents wish. *Lazim*—I must."

Sheffa's own baby was delivered by doctors in Shendi hospital. Her pregnancy was not problematic, nor was the birth; she just preferred to make an appointment and do it that way.

As Sheffa changed back into her work clothes a woman burst into the courtyard. Nemad's labor is hot, she says. We must come quickly. Now!

We found Nemad lying on her red fertility mat. Again Sheffa washed up and examined her. Two-and-a-half-fingers. Not quite there. Nemad's mother helped her walk back and forth across the room to bring the baby's head into position. Within half an hour she had dilated to three fingers, the head was down, and her pains were truly "hot." This will take time, cautioned Sheffa, it could be several hours yet.

We drink syrupy tea and converse. The women ask about birth in Canada, and I tell them about being a friend's pregnancy coach. "But normally," I say, "the woman's husband attends and helps." My companions were aghast, but thought it rather sweet. In Sudan a woman's husband cannot set foot in the birth chamber the entire forty days of her confinement. He may not even hold his child until it is five months old. But this does not apply to all men, only the baby's father. Nemad's brothers were there today, impatient to welcome the baby.

Ninety minutes later Sheffa measured Nemad's pelvis relative to the width of the baby's head. She would be ready to deliver in an hour or two. As dusk descended we left in search of a car to return us to Hofriyat; Salima and I were bound to stay until the end, but with no moon and no flashlight, walking was out of the question. We set off for the Italian textile factory, built six years ago but never opened.

Inside a fenced compound on the desert fringe, massive wooden crates and bare machines were stacked and smothered by sand. Drifts had collected around derelict turbines, and with them the spent hopes of local

families. An Italian manager and his Eritrean assistant lived here, guarding the ghostly structure. They'd placed their Land Rover at Sheffa's disposal and kindly agreed to drive us home later on.

Before returning to Nemad's we visited a woman the Land Rover had saved a few days ago. She'd delivered prematurely, a stillborn child. Now she was home from hospital, and Sheffa wanted to ensure she was taking her antibiotics to prevent puerperal fever and counteract the inflammation caused by remedial infibulation. The *nufasâ* (postpartum woman) lay resplendent in her wedding gold and the charms that deflect misfortune, her hair freshly plaited, her hands and feet stained with henna. Friends teased her about being in confinement, pampered like a bride and freed from chores for forty days. One quipped that forty days were not enough to recover from being opened and resewn.

By 5:15 we were back and Nemad was close to giving birth. Sheffa readied the "delivery room." Working at a table near the south-facing windows—for now, the only source of light—she placed scissors, cotton gauze, plastic tubing, and a piece of string in a large enamel bowl and poured boiling water over all. She filled a clean syringe with anaesthetic, then directed that an *angarîb* be moved to the center of the room. A lawn chair was placed at the end of the bed, where Sheffa would sit. Immediately behind it to the left was the *angarîb* where I would watch and lift the kerosene lantern when required. Beside me was another chair, with arms, to serve as the baby's crib. Mattresses were piled up at one end of the birth bed and behind them in its center was set a rope-strung stool. Over the mattresses the Pepsi mackintosh had been laid as before.

Nemad was led into the room accompanied by four middle-aged women. The door was shut. Her mother's sister lifted herself onto the stool atop the *angarîb*, then extended her legs to either side of the mattress roll. Two other aunts helped Nemad onto the sheet before her. Nemad would give birth in her kinswoman's arms, her back leaning against her aunt's chest, her torso and hips angled upright. Sheffa had modified the supine position to better resemble rope delivery with its gravitational help.

The room grew hot; its mud-brick walls, having absorbed the heat of the day, now radiated it with a vengeance. A hint of breeze wafted through the north windows; we were lucky the wind had dropped and there was no blowing sand. The room was shadowy, muted in the fading light and alive with the humming of flies.

Nemad's legs were spread and held back, an aunt on either side of the *angarîb* to perform this task. The one nearest me wore Bruce Lee "Kung Fu" plastic sandals. Nemad's skirt was stretched between her elevated knees for modesty and to keep her from seeing what Sheffa might do. On

instruction Nemad lifted her arms and locked them backward round her aunt's neck. Her mother stood by her side, fanning her face.

Sheffa told Nemad to breathe; she wanted her to cry out with the pain, rather than observe the custom of silence lest she hold her breath and deprive the baby of oxygen. A lamp was lit and handed through the window. I held it high over Sheffa's shoulder. She inserted the syringe into the vaginal opening and made several small injections around the area to be cut, much like a dentist freezing one's gums. Nemad bore down; Sheffa felt inside her and punctured the amniotic sac; fluid gushed onto the vinyl sheet and into a basin below. I fanned away the flies. Soon the top of the baby's head showed through the opening. Sheffa poured water over the area to clean away some blood. She washed Nemad with carbolic soap then inserted two fingers between the head and the perineum. She waited until the head was crowning well, then quickly cut through the muscle to the left and down. There was a spurt of blood. Kung Fu auntie swooned and left the room; Nemad's mother took her place. The flies were growing thick; hands rhythmically brushed them away. After several more contractions the baby still could not pass; Sheffa cut a further inch or so. Next push, she eased back the muscle, gently grasped the baby's head and slid him into the world.

Sheffa sucked mucous from the baby's mouth with a small plastic pipe. He gave a hearty cry. Nemad's kinswomen were elated and congratulated her on the birth of a son. Sheffa tied the cord close to the baby and cut it, then wrapped him in a clean cloth and placed him in the chair. He whimpered and tested his legs, then put his hand to his mouth and sucked. He was tiny but very alert. Sheffa closed the windows and returned her attention to Nemad. The afterbirth was delivered without mishap; now she threaded a needle with suture and prepared to sew up the wound. I held the lamp closer and waved away more flies.

Nemad was helped down and supported by her aunts as Sheffa and her mother rearranged the room. The *angarîb* was moved back against the wall and Nemad soon put to bed. Sheffa used oil to clean the baby of vernix and blood, then swaddled him in clean soft cotton and gave him to his mother to feed. I am taken by the simple humanity of it all.

Nemad's mother stayed behind as the rest of the delivery team went out onto the veranda for a breath of air. Incense was lit beneath an *angarîb*. Nemad's brothers arrived, overjoyed that the child is a boy; her husband's family were heard cheering a few doors away. As we sipped the celebratory coffee, women asked again how birth in my country differs from what I'd just seen. I am tired and emotional, and want to avoid a lengthy discussion. I reply that it's similar, but that we do not circumcise. "*Baraka*," someone said, "a blessing," and the others murmured assent.

Last Thoughts

I began by suggesting that this book be considered an allegory. As such, any analogies it offers to present conditions are partial and indirect, and preclude a singular reading. Moreover, the events detailed here did not stem from internally homogeneous positions held by officials or their subjects; nor were the two "natural categories" or neatly opposed. Their worlds were, however, incongruent, if sometimes unevenly shared. The reciprocal imaginings of British and Sudanese were those of mutual but disproportionate foils, much like the relationship between *zayran* and the women whose bodies they claim. Colonialism on the ground is a shifting and provocative embodied process; its nuances are many and its effects seldom what its protagonists intend.

"Christianity and commerce," flaunted since Victorian times as progress, reason, and universal individualism, have underwritten crusades other than those against infibulation in Sudan, whether violent or subtle or both. That they have largely failed to "normalize" the contours of subjects' lives, or loosen the purchase of Islam, attests to the poverty of an imagination that discounts the commitment of others while exalting the truth of its own, and finds "culture" everywhere but in itself. Today, as the concept of civilization sees its hard-won plurality eroded by that of a "freedom" which threatens the existence of us all, the legacy of General Gordon's clash with the Sudanese Mahdi should, at least, give us pause.

NOTES

INTRODUCTION

Evans-Pritchard 1962:48.

1. W.H.O. 2000, 1999; see also Cook 1979; Shandall 1967; Verzin 1975. Excision is referred to as "Type II," and infibulation as "Type III." Type I is the form called *sunna*, meaning "the way of the Prophet," in which the hood of the clitoris is either nicked or removed and sometimes part or all of the clitoris too; while still much less frequent than types II or III, it has recently gained ground in Muslim Sudan (Gruenbaum 2001). A fourth, "unclassified," type includes all other practices, such as piercing, incising, and stretching the clitoris and/or labia (W.H.O. 2000, 1999).

2. See Obermeyer 1999 for a discussion of this point.

3. Shweder 2005:181.

4. W.H.O. 2001: 7.

5. See Bell 2005.

6. Walker 1992; Accad 1989.

7. Bardach 1993.

8. Gruenbaum 2001.

9. Shell-Duncan and Hernlund 1999, and forthcoming from Rutgers University Press.

10. James and Robertson 2002.

11. Nnaemeka 2005.

12. See Van der Kwaak 1992 for a discussion of the self-referential nature of these publications, also Obermayer 1999, Kirby 1987.

13. See Boddy 1997 for a review of some of this literature, also Obermeyer 1999 and the ensuing exchange between Mackie and Obermeyer in *Medical Anthropology Quarterly* 17 (2, 3) 2003.

14. Nagel 1986.

15. See, for instance, Ram and Jolly 1998.

16. See Daly and Hogan 2005, chapter 10.

17. Boddy 1989.

18. Balfour, E. A. Memoirs, SAD 759/11/63; Deng & Daly 1985:143.

19. See Daly and Hogan 2005:52ff.

20. Comaroff and Comaroff 1991:30.

21. E.g. see Prunier 1995.

22. See the preface to Comaroff and Comaroff 1997 for a discussion of this point.

23. Captain A. E. Hubbard, in Harrington and Sharp, eds. 1998:72. Participants sensed themselves part of a lethal apparatus that was marching back in time.

CHAPTER 1

Cromer 1908, v.2:15.

Churchill 1987 (1899):57.

1. RH Mss Perham 594/1, clipping: January 30, 1945. "Gordon Commemorated in the Sudan. Ceremonies at Khartoum," from our correspondent (the *Times?*); Woodward 1985:39 contains an account of the fiftieth anniversary, when some fifty of Gordon's former soldiers took part.

2. Magnus 1958:132.

3. Burleigh 1899:257–61.

4. See Alford & Sword 1969 (1898):280ff.

5. Marlowe 1969:10; Coray 1984:29. Attendance held until at least World War II, after which it seems to have faded (Peter Shinnie, pers. com.).

6. Jackson 1960:131; Warburg 1971:112. Local ceremonies were held in the provincial capitals (Jackson 1954).

7. Jackson 1960:131–32; Woodward 1990:33. According to Marlowe (1969:7), "The Dean of Lichfield, preaching at a memorial service to Gordon, stated that, if he had been born a Roman Catholic, he would have been canonized," and in England he became a popular saint, "worshipped by a cult and commemorated by a growing legend, in a way which was less typical of England than of the land where Gordon died." Though the legend tarnished over time, his probity and courage were not questioned.

8. Sarsfield-Hall 1975:112.

9. See Comaroff and Comaroff 1991.

10. Connerton 1989:18ff.

11. Marlowe 1969:10

12. See Collins and Deng 1984; Deng and Daly 1989; also memoirs of Sudan officials in the Sudan Archive at Durham, UK.

13. Holt 1970:32. This is further discussed in chapter 6.

14. See ibid., 1966; Holt and Daly 1979. The occupation lasted over seventy years.

15. In fact, according to Holt and Daly (1979:86ff), his departure from Sudan in 1879, coupled with the deposition of Khedive Isma'il that was engineered by Britain and France the same year, created a power vacuum in Sudan that provided the opportunity for revolt.

16. Jackson 1954:12.

17. See Marlowe 1969; Johnson 1985; Holt 1970; Wingate 1955.

18. *Khartoum*, Robert Ardrey, writer; Basil Dearden, director; Julian Blaustein, producer. MGM/UA, 1966.

19. Churchill 1987 (1899):73.

20. Judd 1985.

21. Cutting in RH Mss Africa s. 2186.

22. Johnson 1985:33ff.; Jackson (1954:109) cites a conversation with Slatin in which the latter, who knew Gordon well, refutes the accusation that he was a heavy drinker.

23. Marlowe (1969:28ff, 62), notes that between his two missions to Sudan, Gordon attempted to locate the Garden of Eden, establishing by detailed cal-

culation that it lay beneath the Indian Ocean somewhere between Mauritius and the Seychelles.

24. Judd 1985:20
25. Cromer 1908 v.1: 429–32.
26. Marlowe 1969:50.
27. Helly 1987.
28. Magnus 1958:141; see also Arthur 1920, v.1:251.
29. Holt 1970:93.
30. Compton 1974:140, 133.
31. Johnson 1985:151.
32. Faussett 1939 passim; see the Robertson papers, SAD.
33. Slatin had "converted" and accepted the *jibba* in order to save his men; Gordon never forgave him.
34. SAD 661/4/17–21 (Henderson).
35. Wingate 1955:65.
36. Holt 1970:104; Jackson 1954:22.
37. Ibid., 224; see also Wingate 1955:89–102.
38. Alford and Sword 1969:196.
39. Farwell 1973:334.
40. Steevens 1898:22.
41. Captain A. E. Hubbard, in Harrington and Sharp, eds. 1998:72. Participants sensed themselves part of a lethal apparatus that was marching back in time.
42. Ziegler 1973:42.
43. Magnus 1958:125.
44. Numbers of wounded vary according to source. Magnus (1958:131) puts it at 434, Collins (1984:9) at 382, Wingate (1955:116) at 363.
45. The biographer of Katharine Duchess of Atholl, whose husband ("Bardie") took part in the campaign [see ch. 9], notes that on the day after the battle "Bardie and a young officer in the 21st Lancers named Winston Churchill—who was also acting as war correspondent for the *Morning Post*—were moved by compassion and returned to the Kerreri plain to give water to the wounded and dying Dervishes. Kitchener was wholly unmoved and later instigated the looting of the holy places of the warriors. Bardie, having had such an example set by his lofty superior, was not to be outdone. When he returned to Blair months later, trunks full of Dervish weaponry and loot arrived, including a finial from the tomb of the Mahdi" (Hetherington 1989). See also Daly 1986:3–4; Babikr Bedri 1980, vol.2:80–81.
46. Cromer to Salisbury March 12, 1899, PRO 57/14:29–31.
47. Magnus 1958:133. Kitchener denied complicity in keeping the skull, begging that he was at the time en route to Fashoda to confront the French who had laid claim to the Upper Nile.
48. Cromer to Salisbury, March 12, 1899, PRO 57/14:29–31.
49. Magnus 1958:148 quoting Kitchener to Wingate, January 26, 1899.
50. Warburg 1971:3.
51. One of the battalions mutinied in December 1899.
52. Magnus 1958:144–46, quoting Salisbury to Kitchener, 21 Nov. 1898 and the *London Times*, 30 Nov. 1898.

53. Daly 1986:24–25; Magnus 1958:144–46; Arthur 1920, v.1:253–55.

54. Or a series of Union flags. Daly 1986:25, Kenrick 1989:123; Walkley 1936; Jackson 1954:24. See also SAD 691/7/99 (Humphreys).

55. Kenrick 1989:129.

56. In 1905 he became archdeacon, and later bishop of Khartoum.

57. Gordon, who forever sought Old Testament analogies for present situations, would have appreciated Gwynne's parable. See Compton 1974:173.

58. Wingate papers, SAD 275/2/22–25.

59. Jackson 1954:18.

60. Cromer 1908 v.1, on Salisbury, see Steele 1998.

61. The three Nubian kingdoms of Sudan were Christian from the sixth century. With the absorption of Egypt into the Islamic Empire in 639, the upper Nile became increasingly isolated from the center of Coptic Christianity in Alexandria, and Muslim merchants and herders began trickling into Sudan from Egypt and the Red Sea coast. It was only in the fourteenth century, however, that Christian Nubia fell to Muslim invaders. By the start of the sixteenth century an indigenous state had arisen at Sennar on the Blue Nile whose rulers were at least nominally Muslim. See Adams 1984.

62. Gwynne memoirs, SAD 421/1/283.

63. Walkley 1936:90; see Vantini 1981:33–34, citing Acts 8:26–39.

64. See Callaway 1987:42ff. for similar observations on the British in Nigeria, also Kenrick 1987 on Sudan.

65. Webb 1969:380. From 1891, the state made it possible for all working-class children to receive a basic education without fees.

66. Eksteins 1985:2.

67. Even before his fatal excursion was proposed, a biography had appeared (1883) and a volume of correspondence from his first mission to Sudan (1881). There were also two books about his exploits in China, plus numerous letters to the press, magazine articles, and pamphlets written and circulated by Gordon himself.

68. Johnson 1985:43. The article was by W. T. Stead.

69. Cromer 1908, v.1:432.

70. Henty 1892:117–18, 123.

71. Kipling 1900.

72. Henty 1892:135, 190.

73. Ibid., 217.

74. Ibid., 173.

75. Ibid., 217.

76. Ibid., 171.

77. McClintock 1995.

78. Thanks to Douglas Johnson for pointing this out. The episode is captured in the aforementioned film *Khartoum* (Robert Ardrey, writer; Basil Dearden, director; Julian Blaustein, producer. MGM/UA, 1966).

79. Mason 1903.

80. See Said 1979.

81. Burton (1964, vol.1:2) wrote, "Thoroughly tired of 'progress' and of 'civilisation'; curious to see with my eyes what others are content to 'see with their ears,' namely, Moslem inner life in a really Mohammedan country; and longing,

if truth be told, to set foot on that mysterious spot which no vacation tourist had yet described, measured, sketched and photographed, I resolved to resume my old character of a Persian wanderer, a 'Darwaysh,' and to make the attempt." On the translation of spatial into temporal distance, see Fabian 1983, discussed below.

82. Said 1979:196.

83. Ibid., 59–60, 206ff.; Gilman 1985a.

84. Gilman 1985a:x.

85. Davin 1997; Nye 1985.

86. McClintock 1995:46–47. See Douglas 1966 on relations between body and society.

87. McClintock 1995:47.

88. Davin 1997.

89. McClintock 1995:47.

90. See also Burke 1999, ch. 1.

91. Fabian 1983.

92. Gramsci 1971.

93. Conan Doyle, *The Tragedy of the Korosko* (1898).

94. Farwell 1973:280.

95. Judd 1985:25. Cromer (1908, 1:589) mocked, "General Gordon and Colonel Stewart were beleaguered in a remote African town by a horde of warlike savages, who were half mad with fanaticism and elated at their recent success. Yet Mr. Gladstone wanted further proof that they were in danger."

96. Burton 1964, v.1:11.

97. Mason 2002 (1902).

98. See McClintock 1995:69 on "colonial passing" in Kipling's *Kim*; she suggests that Kim is able to pass because of his ambiguous racial heritage; being half-Irish, he is "racially closer to the Indians than if he had been wholly English." This is not true for the blue-blooded heroes of Henty's books considered here.

99. *The Four Feathers* can be read on several levels, as a romance, an adventure, a denunciation of war; nonetheless, the plot hangs on Feversham recouping his honor by plunging into the heart of Mahdist territory to save fellow Englishmen from dervish brutality.

100. Henty 1903:238.

101. Steele 1998.

102. Henty 1903:245.

103. Ibid., 71.

104. *The Egyptian Red Book* (a satire on the Foreign Office "Blue Book" of correspondence), London: Blackwood, 1885, cartoon reproduced in Johnson 1985:137. Wolseley's Congo Tea may be a take off on Vaissier's Congo Soap later endorsed by Stanley who gained fame by relieving Gordon's colleague, the khedival governor of Equatoria Province, Emin Pasha (Eduard Schnitzer, a German physician) in 1889.

105. Henty 1892:247

106. See Jackson 1954:96 on Sudanese drums. Petrol tins and metal washbasins were standard instruments of the *zâr* spirit possession cult in the 1970s and 1980s, discussed below.

107. Henty 1892:248. There is retrospective irony in this, as tea became the Sudanese national drink, but mixed with large amounts of sugar, which Edgar does not use.

108. Sahlins 1994:439.

109. Henty 1892:245

110. Henderson 1965:33; Daly 1986:22.

111. Daly 1986:22.

112. Spaulding 1985.

113. McClintock 1995:207

114. Foucault 1990:123; see also Davin 1997.

115. Stoler 1996:7.

116. Douglas 1966, Burke 1996.

117. I borrow the phrase from Richards 1990:133ff.

118. McClintock 1995: chapter 5.

119. Stoler 1996; 2002.

120. *Illustrated London News*, Sept. 17, 1887, p. 353.

121. Williamson 1978:99 in Burke 1996:3.

122. Thomas 1990:123, 121.

123. McClintock 1995:225.

124. See Richards 1990:122.

125. Kenrick 1989:9–10.

126. Acland to Baily, 11 August 1932, SAD 533/3/30.

127. *Illustrated London News*, October 8, 1898, p. 525.

128. Johnson 1985:175, 176.

129. According to historian Douglas Johnson, figures of dervish soldiers were produced later on (D. Johnson, pers. com. February 2003).

130. Beasley 1992:15.

131. For example, Ina Beasley, inspector and later controller of girls' education in Sudan from 1939 to 1949. Beasley 1991:15.

132. McClintock 1995:209.

133. Cromer 1908, v.2:544, 538.

134. Henty 1903:98. As with much of his narrative, Henty's description is here informed by actual events. Stories of native women warriors had circulated among Britons in Sudan, based in part on an incident in September 1884, in which a force of Sudanese soldiers in the Egyptian Army was defeated by Mahdist troops at Kurnus, south of Khartoum. Afterward, when the dervishes came to look at the enemy bodies, it was said they found many of them to be women, dressed as men and carrying arms. The British official relating this suggests that women were employed as water carriers on the expedition and it was they who had been killed (Longe, SAD 641/6/40). He does not account for the weapons or cross-dressing.

135. Gilman 1985b; p. 85. The body of Saartje (Sarah) Bartmann, the so-called Hottentot Venus, provided physical evidence that was used to ground this ideology in "fact." Bartmann was a young indentured woman from southern Africa who in 1810 was placed on humiliating public exhibit throughout Europe. Though from a lighter-skinned population than many in Africa, she was presented as the essence of difference because of her sexual features: Europeans were fascinated by her steatopygia (protruding buttocks) and the apparently aberrant for-

mation of her genitals. She became a symbol of the primitive sexuality associated with Africans as a whole.

136. Gilman 1985b, chapter 3; see also Comaroff and Comaroff 1992, chapter 8.

137. Sheehan 1997.

138. See Comaroff and Comaroff 1991, 1992, 1998.

139. Powell 1995, 2003.

140. Churchill 1987 [1899]:97. See also Daly 1986.

141. Alford and Sword 1969 [1898]:144–45. See also p. 83.

142. SAD 304/2/30 (Farley).

143. Alford and Sword 1969:145, cited in SAD 304/2/29 (Farley).

144. Kipling1900, v.3:408.

145. Mason 1902:165.

146. E.g. Langley 1950.

147. Hetherington 1989:23. This was common in the British army as a whole. See Kenrick 1987.

148. Kenrick 1987.

149. See Deng and Daly, eds., 1989 passim; Hyam 1990.

150. See the novel *Pilate Pasha*, 1937, set in west-central Sudan, in which a British officer receives regular visits from a local woman, Miriam. There was also a famous brothel in Khartoum apparently frequented by British staff.

INTERLUDE 1

1. F.C.C. Balfour, letter to his mother, SAD 303/6/56–57. "Fuzzies" refers to Eastern Sudanese such as Beja and Hadendowa who wore their hair in an "Afro" style. The term can be traced at least to Kipling's poem "Fuzzy-Wuzzy" noted in chapter 1.

2. Zenkovsky 1950; Kenyon 1991, 1994, 2004; Makris 2000.

3. See Masquelier 2001.

4. Makris 2000 passim.

5. Constantinides 1972, 1991. See also Boddy 1989. There is some evidence that *zâr* is practiced in the Maghreb as well (Cloudsley 1983:75).

6. Constantinides 1972.

7. See Suras 6, 17, 18, 34, 37, 46, 55, 72, and 114.

8. Feminine plural of *shaykh*. There are male *zâr* specialists too, but they are less common than female and more typical of *zâr ṯumbura* than *zâr bori*.

9. Boddy 1989. Interestingly, this is similar to the situations of men and women in a marriage: while men may divorce an unwanted wife at will, women usually must accommodate themselves to the marriage, however unhappy.

10. Where I worked there were said to be seven *zâr* nations, though in practice more were recognized.

11. For more on *zâr* in Sudan, see Boddy 1989, Constantinides 1991, Kenyon 1991, Lewis et al. 1991.

12. Cf. Constantinides 1972. See also Zenkovsly (1950:70) who refers to "Gowri or Kowri Pasha."

CHAPTER 2

Artin 1911:15.

Salih 1969:59.

1. Cromer 1908, v.2:117–18.

2. Beshir 1974:21.

3. Deng and Daly 1989:6.

4. See Spaulding 1985; Kapteijns 1984.

5. As was the case in Egypt where they limited government powers.

6. Warburg 1971:21.

7. See Daly 1986, Warburg 1971, Woodward 1990.

8. Anderson 1970 [1955]:11.

9. Messick 1993:65–66, on the British in Aden Protectorate. The same could be said for Nigeria, as for Sudan.

10. Salomon 2003:5.

11. For Muslims the Qurʿan is the "seal" of the prophetic revelations also documented in Jewish and Christian texts, Muhammad was the "seal" or last of the prophets, and Jesus was a righteous prophet in the same line as Moses and Abraham. *Hadith*s (reported sayings and acts of the Prophet Muhammad) and later Islamic traditions predict Jesus's return. See Esposito 2003.

12. Holt and Daly 1979:119, Esposito 2003:21–22, Ibn Khaldun 1967:257ff.

13. Woodward 1990:27; see also Warburg 1971:100–106.

14. See Daly 1986; Warburg 1971.

15. Most Egyptian jurists followed the Hanafi school of religious jurisprudence (favored by the Ottomans), while Malaki codes were common in Sudan.

16. Except for Port Sudan, which conformed to the international shipping convention of keeping Sunday as a day of rest (Frost 1984:87). For discussions of religious policy see Warburg 1971, Daly 1986, Khalid 1990.

17. Frost 1984:69. See also Warburg 1971:95–100.

18. Sanderson and Sanderson 1981:27.

19. "A New Call from the Heart of Africa" Jan. 1905, CMS G3/E/L3; Wingate 1955:147; Baylis and Wilkinson to Gwynne and Harpur, Oct. 1899, Lang to Kitchener, 30 June 1899, Lang to Kitchener July 28, 1899, CMS G3/E/L2/128–31; Baylis to Adeney, 12 Jan. 1900, CMS G3/E/L2/ 147–48; Committee of Correspondence to Wingate, 1900, CMS G3/E/L2/163, 165; Warburg 1971:109ff.

20. The Presbyterians arrived in 1899. The Catholics had been working in Sudan since 1848, and some, such as Father Orwhalder, had been captives during the Mahdiya.

21. MacInnes to the Committee of Correspondence, CMS G3/E/O 1904, no. 4., p. 14.

22. CMS G3/E/L2, *Instructions delivered to missionaries proceeding to the field in the Autumn of 1897*, insert at p. 30.

23. Gwynne memoirs, SAD 421/1/50.

24. Wingate 1955:147.

25. Warburg 1971:110; Baylis to Adeney 6 July, 1900, CMS G3/E/L2/173.

26. See Bermingham and Collins 1984.

27. Baylis to Adeney, 4 Mar. 1901, CMS G3/E/L2/218–219; "Memorandum upon the Position of the Church Missionary Society in the Egyptian Soudan, submitted to His Majesty's Principal Secretary of State for Foreign Affairs" July 17, 1901, CMS G3/E/P2.

28. Findlay to Baylis, 1903, CMS G3 E L2/331; CMS G3/E/P/85/June 14, 1902.

29. Sharkey 2003.

30. Daly 1986:242–44; Warburg 1971:96.

31. Gladstone to Baylis, 1 Jan. 1903, CMS G3/E/L2/312. The controversy continued to bubble, eliciting a point-for-point response from Cromer in May 1905 (Cromer to MacInnes, 16 May, 1905, CMS G3/E/O/No. 115).

32. Cromer to MacInnes, 16 May 1905, CMS G3/E/O/No. 115.

33. Gwynne to Baylis, 31 Jan. 1903, Gwynne to Wingate, 26 Jan. 1903, CMS G3/E/O 1903, no. 24.

34. Daly 1986:246. Sharkey (2002:58) notes that other missions were permitted to open schools in Khartoum under similar restrictions, but concentrated on different populations: children of European Christian expatriates (the Austrian Catholic mission), and Sudanese ex–slave boys (the American Presbyterians).

35. "This great dying Sudan has not yet been given a chance. Flood it with girls schools in which is taught the pure word of God and you will be preparing a godly and peaceful future for it. Leave it for the Government to put girls schools and who knows what will follow?" McNeile to Manley, 16 Mar. 1916, CMS G3 E/O/1916/No. 19. See also Manley to Gairdner, 3 Apr. 1918, CMS G3E/L4/ 176–77 and the report by Miss E.K.W. Maxwell, Omdurman Girls' Schools, Minutes of Annual Conference 27 Jan. 1940. CMS G3/SN2 /1935–49.

36. Gwynne to Baylis, 24 Feb. 1903, CMS G3 E/O/1903/No. 37; Warburg 1971:114; cf. Jackson 1960.

37. "Report on the CMS Girl's School in Khartoum" Saada Haddad, CMS G3/E/O 1903, no. 116. The file includes examples of the girls' handiwork and a lock of hair braided in the style of *mashât* (thin cornrows). See also Jackson 1960, ch. 15.

38. Frost 1984:81.

39. Gwynne to Baylis, 5 Feb. 1904, CMS G3/E/O/1904/No. 17, 49.

40. Wingate 1955:32.

41. Warburg 1971:111, citing "Khartoum Cathedral" [nd] SAD 103/3.

42. Wingate 1955.

43. Gwynne to Baylis, 24 Feb. 1903, CMS G3 E/O/1903, no. 37.

44. "*A New Call from the Heart of Africa*" CMS G3E /L3, Jan. 1905.

45. Indeed, Gwynne gained inspiration in the face of his setbacks by reading passages of Gordon's diaries and contemplating his sufferings (Jackson 1960:58–59, 61).

46. In order to be installed as archdeacon of Khartoum in 1905 (later bishop, 1908), Gwynne was required to resign from the CMS, for the government represented the monarch whom the Church of England served, and his membership in an evangelical organization opposed to government policy would compromise the administration. He was, however, permitted to remain an agent of the CMS, and his loyalty to its objectives held fast. He became something of a mediator between

institutions, yet his own change of role foreshadowed the fate of the CMS in northern Sudan: ultimately they ministered more to the British community than to "heathens."

47. Stoler 2002:42.

48. Collins 1984:15.

49. Ranger 1983.

50. Daly 1986:93, 96, citing S. S. Butler, "The Egyptian Army, 1909–1915," SAD 422/12.

51. Wingate 1955:144.

52. Daly 1986:96, citing H. C. Bowman diary, 10 Nov. 1911, MECOX.

53. Such journeys were unwitting echoes of the circulating courts of sixteenth- and seventeenth-century Sennar, the indigenous state whose remnants fell to Mohammad Ali's troops in 1821. See Spaulding 1985.

54. Daly 1986:101 citing Wingate to Matthews, 7 Feb. 1908, SAD 282/2.

55. Bailey memoirs, SAD 533/4/21. Robin Baily was a great-nephew of Samuel Baker and worked in Sudan from 1909 to 1933.

56. Frost 1984:68.

57. Daly 1986:95.

58. Daly 1986:100 citing Wingate to Cecil, 6 Jan. 1905, SAD 276/1. See Daly 1986:93–104; Warburg 1971:22–23.

59. Warburg 1971:22–23, citing Wingate to Clayton (private), 9 Apr. 1916, SAD 470/1.

60. Ranger 1983:215.

61. When the British agent and consul general in Cairo insisted the khedive preside over the opening of Port Sudan in 1909 and imperial symbols be kept in the background, he thought to reconcile the Egyptian ruling class to British control and drive a wedge between them and Egyptian nationalists by means of Sudan. Wingate was not pleased. See Warburg 1971:36–38.

62. See Ranger 1983, Cannadine 1983.

63. Daly 1986:98.

64. Ibid.: 97, citing Wingate to Wigram, 15 Sept. 1911, and 20 Sept. 1911, SAD 299, and Wingate to Kerr, 30 Dec. 1911, SAD 301/6/2.

65. Butler to his family, 15 Jan. 1912, SAD 304/6/2–3.

66. Ibid., 30 Jan. 1912, SAD 304/6/8–9.

67. SAD 691/7/90 (Humphreys); SAD 726/1/38 (Arthur); Woodward 1990:32.

68. Burleigh 1899:229–30; Daly 1986:121.

69. Butler to his family, 30 Jan. 1912, SAD 304/6/8–9.

70. NRO CIVSEC 2/26/1/1. The exception was Darfur, after it was incorporated into Sudan in 1916, as it was too far and the journey too arduous.

71. See Daly 1986:96.

72. Gwynne memoirs, SAD 421/1/308, 309.

73. Butler to his family, 25 July 1912, SAD 304/6/35.

74. Ranger 1983:212.

75. Daly 1986:83.

76. Kirk-Greene, "The Sudan Political Service" SAD 624/12/8; Deng and Daly 1985:3, citing Cromer's introduction to S. Low, *Egypt in Transition*, 1914.

77. Low 1914:89–91.

78. Kirke-Greene SAD 624/12/33.

79. Mangan (1982:687) writes, "While physical fitness, toughness, and stamina were valuable qualities in a gruelling climate and an underdeveloped country, it is also important to recognize that the administration of the 'backward peoples' of the Sudan was frequently a game of political bluff requiring superb self-assurance on the part of the handful of administrators involved. And the hero-worship that accompanied the extrovert school 'blood' (athletic hero) was a highly effective means for creating this self-assurance."

80. Daly 1986:87.

81. Mangan 1982.

82. Fewer than 5 percent of a graduating class would normally receive a "first," and in some years no firsts were awarded at all (Kirk-Green 1982:37; R. Wright pers. com.).

83. Kirk-Greene 1982, Deng and Daly 1985, Mangan 1972.

84. The figure is supplied by Collins 1972:301. The point was often remarked upon. In fact the CMS received a great deal of support from SPS clerical offspring, many of whom acted as "friends" and advisors to the mission.

85. Baily memoirs, SAD 533/4/32.

86. Collins 1972:300–301.

87. Deng and Daly 1985:120.

88. Acland memoirs, SAD 707/15/10. P.B.E. Acland suggests that low recruitment during WWI as the reason responsibility was assigned so early in his career.

89. Salih 1969:53.

90. Deng and Daly 1985; see also Collins and Deng, memoirs in the Sudan Archive (SAD), and the entries by Sudan officials in the bibliography to this book.

91. Elliott Balfour (SPS) suggested much the same: "There was at that time a current ideal of conduct known as 'that of an English gentleman.' Its prototypes can be found in the novels of John Buchan or among the heroes of that prolific writer of boys stories, G.A. Henty. . . . The men I met when I was very young still believed in it and tried to live up to the perhaps unrealistic standards it set. It was these men who were laying the foundations on which the future Political Service would build" (SAD 759/11/2).

92. Kenrick 1987; Jackson 1954:41 (the early badge bore SCS for Sudan Civil Service).

93. Ranger 1984:220–21, 227.

94. E. A. Balfour, background notes, SAD 606/3/2. His father, Dr. Andrew Balfour, was first director of the Wellcome Tropical Research Laboratories, which opened in Khartoum in 1903.

95. "The Lighter Side of the Sudan," *Manchester Guradian*, 6 Nov. 1913, SAD 578/8/52.

96. Kenrick 1987:26.

97. Thesiger 1987:206; passim.

98. Arthur letters, SAD 726/6/12.

99. Vidler, "Fallen Angels, 1956–1989, Their Story" SAD 745/10. The club initially included the cohorts of 1933–39. The tenor of the service changed appreciably with recruits who signed on after World War II.

100. However, difficulties in finding suitable housing for families could unofficially restrict women's presence (pers. com. Peter Shinnie, 1999).

101. Jackson 1954:26–27.

102. Henderson interview, quoted in Deng and Daly 1989:45. Baily apparently gave one hundred days to Geoffrey Barter's wife (Frost 1984:83).

103. Daly 1986:357. See Kenrick 1987, Deng and Daly 1989.

104. Kenrick 1987:22.

105. Deng and Daly 1989:45ff.

106. Ibid., 116, 52. See also Spaulding and Beswick 1995:528–29, note 66.

107. Deng and Daly 1989:57.

108. Daud ʿAbd al-Latif in Deng and Daly 1989:124.

109. Acland memoirs, SAD 707/15/3.

110. Deng and Daly 1989:50–52, 117, 182–83. Baily notes that an early governor of Khartoum had a son by "his black mistress" for whom Gwynne acted as "a sort of godfather" administering "the allowance the father had set aside for the boy's education. He was brought up as a Moslem and became a clerk in government service" (Baily memoirs, SAD 533/4/32).

111. Deng and Daly 1989:49, see also p. 39.

112. Balfour memoirs, SAD 759/11/11.

113. Ref. Conrad's *Heart of Darkness*, orig. 1899.

114. Balfour memoirs, SAD 759/11/31–32.

115. See, especially, Balfour memoirs, SAD 759/11/13.

116. Kipling uses the pseudonym Gihon, a biblical name for the Nile, though references to the Mahdi at once betray his disguise.

117. Kipling 1909.

118. Balfour 1999:40, 41.

119. See Kenrick 1987; the Wolff sisters, who ran the Midwifery Training School in Omdurman in the 1929s and 1930s, had a female cook, a rarity in Sudan.

120. See Sikainga 1996.

121. Kenrick 1987:71–75.

122. Ibid., 71.

123. Beswick 1995:447, 449.

124. Shinnie, memoirs, pers. com.

125. Gladys Leak to her mother, 25 Oct. 1924, RH Mss. Afr.s. 416/37.

126. Kenrick 1987:21; "A Swedish Correspondent's Recent Impressions of the Sudan," Bulletin 265, Public Relations Dept., Khartoum, 4 Apr. 1952. SAD 403/10/20.

127. Dress of civilians when dining in the regimental mess. 3 Apr. 1937. NRO CIVSEC 2/24/10/44; 1939.

128. Rappaport 1979:173–221; Connerton 1989, ch. 3.

129. Said 1979:42.

INTERLUDE 2

1. Susan Kenyon, pers. comm.

2. The name Abu Rish appears in late eighteenth and early nineteenth century accounts. According to one source, Abu Rish was a member of the Hamaj Awlad Abu Likaylik, regents to the Funj in Sennar ("Survivals of the Fung," SAD 478/4/66 [Henderson]). A more reliable authority is Spaulding (1985:389), who notes

that Abu Rish was the son of Shayhk Ahmad bin al-Radi of the eastern Rufaʿa living in the Ethiopian borderlands at the same time. The use of the name for a British *sirdar* reflects the collapsing of names, times, and figures of power, which is common in the *zâr*, part of its creative "bricolage" that keeps local history alive in a mythical way. Ancestors of people in Shendi district where I learned about Abu Rish had taken refuge in the Ethiopian borderlands to avoid the Turks' wrath after Khedive Mohammed ʿAli's son Ibrahim and his entourage were murdered in Shendi town in 1822.

3. Frost 1984:74–75.

4. Boddy 1989:289.

5. Squires 1958:87.

6. Thanks to Rogaia Abusharaf (pers. com.) for this additional information, and confirmation that the "pigeon" metaphor is widespread in Arab Sudan. My earlier discussions had been based on research conducted in a three-village area of the north, and did not atttempt to generalize (Boddy 1982, 1989).

7. She is similar in these respects to Luliya Habishiya (Luliya the Abyssinian), an extremely popular spirit who wears a multicolored *rahat* and attempts to perform the exacting northern Sudanese bridal dance, but fails to pass muster by opening her eyes and peering at the audience, something a bashful young bride would never do. See Boddy 1989:282–83. "Luliya" is a diminutive of Lu'ul, meaning Pearl, a name typically given to slaves (many of whom were their masters' concubines). The British feared that they would become prostitutes if freed.

8. Thanks to Wendy James for suggesting this clarification.

9. Churchill 1969 [1899]:175.

10. Constantinides 1972:202.

CHAPTER 3

Cohn 1996:4.

1. Ibid., 5.

2. Ibid., 7–11.

3. A. W. Haggis, "The Life of Sir Henry Wellcome," part 3, file copy. WA/HSW/PE/C. 12.

4. Bell 1999:58.

5. *Seattle Daily Times*, May 15, 1917, p. 5. WA/HSW/PE (old cat. Box 43).

6. A. W. Haggis, "The Life of Sir Henry Wellcome," part 3, file copy. WA/HSW/PE/C. 12, p. 357.

7. Wingate to Wellcome, 22 Sept. 1901. WA/HSW/CO/Bus/C. 2.

8. Bayoumi 1979:123; Daly 1986:261.

9. Arnold 1993:26.

10. *First Report of the Wellcome Research Laboratories*, 1904, p. 7.

11. Wellcome owned commercial laboratories in London, which, though affiliated with Burroughs Wellcome & Co., undertook autonomous research; he understood the salience of research to medical practice, a link underappreciated in Britain at the time despite general acceptance of the germ theory of disease (Bell 1999:59–63).

12. See Bell 1999:61ff. on the potential benefits to Wellcome of the WRL.

13. Wellcome quoted in "In Search of Microbes," *Daily Mail* 25/8/06. SAD 759/12.

14. Bell 1999: ch. 3; Squires 1958:4–8; Bayoumi 1979:122–27; Daly 1986:260–61.

15. Bell 1999:56.

16. *Third Report of the Wellcome Research Laboratories*, 1908.

17. Waterston 1908, Vallance 1908. Pirrie died of *kala azar* (leishmaniasis) in 1907, a parasitic disease said "rarely" to affect Europeans; research at the WRTL later led to a treatment (from which I benefited in the late 1970s).

18. Anderson 1908, 1911, 1908:239, 1911:281.

19. Respectively: sleeping sickness and leishmaniasis, N 20.

20. See the Reports of the Wellcome Research Laboratories (1904–10), thereafter Reports of the Wellcome Tropical Research Laboratories.

21. Published in 1920 after Balfour's retirement from the WTRL.

22. *Nature*, Oct. 21, 1920, p. 236. WA/BSR/BA/Pub/D.

23. Bell 1999:92.

24. Spaulding 1985:78; Kapteijns and Spaulding 1982.

25. James 1979:48.

26. Kenrick 1987.

27. Hunt 1999:122.

28. Bhabha 1997:153. Emphasis in the original.

29. In Deng and Daly 1989:102, 170. Other bodily practices were kept from crossing ethnic and racial lines as well. Gwynne, for example, wrote that "for some reason or other it was decided not to teach the natives to play cricket" (in Frost 1984:77). Yet they were taught soccer, widely considered a lower-class sport.

30. Kaptiejns and Spaulding 1982:30. See also Spaulding 1985.

31. James 1977:97–98.

32. See, e.g., "Arabic and the Southern Sudan," H. A. MacMichael, 10 May 1928. RH Mss. Brit. Emp. s. 421(2), quoted in ch. 3.

33. E.g. James 1977, 1988; Ibrahim 1988.

34. James 1977, 1988.

35. The journal survived well into postindependence and was being revived in the 1990s.

36. The branch of the Quraysh descended from Abbas formed the Abbassid dynasty, which ruled the Arab Empire from 750 to (formally at least) 1258.

37. MacMichael 1922, vol 1:235.

38. James 1977:129.

39. Ibrahim 1988; 229–30.

40. MacMichael 1932:xvii–xviii.

41. In her 1977 article, but also in more extended works such as *The Listening Ebony* (1988).

42. Sanderson and Sanderson 1981:124.

43. "Feature No. 253, The Position of Tribal Leaders in the Life of the Sudan," Civil Secretary's Office, 16 July, 1953. SAD 519/5/20 (Robertson).

44. See, for instance, Asad 1973, James 1977.

45. See SAD 519/5/20–20b (Robertson).

46. See Collins 1983, ch. 8.

47. "Tribes of the Sudan," n.d. SAD 403/10/29–41 (MacMichael).

48. Collins 1983:165.

49. Sanderson and Sanderson 1981:179.

50. Wheatley to D. C. Wau, 22 Nov. 1923, SAD 403/9/1 (MacPhail).

51. MacMichael to Financial Secretary, 10 Jan. 1929, SOAS (Arkell papers) MS 210522/2/1/1.

52. "Note on Anthropological and Archaeological Coordination," Gillan to H.E. (Symes), 19 May 1937, SOAS (Arkell papers) MS 210522/2/1/1.

53. RH Mss Perham 229/4/12.

54. "Note on Anthropological and Archaeological Coordination," Gillan to H.E. (Symes), 19 May 1937, SOAS (Arkell papers) MS 210522/2/1/1.

55. Asad 1973:17.

56. Seligman to Arkell, 9 June 1937, SOAS MS 210522/2/1/1, p. 14.

57. Several political officers (e.g. B. A. Lewis, Paul Howell) went on to become professional anthropologists.

58. SOAS (Arkell) MS 210522/2/1/1, p. 5.

59. Sanderson and Sanderson 1981:94.

60. Nadel 1947.

61. Wright to Standing Committee, CMS G3/SN/P1/1934.7 (Feb.) and 1934.12 (Apr.); Standing Committee, Minutes of Conference on the Nuba Mountains Project, 6 Feb. 1933, CMS G3/SN/P1/1933.8. Technically, the Nuba Mountains were in the "Arab" north and immune to Christian proselytization. I return to this case later on.

62. Gillan to Secretary for Health, Education, etc., 3 Feb. 1930, NRO CIVSEC 1/44/2/12, p. 19–22.

63. Sanderson and Sanderon 1981:188. See also ch. 4.

64. Kirk-Greene 1982:36. All six had Cambridge degrees.

65. E. A. Balfour memoirs, SAD 759/11/3.

66. Cited in Kuper 1983:103–104.

67. E.g., J. W. Crowfoot (1919, 1922), Ahmed Abdel Halim (1939), Elaine Hills-Young (1940), and Sophie Zenkovsky, (1945, 1949, 1950).

68. MacMichael 1954:107 (emphasis mine).

69. Evans-Pritchard to Arkell, 7 Sept. 1937, SOAS (Arkell papers) MS 210522/2/1/1, p. 48.

70. H. B. Arber, "Sudan Political Service 1928–1954." SAD 736/2/21.

71. C.A.W. Lea to his parents, 2 Feb. 1926, SAD 645/7/37.

72. Deng and Daly 1989:20–22.

73. Baily, "Early Recollections of the Sudan." SAD 533/4/28.

74. See, e.g., Baily to MacMichael, 16 Oct. 1932, RH Mss. Brit. Emp. s.421(2).

75. Deng and Daly 1989:34–35, 44.

76. Frost 1984:83.

77. Baily "Early Recollections of the Sudan." SAD 533/4/28. The request suggests that "savages" and "criminals" occupied a common category.

78. Kenrick 1987:106–114.

79. Deng and Daly 1989:35.

80. Kenrick 1987:110.

81. Butler to his family, 30 Jan. 1912, SAD 304/6/9.

82. Henderson in Deng and Daly 1989:55.
83. Deng and Daly 1989:114.
84. Ibid.
85. See Boddy 1989, 1997, 1998b. I return to this issue later.
86. Deng and Daly 1987:115.
87. NRO CIVSEC, 2/20/1/2.
88. Sarsfield-Hall to MacMichael, 4 June 1931, NRO CIVSEC 2/20/1/2.
89. Acland memoirs, SAD 707/15/11.
90. E. A. Balfour memoirs, SAD 759/11/56–57.
91. Spaulding and Beswick 1995:533, 532.
92. Exceptions include feminist accounts such as Sanderson 1981 and Beasley 1996.
93. E.g. Comaroff and Comaroff, 1991, 1997; Hunt 1999.

INTERLUDE 3

1. Alford and Sword 1969 (1):116.
2. Evans-Pritchard 1940.
3. Spaulding 1985:193.
4. Hargery (1981:70) notes that during the Mahdiya practically all female slaves were circumcised in one way or another; there is no reason to suppose the situation had changed by the reconquest.
5. Sikainga 1996:66–67; Daly 1985: 238; O'Brien 1986.
6. "Report on the Pilgrimage and the Slave Trade," C. A. Willis, SAD 212/3. See also Sudan Government: "Memorandum on the Immigration and Distribution of West Africans in the Sudan" Khartoum, nd (c. 1938).

CHAPTER 4

Salih 1981:51.
1. See, e.g., Crowfoot 1922; Al-Shahi 1986; A. El Tayib 1955; Kenyon, ed. 1987; Kenyon 1991; Constantinides 1972. See Holy 1988, 1991 on Darfur.
2. Spaulding 1985 describes historical social features and cultural tendencies, some of which are consonant with those outlined in Boddy 1989.
3. For different elaborations of this discussion, see Mitchell 1991 and Strathern 1988.
4. The enthography and much of the argument below have appeared in slightly different forms in earlier publications, notably Boddy 1989, 1997 (1982), 1998b, 1998c.
5. Boddy 1997, 1989. This contrasts somewhat with Gruenbaum's findings from the Gezira, where women said that men find sex with infibulated women more exciting and satisfying, and they continue the practice so as to please them (Gruenbaum 1996; see also Gruenbaum 2001).
6. See Boddy 1989, 1997 for a fuller account of Hofriyati material logic.
7. My thanks to Wendy James for suggesting this important point.
8. See Boddy 1989, also 1998b, 1998c.
9. Cf. Strathern 1988; also Rubin 1975.

10. See, for e.g., Hosken 1982; Slack 1984; Kellner 1993; cf. Winter 1994; Bardach 1993.

11. See e.g. Winkel 1995.

12. Cf. Holy 1991:48.

13. Delaney 1991.

14. Cf. Holy 1991. For a comparable case, see Delaney 1991. For consideration of how these issues play out in northern Sudanese kinship, see Kronenberg and Kronenberg 1965. On marriage patterns and the importance of maternal connection in historic Sennar, see Spaulding 1985.

15. I have argued elsewhere (Boddy 2002b) that lineages in Hofriyat emerge only in retrospect out of the messiness of endogamous marriages repeated over time. Kinship is thus cognatic and prospective (people are concerned to re-create close marriages among kin in future generations) in the present and patrilineal historically.

16. Thus, to summarize villagers as "patrilineal" leaves much that is important about their lives unsaid. It should not go unremarked that my information came more often from women than men. Yet I do not think that the emphasis on maternal connection was solely women's elaboration, for it was a man who first alerted me to how close marriages are made through the children of maternal aunts.

17. Weddings used to last seven days or more, and have been abbreviated to fit with contemporary patterns of work: most men have jobs outside the village and can no longer afford to be away from them for so long. British officials' concerns about Sudanese "indolence" would seem to have been addressed.

18. See also Kennedy (1978) for a discussion of *mushâhara* in Nubian Egypt.

19. Ibid., and see Abu Lughod 1996 on similar practices among Awlad ʿAli bedouin if the western Egyptian coast.

20. See also D. G. El Tayib (1987) and Lightfoot-Klein (1989:87–89).

21. Lightfoot-Klein (1989:88) suggests that once a woman is married, use of *dukhâna* enables her to signal sexual interest to her husband covertly, thus to preserve a façade of untouchability and dutiful acquiescence to her husband's demands.

22. Men who are possessed provide the ritual for themselves, and that of a possessed boy is paid for by his parents; both are rare occurrences. Moreover, girls seldom acknowledge possession until they are married and their bodies opened, for they cannot know if their fertility is compromised until then.

23. This issue is more fully explored in Boddy 1989.

24. See earlier *zâr* interludes, and Boddy 1989 for a fuller discussion of how spirits at once subvert and uphold local ideals.

25. My oldest informant in 1976 claimed to be "a hundred years old"; she and her twin sister had been five or six (not yet circumcised) when Mahdist forces established a camp about ten km. north of Hofriyat, probably around 1889; her mother was forced to work for the Ansâr.

26. Wolff papers, Notebook on "customs" (G. Wolff) SAD 745/3/26–30.

27. On the rule against cross-dressing, see Spaulding and Beswick 1995:530–31, and on the Vagabonds Act generally, see Sikainga 1996. On the participation of ex-slaves in the *zâr*, see Zenkovsky 1950, Makris 2000.

28. Cf. Arnold 1993:9.

29. Churchill 1969 [1899]:175.

30. The term is thus consonant with local reality. Yet its potential to reframe a woman's position is equally clear. For the term implies that a woman's husband is *her* doorman. But in the past such Nubian doormen may have been eunuchs. It thus asserts her nobility and worth while subtly challenging his sexuality.

31. A female Canadian spirit showed up in Hofriyat shortly before I left in 1977, yet she failed to catch on, ultimately proving to be a version of a female Egyptian *zâr*. See Boddy (1989:359).

CHAPTER 5

Churchill 1969 [1899]:361.

1. Baily memoirs, SAD 533/4/20.

2. Warburg 1971:116, citing Boulnois to Currie, Jan. 1904; Currie to Boulnois, Jan. 1904, SAD 103/7/2.

3. Warburg 1971:117.

4. Daly 1986:116.

5. E.g. see Lienhardt 1961:7–8.

6. Daly 1986:116.

7. Ibid., 116–18; Warburg 1971:117–18.

8. Daly 1986:159.

9. Wingate 1955:168.

10. Mansour 1990:51.

11. Abdel Rahim 1966:43, and 1969:6–97.

12. Warburg 1971:107; Daly 1986:169.

13. Woodward 1985:41.

14. Daly 1986:168.

15. Warburg 1971:144ff, 143–47.

16. Holt 1966:295.

17. Ibid., 298. Milner also recommended checking the growth of the educated class in Sudan who would be likely to express anti-British nationalist sentiments, discussed below (Daly 1986:289).

18. Daly 1986:269–70.

19. H. A MacMichael, "The Sudan: Historical Survey." SAD 448/13/18 (Barter papers).

20. Daly 1986:363, 297.

21. See Niblock 1987, Mansour 1990, and Daly 1986 on the development of nationalist organizations in colonial Sudan.

22. See Baily memoirs, SAD 533/4/28.

23. Niblock 1987:165. In the official report on the events of 1924 they were referred to as "the 'denationalised' class" presumably because they included "Egyptians born and domiciled in the Sudan" along with "Sudanese of mixed extraction" and "negroids of slave or ex-slave extraction and often mixed descent." Report on Political Agitation in the Sudan," Apr. 1925. FO 407/201/No. 131, p. 154.

24. "Report on Political Agitation in the Sudan," April 1925. FO 407/201/No. 131, p. 154–55.

25. Mitchell 1991:120; see also Anderson 1983.

26. Deng and Daly, eds., 1989 *passim*.

27. Mitchell 1971:119.

28. Archer to Lloyd, 18 Nov. 1925, FO 407/201, no. 136, Enclosure.

29. Daly 1986:305.

30. Protests began after a delegation bearing petitions of loyalty to Egypt was arrested at Wadi Halfa and arrived back in Khartoum on June 17. "The League of the White Flag," Sudan Monthly Intelligence Reports, 1924. FO 371/10039. See also ʿAbd al-Rahim 1966:50.

31. Niblock 1987:167.

32. "Report on Political Agitation in the Sudan," Apr. 1925. FO 407/201/No. 131, p. 164.

33. "A Note on the Recent History of Mahdism . . ." FO 407/201/No. 151, p. 215; also Daly 1986:285–87.

34. Sudan Monthly Intelligence Report, Oct. 1924. Appendix I, "Paraphrase of Translation of a Circular Found in Omdurman," FO 371/10039/54.

35. Sudan Monthly Intelligence Report, Oct. 1924, appendix II, "Translation of a Seditious Notice Signed 'Society of the 'Ulemas' in the Sudan, found on the morning of 14 October, 1924, posted on a telegraph pole in the vicinity of the tombs (Qubab) Khartoum." FO 371/10039/54.

36. Daly 1986:306.

37. Holt and Daly 1979:134.

38. "Report on Political Agitation in the Sudan," Apr. 1925. FO 407/201/No. 131, p. 169.

39. See Daly 1986:307–309; Collins (Introduction) in Collins and Deng 1984:17.

40. "Report on Political Agitation in the Sudan," Apr. 1925. FO 407/201/No. 131, p. 169.

41. Daly 1986:380–81.

42. Daly 1986:309–11; Schuster to MacMichael, 25 Feb. 1929, MacMichael papers, MECA GB165–0196.

43. Schuster to MacMichael, 25 Feb. 1929, MacMichael papers, MECA GB165–0196.

44. Daly 1986:313–15.

45. Woodward 1990:43.

46. Frost 1984:81, citing Baily to his father, Nov. 1924, misc. letters, SAD (now SAD 533/3).

47. Woodward 1985:43–44.

48. Archer to Lloyd 18 Nov. 1925, FO 407/201, p. 211.

49. Woodward 1985:44.

50. Lethem papers: "Statement of Mallam Shuaibu" RH Mss. Br. Emp. s. 276/9/28; "Report by H. N. Palmer to Colonial Office" Mar. 1924, RH Mss. Br. Emp. s. 276/10/6; Governor of Nigeria to Lethem, 29 Nov.1924, RH Mss. Br. Emp. s. 276/11/1; Dupuis to Lethem 13 Feb. 1926, RH Mss. Br. Emp. s. 276/12/3. See also "A Note on the Recent History of Mahdism" 1925. FO 407/201/No. 151, pp. 213–17, and FO 371/10065 on Mahdism, 1922–24.

51. Henderson 1965:58.

52. "Minute by His Excellency the Governor General" (Sir John Maffey), 1 Jan. 1927. SAD 403/9/5–6 (MacPhail), p. 5.

53. Daly 1986:353.

54. "Report of Mr. J. M. Ewart, Indian Police, on the Organisation of Public Security Intelligence in the Sudan," 8 June 1925, RH Mss. Brit. Emp. s. 276/12/1/ 9–26 (Lethem). See also "Report on Political Agitation in the Sudan," Apr. 1925, compiled by a committee led by Ewart. FO 407/201/No. 131, p. 171, and appendix 6: Willis to (H.E.'s) Private Secretary, July 1, 1924.

55. His replacement was Reginald Davies; see Daly 1986:329–32.

56. See O'Brien and O'Neil 1984.

57. See ʿAbd al Rahim 1966:53–56. *Zâr*, of course, is another such venue of insubordination and protest in disguise, though as the preserve of women, it is doubly decentered. See Boddy 1989, 1995.

58. Niblock 1987:168ff.; ʿAbd al Rahim 1969.

59. Daly 1986:367–70; 1991:5.

60. Perhaps the best example was Ali al Tom of the Kababish. See Asad 1970.

61. Woodward 1990:45.

62. Daly 1986:405.

63. Sanderson and Sanderson 1981:81.

64. Daly 1986:408.

65. Collins 1983:167ff.

66. Daly 1991:38, 39. See Sanderson and Sanderson 1981:116–26.

67. Sanderson and Sanderson 1981:176.

68. MacMichael to Loraine, 17 June 1930, FO 407/212, p. 215, emphasis mine.

69. Balfour memoirs, SAD759/11/40–43; Daly 1991:44.

70. SAD 723/5/45–48, 51–52 (Gillan papers). I return to this point in part 3.

71. "Memorandum: Arabic and the Southern Sudan" H. A. MacMichael, 10 May 1928, RH Mss. Brit. Emp. s. 421(2).

72. Daly 1991: 44. On suppressing Arabic, see MacMichael to Loraine, 17 June 1930, FO 407/212.

73. Collins 1983:184; Daly 1986:415; Daly 1991:44. For details, see Collins 1983:176–96.

74. "Female Circumcision in the Sudan" O.F.H. Atkey, Director SMS, 7 Apr. 1930. FO 371/41433 and NRO CIVSEC 1/57/3/121. See Daly 1991:44.

75. Collins 1983:180, citing Brock to MacMichael, Mar. 4, 1930, NRO BaG I/1/2.

76. Brayant, Malakal to DC Shilluk, 27 Oct. 1936; MacPhail to Governor, Upper Nile, 5 Nov. 1936; SAD 762/6/28–30 (MacPhail).

77. Martin Parr to the *British Weekly*, 29 Nov. 1963, SAD 722/2/14 (Bolton).

78. Sanderson and Sanderson 1981:177.

79. "Minute by His Excellency the Governor General" (Sir John Maffey), 1 Jan. 1927, SAD 403/9/5–6 (MacPhail).

80. On this point, see Saha et al. 1990.

81. Daly 1986:414.

82. He dominated from 1919 to 1936, first as assistant civil secretary to two less able superiors (1919–25), then as civil secretary from 1926 to 1934.

83. Sikainga 1996:139.

84. ʿAbd al-Rahim 1966:57, 58.

85. Daly 1986:379, 381.

86. Ibid., 383. The figures are from Holt and Daly 1979:138.

87. Daly 1986:379ff., 1991:104ff. Secondments of this sort continued into the mid-1930s. See Balfour letters, SAD 606/5/40.

88. Daly 1991:107–108.

89. "Dar Masalit Native Administration," SOAS (Arkell papers) MS 210522/2/3:23–30.

90. Daly 1986:382–83.

91. Beshir 1969:96ff.

92. Daly 1991:70.

93. Ibid., 113, citing Cox to Perham, 13 May 1938, RH Mss Perham 536/1/28.

94. Memorandum, "The Future Development of Girls' Education in the Sudan," Williams, Education Department, Khartoum, 25 July 1943. SAD 657/1/67 (Beasley).

95. ʿAbd al-Rahim 1966:56. See also ʿAbd al-Rahim 1969.

96. Daly 1991:51.

97. Collins 1984:20.

98. Daly 1991:65.

99. That story has been well told. See ʿAbd al-Rahim 1969, Beshir 1974; Niblock 1987, Mansour 1990, Daly 1991.

100. Henderson 1953:507; Daly 1991:146.

101. Niblock 1987:193.

102. *Umma* (Arabic) refers to the community of the faithful.

103. Khalid 1990:52.

104. Deng and Daly 1989:75.

105. Daly 1991:150.

106. Niblock 1987:61–62.

107. *Sudan Star*, Nov. 7 1945, p. 1. SAD 658/5/11 (Beasley).

108. Thesiger 1987:214.

109. Sharkey 2003:13.

110. NRO Sudan Monthly Intelligence Summary No. 43, Aug. 1937, in ʿAbd al-Rahim 1966:61.

111. "Note on Public Enlightenment—March 1938" (Gillan) Civil Secretary's Department. RH Mss. Perham 585/1/42–46, p. 42.

112. "Memorandum on the Dissemination of British Culture and Propaganda" ca. 1938, Civil Secretary's Department. RH Mss Perham 585/1/47–75, pp. 59, 61, 62, 63–64, 66.

113. RH Mss Perham 585/2/1–9.

114. "Cultural Contact. Fourth Group meeting held on 18.3.1939" (Minutes.) RH Mss. Perham 585/2/26.

115. Wallis to Gillan, 4 Nov. 1941, RH Mss. Perham 585/2/65–69.

116. "The Sudan Cultural Centre and What It Stands For," broadcast by R. Hill, 22 Nov. 1945. Appendix to the Sudan Weekly Newsletter No. 47, Public Relations Office, Khartoum. RH Mss. Perham 585/2/76. Hill later founded the invaluable Sudan Archive at Durham University.

117. Wallis to Gillan 4 November, 1941, RH Mss. Perham 585/2.

118. CIVSEC Intelligence Report No. 95, 12 March 1946 (Robertson). RH Mss Perham 571/2. See also Arber to Robertson, SAD 530/5/38–42; Margery Perham, "Cultural Relations between Britain and the African Dependencies" RH Mss Perham 585/2; "Note on Communist Activities in the Sudan" FO 371/ 63082, 1947.

119. CIVSEC Monthly Intelligence Report No. 97, 11 May 1946 (Robertson). RH Mss. Perham 571/2.

120. Deng and Daly 1989:35.

CHAPTER 6

Keun 1930:9–10. See also the abridged version in the *Nineteenth Century*, Sept. 1930, circulated to Khartoum and the Foreign Office (FO 371/1460).

1. MacMichael 1932:xvii–xviii.

2. "Memorandum: Arabic and the Southern Sudan" H. A. MacMichael, 10 May 1928. RH Mss. Brit. Emp. s. 421(2).

3. Cromer 1908, vol.2:545.

4. Alford and Sword 1969 [1898]:159.

5. On the early history of the Condominuim, see (among others) Daly 1986, Warburg 1971.

6. Warburg 1971:155.

7. See Hargey 1981:87ff. on the discontent aroused by the young administration's tentative moves to transform slavery into paid labor.

8. Spaulding 1982, 1985; Bjorkelo 1989.

9. Spaulding 1985:81.

10. Ibid., 1982:5.

11. Bjorkelo 1989:63.

12. *Shayla* was still in effect when I worked in the north during the 1970s and 1980s.

13. Spaulding 1982; Bjorkelo 1989 passim on the Ja'ali diaspora; ʿAli 1972: 11 on Mohammed ʿAli's monopolies.

14. See Spaulding and Beswick (1995), Spaulding (1982).

15. Spaulding 1982, 1985; Sikainga 1996.

16. Burckhardt 1822:324. Shendi was an important caravan *entrepôt*, and many more slaves than that passed through the town en route to Suakin (thence Arabia and beyond), Egypt, and Sennar.

17. Hill 1970:32–33.

18. Bjorkelo 1989:79.

19. Spaulding 1982:11; see also Bjorkelo 1989:79.

20. Mowafi 1981:23; ʿAli 1972:22–23. See also Isaacman and Roberts 1995.

21. On early nineteenth century Sennar, see Spaulding 1985:209; for figures at the end of the Turkiyya, see Warburg 1978b:221, Hargey 1981. The distribution of slaves was uneven in Ottoman northern Sudan. In the rain-fed farming regions south of Khartoum, where productive land was abundant and did not need mechanical irrigation, land was traditionally "held under communal forms of tenure and rarely encumbered or sold" (Spaulding 1988:26). There, extensive individuation and commercialization of property took place only under the British. Like-

wise, the internal market for slaves was limited, confined to local elites as it had earlier been in the north, and broadened in response to the expansion of market forces that accompanied Condominium rule (ibid.). Along the main Nile slaves were more numerous and dispersed, their relative concentration depending on their owners' status and the vagaries of inheritance, soil depletion, weather, and taxation.

22. Sikainga 1996:10.

23. Burckhardt 1822:332.

24. Spaulding 1985:293, 1988; see also Sikainga 1996.

25. Sikainga 1996:4–5; Spaulding 1982.

26. Spaulding 1982:12; see also Sikaiga 1996.

27. Spaulding 1982:12, n. 53.

28. Compare this to Miers and Kopytoff (1977), who suggest that African slavery should be seen in the context of "rights in persons" and was part of a temporal continuum leading to absorption through kinship and marriage. There was one family of known slave origins in the village north of Shendi where I lived; others would not marry them, though for other purposes they were well integrated with village life. I was warned not to mention the servile status of the family's forebears (see Boddy 1989).

29. ʿAli 1972. According to Holt (1966), Ismail himself may have shared their humanitarian concerns.

30. ʿAli 1972:35, citing Baker 1866, vol.1:294.

31. Sikainga 1996:66–67, quoting Labour Bureau Annual Report, 1909, NRO Intel 4/3/15 and Sudan Reports 1908:558. The term "Fallata" in Sudan has acquired pejorative connotations; those to whom it is ascribed refer to themselves as Takari or Takarin, referring to eleventh-century Fulani origins in Takrur, Senegal.

32. Sikainga 1996:xiii; 1995. It was no guarantee, however, because even professed Muslims in Sudan were enslaved, especially darker-skinned peoples from the west, though their numbers were fewer than nonbelievers. Such tensions have resurfaced in the recent crisis in Darfur (Prunier 2005).

33. Jackson 1954:71.

34. Sikainga 1996:8. In fact, Spaulding (1988), analyzing Arkell's information about the origins of slaves imported into Central Sudan in the 1920s, suggests that on the evidence of names (an admittedly unreliable test), the majority were Muslims. No criterion that Arkell had initially anticipated as distinguishing free persons from slaves proved sound: a slave might have been born to Muslim parents, speak no language but Arabic and, if female, have been circumcised (Spaulding 1988:30–31), presumably prior to having been abducted.

35. Warburg 1978b:225.

36. See SOAS (Arkell papers) MS 210522/2/2 Box 1; "Report on Slavery and the Pilgrimage," C. A. Willis, SAD 212/2; Sikainga 1996 passim; Spaulding 1988.

37. Jackson 1954:71. Jackson was a member of the SPS from 1907 to 1931.

38. Warburg 1978b:233.

39. Cromer 1908 (v.2):544ff.; Jackson 1954:43; for a fuller treatment of this point, see Hargey 1981.

40. Cited in Daly 1986:232.

41. Hargey 1981:79.

42. Jackson 1954:44.

43. Daly 1986:233–34.

44. SAD 720/4/29 (Simpson).

45. Daly 1986:234.

46. Archer to League of Nations, 20 July 1925, Enclosure in no. 151, FO 407/201. See also Jackson 1954:44: "Runaway slaves usually took to thieving or prostitution according to their sex."

47. Jackson 1953:93–94.

48. Spaulding and Beswick 1995:530–31, and Sikainga 1996. On the development of the northern Sudanese *bayt indaya* or beer shop, see Spaulding and Beswick 1995:522.

49. Sikainga 1996:83–85. See Jackson 1954; Daly 1986:234–35; Hargey 1981.

50. See Sikainga 1996:76ff; see also Khartoum Province Annual Report 1946, RH Mss. Perham 552/4/126–43.

51. Warburg 1971:162.

52. Ibid., 175; see also SAD 720/4/28–29 (Simpson).

53. Jackson 1954:43.

54. Sikainga 1996:76; 1995:11; see also Hargey 1981.

55. Sikainga 1996:55.

56. Cf. White 1990.

57. Sikainga 1995:11, 14.

58. Sikainga 1996:112–21. See Robertson and Klein 1983 on the preponderance of female slaves in Africa. See also Spaulding (1988:29): of the 392 slaves documented by Arkell as having been brought into Central Sudan from Ethiopia between 1919 and 1927, 65.8 percent were female and the majority between eight and seventeen years of age.

59. Mowafi (1981:15) notes that in nineteenth-century Egypt, black slaves experienced low levels of fertility as well as high mortality; it is unclear whether an analogous pattern was characteristic of northern Sudan.

60. Spaulding 1985:193; Spaulding (1988:29) also notes that during the early decades of British rule slaves were "purchased to secure for the owner a measure of bourgeois Islamic respectability through at least partial withdrawal of his womenfolk from productive labour."

61. The *rahat* is no longer worn. Adolescent girls wear a knee-length dress (*fustân*) and headscarf, gradually replacing the latter with a full ankle-length *tôb* as they mature but usually well before marriage. Alternatively, they may wear the international *hjiâb*, a long loose smock and headscarf fastened beneath the chin, after marriage and before.

62. References to such practices are found in documents dating at least to 500 B.C. See Widstrand (1964).

63. Aesthetic exegeses are found elsewhere that female circumcision is practiced. Accad (1993), for instance, describes nurses in urban Egypt who, if they find a woman in labor who has not been excised, cut her small labia in order to "embellish" her and remove what is anatomically repugnant. Talle (1993) suggests that in Somalia the hardness of the altered genital area and the shape of its scar approximate the male organ, which is emblematic of pure agnatic kinship; women are thereby tied more firmly to their patriline. (See also Barnes and Boddy 1994).

64. Boddy 1989,1997, 1998b.
65. E.g. Lan 1985; Boserup 1970.
66. O'Brien 1984:139.
67. See O'Brien 1984.
68. Warburg 1971:159.
69. Daly 1986:216–17. Daly (1986:216) cites Cromer's annual report for 1903: "The lesson . . . that a man must work or starve, has not yet been brought home to the mass of the inhabitants of the Soudan."
70. Sikainga 1996: passim.
71. Daly 1986:237.
72. Hargey 1981:92.
73. Daly 1986:222–23.
74. Gaitskell 1959:54.
75. See Mitchell 1991:96–98.
76. "Some Aspects of Development in Northern Province" Feature No. 242, Public Relations Branch, 7 May 1953. SAD 519/5/8b (Robertson).
77. Daly 1986:424.
78. Cf. O'Neill 1984:33.
79. Cf. McClintock 1995:252.
80. Bernal 1997:451.
81. See Barnett 1977:89ff for a discussion; also O'Brien (1984:122, 1983); Bernal (1997:457). Of the capital share, 35 percent was initially allotted to the government, and 25 percent to the syndicate; this was later changed to 40 and 20 percent respectively in 1929, in return for the syndicate being allowed to take part in an extension of the scheme (Daly 1986:425).
82. Bernal 1995:107.
83. Gaitskell 1959:214–15.
84. Barnett 1977.
85. Bernal 1997:461.
86. See Barnett 1977.
87. Gaitskell 1959:199.
88. Keun 1930:19, 20–21, 19–20.
89. As O'Brien (1984:123) notes, "from 1925 to 1956 cotton exports from Gezira accounted for about 60 percent of Sudan's export earnings and the direct government share provided about 50 per cent of total government revenues."
90. Daly 1986:426.
91. See Gaitskell 1959:315–16 on attitudes toward work.
92. Daly 1986:441.
93. Sikainga 1996:100 citing Diggle to Governor General, 11 Feb. 1924, NRO CIVSEC 60/1/2; see also Daly 1986:444.
94. Sikainga 1996:101, citing Sayyid ʿAli Mirghani, Sharif Yusuf al-Hindi, and Sayyid ʿAbd al-Rahman al-Mahdi to the director of intelligence, 6 Mar. 1925, NRO CIVSEC 60/I/3.
95. Daly 1986:444–45; Sikainga 1996:100–102.
96. "Memorandum on Slavery in the Sudan." Archer to League of Nations, 20 July 1925, FO 407/201/228, 229, quoting from Lugard 1923:376. See also Letter from the Governor-General of the Sudan Relative to the Question of Slav-

ery, Lyall (Acting Governor General of the Sudan) to League of Nations and enclosures, 29 Aug. 1925 (League of Nations Circular No. A.69. 1925. VI, Geneva, Sept. 14, 1925).

97. Bell 1999.

98. Sikainga 1996:128; see also O'Brien 1984:124.

99. Sikainga 1996:129.

100. See O'Brien 1988, 1984, 1983; Ali and O'Brien 1984; Bawa Yamba 1990; Sikainga 1996; Daly 1986. See also Sudan Government, "Memorandum on the Immigration and Distribution of West Africans in the Sudan" Khartoum, c.1938, p. 39ff. RH Mss Perham 529/9.

101. On the importance of Fallata labor villages to Gezira weeding operations, see O'Brien 1984.

102. Sudan Government, "Memorandum on the Immigration and Distribution of West Africans in the Sudan" Khartoum, c.1938. RH Mss Perham 529/9, pp. 47, 35.

103. Ibid., pp. 23ff.

104. Lethem to Palmer, 13 Sept.1925, RH Mss Brit. Emp. s. 276 (Lethem) 11/1/91.

105. See O'Brien 1984.

106. A cousin of Hubert Huddleston who put down the mutiny of 1924 and became governor-general in 1940.

107. Lethem to Palmer, 13 Sept. 1925, RH Mss Brit. Emp. s. 276 (Lethem) 11/1/92.

108. Sudan Government, "Memorandum on the Immigration and Distribution of West Africans in the Sudan" Khartoum, c.1938. RH Mss Perham 529/9, p. 47. Lethem to Palmer 13 Sept. 1925, RH Mss Brit. Emp. s. 276 (Lethem) 11/1/89; Lethem to Clifford, 24 July 1925, RH Mss Brit. Emp. s. 276 (Lethem) 11/1/57–61.

109. Sikainga 1996:131.

110. See Bell 1999, chapter 4.

111. Sikainga 1996:130.

112. Lethem to Palmer 13 Sept. 1925, RH Mss Brit. Emp. s. 276 (Lethem) 11/1/86–87.

113. "Report on Slavery and the Pilgrimage." SAD 212/2/3ff (Willis). See also Sudan Government: "Memorandum on the Immigration and Distribution of West Africans in the Sudan." Khartoum, c. 1938.

114. Warburg 1978b:242.

115. Daly 1986:284.

116. Henderson 1965:60.

117. Sikainga 1996:132.

118. The *sayyid* was brought to the point of bankruptcy in 1927, whereupon Maffey's government lent assistance, securing him a license to grow pump-irrigated cotton on Aba Island in 1928. As Maffey put it, if ʿAbd al-Rahman behaved "reasonably in the religious and political field, we ought as a measure of political expediency to bind him to us by economic fetters." Mahdism and El Sayed Abd El Rahman El Mahdi K.B.E. , C.V.O., Summary of affairs during the years 1926–34. SAD 642/10/1–11 (Longe).

119. MacMichael 1954:73. MacMichael's figures echo Wingate's, referring to a decline "during the Dervish régime from over 8,500,00 to less than 2,000,000" at its end, based on estimates of the number of villages destroyed, towns abandoned, and *sâqiya*s lying idle when the British advanced up the Nile.

120. Thesiger (1987:182) suggests the population had been reduced by half during the Mahdya.

121. This is not to imply, however, that the north was economically isolated prior to this: as a colony of Ottoman Egypt in the nineteenth century, it had been part of the global economy for some time. See Hill (1970).

122. Eg. Lightfoot-Klein 1989 and Hosken 1982.

123. MacMichael was assistant civil secretary in 1924 and began tracking the history of officials' debates over female circumcision at that time. See the file NRO CIVSEC 1/44/2/12.

124. Medical Department Circular, 17 Feb. 1924. NRO CIVSEC 1/44/2/12, p. 4.

125. Ibid.

126. Ibid., p. 4b.

127. Willis to DCs, 19 Feb. 1924, NRO CIVSEC 1/44/2/12, p. 8.

128. MacMichael to Bardsley, 23 Feb. 1924, NRO CIVSEC 1/44/2/12, p. 5.

129. Bardsley (Stack's secretary) to MacMichael, 25 Feb. 1924, NRO CIVSEC 1/44/2/12, p. 6.

130. See Pedersen 1991 for similar conclusions on efforts to abolish female circumcision in colonial Kenya. I consider the Kenya case in view of its implications for Sudan in part 3.

131. Bardsley to MacMichael, 25 Feb. 1924, NRO CIVSEC 1/44/2/12, p. 6.

132. Atkey to Bardsley and MacMichael, 1 Mar. 1924, NRO CIVSEC 1/44/2/12, p. 11.

133. Bardsley to Atkey, 29 Apr. 1924, NRO CIVSEC 1/44/2/12, p. 16. See Daly (1986:303) on the negotiations with Egypt.

134. Nicholls (Gov. White Nile) to senior officials 10 Mar. 1924, NRO CIVSEC 1/44/2/12, p. 13a; Willis to MacMichael 18 March 1924, NRO CIVSEC 1/44/2/12, p. 14.

135. Atkey to Bardsley and MacMichael, 1 Mar. 1924, NRO CIVSEC 1/44/2/12, p. 11.

136. Willis to Civil Secretary, Dec. 1924, NRO CIVSEC 1/44/2/12, p. 17.

137. Bell 1999:75ff. The priority given to economic expansion after World War I resulted in the precedence of utilitarian over ostensibly pure research. Pressure to assume responsibility for the Wellcome laboratories was brought by the departments of agriculture and medicine, tasked with ensuring the Gezira Scheme's success by providing bountiful crops, sound workers, and healthy returns. Greater cooperation between scientists and practitioners was thought advisable—indeed crucial where agriculture was concerned—and the various means used to achieve it led to a gradual decentralization of the WTRL. In 1924 the Kitchener School of Medicine was established to train Sudanese doctors; adjacent to it so as to be readily available to physician trainees were built new premises for the bacteriological section of the WTRL, funded by the indemnity paid by Egypt for Stack's assassination, and reopened in 1927 as the Stack Medical Research

Laboratories (Bayoumi 1979:126–27). The WTRL maintained research autonomy for several years more until it succumbed, like MacMichael's plans for an independent anthropological advisor, to depression retrenchments and political demands. In 1935 the institution was dismantled and its medical and agricultural staff absorbed into relevant government departments (Bell 1999:83ff., Bayoumi 1979:126ff.)

138. The phrase comes from the monthly letter of the Bakht er-Ruda teacher-training college to its graduates teaching in schools throughout the north, no. 13, 1942. NRO CIVSEC 2/10/2/4.

139. ʿAli and O'Brien 1984:221.

140. See Arnold (1993), ch. 6, on comparable developments in India.

CHAPTER 7

Salih 1969:135–36.

1. Medical Department Circular, 17 Feb. 1924. NRO CIVSEC 1/44/2/12, p. 4.

2. The image is borrowed from Mitchell 1991:112.

3. Cromer 1908, v.2: 538–39, 542.

4. Mitchell 1991:111–12.

5. Beasley 1996:24.

6. *Qurʾan* means that which was/is recited. Reflecting on Islam in practice, Michael Gilsenan (1982:16) notes, the *Qurʾan* "is the Word," and "the conception and communal experience of the Word in prayer, in study, in talismans, in chanting of the sacred verses, in *zikr* (Sufi rituals of remembrance), in the telling of beads, in curing, in social etiquette, and in a hundred other ways are at the root of being a Muslim. The directness of the relationship with Allah through the Word and its intensely abstract, intensely concrete force is extremely difficult to evoke, let alone analyze, for members of societies dominated by print and the notion of words standing for things."

7. V. L. Griffiths, Principal, Bakht er-Ruda Teacher Training School, ms. booklet: "Qualities Needed to Become Equipped for Self-Government in the Modern Sudan: Character Development," 1944. RH Mss Perham 583/2. See also *Bakht er Ruda Newsletter* No. 17, 1 Apr. 1944. RH Mss Perham 561/3/114–21.

8. Bhabha 1997:153.

9. MacMichael, Harold A. 1932:xvii–xviii.

10. The concept of biopolitics is, of course, Foucault's (e.g. 1990). See also Stoler 1996.

11. Arnold 1993:14–15.

12. Bell 1998:307.

13. Snively 1994.

14. M. Wolff to British Social Hygiene Council, Feb. 1933, SAD 582/10/16.

15. Bell 1998:296.

16. Bayoumi 1979.

17. Trimingham 1948:13.

18. Jackson 1960:49; see also Bayoumi 1979:113.

19. Bayoumi 1979:115, 113–14, quoting Dr. Lloyd to CMS headquarters, 1908.

20. Trimingham 1948:20.

21. Squires 1958:120. From the 1920s, the CMS managed the government leper hospital. On educational subventions in the north, see Gwynne to PC, 27 Apr. 1927 and 7 June 1927, CMS G3 E/P4/ 27, 38. On CMS proposals to receive support from the Stack indemnity fund for medical work among the poor, see CMS G3 E/P4/56, 71.

22. Bell 1999, ch. 2; see also Gruenbaum 1982, Cruikshank 1985, Bayoumi 1978.

23. Cruickshank 1985:86ff.; Bayoumi 1979:91, Squires 1958:6. See Bell 1999 for a systematic analysis of medical efforts to control endemic and epidemic diseases in Sudan.

24. Bell 1998:296–97. See also Squires 1958:48, Bayoumi 1979:92ff.

25. Ram and Jolly 1998; Fildes et al. 1992; Davin 1978; Lewis 1980.

26. See Greaves 1931, Zimmern 1936.

27. See Vaughan 1991, Summers 1991, Hunt 1999.

28. As it was in colonial Malaysia (Manderson 1998).

29. See Torsvik 1983, ch. 1.4; Kendall 1952.

30. "Discussion" by Dr. Kirk, in Kendall 1952:52.

31. See SAD 582/7.

32. Tew 1990.

33. M. Wolff, Letters on Trek, SAD 582/7/38R.

34. Alford and Sword 1969 [1898]:144–45.

35. Kenrick 1987:110.

36. Medical Officer of Health, Khartoum, to M. Wolff, 23 Feb. 1921, SAD 579/3/5.

37. Bayoumi 1979:145. See Sudan Medical Department Annual Report for 1923, RH Mss Perham 558/1/25; Bayoumi 1944 ff., Squires 1958: 9, Cruikshank 1985:88.

38. Bell 1999:28; Squires 1958:65.

39. See Bayoumi 1979, Squires 1958, Torsvik 1983, Cruickshank 1985, Hall and Ismail 1981.

40. Sudan Medical Department Annual Reports, RH Mss. Perham558 /21.

41. Cruikshank 1985:87.

42. Tew 1990.

43. Quoted in Bell 1999:108.

44. See Atkey to Bardsley and MacMichael, 1 Mar. 1924, NRO CIVSEC 1/44/ 2/12, p. 11. Also Bell 1999.

45. Jackson 1960:201–202.

46. Beshir 1969:45, citing *Al Moayad*, 17 Dec. 1906; 1969:46, citing Gwynne to Wingate 13 Mar. 1907, SAD/103. On the earlier agreement, see Gwynne to Baylis, 5 Feb. 1904, CMS G3/E/O/1904/No. 17, 49.

47. Starkey 1992:417.

48. Annual Report of the Department of Education, 1911, extract. Beasley papers, SAD657/1/15.

49. Starkey 1992:417 quoting Blue Nile Province Report, 1910.

50. Annual Report of the Department of Education, 1908, extract. Beasley papers, SAD 657/1/13.

51. Beshir (1969:49) reports that the Atbara school was coeducational.

52. Blue Nile Province Report, 1912, extracts in SAD657/1/15–16. The school was managed by Mrs. Hall, whose husband had been a CMS medical missionary in Omdurman. Two years after Dr. Hall's death in 1903, Mrs. Hall returned to Sudan and became involved in girls' education; following a common pattern, she was later joined by her sister, Lilian Jackson. See Trimingham 1948, ch. 1.

53. Annual Report of the Department of Education, 1909, extract. Beasley papers, SAD657/1/14.

54. Manley to Jackson, 19 Feb. 1917, CMS G3 E/L4/103.

55. Annual Report of the Department of Education, 1912, extract. Beasley papers, SAD657/1/16. In 1917 the CMS opened a school for girls in El Obeid, the largely Muslim capital of Kordofan and former Mahdist stronghold.

56. Trimingham 1948:21.

57. Beshir 1969:50. Beshir's further suggestion that "the majority of pupils in the missionary schools were Sudanese Moslem girls," though intriguing, is belied by both government and CMS reports. It does, of course, reflect CMS aims and propaganda.

58. Report on the CMS Girls' Schools in the Northern Sudan, Mabel Warburton, Feb. 1927, p. 7. CMS G3 E/P4, opp. p. 19.

59. Blue Nile Province Report, 1912, extract. Beasley papers, SAD657/1/16–17. The number of government funded schools was reported as four in 1912 and three in 1914.

60. Beasley 1992:346, n.20.

61. Ibid., 345–46, 347, 346. In 1932 a committee looking into the structure of boys' education advised that it be reorganized along similar lines (Beasley 1992:356, n.39). This was undertaken with the founding of Bakht er-Ruda in 1934, p. 349.

62. Beasley, notes on girls' education in the Sudan, SAD 357/1/17, see also Beasley 1992:419.

63. The missionaries felt they were being pushed to open schools and keep their existing ones going by government threats to "start Moslem schools" if they could not, and thus end the missions' virtual monopoly on female education. See Jackson to Manley 26 Mar. 1917, CMS G3 E/O/1917/23.

64. Resolutions of the Committee of November 1, 1921. CMS G3E/L4/408.

65. Mabel Warburton, Report on the CMS Girls' Schools in the Northern Sudan, Feb. 1927. CMS G3 E/P4, opp. p. 19.

66. Sharkey 2002:62.

67. Warburton, op. cit.

68. Gwynne to PC, 25 Apr. 1927, CMS G3 E/P4/27. See also Gwynne to PC, 7 June 1927, CMS G3 E/P4/38.

69. Beshir 1969:50.

70. Gwynne to Baylis, 24 Feb. 1903, G3 E/O/1903, no. 37, for the fuller text, see ch. 2, p. 89.

71. Jackson 1960:204, 205. The last is an unattributed quote from Gwynne.

72. Trimingham 1948:21, 22.

73. Beasley 1992:345–46.

74. Hall and Ismail 1981:58, 57–58.

75. Beasley 1992:347. See also SAD 658/2/307.

76. Beasley 1992:359, 357.

77. G. C. Scott, "Note on Education in the Northern Sudan" quoted in Daly 1987:386. See also Beshir 1969:96ff.

78. Sanderson 1961:91.

79. Beshir 1969:93ff, quoted on p. 97; 98–99.

80. The director was R. K. Winter, and the body referred to as the Winter Committee.

81. Daly 1987:387, citing Maffey to Act. High Commissioner, 3 Apr. 1933, FO 1441/705/604.

82. Beasley 1992:356, n.39.

83. *Bakht er Ruda Newsletter* No. 13, 21 Mar. 1942. RH Mss Perham 561/3/93; No. 5, 13 Mar. 1938. RH Mss Perham 531/3/8; No. 7, 10 Mar. 1939. RH Mss Perham 531/3/53; NRO CIVSEC 2/10/2/4.

84. As noted in ch. 3, education for southern boys was even more rudimentary and remained largely in missionary hands.

85. Willis to DCs, 19 Feb. 1924 , MacMichael to Bardsley, 23 Feb. 1924, Bardsley to MacMichael, 25 Feb. 1924. NRO CIVSEC 1/44/2/12.

86. M. Wolff to the British Hygiene Council, Feb. 1933, SAD 582/10/12.

87. The majority of the Wolffs' papers are housed in the Sudan Archive at Durham University. Additional collections concerning or referring to the MTS can be found in the National Record Office, Khartoum; the Public Record Office, Kew; the Royal College of Obstetricians and Gynaecologists, London; and Rhodes House, Oxford. Throughout, Mabel's voice predominates, as she launched the MTS and spent five years longer in Sudan than her sister Gertrude. When "Wolff" appears in the singular, it is to Mabel I refer.

88. See, for example, SAD 581/5/13.

89. MTS First Annual Report, 20 Oct. 1921, SAD 579/3/15; see also Speech to the Committee of Guild of Service, SAD 579/3/24; Kendall 1952.

90. Though a woman cannot modestly admit to being possessed until she is married. See Boddy 1989.

91. See also Kenyon 1991b.

92. The description is from E. M. Kendall (1952:42), matron of the MTS from 1946 to 1955. Also O. Atkey, "Female Circumcision in the Sudan" Apr. 7, 1930. NRO CIVSEC 1/57/3/121 and 1/44/2/12, 1924–37.

93. Bousfield (Medical Officer of Health, Khartoum) to Wolff, 23 Feb. 1921, SAD 579/3/5. See also Bell 1998.

94. See Boddy 1989; cf. Duden 1993.

95. Crowfoot 1922, Zenkovsky 1950. See the Wolffs' photo albums and note-books on customs in the Sudan archive. E.g. SAD 583/5, 583/3, 745/2, 745/3, 580/1.

96. Discussions with Sudanese anthropologists, especially Dr. Rogaia Abusharaf and Amal Fadlallah have confirmed the widespread significance of the symbolic lexicon here described; the Wolffs' photographs and ethnographic observations indicate that it has historical depth. See SAD 580/1, 745/3

97. Sahlins 1999:43.

98. See Boddy 1989, part 1.

99. Bourdieu 1990, ch. 3.

100. Boddy 1989, 1997, 1998b, 1998b:102.

CHAPTER 8

Salih 1981:59–60.

1. "Female Circumcision." NRO CIVSEC 1/44/2/12.

2. In my experience it is by no means "taboo" for Sudanese to discuss the topic with non-Sudanese, as Ellen Gruenbaum (2001) also found.

3. G. L. Elliot-Smith to M.E. Wolff, 5 Oct. 1937, SAD 582/8/25.

4. Dareer 1982; Gruenbaum 1982.

5. Toubia 1994:712.

6. Ibid., 1995:10

7. Cf. Ibid., 1994:712.

8. Lightfoot-Klein 1989:35. The transliteration is hers (1989:35); I presume the word is *maqâtîʿa*. Given that the Qurʿan prohibits maiming, the term is a religious contradiction.

9. Gruenbaum 1991:642.

10. Boddy 1989; Dareer 1982.

11. Abdalla 1982:21; Boddy 1989; El-Dareer 1982; Hayes 1975; Lightfoot-Klein 1989a, 1989b; Toubia 1994:715; van der Kwaak 1992:781, Mohamud 1991:208.

12. Sudan Govt. 1982:63; Boddy 1989; Gruenbaum 1996.

13. Thiam (1983) estimates a 6 percent annual death rate among some Somali groups, but cites no source. In a study of 7,505 women in Khartoum, 95.9 percent of whom were pharaonically circumcised, Aziz (1980) reported seventeen hospitalizations for severe bleeding.

14. Toubia 1994:713.

15. Aziz 1980; Boddy 1982; Dareer 1982; Gruenbaum 1982; Toubia 1994.

16. Hall and Ismail 1981:99.

17. WHO 1999, 2000, 2001.

18. Shandall's data (1967) suggest that some 28 percent are infected at any given time.

19. Gruenbaum 2001:5.

20. MTS First Annual Report, 1921. SAD 579/3/15.

21. M. E. Wolff, Speech to the Guild of Service, 1922. SAD 579/3/25.

22. "Facts about Pharaoh's Circumcision," M. E. Wolff, 13 Feb. 1924. SAD 582/8/2. See also "Facts about the 'Circumcision' of Girls," M. E. Wolff, 19 Mar. 1924. SAD 579/4/26.

23. M. E. Wolff, Speech to the Guild of Service, 1922. SAD 579/3/24–29.

24. Aziz 1980, Obermeyer 2003.

25. "Facts about Pharaoh's Circumcision," M. E. Wolff, 13 Feb. 1924. SAD 582/8/2.

26. Gruenbaum 2001.

27. "Facts about Pharaoh's Circumcision," M. E. Wolff, 13 Feb. 1924. SAD 582/8/2.

28. Willis to Civil Secretary, 19 Feb. 1924, NRO CIVSEC 1/44/2/12/8.

29. He formally acceded to the position of civil secretary in April 1926.

30. Bardsley (for H.E.) to MacMichael, 25 Feb. 1924, NRO CIVSEC 1/44/2/12/6.

31. Atkey to Bardsley and MacMichael, 1 Mar. 1924, NRO CIVSEC 1/44/2/12, p. 11.

32. Bardsley to Atkey, 29 Apr. 1924, NRO CIVSEC 1/44/2/12, p. 16. On the negotiations with Egypt and the Foreign Office, see Daly 1986:303.

33. Medical Department to Civil Secretary, 17 Feb. 1924, NRO CIVSEC 1/44/2/12/4, 4a.

34. M. E. Wolff to Atkey, 1 Feb. 1931, SAD 582/8/10; "Husband's desire for his wife's after birth remedial operation" 5 July 1935, SAD 582/8/23–24.

35. "Facts about Pharaoh's Circumcision," M. E. Wolff, 13 Feb. 1924. SAD 582/8/2.

36. "Facts About the 'Circumcision' of Girls," M.E. Wolff, 19 Mar. 1924. SAD 579/4/26.

37. See correspondence surrounding Wolffs' paper for presentation to the British Social Hygiene Council, Feb. 1933, SAD 581/10/4–15: Gillan to Atkey 25 Mar. 1933, SAD 582/10/3, 582/8/18; M. E. Wolff to Hans Vischer, Colonial Office, 2 Feb. 1933, SAD 582/8/20; M. E. Wolff to Atkey, 3 Feb. 1933, SAD 582/8/19; M. E. Wolff and G. Wolff to Mrs. Rolfe, 3 Apr. 1933, SAD 582/8/19; Vischer to M. E. Wolff, 25 July 1933, SAD 582/8/22. The controversy is considered below.

38. "Midwives Inspection Tour Report for 1928." SAD 582/1/51.

39. "Elementary Practical Lessons for Midwives of the Sudan," n.d. SAD 581/5/5.

40. M. E. Wolff, Speech to the Committee of the Guild of Service, 1922. SAD 579/3/29.

41. "Elementary Practical Lessons for Midwives of the Sudan," n.d. SAD 581/5/8.

42. See Hunt 1999 for a sustained discussion of Western-trained native mediators, or "middles" as she calls them, in colonial Zaire.

43. See also Bell 1999, ch. 7, on the Wolff sisters and their methods.

44. "From the Sudan," *Nursing Notes*, Apr. 1937:56. SAD 581/4/4.

45. Holland 1946:9.

46. "Midwifery Service in the Sudan," Report of Dr. Fairbairn, Royal College of Obstetricians and Gynaecologists, 1936. SAD 581/4/1.

47. "Elementary Practical Lessons for Midwives of the Sudan," n.d., SAD 581/5/7.

48. Bell 1999:209.

49. "Elementary Practical Lessons for Midwives of the Sudan," SAD 581/5/7.

50. McClintock 1995:226.

51. M. Wolff, 1926, quoted in Bayoumi 1979:150,

52. I borrow "mindful bodies" from Scheper-Hughes and Lock 1987.

53. MTS Annual Report, 1931, SAD 581/1/28.

54. Bell 1999:206, citing SAD 579/8/1–40.

55. Kendall 1952:45.

56. Bell 1999:207, n.30.

57. Wolff to Director, Medical Department (Crispin), undated 1921; Crispin to Wolff, 6 Mar. 1921; Wolff to Director, 7 Mar. 1921, SAD 579/3/3, 6, 7. Wolff's suggestion that the school provide rations was vetoed as too extravagant, though free board was provided from the 1930s on.

58. "A few notes on our management of staff teacher midwives, etc." SAD 580/2/12 (Wolff).

59. "Re. Dr. Fairbairn's letter of 21st May, 1937." SAD 581/4/6 (Wolff).

60. "A Visit to the Midwifery Institution Omdurman" by Magboul El Sayed Al Awad, Omda of Omdurman, 6 July 1937. SAD 581/4/10 (Wolff).

61. Kendall 1952:49.

62. SMS report for 1932, cited in A. Cruickshank and J.F.E. Bloss, "The Sudan: A Medical History." MS in Bloss papers, SAD 704/4/69.

63. Wolff quoted in Kendall 1952:48.

64. "List of trained midwives struck off or suspended to 1931." SAD 582/2/51 (Wolff).

65. E.g. SAD 583/5, 583/3, 745/2, 745/3, 580/1 (Wolff).

66. M. E. Wolff, Speech to the Committee of the Guild of Service, 1922. SAD 579/3/24–25.

67. MTS First Annual Report 1921. SAD 579/3/15; Kendall 1952.

68. M. E. Wolff, Speech to the Committee of the Guild of Service, 1922. SAD 579/3/24–25, punctuation altered for readability, emphasis in the original.

69. MTS Annual Report, 1925–26. SAD 581/1/2.

70. Wolff to Director, SMS, 8 April 1934, SAD 582/4/26.

71. Draft of a paper for the British Hygiene Council, M. Wolff, Feb. 1933. SAD 582/10/12.

72. Ibid.

73. Rothman 1982:36–37.

74. See Martin 1991.

75. "Learning to scrub up" SAD 583/5/38. The poster is difficult to make out in the photograph, but appears to depict organic processes in the form of assembly-line production of material goods.

76. MTS Annual Report, 1932. SAD 581/1/46.

77. MTS Annual Report, 1921. SAD 579/3/15.

78. See also Gruenbaum 1982, 1991.

79. See Arnold 1993:256.

80. Wolff to Director, SMS, 17 Jan. 1929, SAD 581/1/11; following up Wolff to MOH Khartoum, 7 Jan. 1929, SAD 582/1/55.

81. Rugman to Director SMS, 3 Mar. 1929, SAD 582/1/58; see also MTS Annual Report, 1929, SAD 581/1/8–11; Wolff to Governor, Dongola Prov., 22 Feb. 1930, SAD 582/2/19; Midwives Inspection 1931, SAD 582/2/73.

82. Wolff to Director, SMS, 17 Jan. 1929, SAD 581/1/11.

83. Recall Reverend Gwynne's experience of being placed at the back of an official parade because of his modest rate of pay (ch. 2).

84. Wolff to Director SMS, 16 June, 1932, SAD 582/3/4. See also "MTS Annual Report—1933." M. E. Wolff, 17 Jan. 1934, SAD 581/11/60, and M.E. Wolff to G. Wolff, 30 Nov. 1935, SAD 582/7/106.

85. Wolff to Director SMS, 16 June 1932, SAD 582/3/4.

86. Quoted in Boddy 1998a, citing Wolff papers, "Letters on Trek," SAD 582/7/45–46, punctuation altered for readability; original emphases; and SAD 582/7/38.

87. M. E. Wolff, Speech to the Committee of the Guild of Service, 1922. SAD 579/3/28.

88. M. Wolff to Director, Medical Department, 7 Mar. 1921, SAD 579/3/7–8. Harris to M. Wolff, 9 Mar. 1921, SAD 579/3/9.

89. MTS 2nd Report 1921, 29 Jan. 1922. SAD 579/3/20.

90. Kendall 1952:50.

91. M. E. Wolff, Speech to the Committee of the Guild of Service, 1922. SAD 579/3/29.

92. "Midwives Inspection 1931." M. E. Wolff, 1932. SAD 582/2/73.

93. Boddy 1989, Constantinides 1972.

94. Kenyon 1991a:101; see also 1991b.

95. The term derives from *umm*, mother, and is "also used colloquially for an electricity mains transformer" (Kenyon 1991:115, n.8). The link to electrical power—unseen, like a spirit, except through its effects—is intriguing, but it is not common in the not-then-electrified region where I lived. There is, however, a *zâr* spirit called *Kahrabâ*—electricity.

96. Ibid., 1991a:101, 101–102.

97. Kenyon personal communication, Nov. 2000; and see Kenyon 1991b: plate 12.

98. MTS Annual Report 1928. SAD 581/1/5. Spelling standardized and punctuation added for readability.

99. Medical Inspector, Omdurman Civil Hospital to Medical Inspector of Health, 25 July 1928, SAD 582/1/19 (Wolff).

100. Acting Medical Officer of Health to Medical Inspector, Omdurman Civil Hospital, 26 July 1928, SAD 582/1/20 (Wolff).

101. M. E. Wolff to Medical Officer of Health, 19 Sept. 1928, SAD 582/1/25 (Wolff).

102. Hunt 1999:6. Hunt (1996:10) considers the "hygienic modality of colonial power" that aimed to suppress practices such as female circumcision and *sati* to contrast with that in the Belgian Congo where positive power was exercised through practices that were pronatalist, enumerative, and maternalist. However, colonial Congo and Sudan were similar in several respects. Both administrations were intent on improving maternity outcomes in the interests of building a stable labor force, and both employed European and native agents to suppress indigenous practices while promoting women's and children's health. They exercised positive and repressive power simultaneously.

103. Gindiyah Salah was the first staff midwife, appointed in 1921; she died of breast cancer in 1936. Wolff wrote that "her cancer was the result of a kick from a Pharaonic Circumcised Primipara [woman about to deliver for the first time] manaically terrified of being cut up at [the] birth of her baby." M. E. Wolff to Phyllis Dickens, 12 Feb. 1946, SAD 581/4/18. Sitt Batul was made staff teacher–midwife in 1925 and continued after the Wolffs' departure from Sudan. I return to her in chapter 11.

104. The form of literacy taught by the CMS was controversial and is discussed in chapter 11.

105. M. E. Wolff, "Confidential Reports on Staff midwives & Chauffeur etc. . . ." 31 Aug. 1937. SAD 580/2/1–8.

106. "Elementary Practical Lessons" for Midwives of the Sudan. SAD 581/5/13.

107. Ibid., p. 16

108. M. E. Wolff to Medical Officer of Health, 21 Mar. 1926, SAD 579/5/21.

109. "Verbatim report of trained midwife," in M. Wolff to Medical Officer of Health, 21 Mar. 1926, SAD 579/5/21.

110. Al-Safi 1970:69. Wehr (1976:341) translates it as "garden peppergrass" (*Lepidium sativum*). "Verbatim report of trained midwife," in M. Wolff to Medical Officer of Health, 21 Mar. 1926 (original emphasis), SAD 579/5/21.

111. M. E. Wolff to Medical Officer of Health, 21 Mar., 1926, SAD 579/5/21.

112. Ibid., 7 Apr., 1926, SAD 579/5/22, original emphasis.

113. M. E. Wolff to Director SMS, 5 Mar. 1931, SAD 582/2/51. Reasons for discipline included neglect to notify authorities of a birth or puerperal infection, unsatisfactory condition of the midwifery box, and "moral reasons." Given the sisters' concerns, performing an unmodified pharaonic procedure could well have been a moral reason, though the phrase typically meant habitually drinking merissa, a native beer. See M. Wolff to Senior Medical Officer, Blue Nile Distr., Singa, 14 Dec. 1928, SAD 582/2/44.

114. SAD 745/3/23–24.

115. M. E. Wolff and G. L. Wolff to Dr. Henry, 27 Feb. 1961, SAD 582/8/80.

116. Sudan Government 1982, vols. 1 and 2.

117. For discussions of medical consequences, see Toubia 1994, 1994; El-Dareer 1982; Boddy 1998b. Gruenbaum 2000:4–7 provides a cogent summary.

118. Hayes 1975.

119. Sudan Government 1982, vols.1 and 2.

120. Sudan Annual Report 1927, Public Health. RH Mss Perham 558/1/42.

121. Newbold to Wolff, 3 May 1932, SAD 582/6/10–11.

122. Wolff to Newbold, 30 May 1932, SAD 582/6/15–16.

123. NRO CIVSEC 1/57/3/121, p. 62.

124. See, for example, M. Wolff's "Midwives Inspection Tour Report 1928." SAD 582/1/51.

125. NRO CIVSEC 1/57/3/121, p. 28.

126. Figures are summarized in Tew 1990.

127. Sudan Annual Reports, Public Health, 1913, 1914. RH Mss Perham 558/1/21. On the drought, see Daly 1986:216–17. If fewer women were becoming pregnant or carrying offspring to term, there would have been fewer crude numbers of infant deaths, though the rate per 1,000 births would not necessarily have declined.

128. Sudan Annual Report 1923, Public Health. RH Mss Perham 558/1/26; 1925, Public Health. RH Mss Perham 558/1/32; 1929, Public Health. RH Mss Perham 558/1/57.

129. Tew 1990.

130. M. E. Wolff and G. Wolff to Dr. Henry, 27 Feb. 1961, SAD 582/8/80.

CHAPTER 9

Salih 1981:3.

1. Information in this paragraph comes from Hetherington 1989. The quote is from p. 7.

2. Ibid., 33; 34.

3. See also K.D.D. Henderson," Notes on the Collection of Dervish Arms and Armour at Blair Castle."SAD 660/1/33–35.

4. Hetherington 1989:39–96; Gazeteer for Scotland, 2001 (Katharine Marjory Murray [Duchess of Atholl]). See also Pedersen 1991.

5. Hetherington 1989:130.

6. Mayo 1927:12, 22.

7. Jayawardena 1995:97.

8. Hetherington 1989:130; 131; Pedersen 1991:657.

9. Eleanore Rathbone, "A Summary of the more salient facts respecting the Status and Conditions of Indian Women and of some of the proposals for improving and safeguarding their well-being," ca. 1928. British Library: Atholl Papers. MSS EuroD903/1. Rathbone had called a conference on the conditions of women in India that circulated a questionnaire to Indian groups, and raised "criticism from Indian women who had not been consulted" (Jayawardena 1995:100).

10. Not to be confused with the CMS, the Church Missionary Society.

11. Hetherington 1989:135–36.

12. "Description by Miss Brown of the Church of Scotland Mission . . . of a Circumcision of African Girls She Witnessed in January 1929," Liverpool University Archives, Rathbone Papers (R.P.) XIV.2.1 (7), p. 1–2.

13. Hetherington 1989:136. Atholl was also gravely concerned about the physical and mental effects of child marriage in India, where a young girl of seven or eight married to an adult could suffer internal damage, severely dislocated hips, blood loss, and even death from sexual intercourse.

14. Kenyatta, in his testimony before the committee, raised doubts about this claim. "Kinyatta does not think it true that the first baby usually dies as a result of its mother having undergone the practice. He knows personally that many women are able to bear their first baby safely, in spite of the operation." Statement of Mr. Johnson Kinyatta to the CPCW, 18 Dec. 1929. R.P. XIV2.1.(5), p. 2.

15. Statement by Mrs. Hooper to the CPCW, Oct. 1929. R.P. XIV.2.1.(9), p. 2.

16. Statement of Dr. Gilks to the CPCW, Nov. 1929. R.P. XIV.2.1.(11), p. 1.

17. Dr. Stanley Jones, "Memorandum re Native Kikuyu Women" submitted to the CPCW, Nov. 1929. R.P. XIV.2.1.(4), p. 2. Jones was a Church of Scotland missionary in charge of Kikuyu Hospital from 1914 to 1924 (CO 533/418/2, p. 13). See also CO 533/418/2: "Female Circumcision: Memorandum Prepared by the Mission Council of the Church of Scotland," 1 Dec. 1931.

18. CPCW to Passfield, 24 Feb. 1930, R.P. XIV.2.1.(15), p. 1. Also Hetherington 1989:136.

19. "Suggested Questions for Circulation to Governors and High Commissioners of Colonies and Protected and Mandated Territories," R.P. XIV.2.1 (53).

20. Pedersen 1991, p. 656.

21. Parliamentary Debates (Commons), 5th ser., vol.233 (December 11, 1929), cols.600–603; Enclosure No. 2 in Passmore to Grigg, 19 Dec. 1929, CO 533/392/10.

22. Parliamentary Debates (Commons), 5th ser., vol. 233 (Dec. 11, 1929), cols. 600–603; Pedersen 1991:658; Hetherington: 1989:137.

23. Pedersen 1991:659.

24. Passfield to Grigg, Kenya no. 26, 8 Jan. 1930, CO 533/392/10/28. Shiels was quoting from Circular Letter No. 28, Native Affairs Dept., Nairobi, to all senior commissioners and district commissioners, 23 Aug. 1926. CO 533/392/1, p. 32.

25. "Kikuyu Circumcision Ceremony," minute, "T.D.S.," 23 Jan. 1930. CO 533/394/10/3.

26. Statement by Dr. E. Lloyd to the CPCW, 24 Mar. 1930. R.P. XIV.2.1.(16), pp. 4, 2.

27. Secretary of the CPCWC to Atholl, 2 Apr. 1930, R.P. XIV. 2.1.(10).

28. Statement by Dr. Hodson to the CPCW, 31 Mar. 1930. R.P. XIV.2.1.(17), p. 1.

29. "Suggested Questions for Circulation to Governors and High Commissioners of Colonies and Protected and Mandated Territories," R.P. XIV.2.1.(53), pp.1; 1–2.

30. NRO CIVSEC 1/57/3/121; NRO CIVSEC 1/44/2/12, p. 5.

31. NRO CIVSEC 1/44/2/12, p. 11. The article, written by Abdel Rahman El Atabani, was eventually published in February 1931.

32. Gillan to Secretary of Education and Health, 3 Feb. 1930, NRO CIVSEC 1/44/2/12/19–22.

33. MacMichael to Gillan, for general circulation, 10 Feb. 1930, NRO CIVSEC 1/44/2/12/23–26.

34. NRO CIVSEC 1/44/1/12/5.

35. MacMichael to Gillan, for general circulation, 10 Feb. 1930, NRO CIVSEC 1/44/2/12/23–26.

36. Matthew to Atkey, 19 Feb. 1930, NRO CIVSEC 1/44/2/12/28.

37. The *London Times*, 18 Feb. 1930. NRO CIVSEC 1/44/2/12/29a.

38. This was a nondenominational group. A pentecostal branch, the Gospel Mission Society, formed somewhat later (Oliver 1965).

39. The *London Times*, Feb. 18, 1930. NRO CIVSEC 1/44/2/12/29a.

40. "Inquest held under sec. 143 of C.P.O. in regard to the death of Miss Hulda Jane Stumpf, at Kijabe Mission, on the night of January 2/3, 1930," 20 Jan. 1930. CO 533/394/11/74–114.

41. Grigg to Colonial Office, 20 Jan. 1930, CO 533/394/30/78.

42. NRO CIVSEC 2/20/1/2.

43. Stoler 2002:59, 59.

44. See, especially, Pedersen 1991, Snively 1994, and Murray 1974. See also Hyam 1990. On nationalsim in Kenya, see Spencer 1985, Rosberg and Nottingham 1966, Tignor 1976.

45. See Kenyatta 1961 (1938), Leakey 1977, Middleton 1965, Davison 1989. Age-mates circumcised together became symbolic siblings and as such were forbidden to marry. Circumcision age groups (*rika*) were an important means by which the Kikuyu Central Association, a proto-nationalist organization discussed below, was organized. (See "Female Circumcision," Memorandum prepared by the Mission Council of the Church of Scotland, Appendix III, The Kikuyu Central Organization, 1 Dec. 1931. CO 533/418/2.)

46. In his 1938 ethnography, *Facing Mount Kenya*, Jomo (Johnstone) Kenyatta wrote that for the Kikuyu, excision had "enormous educational, social, moral,

and religious implications" and it was "impossible for a member of the tribe to imagine an initiation without [it]." Thus to eliminate "the surgical element in this custom" would mean "the abolition of the whole institution" (Kenyatta 1961 [1938]:133). Bear in mind, however, that the import of excision had been modified by colonial domination and the crisis described below.

47. Snively 1994:18.

48. "Female Circumcision: Memorandum Prepared by the Mission Council of the Church of Scotland," 1 Dec. 1931. CO 533/418/2, p. 20.

49. Dr. Stanley Jones, "Memorandum re Native Kikuyu Women" submitted to the CPCW, Nov. 1929. R.P. XIV.2.1.(4), 2.

50. "Female Circumcision: Memorandum Prepared by the Mission Council of the Church of Scotland," 1 Dec. 1931. CO 533/418/2, p. 11.

51. Grigg to Passfield, 12 Oct. 1929, CO 533/392/1.

52. G. V. Maxwell, Native Affairs, Circular Letter No. 28, 23 Aug. 1926. CO/ 522/392/1 p. 30–31. This, despite the fact that Kenyatta described partial clitoridectomy as the whole of the operation. On his own admission, however, he would not have observed the women's ceremony as "any man caught doing so would be severely punished" (Kenyatta 1961:145).

53. Kenyatta 1961:130–31.

54. Pedersen 1991:650–51. Throughout her article Pedersen refers to the practice as clitoridectomy, yet it is clear from the record that the procedure was excision (clitoridectomy with excision of the minor and sometimes major labia) and, possibly among some sections of the Kikuyu, excision with partial infibulation. Kenyatta (1938) also calls the procedure clitoridectomy, an apparent obfuscation.

55. Kenyatta 1961:134, 135.

56. Ibid., 153.

57. This point is elegantly made by Judith Snively in her M.A. thesis, McGill University, 1994.

58. "Dr. Shiels' interview with Mr. Kenyatta," 23 Jan. 1930. CO 533/384/9.

59. Snively 1994, Clark 1980, Middleton 1965.

60. Kenyatta 1961:132.

61. Snively 1994:9.

62. Clark 1980.

63. Snively 1994:24.

64. Among these, Louis Leakey, who spoke of himself as a "white Kikuyu" (having been born to CMS missionaries in central Kenya) and sought to unsettle Europeans' confidence in their enlightened ways (Shaw 1995:63). In evidence given to Atholl's committee, Leakey claimed that colonization had interfered with the flow of traditional knowledge, leading to a decline in circumcisers' skills and more extensive cutting than before. Indeed, colonization had so weakened the Kikuyu moral fabric that premature pregnancies and a rise in prostitution had ensued. "Statement by Mr. Leakey—Anthropologist" to the CPCWC, 5 Feb. 1930. R.P. XIV.2.1.(14).

65. Robertson (1996) suggests that the conflict over the missionary ban was also related to men's desire to control women's activities as many had become independent in trade. On Kenya, see also Kratz 1994, Walley 1997.

66. "Statement of Mr. Johnson Kinyatta" to the CPCW, 18 Dec. 1929. R.P. XIV.2.1.(5).

67. "Dr. Shiels' interview with Mr. Kenyatta," 23 Jan. 1930. CO 533/384/9.

68. Ibid.

69. The KCA declared in early 1928 that "they stood for the preservation of the old tribal customs, laying special emphasis on 'female circumcision' " (Arthur to Cuniffe-Lister, Memorandum, 18 Jan. 1932, CO 533/418/2.) Kenyatta reiterated that stand in *Facing Mount Kenya*, n.64 above.

70. Thomas 2003:2.

71. "Female Circumcision," memorandum prepared by the Mission Council of the Church of Scotland, 1 Dec., 1931. CO 533/418/2, p. 49ff.

72. Thomas 2003.

73. "Female Circumcision," memorandum prepared by the Mission Council of the Church of Scotland, 1 Dec., 1931. CO 533/418/2.

74. Reports by S. I. Luka (C.I.D.) and C. Kagwanarwa (C.I.D.) Re—Kikuyu Circumcision. Oct. 1929. CO 533/392/1.

75. "Female Circumcision," memorandum prepared by the Mission Council of the Church of Scotland, 1 Dec., 1931. Appendix V. The Muthirigu Dance-Song. CO 533/418/2.

76. In Wolff's reports, "internal connection" means sexual intercourse; the same may be intended here.

77. Telegram from Grigg to Passfield, Part 1, 20 Jan. 1930, CO 533/394/10.

78. "Female Circumcision," memorandum prepared by the Mission Council of the Church of Scotland, 1 Dec. 1931. Appendix V: The Muthirigu Dance-Song. CO 533/418/2.

79. Telegram from Grigg to Passfield, Part 2, 21 Jan. 1930, CO 533/394/10.

80. "Female Circumcision and Subversive Propaganda," 2 Feb. 1930. CO 533/394/10.

81. Edgcumbe to McGregor Ross, 17 Feb. 1930, CO 533/394/10.

82. "Female Circumcision," memorandum prepared by the Mission Council of the Church of Scotland, 1 Dec. 1931. CO 533/418/2, pp. 49–50.

83. Shaw 1995:65; cf. Bhabha 1997.

84. Pedersen 1991:651.

85. Thomas 2003:5, 4.

86. Pedersen 1991:660.

87. "Arabic and the Southern Sudan," H. A. MacMichael, 10 May 1928. RH Mss. Brit. Emp. s. 421(2).

88. Wolff to Atkey, 18 Mar. 1930, SAD 582/2/21–22.

89. NRO CIVSEC 1/57/3/121; NRO CIVSEC 1/44/2/12; NRO CIVSEC 1/57/3/121; FO 371/41433.

90. NRO CIVSEC 1/44/2/12, p. 30.

91. "Extract from a Note by an Eminent Divine," in Maffey to Hoare, Acting High Commissoner for Egypt and the Sudan, 8 May 1930, FO 371/41433.

92. "Minute by His Excellency the Governor General" (Sir John Maffey), 1 Jan., 1927. SAD 403/9/5–6 (MacPhail).

93. Cf. Daly 1991:51.

94. Maffey to Hoare, Acing High Commissoner for Egypt and the Sudan, 8 May 1930, FO 371/41433.

95. "Female Circumcision in the Sudan," O.F.H. Atkey, Director, SMS, 7 Apr. 1930. FO 371/41433.

96. Ibid.

97. C. Huddleston to Matthew, 14 Jul. 1930, NRO CIVSEC 1/44/2/12/62.

98. Matthew to MacMichael, 15 Jul. 1930, NRO CIVSEC 1/44/2/12/63, original emphasis.

99. Atholl to Murray, 26 Jul. 1930, NRO CIVSEC 1/44/2/12/64.

100. Founded in London in 1919, it became the International Save the Children Union in 1920 and drafted "The Declaration of Geneva" (precursor to the UN Convention on the Rights of the Child), which was passed by the League of Nations in 1924 (http://www.savethechildren. net).

101. Matthew to MacMichael, 31 Jul. 1930, NRO CIVSEC 1/44/2/12/65–66.

102. Maffey to Matthew, 7 Aug. 1930, NRO CIVSEC 1/44/2/12/68.

103. Informant, Omdurman, 19 Oct. 1930, NRO CIVSEC 1/44/2/12/71c.

104. Gillan to MacMichael, 29 Nov. 1930, NRO CIVSEC 1/44/2/12/12.

105. NRO CIVSEC 1/44/2/12, some of which is in the PRO in CO 533/392/1 and Grigg to Passfield, Kenya No. 44 Confidential, 15 Mar. 1930. CO 533/394/11.

106. Grigg to Passfield , Kenya No. 44 Confidential, 15 Mar. 1930. CO 533/394/11; NRO CIVSEC 1/44/2/12.

107. MacMichael to Legal Secretary, 19 Feb. 1931, NRO CIVSEC 1/44/2/12.

108. NRO CIVSEC 1/44/2/12.

109. Note by A.C.C. [Sir Cosmo] Parkinson on Kenya No. 44, 15 Mar. 1930. CO 533/394/11.

110. "Minutes of the Meeting of the Crown Colonies Women's Committee," 2 Feb. 1931. R.P.XIV.2.1(36).

111. Pedersen 1991:666ff. See correspondence between Atholl and Shiels and related documents in CO 533/394/11 and CO 533/407/14.

112. Pedersen 1991:674–77; see also CO 533/407/14 (1930–31), CO 533/418/2 (1931–32). On the committee's wish to see even "simple" clitoridectomy stopped, if not by legislation then by "an energetic campaign of education and propaganda," see Minutes of the Meeting of the Crown Colonies Women's Committee, 2 Feb. 1931. R.P.XIV.2.1(36).

113. Atkey to Wolff, 26 Jan. 1931, SAD 582/2/48.

114. Wolff to Atkey, 1 Feb. 1931, SAD 582/8/10; Wolff to Atkey, 5 Feb. 1931, SAD 582/8/8.

115. Ibid. SAD 582/8/10; 5 Feb. 1931, SAD 582/8/8.

116. Ibid. SAD 582/8/10–13; 5 Feb. 1931, SAD 582/8/8–9.

117. Grand Kadi to MacMichael, 7 Feb. 1931 and 8 Feb. 1931, NRO CIVSEC 1/44/2/12.

118. Sequeira 1931:1054–56; Stephens 1931:1159.

119. Sequeira 1931:1055.

120. Stephens 1931:1159.

121. "Female Circumcision in the Sudan" (reply to Dr. J.R.C. Stephens's statement in the Lancet of Nov. 21, 1931), 19 Apr. 1932. SAD 582/8/14–16.

122. Newbold to M. Wolff, 3 May 1932, SAD 582/6/10b.

123. M. Wolff to Newbold, 30 May 1932, SAD 582/6/15–16.

124. Newbold to M. Wolff, 3 May 1932, SAD 582/6/11–11b, original emphasis.

125. M. Wolff to Newbold, 30 May 1932, SAD 582/6/16.

126. "On Female Slavery within the Family," Memorandum submitted by the Duchess of Atholl, M.P., Col. Josiah Wedgewood, M.P., Miss Eleanor Rathbone, M.P. May 1932. R.P. XIV.2.1.(40). See also R.P. XIV.2.1.(44), R.P. XIV.2.1.(46), R.P. XIV.2.1.(50).

127. E.g. R.P.XVI.2.1.(42).

128. NRO CIVSEC 1/44/2/12 p. 132–37.

129. McPhail to Governor, Upper Nile Province, 5 Nov. 1936, SAD 762/6/29–30.

130. See M. Wolff to Mrs. Neville Rolfe, 27 Feb. 1933, SAD 582/8/17; M. Wolff and G. Wolff to The British Social Hygiene Council, Feb. 1933, SAD 582/10/4–15.

131. Maffey, quoted in Gillan to Atkey, 25 Mar. 1933, SAD 582/10/3 and SAD 582/8/18; see also NRO CIVSEC 1/44/2/12/175–77.

132. M. Wolff to Vischer, 2 Apr. 1933, SAD/582/8/20. See also Wolff to Atkey, 3 Apr. 1933, SAD 582/8/19 and NRO CIVSEC 1/44/2/12/182.

133. Vischer to Wolff, 25 Jul. 1933, SAD 582/8/22.

134. Bell 1999:226, 228.

135. Callaway 1987:31, discussing colonial Nigeria.

CHAPTER 10

Balfour 1999:81.

1. M. E. Wolff to MOH, Khartoum, 25 June 1932. SAD 582/3/19, emphasis mine.

2. M. E. Wolff to Atkey, 10 Mar. 1933, SAD 582/3/28, original emphasis.

3. M. E. Wolff to Dickens, 12 Feb. 1946, SAD 581/4/19.

4. Because Egyptian subventions continued until 1941, the Sudan government's declining revenues were somewhat buffered during the Depression, though plagued by uncertainty over the price of cotton, weather, and agricultural disease. See Daly 1991, ch. 5.

5. SMS reports for 1927, 1930, 1932, 1935. RH Mss Perham 558/1.

6. "Historical Survey of the Development of the Sudan Medical Service" SMS 1937. RH Mss Perham 558/3/166–74.

7. Gillan to Secretary for Education, Health, etc., 3 Feb. 1930, NRO CIVSEC 1/44/2/12; SAD 723/8/35–38.

8. D. R. Macdonald, "Female circumcision in the Sudan," 9 Mar. 1936. SAD 657/4/9 (Beasley papers). Also RH Perham 558/2.

9. Ibid., p. 12, referring to Bruce 1790. The woman's name was Sarah (Sarjee) Baartman; she had been a slave of a farmer in the Cape who sold her to European opportunists who took her to England and France, charging the public to see her. See *The Life and Times of Sara Baartman "The Hottentot Venus,"* a film by Zola Maseko. Dominant 7, Mail and Guardian Television, France 3 and SABC 2. New York: First Run/Icarus Films, 1998.

10. Brown 1866; Barker-Benfield 1975.

11. D. R. Macdonald, "Female circumcision in the Sudan," 9 Mar. 1936. SAD 657/4/12; pp. 12–13.

12. Vaughn 1991:129ff.

13. El Dareer 1982; on the responsibility of men, see Hosken 1992.

14. See Mahmood 2001, 2004 for an excellent discussion of the constitution of ethical personhood among contemporary Egyptian women in the Islamic piety movement.

15. Foucault 1990.

16. Scheper-Hughes and Lock, 1987.

17. Boddy 1989, 1998b.

18. D. R. Macdonald, "Female circumcision in the Sudan," 9 Mar. 1936. SAD 657/4/13.

19. See Gruenbaum 2001, Boddy 1989, 1998b.

20. J.A.R. to C.S. (date illegible), c. 1937, NRO CIVSEC 1/44/2/12/49.

21. J.G.R. to J.A.R. c.1937, NRO CIVSEC 1/44/2/12/49–51.

22. See Daly 1991:78–79 for details of this visit.

23. J.G.R. to J.A.R. c.1937, NRO CIVSEC 1/44/2/12/49–51.

24. NRO CIVSEC 1/44/2/12/192.

25. Newbold to Shone, 17 Oct. 1944, FO 371/41433; Sanderson 1980:78.

26. Hills-Young, "Female Circumcision in the Sudan," Nov. 1944. SAD 631/3/36–37. See also Sanderson 1981:79.

27. Hills-Young, "Female Circumcision in the Sudan," Nov. 1944. SAD 631/3/36–37; M. E. Wolff to Dickens 12 Feb. 1946, SAD 581/4/18; Sanderson 1981:79.

28. M. E. Wolff to Dickens 12 Feb. 1946, SAD 581/4/18.

29. Sanderson 1981:80.

30. Hills-Young, "Female Circumcision in the Sudan," Nov. 1944. SAD 631/3/36–37.

31. As noted in ch. 7, British medical personnel, like those in the political service, did not voice concern about male genital cutting, even though it too was performed in unsanitary conditions. This was, in part, because male circumcision is decreed by Islam, and administrators were loath to offend their Muslim subjects on pragmatic grounds. In part, too, it was because male circumcision was considered not to jeopardize population levels to the extent that infibulation did. Indeed, the lesser form of female circumcision, called *sunna* or "religiously approved," was not discouraged by male officials in the least, as discussed below.

32. Hills-Young, "Female Circumcision in the Sudan," Nov. 1944. SAD 631/3/38.

33. Beasley 1992.

34. Newbold to CS (Gillan), 3 Nov. 1938, RH Mss Perham 558/2/20.

35. Pring Farmer to Newbold 23 Aug. 1938, RH Mss Perham 558/2/28.

36. Newbold to Perham, 5 Nov. 1938, RH Mss Perham 558/2/19.

37. Newbold to CS (Gillan), 3 Nov. 1938, RH Mss Perham 558/2/23.

38. Ibid; and p. 24.

39. Daly 1991:82.

40. Newbold to CS (Gillan), 3 Nov. 1938, RH Mss Perham 558/2/24; p. 25.

41. The governor-general, Hubert Huddleston, preferred a more ceremonial role (Daly 1991:140).

42. "Address by Sir Angus Gillan" 11 Jul. 1939. RH Mss Perham 558/5/13.

43. Newbold to Shone, 17 Oct. 1944, FO 371/41433; translation of Abu Shama Abd el-Mahmud, "The Mufti's Fetwa concerning Female Circumcision," *El Nil*, 31 Jul. 1939. ref. article by "Dr. El-Sayed And [*sic*] el-Hadi" (i.e., el-Sayed ʿAbd el-Hadi), in *El Nil*, 25 Jul. 1939. FO 371/41433.

44. Translation of Abu Shama Abd el-Mahmud, "The Mufti's Fetwa concerning Female Circumcision" *El Nil*, 31 Jul. 1939. FO 371/41433.

45. Newbold to Shone, 17 Oct. 1944, FO 371/41433.

46. Beasley 1992 passim, and p. 8.

47. Sudan Medical Service Circular, c. 1940, Encl. No. 3 in Eden to Ward, 14 Dec. 1944. FO 371/41433.

48. Printed as "Mohammed Saleh Shanqeiti." He became a prominent member of the Umma party, supported and heavily influenced by Sayyid ʿAbd al-Rahman al-Mahdi.

49. "Sudan Cultural Centre," *Sudan Herald* 23 Apr. 1942. Encl. No. 4 in Eden to Ward, 14 Dec. 1944, FO 371/41433.

50. Ibid.

51. "Local Vernacular Press Summary No. 209," May 1942. RH Mss Perham 575/1.

52. The writer was Ahmad Zain Al-ʿAbdin Omar, School of Arts. "Local Vernacular Press Summary No. 210," May 1942. RH Mss Perham 575/1.

53. C.S. Office 29 Jun. 1942. SAD 657/4/23–24 (Beasley papers).

54. Ibid.

55. One of the men who had drafted the famous Graduates' Congress memorandum to the government a few months earlier, in April 1942. See below, p. 438. He was also a founding member of the group that published the magazine *al-Fajr* in the mid-1930s. He belonged to the Ashigga party, rival to the neo-Mahdist Umma.

56. C.S. Office 29 Jun. 1942, SAD 657/4/23–24.

57. Sharkey 2003:130.

58. Sanderson 1981:87; Beasley 1992:129, n. 91, and passim.

59. Beasley 1991:185, 58, 63, 66 and passim.

60. Hills-Young, "Care of the Child in the Sudan," Address to the Nurses League, 4 Nov. 1944. SAD 631/3/34; p. 47.

61. Cf. Vaughn 1991.

62. Beasley 1992:405; Sanderson 1981.

63. Beasley 1992 passim.

64. "Translation of the Speech against Pharaonic female Circumcision made by S.A.R. Monday 17.7.44." SAD 657/4/26 (Beasley papers).

65. Hills-Young to Ward, 22 Jul. 1944, FO 371/41433; Hills-Young to Ward, 3 Oct. 1944, FO 371/41433; Hills-Young to Mitchell, College of Midwives, 21 Nov. 1944, RCOG B2/5.

66. "Female Circumcision—Progress" SAD 657/4/36 (Beasley).

67. "Extract from the *Medical Women's Federation Quarterly Review*, October 1944." SAD 657/4/37 (Beasley).

68. RCOG B2/5; FO 371/41433. She also approached the secretary of the Save the Children Fund (Miss Pittman-Davies); president of the Royal College

of Obstetricians and Gynaecologists (Eardley Holland); general secretary of the College of Midwives (Miss F. R. Mitchell), and president of the National Council of Women of Great Britain (E. Wilhelmina Ness).

69. Hills-Young to Holland, 28 Jun. 1944, RCOG B2/5.

70. "Female Circumcision in the Sudan (Surgical Seal of Chastity)," Dec. 1944. SAD 631/3/36. (Hills-Young); pp. 36–39.

71. Ward to Stanley, 5 Aug. 1944, FO 371/41433.

72. Stanley to Ward, 11 Aug. 1944, FO 371/41433.

73. "Minutes," 12–16 Aug. 1944. FO 371/41433.

74. Or perhaps the note refers to files kept in Cairo, which may have undergone similar weeding in the face of potential German occupation. This may account for the patchiness of the files on this topic in the PRO.

75. "Minutes," 12–16 Aug. 1944. FO 371/41433.

76. Eden to Ward, 25 Aug. 1944, FO 371/41433.

77. Ibid.

78. Ward to Eden, 1 Sept. 1944, FO 371/41433.

79. See, for instance, the following documents: Hills-Young to Holland, 26 Jun. 1944; Holland to Hills-Young, 30 Jun. 1944; Hills-Young to Holland, 9 Jul. 1944; Holland to Hills-Young, 26 Jul. 1944; Hills-Young to Mitchell (College of Midwives), 21 Nov. 1944; Mitchell to Holland, 11 Dec 1944; Hon. Secretary RCOG to Mitchell 16 Mar. 1945. All are in RCOG/B215.

80. Hills-Young to Ward, 3 Oct. 1994, FO 371/41433. The proposal had also been put to Newbold by C. L. Armstrong, governor of Khartoum. RH Mss Perham 538/1/68.

81. Prime Minister Churchill had replaced Symes with Hubert Huddleston shortly after the outbreak of the war, as little had been done under Symes to secure Sudan's defenses; Huddleston, a soldier-administrator with long experience in Sudan, assumed his post in the fall of 1940. See Daly 1991:137–39. Newbold had control over internal affairs (Daly 1991:139–40).

82. Newbold to Shone, 17 Oct. 1944, FO 371/41433.

83. Ibid.

84. Eden to Ward, 14 Dec. 1944, FO 371/41433; Ward to Eden, 20 Dec. 1944, FO 371/41433.

85. "Position of Women in Sudan," 6 Dec. 1944–16 Mar. 1945, FO 371/41433.

86. Ward to Eden, 8 Mar. 1945, FO 371/41433.

87. Ness (President, NCWGB) to Eden, 15 Jan. 1945. FO 371/41433.

88. Newbold to Mayall, 24 Feb. 1945, FO 371/4133.

89. Ibid.

90. Hills-Young to Ward, 15 Feb. 1945, FO 371/1945.

91. Perham 1953:xxii.

92. This was the declaration of common postwar objectives signed by Churchill and Roosevelt in August 1941, proclaiming the determination of the U.S. and British governments not to extend their territories and to promote all peoples' right to independence and self-determination.

93. Mekki Abbas 1952:107ff.; Perham 1953:xxii–xxv; the text of Newbold's reply can be found in Henderson 1953:542–43.

94. Henderson 1953:542.
95. Perham 1954:xxiii.
96. Daly 1991:157.
97. Perham 1954:xxii.
98. Henderson 1954:233 (Newbold to Mayall, 9 Feb. 1942), 570, 571.
99. Daly 1991:167.
100. Sharkey 2003:10.
101. Cf. Anderson 1983.
102. For examples, see Sharkey 2003:59.
103. Ibid., 10.
104. Ibid., 10–11.
105. Ibid., 130.
106. Boddy 1989.
107. E.g. Anderson 1983.

CHAPTER 11

Fausset 1939:32–33.
1. "Northern Sudan Advisory Council. Minutes of the Second Sessions. December 5th to 10th 1944." FO 371/45984.
2. Newbold to Mayall, 24 Feb. 1945, FO 371/41433.
3. "Female Circumcision in the Anglo-Egyptian Sudan," E. D. Pridie et al., Khartoum: Sudan Government, 1 Mar. 1945. SAD 658/9.
4. Beasley, marginal notes to "Female Circumcision in the Anglo-Egyptian Sudan," E. D. Pridie et al., Khartoum: Sudan Government, 1 Mar. 1945. SAD 658/9, pp. 5–6; she refers here to a" Report on method of delivery of child, in normal labour on a woman who has been circumcised, pharaonic type," by Dr. A. Muir Leach, 22 Jan. 1945. SAD 657/4/42.
5. Beasley, marginal notes to "Female Circumcision in the Anglo-Egyptian Sudan," E. D. Pridie et al., Khartoum: Sudan Government, 1 Mar. 1945. SAD 658/9, pp. 6–7.
6. "Female Circumcision in the Anglo-Egyptian Sudan." E. D. Pridie et al., Khartoum: Sudan Government, 1 Mar. 1945. SAD 658/9, p. 6, and Beasley's marginal notes in same.
7. Beasley's marginal notes to "Female Circumcision in the Anglo-Egyptian Sudan," E. D. Pridie et al., Khartoum: Sudan Government, 1 Mar. 1945. SAD 658/9, p. 8.
8. Eden to Ward, 14 Dec. 1944; Newbold to Mayall 24 Feb. 1945, FO 371/41433.
9. "Female Circumcision in the Anglo-Egyptian Sudan," E. D. Pridie et al., Khartoum: Sudan Government, 1 Mar. 1945. SAD 658/9.
10. "Letter from His Excellency, the Aga Khan, to the Advisory Council of the Northern Sudan," 27 Mar. 1945, SAD 658/9.
11. Daly 1991:141, 246–47, citing Robertson to Mayall, 24 March 1950, SAD 522/8.
12. One of the first group of doctors educated at the Kitchener School of Medicine, and son of Babikr Bedri, the founder of schools for girls.

13. Minutes, Third Session of the Advisory Council for the Northern Sudan, 23–28 May 1945. FO 371/45984.

14. Huddleston to Killearn, 10 June 1945, FO 371/45984.

15. See Beasley 1992:403–407, also Hills-Young to Ward 3 Oct. 1944, FO 371/41433.

16. "Note on Female Circumcision" by Ina Beasley, 21 Mar. 1945. SAD 657/4/38–40; Beasley 1992:287–88, 403–407.

17. Boddy 1989, Kenyon 1991, Gruenbaum 2001.

18. For an extended ethnographic example from Bedouin in Egypt, see Abu-Lughod 1986.

19. Local Vernacular Press Summary: "Untimely Circumcision," *El-Sudan El-Gedid*, 8 June 1945. RH Mss Perham 575/3; NRO CIVSEC Intelligence Report No. 87, 8 June 1945. RH Mss Perham 571/1/18–19; Beasley to Robertson, 16 Aug. 1945. SAD 657/4/51; "Translation of a speech given by Sitt Nafissa to the mothers of Omdurman," 7 Mar. 1946. SAD 657/4/107.

20. See Fausto-Sterling (2003) on how the medical profession defines genital ambiguity.

21. Sex reassignment surgeries do something similar, of course, but without acknowledging that it is a social not a natural model that is at stake. See Fausto-Sterling 2003, also Martha Coventry (1998) "The Tyranny of the Esthetic: Surgery's Most Intimate Violation," on clitoral reduction in childhood.

22. Boddy 1989, 1998b; Holy 1991, cf. Laqueur 1990:8.

23. See Beasley 1992:285–87 passim on "normal, sensible relations between the sexes."

24. Beasley to Civil Secretary, 16 Aug. 1945. SAD 657/4/51.

25. Minutes, "Meeting held in the Civil Secretary's Office on May 30th, 1945." SAD 657/4/50.

26. "The Fight against Female Circumcision," *Sudan Star*, 14 June 1945. NRO CIVSEC 2/10/1/13, p. 3.

27. Newbold to Shone, 17 Oct. 1944, FO 371/41433.

28. NRO CIVSEC 2/10/1/13, p. 17.

29. It was edited and owned by Isma'il al-'Atabani, an advocate of union with Egypt. Daly 1991: 169.

30. Translation of an editorial in *Al-Rai al-'Amm* , 21 June 1945. NRO CIVSEC 2/10/1/13, p. 6.

31. Others were Mr. Carel Birkby, editor of the *Sudan Star*, and Mrs. Copland Griffiths, "Lady Superintendent-in-Chief, the St. John Ambulance Brigade Overseas" who made a generous donation. C. Huddleston to Owen, 9 Nov. 1945, NRO CIVSEC 2/10/1/13, p. 25.

32. C. Huddleston to Wolff, 13 Dec. 1944, SAD 528/8/34.

33. Record, discussion at Colonel Clarke's house 22 Nov. 1945. NRO CIVSEC 2/10/1/13, p. 35.

34. C. Huddleston to Owen, 7 Jan. 1946, NRO CIVSEC 2/10/1/13, p. 39.

35. NRO CIVSEC 2/10/1/13, p. 51–52.

36. Minutes of the Official Publications Board, 16 June 1946. NRO CIVSEC 2/10/1/13, p. 54.

37. Corkill to Miller, 1 June 1946, NRO CIVSEC 2/10/1/13, p. 54.

38. SAD 657/4/71.

39. "Drastic laws to kill Sudan custom," *Sudan Star*, no. 566, 7 Nov. 1945, p. 1.

40. Sharkey (2003), for instance, examines the awkward position of Gordon College graduates, the Sudanese male elite who filled the lower ranks of the civil service and professional cadres.

41. "Translation by Bushra Eff of a speech by Sitt Nafissa to mothers in G.I.S. Omdurman, 7 Mar. 1946." SAD 657/4/103.

42. Beasley 1992:288.

43. "Sitt Nafissa Awad El Karim," SAD 657/4/208.

44. Hills-Young "The Training of Midwives in the Sudan," *Nursing Times*, Jan. 12, 1943, p. 30. SAD 631/3/47.

45. Kendall 1952, Beasley 1992:397, n.36.

46. Kendall 1952:47–48.

47. A follow up to this study would be to trace these early government midwives and their families to obtain oral histories.

48. Peel 2000; see also Hunt 1999.

49. One was Sitt Kathira Abdullahi, some of whose letters survive in the Wolff's papers (Bell 1999).

50. Ahmed Uthman Muhammad Ibrahim 1985:64–76.

51. Sharkey 2002:52. Sharkey (2002:67) notes, however, that in CMS schools with many affluent expatriates—Egyptians, Lebanese, etc.—standards and fees were higher, and girls studied standard Arabic as well as some English with expatriate teachers at least until the Egyptian expulsions in 1924–25.

52. Beasley to Director of Education, 24 Jan. 1946, SAD 657/4/83.

53. Poster: "To the Women of Sudan," Beasley to Director of Education, 24 Jan. 1946. SAD 657/4/84.

54. Poster: "A Happy Family," Beasley to Director of Education, 24 Jan. 1946. SAD 657/4/85.

55. Beasley to Director of Education, 24 Jan., 1946, SAD 657/4/86; pp. 87, 88, 89.

56. Such knowledge had not, however, lessened their devotion to the *zâr*, for spirits are known to take advantage of women whose fertility is compromised by disease.

57. See, e.g., Beasley 1992:8.

58. Hills-Young, "Female Circumcision in the Sudan (Surgical Seal of Chastity)," Dec. 1944. SAD 631/3/36.

59. Beasley to Civil Secretary, 18 Aug. 1945, SAD 657/4/54–55.

60. Beasley 1992:405.

61. Boddy 1989:177ff.

62. Beasley 1992:405

63. It came to power on 1 July 1989.

64. Boddy 1995.

65. Minutes, First Meeting of the Standing Committee on Female Circumcision, 18 June 1946. SAD 657/4/126; Minutes, Second, Meeting of the Standing Committee on Female Circumcision, 16 Sept. 1946. SAD 657/4/129.

66. Minutes, First Meeting of the Standing Committee on Female Circumcision, 18 June 1946. SAD 657/4/127.

67. Elfrida Whidbourne, "Report to the Civil Secretary,", 31 Aug. 1946. SAD657/4/121.

68. "Note for Civil Secretary," J. C. Penney, 7 July 1946. SAD 657/4/122.

69. Minutes, Second Meeting of the Standing Committee on Female Circumcision, 16 Sept. 1946. SAD 657/4/132.

70. Robertson to Governors, 4 Sept. 1946, SAD 524/11/8.

71. Minutes, Second Meeting of the Standing Committee on Female Circumcision, 16 Sept. 1946 SAD 657/4/133.

72. Ibid., p. 134; Minutes, Third Meeting of the Standing Committee on Female Circumcision, 6 Mar. 1947. SAD 657/4/168–69.

73. E.g., Lampen, Governor Darfur, to Civil Secretary, 4 Dec. 1946, SAD 657/4/139.

74. Corkill, SMS HQ to Provincial Medical Inspectors, 20 Feb. 1946, SAD 657/4/145; Civil Secretary to Director SMS, 20 Jan. 1947, SAD 657/4/148; Lorenzen (Director SMS) to Civil Secretary, 22 Jan. 1947, SAD 657/4/149; Minutes, Third Meeting of the Standing Committee on Female Circumcision, 6 Mar. 1947. SAD 657/4/170.

75. Reports by Governors, n.d. (c. 1947), SAD 657/4/154.

76. SAD 657/1/184.

77. See Abusharaf 2001b:119 for more on Taha's position.

78. Sudan Political Intelligence Summary (SPIS) No. 59, Aug.–Sept. 1946. FO 371/53328.

79. Ibid.

80. Ibid.

81. Civil Secretary to Governors, Dec. 1946, SAD 524/11/26.

82. SPIS Aug.–Sept. 1946, No. 59. FO 371/53328.

83. Civil Secretary to Governors, Oct. 1946, SAD 524/11/12.

84. For details, see Daly 1991, chapter 8.

85. Daly 1991:208.

86. SPIS May–June 1946, No. 57; SPIS July–Aug. 1946, No. 58. FO 371/53328.

87. SPIS No. 59, Aug.–Sept. 1946. FO 371/53328.

88. SPIS No. 56, Jan.–Apr. 1946. FO 371/53328. She was eventually released to the CMS hospital in Khartoum North and resettled in Atbara. Robertson reported that Trimingham went deliberately against procedures in order to improve the rules by which conversions can take place. Robertson to Governors, 11 May 1946, RH Mss Perham 571/2/29–30.

89. SPIS No. 56, Jan.–Apr. 1946. FO 371/53328.

90. Robertson to Governors, 9 June 1946, RH Mss Perham 571/2/38.

91. SPIS No. 60, Oct. 1946. FO 371/53328.

92. Under the treaties of 1899 and 1936. Civil Secretary to Governors, 14 Nov. 1946. SAD 524/11/20.

93. Daly 1991:213.

94. On 30 Oct. 30 and 1 Nov. Daly 1991:226.

95. SPIS No. 61, Nov. 1946. FO 371/53328.

96. Ibid.
97. Civil Secretary, Report to Governors, Oct. 1948. RH Mss Perham 571/4/68. Though the British dismissed him as a fanatic, Taha developed a highly democratic religious philosophy that later gained him great respect among Sudanese, and the hatred of the Nimieri regime that led to his execution in 1985. On Nabi 'Isa, see ch. 2.
98. Sharkey 2002.
99. SAD 657/4/172, SAD 657/4/180 (Beasley).
100. SAD 657/4/184 (Beasley); p. 183.
101. Minutes, Third Meeting of the Standing Committee on Female Circumcision, 6 Mar. 1947. SAD 657/4/168–71; Summary, Meetings of the Standing Committee, 14 Mar. 1949. SAD 657/4/231.
102. Minutes, Third Meeting of the Standing Committee on Female Circumcision, 6 Mar. 1947, SAD 657/4/171 (Beasley).
103. Huddelston to Robertson, April 3, 1947, printed in Agenda, Standing Committee on Female Circumcision, 1948. SAD 657/4/191; p. 192.
104. Beasely to Robertson, 4 Feb. 1948, SAD 657/4/197.
105. Ibid.; p. 198.
106. Summary of Reports from Provinces, 14 Mar. 1949. SAD 6573/4/232–33.
107. Beasley to Robertson, 4 Feb. 1948, SAD 657/4/197.
108. "Action Taken Since the Formation of the Standing Committee," 14 Mar. 1949. SAD 6573/4/238.
109. Boddy 1989, 1997. Hofriyat is very near Bagrawiya, which may have given this form its name.

<center>CHAPTER 12</center>

In Potter and Potter 1984:108.
1. C. Huddleston to Dame Hilda Lloyd, 11 May 1950, RCOG B2/5.
2. "Parliamentary Question," 26 Jan. 1949. FO 371/73668.
3. SAD 723/11/5–16 (Gillan papers); Crowfoot to M.E. Wolff, 10 Feb. 1949, SAD 582/8/64.
4. "Note on the interest being taken in Great Britain on female circumcision in the Sudan," SAD 657/4/239.
5. Daly 1991:262–70.
6. Gillan to the *Times*, 29 Jan 1949, SAD 582/8/55; SAD 723/11/14–15.
7. Mayall to Robertson, 1 Feb. 1949, SAD 522/4/14; 3 Feb. 1949, SAD 522/4/17.
8. "Sudan: Female Circumcision" *Hansard*, 18 Feb.1949, p. 1564. See also Mayall to Maitland, FO 371/73668 and enclosure.
9. "Sudan: Female Circumcision" *Hansard*, 18 Feb. 1949, pp. 1563–69.
10. Mayall to Robertson, 9 Mar. 1949, SAD 522/4/47.
11. "Sudan: Female Circumcision" *Hansard*, 18 Feb. 1949, pp. 1571–72.
12. "A Barbaric Custom" letters, the *Spectator*, February–March 1949; "Ritual Mutilations," letters, the *New Statesman and Nation*, March–April 1949; "African Mutilations," letter, the *New Statesman and Nation*, April 1949; "Ritual Mutilation," the *New Statesman and Nation*, 25 May 1949, in SAD 657/4/262–69.

13. Critic, the *New Statesman and Nation*, 19 Mar. 1949, in SAD 657/4/266.

14. Mayall to Robertson, 9 Mar. 1949, SAD 522/4/47; 30 Mar. 1949, SAD 522/5/1; 16 Mar. 1949, SAD 522/4/53; 30 Mar. 1949, SAD 522/5/1.

15. Crowfoot to M. E. Wolff, 1 Feb., 1949 and 10 Feb., 1949, SAD 582/8/61–65; M. E. Wolff to Crowfoot, Feb., 1949, SAD 582/8/59–60; M. E. and G. L. Wolff to "The Editor of *The Times*," 21 Feb. 1949, SAD 582/8/57–58; Grace Crowfoot to the editor, *New Statesman and Nation*, 20 Mar. 1949, SAD 582/8/68.

16. Crowfoot to M. E. Wolff, 10 Feb. 1949, SAD 582/8/64; Davies to Clutton, 14 Feb. 1949, FO 371/73668.

17. Civil Secretary [Robertson] to Sudan Agent [Mayall] 14 Feb. 1949, FO 371/73668.

18. M. E. and G. L Wolff to Huddleston, 14 Oct. 1946, SAD 582/8/35.

19. M. E. and G. L. Wolff to the editor of the *Times*, 21 Feb. 1949, SAD 582/8/58.

20. Minutes, Fifth Meeting of the Standing Committee on Female Circumcision, 19 Mar. 1949. SAD 657/4/259.

21. Minutes, Fifth Meeting of the Standing Committee on Female Circumcision, 19 Mar. 1949. SAD 657/4/258–60.

22. "Action taken since the formation of the Standing Committee," SAD 657/4/237–38.

23. Minutes, Fifth Meeting of the Standing Committee on Female Circumcision, 19 Mar. 1949. SAD 657/4/260.

24. Robertson to Foreign Office, April 2, 1949, FO 371/73668.

25. Sanderson 1981, Beasley 1992.

26. Hosken to Beasley, 17 Oct. 1978, SAD 204/7/11–12; Hosken to Beasley, 4 Dec. 1978, SAD 204/7/25. See also Hills-Young to the Editor, Radio Times, 8 Mar. 1983, SAD 204/7/51. See, e.g., Hosken 1982.

27. Hosken 1982:3. See also Walker 1992, Walker and Parmar 1993.

28. Obiora 2005:183, 184.

29. Boddy 1998b. See also Abusharaf 2001a, 2001b; Gruenbaum 2001; Kirby 1987; Gunning 1992; James and Robertson 2002; Lyons 1981; Nnaemaka 2005; Obiora 1997, 2005; Shweder 2002, 2005; Walley 1997. Medical ethicist Jeffrey Bishop (2004:473ff.) notes the futility of such attempts, in that the principles of Western liberalism are themselves culture-bound and temporally specific, while the practices "cohere within the web of beliefs, the tradition, of those who practice them" and are "rationally justified within those traditions." See also Robertson 1996 on Kenya.

30. The debate over *sati* in India was similar, less about women than about what constituted civilization and the "civilizing mission" (Mani 1998).

31. Gruenbaum 2001:206–207.

32. See Scheper-Hughes 1991.

33. The 1980 Non-Governmental Organizations Forum held in Copenhagen was especially acrimonious. See Kirby 1987, Thiam 1983, Boulware-Miller 1985, Winter 1994, Gilliam 1991.

34. Mohanty 1991, Gilliam 1991; on Sudan, see Abusharaf 2001a, 2001b.

35. Hale 2005:213.

36. Abusharaf 2001a, Hale 1996.

37. Interview in Abusharaf 2001a:158–59.
38. Gruenbaum 2001:197.
39. Abusharaf 2001a:165; see also Manal Abdel Halim, 1999: *www3.undp.org/ww/women-health1/msg00106.html* (visited Mar. 11, 2006).
40. Gruenbaum 2001:189.
41. WHO 1986:35, Hall and Ismael 1981:99.
42. See, e.g., Derby 2004.
43. This material first appeared in Boddy 1998a.
44. A paved road has since been built parallel to the Nile.
45. WHO 1986:31.

REFERENCES CITED

ARCHIVES

CMS: Church Missionary Society Archives, University of Birmingham
CO: Colonial Office
FO: Foreign Office
MECA: Middle East Centre Archive, St. Anthony's College, Oxford
NRO: National Record Office, Khartoum
PRO: Public Record Office, London: includes FO (Foreign Office), CO (Colonial Office), PRO, and Confidential Print
RCOG: Royal College of Obstetricians and Gynaecologists, London
RH: Bodleian Library of Commonwealth and African Studies at Rhodes House, Oxford
R.P.: Rathbone Papers, Liverpool University
SAD: Sudan Archive, Durham University
SOAS: School of Oriental and African Studies Archives, London
WA: Wellcome Library for the History and Understanding of Medicine, London

PRIMARY AND SECONDARY PUBLISHED SOURCES

Abbas, Mekki. 1952. *The Sudan Question: The Dispute over the Anglo-Egyptian Condominium, 1884–1951*. London: Faber and Faber.
ʿAbd al-Rahim (as Abdel Rahim), Muddathir. 1966. Early Sudanese Nationalism: 1900–1938. *Sudan Notes and Records* 47 (1 and 2):39–64.
———. 1969. *Imperialism and Nationalism in the Sudan*. Oxford: Clarendon.
Abdalla, Raqiya H. D. 1982. *Sisters in Affliction: Circumcision and Infibulation in Africa*. London: Zed.
ʿAbdel Halim, Ahmed. 1939. Native Medicine and Ways of Treatment in the Northern Sudan. *Sudan Notes and Records* 22(1):27–48.
Abu Lughod, Lila. 1986. *Veiled Sentiments*. Berkeley: University of California Press.
Abusharaf, Rogaia Mustafa. 2001a. Revisiting Feminist Discourses on Infibulation: Responses from Sudanese Feminists. In *Female "Circumcision" in Africa: Culture, Controversy, and Change*. Bettina Shell-Duncan and Ylva Hernlund, eds. Boulder CO: Lynne Reinner, pp. 151–66.
Abusharaf, Rogaia Mustafa. 2001b. Virtuous Cuts: Female Genital Circumcision in an African Ontology. *Differences* 12(1):112–40.
Accad, Evelyne. 1989. *L'Excisée*. Trans. D. Bruner. Washington: Three Continents Press.
———. 1993. Excision: Practices, Discourses and Feminist Commitment. *Feminist Issues* 13 (2):47–68.

Adams, William Y. 1984. *Nubia: Corridor to Africa*. Princeton: Princeton University Press.

Alford, Henry S. L., and W. Denniston Sword. 1969 (1898). *The Egyptian Soudan, Its Loss and Recovery*. New York: Negro Universities Press.

'Ali, Abbas Ibrahim Muhammad. 1972. *The British, the Slave Trade and Slavery in the Sudan, 1820–1881*. Khartoum: Khartoum University Press.

'Ali, Taisier, and Jay O'Brien. 1984. Labor, Community, and Protest in Sudanese Agriculture. In: *The Politics of Agriculture in Tropical Africa*. Jonathan Barker, ed. London: Sage, pp. 205–38.

Al-Safi, Ahmad. 1970. *Native Medicine in the Sudan: Sources, Conception, and Methods*. Khartoum: University of Khartoum Press.

Al-Shahi, Ahmed. 1986. *Themes from Northern Sudan*. London: Ithaca.

Anderson, Benedict. 1983. *Imagined Communities*. London: Verso.

Anderson, J.N.D. 1970 (1955). *Islamic Law in Africa*. London: Frank Cass.

Anderson, R. G. 1908. Medical Practices and Superstitions amongst the People of Kordofan. *Third Report of the Wellcome Research Laboratories*. A. Balfour, ed. Khartoum: Department of Education, Sudan Government.

———. 1911. Some Tribal Customs in Their Relation to Medicine and Morals of the Nyam-Nyam and Gour People Inhabiting the Eastern Bahr-El-Ghazal. *Fourth Report of the Wellcome Research Laboratories*. A. Balfour, ed. Khartoum: Department of Education, Sudan Government.

Arnold, David. 1993. *Colonizing the Body: State Medicine and Epidemic Disease in Nineteenth-Century India*. Berkeley: University of California Press.

Arthur, George, Sir. 1920. *Life of Lord Kitchener*. v.1. London: Macmillan.

Artin, Yacoub Pasha. 1911. *England in the Sudan*. Trans. George Robb. London: Macmillan.

Asad, Talal. 1970. *The Kababish Arabs*. London: C. Hurst.

———, ed. 1973. Introduction to *Anthropology and the Colonial Encounter*. New York: Humanities Press.

Aziz, F. A. 1980. Gynaecologic and Obstetric Complications of Female Circumcision. *International Journal of Gynaecology and Obstetrics* 17:560–63.

Badri, Babakr (Babikr Bedri). 1969. *The Memoirs of Babikr Bedri*. Yousef Bedri and George Scott, trans. London: Oxford University Press.

Baker, Samuel White. 1888 (1866). *Albert N'Yanza, Great Basin of the Nile*. London: Macmillan.

Balfour, Andrew, ed. 1904. *First Report of the Wellcome Tropical Research Laboratories at the Gordon Memorial College Khartoum*. Khartoum: Department of Education, Sudan Government.

Balfour, Andrew. 1920. *War against Tropical Disease, Being Seven Sanitary Sermons Addressed to All Interested in Tropical Hygiene and Administration*. London: Baillière, Tindall & Cox.

Balfour, Elliot. 1999. The District Commissioner's Tale. In *Sudan Canterbury Tales*. D. Hawley, ed. Wilby, Norwich: Michael Russell, pp. 38–88.

Bardach, Ann L. 1993. Tearing Off the Veil. *Vanity Fair* 56 (8 August):122–27, 154–58.

Barker-Benfield, Ben. 1975. Sexual Surgery in Late-Nineteenth-Century America. *International Journal of Health Services* 5 (2):279–98.

Barnes, Virginia L., and J. Boddy. 1994. *Aman: The Story of a Somali Girl.* Toronto: Knopf.

Bawa Yamba, Christian. 1990. *Permanent Pilgrims: An Anthropological Study of the Role of Pilgrimage in the Lives of West African Muslims in Sudan.* Stockholm: Dept. of Social Anthropology, University of Stockholm.

Bayoumi, Ahmed. 1979. *The History of Sudan Health Services.* Nairobi: Kenya Literature Bureau.

Beasley, Ina. 1992. *Before the Wind Changed.* J. Starkey, ed. Oxford: Oxford University Press.

Bell, Heather. 1998. Midwifery Training and Female Circumcision in the Inter-War Anglo-Egyptian Sudan. *Journal of African History* 39:293–312.

———. 1999. *Frontiers of Medicine in the Anglo-Egyptian Sudan, 1899–1940.* Oxford: Clarendon.

Bell, Kirsten. 2005. Genital Cutting and Western Discourses on Sexuality. *Medical Anthropology Quarterly* 19(2):125–48.

Bermingham, Jack, and Robert O. Collins. 1984. The Thin White Line. In *The British in the Sudan, 1898–1956: The Sweetness and the Sorrow.* R. O. Collins and F. M. Deng, eds. London: Macmillan, pp. 172–215.

Bernal, Victoria. 1995. Cotton and Colonial Order in Sudan: A Social History with Emphasis on the Gezira Scheme. In *Cotton, Colonialism, and Social History in Sub-Saharan Africa*, Allen Isaacman and Jean Hay, eds. London: James Currey, pp. 96–118.

———. 1997. Colonial Moral Economy and the Discipline of Development: The Gezira Scheme and "Modern" Sudan. *Cultural Anthropology* 12(4):447–79.

Beshir, Mohamed Omer. 1969. *Educational Development in the Sudan, 1898–1956.* Oxford: Clarendon.

———. 1974. *Revolution and Nationalism in the Sudan.* London: Rex Collings.

Beswick, Stephanie F. 1995. Master-Servant Relations in the Sudan 1898–1956. *Michigan Academician* 27:441–63.

Bhabha, Homi. 1997. Of Mimicry and Man: The Ambivalence of Colonial Discourse. In *Tensions of Empire: Colonial Cultures in a Bourgeois World.* Frederick Cooper and Ann Stoler, eds. Berkeley: University of California Press, pp. 152–60.

Bishop, Jeffrey P. 2004. Modern Liberalism, Female Circumcision, and the Rationality of Traditions. *Journal of Medicine and Philosophy* 29(4):473–97.

Boddy, Janice. 1989. *Wombs and Alien Spirits: Women, Men and the Zar Cult in Northern Sudan.* Madison: University of Wisconsin Press.

———. 1995. Managing Tradition: "Superstition" and the Making of National Identity among Sudanese Women Refugees. In *The Pursuit of Certainty: Religious and Cultural Formulations.* Wendy James, ed., London: Routledge, pp. 17–44.

———. 1997. Womb as Oasis: The Symbolic Context of Pharaonic Circumcision in Rural Northern Sudan. In *The Gender/Sexuality Reader: Culture, History, Political Economy.* Roger N. Lancaster and Micaela di Leonardo, eds. New York: Routledge, pp. 309–24. (revised from 1982).

Boddy, Janice. 1998a Remembering Amal: On Birth and the British in Northern Sudan. In *Pragmatic Women and Body Politics*. Margaret Lock and Patricia Kaufert, eds. Cambridge: Cambridge University Press, pp. 28–57.

———. 1998b. Violence Embodied? Female Circumcision, Gender Politics, and Cultural Aesthetics. In *Rethinking Violence against Women*. R. Dobash and R. Dobash, eds. Thousand Oaks, CA: Sage, pp. 77–110.

———. 1998c. Embodying Ethnography. In *Bodies and Persons: Perspectives from Africa and Melanesia*. M. Lambek and A. Strathern, eds. Cambridge: Cambridge University Press, pp. 252–73.

———. 2002a. Tacit Containment: Social Value, Embodiment, and Gender Practice in Northern Sudan. In *Religion and Sexuality in Cross-Cultural Perspective*. Stephen J. Ellingston and M. Christian Green, eds. New York: Routledge, pp. 187–221.

———. 2002b. Genealogy, Endogamy, and Alliance in Northern Sudan. Paper presented at the American Anthropology Association Meetings, New Orleans, Nov.

———. 2003. Barbaric Custom and Colonial Science: Teaching the Female Body in the Anglo-Egyptian Sudan. *Social Analysis*, 47(2), Special Issue: *Illness and Irony*, Michael Lambek and Paul Antze, eds., pp. 60–81.

———. 2005. Purity and Conquest in the Anglo-Egyptian Sudan. In *Transgressive Surfaces: Dirt, Undress, and Difference in Comparative Perspective*, Adeline Masquelier, ed. Bloomington: University of Indiana Press, pp. 168–89.

Boserup, Ester. 1970. *Women's Role in Economic Development*. London: Allen and Unwin.

Boulware-Miller, Kay. 1985. Female Circumcision: Challenges to the Practice as a Human Rights Violation. *Harvard Women's Law Journal* 8:155–77.

Bourdieu, Pierre. 1990. *The Logic of Practice*. Translated by R. Nice. Cambridge: Polity Press.

Brown, Isaac B. 1866. *On the Curability of Certain Forms of Insanity, Epilepsy, Catalepsy, and Hysteria in Females*. London: Robert Hardwicke.

Bruce, James. 1790. *Travels to Discover the Source of the Nile*. Edinburgh : G.G.J. and J. Robinson. 5 vols.

Burckhardt, John Lewis. 1822 (1819). *Travels in Nubia*. 2nd ed. London: John Murray.

Burke, Timothy. 1996. *Lifebuoy Men, Lux Women*. Durham, NC: Duke University Press.

Burleigh, Bennet, 1899. *Khartoum Campaign* . 3rd ed. London: Chapman & Hall.

Burton, Sir Richard Francis. 1964 (1855). *Personal Narrative of a Pilgrimage to Al-Madinah and Meccah*, 2 vols. Toronto: General.

Callaway, Helen. 1987. *Gender, Culture and Empire: European Women in Colonial Nigeria*. London: Macmillan.

Cannadine, David. 1983. The Context, Performance, and Meaning of Ritual: The British Monarchy and the "Invention of Tradition," c. 1820–1977. In *The Invention of Tradition*. E. Hobsbawm and T. Ranger, eds. Cambridge: Cambridge University Press, pp. 101–64.

Churchill, Winston. 1987 (1899). *The River War: the Sudan, 1898*. Sevenoaks: Sceptre.

Clark, Carolyn M. 1980. Land and Food, Women and Power, in Nineteenth Century Kikuyu. *Africa* 50(4):357–70.

Cohn, Bernard. 1996. *Colonialism and Its Forms of Knowledge: The British in India*. Princeton, NJ: Princeton University Press.

Collins, Robert O. 1971. *Land beyond the Rivers: The Southern Sudan, 1898–1918*. New Haven: Yale University Press.

———. 1983. *Shadows in the Grass: Britain in the Southern Sudan, 1918–1956*. New Haven: Yale University Press.

———. 1984. Introduction to Collins, Robert O., and Francis M. Deng, eds. *The British in the Sudan, 1898–1956 : The Sweetness and the Sorrow*. London: Macmillan, pp. 1–27.

Collins, Robert O., and Deng, Francis Mading, eds. 1984. *The British in the Sudan, 1898–1956 : The Sweetness and the Sorrow*. London: Macmillan.

Comaroff, Jean, and John Comaroff. 1991. *Of Revelation and Revolution (Vol. 1): Christianity, Colonialism, and Consciousness in South Africa*. Chicago: University of Chicago Press.

———. 1992. *Ethnography and the Historical Imagination*. Boulder: Westview Press.

———. 1997. *Of Revelation and Revolution (Vol. 2): The Dialectics of Modernity on a South African Frontier*. Chicago: University of Chicago Press.

Compton, Piers. 1974. *The Last Days of General Gordon*. London: Robert Hale.

Connerton, Paul. 1989. *How Societies Remember*. Cambridge: Cambridge University Press.

Conrad, Joseph. 1999 (1899). *Heart of Darkness*. D. Goonetilleke, ed. Peterborough, ON: Broadview Press.

Constantinides, Pamela. 1972. Sickness and the Spirits: A Study of the "Zar" Spirit Possession Cult in the Northern Sudan. Ph.D. dissertation, University of London.

———. 1991. The History of the Zar in Sudan. In *Women's Medicine: The Zar-Bori Cult in Africa and Beyond*. I. M . Lewis, Ahmed al-Safi, and Sayyid Hurreiz, eds. Edinburgh: Edinburgh University Press for the International African Institute, pp. 83–99.

Cook, Robert. 1979. Damage to Physical Health from Pharaonic Circumcision (Infibulation) of Females. In *Traditional Practices Affecting the Health of Women and Children*. Alexandria: WHO/EMRO Technical Publication No. 2, pp. 53–69.

Coray, Michael S. 1984. In the Beginning. In *The British in the Sudan, 1898–1956: The Sweetness and the Sorrow*. R. O. Collins and F. M. Deng, eds., London: Macmillan, pp. 28–63.

Coventry, Martha. 1998. The Tyranny of the Esthetic: Surgery's Most Intimate Violation. *On the Issues* (summer), *http://www.ontheissuesmagazine.com/su98coventry.html*.

Cromer, Evelyn Baring, 1908. *Modern Egypt*. 2 vols. London: Macmillan.

Crowfoot, J. W. 1919. Angels of the Nile. *Sudan Notes and Records* 2(3): 183–97.

———. 1922. Wedding Customs in the Northern Sudan. *Sudan Notes and Records* 5(1):1–28.

Cruikshank, Alexander. 1985. The Golden Age of Tropical Medicine and Its Impact on the Modernization of the Sudan. In *Modernization in the Sudan: Essays in Honor of Richard Hill*. M. W. Daly, ed. New York: L. Barber Press, pp. 85–100.

Daly, M. W. 1984. Principal Office-Holders in the Sudan Government, 1895–1955. *International Journal of African Historical Studies* 17(2):309–16.

———. 1986. *Empire on the Nile: The Anglo-Egyptian Sudan 1898–1934*. Cambridge: Cambridge University Press.

———. 1991. *Imperial Sudan: the Anglo-Egyptian Condominium, 1934–1956*. Cambridge: Cambridge University Press.

Daly, M. W., and Jane R. Hogan. 2005. *Images of Empire: Photographic Sources for the British in the Sudan*. Leiden: Brill.

Davin , Anna. 1997 (1978). Imperialism and Motherhood. In *Tensions of Empire*. F. Cooper and A. Stoler, eds., Berkeley: University of California Press, pp. 87–151.

Davison, Jean. *Voices from Mutira: Lives of Rural Gikuyu Women*. Boulder, CO: Lynne Reinner.

Delaney, Carol. 1991. *The Seed and the Soil: Gender and Cosmology in Turkish Village Society*. Berkeley: University of California Press.

Deng, Francis M., and M. W. Daly, eds., 1989. *Bonds of Silk: The Human Factor in the British Administration of the Sudan*. East Lansing: Michigan State University Press.

Derby, C. Nana. 2004. The Case Against the Medicalization of Female Genital Mutilation. *Canadian Woman Studies* 24 (1):95–100.

Douglas, Mary. 1966. *Purity and Danger*. London: Routledge & Kegan Paul.

Doyle, Arthur Conan. 1898. *The Tragedy of the Korosko*. London: Smith, Elder.

Eksteins, Modris. 1985. History and Degeneration: Of Birds and Cages. In *Degeneration: The Dark Side of Progress*. J. Edward Chamberlin and Sander L. Gilman, eds. New York: Columbia University Press, pp. 1–23.

El Dareer, Asma. 1982. *Woman, Why Do You Weep? Circumcision and Its Consequences*. London: Zed.

El Tayib, Abdalla. 1955. The Changing Customs of the Riverain Sudan. *Sudan Notes and Records* 26(2):146–58.

El Tayib, D. Griselda. 1987. Women's Dress in the Northern Sudan. In *The Sudanese Woman*. Susan Kenyon, ed. Khartoum: Graduate College Publications 19, University of Khartoum, pp. 40–66.

Esposito, John L., ed. 2003. *The Oxford Dictionary of Islam*. New York: Oxford University Press.

Evans-Pritchard, E. E. 1940. *The Nuer*. Oxford: Clarendon.

———. 1962. *Essays in Social Anthropology*. London: Faber & Faber.

Fabian, Johannes. 1983. *Time and the Other: How Anthropology Makes Its Object*. New York: Columbia University Press.

Farwell, Byron. 1973. *Queen Victoria's Little Wars*. London: Allen Lane.

Fausset, Michael. 1939. *Pilate Pasha*. London: Jonathan Cape.

Fausto-Sterling, Anne. 2003. Sexing the Body. In *Constructing Sexualities*. S. La-Font, ed., Upper Saddle River, NJ: Prentice Hall, pp. 18–22.

Fildes, Valerie, Lara Marks, and Hilary Marland, eds. 1992. *Women and Children First: International Maternal and Infant Welfare, 1870–1945*. New York: Routledge.

Foucault. Michel. 1990. *The History of Sexuality, Vol 1*. New York: Vintage.

Frost, John W. 1984. Memories of the Sudan Civil Service. In Robert O. Collins and Francis M. Deng eds. *The British in the Sudan, 1898–1956: The Sweetness and the Sorrow*. London: Macmillan, pp. 65–103.

Gaitskell, Arthur. 1959. *Gezira: A Story of Development in the Sudan*. London: Faber and Faber.

Gilliam, Angela. 1991. Women's Equality and National Liberation. In *Third World Women and the Politics of Feminism*. C. T. Mohanty, A. Russo, and L. Torres, eds. Bloomington: University of Indiana Press, pp. 215–36.

Gilman, Sander. 1985a. Introduction to *Degeneration: The Dark Side of Progress*. J. Edward Chamberlin and Sander L. Gilman, eds. New York: Columbia University Press, pp. ix–xiii.

———. 1985b. *Difference and Pathology: Stereotypes of Sexuality, Race and Madness*. Ithaca: Cornell University Press.

Gilsenan, Michael. 1982. *Recognizing Islam*. London: Croom Helm.

Gramsci, Antonio. 1971. *Selections from the Prison Notebooks*. Quintin Hoare and Geoffrey N. Smith, eds. and trans., New York: International.

Greaves, H.R.G. 1931. *The League Committees and World Order*. Oxford: Oxford University Press.

Gruenbaum, Ellen. 1982. The Movement against Clitoridectomy and Infibulation in Sudan: Public Health Policy and the Women's Movement. *Medical Anthropology Newsletter* 13(2):4–12.

———. 1991. The Islamic Movement, Development, and Health Education: Recent Changes in the Health of Rural Women in Central Sudan. *Social Science and Medicine* 33 (6):637–45.

———. 1996. The Cultural Debate over Female Circumcision: The Sudanese Are Arguing This One Out for Themselves. *Medical Anthropology Quarterly* 10(4):455–75.

———. 2001. *The Female Circumcision Controversy: An Anthropological Perspective*. Philadelphia: University of Pennsylvania Press.

Gunning, Isabelle R. 1992. Arrogant Perception, World-Traveling and Multicultural Feminism: The Case of Genital Surgeries. *Columbia Human Rights Law Review* 23(8):188–248.

Hale, Sondra. 1996. *Gender Politics in Sudan: Islamism, Socialism, and the State*. Boulder, CO: Westview.

———. 2005. Colonial Discourse and Ethnographic Residuals: The "Female Circumcision" Debate and the Politics of Knowledge. In *Female Circumcision and the Politics of Knowledge*. O. Nnaemeka, ed. Westport, CO: Praeger, pp. 209–18.

Halkett, George Roland. 1885. *The Egyptian Red Book: A Political Satire*. Edinburgh: W. Blackwood.

Hall, Marjorie, and Bakhita Amin Ismail. 1981. *Sisters under the Sun: The Story of Sudanese Women*. London: Longman.

Hargey, Taj M. 1981. The Suppression of Slavery in the Sudan, 1898–1939. D. Phil. Dissertation, St. Anthony's College, Oxford University.

Harrington, Peter, and Frederic A. Sharp, eds. 1998. *Omdurman 1898: The Eywitnesses Speak*. London: Greenhill Books.

Hayes, Rose Oldfield. 1975. Female Genital Mutilation, Fertility Control, Women's Roles, and the Patrilineage in Modern Sudan: A Functional Analysis. *American Ethnologist* 2:617–33.

Helly, Dorothy O. 1987. *Livingstone's Legacy: Horace Waller and Victorian Mythmaking*. Athens, OH: Ohio University Press.

Henderson, Kenneth David Druitt. 1954. *The Making of the Modern Sudan: The Life and Letters of Sir Douglas Newbold*. London: Faber & Faber.

———. 1965 (1956). *Sudan Republic*. London: E. Benn.

Henty, George Alfred. 1892. *The Dash for Khartoum: A Tale of the Nile Expedition*. London: Blackie.

———. 1903. *With Kitchener in the Soudan: A Story of Atbara and Omdurman*. London: Blackie.

Hetherington, S. J. 1989. *Katharine Atholl 1874–1960: Against the Tide*. Aberdeen: Aberdeen University Press.

Hill, Richard. 1970. *On the Frontiers of Islam: Two Manuscripts Concerning the Sudan under Turco-Egyptian Rule, 1822–1845*. Oxford: Clarendon.

Hills-Young, E. 1940. Charms and Customs Associated with Childbirth. *Sudan Notes and Records* 23(2):331–36.

———. 1943. The Training of Midwives in the Sudan. *Nursing Times* (Jan.).

Holland, Eardley. 1946. *President's Report on His Visit to the Sudan, December, 1945*. London: Annual Report of the Royal College of Physicians and Gynaecologists.

Holt, P. M. 1966. *Egypt and the Fertile Crescent 1516–1922: A Political History*. Ithaca: Cornell University Press.

———. 1970. *The Mahdist State in the Sudan, 1881–1898*. Oxford, Clarendon.

Holt, P. M., and M. Daly. 1979. *The History of the Sudan*. London: Weidenfeld & Nicholson.

Holy, Ladislav. 1988. Gender and Ritual in an Islamic Society: The Berti of Darfur. *Man n.s.* 23:469–87.

———. 1991. *Religion and Custom in a Muslim Society: The Berti of Sudan*. Cambridge: Cambridge University Press.

Hosken, Fran. 1982. *The Hosken Report*. Lexington, MA: Women's International Network News. 3rd ed.

Hunt, Nancy Rose. 1999. *A Colonial Lexicon: Of Birth Ritual, Medicalization and Mobility in the Congo*. Durham, NC: Duke University Press.

Hyam, Ronald. 1990. *Empire and Sexuality: The British Experience*. Manchester: Manchester University Press.

Ibn Khaldun. 1967. *The Muqaddimah*. F. Rosenthal, trans.; N. J. Dawood, ed. Princeton: Princeton University Press.

Ibrahim, Abdullahi Ali. 1988. Breaking the Pen of Harold MacMichael. *International Journal of African Historical Studies* 21(2):217–31.

Ibrahim, Ahmed Uthman Muhammad. 1985. *The Dilemma of British Rule in the Nuba Mountains, 1898–1947*. Khartoum: Graduate College Publications, no. 15, University of Khartoum.

Isaacman, Allen, and Richard Roberts. 1995. Introduction to *Cotton, Colonialism, and Social History in Sub-Saharan Africa*. A. Isaacman and R. Roberts, eds. London: James Currey, pp. 1–39.

Jackson, Henry Cecil. 1954. *Sudan Days and Ways*. London: Macmillan.

———. 1955. *Behind the Modern Sudan*. London: Macmillan.

———. 1960. *Pastor on the Nile*. London: S.P.C.K.

James, Stanlie M., and Claire C. Robertson, eds. 2002. *Genital Cutting and Transnational Sisterhood: Disputing U.S. Polemics*. Urbana: University of Illinois Press.

James, Wendy. 1977. The Funj Mystique: Approaches to a Problem of Sudan History. In *Text and Context: The Social Anthropology of Tradition*. Ravindra K. Jain,. ed. Philadelphia: ISHI, pp. 95–133.

———. 1979. *'Kwanim Pa: The Making of the Uduk People*. Oxford: Oxford University Press.

———. 1988. *The Listening Ebony: Moral Knowledge, Religion, and Power among the Uduk of Sudan*. Oxford: Clarendon.

Jayawardena, Kumari. 1995. *The White Woman's Other Burden: Western Women and South Asia during British Colonial Rule*. New York: Routledge.

Johnson, Douglas. 1988. The Sudan under the British. *Journal of African History* 29, 1988:541–46.

Johnson, Peter. 1985. *Gordon of Khartoum*. Wellingborough: Patrick Stephens.

Judd, Denis. 1985. Gordon of Khartoum: The Making of an Imperial Martyr. *History Today* 35 (Jan.):19–25.

Kapteijns, Lidwien. 1984. *Mahdist Faith and Sudanic Tradition : The History of the Masalit Sultanate 1870–1930*. Boston: K.P.I.

Kapteijns, Lidwien, and Jay Spaulding. 1982. Precolonial Trade between States in the Eastern Sudan, ca 1700–ca 1900. *African Economic History* 11, pp. 29–62.

Kellner, Nancy I. 1993. Under the Knife: Female Genital Mutilation as Child Abuse. *Journal of Juvenile Law* 14:118–32.

Kendall, E. M. 1952. A Short History of the Training of Midwives in the Sudan. *Sudan Notes and Records* 33(1):42–53.

Kennedy, John G. 1978. *Nubian Ceremonial Life*. Berkeley: University of California Press.

Kenrick, Rosemary. 1987. *Sudan Tales: Recollections of Some Sudan Political Service Wives, 1926–56*. Cambridge: Oleander Press.

Kenyatta, Jomo. 1961 (1938). *Facing Mount Kenya: The Tribal Life of the Gikuyu*. London: Mercury.

Kenyon, Susan M. 1991. The Story of a Tin Box. In *Women's Medicine: The Zar-Bori Cult in Africa and Beyond*. I. M. Lewis, A. al-Safi, and S. Hurreiz, eds. Edinburgh: Edinburgh University Press for the International African Institute, pp. 100–117.

———. 1995. Zar as Modernization in Contemporary Sudan, *Anthropological Quarterly* 68(2):107–20.

Kenyon, Susan M. 2004. *Five Women of Sennar: Culture and Change in Central Sudan.* 2nd ed. Long Grove, IL: Waveland.

Keun, Odette. 1930. *A Foreigner Looks at the British Sudan.* London: Faber & Faber.

Khalid, Mansour. 1990. *The Government They Deserve: The Role of the Elite in Sudan's Political Evolution.* London: Kegan Paul.

Kipling, Rudyard. 1900. Fuzzy Wuzzy. In *Selected Works of Rudyard Kipling.* Vol. 3. New York: P. F. Collier, pp. 407–408.

———. 1909. Little Foxes. In *Actions and Reactions*, Rudyard Kipling. Toronto: Macmillan, pp. 225–58.

Kirby, Vicki. 1987. On the Cutting Edge: Feminism and Clitoridectomy. *Australian Feminist Studies 5* (Summer):35–55.

Kirk-Greene. 1982. The Sudan Political Service: A Profile in the Sociology of Imperialism. *International Journal of African Historical Studies* 15(1):21–48.

Kratz, Corinne. 1994. Appendix A: Initiation and Circumcision. In *Affecting Performance: Meaning, Movement, and Experience in Okiek Women's Initiation.* Washington, DC: Smithsonian Institution Press.

Kronenberg, A., and W. Kronenberg. 1965. Parallel Cousin Marriage In Mediaeval and Modern Nubia, Part 1. *Kush* 13:241–60.

Kuper, Adam. 1983. *Anthropology and Anthropologists: The Modern British School.* London: Routledge & Kegan Paul.

Lan, David. 1985. *Guns and Rain: Guerillas and Spirit Mediums in Zimbabwe.* Oxford: James Currey.

Lane, Edward W. 1973 (1836). *Manners and Customs of the Modern Egyptians.* Toronto: General.

Langley, Michael. 1950. *No Woman's Country: Travels in the Anglo-Egyptian Sudan.* London: Jarrolds.

Laqueur, Thomas. 1990. *Making Sex: Body and Gender from the Greeks to Freud.* Cambridge, MA: Harvard University Press.

Leakey, Louis S. B. 1977. *The Southern Kikuyu before 1903.* Vols. 1–3. London: Academic.

Lewis, I. M ., Ahmed al-Safi, and Sayyid Hurreiz, eds. 1991. *Women's Medicine: The Zar-Bori Cult in Africa and Beyond.* Edinburgh: Edinburgh University Press for the International African Institute.

Lewis, Jane. 1980. *The Politics of Motherhood: Child and Maternal Welfare in England, 1900–1939.* London: Croom Helm.

Lienhardt, Godfrey. 1961. *Divinity and Experience: The Religion of the Dinka.* Oxford: Oxford University Press.

Lightfoot-Klein, Hanny. 1989. *Prisoners of Ritual.* New York: Harrington Park Press.

Lovejoy, Paul. 1983. *Transformation in Slavery: A History of Slavery in Africa.* Cambridge: Cambridge University Press.

Low, Sidney. 1914. *Egypt in Transition.* London: Smith, Elder & Co.

Lugard, F.J.D. 1923. *The Dual Mandate in British Tropical Africa.* 2nd ed. Edinburgh: W. Blackwood.

Lyons, Harriet. 1981. Anthropologists, Moralities, and Relativities: The Problem of Genital Mutilations. *Canadian Review of Sociology and Anthropology* 18(4):499–518.

Mackie, Gerry. 2003. Female Genital Cutting: A Harmless Practice? *Medical Anthropology Quarterly* 17(2):135–58.

MacMichael, Harold A. 1922. *A History of the Arabs in the Sudan* Vols. 1, 2. Cambridge: Cambridge University Press.

———. 1932. Introduction to *The Pagan tribes of the Nilotic Sudan*. C. G. Seligman and Brenda Seligman, London: Routledge & Kegan Paul.

———. 1954. *The Sudan*. London: Ernest Benn.

Magnus, Philip M. 1958. *Kitchener, Portrait of an Imperialist*. London: Murray.

Mahmood, Saba. 2001. Rehearsed Spontaneity and the Conventionality of Ritual: Disciplines of Salât. *American Ethnologist* 28(4):827–53.

———. 2004. *Politics of Piety: The Islamic Revival and the Feminist Subject*. Princeton, NJ: Princeton University Press.

Makris, G. P. 2000. *Changing Masters: Spirit Possession and Identity Construction among Slave Descendants and Other Subordinates in the Sudan*. Evanston, IL: Northwestern University Press.

Malkki, Liisa. 1995. *Purity and Exile*. Chicago: University of Chicago Press.

Mana, Lati. 1998. *Contentious Traditions: The Debate on Sati in Colonial India*. Berkeley: University of California Press.

Manderson, Lenore. 1998. Shaping Reproduction: Maternity in Early Twentieth-Century Malaysia. In *Maternities and Modernities: Colonial and Postcolonial Experiences in Asia and the Pacific*. Kalpana Ram and Margaret Jolly, eds. Cambridge: Cambridge University Press, pp. 26–49.

Mangan, J. A. 1982. The Education of an Elite Imperial Administration: The Sudan Political Service and the British Public School System. *International Journal of African Historical Studies* 15(4):671–99.

Marlowe, John. 1969. *Mission to Khartum: The Apotheosis of General Gordon*. London: Gollancz.

Martin, Emily. 1991. *The Woman in the Body*. Boston: Beacon.

Mason, A.E.W. 2002 (1902). *The Four Feathers*. New York: Simon and Schuster.

Masquelier, Adeline. 2001. *Prayer Has Spoiled Everything: Possession, Power, and Identity in an Islamic Town in Niger*. Durham, NC: Duke University Press.

Mayo, Katherine. 1927. *Mother India*. New York: Harcourt Brace.

McClintock, Anne. 1995. *Imperial Leather: Race, Gender and Sexuality in the Colonial Contest*. New York: Routledge.

Meillassoux, Claude. 1986. *The Anthropology of Slavery*. Chicago: University of Chicago Press.

Messick, Brinkley. 1993. *The Calligraphic State: Textual Domination and History in a Muslim Society*. Berkeley: University of California Press.

Middleton, John. 1965 (1953). *The Central Tribes of the North Eastern Bantu: The Kikuyu, including Embu, Meru, Mbere, Chuka, Mwimbi, Tharaka, and the Kamba of Kenya* (rev. ed.) London: International African Institute.

Miers, Suzanne, and Igor Kopytoff, eds. 1977. *Slavery in Africa: Historical and Anthropological Perspectives*. Madison: University of Wisconsin Press.

Mitchell, Timothy. 1991. *Colonizing Egypt*. Cambridge: Cambridge University Press.

Mohamud, Omar A. 1991. Female Circumcision and Child Mortality in Urban Somalia. *Genus* 67:203–23.

Mohanty, Chandra T. 1991. Under Western Eyes: Feminist Scholarship and Colonial Discourse. In *Third World Women and the Politics of Feminism*, C. T. Mohanty, A. Russo, and L. Torres, eds. Bloomington: Indiana University Press, pp. 51–80.

Mowafi, Reda. 1981. *Slavery, Slave Trade and Abolition Attempts in Egypt and the Sudan 1820–1882*. Stockholm: Esselte Studium.

Murray, Jocelyn. 1974. The Kikuyu Female Circumcision Controversy, with Special Reference to the Church Missionary Society's "Sphere of Influence." Ph.D. diss., University of California, Los Angeles.

Nadel, S. F. 1947 *The Nuba: An Anthropological Study of the Hill Tribes of Kordofan*. New York: AMS Press.

Nagel, Thomas. 1986. *The View From Nowhere*. New York: Oxford University Press.

Niblock , Tim. 1987. *Class and Power in the Sudan: The Dynamics of Sudanese Politics, 1898–1985*. Albany: State University of New York Press.

Nnaemeka, Obioma, ed. 2005. *Female Circumcision and the Politics of Knowledge: African Women in Imperialist Discourses*. Westport, CT: Praeger.

Nye, Robert A. 1985 Sociology and Degeneration: The Irony of Progress. In *Degeneration: The Dark Side of Progress*. J. Edward Chamberlin and Sander L. Gilman, eds. New York: Columbia University Press, pp. 49–72.

Obermeyer, Carla M. 1999. Female Genital Surgeries: The Known, the Unknown, and the Unknowable. *Medical Anthropology Quarterly* 13(1):79–106.

———. 2003. The Health Consequences of Female Circumcision: Science, Advocacy, and Standards of Evidence. *Medical Anthropology Quarterly* 17(3):394–412.

Obiora, L. Ademe. 1997. Rethinking Polemics and Intransigence in the Campaign against Female Circumcision. *Case Western Reserve Law Review* 47:275–378.

———. 2005. The Anti-Female Circumcision Campaign Deficit. In *Female Circumcision and the Politics of Knowledge*. O. Nnaemeka, ed. Westport CT: Praeger, pp. 183–208.

O'Brien, Jay. 1983. The Formation of the Agricultural Labour Force in Sudan. *Review of African Political Economy* 26(1):15–34.

———. 1984. The Political Economy of Semi-Proletarianisation under Colonialism: Sudan 1925–1950. In *Proletarianisation in the Third World*. B. Munslow and H. Finch, eds. London: Croom Helm, pp. 121–47.

———. 1988. Toward a Reconstitution of Ethnicity: Capitalist Expansion and Cultural Dynamics in Sudan. *American Anthropologist* 88:898–907.

O'Brien, Jay, and Norman O'Neill, eds. 1988. *Economy and Class in Sudan*. Aldershot, UK: Avebury.

Ohrwalder, Joseph. 1892. *Ten Years' Captivity in the Mahdi's Camp, 1882–1892*. F. R. Wingate, trans. London: Low.

Oliver, Roland. 1965. *The Missionary Factor in East Africa*. 2nd ed. London: Longmann.

O'Neill, Norman. 1988. Class and Politics in the Modern History of Sudan. In *Economy and Class in Sudan*. O'Brien and O'Neil, eds. Aldershot, UK: Avebury.

Pedersen, Susan. 1991. National Bodies, Unspeakable Acts: The Sexual Politics of Colonial Policy-Making *Journal of Modern History* 63 (Dec.):647–80.

Perham, Marjorie. 1954. Forward to *The Makng of the Modern Sudan: The Life and Letters of Sir Douglas Newbold*. K.D.D. Henderson, ed. London: Faber & Faber.

Potter, Margaret, and Alick Potter. 1984. *Everything Is Possible: Our Sudan Years*. Gloucester: Alan Sutton.

Powell, Eve Troutt. 1995. Egyptians in Black Face: Nationalism and the Representation of the Sudan in Egypt, 1919. *Harvard Middle Eastern and Islamic Review* 2(2):27–45.

———. 2003. *A Different Shade of Colonialism: Egypt, Great Britain, and the Mastery of the Sudan*. Berkeley: University of California Press.

Preston, Adrian W. 1967. Introduction to *In Relief of Gordon: Lord Wolseley's Campaign Journal of the Khartoum Relief Expedition, 1884–1885*. Wolseley, Garnet and Adrian Preston, eds. London: Hutchinson.

Prunier, Gérard. 2005. *Darfur: The Ambiguous Genocide*. London: Hurst.

Ram, Kaplana, and Margaret Jolly, eds. 1998. *Maternities and Modernities : Colonial and Postcolonial Experiences in Asia and the Pacific*. Cambridge: Cambridge University Press.

Ranger, Terence. 1983. The Invention of Tradition in Colonial Africa. In *The Invention of Tradition*. E. Hobsbawm and T. Ranger, eds. Cambridge: Cambridge University Press, pp. 211–62.

Rappaport, Roy. 1979. The Obvious Aspects of Ritual. In *Ecology, Meaning and Religion*. Richmond, CA: North Atlantic Books.

Richards, Thomas. 1990. *The Commodity Culture of Victorian Britain: Advertising and Spectacle 1851–1914*. London: Verso.

Robertson, Claire. 1996. Grassroots in Kenya: Women, Genital Mutilation, and Collective Action. *Signs* 21(3):615–42.

Robertson, Claire, and Martin A. Klein, eds. 1983. *Women and Slavery in Africa*. Madison: University of Wisconsin Press.

Rosberg, Carl G., and John Nottingham. 1966. *The Myth of "Mau-Mau": Nationalism in Kenya*. New York: Praeger.

Rothman, Barbara K. 1982. *In Labor: Women and Power in the Birthplace*. New York: W. W. Norton.

Rubin, Gayle. 1975. The Traffic in Women. In *Toward an Anthropology of Women*. Rayna Reiter, ed., New York: Free Press, pp. 157–210.

Saha, N., R. E. Hamad, and S. Mohamed. 1990. Inbreeding Effects on Reproductive Outcome in a Sudanese Population. *Human Heredity* 40:208–12.

Sahlins, Marshall. 1999. *Waiting for Foucault and Other Aphorisms*. 3rd ed. Cambridge: Prickly Pear Press.

Said, Edward. 1979. *Orientalism*. New York: Vintage.

Salih, Tayeb. 1981 (1969). *Season of Migration to the North*. Denys Johnson-Davies, trans. London: Heinemann.

Salomon, Noah. 2004. Undoing the *Mahdiyya*: The Imposition of Orthodoxy and "Indirect *Da'wa*" in the Anglo-Egyptian Sudan, 1898–1914 (*http:// www. marty-center.uchicago.edu/webforum/052004/commenta*).

Sanderson, L. Passmore. 1961. Some Aspects of the Development of Girls' Education in the Northern Sudan. *Sudan Notes and Records* 42(1, 2):91–101.

———. 1981. *Against the Mutilation of Women: The Struggle against Unnecessary Suffering.* London: Ithaca.

Sanderson, L. Passmore, and G. M . Sanderson. 1981. *Education, Religion and Politics in the Southern Sudan 1899–1964.* London: Ithaca.

Sarsfield-Hall, E. G. 1975. *From Cork to Khartoum.* Keswick: E. Sarsfield-Hall.

Scheper-Hughes, Nancy. 1991. Virgin Territory: The Male Discovery of the Clitoris. *Medical Anthropology Quarterly* 5(1):25–28.

Scheper-Hughes, Nancy, and Margaret Lock. 1987. The Mindful Body. *Medical Anthropology Quarterly* 1(1):6–41.

Seligman, C. G., and Brenda Seligman. 1932. *The Pagan Tribes of the Nilotic Sudan.* London: Routledge & Kegan Paul.

Sequeira, James H. 1931. Female Circumcision and Infibulation. *The Lancet* (Nov. 7):1054.

Shandall, A. A. 1967. Circumcision and Infibulation of Females. *Sudan Medical Journal* 5:178–212.

Sharkey, Heather J. 2002. Christians among Muslims: The Church Missionary Society in the Northern Sudan. *Journal of African History* 43(1):51–75.

———. 2003. *Living with Colonialism: Nationalism, and Culture in the Anglo-Egyptian Sudan.* Berkeley: University of California Press.

Sheehan, E. 1997. Victorian Clitoridectomy: Isaac Baker Brown and His Harmless Operative Procedure. In *The Gender/Sexuality Reader.* R. N. Lancaster and M. di Leonardo, eds. New York: Routledge, pp. 325–34.

Shell-Duncan, Bettina, and Ylva Hernlund, eds. 2000. *Female "Circumcision" in Africa: Culture, Controversy, and Change.* Boulder, CO: Lynne Reinner.

Shweder, Richard A. 2002. "What about 'Female Genital Mutilation'?" and Why Understanding Culture Matters in the First Place. In *Engaging Cultural Differences: The Multicultural Challenge in Liberal Democracies.* R. Shweder, M. Minnow, and H. R. Markus, eds. New York: Russell Sage Foundation, pp. 216–51.

———. 2005. When Cultures Collide: Which Rights? Whose Traditional Values? A Critique of the Global Anti-FGM Campaign. *In Global Justice and the Bulwarks of Localism: Human Rights in Context,* C. Eisgruber and A. Sajo, eds. Leiden: Martinus Nijhoff, pp. 181–200.

Sikainga, Ahmad A. 1995. Shari'a Courts and Manumission of Female Slaves in the Sudan, 1898–1939. *International Journal of African Historical Studies* 28(1):1–23.

———. 1996. *Slaves into Workers: Emancipation and Labor in Colonial Sudan.* Austin: University of Texas Press.

Slack, Alison T. 1984. Female Circumcision: A Critical Appraisal. *Human Rights Quarterly* 10 (Nov.):437–86.

Slatin, Rudolf Carl. 1896. *Fire and Sword in the Sudan; a Personal Narrative of Fighting and Serving the Dervishes, 1879–1895.* F. R. Wingate, trans. London: Arnold.

Snively, Judith. 1994. Female Bodies, Male Politics: Women and the Female Circumcision Controversy in Kenyan Colonial Discourse. Unpublished M.A. thesis, Department of Anthropology, McGill University.

Spaulding, Jay. 1982. The Misfortunes of Some—the Advantages of Others: Land Sales by Women in Sinnar. In *African Women and the Law*. Margaret Jean Hay and Marcia Wright, eds. Boston: Boston University, African Studies Center, pp. 2–18.

———. 1985. *The Heroic Age in Sinnar*. East Lansing: African Studies Center, Michigan State University.

———. 1988. The Business of Slavery in the Central Anglo-Egyptian Sudan, 1910–1930. *African Economic History* 17(1):23–44.

Spaulding, Jay, and Stephanie Beswick. 1995. Sex, Bondage and the Market: The Emergence of Prostitution in Northern Sudan, 1750–1950. *Journal of the History of Sexuality* 5(4):512–34.

Spencer, John. 1985. *The Kenya African Union*. Boston: KPI.

Squires, H. C. 1958. *The Sudan Medical Service: An Experiment in Social Medicine*. London: William Heinemann.

Starkey, J.C.M. 1992. Girl's Education in the Condominium. Appendix III. In *Before the Wind Changed*, by Ina Beasley. Janet Starkey, ed. Oxford: Oxford University Press, pp. 416–19.

Steele, David. 1998. Lord Salisbury, the "False Religion" of Islam, and the Reconquest of the Sudan. In *Sudan: The Reconquest Reappraised*. E. M. Spiers, ed. London: Frank Cass, pp. 11–33.

Stevens, G. W. 1898. *With Kitchener to Khartoum*. Edinburgh: Wm. Blackwood & Sons.

Stoler, Ann. 1996. *Race and the Education of Desire*. Durham, NC: Duke University Press.

———. 2002. *Carnal Knowledge and Imperial Power*. Berkeley: University of California Press.

Strathern, Marilyn. 1988. *The Gender of the Gift*. Berkeley: University of California Press.

Sudan Government. n.d. Memorandum on the Immigration and Distribution of West Africans in the Sudan Khartoum (c. 1938).

———. 1982. *Sudan Fertility Survey 1979*. Khartoum: Department of Statistics.

Summers, Carol. 1991. Intimate Colonialism: The Imperial Production of Reproduction in Uganda, 1907–1925. *Signs* 16:787–807.

Talle, Aud. 1993. Transforming Women into "Pure" Agnates: Aspects of Female Infibulation in Somalia. In *Carved Flesh, Cast Selves: Gendered Symbols and Social Practices*. V. Broch-Due, I. Rudie, and T. Bleie, eds. Oxford: Berg, pp. 83–107.

Tew, Marjorie. 1990. *Safer Childbirth? A Critical History of Maternity Care*. London: Chapman & Hall.

Thesiger, Wilfred. 1987. *The Life of My Choice*. London: Collins.

Thiam, Awa. 1983. Women's Fight for the Abolition of Sexual Mutilation. *International Social Science Journal* 35 (4):747–56.

Thomas, Lynn M. 2003. *The Politics of the Womb: Women, Reproduction and the State in Kenya*. Berkeley: University of California Press.

Tignor, Robert L. 1976. *The Colonial Transformation of Kenya: The Kamba, Kikuyu and Maasai from 1900 to 1939*. Princeton, NJ: Princeton University Press.

Torsvik, Bente. 1983. Receiving the Gifts of Allah: The Establishment of a Modern Midwifery Service in the Sudan, 1920–1937. Unpublished M.A. thesis, University of Bergen.

Toubia, Nahid. 1994. Female Circumcision as a Public Health Issue. *New England Journal of Medicine*, 331:1 (Sept. 15):712–16.

———. 1995. *Female Genital Mutilation: A Call for Global Action*. 2nd ed., New York: Women, Ink.

Trimingham, J. Spencer. 1948. *The Christian Approach to Islam in the Sudan*. London: Oxford University Press.

Vallance, D. J. 1908. Notes on Ethnographical Specimens Collected by Dr. A. Mac-Tier Pirrie. *Third Report of the Wellcome Research Laboratories*. A. Balfour, ed. Khartoum: Department of Education, Sudan Government, pp. 377–84.

Van der Kwaak, Anke. 1992. Female Circumcision and Gender Identity: A Questionable Alliance? *Social Science and Medicine* 35 (6):777–87.

Vantini, Giovanni. 1981. *Christianity in the Sudan*. Bologna: EMI.

Vaughan, Meagan. 1991. *Curing Their Ills: Colonial Power and African Illness*. Stanford: Stanford University Press.

Verzin, J. A. 1975. Sequelae of Female Circumcision. *Tropical Doctor* 5:163–69.

Walker, Alice. 1992. *Possessing the Secret of Joy*. New York: Harcourt Brace.

Walker, Alice, and P. Parmar. 1993. *Warrior Marks: Female Genital Mutilation and the Sexual Blinding of Women*. New York: Harcourt Brace.

Walkley, C.E.J. 1936. The Story of Khartoum. *Sudan Notes and Records* 19(1):71–92.

Walley, Christine. 1997. Searching for "Voices": Feminism, Anthropology, and the Global Debate over Female Genital Operations. *Cultural Anthropology* 12(3):405–38.

Warburg, Gabriel. 1971. *The Sudan under Wingate: Administration in the Anglo-Egyptian Sudan, 1899–1916*. London: F. Cass.

———. 1978a. *Islam, Nationalism and Communism in a Traditional Society, the Case of Sudan*. London: Frank Cass.

———. 1978b. Slavery and Labour in the Anglo-Egyptian Sudan. *African and Asian Studies* 12: 221–45.

Waterston, D. 1908. Report upon the Physical Characteristics of Nilotic Negroid Tribes. *Third Report of the Wellcome Research Laboratories*, A. Balfour, ed. Khartoum: Department of Education, Sudan Government, pp. 325–76.

Webb, R. K. 1969. *Modern England*. New York: Dodd, Mead & Co.

Wehr, Hans. 1976. *A Dictionary of Modern Written Arabic*. J. M. Cowan, ed. 3rd ed. Ithaca, NY: Spoken Language Services.

White, Luise. 1990. *The Comforts of Home*. Chicago: University of Chicago Press.

Widstrand, Carl Gösta. 1964. Female Infibulation. *Varia I: Occasional Papers of Studia Ethnographica Upsaliensia* 10:95–124.

Wingate, Ronald. 1955. *Wingate of the Sudan*. London: Murray.

Winkel, Eric. 1995. A Muslim Perspective on Female Circumcision. *Women and Health* 23(1):1–7.

Winter, Bronwyn. 1994. Women, the Law, and Sexual Relativism in France: The Case of Excision. *Signs* 19(4):939–74.

Woodward, Peter 1985. In the Footsteps of Gordon: The Sudan Government and the Rise of Sayyid Sir Abd al-Rahman, 1915–1935. *African Affairs* 84 (334):39–51.

———. 1990. *Sudan, 1898–1989: The Unstable State*. Boulder: Lynne Rienner Publishers.

World Health Organization. 1986. A Traditional Practice that Threatens Health—Female Circumcision. *WHO Chronicle* 40(1):31–36. 1999. *Female Genital Mutilation: Information Kit*. Geneva: Health Systems and Community Health Cluster. Dept. of Women's Health.

———. 2000. *Female Genital Mutilation*. Fact sheet No. 241 (*http://www.who.int/mediacentre/factsheets/fs241/en*).

———. 2001. *Female Genital Mutilation: Policy Guidelines for Nurses and Midwives*. Geneva: W.H.O. Department of Gender and Women's Health.

Zenkovsky, Sophie. 1945. Marriage Customs in Omdurman. *Sudan Notes and Records* 26(2):241–55.

———. 1949. Customs of the Women of Omdurman, Part 2. *Sudan Notes and Records* 30(1):39–46.

———. 1950. Zar and Tambura as Practised by the Women of Omdurman. *Sudan Notes and Records* 31(1):65–81.

Ziegler, Philip. 1973. *Omdurman*. London: Collins.

Zimmern, Alfred, ed. 1936. *The League of Nations and the Rule of Law, 1918–1935*. London: Macmillan.

INDEX